BENVENUTO CELLINI was born in 1500 in Florence, where he spent the early years of his life training to be a goldsmith. His ties with the city remained close, and he returned there to work for Grand Duke Cosimo in the latter part of his life. But like many other Renaissance artists, he was attracted to Rome as a young and ambitious craftsman, and worked there for a variety of patrons including Popes Clement VII and Paul III. He also spent a period in France at the court of King Francis I.

Cellini was admired by his contemporaries as a goldsmith and sculptor and his powerful talent can still be seen in such works as the bronze statue of Perseus (in the Loggia dei Lanzi, Florence) and the gold saltcellar made for Francis I (in the Kunsthistorisches Museum, Vienna). But he is chiefly remembered for his vivid and revealing autobiography.

In this book, which Cellini started to write in 1558, he describes in a highly emotional and subjective manner the events of a full and colourful life, including his escapades as a boy in Republican Florence, his amorous and artistic adventures in Rome and at Fontainebleau, his travels through Italy and France, his lively encounters with the great artists and rulers of the day, his mystical visions and his terms in prison. He left the last few years of his life unrecorded, and died in 1571.

GEORGE BULL was an author and journalist who translated six volumes for Penguin Classics: Benvenuto Cellini's *Autobiography*, *The Book of the Courtier* by Castiglione, Vasari's *Lives of the Artists* (two volumes), *The Prince* by Machiavelli and Pietro Aretino's *Selected Letters*, as well as Aretino's *The Stablemaster* in *Five Italian Renaissance Comedies*. After reading History at Brasenose College, Oxford, George Bull worked for the *Financial Times*, McGraw-Hill *World News*, and for the *Director* magazine, of which he was Editor-in-Chief until 1984. He was appointed Director of the Anglo-Japanese Economic Institute in 1986. He was a director of Central Banking Publications and the founder and publisher of the quarterly publications *Insight Japan* and *International Minds*. His books include *Vatican Politics*; *Bid for Power* (with Anthony

Vice), a history of take-over bids; *Renaissance Italy*, a book for children; *Venice: The Most Triumphant City*; *Inside the Vatican*; a translation from the Italian of *The Pilgrim: The Travels of Pietro della Valle*; and *Michelangelo: A Biography* (Penguin, 1996; St Martin's Press NY, 1997). George Bull was elected a Fellow of the Royal Society of Literature in 1981 and a Vice-President of the British-Italian Society in 1994. He was awarded an OBE in 1990. George Bull was made Knight Commander of the Order of St Gregory in 1999, and awarded the Order of the Sacred Treasure, Gold Rays with Neck Ribbon (Japan) in 1999. He died on 6 April 2001.

THE AUTOBIOGRAPHY
OF BENVENUTO CELLINI

Translated and with an Introduction by
GEORGE BULL

PENGUIN BOOKS

FOR
JEREMY MITCHELL

PENGUIN BOOKS

Published by the Penguin Group
Penguin Books Ltd, 80 Strand, London WC2R 0RL, England
Penguin Putnam Inc., 375 Hudson Street, New York, New York 10014, USA
Penguin Books Australia Ltd, 250 Camberwell Road, Camberwell, Victoria 3124, Australia
Penguin Books Canada Ltd, 10 Alcorn Avenue, Toronto, Ontario, Canada M4V 3B2
Penguin Books India (P) Ltd, 11 Community Centre, Panchsheel Park, New Delhi – 110 017, India
Penguin Books (NZ) Ltd, Cnr Rosedale and Airborne Roads, Albany, Auckland, New Zealand
Penguin Books (South Africa) (Pty) Ltd, 24 Sturdee Avenue, Rosebank 2196, South Africa

Penguin Books Ltd, Registered Offices: 80 Strand, London WC2R 0RL, England

www.penguin.com

This translation published in 1956
Reprinted with a Bibliography 1996
Revised edition 1998

8

Copyright © George Bull, 1956, 1996, 1998
All rights reserved

Set in 10/12.5 pt PostScript Monotype Bembo
Typeset by Rowland Phototypesetting Ltd, Bury St Edmunds, Suffolk
Printed in England by Clays Ltd, St Ives plc

CONTENTS

INTRODUCTION

Benvenuto Cellini was born in 1500, wrote his autobiography at intervals during the years 1558–66, and died in 1571. The first printed edition of the *Life* did not appear until 1728, and it did not become widely known outside Italy until the early nineteenth century. During the past hundred years it has taken its place as the most famous, or notorious, of all autobiographies.

Despite its egotism and bias, it gives us the most vivid and convincing account we have of the rulers of the sixteenth century and of the manners and morals of their subjects. Cellini's friends and enemies were drawn from every level of society: we are introduced, in rapid succession, to inn-keepers and prostitutes, merchants and soldiers, musicians and writers, cardinals and dukes. Cellini is the protagonist of this world: he alone appears in the round, the men and women he describes are in half or low relief.

The reader can appreciate Cellini's character and the adventures he recounts without knowing a great deal about the sixteenth century. The *Life*, after all, is itself a revealing historical document, shedding light on matters as diverse as prison conditions in Rome, the behaviour of Florentine exiles, or the relationship between Francis I and his mistress. Apart from his devotion to the House of Medici and from the occasional, rather intelligent comments that were forced out of him (as, for example, when Alessandro de' Medici was murdered), Cellini was always anxious to dismiss politics as being no concern of his. And, although his pen often ran away with him, he was trying to write the story of his own life, not the history of his times.

Yet during his lifetime the republic of Florence was overthrown by

a *coup d'état*, the Medici were restored to the government of Florence, and then driven out, and then restored again; Rome was sacked by the Imperial army; the Papacy diffidently initiated the Counter-Reformation; the Continent was rent by religious and dynastic wars.

Only six years before Cellini was born the peace of Italy had been shattered by the invasion of King Charles of France. Besides quickening the pace at which Italian art and ideas spread to the rest of Europe, the invasion was a prelude to the struggle between France and Spain for the mastery of Italy and, arising out of the Italian wars, to the prolonged conflict in every part of the Continent between the House of Habsburg and the House of Valois. Charles's invasion was followed up with more vigour and intelligence by his successors, first Louis XII and then Francis I. But during the reign of Francis, when the rivalry between France and Spain became more embittered by the concentration of enormous territorial power in the hands of the Emperor, Charles V, Italy passed decisively into the orbit of Spain.

In 1500, Italy was a mosaic of states, each maintaining a precarious independence; Florence was experimenting with a republican form of government inaugurated under the guidance of Savonarola. When Cellini died, Italy was still composed of many great and small principalities. But national unity and independence were frustrated by the power of the Papal States and by the rule of Spanish viceroys in Naples and Milan. After several abortive attempts to found a lasting republic, Florence had succumbed to despotism in the person of Cosimo de' Medici.

Elsewhere in Europe the rapid progress of the Reformation was halted by the wars of religion in France and by the harsh alliance of Spain with the Counter-Reformation. The way towards a Europe of self-contained sovereign states was confirmed by the strengthening of national monarchies. In France the wars and startling diplomatic intrigues pursued by Francis I did not prevent the consolidation of royal power at home. The King continued the centralizing policy of his predecessors, gradually reducing the feudal nobility to impotence. By active patronage and by a policy which increased the prosperity of the smaller nobles and middle classes he ensured the assimilation of the 'Renaissance'.

Cellini played a vigorous part in the wars and struggles of his age, acting as one of Pope Clement's gunners during the sack of Rome,

helping in the fortification of Paris or Florence. But more important to him than the campaigns of the French King was the shortage of money at the French court; more important than the Reformation was the knavery of the Lutheran friar whom he met in Castel Sant'Angelo. What to us are decisive dates of history – 1519, the election of Charles as Emperor; 1520, the excommunication of Luther; 1527, the sack of Rome – were to him insignificant in comparison with the details of his personal triumphs and tragedies.

The first nineteen and the last twenty-six years of Cellini's life were spent in Florence. He went to Rome in 1519 and – except for occasional visits to Florence and elsewhere, and a disappointing trip to France – he remained in Rome, serving Clement VII and then Paul III, from 1523 until 1540. In that year he travelled to Ferrara and then to France, where he undertook several important works, including the renowned salt-cellar, for King Francis I, in whose service his thoughts turned eagerly towards the art of sculpture.

Cellini's patriotism is attested in the *Life* itself; his closest friends were Florentines and he seems to have kept in close touch with the Florentine colony both at Rome and Paris. Long before the end of his life he was drawn back to Florence, and, even though he bitterly complained that he longed to return to the French court, it was mainly old age and frustration that caused him to look back to the time when he was serving Francis I as the golden period of his life. His love of Florence did not prevent his deserting the city when it was attacked by Imperial troops intent on restoring the Medici. (His desertion was matched by Michelangelo's, who, in Vasari's words, decided 'to leave Florence secretly for Venice, to make sure of his personal safety'.)

And, to be sure, Cellini owed more to the Medici than to a republican government. Both his art and his character were moulded by the despotic court life of the period: the Papacy in Rome, the increasingly powerful Monarchy at Fontainebleau, the ruthless authority of Grand Duke Cosimo at Florence.

These rulers Cellini regarded as being above the laws by virtue of their authority, as he was above the laws by virtue of his genius. But his heroic stature was such that even they, at times, were dwarfed in his presence. Cellini's heroic view of himself is successfully matched

by the virile, heady style in which the *Life* is written. It is a great work of art, and it has been common criticism that he created his masterpiece unconsciously. But the idea that he merely rambled on without plan or polish fails to take account of the obvious care he took to discipline his material, to model his story on the humanist rules of classical reference and distinguished ancestry, and to correct its language, if possible under the eye of an expert. He was a fairly well-read and a reasonably cultured man, well aware of the exalted literary standards set by his friends and contemporaries.

Cellini himself encouraged the idea that the *Life* was a work of rapid spontaneity, mostly dictated to a boy of about fourteen while he himself was busy with the real, furiously intense work of the sculptor and gold-smith. Most writers on Cellini have accepted Benvenuto's own version of the genesis and composition of the autobiography. But Cellini's account is at least questionable and based rather on what he thought would be appropriate than on reality. The argument that the *Life* was in fact con-sciously planned and shaped, a calculated and complex literary pro-duction, is first prompted by appreciation of the scarcely possible nature of the task of dictating the nearly 900 pages of the surviving manuscript to yield what is a literary masterpiece sustained by specific themes and divided into two books with sharply different aims.

This reappraisal of critical aspects of the purpose and composition of the *Life* is strengthened by material evidence that Cellini produced a first draft of the *Life* which was lost or destroyed. This supports the conclusion that he wrote an early draft or even several drafts, and that in painstakingly preparing his text surely wished to present an idealized self-image, a coherent narrative, and a cast of characters relevant to his epic. As further evidence, Paolo Rossi notes that the autograph end passages of the text present a rambling, somewhat confused story.★

Cellini was a prolific writer producing, as well as the *Life*, important treatises on goldsmithing and sculpture, another treatise on architecture

★ For the full and convincing demonstration of the contrived character of the *Life* see the revealing paper by Paolo L. Rossi, 'Sprezzatura, patronage and fate; Benvenuto Cellini and the world of words' in *Vasari's Florence: Artists and Literati at the Medicean Court* ed. P. Jacks (Cambridge, 1998 pp. 55–69). Rossi argues that the famous manuscript of the *Life* in the Laurenziana in Florence is a fine copy, possibly completed ready for the printer.

and the art of drawing, and a great deal of verse. Flexibly and brilliantly employed in the *Life*, his language was as idiosyncratic as his character. Carefully as he planned the unfolding of the story, often what he writes has all the repetitiveness and insistence of the spoken word. There are long passages where his sentences follow each other with the staccato of a legal document; others where there is no grammatical connexion between the end of a period and its beginning; sometimes the manuscript itself is defective. He is often inconsistent. His language is rich in slang, involved, occasionally almost incoherent.

But he was an adroit raconteur with a clever sense of plot and character. He knew how to move gracefully from comedy to tragedy. All the stories embedded in the *Life* – of Angelica and the demons, or the drama of his brother's death, or the justice that overtook Luigi Pulci – show a neat, calculated use of suspense. The description of his meeting the Roman lady, Porzia, displays a surprising delicacy of character and language which makes itself apparent more than once in the book. His brief account of how Pope Clement, when on his death-bed, unable to see the medals brought him, fingered them and sighed deeply, tells us as much about the Renaissance Papacy as many a detailed history. Despite his egotism, he was interested enough in other people to be able to convey vividly if not impartially the essential qualities of those who moved across his life: his philoprogenitive father, his speech choked with biblical allusions, drawn as a young suitor, an ambitious, wrong-headed musician, a shrewd old gentleman; or the beautiful Spanish boy Diego, the wily courier Busbacca, the timid Tribolo, the schizophrenic castellan, to name some of the minor actors alone.

His powers of invective are enviable. And, as Tribolo complained on the return journey from Venice, he has an irrepressible sense of humour, sometimes turning to irony, more often to Rabelaisian explosions that subside into melancholy. He loves punning – on his own name, on Felice Guadagni's, on Durante's. The doctors and priests provoke his dry sarcasm. Like Pangloss who lost only an eye and an ear during treatment, Cellini was doctored 'with everything they knew; and every day [I] grew worse'.

Intent on achieving literary excellence, Cellini, in 1559, sent what he had written to the renowned scholar Benedetto Varchi (to whose

published debates on the rival merits of painting and sculpture he had contributed his own forthright views). Instead of revising it as his friend had asked, Varchi merely added some notes and made a few very minor revisions. Whether he felt the task was superfluous or beneath him, we do not know; at this time, artists and men of letters, the professional *letterati*, were jealously competing for intellectual and social status, not least at the court of the Medici.

The *Life* brings the story of Cellini's adventures down to the year 1562. He stresses its devout purpose: he wrote to thank God. But he also wrote with an eye to his public: the book was his apologia, intended to show the world what kind of man and artist he was. The manuscript ends abruptly, with the words 'and then I set off for Pisa' written at the top of an otherwise blank page. Cellini was then aged sixty-two. His best work was done, and, frequently ill and none too well off, he had finally settled in Florence. Judging by the concluding pages of the *Life* and by what we know of his subsequent troubles, had he continued the story after 1562 it would have been an ill-tempered catalogue of bad treatment and undeserved misfortune.

In 1554 he had been officially recognized as a member of the Florentine nobility, but two years later he was imprisoned for assaulting another goldsmith, and the following year occurred his condemnation and sentencing on the charge of practising unnatural vice with his apprentice.[*] In 1558, strongly reacting to the bitter challenge of his

[*] The crime of sodomy in Cellini's time usually referred to sexual intercourse between males though it could stand for a range of sexual practices contrary to Roman Catholic teaching on sex and procreation. The modern term 'homosexuality' was not in use. Cellini's lust for young men and his bisexuality are clear from several revealing passages in the *Life*, though understandably – penalties could be horrific – he reacted scathingly, sometimes hilariously, against the accusations of sodomy which he did report.

He was convicted for sodomy in Florence in 1523 and 1557 and unsuccessfully prosecuted for sodomy with a woman, Caterina, in France in 1543.

Before 1557 Cellini had been living with his *ragazzo*, Ferrando di Giovanni da Montepulciano, for several years. He had made a will somewhat in his favour but, when Ferrando deserted him in the summer of 1556, cut out any legacy to him. The charge against Cellini followed in February 1557, possibly through the efforts of members of the court to curb his excesses. For the general context of Cellini's sexual life, see Rossi's 'The writer and the man. Real crimes and mitigating circumstances: *il caso Cellini*' in *Crime, Society and the Law in Renaissance Italy*, eds Trevor Dean and K. J. P. Lowe (Cambridge, 1994).

recent trials and tribulations, he decided to write the story of his life's great struggles and triumphs and, in repentance, to take the minor orders of the Church. He received the tonsure, only to be released from the obligations this imposed and, a few years on, to marry a Piera di Salvadore Parigi. Soon after, he began writing the *Trattati* – the treatises on goldsmithing and sculpture – a technical work occasionally enlivened by references to his own achievements and experiences. In 1564 he had been elected, along with Bronzino, Vasari, and Ammannati, to attend the obsequies for Michelangelo's funeral, but he was too ill to take part.

Not content with having fathered at least eight children, legitimate and illegitimate, of his own, in 1560 he had adopted the son of his model Dorotea and her husband, Domenico Parigi. None of his own sons had lived, and he intended to make the boy his heir. But Antonio proved worthless, his father began to interfere in the arrangements, and in 1569 Cellini disinherited him, though he was compelled to pay an allowance for his upkeep. In February 1571 Cellini died of pleurisy and was buried with honour in the church of the Annunziata.

The Florentines honoured him at his death, and they thought highly of him as a craftsman when he was alive, although their opinion was divided on his ability as a sculptor. The modern concept of the artist is, perhaps, too narrow to include Cellini, and it is limiting to categorize him as simply a dedicated artist. The *Life* makes abundantly clear that Cellini like many of his contemporaries, including Michelangelo's biographer Ascanio Condivi, found astrology of absorbing interest and relevance to the story of a life in whose telling he constantly referred to experiences with magic and – as in the amazing religious revelation when he was imprisoned in Castel Sant' Angelo – with mysticism. In his penetrating analyses of Cellini's psychology, Paolo Rossi has linked the division of the *Life* into two texts – dramatically divided by a long poem – to Cellini's conviction that an uncontrollable force had shaped his destiny. The message given to Cellini through his astrological chart was that after a period drenched in violence and vengeance, he would experience a dramatic conversion taking him to the redeeming processes of travel and spirituality. Cellini's trial and condemnation for sodomy in 1557, his unpopularity at court, the fear that caused him to take

minor orders after he had been fined, imprisoned and deprived of the right to hold public office, moved him to write the first book of his life as the account of an innocent man persecuted by the malignant stars who in the end triumphs over his adversaries and is reconciled to God. The second book, which he started to write in 1561, in contrast to the ordered astrologically determined structure of the first, presents Cellini in the simpler guise of an artist at court, successfully striving against great odds to create magnificent works.

In Cellini's *Life* there have also been perceived sustained efforts to establish the protagonist as a man in the mould of Michelangelo with experiences constantly similar to those of the master and, on the other hand, the composition of a new literary form, anticipating the fiction of the post-Renaissance world, 'best interpreted in the light of the theory of the novel and its fundamental analytical criteria'.*

Cellini himself, discussing the works of Dante, remarked caustically that the commentators made him say things 'of which he never even thought'. The *Life* will always be a rich pasture for imaginative exegesis and original interpretation.

Undoubtedly, it was chiefly as an artist that Cellini wrote his autobiography. With his love of beauty – especially the beauty of the human form – went a delight in craftsmanship and difficult achievement. He writes of his art as if it were his mistress: sometimes he was unfaithful to her, as when during the siege of Castel Sant'Angelo his drawing, his studies, and his wonderful music were all forgotten in the sound of the guns. But even his liking for warfare was a delight in dramatic execution and skilful effect.

So, if the first climax of the *Life* occurs when Cellini is assured by a vision during his imprisonment of God's approval of his character and deeds, the second occurs when his own frenzied labours and divine intervention bring about the successful casting of the *Perseus*.

As an artist, he regarded himself as a faithful disciple of Michelangelo, and he never tired of repeating how much he owed 'that great Michelangelo, from whom alone and from no one else I have learnt all I

* See *The 'Vita' of Benvenuto Cellini: Literary Tradition and Genre* by Dino Sigismondo Cervigni (Ravenna, 1979).

know'. Michelangelo did exert a continually strong influence on his style, both while he was at Rome and when he was back in Florence, showing itself particularly in his two most famous works, in the salt-cellar made for Francis I and in the base of the Perseus. Besides the Perseus and the salt-cellar (the former now in the Loggia dei Lanzi, at Florence, and the latter at the Kunsthistorisches Museum, Vienna) sufficient remains of his work to give some idea of his artistic status.

Cellini's own exalted estimate of his artistic powers cannot be dismissed merely as part and parcel of an habitual rhodomontade. Two contemporaries – Varchi and Giorgio Vasari – acknowledged his competence as a jeweller. Vasari, again, wrote that he made medals in a way surpassing the ancients, that he was the most famous goldsmith of his day and a distinguished sculptor. And we have evidence of his skill as a goldsmith and medallist in the salt-cellar, in medals and coins struck for Pope Clement and Alessandro de' Medici, in studies of Pope Clement's morse, and in impressions of various seals. But the question of his status finally revolves, as Cellini himself would have wished, round his work as a sculptor.

By the time Cellini arrived in France in 1540, Italian influence was strong and widespread. He was able to use the kingly if erratic generosity of Francis I to display his virtuosity as a sculptor. The work done at Fontainebleau was a variety of Mannerism to which Cellini made his own distinctive contribution, but, typically, this contribution was in his treatment of detail and his technical skill. The great statue of Mars, mentioned in the *Life*, illustrated his corresponding urge for the grandiose and the sensational, but his main achievement was the *Nymph of Fontainebleau*, which still survives.

When he returned to Florence, he determined to show the Florentines that he now ranked as a sculptor second to none. Among the extant productions of this period are the *Perseus*; the *Greyhound*, the bust of Cosimo, the *Ganymede* in marble, *Apollo and Hyacinth*, and the *Narcissus* (all in the Museo Nazionale); the bust of Bindo Altoviti (now in the United States); and the Crucifix (in the Escorial).

Symonds' judgement, still sometimes echoed, was that Cellini had the 'qualities of a consummate craftsman, but not those of an imaginative artist' and that his work is 'deficient in depth, deficient in true dignity

and harmony'. More recently, with insistence on the right of Mannerism to be considered not as a decadent art form but as a distinct artistic style, existing in its own right, the tendency has been to reinstate Cellini as a sculptor and to set a far higher value on his work.★

It is, however, the *Life* which has won Cellini his immortality. After various vicissitudes, the manuscript disappeared during the eighteenth century. In 1805 it was discovered in a bookshop, and, twenty years later, was bequeathed by its owner to the Laurentian Library at Florence, where it now is. The first printed edition which appeared in Naples in 1728 was taken from an unknown source. Some time before the *Life* was translated into French or German it was known here in the version of Thomas Nugent, first published in 1771. In 1796 it was translated into German; and in 1822 it found its way into French, near the height of the romantic movement. There have been several English translations, by Nugent, by Thomas Roscoe (1822), by John Addington Symonds (1887), by Anne Macdonell (1903), and by Robert Cust (1910).

In my own translation I have tried to bring out the extravagance of the original and its frequent changes in tempo and emphasis. It is hardly possible to match all Cellini's colloquialisms in present-day English, and inevitably many subtleties – particularly in his vocabulary of abuse – are lost. I have not hesitated to shorten his periods now and then, to remove obscurities where possible, and to break the text with frequent paragraphing. I have generally standardized place and proper names, but otherwise left them in their original form, save where it seemed reasonable to give them in a form easily recognizable by the English reader. Finally, I can best bring this introduction to a close by quoting, with mixed feelings, the comment of a French scholar – Eugène Plon – on translating the *Life*. Cellini's language, he wrote, 'is the dialect of the Florentine people, so pure, so original, and so witty, that it defies translation'.

★ For important reassessments see in particular the Conference reports *Benvenuto Cellini Artista e Scrittore* (Accademia Nazionale dei Lincei, 1972).

In his assessment of Cellini's artistic achievements, Pope-Hennessy singles out his marble Crucifix as intended to embody 'the technical sophistication, the humanity, and the imaginative sweep of the Renaissance at its height' and in its 'truly Michelangelesque' technique as 'the supreme marble sculpture of its time'.

ACKNOWLEDGEMENTS

For being able to work happily on this revised and extended edition of my translation of the *Life* I am grateful to my editor and friend, Peter Carson, who in this context follows in the footsteps of the remarkable E. V. Rieu who first boldly commissioned the translation from me as an early Penguin Classic. My special thanks are also due to the scholarly and editorial advice and help given by Paolo Rossi, Helen Hyde and Jennie West in the preparation and completion of this edition, with notes, index and extended introduction.

G. B.

et alcuanto lapiu amoreuole et dicontinuo misgridaua che io
mi ero sbigottito et dallaltra banda mi facieua le maggiore
amoreuolezze diseruitu che maifar sipolsa almondo, i
pero uedendomi con cosi smisurato male et tantosbigot-
tito (o tutto il suo brauo cuore lei nosipoteua tenere
che qualche quantita dilacrime nonghicadessi da
ghiocchi, et pure lei guanto poteua siriguardaua che
io nollte uedessi. stando iqueste smisurate tribulatio-
ne io miuegghio, entrorei camera un certo huomo
il guale nella sua persona ei mostraua dessere storto
comie una esse, manuscosa &comincio a dire conunt
certo suon, diuosce mezo afflitto, come coloro che
danno il comadamento dellanima a guei cheanno
andare a giostina. e disse 'o, benuenuto lauostra
'opera si, e guasta, et nocie piu un rimedio almondo
Subito che io senti leparole di quello sciagurato, mes-
si un grido tanto smisurato che sisarebbe sentito
dal cielo del fuoco et solleuatomi delle ho presi
lima panni et micominciai auestire ey leserue el
mio ragazzo et oghuno che misi accostaua paiu-
tarmi, atutti io daua, o calci, o pugnia ermila-
mentauo dicendo a,i, traditori Tudiosi, questo si'e,
un tradimento fatto à Aorte ma io giurro p cuo

CELLINI'S PREPARATORY SONNET

I write about my troubled life
to thank the God of nature
who gave me my soul and then took care of it.
I have been involved in astounding exploits and I have
 lived to tell the tale.

That cruel destiny of mine has diminished my life,
my wealth, my glory and my virtue more than I deserved.
In grace, valour, beauty, and in my art
I have surpassed many and arrived at the level of the one
 who was my better.*

The one thing that grieves me greatly
is that I can now see the time lost in vain pursuits
the wind carries away our fragile aspirations

But since regret is futile, I shall be happy
to ascend to heaven welcome as I was when born
in the flower of this Tuscan land.

This prose translation is presented for convenient comparison with Cellini's complex and sometimes obscure Italian verse. It is the challenging version by Paolo Rossi based on his original interpretation of the sonnet, discussed fully in Rossi's forthcoming Monograph on Cellini (Manchester University Press).

* Surely Michelangelo.

A CHRONOLOGY OF CELLINI

(Adapted from *The Life of Benvenuto Cellini*, trans. R. Cust)

1500–1515 Cellini is born in Florence on 3 November 1500. His father makes him study music. He is taught the goldsmith's craft by the father of the sculptor Baccio Bandinelli. He works in the shop of Marcone the goldsmith.

 From 1502 Piero Soderini governs Florence as '*gonfaloniere* for life' till 1512, when the Medici return to power.

1516–18 Cellini is banished to Siena and enters the workshop of the goldsmith Francesco Castoro. After six months he returns home and then goes to Bologna where he studies music and the working of precious metals.

 After returning to Florence, he leaves for Pisa and remains a year with Ulivieri della Chiostra. He returns to the workshop of Marcone in Florence.

1518–23 Cellini endeavours to imitate the style of Michelangelo, and copies Filippo Lippi's drawings. He goes to Rome with the woodcarver Tasso. In the shop of Firenzuola he makes a salt-cellar.

 At the end of two years he returns to Florence, to Salimbene, in whose shop he makes a silver 'heart-key' (*chiavacuore*). He is heavily fined for violence and makes a furious attack on his enemies. He flees to Rome.

1523–4 Clement VII (Cardinal Giulio de' Medici) becomes Pope.

 In Rome Cellini enters the workshop of Lucagnolo of Jesi. He comes to know Gianfrancesco Penni, '*il Fattore*'; and

studies the works of Raphael and Michelangelo. He works for Porzia Chigi and makes a large vase for the Bishop of Salamanca. He shares a workshop with Giovanpietro della Tacca, a goldsmith from Milan, and joins the papal orchestra.

Cellini works for the Pope and several cardinals. He takes a shop of his own, where he makes a medal of Leda and the Swan for Gabrielo Cesarini.

1524 Cellini is involved in a duel. He works in rivalry with Lautizio, Caradosso and Amerighi on seal-cutting, engraving with the chisel and enamelling. He studies the antiquities of Rome. He makes two vases for Jacomo Berengario da Carpi.

After an illness, he goes to Cervetri to visit the painter il Rosso. He engraves foliage and grotesques and works in rivalry with Caradosso in making medals. He nurses, assists and quarrels with Luigi Pulci who is thrown from his horse and dies.

1527 In February, German *Landsknechts* join forces with the Spanish troops under the Duke of Bourbon whose undisciplined army moves south to besiege Rome. Bourbon is killed by a chance bullet perhaps fired by Cellini who takes refuge in Castel Sant'Angelo.

Cellini melts down the gold from the papal jewels. He apparently wounds the Prince of Orange, successor to Bourbon as Captain-General.

1528–9 Cellini returns to Florence and buys remission of the Ban against him. He goes to Mantua, works in the shop of Master Niccolò and is welcomed by Giulio Romano.

He executes a reliquary for the Duke of Mantua, and a seal and other works for Cardinal Gonzaga. He leaves Mantua for Florence where he finds his father dead. For Girolamo Marretti he makes a medal showing Hercules and the Nemean Lion, and for Federigo Ginori a medal of Atlas.

Clement VII declares war on Florence. He recalls Cellini to Rome.

1529–30 Florence surrenders to the Papacy. Clement VII receives Cellini in Rome and absolves him. Cellini is commissioned to make a morse for the Pope's cope. He is employed to make dies for the pontifical Mint and is made Keeper of the Dies of the papal coinage.

Cellini continues in the workshop of Raffaello del Moro and makes friends with Monsignor Gaddi, Annibale Caro, and other scholars. He strikes a coin, upon which is a figure of St Peter walking upon the sea.

Cellini's brother is slain in a scuffle; Cellini kills the assassin. His shop is broken into but the Pope's jewels are safe.

1530–32 Cellini is suspected of forgery but proven innocent. He is appointed a papal mace-bearer and designs a chalice for the Pope. He applies unsuccessfully for a vacant post in the Privy Seal Office, which is given to Sebastiano, thereafter known as Sebastiano del Piombo.

1532 Alessandro de' Medici is named Duke of Florence.

Cellini competes in designing the mount for a unicorn's horn. He is deprived of his post at the Mint and refuses to give up the unfinished chalice.

1533–4 Cellini falls in love with a Sicilian girl. He befriends a priest who practises necromancy.

He competes for a medal with Giovanni Bernardi of Castel Bolognese.

Accused of killing his rival Tobbia, Cellini flees to Naples where he visits the antiquities and is received by the viceroy. He returns to Rome to the house of Cardinal Ippolito de' Medici. He presents to the Pope a medal bearing the figure of Peace, and receives a commission to make another reverse for it representing an episode in the life of Moses.

1534–5 Pope Clement VII dies and is succeeded by Alessandro Farnese, Paul III. Cellini kills Pompeo the goldsmith.

Pope Paul desires Cellini to undertake his coinage and

provides him with a safe-conduct. Cellini makes *scudi* adorned with the design of the *Vas Electionis*.

Persecuted by Pier Luigi Farnese, Cellini is warned by one of his intended assassins and escapes to Florence.

1535 From Florence, with the sculptor Tribolo, Cellini travels to Venice where he visits the sculptor Sansovino.

After returning to Florence he makes coins and other works of art for Duke Alessandro de' Medici. Recalled by the Pope, he returns to Rome against the will of the Duke, for whom, however, he promises to make a medal.

In Rome Cellini is pardoned for the murder of Pompeo.

1535–7 In November Cellini goes to Florence and encounters the Duke. He returns to Rome, where he works upon the Duke's medal.

The vision of a conflagration in the air in the direction of Florence warns him of the death of Duke Alessandro. Cosimo de' Medici is called on to take power in Florence.

For the Emperor Charles V on the occasion of his visit to Rome Cellini makes the cover for a *Book of Offices of the Madonna*.

1537 Cellini sets a diamond in a ring for Paul III. He completes the bookcover for the Emperor Charles V.

He decides that he will go to France and leaves Rome on 2 April. At Padua he makes designs for a medal for Pietro Bembo. He journeys through Switzerland. In June he arrives in Paris.

1537–8 After the assassination of Alessandro de' Medici, Cosimo de' Medici is named Duke of Florence and rules till 1574.

In Paris Cellini visits Rosso, the painter. He is received by King Francis I, and accompanies the court to Lyons. Falling sick he returns to Italy, visiting Ferrara and Loreto en route, reaching Rome in December.

Cellini executes a commission for the wife of Gerolamo Orsini; and makes a basin and ewer for the Cardinal of Ferrara.

He is recalled to France, but is then arrested and thrown into the Castel Sant'Angelo.

1538 Cellini is accused of stealing and imprisoned in Castel Sant'Angelo. Monsignor di Morluc demands his release, in the name of the King of France. Having broken his leg in escaping by descending the keep of the castle, Cellini is taken into Cardinal Cornaro's palace.

1538–9 Cardinal Cornaro and Roberto Pucci beg the Pope to release Cellini. Cardinal Cornaro hands Cellini over to the Pope. He is transported to the Torre di Nona and then taken back to the Castel Sant'Angelo.

1539 Cellini tries to commit suicide. After having a vision of a beautiful young man, he prays to God in ecstasy. He is taken back to the large cells occupied by him at the beginning of his imprisonment. The castellan dies, and Cellini suspects his enemies of trying to poison him.

The Cardinal of Ferrara procures Cellini's liberty from the Pope. Cellini notices that a halo remains around his head in consequence of his visions. He writes a poem celebrating his imprisonment.

1539–40 Cellini stays with the Cardinal of Ferrara for whom he makes a silver basin and ewer and a pontifical seal. The cardinal gives him a commission for a salt-cellar. He makes the model after a design of his own.

He leaves Rome on his way to France. From Florence he proceeds to Ferrara, where he finds Cardinal Ippolito d'Este. For Duke Ercole he makes a portrait upon a medallion of black stone, with a reverse representing Peace.

1540 Summoned by the Cardinal of Ferrara, Cellini leaves Ferrara for Paris. At Fontainebleau he exhibits his basin and ewer to the King. He leaves determined to make a pilgrimage to the Holy Sepulchre; but is persuaded to turn back.

Ordered to make twelve silver statues Cellini presents the

King with models for Jove (Jupiter), Juno, Apollo and Vulcan. The Château de Petit Nesle is allotted as his residence and workshop. He makes large-sized models of Jove, Vulcan and Mars. He receives a commission from King Francis to make a salt-cellar after he shows the wax model prepared for the Cardinal of Ferrara; he is told to carry it out in gold.

1540–43 Cellini works on a salt-cellar and a large silver vase. He casts in bronze the base for a figure of Jove, adorned with bas-reliefs.

 The King orders him to adorn the château of Fontainebleau for which he produces the models for the entrance and a fountain.

 Becoming in danger of falling into disgrace with the King, he is favoured by the Dauphin and the Queen of Navarre.

1543 The order for the fountain at Fontainebleau is transferred to Primaticcio. Cellini expels Paolo Miccieri and his model and mistress from his premises. Cellini visits Fontainebleau to discuss the dies for the King's coins, but fails to reach agreement. He compels Miccieri to marry Caterina.

1543–4 Cellini continues work on the doorway at Fontainebleau, on the salt-cellar and on the statue of Jove and completes the doorway. He shows the King the statue of Jove.

1544 Cellini assembles the Fontainebleau doorway and is consulted by the King on the fortifications of Paris. Disgruntled by lack of supplies, Cellini for a second time begs for permission to return to Italy.

1545 Cellini leaves Paris and arrives at Piacenza, where he meets Duke Pier Luigi Farnese. He visits Duke Cosimo I de' Medici at Poggio a Caiano and discusses the making of a *Perseus*. Tasso the joiner makes up the framework for the model of Perseus. After his allowance is fixed at two hundred *scudi*, Cellini starts work on the *Perseus*.

1545–6 Cellini makes a *Perseus* in plaster and a *Medusa* in clay. In the Duke's wardrobe he works with the goldsmith brothers,

Giovan Paolo and Domenico Poggini, and executes a larger than life bust of Duke Cosimo in clay.

Cellini is accused of unnatural vice and quits Florence for Venice, where he is received by Titian and Sansovino, and where he meets Lorenzino de' Medici (the assassin of Duke Alessandro) and the Prior, Leone Strozzi, who exhort him to return to France. He returns to Florence.

1546–7 Cellini casts the bust of Duke Cosimo in bronze. He prepares the sketch-model for a pendant in which to set a diamond. He offers to make the Duke's coinage. He executes some small silver vases for the Duchess. Cellini goes to Fiesole to see a natural son of his who is accidentally smothered.

Bandinelli offers Cellini a block of marble. Cellini offers to restore a mutilated fragment of an antique statue as a *Ganymede* for Duke Cosimo. He makes a group of Apollo and Hyacinth and then sculptures a *Narcissus*. There are floods in Florence.

1548–9 Cellini disputes with Duke Cosimo over the casting of the *Perseus* in bronze and over the head of *Medusa*.

The casting is unveiled.

Pope Paul III dies and is succeeded by Cardinal de' Monti (Pope Julius III).

1552 Michelangelo praises Cellini's portrait-bust of Bindo Altoviti. In April Cellini goes to stay with Altoviti in Rome. He visits Pope Julius and he tries to persuade Michelangelo to return to Florence.

1552–4 In the programme to fortify Florence – because of the war with Siena – Porta al Prato and the postern leading to the Arno are entrusted to Cellini. He fortifies the bastion and completes the *Perseus*.

A figure of a Chimera is discovered near Arezzo. Cellini transports the statuettes for the base of the *Perseus* to the palace. The *Perseus* is finally uncovered still incomplete. In April 1554 the completed *Perseus* is exhibited.

1554–6 Pope Julius dies and is succeeded by Cardinal Cervini (Pope Marcellus) and then (May 1555) by Cardinal Caraffa (Pope Paul IV).

At Bagno Cellini is received by the family of his workman Cesare. He returns to Florence to warn the Duke of the threat of a sudden invasion by Piero Strozzi.

After a dispute over payments for the *Perseus* the Duke orders Cellini to make some bronze bas-reliefs for the choir of the Duomo in Florence. He proposes to the directors of the Opera del Duomo that he should make a bronze door like those of the Baptistery. The Duke approves of his making models for two pulpits for the choir. These are never commissioned.

1559 Cellini inspects the marble for the *Neptune* and shows the Duke two small models for the statue. He exhibits the model of Neptune. Baccio Bandinelli dies. Cellini destines his Crucifix for the Church of SS Annunziata. He continues to make models for the *Neptune*.

In the summer he visits Trespiano and Vicchio, where he is poisoned. Ammannati tells Cellini that he has acquired the marble for the *Neptune*.

1559–62 Pope Paul dies and is succeeded by Cardinal Medici (Pope Pius IV). One of Ammannati's sons removes part of the curtain that veils the model of Cellini's *Neptune*. Cellini visits Duke Cosimo at Livorno and returns to Florence satisfied. He shows the Duke and Duchess the completed Crucifix and models for the *Neptune* and the proposed fountain. The Duchess promises him a piece of marble.

Cardinal Giovanni de' Medici dies and Cellini goes to Pisa.

THE LIFE OF BENVENUTO
THE SON OF GIOVANNI CELLINI
WRITTEN BY HIMSELF
IN FLORENCE

I first began writing this Life of mine in my own hand, as can be seen from some of the odd pages attached here, but it took up too much of my time and seemed utterly pointless. So when I came across a son of Michele Goro, of Pieve a Groppine, a young boy of about fourteen who was in a poor state of health, I set him to the task. And while I worked I dictated my Life to him, with the result that as I quite enjoyed doing this I worked much more keenly and produced a good deal more. So I left the burden of writing to him and I hope to carry on with the story as far as my memory allows.

No matter what sort he is, everyone who has to his credit what are or really seem great achievements,[1] if he cares for truth and goodness, ought to write the story of his own life in his own hand; but no one should venture on such a splendid undertaking before he is over forty. Now that I am leaving the age of fifty-eight behind me and find myself in my native place, Florence, my thoughts naturally turn to such a task. Like all other men I have often had to struggle hard with fortune; but now I am less troubled by adversity than at any time before in my life and, in fact, I believe that my mind is more at rest and that I am enjoying better health than ever. I remember some of the delightful and some of the indescribably terrible things that have happened to me, and when I think back to them I am startled to realize that I really am fifty-eight years old and, with God's help, am prosperously growing older.

It is true enough that men who have worked hard and shown a touch of genius have already proved their worth to the world. They

have shown that they are capable men, and they are famous, and perhaps that should be sufficient. Still, I must do as I find others do, and so I intend to tell the story of my life with a certain amount of pride. There are many kinds of conceit, but the chief one is concern to let people know what a very ancient and gifted family one descends from.

My name is Benvenuto Cellini. My father's name was Giovanni, my grandfather was Andrea, and his father was Cristofano Cellini; my mother's name was Elisabetta and she was the daughter of Stefano Granacci. And both my parents were Florentines.

Now we find that our ancient Florentine chroniclers, men who are completely trustworthy, record that, just as Giovanni Villani writes,[2] Florence was clearly founded in imitation of the beautiful city of Rome: and it still shows some traces of the Colosseum and the Baths. These are near Santa Croce: the Capitol used to stand on what is now the Old Market; and the Rotunda, which was built as a temple to Mars and is still intact, is now our church of St John. The buildings I have mentioned are far smaller than the corresponding ones at Rome, but the origin of our city is quite plain and can be denied by no one.

They say that Julius Caesar himself was responsible for founding Florence, and that after Fiesole had been attacked and captured he determined in company with several other Roman nobles to build a city in which each one of them would undertake the construction of one of these notable edifices.

One of Caesar's first-ranking and bravest officers was called Fiorino and came from Cellini, a village about two miles away from Monte Fiasconi. This Fiorino decided to have his quarters under the hill of Fiesole, where Florence is today, because it would be convenient for the troops to be stationed near the river Arno. All the soldiers and other people connected with this captain acquired the habit of saying when they went to pay him a visit: 'Let's go along to Fiorenze.'

They said this because Fiorino, as I mentioned before, was the captain's name, and also because the natural fertility of the soil encouraged an abundant growth of flowers in the place where he had his camp. So Caesar decided to call the new city Florence (Fiorenze), as it was a very beautiful name and very apposite, and it seemed, with its suggestion of flowers, to make a good omen; and besides that he wanted

to show what a high regard he had for his courageous captain, especially as he himself had raised Fiorino from a very humble rank and was responsible for his greatness.

Those learned, ingenious etymologists who say that the name of Florence is derived from *fluente* and means merely that it was situated near the flowing Arno are claiming the impossible. We have only to look at Rome, which is on the flowing Tiber, or Ferrara on the flowing Po, or Lyons on the flowing Saône, or Paris on the flowing Seine, and we find that all these names are nevertheless different and originated in quite a different way.

There you have my reasons: and so I believe that our family is descended from a very great man. As well as this, there are Cellinis at Ravenna, which boasts some very aristocratic families and is an even older Italian city; and there are Cellinis living at Pisa. I myself have discovered members of the Cellini family all over Christendom; and there are some excellent fighting-men in Tuscany who bear the name Cellini. For as a matter of fact not so many years ago a beardless young man called Luca Cellini had a fight here with a very bold and experienced soldier called Francesco da Vicorati. This Francesco was used to single combat, but all the same Luca, by himself, with his sword in his hand, overcame and killed him with such courage and skill that everyone was astonished, especially as it had been expected that the result would be the other way round. So I take great pride in tracing my origin back through men of mettle.

Now as for the few honours that I myself have won for my family – living the sort of life that we know is lived today, and by means of my art, although it does not amount to much – I shall talk about them in the appropriate place. I take far more pride in my humble birth and in my having laid down an honourable foundation for my family, than if I had been born into an ancient, noble family and had stained or sullied it by an evil nature. I shall begin, then, describing the way in which – as pleased God – I came into the world.

My ancestors used to live in the Val d'Ambra where they had withdrawn because of the political strife that was raging. They had a great many possessions and lived like little lords; and they were all fond of soldiering and all very brave. About that time a younger son of the

family, called Cristofano, began a tremendous feud with some of their neighbours and friends. The heads of both families joined in, and the fire that Cristofano had started burned so furiously that it looked as though it would utterly destroy both families. Faced with this prospect, the oldest members came to an agreement as a result of which my ancestors sent Cristofano away and the other family banished the young man who had started the quarrel with him.

He was sent off to Siena, while Cristofano was sent to Florence, where the family bought him a little house in the Via Chiara near the convent of Santa Orsola, as well as some very good property at the Ponte a Rifredi. Cristofano found himself a wife in Florence and brought up a family of sons and daughters. The daughters were all well provided for and then, after the death of their father, the sons shared out what remained of his property.

The house in the Via Chiara, together with a few other things, fell to one of the sons called Andrea, who got married in turn and had four boys. The name of the first was Girolamo, the second was Bartolomeo, the third – who became my father – was Giovanni, and the fourth was called Francesco. Andrea Cellini was an authority on contemporary architecture, and in fact he made architecture his profession. My father, Giovanni, gave more time to it than did any of his brothers, and because – as is said, among other things, by Vitruvius[3] – anyone who wants to make a success at architecture must also acquire some knowledge of music and good draughtsmanship, Giovanni taught himself how to draw well and then began to study the theory of music. At the same time he learnt to play the viol and the flute with great skill. He was such a studious man that he hardly ever left the house.

Living as their next-door neighbour was a man called Stefano Granacci, the father of several very beautiful daughters. It was God's will that Giovanni's eye fell on one of these girls, whose name was Elisabetta, and she attracted him so much that he asked if he could marry her. With both fathers living so near together and knowing each other so well, it was easy to arrange a match; in fact each of them reckoned it would be a good thing from his own point of view.

First the two good old fellows agreed that the marriage should take place, and then began discussing the dowry. At this stage there was a

little good-humoured argument. Andrea began by saying to Stefano:

'This son of mine, he's not only the finest boy in Florence, he's the finest in all Italy. If I'd wanted to have him married off before now I could have got the largest dowry ever given to people of our class.'

'You're absolutely right,' replied Stefano, 'but what with my having five daughters and just as many sons I've worked it out that this is as much as I can afford.'

All this time, without their seeing him, Giovanni had been standing there listening to them; and then he broke in unexpectedly and said:

'It's Elisabetta I love and want to marry, father, not their money. Bad luck to anyone who wants to get rich on his wife's dowry! As you've been boasting that I'm such a clever fellow, don't you think that I'll be able to support my wife and look after all her needs, even if I get a dowry smaller than you want? Let me assure you that the girl belongs to me, and as for the dowry I want you to keep it yourself.'

Andrea Cellini was rather quick-tempered, and this made him pretty furious; but all the same the wedding took place a few days later and Giovanni never asked for any dowry other than what he received.

For eighteen years they were very happy together, enjoying their youth and their holy love, but all the time longing to have children. At the end of this eighteen years Elisabetta had a miscarriage because of the doctors' bungling, and she lost twin boys. Then she became pregnant again and gave birth to a daughter whom they called Cosa, after my father's mother. Two years later she was pregnant a third time; and as those strange longings which are so powerful in pregnant women were exactly the same as the ones she had shown in her former pregnancy they were certain that she was going to have another girl, and so they decided they would call it Reparata, after my mother's mother.

The child was born during the night after All Saints' Day, at exactly half past four, in the year 1500. The midwife knew that they were expecting a girl and as soon as she had washed the baby she wrapped it up in some fine white linen and then came up very, very softly to my father and said: 'I've brought you a wonderful present – and one you didn't expect.'

My father was a true philosopher; he had been pacing the room and when the midwife came to him he said: 'Whatever God gives is dear

to me.' Then, drawing back the swaddling clothes, he saw with his own eyes the son that no one had expected. He clasped his old hands together, and with them lifted his eyes up to heaven, and said: 'Lord, I thank You with all my heart. This is a great gift, and he is very welcome.'

Everyone there began talking happily and asking him what he was going to call the boy. But Giovanni kept on repeating: 'He is Welcome (Benvenuto).' So that was the name they decided on. I was baptized with it, and by the grace of God I carry it to this day.

When I was already about three years old my grandfather Andrea was still alive and over a hundred. One day they were changing a cistern pipe when a large scorpion which they had not noticed crawled out of it, slipped to the ground, and scuttled away under a bench. I caught sight of it, ran over, and picked the thing up. It was so big that when I had it in my little hand its tail hung out at one end and both its claws at the other. They say that laughing happily I ran up to my grandfather and said: 'Look, grandpapa, look at my lovely little crab.' He recognized what it was and almost dropped dead from shock and anxiety. Then he tried to coax me into giving it to him, but the more he did so the more I screamed tearfully, refusing to give it to anyone.

My father was also in the house and, hearing the noise, he ran in to see what it was all about. He was so terror-stricken that his mind refused to work and he could not think up any way of stopping the poisonous creature from killing me. Then his eyes fell on a pair of scissors and he managed to wheedle me into letting him snip off the scorpion's tail and claws. When the danger was past he regarded it as a good omen.

Another time, when I was about five, my father was sitting alone in one of our small rooms, singing and playing his viol. Some washing had just been done there and a good log fire was still burning. It was very cold, and he had drawn near the fire. Then, as he was looking at the flames, his eye fell on a little animal, like a lizard, that was running around merrily in the very hottest part of the fire. Suddenly realizing what it was, he called my sister and myself and showed it to us. And then he gave me such a violent box on the ears that I screamed and burst into tears. At this he calmed me as kindly as he could and said:

'My dear little boy, I didn't hit you because you had done wrong. I only did it so that you will never forget that the lizard you saw in the fire is a salamander, and as far as we know for certain no one has ever seen one before.'

Then he kissed me and gave me a little money.

When my father began teaching me to play the flute and to sing, although I was at the tender age when children love blowing whistles and playing with toys of that kind, I hated every moment of it and would only sing or play the flute to obey him. At that time he was busy constructing wonderful organs with wooden pipes, and harpsichords – the most beautifully-made that one could find at that period – as well as viols and lutes and harps, all of them superb works of craftsmanship. Besides this he was an engineer and he worked wonders in designing all kinds of apparatus, for lowering bridges, for example, or for operating mills. He was also the first to do good work in ivory.

But he fell in love with music, which became a second wife to him, and, perhaps because of that little flute which he played far too much, the fifers of the Signory asked him to join them. For a time he played with them merely to amuse himself, and then they pestered him into becoming a member of their band. Later on, when Lorenzo de' Medici and his son Piero, who were very fond of him, saw that he was spending all his time on the fife and so neglecting his real talents and his fine profession, they had him removed from it. My father took this very badly, convinced that they had wronged him deeply.

He immediately resumed his trade and he made a mirror of bone and ivory, about a cubit in diameter and ornamented with figures and foliage. It was exquisitely designed and executed, in the shape of a wheel, with the glass in the middle; and round it were seven circles in which he had carved in ivory and black bone the seven Virtues. The looking-glass itself and these Virtues were balanced in such a way that when the wheel was spun all the Virtues revolved with it but, as they were weighted at the base, stayed upright all the time. As he knew a little Latin he had inscribed around the mirror a verse in Latin which ran: 'For all the turns of Fortune's wheel, Virtue remains erect.'

Rota sum; semper, quoquo me verto, stat virtus.

Shortly afterwards he was restored to his post among the fifers. Some

of these things took place before I was born, but as I remember being told about them I do not want to leave them out.

In those days the musicians were all members of the most respected trades, and some of them belonged to the greater guilds of silk and wool. That was why my father was not ashamed to follow such a profession. And his greatest ambition as far as I was concerned was to turn me into an accomplished musician; and I was never more miserable than when he used to talk to me about it, saying that I showed so much promise that if I wanted I would outshine anyone in the world.

As I said, my father was a devoted and very loyal follower of the House of Medici; and when Piero was banished[4] he entrusted my father with very many extremely important matters. And then when subsequently the magnificent Piero Soderini was elected, he remained in his post as a musician, and Soderini, knowing his tremendous abilities, began to make use of him in a large number of important undertakings as an engineer. For as long as Soderini was at Florence he treated my father with every possible mark of favour.

It was at that time, when I was still very young, that my father had me carried to the Signory and made me play the flute as a soprano accompaniment to the palace musicians. I played away at my music and was held up by one of the palace officials. Afterwards the Gonfalonier, that is Soderini, made me talk to him and, delighted at my chatter, gave me some sweets and said to my father:

'Giovanni, besides music teach him some of the other splendid arts you're so good at.'

'I don't want him to learn anything,' answered my father, 'except playing and composing, because if God lets him live I hope to turn him into the greatest musician in the whole world.'

Then one of the old counsellors had his say, 'No, Giovanni,' he said, 'do what the Gonfalonier suggests. Will he never be anything other than a good musician?'

Some time went by, and then the Medici came back to Florence.[5] As soon as they had returned, the Cardinal, who later became Pope Leo, began to treat my father with special favour. Now, while the Medici had been in exile the balls on their coat of arms at the palace had been removed and a great red cross – the arms and emblem of the

Commune – had been painted on in their place. So when the Medici reappeared the red cross was at once scraped off and the shield repainted with the red balls on a field of gold, and finished off very beautifully.

My father, who was something of a natural poet and also had in him a touch of the prophet that certainly came from heaven, wrote these four lines under the coat of arms as soon as it was uncovered:

> These arms long buried here
> Beneath the gentle Cross and holy
> Now wait in joy and glory
> For Peter's mantle to appear.

This epigram was read by all Florence. A few days later Pope Julius II died.[6] When Cardinal de' Medici went to Rome, against everyone's expectation he was elected Pope, becoming the great and generous Pope Leo. My father sent him the four prophetic lines he had written. In return he had a message back from the Pope saying that he would find it well worth his while to come to Rome. But my father had no wish to leave Florence, and indeed instead of a reward as soon as Jacopo Salviati[7] was elected Gonfalonier his position at the palace was taken from him. This was the reason why I began to learn the goldsmith's art. Some of the time I was studying how to be a goldsmith and some of the time – much against my will – how to play the flute.

When my father insisted that I was to become a musician I begged him to let me spend a few hours a day at designing, and I promised that just to please him I would give the rest of my time to practising music. When he heard this he said: 'So you get no pleasure out of playing?' I replied that I did not and that I thought it a despicable art compared with the one I was set on.

My good father, in despair, sent me along as an apprentice to Cavaliere Bandinello's father, who was called Michelagnolo and was a very competent goldsmith from Pinzi di Monte. His family was very undistinguished and he was the son of a charcoal-burner. There is no blame attached to Bandinello because of this, and after all he founded the fortunes of his family.[8] But it is a pity he did it so dishonourably. However that may be, I have no need to say anything about him here.

I had only been there a few days when my father took me away again as he could not bear living without seeing me all the time. So I had to go on playing the flute, very unhappily, till I was fifteen. If I set out to describe all the great events in my life up to then and all the great perils that came my way, I would astonish anyone reading about them. But as I must not write too much and have a great deal to say I shall leave them out.

When I reached the age of fifteen, against my father's will I placed myself in a goldsmith's shop with a man called Antonio di Sandro, who was known as Marcone the goldsmith. He was a first-rate craftsman and a very fine man, high-minded and generous in everything he did. My father would not let me be paid like the other apprentices, in order that, as I had adopted this craft from choice, I might be able to spend as much of my time designing as I liked. I was only too glad to do so, and that excellent master I was serving took incredible pleasure in my work: he had an only son, who was illegitimate, and he often used to give him his orders, in order to spare me.

My desire to learn the art, or rather my natural talent for it, in fact both of them, was so impelling that within a few months I found myself rivalling not only the good but the best young craftsmen there were, and I began to profit from my labours. For all this, I remembered to cheer up my lovable old father now and then by playing the flute or the cornet. He used to weep and sigh his heart out whenever he heard me play. So out of filial affection I very often used to give him pleasure in this way, even pretending to enjoy it myself.

At that time I had a brother who was two years younger than me. He was very high-spirited and daring, and afterwards he became one of the great soldiers in the school of that marvellous lord Giovannino de' Medici,[9] the father of Duke Cosimo. My young brother was then about fourteen and I was two years older. One Sunday just about two hours before sunset he started a fight between the San Gallo and the Pinti gates with another young fellow of about twenty. They were both carrying swords, but my brother attacked with such boldness that he wounded him badly and then went to close in.

There was a crowd of people standing by, including a good number of the wounded man's relations. When they saw that things were going

badly for him they began using all their slings, and one of the stones struck my poor young brother on the head. Immediately he fell to the ground as if dead. Now I had happened to come on the scene, completely unarmed and unaccompanied, and had been yelling at him to beat a retreat, since what he had done was enough. In the meantime he fell down senseless in the way I said.

Straight away I ran up, seized hold of his sword, and stationed myself in front of him, confronting a row of swords and a shower of stones. But I stayed my ground till some tough soldiers came up from the San Gallo gate and, astonished at finding such great courage in someone so young, rescued me from that furious mob. I carried my brother home for dead, and then after we went in, with a great deal of effort he came to his senses.

When he was better, the Eight[10] – who had already condemned our adversaries, banishing them for a number of years – sentenced us to be exiled for six months at a distance of ten miles from Florence. 'Let's go together then,' I said to my brother. So we left our poor father: and as he had no money to give us he gave us his blessing.

I made my way to Siena to find a charming man I knew called Maestro Francesco Castoro. I had been with him once before, when I ran away from my father, and I had stayed with him several days, working at the goldsmith's trade, till my father sent for me. So when I arrived Francesco recognized me at once and gave me some work. As well as this he provided me with lodgings for as long as I should be in Siena. My brother and I moved in and for several months I concentrated on my work. My brother knew a little Latin, but he was still too young to have acquired any taste for study and he used to spend all his time amusing himself.

The next thing that happened was that Cardinal de' Medici, who later became Pope Clement,[11] was appealed to by my father and called us back to Florence. Then one of my father's pupils, in tune with his own nasty character, suggested to the Cardinal that I should be sent to Bologna so that I could learn how to play really well from a famous professor there called Antonio. In fact this man certainly was a great musician. The Cardinal informed my father that if he sent me to Bologna he himself would provide me with useful letters of introduction. My

father, who nearly died of joy at such a prospect, had no hesitation: and at the same time as I wanted to see the world I was only too willing to go.

At Bologna I found a job with a man called Maestro Ercole del Piffero and began to earn some money for myself. All the same I used to go along every day for my music lessons, and within a few weeks I had made very good progress in that cursed art. But I reaped a great deal more from being a goldsmith, because, as the Cardinal had not given me any help at all, I went to live with a Bolognese miniaturist called Scipione Cavalletti (his house was in the street of Our Lady of Baraccan) and there I started doing designs and working very profitably for a Jew called Graziadio.

At the end of six months I made my way back to Florence, much to the annoyance of that former pupil of my father's, Piero. To please my father I used to go along to his house to play the cornet or the flute with his brother, Girolamo, who was a few years younger than Piero. Quite unlike his brother, Girolamo was an honest, likeable young man. One day my father turned up at Piero's house to hear us play, and he was so pleased with my performance that he said: 'I don't care who tries to stop me, I shall still make a marvellous musician out of him.'

Piero gave a true enough answer to this. 'Your Benvenuto,' he said, 'will get much more honour and profit if he studies how to be a goldsmith than he will out of all this fifing nonsense.'

My father was so furious, especially when he saw that I agreed with this, that he lost his temper and said: 'I knew all the time that it was you who was trying to frustrate this great ambition of mine, and it was you who had me dismissed from my post at the palace. You paid me with the kind of ingratitude that is usually shown in return for great benefits. I got you your post and you lost me mine. I taught you all the music you know and you prevent my son from carrying out my wishes. But just you bear in mind these few words of prophecy: in a matter of a few weeks – not years or months – your fortunes will utterly collapse because of this shameful ingratitude of yours.'

Then Piero answered back:

'Maestro Giovanni, most men when they grow old grow soft in the head as well: and that's what you've done. I'm not at all surprised,

seeing the way you've squandered all you ever had without considering what your children might need. Now I mean to do exactly the opposite: I shall leave so much to my sons that they'll be able to help yours out.'

To this my father replied:

'No bad tree ever bore good fruit – quite the opposite in fact. And let me add that you're a scoundrel, and that your children will go soft in the head, and that they'll be poor and come begging from my rich, clever sons.'

Then he went off, with him and Piero muttering madly at each other. I had sided with him and I left at the same time, saying that I would get revenge for the way that ruffian had insulted him if he would let me carry on with my designing.

'My dear boy,' he said, 'in my time I was a good draughtsman too. But as a delightful rest from the hard work it calls for, and for the sake of your father, who brought you into the world, and looked after you, and sowed the seeds of all your splendid talents, won't you promise sometimes to take your flute and that lovely cornet and amuse yourself by playing them?'

I said, yes, and that for his sake I would be only too glad to do so. And then that good old father of mine told me that my skill at music would be the best revenge I could take for the way his enemies had insulted him.

Before the month was up, Piero, who was having a cellar built in one of the houses that he owned in the Via dello Studio, happened one day to be standing with a crowd of his friends in a ground-floor room just above the cellar when he began to talk about the man who had been his master. He repeated the words that my father had said about the way his fortunes would collapse, and no sooner were they out of his mouth than the floor he was standing on collapsed. Perhaps the cellar was badly built, or perhaps God – who doesn't wait till the end of the week to pay out what's due – was showing His hand: at any rate a load of stones and bricks crashed down with him and broke both his legs.

The people who were with him were left standing on the edge of the cellar completely unscathed but dumbfounded with astonishment, especially in view of what he had told them with such contempt only

a moment before. When my father heard what had happened he put on his sword and went round to the house. Then, in the presence of Piero's father, a trumpeter of the Signory called Niccolaio da Volterra, he said:

'Piero, my dear pupil, I'm terribly grieved at your misfortune, but, if you remember, it's not so long since I warned you what to expect. And the relations between my sons and yours will also be exactly what I said.'

A short time afterwards this Piero, who had been so ungrateful, died as a result of his accident. He left a slut of a wife and a son who, a few years later when I was in Rome, came and asked me for help. I gave him some assistance because I am naturally charitable, but also because, with tears, I remembered how prosperous Piero had been when my father spoke to him, that is when he said that Piero's sons would one day come begging for help from his clever sons. I have written enough about this incident. But no one should ever make fun of the predictions of an upright man who has been unjustly abused, because such predictions are not his but those of God, who is speaking through him.

Meanwhile I was carrying on with my work as a goldsmith and helping my father out of what I earned. Since his other son – my brother Cecchino – had as I said before some knowledge of Latin, my father wanted me, the elder, to become a great instrumentalist and musician, and Cecchino, the younger son, to become a great and erudite lawyer. But he was powerless against our own natural inclinations, which in my case were towards the art of designing, and as far as my brother, who was a well-built, handsome young man, was concerned, the profession of soldiering.

When he was still very young Cecchino came home one day from his first lesson in the school of the wonderful Giovannino de' Medici and, finding me out when he arrived, as he was far worse off for clothes than I was, he approached our sisters and they, without my father knowing, handed him over my beautiful new cloak and doublet. I had bought these fine clothes out of what was left over from my earnings when I had helped my father and my good, honest sisters. As soon as I found I had been cheated out of my clothes, not being able to find my brother and recover them, I asked my father why he had allowed

me to be wronged so greatly, seeing how gladly I used to work in order to help him. He replied to this that I was his good son, but that Cecchino was the son he had thought lost and then found again, and that it was only right, in fact it was God's own command, that he who had should give to him who had nothing. He added that for his sake I should put up with the outrage and that God would load me with blessings.

Like the raw young man I was I answered my poor, distressed father back, and, taking the few wretched clothes and the odd couple of coins that I had left, went out of the house and began walking towards one of the city gates. I had no idea which gate was the one for Rome, and I ended up at Lucca, and from Lucca I went on to Pisa.

I was sixteen when I arrived at Pisa. I stopped by the middle bridge, where they hold a market at a place called the Fish Stone, near to a goldsmith's shop, and I began staring attentively at what the owner of the shop was doing. Then he asked who I was and what my trade was, and I replied that I worked a little at the same art as himself. At this the good man asked me to come into his workshop, gave me some work to do straight away, and said: 'I can see by your honest face that you're a good, upright young man.' Then he set me to work on gold and silver and jewels. That evening, after my first day's work was finished, he took me back to his house, where he lived respectably with his beautiful wife and children.

I thought of how upset my good father must be about me and I decided to write to him. I told him that I was living with a good, honest man, called Ulivieri della Chiostra, and was doing very fine and important work under his direction. I added that he was not to be unhappy, because I was intent on acquiring knowledge, and that with the skill I learned I hoped very soon to bring him profit and honour.

My father answered my letter without delay, writing as follows:

My dear boy, I love you so much that if it weren't against my honour, which I cherish more than anything, I would have come for you straight away. Without any exaggeration, not to see you every day as I used to is like losing the light of my eyes. But I shall carry on here leading my family in the paths of righteousness, and you must learn to be a good

craftsman. Only, you must never forget these few simple words; let them guide you always:

> Follow the honest, upright way
> In whatever house you stay.

This letter from my father fell into the hands of my master, Ulivieri, who read it without my knowing. Later on he told me he had done so and said:

'There! my dear Benvenuto, I wasn't wrong about your honest appearance. I can prove it by a letter from your father that I came across. It shows that he's a good upright man himself. I want you to treat my home as if it were your own and as if you were living with your father.'

I went to see the Campo Santo while I was in Pisa, and there I discovered many beautiful antiques, that is, marble sarcophagi. In various other parts of Pisa I came across many other ancient works, and I used to study them assiduously whenever I had time off from work. My master used to get a great deal of pleasure coming into the tiny room he had given me and finding me always hard at work. He began to love me like a father. For me the year I spent with him was a very fruitful one. I made a number of important and beautiful things out of gold and silver, and these made me ambitious to do even better. Meanwhile my father kept writing me piteous letters in which he begged me to come home, and he never left off reminding me that I should not lose the skill in playing music that he had been at such pains to teach me. When I read his letters I lost any desire I had ever to go back to him, such was my hatred for that damned playing. In fact my stay at Pisa, where I never touched the flute, seemed like a year in paradise.

At the end of the year my master Ulivieri had occasion to go to Florence to sell some of his gold and silver sweepings. The unhealthy air at Pisa had given me a touch of fever, and so along with that and along with my master I went back to Florence. My father gave him a very enthusiastic welcome and, without my knowing, pleaded with him affectionately not to take me back to Pisa.

I was still ill and I remained so for about two months. My father had me looked after and nursed very lovingly, and he kept saying that it seemed an eternity till I should be well again and he could hear me play a little. When he used to chat to me about playing – with his fingers resting on my pulse, because he knew something about medicine and had a little Latin – as soon as he approached the subject of music he felt my pulse quicken. This was so noticeable that very often he was dumbfounded and would leave me in tears.

Realizing how very unhappy he was I told one of my sisters to bring me a flute. Although I was continually feverish, the flute is not a very tiring instrument and it did me no harm to play it. So I began to do so, with such beautiful fingering and tonguing that when my father came in suddenly he loaded me with blessings, saying that he thought I had made tremendous progress during the time I had been away from him. He begged me to carry on with my playing and not to lose such a fine accomplishment.

As soon as I was better I went back to the goldsmith, Marcone. He was an honest man, and he made it possible for me to earn some money out of which I helped my father and the family. About that time a sculptor called Piero Torrigiano[12] came to Florence. He had returned from England after a visit lasting quite a few years, and as he was a great friend of my master he used to come and see him every day. When he saw my designs and what I had made, he said:

'My reason for coming to Florence is to engage as many young craftsmen as I can, because I've an important piece of work to execute for my King and I want my Florentines to help me with it. Now your method of going about things and your designs are far more suitable for sculpture than for a goldsmith's work: so as I have to make a great statue in bronze, I shall at the same time make you an expert sculptor and a rich young man.'

This Torrigiano was an extraordinarily handsome man, and very hot-tempered, and he seemed more like a great soldier than a sculptor, especially because of his powerful gestures and his resounding voice and the habit he had of frowning in a way that would frighten the life out of even the bravest man. Every day he had stories to tell concerning his brave deeds when he was living among those brutes of Englishmen.

Then one day he started to talk about Michelangelo Buonarroti, after his eye had fallen on one of my drawings copied from a cartoon by that divine artist. This cartoon was the first wonderful work in which Michelangelo[13] showed his magnificent genius, and he made it in competition with another artist – with Leonardo da Vinci;[14] the two cartoons were meant for the Council Hall of the palace of the Signory. The subject was the capture of Pisa by the Florentines.

The splendid Leonardo had chosen to show a battle-scene, with horsemen fighting together and standards being captured, and he had drawn it magnificently. In his cartoon, Michelangelo depicted a number of infantrymen who because of the summer heat had gone down to bathe in the river Arno: he caught in his drawing the moment when the alarm is sounded and the naked soldiers rush for their arms. He showed all their actions and gestures so wonderfully that no ancient or modern artist has ever reached such a high standard. Leonardo's as well, as I said, was wonderfully beautiful. One of these cartoons was in the Medici palace, and the other in the Pope's hall: and while they remained intact they served as a school for all the world.

Although the divine Michelangelo later on painted the great chapel of Pope Julius[15] he never reached half the same perfection; his genius never again showed the power of those first studies.

To return to Piero Torrigiano: holding my drawing in his hand, he said:

'This Buonarroti and I used to go along together when we were boys to study in Masaccio's chapel in the Church of the Carmine.[16] Buonarroti had the habit of making fun of anyone else who was drawing there, and one day he provoked me so much that I lost my temper more than usual, and, clenching my fist, gave him such a punch on the nose that I felt the bone and cartilage crush like a biscuit. So that fellow will carry my signature till he dies.'

This story sowed in me, who used to see Michelangelo's divine masterpieces every day, such a hatred for Torrigiano that far from wanting to go to England with him I could not bear to look at him. All the time I was in Florence I tried to capture Michelangelo's beautiful style and I have never stopped doing so.

At that time I formed a close and intimate friendship with a charming

young man of my own age who was a...
name was Francesco[17] and he was the son...
the splendid painter Fra Filippo. We came to...
that we were never apart, day or night. Also, his...
the wonderful studies that his brilliant father had m...
several books of them in his own hand, taken from t...
antiquities of Rome. When I saw these I completely lost n...
Francesco and I went together for about two years.

It was at that period that I made a piece of silver in low relief. It was about the size of a little child's hand and was meant for the buckle of a man's belt, since in those days they used to be worn as large as that. I carved on it a bunch of leaves, in the antique style, with a number of cherubs and some very beautiful masks. I did the work in Francesco Salimbene's shop, and when it was seen by the members of the gold-smiths' guild they praised me as the most talented young man in the trade. Then a young man of exactly my own age, Giovanbatista, who was known as Tasso[18] and who worked as a wood-carver, began saying that if I meant to go to Rome he would be only too glad to come with me. We were talking about the project just after dinner, and as I was feeling angry with my father – for the usual reason, music – I said to Tasso: 'You only talk, you never do anything.'

'Look,' he replied, 'I'm furious with my mother as well, and if I had enough money to get to Rome I wouldn't even wait to lock up that hovel of a shop that I've got.'

I said that if that was all that was keeping him back I had enough money on me to take us both to Rome. We were walking along and talking to each other in this way when, quite unexpectedly, we found ourselves at the gate of San Pietro Gattolini.

At this juncture I said: 'Tasso, it's God's doing – neither of us noticed where we were going. Now I'm here I feel as if I've done half the journey already.'

So we made up our minds and set off. As we went along we kept saying: 'Oh, what will our old folks be saying this evening?' And then we agreed not to give them another thought till we had arrived at Rome. We tied our aprons behind our backs and, hardly speaking a word, pushed on towards Siena. When we reached the town Tasso

had hurt his feet and that he had gone far enough, and he
ed me to lend him the money to return home. I told him that I
would not have enough to carry on with the journey and that he ought
to have thought of that before he left Florence.

'If it's because of your feet that you don't want to come,' I said, 'we
will find a horse that has to make the return journey to Rome, and
then you won't have any excuse at all.'

Then I hired a horse and, seeing that he refused to say a word, set
off towards the gate for Rome. When he realized that my mind was
made up, grumbling all the time he started limping slowly along as well
as he could some distance behind me. I reached the gate, and then
feeling sorry for the boy waited and took him up behind me.

'Tasso,' I said, 'what would our friends say tomorrow if after setting
out for Rome we hadn't the guts to go beyond Siena?'

The good fellow agreed that I was right and then as he had a happy
disposition he started laughing and singing. So, singing songs and joking
together, we travelled on to Rome. I was exactly nineteen at the time
– the same age as the century.

As soon as we had arrived in Rome I found work with a craftsman called
Firenzuola.[19] His real name was Giovanni but he came from Firenzuola, in
Lombardy. He was quite expert at making large plate and things of that
sort. I showed him something of the design for the buckle that I had
made in Florence, when I was with Salimbene, and it pleased him so
tremendously that he turned to one of his apprentices, a Florentine called
Giannotto Giannotti[20] who had been with him several years, and said:
'This is one of the Florentines who know something, and you're one of
the Florentines who don't know anything.'

When he said this I recognized Giannotto and turned to talk to him.
Before he went to Rome we had often gone out drawing together and
had been very close friends. But he was so annoyed at what his master
had said that he protested he did not recognize me and did not know
who I was. I was very indignant at this and reminded him that he had
been my friend and that we had been together in such and such a place,
and eaten and drunk together, and slept in his country house.

'But I don't care,' I said, 'if you refuse to recommend me to this
honest master of yours, because I have hopes of proving what sort

of man I am from the work of my hands, without any help from you.'

When we were finished, Firenzuola, who was a bold, very quick-tempered man, turned to Giannotto and cried: 'You vile rascal, aren't you ashamed of treating one of your best friends in this way?'

Then acting on the same impulse he turned to me and added: 'Come into the workshop and do what you said: let me see your hands prove what sort of man you are.'

Then he set me to work on a very fine silver object that was being made for a cardinal. It was a little casket, designed after the porphyry sarcophagus that stands in front of the door of the Rotunda.[21] Besides what I copied, I enriched it with a number of beautiful little masks of my own design, and as a result my master went round boasting and showing it off to all the other goldsmiths as an example of what fine work was turned out in his shop. It was about half a cubit in size and meant for a salt-cellar.

It was this salt-cellar that earned me my first money in Rome. I sent some of it to help out my good father and I kept the rest for myself. On the strength of what I had earned I went round studying the antiques, until my money ran out and I had to return to the shop and do some work. My companion, Giovanbatista del Tasso, did not stay long in Rome before returning to Florence. But I started on some new work, though I made up my mind that when I finished it I would go and work for someone else. I was tempted to do this by a certain Milanese called Pagolo Arsago.[22]

The next thing that happened was that Firenzuola had a tremendous quarrel with this Arsago and began flinging insults at him. I happened to be present so I joined in to defend my new master. I protested that I was born free and meant to remain free, and that he could not complain of Arsago, still less of me, since he still owed me a few crowns of my wages. As a free workman, I said, I meant to go where I pleased, knowing full well that I was wronging no one.

Then my new master had his say, and it was to the effect that he had not asked me to come to him and that he would be very pleased if I would return to Firenzuola. I repeated that I was not aware of having wronged Firenzuola in any way at all, and that I had finished the work he gave me:

I meant to direct my own life and whoever wanted my services should apply to me. At this Firenzuola cried out that he had no intention of applying to me for my services, and he added: 'Don't you ever show your face here again.' When I reminded him of my money, he laughed at me.

'I can use a sword to get what's owing to me,' I said, 'every bit as well as I've used tools for the work you've seen me do.'

At this juncture an old fellow called Antonio da San Marino happened to come up. He was the finest goldsmith in all Rome and had once been Firenzuola's master. He overheard my argument – which I took care he should understand only too clearly – took my part, and told Firenzuola to pay me. The quarrel began to get very heated, because as a matter of fact Firenzuola was a splendid swordsman, far better at arms than he was as a goldsmith. However, reason had its way – with my determination helping it to do so – and in the end I was paid. Later on Firenzuola and I became friends again; when he asked me, I stood as godfather to one of his children.

I went on working with Pagolo Arsago and earned a good deal of money, most of which I used to send home to my good father. But at the end of two years I gave in to his pleading and made my way back to Florence, where I returned to work with Francesco Salimbene. I still earned a good deal, and I concentrated on improving my skill. I started going with Francesco di Filippo again, and that wretched music tempted me to spend a great deal of time chasing after pleasure. But I always managed to find a few hours, either in the daytime or at night, to do some studying.

It was about that time that I made what used then to be called a heart-key. It was a silver girdle, about three inches across, to be worn by a new bride. It was in half relief, with some little figures in the round; and I made it for someone called Raffaello Lapaccini. Although I was very miserably paid for it, the honour it brought me was worth much more than the price I should have had.

By that time I had worked with a great number of different people in Florence, and I had found among the goldsmiths some honest men, like my first master, Marcone. But there were others who had good reputations and yet tried to ruin me, and they robbed me as wickedly as they could.

When I saw this I had nothing more to do with them and looked on them as thieves and scoundrels. One of the goldsmiths, called Giovanbatista Sogliani, was kind enough to let me use part of his workshop which was on the corner of the New Market near the Landi's bank. There I finished many fine little pieces of work, earned a good deal, and was able to give considerable help to my family. This provoked the jealousy of two villainous men who had once been my masters – Salvadore and Michele Guasconti.[23] They owned three big goldsmiths' shops and did a very prosperous trade. When I realized that they had it in for me, I went and complained to a decent fellow I knew that they ought to have been satisfied with the way they had robbed me under the cover of their hypocritical goodness. They heard of what I had said and started boasting that they would make me eat my words. But since I never knew the meaning of fear I refused to worry about them.

One day I happened to be leaning against the shop of one of these goldsmiths. He called out to me and began abusing and threatening me. I retorted that if they had treated me right I would have spoken about them as good, honest men, but as they had done the opposite they had themselves and not me to blame. While I was arguing, a cousin of theirs called Gherardo Guasconti, possibly at their instigation, drove a mule loaded with bricks in my direction. When the beast lumbered up to me he gave it such a forceful push that I was very badly hurt. I turned round suddenly, caught him laughing, and gave him such a hard blow on the side of the head that he fell down senseless. Then I faced his cousins and said: 'That's how to treat thieving cowards like you.'

Trusting in their numbers they began to make a show of attacking me, so I took hold of a little knife that I had and fuming with anger I cried out: 'If one of you leaves the shop, let the other run for a priest, because there'll be no need for a doctor.'

This scared them so much that not one of them moved to help their cousin. Then I made off, and straight away the whole family ran complaining to the Eight that I had committed an armed assault on them in their workshops, a thing unheard of in Florence. The Eight had me called before them and when I appeared gave me a severe

reprimand and began condemning me. This may have been because I was dressed like a soldier, in a cloak, while my opponents were wearing the mantle and hood of private citizens; but it was also because they had previously gone to the houses of the magistrates and had a few words on the side, unlike me who in my innocence had not said a word to any of them because I trusted in the fact that my cause was a very just one. I pleaded that in reply to all Gherardo's insults and injuries I had completely lost my temper and only given him a slap, which I thought hardly deserved such a strong reprimand. I had hardly got the word 'slap' out of my mouth when Prinzivalle della Stufa, one of the magistrates, said: 'You gave him a blow with your fist, not a slap.'

Then the bell sounded and everyone was sent outside. Prinzivalle spoke to the assembly in my defence.

'Just consider, my lords,' he said, 'this poor young man's simplicity. Here he is accusing himself of having given someone a slap because he thinks it less of an offence than it is to give a punch, while in fact the penalty for slapping someone in the New Market is twenty-five crowns, as against little or nothing when it comes to punching. He is a very talented young man and he supports his family by the hard work he's always doing. I wish to God there were a great many more of his kind in Florence, instead of a shortage.'

Among the magistrates were some of those republicans, wearing their hoods twisted up, who were influenced by the appeals and false information of my opponents, because they belonged to Fra Girolamo's party. They would have been only too glad to send me to prison with a stiff sentence. But the good Prinzivalle prevented all that, and instead they imposed a small fine of four bushels of flour to be given to the convent of the Murate. When I was called in again, he ordered me to keep quiet, under pain of their displeasure, and said that I must accept my sentence. Then I was given a severe dressing-down and we were sent to the chancellor, with me muttering to myself: 'It was a slap, not a punch.' So we left the magistrates roaring with laughter.

The chancellor commanded us on behalf of the magistracy to give securities, but only I was condemned to pay the four bushels. I felt as if I had been assassinated: but all the same I sent for one of my cousins, a surgeon called Annibale, the father of Librodoro Librodori, with the

idea of asking him to go bail for me. But he refused to come. So in a furious temper, swelling up like an asp, I made up my mind to do something desperate. This just shows how the stars completely rule rather than merely influence our lives.

Knowing how much this Annibale owed my family, I grew so angry that I was utterly determined to make mischief, and anyway I am rather hot-blooded by nature. I waited till I saw that the magistrates had gone to dinner, and then finding myself alone and seeing that none of the officials were keeping watch on me any more, I left the palace fuming with rage and rushed back to my workshop. There I seized hold of a stiletto and hurried round to where those enemies of mine lived. I found them sitting down at dinner, in their home above the shop, and as soon as I appeared that young Gherardo who had started the quarrel hurled himself on me.

I stabbed him in the chest, piercing his doublet and jacket right through to the shirt, without in fact touching his skin or doing him the slightest injury. But from the way my hand sank in and the way his clothes were torn I imagined I had given him a very nasty wound. He fell to the ground, terrified out of his wits, and I shouted out: 'You traitors, today I'm going to kill the whole bunch of you.'

All of them, the father and the mother and the sisters, thinking that the Day of Judgement had come, threw themselves on their knees and without any restraint began screaming for mercy. With their making no attempt to defend themselves and Gherardo stretched out on the ground like a corpse, I decided that it would be too cowardly to touch them. But still mad with anger I ran downstairs and out into the street, and there I found all the rest of the household waiting for me, more than a dozen of them. One of them had an iron shovel, another a thick length of iron piping, and others of them stake-heads, hammers, and cudgels. I joined battle, snorting like a mad bull, threw four or five to the ground and fell down with them, all the time hitting out with my dagger.

Those who were still standing up joined in as well as they could, letting me have it with both hands, with their hammers and cudgels and stakes. But, as God in His mercy sometimes takes a hand in things, I did not do them the slightest injury, nor they me. All I lost was my

hat, captured by the enemy who treated it roughly, though before that they had kept clear of it. Then they looked for their dead and wounded; but not one of them had been injured.

I made off towards Santa Maria Novella and all of a sudden ran into Frate Alesso Strozzi. I did not know this good friar, but I begged him for the love of God to save my life as I had committed a great sin. He said that I was not to be at all frightened, because even if I had done all the evil in the world I would be perfectly safe in his cell. Then about an hour later the magistrates, having held a special meeting, published one of the most terrible proclamations that had ever been known, threatening the most severe penalties against anyone, no matter what his position or rank, who gave me shelter or knew where I was. My poor afflicted father, like the good man he was, went to the magistrates, threw himself on his knees, and begged them to have mercy on his poor young son. Then one of those hot-heads, shaking the top of his twisted hood, rose to his feet and began insulting my unhappy father.

'Get off your knees and leave this place immediately,' he said. 'Tomorrow we shall have this son of yours marched out to his execution.'

My poor father retorted fiercely: 'You will do what God wills and nothing more.'

Then the same man replied: 'What I said is certainly what God wills.'

Finally my father told him that he was consoled by the thought that he most certainly did not know what was God's will, and with that he walked out. He went in search of me with a young man of my own age, called Piero, the son of Giovanni Landi. We loved each other more than if we had been brothers. Under his cloak Piero hid a splendid sword and a very fine coat of mail. When they found me, my plucky father told me how things had gone and what the magistrates had said to him. Then he kissed me on the forehead and eyes, and gave me his affectionate blessing with the words: 'May God's power assist you.' With his own hands he buckled on the sword and helped me into the coat of mail, and then he added:

'My dear son, with these you're ready either to live – or die.'

Piero Landi who was there as well, his eyes continually wet with tears, had brought me ten gold crowns. I asked him to pull out a few

hairs that were on my chin, the first sign of my beard, and then Alesso dressed me up like a friar and gave me a lay brother to go along with me. I left the convent, walked through the Prato gate and along by the city walls as far as the Piazza di San Gallo. Then I climbed up the slope of Montui and in one of the first houses I came to I found a man called Grassuccio, the brother of Messer Benedetto da Monte Varchi.[24] I immediately unfrocked myself and became a man once more. Then we mounted the two horses that were waiting for us and rode through the night to Siena. Grassuccio returned to Florence, met my father, and told him that I had reached a place of safety.[25]

The old man was almost beside himself with joy, and it seemed an eternity before he found the magistrate who had been so insulting. When he came across him he said:

'You see, Antonio, God knew what was to happen to my son, not you.'

The fellow replied: 'Just let us get hold of him again.'

And finally my father said, 'Meanwhile I'll be thanking God for saving him from you.'

At Siena I waited for the courier to Rome and joined up with him. When we had passed the Paglia we met the messenger who was bringing news about the new Pope – it was Pope Clement. Then, when I reached Rome, I went and found work in the goldsmith's shop belonging to Maestro Santi; he himself had died, but one of his sons was in charge. This son did no work there himself, and the workshop was run completely by a young man from Jesi called Lucagnolo. He was a countryman who had come to work for Santi when he was a young child. He was small but very well built, and he was a better craftsman than anyone I had so far come across. He worked very easily and skilfully, but he restricted himself to large things, like very beautiful vases and bowls.

After I had started work I undertook to make some candlesticks for the Bishop of Salamanca, a Spaniard. They were as richly ornamented us such objects can be. The next thing that happened was that a pupil of Raphael's called Gianfrancesco, and usually known as Il Fattore, who was a very fine painter, being a friend of the Bishop got me into his good books. The Bishop commissioned a great amount of work from me, and I earned a good deal of money.[26]

At that time I used to go and draw, sometimes in Michelangelo's chapel and sometimes in the house of Agostino Chigi of Siena,[27] where there were many beautiful paintings done by that splendid artist Raphael of Urbino. I used to go along there only when there was a feast day since Agostino's brother, Gismondo Chigi, was then living there. They became very proud of themselves when they saw young men of my sort coming along to study in their houses.

One day Messer Sigismondo's wife,[28] who had seen me around in her house very often, came up to me and began examining my drawings; then she asked me whether I was a sculptor or a painter. She was an extraordinarily beautiful and gracious woman. When I told her I was a goldsmith she said that I drew far too well for a goldsmith.

Then she sent one of her maids to bring a beautiful lily that she had, made of magnificent diamonds set in gold. She showed it to me and wanted me to say what I thought its value was. I reckoned it was worth eight hundred crowns. She said that I had valued it very rightly and then she asked me if I thought I had enough skill to set it really well. I answered that I would be only too happy to do so, and while she was still there I drew her a little design for it. It was all the better because of the pleasure I got from talking with such a very beautiful and gracious lady. After I had finished the sketch we were joined by another very beautiful Roman lady. She came down from upstairs and asked Madonna Porzia what she was doing there. With a smile, Madonna Porzia said: 'I'm enjoying myself watching this fine young man draw. He's good as well as handsome.'

Suddenly becoming bold, though my daring was mixed with a little honest modesty, I blushed and said: 'Such as I am, madam, I shall always be more than anxious to serve you.'

Then that gracious lady, blushing a little in turn, said: 'You can be sure that I want you to serve me.'

She gave me the lily and told me to take it away with me, and then, handing me twenty crowns that she took out of her purse, she said: 'Do it in the same way that you sketched the design, and save me the old gold that it's set in now.'

At this the other lady broke in: 'If I were that young man I shouldn't hesitate to make myself scarce.'

Madonna Porzia replied that virtues were very rarely found along with vices and that if I did such a thing I would strongly contradict my fine appearance, which was that of an honest young man. Then she turned away, taking the other lady's hand in hers, and laughing very prettily she said: 'Good-bye, Benvenuto.'

I spent some time on the drawing I was doing, which was copied from a figure of Jupiter by Raphael, and then when I had finished I went away and began to make a tiny wax model in order to show what the finished work would be like. When I brought it along for Madonna Porzia to see she was with the Roman lady that I had met before. They were both delighted with what I had done, praising me so much that rather daringly I promised that the actual work would be twice as good as the model.

I set to work, and at the end of twelve days I had finished the jewel, which as I said above was shaped like a lily, adorning it with little masks and cherubs and animals, all of them exquisitely enamelled, so that the diamonds forming the lily had their beauty immensely enhanced.

While I was working on it, that skilled craftsman Lucagnolo – I have already said what an able man he was – let me know that he thought it was a waste of time. He kept on saying that I would reap far more honour and profit if I carried on helping him make his large silver vases as I used to at first. My answer to this was that I could do that sort of work whenever I felt like it, but that what I was doing now did not fall into a man's lap every day, and that anyway there was just as much honour in it as in his large silver vases, and a great deal more profit.

Lucagnolo thought this was very funny. 'You'll realize the truth, Benvenuto,' he said, 'because I shall hurry up, and by the time you're through with your work I shall finish this vase that I began at the same time as you started on the jewel. And then we shall find out clearly enough what I make out of the vase and what you make out of your jewel.'

I said that I was only too pleased to put it to the test with an expert like him, and when it was over we would see who was mistaken. So, smiling rather scornfully, the two of us bent our heads proudly over our work, with such eagerness that at the end of about ten days we had both produced very beautifully-made works of art. Lucagnolo's was a

very large bowl, meant for Pope Clement's table as a receptacle for pieces of bone and rind. It was intended for show rather than use, and was adorned with two fine handles, a great many masks of various sizes, and clusters of beautiful leaves. The whole thing was so wonderfully done that I said it was the most perfect vase I had ever seen.

Thinking that he had convinced me, Lucagnolo answered: 'Your work looks just as beautiful to me, but it won't be long before we see the difference between them.'

Then he took his vase along to the Pope who was very pleased with it and had him paid on the spot at the usual rate. Meanwhile I went back with the jewel to Madonna Porzia. She was astonished when she set eyes on it, and she told me that I had by far and away surpassed what I had promised. Then she said that I must ask whatever I liked in return, since she thought that I deserved so much that even if she gave me a castle it still wouldn't be reward enough. 'However,' she added with a laugh, 'as I can't give you a castle, you must ask for something that I can give.'

My reply to this was that the greatest reward of all was to see how pleased she was with it. Then, laughing with her, I bowed and began to take my leave, repeating that that was the only reward I wanted. She turned to her companion and said: 'Now do you see what sort of company is kept by the virtues that we decided were in him? They have nothing to do with vice.'

They were both astonished at my attitude, and then Madonna Porzia said:

'Dear Benvenuto, have you ever heard the saying that when the poor give to the rich the devil has a good laugh?'

'Still,' I replied, 'he has a great deal of bad luck and this once I want to see him laugh.'

As I left, however, she told me that this time she had no intention of being so kind to him.

I went back to the workshop and I found Lucagnolo there, with the money he had got for his vase in a little packet. As I came in, he called out: 'Come over here and let's compare what you were paid for your little jewel with what I was paid for my vase.'

I told him that he should leave it as it was till the following day, and

that as I believed my work was in its way no less beautiful than his, I expected to be paid just as well.

Next day Madonna Porzia sent one of her head servants round to my shop: he called me outside and then handed me a packet full of money, with a message from her to say that she did not mean the devil to have the laugh to himself. Among other compliments worthy of such a lady she suggested by this that my work deserved much more than she was sending me.

It seemed an eternity to Lucagnolo before he could compare his earnings with mine. He came rushing into the workshop, and then, in the presence of about a dozen workmen and neighbours who were already there, anxious to see the result of the contest, he took hold of his packet, and crying out: 'Phew! Phew!' three or four times, laughing contemptuously, he poured the money very noisily on to the counter. There were twenty-five giulios, and he reckoned that what I had would come to four or five large crowns. Completely unnerved by his shouting and by the looks and smiles of the onlookers, I peeped inside my packet and saw that it was filled with gold. Then keeping my eyes on the ground, from one side of the counter in complete silence I lifted my packet right up in the air and poured out the contents as if from a mill-hopper. There were twice as many coins as he had. As a result, all those eyes that had been staring scornfully at me suddenly switched to Lucagnolo, and everyone said: 'Benvenuto has been paid in gold, and there's twice as much, so it makes a much better show.'

I felt certain that Lucagnolo was going to fall down dead on the spot, he was so filled with shame and envy. In fact a third of my earnings went to him (that is the usual custom – two-thirds fall to the workman and a third to the master of the shop) but his furious envy got the better of his greed. It should have been altogether the other way round, seeing that he was the son of a peasant of Jesi. He started cursing his work and the people who taught him, saying that from now on he would stop making large plate and give all his time to making my pimping little trash, since it was so well paid for. I grew as furious as him and retorted that every bird whistled its own tune and that he was talking after the fashion of the hovels he came from, but that although I reckoned I would find it very easy to make his stuff, which was all balls anyway,[29]

he would never succeed in making my trash. Then I stamped away in a rage, saying that he would soon see what was what. Everyone there told him quite bluntly that he was in the wrong, accused him of being the lout that he was, and praised me for being the man I had shown myself.

Next day I went along to thank Madonna Porzia. I said that she had done the opposite of the proverb, for when I wanted to make the devil laugh she had made him deny God again. We both laughed happily, and then she commissioned some more beautiful work from me.

Meanwhile I managed, through one of Raphael's pupils, to get the Bishop of Salamanca to order a large water-bowl from me. It was the kind called an *acquereccia*, used as a sideboard ornament. As the Bishop wanted two of the same size he had Lucagnolo working on one and me on the other. The design for these was supplied us by the painter Gianfrancesco whom I mentioned before.

A Milanese called Giovanpiero della Tacca allowed me to use a corner of his workshop and I started on the vase with tremendous enthusiasm. I made my calculations, put by enough money for some of my own needs, and sent all the rest to help my poor father in Florence. It happened that when this was paid to him he ran into one of those madmen who were among the Eight when I stirred things up a little. It was the same man who had abused him and sworn that he was determined to have me marched out to execution.

As this fellow had several good-for-nothing sons, my father said very tellingly:

'Accidents can happen to anyone, especially to quick-tempered men who are in the right, as my son was. But his life since then proves how well I brought him up. I hope to God for your sake that your sons behave towards you neither better nor worse than mine do to me. God taught me how to bring them up, and then when my strength failed, despite what you expected, He himself rescued them from your violence.'

Then after he had left him he wrote telling me everything that had happened. In his letter he begged me for the love of God to play a little music now and then, so that I would not lose the wonderful talent he had been at such pains to teach me. He wrote with such fatherly

affection that like the loving son I was I burst into tears, determined that as far as music was concerned I would make him thoroughly happy before he died; so God does indeed grant men all the legitimate requests they honestly make to Him.

While I was working hard on the Bishop's beautiful vase I had only one small boy helping me. I had taken him on as my assistant, giving in to the pressure of friends and half against my own will. His name was Paulino and he was about fourteen; he was the son of a Roman citizen who lived on a private income. This Paulino had the most perfect manners, the most honest character, and the prettiest face of any I have ever come across in all my life. His honest way of behaving and his incredible beauty and the great love he showed me made me love him in turn almost more than I could bear. I loved him so passionately that I was always playing music for him, in order to see his lovely face, which was normally rather sad and serious, brighten up when he heard it. Whenever I took up the cornet such a frank, beautiful smile came over his face that I am not at all surprised at those silly stories the Greeks wrote about their gods. In fact if Paulino had been alive in those days he might have unhinged them even more.

He had a sister called Faustina who was even more beautiful, I think, than the Faustina the ancient books are always babbling about.[30] Sometimes I used to visit their vineyard and from what I could judge it appeared to me that Paulino's father, a thoroughly worthy man, would have liked me as a son-in-law. All this made me play a great deal more than usual.

It was about this time that a man called Gianiacomo, who was a fifer from Cesena in the service of the Pope, and a splendid musician, got in touch with me. He sent a message through Lorenzo, the trumpeter from Lucca who is now serving our Duke of Florence, asking me if I would help them at the Pope's August festival[31] in some very beautiful motets they had chosen, by playing the soprano part on my cornet. Although I was burning to finish my wonderful vase, as music is a marvellous business anyway, and to give my father some satisfaction, I was quite ready to join them. We spent a week before the festival practising together two hours a day. On the day itself we went along to the Belvedere,[32] and while Pope Clement was having dinner we

played the motets we had rehearsed so well that he had to admit he had never heard music played more exquisitely or more harmoniously. Then he called Gianiacomo over and asked him how and where he had put his hands on such a fine cornet-player. He questioned him closely as to who I was, and Gianiacomo told him my full name.

'So he is Giovanni's son?' said the Pope. Gianiacomo told him that this was so, and then the Pope said that he would like me to enter his service along with the other musicians. To this Gianiacomo replied:

'Holy Father, I can't promise you anything definite about that, because he is a goldsmith by profession and that takes up all his time. What's more, he's a first-rate craftsman and he earns far more than he would as a musician.'

'I want him all the more as he has this unexpected accomplishment as well,' said the Pope. 'See to it that he receives the same pay as the rest of you, and tell him from me that he is to enter my service, and it won't be long before I give him plenty to keep him busy at his other trade.'

Then he stretched out his hand and gave Gianiacomo a hundred gold crowns of the Camera, tied up in a handkerchief, saying: 'Divide this up so that Benvenuto gets his share.'

Gianiacomo then came back and told us exactly what the Pope had said. He divided the money between the eight of us, gave me my share, and added: 'I'm going to have you registered as one of us.'

I replied: 'Let it rest for today, and I'll give you a definite answer tomorrow.'

Then I left them and went on my way debating with myself as to whether I ought to accept the offer, considering how upsetting it would be if I abandoned my fine studies. The following night my father appeared to me in a dream: he was crying affectionately, and he begged me for his sake and for the love of God to set out on this new path. I seemed to reply that there was nothing that could persuade me into doing so; and then all at once he appeared to assume a terrible shape and filled with terror I heard him say: 'If you don't, you'll know what a father's curse is like, but if you do, may I always pour my blessings on you.'

When I woke up I was so frightened that I ran to have myself

registered. After that I wrote and told my old father what I had done, and he was so deliriously happy that he made himself ill and was very near to dying. In his reply he wrote that he too had had almost exactly the same dream as me.

I decided that as I had satisfied my good father's honest wishes everything should now work out beautifully for me, bringing glory and honour. So I worked very diligently to finish the vase I had begun for the Bishop of Salamanca. He was a marvellous sort of man, very rich, but very hard to please. Every day he used to send someone along to find out what I was up to, and on one occasion, when his messenger found me out, the Bishop lost his temper and swore that he would take the work away from me and give it to someone else to finish. This was all because of my giving my time to that damned music.

All the same, I worked at the vase very diligently, day and night, till it reached the stage where I could show it to him. As a result the Bishop grew so impatient to have it finished that I regretted having let him see it. At the end of three months it was done. It was adorned with a wonderful variety of pretty little animals, and leaves, and masks. Straight away I sent my boy round to show it to that expert craftsman, Lucagnolo.

Paulino, with his infinite grace and charm, said:

'Lucagnolo, sir, Benvenuto says that, as he promised, here's your sort of balls, and now he's waiting to see some of his pimping little trash.'

Lucagnolo took the vase in his hand and studied it very carefully. Then he said to Paulino:

'My pretty little boy, tell your master that he's a very fine craftsman, and that I beg him to be my friend and leave it at that.'

The result of that splendid young lad's errand made me very happy. I took the vase along to Salamanca and he decided to have it valued. Lucagnolo took part in the valuation, and he put a higher price on it and praised it far more than I would have done. Then Salamanca took hold of the vase and like a typical Spaniard said: 'I swear to God that I'll take as long to pay him as he took over making it.'

When I heard this I found myself in a very nasty frame of mind, cursing all Spain and anyone who stood up for the country.

Now among its other beautiful adornments this vase had a handle

all in one piece that was very delicately made and by means of a spring could move upwards over the mouth. One day Salamanca was showing my vase off to some of his Spanish gentlemen when, after he himself had left the room, one of them started tricking about with the beautiful handle. The delicate spring could not stand up to such rough treatment and broke in his hand. Realizing the harm he had done he begged the butler who was in charge of the vase to take it round straight away to the craftsman who had made it and have it mended immediately. He promised to pay whatever was asked, provided it were done on the spot.

So the vase fell into my hands again. I promised to mend it instantly, and I did so. It was brought to me before dinner. Two hours before nightfall the man who had carried it along to me came back, sweating all over from having run the whole way because Salamanca was asking for it again to show some other noblemen. Before I could say a word he cried out: 'Be quick about it – bring the vase.'

Then I, who was intending to take my time and had no wish to give it to him, said that I did not mean to be all that quick. This threw him into such a rage that he went as if to grasp his sword with one hand, while with the other he threatened to force a way into the shop.

I at once barred his way, thrusting a weapon towards him and shouting out fiercely: 'I don't mean you to have it. Go and tell your master that I intend to be paid for my work before I let it out of this shop.'

Realizing that his bluster had failed, he started pleading with me, just as if he were praying at the foot of the Cross. He said that if I gave it to him he would make absolutely sure that I was paid. But he made no impression on me at all, and I kept repeating what I had already said. In the end he gave up hope and swore that he would come back with enough Spaniards to cut me to pieces. Then he ran off, leaving me determined to defend myself vigorously, since I was inclined to credit what I heard about their murderous habits. I loaded a splendid little gun that I kept for hunting, and I said to myself: 'He's robbed me of my property and labour, am I going to sell him my life as well?'

While I was in this state of agitation a crowd of Spaniards appeared on the scene, led by their majordomo. With typical arrogance this

fellow ordered them to march in, seize the vase, and give me a thrashing. When I heard this I showed them the muzzle of my loaded gun and roared out: 'You treacherous curs[33] – so is this how you loot the shops and houses in a city like Rome? Any one of you that makes a move towards this door, I'll shoot the thief dead.'

Then, pointing the gun at the majordomo as if I were about to fire, I added: 'And as for you, you thieving ringleader, I mean to kill you first.'

Straight away he dug his spurs into his jennet and galloped off as madly as he could. The tremendous hubbub brought all my neighbours out; and as well as this some Roman gentlemen who happened to be passing shouted out: 'Kill the curs, and we'll give you a hand.' This was said with such vehemence that the Spaniards were terrified out of their wits and beat a retreat. So, seeing what had happened, they were forced to tell the whole story to the Bishop. He was a very hot-tempered man, and he gave them all – servants and officers – a thorough dressing-down, first because of their trying to commit such an outrage, and then because once they had begun it they had not gone through with it.

Then the painter who had been concerned in the transaction came in, and the Bishop gave him instructions to tell me from him that if I did not bring the vase immediately the largest part left of me would be my ears, but that if I did bring it he would pay me on the spot. All this did not frighten me in the slightest, and I let him know that I would go and tell the Pope without hesitation. However his anger vanished, and so did my fear. Some important Roman noblemen gave me their word that he would not harm me, and as well as that I was assured that he would pay up. So, prepared with a hefty dagger and with my good coat of mail, I went along to the Bishop's palace.

I made my way in, with Paulino carrying the silver vase behind me, and found all his household drawn up waiting. It was just like walking through the middle of the Zodiac – one of them looked like a lion, another like a scorpion, the third like a crab, and so on till we were face-to-face with that scoundrel of a priest. He started spitting out a stream of abuse, like the priest and Spaniard he was, but I stared at the ground and refused to say a word.

This made him show his temper more than ever. He ordered some

writing materials to be brought to me, and then he said that I was to write in my own hand that I was quite satisfied and that I had received my payment. At this I raised my head and told him that I would be only too glad to do so, provided I was given the money first. The blood rushed to his face, and there was no end of threatening and argument. The upshot was that I was paid first and did the writing afterwards. And I went away, happy and satisfied.

Later on, when the Pope, who had seen the vase before without being told it was my work, heard what had happened, he was vastly amused, praised me to the skies, and said in public that he was very fond of me indeed. As a result the Bishop of Salamanca regretted the way he had bullied me and tried for a reconciliation by sending word through the same painter as before to the effect that he wanted me to do some very important work for him. I replied that I was only too glad to hear this, but that I would want to be paid in advance. This exchange also came to the ears of Pope Clement and made him roar with laughter.

He told Cardinal Cibo,[34] who was with him at the time, about the quarrel I had had with this bishop; then he turned to one of his officials and instructed him to keep me constantly employed on work for the palace. Cardinal Cibo sent for me, and after we had chatted pleasantly commissioned me to make a large vase for him, bigger than the one Salamanca had ordered. Besides this I was given work to do by Cardinal Cornaro and by many other cardinals, especially Ridolfi and Salviati:[35] they all gave me work to do. As a result I made a great deal of money.

Madonna Porzia, whom I talked about before, told me that I ought to open a shop all of my own. I did what she suggested and all the time I carried on working for this good and gracious lady, who paid me very generously. In fact more than likely it was because of her that I showed the world I was somebody. At the same time I struck up a great friendship with Signor Gabriello Ceserino, who was the Governor of Rome; and I did a lot of work for him. One of the outstanding things I made was a large gold medal to be worn in his hat, with a Leda and her swan engraved on it. He was very pleased with it and insisted on having it valued so that I would be paid a fair price. But the medal had

been made with exquisite care and skill and the valuers put a far higher price on it than he had expected. So it remained on my hands, and I got nothing for my pains. That medal suffered the very same fate as Salamanca's vase had done. But I shall have to skip these stories, in case they take up the space for more important matters.

Although it means wandering away from my profession, I want to write about my whole life. So without going into detailed descriptions I shall have to sketch some other events for the reader. Well then, one morning – it was the feast of St John[36] – I was dining with a large number of compatriots of mine who all followed various professions. There were painters and sculptors and goldsmiths, and among these outstanding men was the painter, Rosso,[37] and a pupil of Raphael called Gianfrancesco. I had brought them all together informally and they were laughing and joking as a crowd of men always does when such a wonderful feast day is being celebrated.

In the middle of it all, a feather-brained young swaggerer, one of Rienzo da Ceri's soldiers,[38] happened to pass by. When he heard the noise we were making, he started mocking and hurling insults about the Florentines. As host to all those accomplished artists I took this as a personal affront and so, very softly, without being noticed, I went out and confronted him. He was standing there with his tart, carrying on with his jeering to make her laugh. I went straight up to him and demanded if he was the fellow who had been rash enough to insult the Florentines. He immediately retorted: 'I'm that very man.' When he said that, I lifted my hand, hit him in the face, and shouted: 'Then I'm *this* very man.'

At once we both snatched at our swords, but no sooner had the fight begun than we were separated. Everyone took my part rather than his, because they clearly witnessed that I was in the right.

Next day he sent round a challenge which I was only too glad to accept, saying that this business was something I could polish off far quicker than any of my ordinary work. I immediately went to confer with a fine old fellow called Bevilacqua, who had the reputation of having been the best swordsman in Italy. He had fought more than twenty duels in his time, and come out of them all with honour. This upright man was a great friend of mine; he knew me as a goldsmith,

and besides that he had acted as a go-between in some violent quarrels I had had.

So as soon as he saw me, he said: 'My dear Benvenuto, if you had to fight a duel with Mars himself I'm sure you'd come out of it with honour. All the years I've known you I've never seen you start a quarrel in the wrong.'

He took on the job of second and we went along, armed, to the place that had been agreed on. In fact no blood was shed, because my opponent withdrew. I came out of the affair with honour. I shall not give any more details, since, although they would be very impressive of their kind, I want to save my breath to talk about my art, as that after all is why I am writing. Even then, I still have too much to tell.

Moved by a spirit of honest rivalry I wanted to do the kind of work in which I could equal and even surpass that expert craftsman, Lucagnolo. But at the same time I never abandoned my wonderful jeweller's art. So what with one and the other I earned a great deal of money and even more fame. And in both those arts I produced original work.

At that time there was living in Rome a very able man from Perugia, called Lautizio.[39] He specialized in one kind of art, but in it he was unique in the world. Now, in Rome, every cardinal has his own seal, with his coat of arms engraved on it. These seals are made just about the size of a twelve-year-old's hand, and a variety of figures are cut on them together, as I said, with the cardinal's arms. One of these seals, well made, fetches a hundred crowns and more.

I had an honest ambition to compete with this man as well, even though his kind of art is different from all other branches of the goldsmith's craft – which is why Lautizio only knew how to make seals. So I set out to make myself expert in his profession, though I found it very difficult indeed. All the same, for all the trouble it gave me, I never tired of it, and kept hard at work in search of profit and knowledge.

There was another first-rate artist in Rome, a Milanese called Cara-dosso.[40] He specialized in medals, chiselled on metal plate, and many other things of that kind. He made *paxes* in half relief, and figures of Christ, about a hand's length in size, cut out of very fine gold plate.

These were so beautifully executed that I reckoned him the greatest artist of his kind that I had ever come across, and I was more anxious to rival him than I was anyone else. There were also some other craftsmen who worked at cutting medals out of steel. These medals are the matrices and true guide for anyone who wants to excel at making coins.

I set out very industriously to learn all these different crafts. And then, of course, there was the exquisite art of enamelling! As for that, I never came across a better craftsman than our Florentine, Amerigo. I never knew him, but I knew his magnificent work, and I have never, anywhere in the world, seen any man's work that could approach his splendid perfection by a long chalk. Enamelling is an extraordinarily difficult business, because in the finishing process the fire very often completely ruins the work; but all the same I bent all my energies to learning the craft. I found it very hard going but I got so much pleasure out of it that I looked on my exertions as a kind of relaxation. This attitude was the result of a special gift from God of a temperament so healthy and well balanced that whatever I took it in my head to do I could always accomplish.

All the crafts I have mentioned are so very different that if an artist is good at one of them and then turns to the others, he never succeeds in reaching the same standard as in the one he is perfect at. All the same I did everything I could to become expert in each one of them. And when the time comes I shall prove my success.

About that time, when I was still only a young man of around twenty-three, a plague broke out in Rome and raged so fiercely that every day many thousands died of it. This frightened me a little, and I began to seek relief in a sport that I found very enjoyable. But there was a reason for this that I shall tell you about. It happened in this way. On feast days I used to love going along to study the ancient buildings, and I used to make copies of them, sometimes in wax and sometimes on paper. These buildings are all broken down, and the ruins shelter a vast number of pigeons. I felt the urge to have a shot at some of them, so because of my fear of the plague and to avoid the risk of contagion, I used to get my Paulino to carry the gun and he and I would go off by ourselves to the ruins.

Many a time we used to come back laden with some very plump pigeons. I did not like loading my gun with more than a single ball, so my successful hunting was the result of really good marksmanship. I had a straight fowling-piece made by myself, so bright that it shone outside and in just like a mirror. I also manufactured my own gunpowder, discovering the most wonderful secrets that are still unknown to anyone else. But in order not to digress too long, I shall give just one instance in the connexion that will flabbergast anyone who knows something about the matter. This is it. When I charged my gun with powder, a fifth of the weight of the ball, the shot carried two hundred yards point-blank.

Although the great pleasure I found in these expeditions threatened to draw me away from my trade and my studies – and in fact it did so – in another way it gave me much more than it took, because every time I went hunting my health improved remarkably from the invigorating fresh air.

I have a naturally melancholy disposition, but on these trips I used to grow very light-hearted, and found myself working better and more skilfully than when I spent all my time studying and working. So all in all my gun brought me more gain than loss. Besides this, it was the cause of my becoming friendly with some antique-collectors who hung around the Lombard peasants when they made their seasonal visit to Rome to dig the vineyards. While they were digging these peasants were always finding ancient medals and agates, chrysoprases, cornelians, and cameos, and also precious stones, like emeralds, sapphires, diamonds, and rubies. The collectors were sometimes able to buy these from the peasants for a few coins. And sometimes – in fact quite often – when I met these collectors I gave them, for what they had, more than as many gold crowns as they had paid giulios.

These transactions, without taking into account the great profit I made which was easily tenfold, also helped me establish good relations with nearly every cardinal in Rome. I shall just mention one of the most outstanding and rare of these treasures. Among many other things there fell into my hands a dolphin's head, about the size of one of those big beans used for voting. The head was exquisitely cut, but Nature showed her superiority to art in the magnificence of the emerald itself.

Its colour was such that the man who bought it from me for a few dozen crowns had it set, like an ordinary gem, in a ring, and then sold it for hundreds.

Then there was another kind of stone – a head cut from the most wonderful topaz ever seen in the world. In this, art equalled nature. It was as big as a large hazel-nut, cut with exquisite beauty into a head representing Minerva. And then again there was another, different stone. This was a cameo, with a representation of Hercules binding the three-headed Cerberus cut on it.[41] It was a work of such beauty and genius that even our great Michelangelo had to confess that he had never seen anything so marvellous.

As well as all this, among the many bronze medals that came my way there was one designed with a head of Jupiter. It was the largest medal I had ever seen, and the head was absolutely perfect; on its reverse there were some very beautiful figures that were just as perfect. I could go on talking for ever about all this, but I do not want to take too long.

I shall now go back a little in the story, but this will not be off the subject. As I said above, the plague had broken out in Rome. While it was raging a very great surgeon called Jacomo da Carpi[42] appeared on the scene. Among his other patients this able man took on some who were in a very bad way from the French pox. In Rome, as it happens, this particular disease is very fond of priests – especially very rich priests. So when the great doctor had made himself known, he claimed that in the use of certain fumigations he had a splendid cure for the disease. He insisted, however, on the payment being settled before he began the cure, and his fees were reckoned not in tens but in hundreds.

This able man also knew a great deal about the art of design; and one day he happened to be passing by my shop when his eye fell on some drawings that I had lying around. Among them were designs for fantastic little vases. I had done them to amuse myself, and they were utterly different from anything ever seen before.

The doctor asked me if I would make some of them for him, in silver, and I was only too delighted to do so as it suited my own whim. Although the great doctor paid me very generously for them, the fame they won for me was worth a hundred times more, since the best

goldsmiths in the trade said that they had never seen anything more beautiful or better made. I finished them for him, he at once showed them to the Pope; and the next day he suddenly decamped.

He was a very learned man, and he could talk marvellously about medical matters. The Pope in fact wanted him to stay in his service, but he said that he had no intention of entering anyone's service, and that anyone who wanted him would have to come to him. He was a cunning devil, and he knew what he was doing when he left Rome, because, not many months later, all those he had cured fell so ill that they were a hundred times worse than before. If he had stayed he would have been killed.

He showed off my vases to a great many noblemen, including his Excellency the Duke of Ferrara.[43] He told the Duke that they had been given to him by a great nobleman in Rome and that he had told the nobleman that if he wanted to be cured he must give him the two little vases. The nobleman had replied that they were antiques, and that the doctor might ask for anything else and he would not mind, but that he should leave the vases. Then, the doctor said, he had acted as if he would not perform the cure, and so he had obtained what he wanted.

All this was told me in Ferrara by Alberto Bendedio, who very solemnly showed me some earthenware copies of the vases. When I saw them I burst out laughing and then fell silent. As a result, Alberto Bendedio, who was a very pompous man, lost his temper and cried out:

'You're laughing at them, eh? I can tell you that not for a thousand years has there been any man capable of even copying them.'

In order not to damage their reputation I kept quiet and admired them in amazement.

In Rome many great noblemen told me that they thought these vases were marvellous works of antique art. Some of them were friends of mine, and so, emboldened by all this, I confessed that I had made them myself. When they refused to believe it, to prove that I was telling the truth I had to support my claim by making some new designs. My word by itself was not good enough, as Jacomo had cunningly insisted on carrying off the original drawings. This little operation proved quite profitable for me.

The plague raged away for a good few months, and I remained untouched. Many of my friends died but I stayed safe and sound. One evening one of my associates happened to bring home to supper a Bolognese prostitute called Faustina. The woman was very beautiful, but she was about thirty. However she had with her a little maid of about thirteen or fourteen. As Faustina belonged to my friend I would not have touched her for all the gold in the world. Although she declared that she was madly in love with me I never betrayed my friend's trust. But when they went to bed I had the little maid, who was as fresh as fresh; and it would have been worse for her if her mistress had known it. I had a wonderful time that night and was much more satisfied than I would have been with Faustina.

Next day, towards dinner time, I felt very tired, as if I had been walking for miles, and when I tried to eat I was attacked by a fierce headache. At the same time I discovered some swellings on my left arm, and a carbuncle on the outside of my left wrist.

Everyone in the house was terrified: my friend, the fat cow, and the little one, all ran away, and I was left alone with a wretched shopboy who refused to leave me. I felt stifled round my heart and I knew for certain that I was as good as dead. Then my apprentice's father, who was the household doctor to Cardinal Iacobacci,[44] happened to pass by the shop. My assistant ran out and shouted to him:

'Father, come and have a look at Benvenuto. He's slightly ill in bed.'

Not thinking what could be wrong with me, he came in at once and felt my pulse. Then, after he had seen and felt what he would have preferred not to, he turned on his son and shouted:

'You treacherous boy – you've ruined me. How can I ever go to the Cardinal again?'

His son answered: 'Father, my master is worth all the cardinals in Rome.'

At this the doctor turned to me and said: 'As I'm here I may as well see to you. But I warn you that if this is the result of intercourse you're as good as dead.'

I told him that I had indulged in it that very night, and he said: 'With what sort of creature, and when?'

'Last night,' I answered, 'with a very young girl.'

Realizing he had spoken rather stupidly, he immediately went on to say:

'As the swellings are recent and not yet putrid, and we've started the cure in good time, don't be too frightened. I shall cure you all right.'

He gave me some treatment and went on his way. Almost immediately a very close friend of mine called Giovanni Rigogli appeared on the scene. He commiserated with me for my terrible illness and for having been deserted by my companion, and he told me I could rely on him not to leave till he saw me better. I said that he was not to stay near me, since I was done for. But I begged him to do one thing for me. I wanted him to take the store of crown pieces that were in a little box by my bed, and, when God took me from this world, to send them off to my poor father, with a letter telling him gently that I too had joined the victims of that terrible epidemic.

That dear friend of mine replied with an out-and-out refusal to leave me and said that whatever way things went he knew perfectly well what he ought to do for his friend. So, with God's help, the days went by; and the remedies given me were so efficacious that I began to improve tremendously, till I soon recovered from that terrible illness.

While the sore was still open with a plug of lint in it and bandaged up, I used to go out riding on a little wild pony I had. It was covered with long hair and was about the size of a large bear cub; in fact it looked just like a bear. I rode out on it to find the painter, Rosso, who was staying outside Rome, towards Civitavecchia, at a place called Cerveteri that belonged to the Count of Anguillara.[45] My friend Rosso was delighted to see me, and I said: 'I've come to do to you what you did to me so many months ago.'

He immediately burst out laughing, flung his arms round me and kissed me, and told me to keep quiet because of the Count. I stayed there very comfortably and happily for about a month, enjoying good wine and the best food, and made much of by the Count. Every day I used to wander by myself along the sea-shore, where I would dismount and collect great quantities of various kinds of rare pebbles, and little snails, and wonderfully beautiful shells. The last day I went there I was attacked by a crowd of masked men who had disembarked from a Moorish caravel. When they thought they had cornered me in a way

that escape was impossible, I suddenly leapt on my pony determined to go either to the devil or the deep blue sea, since I was in such a dangerous situation that I knew I would be either shot or drowned. But, thanks to God, my pony – the one I described above – made an incredible jump and I escaped safely, offering prayers to God. I told the Count what had happened. He at once raised the alarm. But the caravel had put out to sea. The next day, healthy and happy, I went back to Rome.

By now the worst of the plague was over, and all those who were still alive went round greeting each other affectionately. This rejoicing gave birth to a society that included the best painters and sculptors and goldsmiths that there were in Rome. The founder of the club was a sculptor called Michelagnolo;[46] he came from Siena and was such an expert craftsman that he could be compared with anyone else in his trade. But above all he was the most agreeable and genial man in the world. As far as age was concerned he was the oldest among us, but his vigour made him seem the youngest.

We used to meet together very often, at least twice a week. I must not forget to mention that our society also included Giulio Romano, the painter,[47] and Gianfrancesco, two splendid pupils of the great Raphael of Urbino. After we had been meeting time and time again, our admirable president decided that the following Sunday we would all meet for supper at his house, and each of us was to bring what Michelagnolo called his 'crow' along with him. Whoever failed to do so would have to stand all the others a supper.

Those of us who did not know any women of the town had to go to no little trouble and expense to get hold of one, in order to avoid being disgraced at our brilliant supper-party. I thought I was well provided for with a very beautiful young woman called Pantasilea who was madly in love with me; but I had to give her up to a close friend of mine, Bachiacca,[48] who had been, and still was, passionately fond of her. This gave rise to a few lovers' quarrels, because when Pantasilea saw how easily I had given her up to Bachiacca she came to the conclusion that I didn't care a straw for her love, great as it was. Shortly after, her determination to pay me back for the insult led to no end of trouble, which I shall describe when the time comes.

When it was nearly time for us to appear at our brilliant meeting and present our crows I was still without one, but I decided it would be wrong to fail over such a silly thing. What gave me most worry was that I had no wish to have that distinguished gathering see me bring in under my wing some bedraggled old scarecrow. So I hit on a trick that would amuse everyone enormously.

I made up my mind as to what I would do, and then I called in a young lad of sixteen who lived next door, the son of a Spanish coppersmith. He was studying Latin, and was very studious. His name was Diego. He was a handsome boy, with a wonderful complexion, and his head was even more beautifully modelled than that of the ancient statue of Antinous.[49] I had drawn him very often and he brought me a great deal of honour. He never went out with anyone and so he was completely unknown. Also, he dressed very badly and slovenly and all he loved was his precious studying.

When he came in I asked him to let me dress him up in the woman's clothes I had got ready. He was quite willing and put them on at once. Then I quickly improved even his beautiful face by the attractive way I arranged his hair, and I put two little rings in his ears. They had two beautiful large pearls, and as the rings were split I just clipped them on, which made it look as if his lobes were pierced. After that I arranged some beautiful gold and richly jewelled necklaces round his neck, and adorned his lovely hands with rings.

Then with a smile I took him by the ear and led him in front of my large mirror. When he saw himself he blurted out: 'Help! is that Diego?'

'It most certainly is,' I said. 'It's the Diego I have never yet asked for anything, but now I want him to do me one harmless favour, which is that I want him to come out to supper, in the same clothes he has on now, with that famous society I've often told him about.'

Now, he was a good-living, thoughtful young man, and very intelligent. He quietened down, stared at the floor, and stood for a while without saying a word. Then, all at once, he looked up at me and said: 'If it's with Benvenuto, I'll come. Let's be on our way.'

I put a large scarf round his head – the sort that in Rome is called a summer-cloth – and when we reached the meeting-place everyone was already there to welcome us. Michelagnolo was standing between

Giulio and Gianfrancesco. When I took the scarf off my pretty young man's head, Michelagnolo, who as I've said before was the pleasantest, wittiest man imaginable, stretched out his hands, placed one on Giulio and one on Gianfrancesco, and with all his strength forced them to bow down. Then he himself, falling on his knees, pretended to cry for mercy and shouted out to everyone:

'Look at this! Look what the angels of paradise are like. Though they are called angels, some of them are women.'

Then he added:

> 'Angel of grace and beauty,
> Bless me and protect me.'

At this, the graceful creature starting laughing, lifted his right hand, and, talking gracefully, gave him a Papal blessing. Then Michelagnolo stood up and said that one kissed the feet of the Pope but the cheeks of angels – and when he suited the action to the words the young man blushed furiously and looked more beautiful than ever. After this introduction, we discovered that the room was full of sonnets that we had written and sent to Michelagnolo. My young companion began to read them, and as he spoke them aloud – every one of them – his incredible beauty was so enhanced that I find it impossible to describe. Then there was a great deal of comment and conversation, which I shall not give in detail as that is not my purpose. But I shall just report one thing, because it was said by that splendid painter, Giulio. He looked round shrewdly at everyone present, staring most of all at the women, and then he turned to Michelagnolo and said:

'My dear Michelagnolo, your name, crows, fits this crowd only too well today. But they haven't even the beauty of crows when they're set by the side of one of the most beautiful peacocks imaginable.'

When the food was ready and served and we were about to sit down at table, Giulio asked as a favour that he should be allowed to decide on our places. His request was granted, and, taking each woman in turn by the hand, he arranged them all round the inside, with my one in the middle. Then he put all the men round the outside, with me in the middle as he said that I deserved the highest honour. There was a

beautiful trellis of natural jasmines behind where the women sat, and with this background their beauty, and my partner's especially, was so wonderfully set off that words fail to describe it. So we all set to with a will on that splendid and sumptuous feast.

After we had eaten, we heard some wonderful singing and music. They were playing and singing from written music, and my lovely companion asked permission to take part. His performance was so much better than almost all the others' that everyone was astonished. In fact Giulio and Michelagnolo stopped talking about him in the joking way they had done at first, and their praise became grave and serious and showed the wonder they felt. When the music was finished a man called Aurelio Ascolano, who was marvellous at improvisation,[50] began to praise the women. While he was reciting his heavenly, beautiful words, the two women who were sitting on either side of my lovely companion never left off chattering. One of them told how she had come to take the wrong turning, the other one started asking my companion how it had happened to her, and who were her men friends, and how long she had been in Rome, and other questions of that sort.

As a matter of fact, if all I had to do was describe what went on, I could give details of a host of amusing incidents that took place because of Pantasilea's infatuation for me. But as they are outside my purpose I shall pass them over briefly. Now the chatter of those beastly women began to annoy my companion – to whom we had given the name of Pomona – and so Pomona, in her anxiety to get away from their stupid babbling, began turning now to one side and now to another. The woman whom Giulio had brought asked if there was something wrong with her, and she said, yes, there was, that she thought she was pregnant by several months and felt a pain in her uterus. At once, in their concern for her, the two women started feeling Pomona's body and discovered she was a male. They drew their hands away quickly, shot up from the table, and began insulting him, in words usually reserved for pretty young men. Immediately uproar broke out, and everyone started laughing and crying out in amazement. The stern Michelagnolo asked permission to give me the penance he thought proper and, when it was granted, with loud cries from everyone else he lifted me up and shouted: 'Long live Benvenuto: long live Benvenuto.'

Then he added that that was the sentence I deserved for such a perfect trick. In this way, with day coming to an end, that charming supper-party finished; and we all went home.

If I wanted to give a detailed description of what work I did, and how many items there were, and what people I did them for, it would take me far too long. All I need say now is that with great care and enthusiasm I gave my time to making myself accomplished in all those different branches of art that I talked about before. I worked away at them all without stopping. I have not yet had an opportunity of describing some of my more notable work, but I shall want to do so when a suitable occasion presents itself, which will not be very long now.

At that time, Michelagnolo, the sculptor from Siena whom I mentioned, was working on the tomb of the dead Pope Adrian.[51] The Roman painter, Giulio, went off to enter the service of the Marquis of Mantua;[52] and the other members of our group were scattered, some here, some there, on their own business. So that brilliant society I talked about was almost completely dispersed.

It was about that time that some small Turkish daggers fell into my hands. The handles, as well as the blades, were made of iron, and even the sheaths were. They had been engraved by iron tools with patterns of beautiful foliage, in the Turkish style, which were nicely filled in with gold. I was seized by a burning desire to try my hand at that kind of art as well, which was so different from the others; and when I found that I could manage perfectly well I made several daggers of that sort. For a variety of reasons these were much finer and far more durable than the Turkish ones. One reason was that I cut much deeper and my undercutting was far wider than that of the Turkish craftsmen. And again, Turkish foliage work is only based on arum leaves, with a few small sunflowers, and, although this is quite pretty, unlike our designs it soon loses its charm. In Italy we have several kinds of foliage design. The Lombards do very beautiful work by copying the leaves of bryony and ivy, in magnificent loops which are very pleasing to the eye. The Tuscans and Romans improve greatly on this because they copy the leaves of the acanthus, commonly known as bear's foot, and show its stems and flowers all twisting and turning. It gives a charming effect if

one has some birds and various kinds of animals engraved on the work as well; and his choice here shows what sort of taste the artist has.

The design for some of these animals can be found by the artist in nature, in wild flowers, for example, like those known as snapdragons; and a skilful artist can work in various beautiful ideas derived from other flowers. People who are ignorant about such matters call these artistic fantasies 'grotesques'. This name has been given them in modern times from their having been found by students in certain underground caves in Rome, which in ancient times were used as dwelling-rooms, bath-houses, studies, halls, and so forth. These places are underground, because they have remained as they are while the level of the ground has risen over the years; and in Rome such underground rooms are called grottoes. That, then, is the origin of the name 'grotesques'. But that is not the right name; because, just as the ancients loved to create monsters by having intercourse with goats, and cows, and horses, and calling their hybrid offspring, monsters, so our artists create another sort of monster, by mingling different kinds of foliage. So monsters, and not grotesques, is the correct term. I designed my foliage in this way, and when it was inlaid the work I produced was much more impressive than the Turkish.

Around that time I got hold of some vases, some ancient urns choked with ashes, and among the ashes I found a number of ancient iron rings, inlaid with gold, in each of which was set a tiny shell. I consulted the experts about these rings and they told me that they used to be worn by people who wanted to remain in a state of equanimity, no matter what wild accidents either for good or ill came their way. When I learned this, at the request of some gentlemen who were great friends of mine I started making a few rings of the same sort. Mine, however, were made of well-tempered steel, and when they were finely engraved and inlaid with gold they looked very, very beautiful. Merely for the work put into one of them I often earned more than forty crowns.

In those days it was the fashion to wear a little gold badge in one's hat and noblemen or gentlemen liked to have them engraved with some emblem or device. I made quite a few of these badges, though it was very difficult work. Caradosso – that very able man I spoke about

before – used to make them; his designs included more than one figure and as a result he never asked for less than a hundred gold crowns each. Because of this, not so much because of what he charged as because he was a slow workman, certain noblemen much preferred to come to me. For them, among other things, I made a medal in competition with that great artist.

There were four figures engraved on this medal, and it gave me a great deal of trouble. As it happened the noblemen I was working for, after they had compared my medal with the one turned out by that splendid artist Caradosso, said that it showed far better craftsmanship and was more beautiful, and that I was to ask whatever I liked for the pains I had taken over it. They wanted to give me as much satisfaction, they said, as I had given them. To this my reply was that the greatest reward for my exertions, and the one I wanted most of all, was to have equalled the work of such an expert artist, and that if their lordships thought I had done so I reckoned myself very well paid. With that I left them, and they immediately sent me such a generous reward that I was perfectly satisfied. My ambition to do really well became so great that it was the cause of all that followed.

Now I shall have to digress a little from artistic matters, as I want to give an account of some troublesome events that disturbed my turbulent life. I have already given some details about that brilliant circle of artists I belonged to, and of the amusing results of my connexion with that woman Pantasilea, whose false love I found so distasteful. She was furious with me because of the joke I played in bringing that Spanish boy, Diego, along to the supper-party, and she swore she would have her revenge. Her chance came when something happened, that I shall describe, which put me in very great danger of my life.

What happened was this. First of all, a young man called Luigi Pulci turned up at Rome. He was the son of the Pulci[53] who had been beheaded for incestuous intercourse with his daughter. This young man was a wonderfully talented poet, was a good Latin scholar, and could write well. At the same time he was very graceful and extraordinarily handsome. He had just left some bishop or other, and he was riddled with the French pox.

When this Luigi had been a boy in Florence it used to be the custom

on summer evenings to gather together in the streets; and on those occasions, he used to sing, improvising all the time, among the very best voices. His singing was so lovely that Michelangelo Buonarroti,[54] that superb sculptor and painter, used to rush along for the pleasure of hearing him whenever he knew where he was performing. A goldsmith called Piloto[55] who was a very talented artist, and I myself, used to accompany him. This, then, was how Luigi Pulci and I came to know each other.

After many years had passed, in the wretched condition I described he sought me out at Rome and begged me, for the love of God, to come to his help. I took pity on him, because of his great talents, for love of my native town, and because I am naturally kind-hearted. So I brought him home, and there had him given medical attention with the result that, as he was still a young man, he soon recovered his health. While he was recovering he studied all the time, and I helped him to lay his hands on as many books as I could. Recognizing how deeply he was in my debt, he thanked me over and over again with tears in his eyes, saying that if ever God put some good fortune in his way he would pay me back for all I had done. My reply to this was that I had not done all I would have liked to, but only what I could, and that anyway all human beings ought to help each other. However, I reminded him that the kindness I had showed him, he in turn should show to anyone else who ever needed his help as he had needed mine. Also, I told him to look on me, now and always, as a friend.

Soon after, this young man began to frequent the court of Rome. He soon found a niche for himself and entered the service of an eighty-year-old bishop, called Gurgensis.[56] This bishop's nephew was a Venetian gentleman, called Giovanni, who made it seem that he was tremendously attracted by Luigi's talents. With these talents for his excuse he made Luigi as much at home in his household as if he were himself. Luigi happened to talk about me and about how tremendously he was in my debt, and as a result Giovanni wanted to meet me.

Following on this, some evening or other when I had prepared a little supper for Pantasilea and invited a crowd of brilliant friends to join us, we were just about ready to sit down, when Giovanni came in with Luigi. After the introductions had been made they stayed to

eat with us. As soon as my brazen-faced whore set eyes on such a handsome young man she began to have designs on him. So immediately our pleasant little supper-party was over, I called Luigi aside and said that as he insisted that he was so much in debt to me he should in no circumstances make any effort to get familiar with that prostitute.

'My dear Benvenuto,' he said, 'do you think I'm raving mad?'

'No, not mad,' I replied, 'just young. As for me, I swear to God I don't care a damn about her. But I would be sorry to see you come a cropper because of her.'

When he heard this he said vehemently that he hoped to God he would come a cropper and break his neck the moment he ever spoke to her. The poor young man must have prayed pretty intensely, because he did in fact break his neck – and I shall tell how it happened in a minute.

It soon became only too clear that Giovanni's love for him was dirty rather than disinterested. Every day Luigi was seen wearing different velvet and silk clothes, and it was obvious that he had completely abandoned himself to wickedness and was neglecting his splendid talents. Then he began pretending not to see me or recognize me, after I had taken him to task and told him that he had allowed himself to become enslaved to the sort of bestial vices that would one day break his neck in the way I said.

His Giovanni had paid out a hundred and fifty crowns on a magnificent black horse for him. The animal was superbly trained, and every day Luigi used to prance around on it, paying his attentions to that whore Pantasilea. I heard all about it, but I never cared a straw. I reflected that everything acted according to its nature, and I concerned myself with my studies.

Then, one Sunday evening, it happened that we were invited to supper by the Sienese sculptor, Michelagnolo – this was during the summer. Bachiacca, whom I have mentioned before, was with us, and he had brought his former bedmate, Pantasilea. When we sat down she was placed between Bachiacca and me, and half-way through supper she stood up asking to be excused as she felt uncomfortable, and saying that she would come back straight away. We carried on, talking and eating very agreeably, but she was away for an unnecessarily long time.

As it was I kept my ears open, and I thought I heard someone laughing softly in the street. I had in my hand the little knife I was using at table. The window was so near where we were sitting that merely by raising myself a little I could see them out in the street – Luigi Pulci and Pantasilea. Then I heard Luigi say:

'If only that devil Benvenuto could see us, we'd be in for it!'

'There's no need to be afraid,' she answered, 'listen to all the noise they're making. They're thinking of anything but us.'

I had recognized them all right, and when I heard what they were saying I hurled myself through the window and seized Luigi by the cloak. I would certainly have killed him with the knife I had in my hand, but as he was sitting on a little white horse he managed to dig in his spurs and leave his cloak in my hands to escape with his life. Pantasilea ran to take refuge in a neighbouring church, and meanwhile everyone inside came running out and begged me not to upset myself or them over a mere tart. I retorted that I was not worried about her, but about that young rascal who had shown such contempt for me. I refused to let any of those worthy men talk me out of it, and seizing my sword I went off by myself towards Prati. The house where we had been having supper was not far from the Castello gate which leads to Prati.

Soon after I set out the sun went down, and walking slowly I went back into Rome. The night was already dark, but the gates of the city were still open. About two hours after sunset I arrived at Pantasilea's house. I was determined that if I found Luigi Pulci there I would make myself very unpleasant to both of them. After I had discovered that there was no one at home, except for a miserable servant girl called Canida, I went to jettison my cloak and sword-scabbard, and then came back to the house which was behind the Banchi, on the Tiber.

There was a garden opposite, which belonged to an innkeeper called Romolo and which was enclosed by a thick hedge of thorns. I hid myself in the hedge, standing upright, and waiting for the woman to return home with Luigi. After a while my friend Bachiacca appeared on the scene, having either guessed or been told where I was. 'Is that my old crony?' he called out softly – we used to call each other 'crony' for a joke. Then, almost in tears, he began to beg me for the love of God not to hurt the poor girl, as she was entirely blameless.

'If you don't move off this instant,' I said, 'I shall hit you on the head with this sword.'

That poor old crony of mine was so terrified at what I said that his bowels started moving and he was forced to retire a little way off to relieve himself. It was a very starry night, and wonderfully bright. All at once I heard a great clatter of horses, approaching from both sides. It was Luigi himself, together with Pantasilea, and accompanied by a certain Messer Benvegnato[57] from Perugia, who was Pope Clement's chamberlain. They had with them four fine young Perugian captains as well as some other intrepid young soldier lads. Altogether there were more than a dozen swordsmen.

When I saw all this, realizing that I had no way of escape I decided to draw back into the hedge. But I was in agony from all those sharp thorns, and, goaded like a bull, I all but made up my mind to leap out and run for it, when Luigi, who had his arm round Pantasilea's neck, said: 'Just one more kiss to spite that treacherous Benvenuto . . .'

At this, maddened by the thorns and forced on by what I had just heard, I sprang out, lifted my sword, and shouted: 'You're all as good as dead!'

My sword fell with such tremendous force on Luigi's shoulder that, even though those satyrs had plated the wretched young man with coats of mail and suchlike, when it was turned it struck Pantasilea across the nose and mouth. The two of them rolled to the ground, and then Bachiacca, with his breeches half down, gave a scream and ran for his life. I attacked the others furiously with my sword, and at the same time there was such a great commotion in the inn that those brave fellows thought they were being set on by an army of a hundred strong. They had all boldly drawn their swords, but two of the horses panicked and threw them into confusion. So when two of their best riders were thrown the rest of them took to flight.

When I saw how well things were going I hurriedly retired from the engagement – at great speed, but with honour – not wanting to tempt fortune more than necessary. There was such a muddle that some of the soldiers and officers wounded themselves with their own swords, and Benvegnato – the Papal chamberlain that I mentioned – was kicked and trampled on by his mule. One of his attendants who had his sword

drawn fell with him, giving him a nasty wound in the hand. This misfortune made him curse more than all the others, and he roared in typical Perugian fashion: 'By God, this Benvegnato will give Benvenuto something to think about.'

Then he ordered one of his captains – more daring than the others, perhaps, but so young that he lacked their good sense – to get hold of me. This captain came looking for me at the place I had retired to. I was in the house of a Neapolitan nobleman who had appreciated some of my work, admired my military character and bearing, and so had taken a great liking to me. He himself was very fond of soldiering. Seeing how welcome I was there, and feeling quite at home, I gave that captain the sort of reply that must have made him feel sorry he ever came to find me.

A few days later, when their wounds were healing up – that is, Luigi's, and his whore's, and the others' – Benvegnato felt a little calmer. He came along to the nobleman I was staying with to try to persuade me to make it up with young Luigi, and he added that those intrepid soldiers had nothing against me themselves, and only wanted to make my acquaintance. The nobleman let them know that he would bring me wherever they wanted, and that he would be only too glad to persuade me to make peace. But he said that there must be no recriminations on either side, as that would be too degrading. We would just have to go through the ceremony of drinking together and embracing; he would do all the talking and would be only too pleased to put himself at their service.

That was what happened. One Thursday evening this nobleman took me along to Benvegnato's house. All the soldiers who had been routed were there, sitting down at table. And, a thing Benvegnato had not expected, my friend brought along with him more than thirty strapping fellows, all well armed. We entered the hall with him leading the way and me after, and he said:

'God be with you, gentlemen! Benvenuto, whom I love like a brother, and I myself have come along here, ready to do all you want.'

Benvegnato, confronted with such a troop of men, answered: 'All we want is to make peace.'

Then he promised that I would not be molested by the authorities,

and we made peace. Immediately afterwards I returned to my workshop, where not an hour went past without that Neapolitan nobleman either coming to see me himself or sending for me.

Meanwhile Luigi Pulci had recovered and began riding about every day on that black horse of his, the one that was so beautifully trained. One day when it happened to be raining and he was putting his horse through its paces just outside Pantasilea's door, he slipped and fell with the horse on top of him, breaking his right leg at the thigh. A few days later he died in Pantasilea's house. That was how he fulfilled the vow he had made so intensely to God. So we can see how God reckons up good and evil, and gives every man what he deserves.

The whole world was now at war.[58] Pope Clement had sent to Giovanni de' Medici for some troops, and when these arrived in Rome they behaved so brutally that it was dangerous to remain in a public shop. Because of this I retired to a pleasant little house behind the Banchi, where I carried on working for all the friends I had made. At this time I was not doing anything of great importance, so there is no call for me to talk about my work. I was finding great relaxation in music and other pleasures of the same kind.

Then, on the advice of Jacopo Salviati,[59] Pope Clement dismissed the five companies sent to him by Giovanni, who himself had already been killed in Lombardy. So the Constable of Bourbon, knowing that there were no soldiers in Rome, began marching his army as rapidly as he could towards the city; and in the face of this threat the whole of Rome flew to arms. I happened to be a great friend of Alessandro, the son of Piero del Bene, and, in fact, when the Colonnesi had attacked Rome he had asked me to guard his palace. As a result, on this far more momentous occasion, he begged me to raise a troop of fifty men, put myself at their head – as I had done before – and guard his palace.

So I collected together fifty courageous young fellows and we took up our quarters in his house, where we were well treated and generously paid.

By this time the Bourbon's army had arrived before the walls of Rome. Alessandro del Bene begged me to go along with him and find out what was happening, and I did as he wanted, taking with me one of my closest comrades. On the way we were joined by a young man

called Cecchino della Casa. When we arrived at the walls of the Campo Santo we caught sight of the Bourbon's impressive army, which was already exerting all its strength to force a way into the city. At the part of the wall we came to, many young men had already been killed by the attackers, the fighting was desperately bitter, and the place was covered by the thickest fog imaginable. I turned to Alessandro and said:

'Let's get back home as quickly as we can – there's nothing we can do here. The enemy are scaling the walls and our men are running for their lives.'

Alessandro panicked and started crying: 'I wish to God we'd never come here!'

And then, mad with fright, he started to run away. But I checked him and shouted: 'Now you've brought me here, we must show that we're men.'

At the same time, I pointed my arquebus towards the thickest and most closely packed part of the enemy, taking direct aim at someone I could see standing out from the rest. The fog prevented my seeing whether he was mounted or on foot. I turned round hurriedly to Alessandro and Cecchino and told them to fire their guns, showing them how to do it so that they themselves could not be hit by the fire of the besiegers.

We all fired, twice in succession, and I looked cautiously over the wall. The enemy had been thrown into the most extraordinary confusion, because one of our shots had killed the Constable of Bourbon. From what I learned later he must have been the man I saw standing out from the others.

Then we retired, going through the Campo Santo, making our way through St Peter's, and then coming out behind by the church of Sant' Angelo. We were hard put to it to get to the gate of the castle, as Rienzo da Ceri and Orazio Baglioni[60] were busy wounding or killing everyone who fled from the fight at the walls. By the time we arrived at the gate some of the enemy had broken into Rome and were at our heels. However, as the castellan wanted to drop the portcullis he cleared a way, and the four of us were able to push on inside.

As soon as I arrived Captain Pallone de' Medici grabbed hold of me because I was on the staff of the castle, and much against my will forced

me to leave Alessandro. As I made my way up to the tower, Pope Clement made his way along the corridors into the castle. He had refused to leave the palace of St Peter before, because he could not believe that the enemy might enter the city.

So there I was in the castle. I went up to some guns that were in the charge of a bombardier called Giuliano the Florentine. He was staring out over the battlements to where his poor house was being sacked and his wife and children outraged. He dared not fire in case he harmed his own family, and flinging his fuse on the ground he started tearing at his face and sobbing bitterly. Other bombardiers were doing the same.

When I saw this I seized one of the fuses, got help from some of the men who were not in such a sorry state, and lined up some heavy pieces of artillery and falconets, firing them where I saw the need. In this way I slaughtered a great number of the enemy. If I had not done so the troops who had broken into Rome that morning would have made straight for the castle and could easily have entered, as the artillery was not in action. I continued firing, with an accompaniment of blessings and cheers from a number of cardinals and noblemen. Inspired by this, I forced myself to try and do the impossible. Anyhow, all I need say is that it was through me that the castle was saved that morning and that those other bombardiers came back to their duty. I carried on with the work all day, and then evening approached.

Then, while the army was marching into Rome by the Trastevere, Pope Clement put a great Roman nobleman called Antonio Santa Croce in charge of all the bombardiers, and the first thing he did was to come up and show me the most extraordinary kindness. He stationed me with five splendid pieces of artillery at the highest point of the castle, which is called the Angel.[61] This platform runs right round the castle and overlooks Prati and the rest of Rome. He put a number of men under my command to help me with the guns, paid me in advance, had me doled out some bread and wine, and then begged me to carry on as I had begun. I was only too eager to do so, being perhaps more attracted to soldiering than to my real profession, and as a result I made a better job of it than I did of being a goldsmith.

Night came on, and the enemy were in Rome. Those of us in the

castle, especially I myself with my constant delight in seeing unfamiliar things, stayed where we were, contemplating the conflagration and the unbelievable spectacle before our eyes. It was such that it could only be seen or imagined by those in the castle. But I shall not begin describing it; I shall just carry on with the story of my own life and the events that really belong to it.

The whole month that we were besieged in the castle I was actively engaged on the guns. This led to all sorts of happenings, all of which are worth the telling; but as I must not write too much and do not want to be too detailed about matters that do not concern my own profession, I shall leave most of them out and only describe the one I must – the few that are most remarkable.

This is the first. One day Messer Antonio Santa Croce had me come down from the Angel so that I could fire on some houses near the castle that a number of the enemy had entered. While I was firing a cannon shot hurtled towards me. But as it struck a corner of the battlement, carrying away a great section of it, I escaped harm. The masonry crashed down and hit me in the chest. With the breath knocked out of me, stretched out on the ground as if I were dead, I could hear all that the people standing round were saying. In his grief, Antonio Santa Croce was crying: 'Oh, now we've lost the greatest support we had.'

All this tumult drew in our direction a companion of mine, called Gianfrancesco the Fifer. Despite his name he was much more skilled in medicine than in music. He saw what had happened, and ran off at once crying for a flask of the best Greek wine. Then he heated a tile till it was red-hot, put a good handful of wormwood on it, and started sprinkling the wine on top. When the herbs were well soaked, he at once pressed them on my chest, where the bruise could be clearly seen. The wormwood was so efficacious that it immediately brought me back to life. I tried to say something but found it impossible, as some stupid young soldiers had stuffed my mouth with earth in the belief that they were giving me communion: as far as my life was concerned they had very nearly excommunicated me. I had a job to recover and the earth did me more harm than the blow I received. Having escaped that accident I went back to the fury of the guns, applying myself with unimaginable energy and zeal.

Pope Clement had sent for help from the Duke of Urbino[62] who was with the Venetian army, sending word by his envoy that as long as the castle continued to fire three beacons on its summit every night, and three times let off a triple cannonade, as long as this signal was given the castle remained untaken. It was part of my duty to light the beacons and fire the guns. During the day I carried on directing our gunfire where it could do most harm. When he saw how properly I was doing my work, I rose even higher in the Pope's estimation. But no help ever arrived from the Duke; and I shall not go into the reason, as that is not my affair.

While I was engaged on this devilish business some of the cardinals who were in the castle used to come along to watch me, especially the Cardinals Ravenna and de' Gaddi.[63] I kept telling these two not to come too near me, as their nasty red birettas could be seen a long way off and in consequence we were in great danger from neighbouring buildings like the Torre de' Bini. At long last I had them kept in, and as a result I made bitter enemies of them.

As well as this, Signor Orazio Baglioni, who was very fond of me, used to pay me frequent visits. On one occasion he happened to be chatting with me when he noticed that there was some disturbance at an inn outside the castle gate, at a place called Baccanello. The inn-sign was a red sun, painted between two of the windows. These windows were closed, and Orazio came to the conclusion that there must be a crowd of soldiers making merry just behind them, and just behind the painted sign.

So he said to me, 'Benvenuto, if you went out of your way to fire your small cannon within an arm's length of that sun, I think it would be well worth while. There's a great deal of noise coming from that place, so there must be some very important people there.'

I answered that I was capable of hitting the target right in the middle, but was anxious about a barrel of stones, set near the mouth of the cannon, being hurtled to the ground because of the force of the gun's discharge.

'Don't waste time, Benvenuto,' he replied. 'In the first place the blast couldn't make it fall from where it is now. And even if it did, and the Pope himself were underneath, there'd be less harm done than you think. So, fire away, fire away.'

Without another thought I fired and hit the sun in the middle, just as I had promised. The barrel tumbled down, as I said it would, falling right between Cardinal Farnese[64] and Jacopo Salviati, and it might well have crushed the two of them, if it had not been for the fact that Cardinal Farnese had just reproached Jacopo with having caused the sack of Rome. Because of this they started swopping insults and as they drew apart to air their opinions the barrel missed them. Hearing such a noise in the courtyard below, that good man, Signor Orazio, came rushing down; I looked down to where the barrel had fallen and heard them say: 'That gunner ought to be killed.'

At this I trained two light cannon on the stairway, determined that whoever came up first would get the full force of one of them. Some of Cardinal Farnese's servants must have been ordered to go up and attack me. So I stood ready with a lighted fuse in my hand, and when I recognized some of them I shouted out:

'You useless fools – if you don't clear off, if one of you dares climb up these stairs, I have two falconets ready and I'll blow you to smithereens. Go and tell the Cardinal that I was carrying out the orders of my superiors. What we've done and what we are doing is in defence of these priests, not an attack on them.'

They made off and then Orazio Baglioni came running up, and I told him, knowing full well who he was, to stand back before he was slaughtered. He drew back a little, rather frightened, and then he said: 'Benvenuto, I'm your friend.'

'All right, sir,' I answered, 'come up by all means, but come by yourself.'

He was a very proud man, and he stood still a little while; then he said angrily:

'I've a good mind to come no farther, and to do exactly the opposite of what I was going to do for you.'

My reply to this was that just as it was my duty to defend others so I could defend myself as well. At this he answered that he would come up by himself, and when he reached the top I saw the changed expression on his face and stood there waiting, with my hand on my sword, staring at him grimly. When he looked at me he began to laugh, his face returned to normal, and he remarked very pleasantly:

'My dear Benvenuto, I have the greatest affection for you – and when God wills I'll prove it to you. I wish to God you had killed those two rogues. One of them is the cause of all the trouble, and more than likely the other will prove even worse.'

Then he asked me, if I was questioned, not to say that he had been near me when I fired the gun, and otherwise, he said, I was not to worry.

The repercussions from this business were tremendous and we did not hear the end of it for a very long time. But I do not want to dwell on it any longer, except to say that I very nearly revenged my father on Jacopo Salviati, who, as my father used to complain, had treated him treacherously time and time again. As it was, inadvertently I put the fear of the devil into him. I shall keep quiet about Farnese, as in due course it will be pretty clear that it would have been all the better if I had killed him.

I carried on with my work at the guns, and not a day passed without my achieving some outstanding success. As a result my stock with the Pope went up and up. Hardly a day ended without my having killed some of the besiegers.

One day the Pope happened to be walking along round the keep when he noticed in Prati a Spanish officer who had once been in his service and whom he recognized from certain characteristics that he had. As he was staring down at him he started to talk about the man. Meanwhile, knowing nothing about all this, I merely looked down from the top of the Angel and noticed that there was someone directing the digging of trenches. He had a lance in his hand and was dressed in a rose-coloured uniform. I began to wonder how I could get at him, took one of the falconets that was near me – the falconet is bigger and longer than the swivel gun and very like a demi-culverin – cleared it, and then loaded with a hefty charge of fine powder, mixed with coarse. I aimed carefully at the man who was dressed in red, elevating the gun way up in the air, as he was too far away for me to be sure of accuracy with a gun of that kind. Then I fired and hit him exactly in the middle.

With typical Spanish swagger he was wearing his sword across his front. The result was that the shot struck the sword and cut him in two. The Pope who was taken by surprise was astonished and delighted,

but he found it impossible to understand how a gun could be fired accurately at such range, or how on earth the man could have been cut in two. So he sent for me and asked me to explain.

I told him how painstaking I had been in aiming the gun, and as for why he was cut in two, I said that neither he nor I could ever understand. And then falling on my knees, I begged him to absolve me of that homicide, and of the others I had committed while serving the Church in the castle. At this the Pope raised his hand, carefully made a great sign of the cross above my head, and said that he gave me his blessing and that he forgave me all the homicides I had ever committed and all those I ever would commit in the service of the Apostolic Church.

After I left him I climbed back to the tower and spent all my time firing away at the enemy, hardly ever wasting a shot. My drawing, my wonderful studies, and my lovely music were all forgotten in the music of the guns, and if I told in detail the great things I did in that cruel inferno I would astonish the world. But, in order not to take too long, I shall pass them over. I shall only describe some of the more outstanding events which I cannot leave out.

Well then, all my thoughts, night and day, were concentrated on what I for my part could do to defend the Church. And knowing that when the enemy changed guard he used to pass through the great gate of Santo Spirito, which was just about within range, I began to direct my fire in that direction. But as I had to fire obliquely I could not inflict all the harm I wanted to, though all the same every day I used to kill a fair number. Then the enemy, seeing his passage hindered, one night piled up more than thirty barrels on top of a roof and managed to block my line of vision. At this I started thinking more carefully about what I should do, trained all five of my guns straight at the barrels, and then waited till two hours before sunset, when the guard was immediately changed.

Imagining that they were quite safe the enemy troops came along far more casually and more crowded together than usual. So when I fired the guns I not only blasted to the ground the barrels that were obstructing me, but also killed more than thirty men at one go. I did the same amount of damage twice again, and threw the enemy troops into tremendous confusion. As a result of this, and also because they

were laden with spoils from the great sack and wanted to enjoy what had cost them so much, they were constantly on the point of mutiny and desertion. However, they were restrained by their intrepid captain, Gian di Urbino,[65] and to their great inconvenience they were forced to take another route when changing guard. The march was a matter of three miles, as against less than half a mile before.

After this exploit all the noblemen in the castle treated me with extraordinary favour. It led to such important results that I wanted to tell and have done with it. These matters have nothing to do with my profession, which is my real reason for writing. If I wanted to adorn the story of my life with events of such a kind it would take me too long to write. But there is just one other thing that I must tell.

I shall skip a good deal and come to the time when Pope Clement, in his anxiety to save the tiaras and the mass of wonderful jewels belonging to the Apostolic Camera, sent for me, and then shut himself up with me in a single room. Cavalierino was also with us. He had been one of Filippo Strozzi's grooms;[66] he was a Frenchman, of very low birth, but he had proved himself a very faithful servant, and Pope Clement had poured money into his pocket and trusted him as much as he did himself.

So there was the Pope, Cavalierino, and myself, all shut up in that room. They placed in front of me the tiaras and the great mass of jewels from the Apostolic Camera, and I was ordered to remove them from their gold settings. I did as I was told; and then after I had wrapped them up in pieces of paper we sewed them into the linings of the Pope's and Cavalierino's clothes. When this was done they gave me all the gold – which came to about two hundred pounds – and told me to melt it down, as secretly as I could. I went up to the Angel, where I could be safe from interruption as I had my own room there and could lock the door. Inside my room I built a little brick furnace, placed at the bottom a rather large cinder-tray, shaped like a dish, and began throwing the gold on top of the coals. Little by little it fell down into the dish.

All the time the furnace was burning I kept a look-out to see what damage I could inflict on our enemies. As the enemy trenches were underneath us, less than a stone's-throw distance, I decided to fire at

them some rubble I found piled here and there that had once been used as ammunition. I got hold of a swivel-gun and a falconet, both of which were rather damaged at the muzzle, rammed in the projectiles, and then fired away. My shots volleyed down like mad, dealing the enemy some nasty blows that he had hardly expected. I was busy at this all the time I was melting down the gold, and a little before vespers I noticed someone riding along the edge of the trench on a mule. The mule was trotting along at a very smart pace, and the rider was talking to the men in the trenches. I was well prepared before he came opposite my line of fire, took accurate aim, and hit him with one of the projectiles I was using, right in the face. The rest of the shot struck his mule, and the animal fell down dead. I heard a tremendous uproar coming from the trenches, fired the other gun, and dealt out death and destruction.

The man I hit was the Prince of Orange. He was carried through the trenches to a nearby inn, where, in a very short while, all the leaders of the army flocked together. When the Pope heard what I had done he sent for me straight away and asked how it had happened. I told him everything, adding that it must have been a man of very great importance since as far as I could judge all the army chiefs had straight away gathered together at the inn he was carried to.

Pope Clement, who was a very quick-thinking man, sent for Antonio Santa Croce – the gentleman, as I mentioned before, who was immediately in charge of the artillery – and told him to order all us gunners to train our cannon, of which there was an infinite number, on the inn, and fire away together with an arquebus shot as signal. In that way all the leaders of the army would be killed, and the troops, who were already disaffected, would take to flight. Perhaps, added the Pope, God had heard the prayers they were continually making to Him, and this was the way they were to be freed from those impious ruffians.

We prepared the artillery under Santa Croce's directions, and were waiting for the signal. Meanwhile Cardinal Orsino[67] heard what was going on and began making protests to the Pope. He said that it would be madness to carry on with it because they were just on the point of making peace, and if their chief officers were killed the leaderless troops would take the castle by storm and bring utter ruin. Such a thing was

not to be allowed. The poor Pope, seeing himself harassed from within and without, completely despaired and said that he left the decision with them. So the order was countermanded.

Realizing that we were going to be told not to fire I could not hold myself back, and I discharged one of my small cannon, striking a column in the courtyard of the house round which a crowd had gathered. This shot caused so much destruction that the enemy was on the point of abandoning the place. Cardinal Orsino wanted to have me hanged or shot down on the spot, but the Pope hotly defended me. Though I know the angry words that passed between them I shall not report them, as I am not meant to be writing history. I shall concern myself only with my own affairs.

When I had melted down the gold I brought it to the Pope, who thanked me very much for what I had done and told Cavalierino to give me twenty-five crowns, apologizing for not having more to reward me with. A few days later peace was declared.

I went off towards Perugia with a company of three hundred men to rejoin Orazio Baglioni; and when we arrived there Orazio wanted to put me in command. I was against this, and I told him that first I wanted to go and see my father and at the same time have the ban that was still on me in Florence lifted. Then that nobleman told me that he had received a commission from Florence. He was in touch with the Florentine envoy, Pier Maria di Lotto, and strongly recommended me to him, as being one of his men.

So with several other companions I made my way to Florence, where at that time the plague was raging very fiercely. When I arrived I found my good old father, who was convinced that I had either been killed in the sack of Rome or would return to him in a state of destitution. But, on the contrary, there I was, alive, with plenty of money, with a servant and a first-rate horse. There was so much rejoicing when I met the old man that while he was hugging and kissing me I felt sure he would die of joy. I told him all the devilry that had accompanied the sack of Rome, and then handed him over a large sum of money that I had earned by my soldiering. We embraced each other time and time again, and then he went straight off to the magistrates to have the ban lifted.

As luck would have it, one of the men who had banished me was serving as one of the Eight again. It was the same fellow who had told my father so rashly that he would have me marched out to execution. So, backed up by the favour shown me by Orazio Baglioni, my father had his revenge with some pretty telling words.

This was how matters stood when I told him that Signor Orazio Baglioni had chosen me as his captain and that I ought to begin thinking about raising my troops. This news upset my poor father terribly; he started begging me for the love of God not to think of such an enterprise, even though he well realized that I had it in me to do that and greater things. He added that his other son, my brother, was doing brave deeds as a soldier and that I should devote myself to my wonderful art on which I had already spent so many years and so much hard study. I gave him my word that I would obey him, but like the shrewd man he was he realized that if Orazio Baglioni appeared on the scene, because of my promise to him, and for various other reasons, I would certainly go off on a fighting expedition. He managed to think up a good excuse for persuading me to leave Florence, and he said:

'My dear boy, this plague is raging so very fiercely that every day I'm convinced you're going to catch it. Now I remember that when I was a young man I went off to Mantua, had a great fuss made of me, and stayed there a good few years. For my sake, and today rather than tomorrow, clear out of Florence and go to Mantua – I beg and order you to do it.'

I have always loved seeing the world, and so as I had never been to Mantua I was only too glad to go. I left with my father most of the money I had brought home, promised that I would always help him out wherever I found myself, and left my elder sister to look after him. Her name was Cosa, and as she had never had any desire to marry she had been accepted as a nun in Santa Orsola; but she postponed going there in order to help and take care of my poor old father, and keep an eye on my younger sister who was married to a sculptor called Bartolomeo.

So, with my father's blessing, I mounted my lovely horse and rode off to Mantua. If I tried to describe that short journey in detail I would have far too much to write. As it was, with the world overshadowed

by plague and war, it was only with great difficulty that I reached my goal. But when I did arrive I set out to find work at once.

I was taken on by a Milanese craftsman called Niccolò, who was the Duke of Mantua's goldsmith. About two days after I had started work I went to call on Giulio Romano, a very fine painter, whom I have already mentioned, and a close friend of mine. He gave me a great welcome but he was very offended at my not having ridden straight to his house. He was living like a lord, and he was engaged on some work for the Duke at a place outside the gates of Mantua called Tè. It was a marvellous enterprise on a large scale, as I expect can still be seen. Giulio lost no time in recommending me to the Duke in very warm terms, and as a result I was commissioned to model a reliquary for the blood of Christ,[68] which the Mantuans say was brought to their city by Longinus.[69] When he was giving me the commission the Duke turned to Giulio and told him to sketch a design for me.

At this Giulio said: 'My lord, Benvenuto is a man who has no need of other people's designs, as your Excellency will be able to judge for yourself when you see the model.'

I began work on the model, designing the reliquary so that the phial would fit into it very nicely. Then I made a little wax model for the lid. This was a figure of Christ, sitting down with His left hand raised on high to hold the great Cross against which He was leaning; and with His right hand He made a gesture as if to open the wound in His side with His finger.

When I had finished the model the Duke was so delighted with it that he gave me to understand that he would keep me in his service on terms that would enable me to lead a very comfortable life. Meanwhile I had paid my respects to his brother, the Cardinal,[70] who begged the Duke to let me make his Eminence's pontifical seal; and I did in fact begin it. But when I was working on the seal I was attacked by the quartan fever, kept falling into delirium, and while I was in that state began cursing Mantua, and the man who ruled it, and anyone who stayed in the place of his own free will.

All that I said was carried to the Duke by his Milanese goldsmith, who realized only too well that the Duke wanted me in his service. When the Duke heard these ravings of mine he flew into a rage; and

as I was in a rage with Mantua our anger was fairly well matched. Anyhow, I finished the seal – it took me about four months – together with some other small work that the Cardinal had commissioned on behalf of the Duke, and his Eminence paid me generously and begged me to return to the wonderful city of Rome, where we had first known each other.

I left Mantua with my pockets full, and came to Governolo, the place where that courageous nobleman Giovanni was killed. Here I had another mild bout of fever, but there was no need to interrupt the journey: I quickly shook it off and that proved the last attack.

I arrived at Florence, expecting to find my good old father. When I knocked at the door, a scraggy hunchbacked old woman looked out of the window and began screaming insults at me, telling me to go away and saying that the sight of me made her sick.

'Good God,' I shouted back, 'you twisted old cripple, is there no one else in the house besides you?'

'No, damn you, there isn't.'

'All right then,' I said, 'I only hope we won't have to put up with you much longer.'

Hearing all the uproar a neighbour came out, and she told me that my father and everyone in the house had died of the plague. As I had partly guessed this already I was less upset than I would have been. Then she added that only my younger sister, Liperata, was left alive, and that she had been taken in by a holy woman called Andrea de' Bellacci.

I left her and set off for the inn, and on the way I ran into a very close friend of mine called Giovanni Rigogli. So I dismounted at his house and we went along to the public square, where I heard that my brother also was still alive. I moved off to find him at the house of a friend of his called Bertino Aldobrandi. As we had each been told that the other was dead, when we met we hugged each other with unbounded affection. Then, roaring with laughter all the time, he took me by the hand and said:

'Come along, Benvenuto, I want to take you somewhere you'd never guess. I've married off our sister Liperata again, and she's positive that you're dead.'

On the way we told each other all the wonderful experiences we had been through. Then, when we arrived at the house where she was, Liperata was so flabbergasted by such an unexpected visit that she fell fainting into my arms. If my brother had not been there, her fainting like that, without saying a word, would have made her husband suspect that I was anything but her brother; and in fact to begin with he did so. But Cecchino explained everything, attended to Liperata and soon brought her round. Shedding a few tears for her father, and her sister, and her husband, and her little son, she began to prepare some supper. We spent the rest of the evening very pleasantly; we never mentioned the dead again, but talked about weddings and in that way enjoyed a very happy little party.

Though I felt like returning to Rome, the prayers of my brother and sister succeeded in keeping me in Florence. Even Piero di Giovanni Landi, who, as I have told, gave me so much help when I was in difficulties before, even he told me that I ought to stay in Florence for a while. As the Medici had been driven out[71] (that is, the lords Ippolito and Alessandro, one of whom later became a cardinal, and the other Duke of Florence), Piero said that I should hold on for a time and see what happened. So I began to work in the New Market, carrying on a thriving business in jewel setting, and making a good profit.

About that time a Sienese called Girolamo Marretti arrived in Florence. He was a man of very lively intelligence, and he had been in Turkey for some time. One day he came along to my shop and commissioned me to make a gold medal to wear in his hat;[72] and he wanted as its design a figure of Hercules wrenching open the lion's mouth. While I was working on it I was very often visited by Michel-angelo Buonarroti. I took great pains on this medal; I broke new ground in my design for the figure, and in the way I expressed the fierceness of the animal; and the divine Michelangelo was quite unfamiliar with my method of working. As a result of this he praised my work so highly that I began to burn with ambition to do really well. However, I had nothing else to do except get on with setting jewels; although this brought in most profit it failed to satisfy me, and I wanted to try my hand at something more exalted than jewel-setting. Then a certain Federigo Ginori appeared on the scene. He was a young man of very

fine spirit who had lived for some years in Naples, where, because of his noble, handsome looks, a princess had taken him for her lover. He happened to want a medal made, showing Atlas holding the world on his shoulders, so he begged the great Michelangelo to sketch a rough design for him.

Michelangelo said to him: 'Go along and get hold of the young goldsmith called Benvenuto. He will serve you very well and he'll certainly have no need of a design from me. But in case you imagine I'm trying to shirk this little task, I'll gladly sketch a design for you. Meanwhile, have a talk with Benvenuto and have him make a little model as well. Then you can have the better one of the two carried out.'

So this Federigo Ginori came along to see me, told me what he wanted, and added that Michelangelo had praised me to the skies. I was to make a little wax model, while the splendid Michelangelo had promised a sketch. I was so inspired by what the great Michelangelo had said that I was eager to start work on the model without a minute's delay. When I had finished it, a painter called Giuliano Bugiardini,[73] who was a great friend of Michelangelo, brought me the sketch. I showed Giuliano my little wax model at the same time. It was completely different from the sketch, and the upshot was that Federigo, and Bugiardini as well, decided that I ought to work from the model.

So I started work on it. When the expert Michelangelo saw it he had nothing for me but tremendous praise. As I said before, there was a figure of Atlas cut on thin plate,[74] with a crystal ball on his back to represent the sky. On the ball I had engraved the Zodiac against a background of lapis-lazuli. It was all unbelievably beautiful, and it was completed with a little motto underneath, which read: *Summa tulisse juvat*.

Federigo was satisfied with it and paid me very generously. At the same time, very often he used to bring along to my workshop Luigi Alamanni who was then at Florence and who was a friend of his. So through him, Luigi and I became close friends.

Then Pope Clement declared war on Florence. The city was put in a state of defence and the militia was organized in every quarter of the town. I had to serve as well. I equipped myself lavishly and mixed with

the highest nobles in Florence; every single one of them seemed anxious to help with the defence, and, as usual, speeches were made in every district. Besides this the young men of Florence started to gather together more than before, and never spoke of anything but the war.

On one occasion, round about midday, a number of strapping young fellows, men from the most important families in Florence, were gathered together in my shop when a letter from Rome was handed to me. It had been sent by a man in Rome called Maestro Jacopino della Barca. His real name, in fact, was Jacopo dello Sciorina, but in Rome he was called della Barca because he owned a bark that provided a ferry-service on the Tiber between Ponte Sisto and Ponte Sant' Angelo. This Jacopo was an intelligent man, as well as being a fluent and witty conversationalist. He had once been a designer for the tapestry-weavers in Florence, and he was now very friendly with Pope Clement, who loved to hear him talk. It seems that one day they were talking together and started to discuss the sack of Rome and the defence of the castle. As a result the Pope remembered me and began to sing my praises, adding that if he knew where I was he would love to have me with him again. Jacopo told him that I was in Florence, and so the Pope ordered him to write to me and ask me to return.

The letter was to the effect that I should enter Clement's service again, and that it would be well worth my while. All the young men standing round were dying to know what was in it, and I had to keep it from them as best I could. Later on I wrote to Jacopo begging him not to send me letters in any circumstances, good or bad. This only made him more determined than ever. He wrote to me again, such an extravagant letter that if it had been discovered I would have found myself in very hot water. This time I was told, on behalf of the Pope, that I should set out for Rome at once, that he wanted to give me work of the greatest importance, and that if I wished to prosper I should drop everything without delay and not remain fighting against a Pope with a crowd of mad rebels.

When I read this letter I was completely terrified, so I went off to find my dear friend, Piero Landi, and as soon as he set eyes on me he asked what had happened to make me so agitated. I said that I could not possibly tell him what it was that had put me in such a state. All I

begged him to do was to take my keys: he was to return the jewels and gold to such and such people – whose names he would find written down in my notebook; then he was to remove all my belongings from my house and look after them with his usual generosity; and in a few days he would learn where I was. This penetrating young man, perhaps half guessing what it was all about, said:

'My dear brother, go away at once, and then write to me. And don't worry a scrap about your things.'

That was just what I did. Piero Landi was the most faithful friend, the most wise, the most upright, the most discreet and the most lovable man I have ever known. I left Florence and went back to Rome; and I wrote to him from there.

As soon as I arrived in Rome[75] I looked up some of my old friends and was given a very affectionate welcome. I began work straight away, to make some money, without producing anything that is worth describing. A fine old goldsmith called Raffaello del Moro, who was thought very highly of in the guild and who was a very honest sort of man, asked me if I would like to work in his shop, as he had been commissioned to make some very important things which would bring in an excellent profit. I was only too glad to accept.

More than ten days had passed without my having gone to see Jacopo della Barca, when one day he ran into me on the off chance, gave me an enthusiastic welcome, and asked how long it was since I had arrived. I told him that it was about a fortnight. He took this news very badly and said that I was behaving very disrespectfully towards a pope who had already insisted on his writing to me three times. Having been even more annoyed than he was I choked back my anger and refused to say a word. Then Jacopo, who was quite a windbag, launched out into a speech and talked on and on till, when I saw he was exhausted, I broke in merely to say that he might take me to the Pope whenever he liked. He replied that any time would suit him, and I said that I too was always ready. Then he began to move in the direction of the palace and I went along with him. It was Maundy Thursday, by the way.

When we arrived at the Pope's apartments, as he was well known and I was expected, we were admitted at once. The Pope was in bed with a slight illness, and he had with him Jacopo Salviati and the

Archbishop of Capua.[76] As soon as the Pope set eyes on me he cheered up enormously; I kissed his feet, in as humble an attitude as possible, and then moved nearer to him, letting him see that I had something important to talk to him about.

Straight away he made a sign with his hand, and Jacopo and the Archbishop moved some distance away from us. I at once began what I wanted to say:

'Holy Father, from the time of the sack of Rome up to now I haven't been able to confess or to receive communion, because no one will give me absolution. What has happened is this: when I melted down the gold and did all that work taking the jewels out of their setting your Holiness ordered Cavalierino to give me some small reward for my pains. But all I ever had from him was abuse. Now, when I went up to the room where I had melted down the gold I washed out the ashes and found about a pound and a half of gold there, in little grains like millet-seed. And as I hadn't enough money to take me home respectably I decided to make use of these, and to pay you back when I had the chance. And here I am, at the feet of your Holiness, who is the true forgiver of sins. I beg you to give me your gracious permission to confess and receive communion, so that by the grace of your Holiness I may be restored to the grace of God.'

Then the Pope, sighing gently – perhaps he was thinking of all that he had suffered – said:

'Benvenuto, I am certainly all that you say – I can absolve you from every fault you have been guilty of, and what is more I want to do so. So don't be afraid to tell me everything, quite frankly. Even if what you had taken was worth as much as a whole tiara, I am more than ready to forgive you.'

'Holy Father,' I replied, 'all I had was what I told you, and when I changed it at the Mint in Perugia it was not worth more than a hundred and forty ducats. I took the money and went to comfort my poor old father.'

The Pope said:

'Your father proved himself as talented, upright, and good a man as ever was born, and you are exactly the same. I am very sorry that the money was so little. Such as you say it was, I make you a present of it,

and I completely forgive you. Tell this to your confessor, if that is all you have done which concerns me. And then, after you've confessed and received communion, come and see me again, and it will be worth your while.'

When I had left, and Jacopo and the Archbishop had drawn near again, he spoke of me more highly than he could of anyone. He said that he had heard my confession and absolved me, and then he told the Archbishop of Capua that he should send for me, ask if there was anything else that troubled me, and give me complete absolution. He gave him complete authority to do this and, moreover, he was to treat me as kindly as he could.

While I was walking off with Jacopino he asked me out of great curiosity what the long conversation that I had had so secretly with the Pope was all about. He kept repeating this question, and in the end I said that I had no intention of telling him since it had nothing to do with him, and that he should stop asking me.

I did everything that had been arranged with the Pope; and then, when the two feast days were over, I went to see him. He received me even more affectionately than before, and he said:

'If you had come to Rome a little sooner I would have asked you to remake those two tiaras of mine that we destroyed in the castle. But as they're of no great value, apart from the jewels, I shall employ you instead on a very important work, where you'll be able to show what you can do. This is the button for my cope.[77] I want it to be about as big as a small trencher – a third of a cubit – and just as round. The design is to be a figure of God the Father, in half relief, and in the middle I want you to set that big, beautifully-cut diamond, as well as a large number of other priceless gems. A man called Caradosso made a start on it, but he never finished it. I want you to finish the work quickly so that I can get some enjoyment out of it. So go off and make me a good design.'

He had all the jewels shown to me, and then I was away like a shot.

While Florence was being besieged, the Federigo Ginori for whom I had made the medal of Atlas died of consumption and the medal came into the hands of Luigi Alamanni, who shortly afterwards brought it in person and made a present of it, together with some of his finest writings,

to the French King, Francis.[78] The King was tremendously pleased with the medal, and that brilliant man Luigi Alamanni told his Majesty something of the sort of man I was, as well as of my artistic talent. He praised me so highly, in fact, that the King showed that he would like very much to know me.

In the meantime I was working away, with all the diligence at my command, on the little model for the Pope's button. I made it exactly the same size as the morse itself was to be. Many members of the goldsmith's trade, who thought they could do it themselves, were extremely resentful about it. At the same time there was a certain Michele, who was very expert at engraving cornelians, who had come to Rome and been commissioned to repair the Pope's two tiaras since he was also a very able jeweller and had a fine reputation. When I began work on the little model, Michele, who was an old man, was very surprised that I had not approached him for advice, seeing that he was a clever craftsman and well in with the Pope. In the end, realizing that I was not coming to him he came to me. He asked what I was doing, and I told him: 'What the Pope gave me to do.'

Then he said that the Pope had commissioned him to supervise all the work done for his Holiness. My reply to this was that I would have to ask the Pope first, and then I would know what sort of answer to give him. He told me I would regret it, and he went off in a temper.

He got together with all the other members of the guild and when they had discussed the matter they agreed to leave it in Michele's hands. His next cunning step was to obtain more than thirty different designs of the button from a number of expert draughtsmen. As he had access to the Pope's ear, he came to an agreement with another jeweller, a Milanese called Pompeo, who was a great favourite of the Pope and related to the head Papal chamberlain, Traiano;[79] and the two of them – that is, Michele and Pompeo – began to tell the Pope that they had seen my model and that it seemed to them that I was not capable of such an elaborate piece of work.

In reply to this the Pope said that he would have to see it as well, and then, if I was not up to it, he would look round for someone who was. Both of them said that they had several splendid designs that were already completed. The Pope replied that he was delighted to hear it

but that he did not want to see them before I had finished my model; then he would judge them all together.

Within a few days I had put the last touches to the model, and one morning I took it along to show the Pope. Traiano made me wait while he hurriedly sent for Michele and Pompeo, telling them to bring their designs with them. When they arrived we were shown inside, and they immediately began to hold out their designs for the Pope to see. As it turned out, the draughtsmen, not being jewellers, had no idea how to set the gems, and the jewellers had not given them any instructions (and a jeweller must when he is introducing figures among his gems know how to draw, otherwise his work will be worthless). And so in all their designs that marvellous diamond had been placed in the middle of God the Father's breast.

The Pope, whose judgement was very sound, saw what had happened and thought they were without merit. After he had inspected about ten of them he threw the rest on the floor, turned to me, who was standing on one side, and said:

'Let me have a glance at your model, Benvenuto, so that I can see if you've made the same mistake as they have.'

I came forward and opened a little round box; the Pope's eyes seemed to light up, and he cried out:

'You wouldn't have done it in any other way, even if you were my very self. The others couldn't have thought up a better way of disgracing themselves.'

Then a great number of important noblemen flocked round, and the Pope pointed out to them the difference between my model and the other designs. He praised it to the skies, with those two standing terrified and dumbfounded in front of him, and then he turned to me and said:

'I can only see one snag, Benvenuto, but it's very important. It's easy to work in wax; the real test comes when one has to work in gold.'

I answered him eagerly: 'Holy Father, if it isn't ten times better than my model, we'll agree that I won't be paid for it.'

At this there was an outcry from the noblemen present, and they protested that I was promising too much. But one of them, a very great philosopher, spoke in my favour.

'From this young man's physiognomy,' he said, 'and from his well-proportioned physique, I am certain of everything he promises, and more.'

'And that's why I think so too,' added the Pope. Then he called his chamberlain, Traiano, and told him to fetch five hundred gold ducats of the Camera. While waiting for the money the Pope examined more carefully the excellent way I had fitted the diamond in with the figure of God the Father.

What I had done was to place the diamond exactly in the centre of the whole work, with the figure of God the Father, gracefully turning to one side, seated above it, and so the design was beautifully balanced, and the figure did not detract from the jewel. With His right hand raised, God the Father was giving a blessing; and beneath the jewel I had placed three cherubs, supporting the diamond with raised arms; the middle one was in full, and the other two in half relief. Round about I had designed a crowd of cherubs, beautifully arranged with the other gems. God the Father was draped in a flowing mantle, from which the other cherubs peeped out; and there were many other exquisite adornments, all enhancing this beautiful work. It was made in white stucco on black stone.

When the money was brought in the Pope handed it to me himself, and then, with great charm, begged me to do the work while he was still alive to enjoy it. He added that it would be well worth my while.

Off I went with the money and the model; and it seemed an eternity till I could begin.

I set to work at once, very diligently, and then at the end of a week the Pope sent word by his chamberlain – a very important Bolognese nobleman – that I was to bring him what I had done so far. On the way, this chamberlain, who was the best-mannered gentleman in all the court, told me that the Pope did not so much want to see what I had done as give me another important commission. I was to make the dies for the money coined at the Mint of Rome. He told me that he thought he ought to warn me first so that I would have an answer ready for his Holiness.

When I came into the Pope's presence I showed him the thin gold plate on which, so far, I had engraved only the figure of God the Father.

But although it was only done roughly it was much more powerful than the little wax model. The Pope in fact was so flabbergasted that he cried out: 'From now on I will believe anything you say.'

Then, after innumerable compliments, he added: 'I want to set you working on something else which is even dearer to my heart than what you are doing now, if you feel you are up to it.'

Then he said that he was anxious to have some dies made for the Mint, asked me if I had ever made any and if I was confident enough to take the work on. I replied that I was willing and confident and that I had seen how they were made, though I had never made any myself.

Now a certain Tommaso da Prato,[80] the Papal datary, was present at this interview; and being a close friend of my enemies he took it on himself to say:

'Holy Father, you're pouring so many favours on this young man, and he's so anxious for them, that he'll be only too ready to promise you a new world. You've already set him one great task, and you're adding a greater one and the result will be that one will hinder the other.'

The Pope, who was really furious at this, turned on him and told him to mind his own business. Then he ordered me to design the model for a gold doubloon. He wanted the design to show the naked figure of Christ, with His hands bound, and the inscription: *Ecce Homo*. The reverse was to show the figures of a pope and an emperor, both of them holding upright a cross that was on the point of falling, with the inscription: *Unus spiritus et una fides erat in eis*.

The Pope had just given me instructions to make this beautiful coin when Bandinello the sculptor came up. This was before he had been knighted; and with his usual mixture of presumption and ignorance he said: 'The goldsmiths must be provided with designs for such beautiful works.'

I immediately turned to him and told him that I had no need of his designs for my work, but that I felt sure that before long my designs would deal some nasty blows to his. The Pope was delighted at what I said, and leaning towards me he added:

'Now go along my dear Benvenuto, put all your energies into serving me, and pay no attention to what these idiots say.'

So off I went, and in next to no time I made two steel dies. I stamped a coin, in gold, and one Sunday after dinner brought this coin and the dies along to the Pope. When he saw them he was astonished as well as delighted, not only because of my superb craftsmanship, which impressed him tremendously, but even more because I had been so incredibly quick about it. To add still further to the Pope's delight and amazement I had brought with me all the old coins that had been stamped years ago by those expert craftsmen who worked for Pope Julius and Pope Leo. Then, when I saw that he thought mine were superior, I took a petition from my breast pocket, in which I asked to be appointed superintendent of the dies.[81] The job itself was worth six gold crowns a month, without counting the dies which were paid for by the Master of the Mint at the rate of a ducat for three.

The Pope took my petition and then turned to give it to his datary, telling him to have it seen to straight away, The secretary took it, and, as he was slipping it into his pocket, he commented:

'Holy Father, your Holiness should not be in such a great hurry; these matters call for a great deal of deliberation.'

'I've heard what you say,' replied the Pope. 'Now give me that petition.'

He took hold of it, impulsively signed it in his own hand, and then handed it back with the remark:

'I don't think you have any answer to that. Hurry the business up, now; that is how I want it. Benvenuto's shoes are worth more than the eyes of all those other numskulls.'

I thanked his Holiness and went back to my work, overjoyed beyond words.

I was at that time still working in the shop belonging to Raffaello del Moro, whom I mentioned before. This worthy man had a very beautiful young daughter, and in his plans for her he had some designs on me. I became partly aware of this and liked the idea very much, but all the same I gave no hint of what I felt. In fact I was so reticent that he was quite astonished.

Now it happened that this poor young girl's right hand became diseased, and the two bones, of her little finger and the one next to it, were eaten into. Through the carelessness of her father the girl was

attended to by an ignorant quack who said that even if worse did not happen her whole right arm would be crippled. When I saw how tremendously dismayed her poor father was I told him not to put his faith in all that was told him by such an ignorant doctor. He then told me that none of his friends were doctors or surgeons, and begged me, if I knew of anyone, to call him in.

Without any delay I sent for a doctor, called Jacomo, who came from Perugia[82] and who was a first-rate surgeon. The young girl was terrified because she must have guessed what the quack had said, but when this competent surgeon saw her he told us that she would not be harmed in the slightest, and that she would be able to use her right hand perfectly well. Even though her two end fingers would remain a little weaker than the others, this would be no impediment at all.

He began his treatment, and then, a few days later when he wanted to cut away some of the diseased bone, her father called me in so that I too should see something of what the poor girl had to suffer. The doctor was using a number of clumsy iron instruments, I saw what little progress he was making, and how terribly he was hurting the girl, and I told him to hold off for five minutes till I returned. Then I ran along to the workshop and made a very delicate little steel tool, curved, and sharp enough for a razor. When I came back the doctor began work with it, so gently that she felt no pain at all, and the operation was soon finished. For this reason among others her worthy father began to love me as much as or even more than he loved his two sons. And he did his very best to restore his beautiful young daughter's health.

In those days I was very friendly with a Messer Giovanni Gaddi,[83] a clerk of the Camera who was very fond of the arts, although he himself had no artistic talent. Living with him there was a very scholarly Greek, called Giovanni;[84] a Lodovico da Fano,[85] also a great scholar; Messer Antonio Allegretti;[86] and Annibal Caro,[87] who was then still a young man. That excellent painter, the Venetian, Bastiano,[88] and I myself enjoyed their company; and we used to meet at Giovanni's almost every day.

It was my friendship with Giovanni that led that upright goldsmith, Raffaello, to say to him:

'My dear Messer Giovanni, I think you know what sort of man I

am. Now, I want to give my young daughter to Benvenuto, and I can't think of any go-between better than your lordship. So I beg you to help me, and I want you yourself to decide what her dowry should be.'

He had hardly finished what he had to say when the hare-brained fellow, completely at random, interrupted him with:

'Talk no more about it, Raffaello – you're farther away from getting what you want than January is from blackberries.'

The poor man completely gave up hope and soon began trying to marry her off to someone else. The mother, the girl herself, and all the family were furious with me, and I did not even know the reason why. As I concluded they must be paying me back with bad money for all the kindness I had shown them, I decided to open in the same district a shop of my own. Giovanni said nothing to me till after the girl was married, which happened a few months later.

Meanwhile I was working hard in order to finish the morse, and I was also serving the Mint, for the Pope had ordered me to design another coin, with the value of two carlins. On one side was to be his Holiness's head, and on the reverse the figure of Christ walking on the sea and stretching out His hand to St Peter, with the inscription: *Quare dubitasti?* The coin pleased everyone so much that one of the Pope's secretaries, who was an extremely accomplished man called Sanga,[89] said to him:

'For all their show, your Holiness can pride himself on having a coinage unequalled by what the ancients had.'

The Pope replied: 'And Benvenuto can take pride in serving an emperor like myself who recognizes his worth.'

While I was employed on the great work in gold I used to show it to the Pope almost every day, at his own request: and whenever he saw it his astonishment increased.

At that time one of my brothers was in the service of Duke Alessandro at Rome.[90] The Duke, for whom the Pope had recently obtained the Duchy of Penna, had in his pay a large number of first-rate fighting-men who had been trained in the school of Giovanni de' Medici. They were all courageous men, but the Duke reckoned that my brother was one of the bravest among them.

One day after lunch he went along to the shop of a certain Baccino della Croce, a place near the Banchi which all those fine fellows were in the habit of frequenting, stretched himself out on a couch, and fell asleep. Just then, the police patrol passed by, with one of Giovanni's men – a captain from Lombardy called Cisti, who was no longer in the Duke's service – under arrest. Another captain, Cattivanza degli Strozzi,[91] happened to be at the door of the shop, and when Cisti saw him he shouted out:

'I was going to bring you those few coins I owe you – if you still want them, you'd better do something before they throw me and my money into prison!'

Captain Cattivanza was the sort of man who was always ready to egg others on but didn't care to risk his own skin; so finding a number of daring young men standing near by, he told them to run after Cisti and get the money from him, and if the police resisted to show their mettle by using force. There were only four of them, bold enough but hardly suited to such a tricky business, and they were all very young. One was called Bertino Aldobrandi, another Anguillotto da Lucca, and I forget the names of the rest. Bertino had been trained by my brother and was a very keen follower of his; and my brother in turn was passionately fond of him.

Well, these four daring young men dashed after the police, who were armed with pikes, arquebuses, and two-handed swords, and who numbered more than fifty, and after exchanging a few words they drew their weapons. They attacked with such tremendous vigour that if Cattivanza had only shown his face, without even drawing sword, the police would have been put to flight.

But after a short struggle Bertino received some ugly wounds and was beaten to the ground, while Anguillotto was wounded in the right arm, couldn't use his sword, and so got away as well as he could. When the other two had made off, Bertino was lifted from the ground, dangerously wounded.

While all this was taking place we were still sitting round the table, because that morning dinner had been served an hour later than usual. Hearing the noise, the eldest son, Giovanni, got up to go and see what all the fracas was about.

I said to him: 'For God's sake don't meddle – in matters like this you're certain to lose something, and there's nothing to be gained.'

His father said much the same, also begging him not to go. But he was already running downstairs without paying the slightest attention to us. As soon as he arrived at the Banchi, where the fight had taken place, he saw Bertino being picked up, and started to run back.

But on the way he met my brother, Cecchino, who asked him what was up; and although some onlookers made signs for him to keep his mouth shut he shouted out like a madman that Bertino Aldobrandi had been murdered by the police. My poor brother let out a roar that could have been heard ten miles away and said: 'Can you just let me know which one of them killed him?'

Giovanni said, yes, that it was the man who carried a two-handed sword and wore a blue feather in his cap. My poor brother dashed off, recognized the murderer by the way he had been described, and with his usual boldness flung himself furiously into the middle of the patrol. Before the man whom he was after had time to get on guard, he ran him right through the belly and forced him to the ground with the hilt of his sword.

Then he turned on the others with such ferocious energy that he would have driven them off by himself, if it had not been for the fact that one of them, firing his arquebus in self-defence, wounded the brave, unlucky young fellow above the right knee. As he lay there on the ground the police ran off, fearing a possible attack from another fighter as formidable as he was.

As the tumult still continued, I too rose from the table, buckled on my sword (in those days everyone used to wear one) and went to the bridge of Sant'Angelo, where I found a crowd had gathered. I was recognized by some of them, who made way for me and when I went forward curiously showed me something I would have been far from taking great pains to see had I known what it was.

At first I did not realize it was my brother, because his clothes were different from those he had had on a short time before. So he recognized me first, and said:

'My dear brother, don't let my bad luck upset you – it's only what my sort of employment asks for. But get me away from here quickly. I've only a few hours left.'

While he was talking, with the terseness that such a situation demands I was told what had happened. I replied to him:

'Brother, this is the saddest blow I could ever receive. But never despair – before you close your eyes you shall see me get revenge on the man who wounded you.'

Our words were packed with significance, but very brief.

By this time the guard was some fifty paces away from us, because the chief constable, Maffio,[92] had made some of them turn back to carry away the corporal my brother had killed. I walked briskly towards them, with my cloak tightly wrapped round me, and went right up to Maffio. I would certainly have killed him, since I mingled with the very thick crowd around him. Then, as quick as lightning, I was half out with my sword, when Berlinghier Berlinghieri[93] bound my arms from behind. This Berlinghier was a very bold young man, who was a great friend of mine. On this occasion he had with him four other young men like himself; and they shouted to Maffio:

'Get out of here – this man was just about to kill you by himself.'

Maffio asked who I was, and they replied: 'He's the brother of the man you see over there.'

That was all he wanted to hear; he hurriedly beat a retreat to the Torre di Nona;[94] and they said to me:

'Benvenuto, we restrained you by force, but it was for your own good. Now let's go and look after your brother – he's sinking fast.'

We walked back to my brother, and I had him carried into a house. The doctors who were consulted treated him, but could not make up their minds whether or not to cut off his leg – and perhaps that would have saved him. Anyhow, as soon as the wound had been attended to Duke Alessandro appeared on the scene. He spoke very affectionately to Cecchino, who was still conscious, and then my brother said to him:

'My lord, my only regret is that you've lost a servant who may not be the bravest of your soldiers but whom you'll never replace with anyone who loves you as much and is as loyal as I have been.'

The Duke said that he must think only of saving his life; and as for the rest, he well knew his courage and loyalty. Then he turned to some of his attendants and told them to make sure that the brave young man went in want of nothing.

When he had left, Cecchino's wound started to bleed so copiously that it was impossible to stanch it, and as a result he went out of his mind. He was raving without stop all the following night, except for when they wanted to give him communion, and then he said:

'You should have given me confession before this. Now it's imposs- ible for me to receive the blessed sacrament in this wreck of a body. Let me receive it spiritually through my eyes, and then it will enlighten my immortal soul, which only begs Him for mercy and forgiveness.'

When he had said this the sacrament was taken away, and he fell into the same delirium as before, compounded of the most horrible words and the most terrifying ravings imaginable. This went on all night, without a break. As the sun rose over the horizon, he turned to me and said:

'My dear brother, I don't want to stay here any longer, because they'll force me to do something desperate that will make them regret having crossed my path.'

Then he flung out both his legs, raising the one that we had put inside a very heavy case, as if he were mounting a horse. Finally, he turned and looked at me and repeated three times: 'Good-bye, good-bye.' With this last word, his brave soul departed.

At the proper time, which was later on in the day, towards nightfall, I had him buried with the greatest honour in the church of the Florentines. Afterwards I had a very beautiful marble monument made for him, with trophies and banners adorning it. I must not forget to mention that when one of his friends had asked him whether he knew the man who had let fire at him with the arquebus, he had said, yes, and had described him. Although my brother had tried hard to prevent my hearing, I had heard only too well; and in due course I shall tell what the result was.

But to come back to the marble stone. A number of brilliant men of letters, who knew Cecchino, gave me an epitaph which they said such a splendid young man well deserved. It ran as follows:

Francisco Cellino Florentino, qui quod in teneris annis ad Ioannem Medicem ducem plures victorias retulit et signifer fuit, facile documentum dedit quantae fortitudinis et consilii vir futurus erat, ni crudelis fati archibuso transfossus, quinto aetatis lustro jaceret, Benvenutus frater posuit. Obiit die xxvii Maii, mdxxix.

He was twenty-five years old. As the soldiers used to call him Cecchino, the Fifer's son – although his real name was Giovanfrancesco Cellini – I wanted to have the name by which he was usually known engraved under our coat of arms. I had this name cut in very beautiful antique letters, all of which were broken except the first and the last. The writers who had composed that fine epitaph for me asked why I had done this. I told them that the letters were broken because his splendid body was itself wasted and dead; and the first and the last were left entire, because the first was in memory of the great gift given him by God of a soul kindled by divine power, a soul which was never broken; and the last was left entire to record the glory and fame of his brilliant courage. This idea they thought very noble, and it has since then been used by others.

I also had the arms of the Cellini family carved on to the stone, but I changed them slightly. In Ravenna, which is a very ancient city, the Cellini family is held in great honour and has for its coat of arms a lion rampant, in gold, against a field of azure, with a red lily clasped in his right paw, with a label above and three little golden lilies. That is the proper Cellini coat of arms. The one my father showed me had only the paw, along with the rest of the bearings; but I would prefer to follow that of the Cellinis of Ravenna, as described above.

To return to what I carved on my brother's tomb: I had the lion's paw, clasping an axe in place of a lily, with the field quartered. The axe was there only to remind me that I had to revenge him.

I worked as industriously as I could, trying to finish the work that I was doing in gold for Pope Clement. He was very anxious to have it, and he used to send for me twice or three times a week in order to have a look at it. Every time he saw it, he was more delighted than before. But very often he would reproach me, almost angrily, because of my great sorrow over my brother's death; and on one occasion, when he saw me unusually crushed and dispirited, he said:

'Oh, Benvenuto? I never realized you were an idiot. Didn't you know before now that there's no remedy for death? You are doing your best to follow him.'

I left the Pope and went back home to carry on with the morse and with my work for the Mint.[95] But at the same time I began to keep a

close watch on the arquebusier who had smashed my brother, as if he were a girl I was madly in love with. This fellow had once been a light cavalry soldier, and then he had joined the chief constable's corporals as an arquebusier. What increased my fury was that he had boasted about what he had done, saying:

'If it hadn't been for my killing that young man, in another minute he would have routed the lot of us with great slaughter.'

I realized that the constant state of passion I was in from seeing him so often was keeping me from my food and sleep, and I was becoming a wreck. So I stopped debating with myself whether what I had in mind was too degrading and dishonourable and one evening I made up my mind to rid myself of my torment.

The fellow had lodgings near to a place called Torre Sanguigna,[96] next door to the house of one of the most popular courtesans in Rome, called Signora Antea. It was nightfall, and the clock had just struck the hour. The arquebusier had finished supper and was standing in his doorway with his sword in his hand. I crept upon him, grasping a Pistoian dagger, and aimed a sudden back-stroke with the idea of cutting his head clean off. But he turned in a flash and the blow landed on the edge of his left shoulder, shattering the bone. He staggered up, was so dazed by the terrible pain that he let go his sword, and then took to flight. I went after him and caught him up in a few steps. Then I raised my dagger above his bent head and drove it exactly between his neckbone and the nape of his neck. The dagger went in so deeply that although I used tremendous force it was impossible to withdraw it, because just then four soldiers, with drawn swords in their hands, burst out from Antea's lodgings, and I was forced to draw my own sword to defend myself. I abandoned the dagger and took to my heels. Then, for fear of being recognized, I made my way to Duke Alessandro's palace, which stood between the Piazza Navona and the Rotunda.

When I arrived I had the Duke informed of what had happened and he gave me to understand that, if I were by myself, I should lie low and not worry, but just carry on working at the job that the Pope was so anxious to have finished. He added that I had better do my work indoors for a week. On top of this, the soldiers who had interrupted

me now appeared on the scene. They had my dagger with them, and they described what had happened, and how they had found it almost impossible to wrench the dagger out of the dead man's neck, who was someone they didn't know. Then, in the middle of all that, Giovan Bandini[97] came in and told them that it was his dagger, and that he had lent it to me and that I wanted to revenge my brother. When they heard this, the soldiers kept on apologizing for having interrupted me though I had had my revenge in good measure.

More than a week went by without the Pope sending for me in the usual way. Eventually he sent word to me through his chamberlain, the Bolognese gentleman I have already spoken of. He warned me very gently that the Pope knew everything, but that I was still in his Holiness's good books and that I should give my mind to my work and keep quiet. When we saw the Pope, he stared at me grimly, the threat in his eyes being enough to frighten the life out of me. But then he began examining my work, his face brightened up and he praised me to the skies, saying that it was a magnificent achievement in so short a time. After that he looked me straight in the eyes and said: 'Now you're cured, Benvenuto, mind out how you go.'

I grasped his meaning, and replied that I certainly would. Immediately after this I opened a very fine shop in the Banchi, opposite Raffaello's; and there, a few months later, I finished the work I was doing for the Pope.

Except for the diamond, which he had been forced to pawn to some Genoese bankers, the Pope had sent me all the jewels that were to adorn the morse. So although I had only a cast of the diamond, all the other stones were in my possession. At that time I had five very skilful workmen assisting me, because besides what I was doing for the Pope I had a great deal of other work on hand. As a result of this the shop was chock-full of valuable stuff, including jewels, gold, and silver.

I did in fact keep a house-dog – a beautiful, large, shaggy brute that Duke Alessandro had given me. It was a first-rate hunting dog, and when I was out shooting used to bring me back any bird or animal that I hit, but it was also a splendid house-guard. As it happened, at that time, as was only fitting at the age of twenty-nine, I had taken a charming and very beautiful young girl as my maid-servant; I used her

as a model, and also enjoyed her in bed to satisfy my youthful desires. Because of this, I had my room at quite a distance from where the workmen slept, and also some way from the shop. I kept the young girl in a tiny ramshackle bedroom adjoining mine. I used to enjoy her very often, and although I am the lightest sleeper in the world, after sexual pleasure I sometimes used to sleep very heavily and deeply.

So it happened when one night a thief broke into the shop. Under the cloak of being a goldsmith he had managed to spy out the land, had a good look at my jewels, and made his plans to rob me of them. He got into the place and found quite a few little gold and silver articles. But while he was busy forcing open some of the drawers to get his hands on the jewels he had seen, my dog sprang at him, and he had to defend himself, rather awkwardly with his sword.

Then the dog started running up and down the house and tore into the workmen's quarters, which were open as it was summer. He barked away furiously, but they paid no attention, and he began pulling the clothes off them. They still ignored him, so he seized them one after the other by the arm till he forced them to wake up. Then he barked fiercely and tried to show them where to go by running on in front of them. But the rascals had no intention of following him. They started to get angry, and began throwing stones and sticks at him. They could do this easily enough, since I had told them to keep a light burning all night. In the end they shut the doors tight, and the dog, giving up hope of getting any help from those villains, went off to do the job himself. He tore downstairs, found that the thief was no longer in the shop, and dashed off in pursuit. After he met up with him, he attacked him and had already torn the cloak off his back when the thief called some tailors to his help, begging them for the love of God to protect him from a mad dog. They believed what he said, rushed out, and with a great deal of trouble drove the dog away.

Next morning my workmen entered the shop, saw that it had been broken into and the drawers had been smashed, and started to scream: 'Help! Thieves!'

The noise they were making woke me up, and I rushed out panic-stricken. When I appeared on the scene, they cried out: 'God help us! Some thief has broken in and ransacked everything.'

I was so shaken by this that I hadn't the courage to go to my chest and see if the Pope's jewels were still there. I was almost blind with terror and anxiety, and I ordered the workmen themselves to open the chest and see how many of the jewels were missing. All my young men, by the way, were standing there dressed only in their shirts. They opened the chest, and there were all the jewels and the gold work, with nothing gone. At once they began shouting joyfully: 'Everything's all right – your work and the jewels are all here. But as for us, the thief has robbed us of everything but our shirts!'

Then they explained that the night before, because of the great heat, they had undressed in the shop and left their clothes there. I recovered myself straight away, began to thank God, and said to them:

'All of you – go along and buy some new clothes. I shall pay for them later on, when I hear exactly what happened.'

What I found most upsetting – indeed quite unlike myself I was in a terrible state of funk – was that everyone might think I had invented the story of the robber as a cover for stealing the jewels myself. In fact, one of his most trusted servants (as well as a number of others,[98] including Francesco del Nero, the Pope's accountant Zana de' Biliotti, and the Bishop of Vasona) had said to Pope Clement:

'Holy Father, why do you trust with such valuable jewels a hot-blooded young firebrand, who isn't yet thirty, and who is more given to fighting than to art?'

The Pope had replied by asking if any of them knew whether I had ever done anything to justify their suspicion. Francesco del Nero, his treasurer, answered him quickly: 'No, Holy Father, because he hasn't had the chance yet.'

Clement's reply to this was that he regarded me as thoroughly trustworthy, and that even if he saw me do wrong he would not believe it.

It was when I suddenly remembered all this that I became really agitated. After I had instructed my young men to buy themselves some new clothes, I took the gold work, arranging the jewels in position as best I could, and immediately carried them to the Pope. Francesco del Nero had already told him something of the stories that were going round about what had happened in my shop, and the Pope's suspicions

were aroused at once. He jumped to the conclusion that the worst had happened, glared at me fiercely, and said in a stern voice: 'Why have you come here? What is it?'

'Look – here are all your jewels, and the gold as well. Nothing is missing.'

Then, with his face clearing, the Pope said: 'Now you are living up to your name – you *are* welcome.'

I showed him what I had done so far, and while he was looking at it, I told him all about the thief, and my anxieties, and what had worried me most. As I was talking he kept looking up and staring me straight in the eyes: Francesco del Nero was present, and for that reason the Pope seemed half annoyed at having doubted me.

In the end he burst out laughing at my long rigmarole and said: 'Keep on being the honest man that I know you are, Benvenuto.'

I pressed on with what I was doing for the Pope, and at the same time I was continually employed for the Mint. Meanwhile some counterfeit money, stamped with my own dies, began to circulate in Rome. Some of the coins were at once brought to the Pope and suspicion was cast on me. The Pope, however, told Jacopo Balducci,[99] who was in charge of the Mint, to do everything he could to find the real criminal, because he knew that I was honest. This treacherous man, who was an enemy of mine, replied: 'I hope to God, Holy Father, that what you say is right. But we have our reasons for suspecting him.'

At this the Pope merely turned to the Governor of Rome and told him to be quick about finding the criminal. In the meantime, his Holiness sent for me. He very cleverly led up to the subject of the coinage, and at the crucial moment he said: 'Benvenuto, would you have it in you to make false money?'

My reply to this was that I could certainly make a better job of it than the men who did do such foul things. Men who are as crooked as that, I said, have no idea how to earn money, and are not very good craftsmen. On the other hand, with what skill I had I earned as much as I needed, since when I made dies for the Mint, every morning before having dinner I came by at least three crowns. I added that it had always been the custom to pay that much, and that that cheat who was in charge of the Mint hated me, because he would like to have got them

for less. What God and the world allowed me to earn, I concluded, was good enough as far as I was concerned, and I would be less well off if I were to turn to coining.

The Pope saw what I was getting at, and whereas he had ordered that I should be closely watched in case I tried to leave Rome, he now ordered a thorough search to be made for the real culprit and said that I was to be left untroubled since he had no wish to offend me, for fear I left him. These strict instructions were given to some of the clerks of the Camera, and after they had carefully carried out their orders, they found the man they were after almost immediately. He was a coiner, working in the Mint itself, called Ceseri Macherone; and he was a Roman citizen. They arrested with him one of the Mint's metal-founders.

That very same day I happened to be walking through the Piazza Navona, with my beautiful spaniel by my side. As I reached the gate of the police headquarters the dog started barking like mad, and then hurled himself through the gate on to a young man who was there. This fellow had been arrested for robbery on the accusation of a man called Donnino, a goldsmith from Parma who had once been a pupil of Caradosso. The dog tried so hard to tear the young man to pieces that the police were moved to take pity on him. They felt all the more sorry for him in view of the fact that he defended himself boldly and eloquently, and Donnino could not bring enough evidence against him, and, what was more, one of the police corporals was from Genoa and knew the young fellow's father. So what with the dog and all the rest of it, it looked as though they wouldn't hesitate to let him off scot-free.

As soon as I came up, however, the dog, who was not at all frightened of swords or sticks, flew at him again, and they threatened to kill the animal if I did not hold him off. I kept him back as best I could, but then, as the young man was drawing back his cloak, some paper packages fell out of the hood. Donnino recognized them as belonging to him, and then my eye fell on a little ring that belonged to me. Straight away I cried out: 'This is the thief who broke into my shop and robbed me – that's why the dog knows him.'

I released the dog, and as he flew back to the attack, the young fellow

began to beg for mercy and said that he would give me everything he had belonging to me. I held the dog off, while he returned the gold and silver, the little rings he had that were mine, and twenty-five crowns besides. Then he begged for mercy again. I said that if he wanted mercy he had better say his prayers to God, since I would neither help nor hinder him.

I went back home and carried on with my business; and then, a few days later, Ceseri Macherone, the forger, was hanged in the Banchi in front of the Mint, and his accomplice was sent to the galleys. The Genoese thief was hanged in the Campo di Fiore; and I was left with a better reputation for honesty than I had ever had before.

I was on the last stages of my work for the Pope when there occurred that tremendous flood that put all Rome under water. It was two hours before sunset, the clock had just struck, and as night came on I waited to see what would happen. The water kept rising very rapidly. The front of my house and workshop faced on to the Banchi, and the rear of the house, which looked towards Monte Giordano, was several feet higher. My first thought was to save my life and, after that, my honour. So I put all the jewels in my pocket, left the gold morse in the charge of my workmen, and then in my bare feet I climbed out through the back window. I waded through the water as best as I could till I reached Monte Cavallo, and there I found Giovanni Gaddi, a clerk at the Camera, and with him the Venetian painter Bastiano. Giovanni was as fond of me as if I were his own brother; so when I came up with him I handed him over all the jewels and asked him to look after them for me.

A few days later the fury of the flood abated, and so I was able to return to the shop and finish the morse. Thanks to God – and my own efforts – I did this so successfully that everyone said it was the most beautiful piece of craftsmanship ever seen in Rome. When I took it along to the Pope he could not praise me highly enough.

'If only I were a rich emperor,' he said, 'I would give my Benvenuto as much land as his eye could reach. But nowadays we princes are poor and bankrupt. All the same I'll at least make sure he has enough bread to satisfy his few wants.'

I waited for this torrent to exhaust itself, and then, as one of the posts

of mace-bearer was vacant, I asked him if I could have it. He replied by saying that he meant to give me something much more important than that. And then I said that, for the time being, perhaps he would grant me what I had asked as a sort of security.

He burst out laughing and said that he was only too willing to give it to me, but that he did not want me to fill the post in an active capacity, and that I should arrange this with the mace-bearers; at the same time, he granted them the favour they had already asked, of being given authority to recover their fees. It was all arranged. This post I was given brought me in just under two hundred crowns a year.

I carried on working for the Pope, now doing one little thing and now another; and then he commissioned me to design him a very rich chalice. I made both a drawing and a model. The model was constructed of wood and wax, and in place of the node I designed three fair-sized figures in full relief, representing Faith, Hope, and Charity. Then, to balance this, at the base of the chalice I designed in three little circles some scenes in low relief; one showed the Nativity, another the Resurrection, and the third, St Peter being crucified upside down. These were what I was told to do.

While I was busy on the chalice the Pope kept on wanting to have a look at it. It occurred to me that his Holiness had forgotten to follow up his previous grant and so, as a post in the office of the Piombo was vacant, one evening I asked him for it. All the enthusiasm he had shown when I finished the morse for him now slipped his memory, and he said:

'That post in the Piombo brings in more than eight hundred crowns, and if I gave it to you, you'd spend all day scratching your belly, lose all your marvellous skill, and get me blamed for it.'

My answer to this was that the purest-bred cats made better mousers when they were fat than when they were starving; and in the same way honest craftsmen did much better work when they had plenty to live on. I said that he should remember that princes who enabled artists to prosper were watering the roots of genius, which to start with were weak and diseased. And anyhow, I added, I did not ask for the post with the idea of obtaining it, since I was quite happy with the miserable post of mace-bearer and was only day-dreaming about the other.

'As your Holiness does not want to let me have it,' I concluded, 'you would be well advised to give it to some artist worthy of it, and not to some ignoramus who would only scratch his belly, as your Holiness said.'

As a parting shot I told him to follow the example of his worthy predecessor Pope Julius, who gave such a post to the wonderful architect, Bramante.[100] Then I bowed abruptly and left in a rage.

When I had gone Bastiano Veneziano, the painter, came forward and said to the Pope:

'Holy Father, why don't you give the post to someone who devotes all his time to his art? I give myself wholeheartedly to my work, and I beg you to consider whether I am worthy of the position.'

The Pope answered: 'That devil Benvenuto cannot bear anyone telling him off. As a matter of fact I was inclined to let him have it – but it's not a good thing to stand on one's dignity in front of a pope. So I'm not sure what I shall do.'

Then straight away the Bishop of Vasona hurried up and began pleading on behalf of Bastiano.

'Holy Father,' he said, 'Benvenuto is young, and he looks much better with a sword by his side than in the friar's robe that he would have to wear if he were given the post in the Piombo. Be content to give the position to this talented man Bastiano; and on some other occasion you'll be able to find something worth while for Benvenuto, which, perhaps, will be more suitable for him.'

Finally, the Pope turned to Messer Bartolomeo Valori[101] and said:

'When you run into Benvenuto, tell him from me that he himself has given the post to the painter Bastiano. But he can bank on having the first better position that falls vacant. Meanwhile he must work well and finish what he's doing for me.'

The following evening, two hours after nightfall, I ran into Bartolomeo Valori at the corner of the Mint. There were two torch-bearers in front of him, and he was in the devil of a rush as he had been sent for by the Pope. When I greeted him he stopped and called me over, and then told me very warmly what the Pope had ordered him to. I replied that I would finish the work more carefully and eagerly than any I had ever done before, but all this would be without the slightest

hope of ever getting anything from the Pope. Bartolomeo reproached me for saying this and added that I ought not to answer the offers of a pope in such a way. I said that knowing full well that I would never get anything, I would be mad if I relied on what he said or replied in any other way than I had. Then I left him and got on with my business.

Bartolomeo must have told the Pope about the angry little speech I had made – perhaps he even added a little of his own – because the Pope let more than two months go by without sending for me, and all that time I had not the slightest intention of going along myself. But he was pining to have a look at the work I was doing for him, and so he told Messer Roberto Pucci[102] to see how I was getting on. This excellent fellow used to visit me every day, and we were always very friendly towards each other.

The time was drawing near when the Pope intended to leave for Bologna,[103] and so at long last, realizing that I would not come to him of my own accord, he gave me to understand through Roberto that I was to bring the work along as he wanted to see what progress I had made.

So I took it along; he saw that the best part of the work was finished, and I begged him to let me have five hundred crowns, partly as payment and partly because I was in urgent need of gold to complete the chalice. All he said was: 'Get on with it – finish the job.'

So I left him, saying as I went that I would certainly finish it if he gave me some money.

When the Pope started off for Bologna he left Cardinal Salviati as his legate in Rome, with orders that he was to hurry me up in my work. What he said was:

'Benvenuto is a man who values his genius very little, and us even less: so make sure you keep him up to the mark, so that it's ready for me when I return.'

At the end of a week that bestial Cardinal sent for me, with instructions that I was to bring the chalice. So I went without it. As soon as he saw me, he said:

'Where's that hash of yours? Is it finished?'

I answered: 'Most reverend monsignor, the hash isn't finished, and it won't be finished till I have some vegetables to put in it.'

When he heard what I said, this Cardinal, who as a matter of fact looked more like an ass than a human being, became more like a brute than ever, and without mincing words broke in:

'I shall send you to the galleys – then perhaps you'll be good enough to finish the work.'

Then I descended to his animal level and replied:

'Monsignor, when I'm criminal enough to deserve the galleys, then you can send me there. But what I've done so far doesn't give me any cause for alarm. And let me add this – because of you, I have no intention of finishing it. Don't send for me again, because you won't see me – unless you send for me by force.'

Afterwards this fine Cardinal kept trying to coax me into carrying on with the work and bringing it to show him. As a result I sent back word that if he wanted me to finish the hash he had better send some vegetables. That was the only reply he ever got, and in the end he gave up the task as hopeless.

When the Pope came back from Bologna he sent for me straight away, as the Cardinal had already written to him damning me as much as he could. He was in the worst of tempers, and I was told to bring my work along with me. And I did so.

As it happened while the Pope was in Bologna my eyes had become so painfully inflamed that I almost died of the agony. This was the main reason for my not finishing the work. In fact I went through so much that I felt sure I would be left permanently blind. I had even worked out how much I would need to live on if this happened. So while I was on my way to the Pope I tried to think out in what way I would have to excuse myself for not having got on with the work. I decided that while the Pope was eyeing what I had done, and summing it up, I would have the chance to tell him about my misfortunes. But that proved out of the question because as soon as I found myself in front of him he said rudely:

'Give the work here! Is it finished?'

I uncovered what I had done, and then, losing his temper, he cried:

'In God's truth, I tell you, you make it your business not to care a jot for anyone. If it wasn't for my position I'd have you and your work thrown out of the window.'

When I saw what a brutal mood he was in my one thought was to get away from him. So while he continued storming at me, I put the work under my cloak and muttered to myself:

'Nothing in the world could force a blind man to work on this sort of thing.'

At this he raised his voice even higher, and cried out: 'Come here. What are you saying?'

I was in two minds as to whether I should make a mad dash down the stairs or not, then I made a decision, threw myself on my knees, and bawled out – since he hadn't stopped bawling himself:

'And if an illness has made me blind, am I still bound to work?'

He replied: 'You were able to see your way here. I don't believe a word you say.'

But I noticed that he had lowered his voice a little, and so I came back with:

'If your Holiness consults his doctor about it he'll find out the truth.'

To this he said: 'When it's more convenient we'll find out whether things are as you say they are.'

I saw that he was ready to give me a hearing, and so I began:

'I'm certain that the only reason for my terrible affliction was Cardinal Salviati. He sent for me the instant your Holiness had left, and when I arrived he called my work a hash and said that he would make me finish it on a galley. His vicious attitude put me in such a passion that I immediately felt my face becoming inflamed, and my eyes smarted so painfully that I couldn't find my way home. Two days later I developed cataracts in both my eyes, which prevented my seeing anything at all. So since your Holiness left I haven't been able to do a spot of work.'

Then I rose to my feet, and cleared off. I was told later that the Pope said:

'One can pass on responsibility, but not the discretion that goes with it. I didn't tell the Cardinal to go at it tooth and nail. If he really does have something wrong with his eyes – and I shall find out from my physician – one must have pity on him.'

There was a great gentleman present, who was very friendly with the Pope and very distinguished. He asked the Pope who I was, saying:

'Holy Father, the reason for my asking this is because I've just seen you pass in a flash from the greatest anger to the greatest compassion. So tell me who he is, since if he deserves help I shall let him into a secret that will cure him of his illness.'

The Pope replied: 'He's the greatest man his profession has ever known. One day, when we're together, I'll show you some of his magnificent work. You can have a look at the man himself at the same time. I'll be very pleased if you can see a way to doing him some good.'

Three days after this the Pope sent for me when he had finished dinner, and I arrived to find this gentleman with him. As soon as I came in his Holiness sent for the clasp I had made for his cope, and meanwhile I brought out the chalice. The Pope's friend said that he had never seen such a marvellous piece of work. Then, when the morse appeared, he was even more astonished. He looked me straight in the eyes and said:

'He's very young to know so much, and he's still ready to learn more.'

He asked me what I was called, and when I told him, Benvenuto, he answered:

'And now you'll find that I'm *benvenuto* too. Take some irises, together with their stalks and petals and roots, then distil them over slow fire, and use the liquid to bathe your eyes several times a day. This will certainly cure you – but purge yourself before you begin the treatment.'

The Pope talked to me quite affectionately; and I went away feeling fairly content.

It was true that I had caught the disease, but I think it must have been from that pretty young servant girl I was keeping at the time I was robbed. The French pox kept its distance for more than four whole months, and then it suddenly broke out all over. It did not show itself in the usual way, but I was covered with a number of small blisters, red ones, about the size of farthings. The doctors refused to christen it the pox, though I told them why I thought it was that. Anyhow I carried on with their treatment, without the least result. In the end, against the advice of the best doctors in Rome, I decided to take *lignum*

vitae. I did so with the greatest imaginable care and abstinence, and within a few days began to feel very much better; to such an extent, in fact, that at the end of fifty days I was completely healed and as sound as a roach.

Then, to make up for the great strain I had been subjected to, as winter was coming on I decided to get some recreation by going out shooting. This led to my being out in all weathers, and plunging through marshlands. The consequence was that in a few days I fell a hundred times more ill than before. I put myself in the hands of the doctors again, but the more they treated me the worse I grew.

When I was attacked by a bout of fever I decided to take *lignum vitae* again. The doctors were dead against it, saying that if I did so while I was feverish I would die within the week. I made up my mind to ignore them, and then, after I had kept to the same rules as before, and had been drinking this blessed *lignum vitae* for four days, the fever left me completely. I began to feel a vast improvement. In fact, all the time I was taking *lignum vitae*, I pushed on with my models for the chalice; and during those weeks of abstinence I made the most exquisite things and the most unusual designs that I have ever made in my life.

At the end of fifty days I was perfectly cured. Then, with the utmost diligence, I set out to build up my health. After that long fast I found myself so free from infirmity that it was just like being born all over again. For all the pleasure I took in building up the healthy state I had been longing for, I refused to neglect my work. I gave as much of my time as I thought I ought both to the chalice and to my work for the Mint.

It happened that Cardinal Salviati, who as I've shown regarded me with such tremendous hatred, was made legate of Parma. Now, the next thing that happened was that a certain Milanese goldsmith, called Tobbia, was arrested in Parma on a charge of forgery. After he had been sentenced to be hanged and burned, the Cardinal was asked to grant a reprieve on the grounds that he was a very fine craftsman. The Cardinal had the course of justice held up while he wrote to the Pope saying that the most expert goldsmith in the whole world had fallen into his hands, that he had been condemned to be hanged and burned for coining false money, but that he was a simple, honest man, who

pleaded that he had sought the advice of his confessor and said that he had been given permission to do what he had done.

On top of this, the Cardinal added:

'If you make this great man come to Rome, your Holiness will succeed in lowering your Benvenuto's tremendous conceit, and I'm positive that Tobbia's work will please you much more than Benvenuto's.'

As a result of this the Pope made him come to Rome at once. As soon as he arrived we were both sent for and both ordered to set to work on a design for mounting a unicorn's horn. This was the most beautiful object of its kind ever seen, it had cost seventeen thousand ducats, and the Pope intended to make a present of it to the King of France.[104] But before doing so he wanted to have it richly ornamented in gold. So we were both ordered to make our designs.

When we had finished them we carried our work along to the Pope. Tobbia's design was in the form of a candlestick, and instead of a candle that wonderful horn was to be stuck in it; at the base of the candlestick he had made four little unicorns' heads, so crudely unimaginative that when I saw his work I could not help grinning to myself on the side.

The Pope noticed this and called out straight away: 'Let's see what you've done.'

My design showed merely a unicorn's head, to match the horn. I had made an extraordinarily beautiful job of it, because I had taken the design partly from the head of a horse and partly from that of a stag, and I had embellished it with a magnificent mane and a number of other charming adornments. As a result, as soon as it was seen everyone declared that mine was superior.

However there were a few very influential Milanese present at the contest, and they seized the chance to say:

'Holy Father, your Holiness is sending this magnificent gift to France – now remember, the French are very uncouth people and they won't recognize the excellence of what Benvenuto has done. Now, a ciborium with the same design as Tobbia has shown us will please them very much; and that sort of thing takes far less time to make. Then Benvenuto can concentrate on finishing your chalice, and you'll have two things

finished in the same amount of time – besides giving that poor fellow you made come here something to do.'

The Pope, who was anxious to have the chalice, was only too pleased to act on their advice. So the next day he commissioned Tobbia to mount the unicorn's horn, and sent word through the Master of the Wardrobe that I was to finish the chalice. My reply to this was that all I wanted myself was to finish such a beautiful piece of work, and that if it were made of anything else but gold I could finish it quite easily without any help, but that as it was in gold his Holiness must supply me with some if he wanted the chalice finished.

The low-class courtier I gave this message to said:

'God help me! don't ask the Pope for gold; you'll put him in such a temper that he'll ruin you.'

I replied: 'Then will your Highness teach me how to make bread without flour? Because, sir, this work of mine will never be finished without gold.'

It began to dawn on this official that I had been making fun of him; and he said that he would carry my words back to the Pope. And he did so. The Pope fell into a furious rage and said that he would just wait and see whether I was fool enough not to finish it. So more than two months passed; and though I had told him that I would not do a stroke of work on the chalice, in fact I worked on it all the time, very lovingly.

When the Pope saw that I was not going to bring it along he began to harbour tremendous resentment against me, and he threatened to have me punished whatever happened. His Milanese jeweller heard him make this threat. This fellow, who was called Pompeo, was very closely related to Pope Clement's most favoured servant, a certain Messer Traiano. The two of them got together and said to the Pope:

'If your Holiness took the Mint away from him perhaps you'd give him the incentive to finish the chalice.'

The Pope replied: 'That would have two bad results – first, I'd be badly served at the Mint, which is so important to me, and second, I'd certainly never get the chalice.'

But in the end, the two Milanese, seeing that I was in the Pope's bad books, succeeded to the extent that he took the Mint away from

me and gave my post to a young man from Perugia who was known as Fagiuolo.[105] Pompeo came along to tell me, on behalf of the Pope, that the Mint had been taken away from me, and that if I did not finish the chalice there would be other things taken away as well.

I replied to this: 'Tell his Holiness that he has robbed himself, not me. And the same applies to those other things. And when he wants to restore it to me, I shan't dream of accepting.'

It seemed an eternity to this miserable wretch before he could tell the Pope all I had said, as well as what he added on his own account. Then, a week later, the Pope sent word through the same fellow, saying that he no longer wanted me to finish the chalice but that he wanted it taken to him exactly in the state I had brought it to so far.

I told this fellow Pompeo that the Pope could not take the chalice from me as he had done my position in the Mint.

'This is how things stand,' I said. 'I have five hundred crowns that belong to his Holiness, and I'll return them to him straight away. The work itself is mine to do as I please with.'

Pompeo dashed off to report this, as well as the bitter words I had felt justified in throwing in for him.

Then, about three days later, on a Thursday, two of his Holiness's favourite chamberlains came to see me. One of them, called Messer Pier Giovanni,[106] who is still alive today and has been made a bishop, was then the Pope's Master of the Wardrobe; the other was of even higher birth than him, but I've forgotten his name.

When they arrived, they said: 'We've been sent by the Pope, Benvenuto. Since you've decided not to take the easy way out, he says you must either hand us over his chalice or we must take you to prison.'

I looked at them very cheerfully and replied: 'My lords, if I gave his Holiness the chalice I'd be giving what belongs to me and not to him. And I don't intend to let him have it, because having taken so much trouble to bring it near completion I don't intend it to fall into the hands of some ignorant beast who would find it only too easy to ruin it.'

The goldsmith whom I mentioned above, called Tobbia, was present when I said this. In fact he was rash enough to ask me for the

models of the chalice as well. There is no call for me to repeat here what answer I gave him; at any rate it was the sort of answer such a wretch deserved.

As the two chamberlains were pressing me to make my mind up quickly about what I meant to do, I told them I was ready and got my cloak. Then, before leaving my shop, I turned very reverently towards an image of Christ, and holding my hat in my hand I said:

'O merciful and everlasting, just and Holy Lord – all the things You do spring from Your justice, which is without equal. You know that I have just reached the thirtieth year of my life, and that never before have I been threatened with imprisonment for anything I have done. Since it is now Your will that I should go to prison, I thank You with all my heart.'

Then I turned to the two chamberlains, and with one of my rather stern expressions on my face I said:

'A man of my sort deserves guards no less exalted than your lordships. So put me between you and take me as your prisoner, wherever you like.'

Those two fine gentlemen burst out laughing, placed me in the middle, and chatting pleasantly all the way led me to the Governor of Rome, who was called Magalotto. He had been expecting me, and he was with the Procurator Fiscal.[107] On our arrival, the chamberlains, who were still laughing, said to the Governor:

'We're handing this prisoner over to you – take good care of him. It's been a great pleasure to carry out your officers' duties, because Benvenuto tell us that as this is the first time he has been arrested he deserved guards of no less rank than us.'

As soon as they had left us they went to the Pope and told him exactly what had happened. At first he looked as if he was going to lose his temper, but then he forced himself to laugh, because there were some noblemen and cardinals present who looked on me very favourably.

Meanwhile, the Governor and the prosecutor were treating me to a mixture of abuse, exhortation, and advice. They said that it was only reasonable that a man who got another to execute a piece of work for him should be able to recover it when he liked and however he liked.

My reply to this was that such behaviour was quite unjust, and certainly a pope could not act in that way, because a pope was not one of those tyrannical little lords who exploited their subjects as harshly as they could, paying regard neither to law nor justice. The Vicar of Christ, I said, could do nothing like that.

Then the Governor, talking and acting like the police official he was, began saying:

'Benvenuto! Benvenuto! you are trying to make me treat you as you deserve.'

'If you treat me as I deserve,' I retorted, 'it will be with honour and courtesy.'

Then he began over again: 'Send for the work at once, and don't wait for me to tell you again.'

'My lords,' I replied, 'be good enough to let me add a few more words in my own defence.'

The prosecutor, who was a much more even-tempered official than the Governor, turned to him and said:

'Monsignor, let's have a hundred words – if he hands over the chalice, that's good enough for us.'

Then I began: 'If some man or other were having a palace or a house built, then he'd be entitled to say to the builder, "I don't want you to work any longer on my house, or my palace," and then, when he had paid him for his work, he'd be perfectly entitled to send him away. Or in the case of a nobleman who was having a jewel worth a thousand crowns set for himself, if he saw that the jeweller wasn't doing it the way he wanted he could say, "I don't want your work, so give me back my jewel." But none of this applies in my case, since it's not a question of a house or a jewel. All I can be ordered to do is return the five hundred crowns I've had. So, my lords, do all in your power, but all you'll get from me are those five hundred crowns. Tell the Pope that. Your threats don't frighten me in the slightest; I'm an honest man, and I've no crimes to be frightened about.'

Then the two of them rose to their feet and told me that they were going to the Pope and would return with instructions that I would find very unpleasant. So there I remained under arrest. I began to pace up and down the hall. It was about three hours before they came back

from the pope, and in the meantime all our top-ranking Florentine merchants visited me to beg earnestly that I should not continue this quarrel of mine with a Pope of Rome because it could spell my ruin. My reply was that I had perfectly made up my mind as to what I meant to do.

As soon as the Governor and the prosecutor returned from the palace they called me before them, and the Governor spoke to this effect:

'Benvenuto, it certainly grieves me to have come back from the Pope with these instructions – either you get the chalice at once, or you had better look out for yourself.'

I answered that since up to then I had never believed that a holy Vicar of Christ could perpetrate an injustice, I intended to see it done before I believed it; 'so', I added, 'do what you can to me'.

The Governor said: 'There's just a little more I have to tell you from the Pope, and then I shall carry out my orders. He says that you must bring the chalice here, and I am to have it put inside a box and sealed, and then take it to him. He promises on his honour not to break the seal and to return it to you without delay. But in all this he wants his honour, as well, to be satisfied.'

I replied with a laugh that I would be only too glad to let him have the work in the way he said, since I wanted to find out for certain what the word of a pope was worth.

And so I sent for my chalice, it was sealed up in the way that had been agreed, and I gave it to the Governor. He then went back to the Pope, with the chalice in that condition. Now, according to that I was told by the Governor, the Pope took the box, turned it over a few times, and then asked him if he had seen what was in it. The Governor said that he had, and that it had been sealed up like that in his presence. He went on to say that it had seemed to him a splendid piece of work. At this, the Pope said:

'Tell Benvenuto that the popes have power to bind and loose much greater things than this.'

And as he said these words, with a slight gesture of anger he opened the box, removing the cord and seal with which it was bound. Then he stared at it for some time and, as I was given to understand later,

showed it to the goldsmith, Tobbia, who praised it very highly. The Pope asked him if he was up to a work of that kind, and when he replied, yes, he told him to follow my design exactly. Then he turned to the Governor and said:

'See if Benvenuto will give it up to us, for if he does he'll be paid what it's valued at by the experts. Or if, in fact, he wants to finish it for us himself, let him fix a date; and if you see that he's ready to do so give him whatever he reasonably needs for the work.'

The Governor replied: 'Holy Father, I know the terrible stuff that young man is made of. Let me have authority to give him a sharp dressing-down in my own way.'

The Pope's comment on this was that he might do as he liked as far as words were concerned, although he felt sure he would only make matters worse. And anyhow, if he saw there was nothing else to be done he was to tell me to take his five hundred crowns to that jeweller of his, Pompeo.

When the Governor returned he had me called into his office and, frowning at me as if I were on trial, he said:

'The popes have the power to bind and loose everything on earth, and whatever they do is accepted in heaven. Well, there is your work – opened and seen by his Holiness.'

Immediately, I said in a loud voice:

'I thank God that I now know what the word of a pope is worth!'

Then the Governor began threatening me violently, till he saw that this was having no effect, abandoned the idea, and started talking a little more gently.

'Benvenuto,' he said, 'I'm very sorry you don't understand your own interests. Anyhow, go away now, and when you feel like it take the five hundred crowns to Pompeo.'

I took my work,[108] left him, and went straight away with the five hundred crowns to that Pompeo. As it happened the Pope, who was anxious to retie the thread of my servitude, thought that either because I had not enough money, or for some other reason, I would not pay up so soon. So when he saw Pompeo coming up to him with a grin on his face and the money in his hand, he began abusing him and complained bitterly at the business having ended in such a way.

Then he said: 'Go and find Benvenuto in his shop, and be as friendly as your beastly ignorance will let you, and tell him that if he likes to finish the work and make me a monstrance to carry the Host in when I walk with It in procession, I will give him whatever he needs to finish it – provided he works.'

When Pompeo arrived he called me out of the shop, began fawning on me like the fool he was, and repeated all that the Pope had ordered him to. My immediate answer was that for me the greatest prize in the whole world was to have won back the favour of such a great pope, which I had lost not through my own fault, I said, but because of my terrible illness and the wickedness of those jealous men who enjoy doing evil.

Then I added: 'As the Pope has plenty of servants, don't let him send you round here again. If you want to stay alive you had better look out for yourself. As for me, I shan't fail to think how to please the Pope and do all I can for him, day and night; but don't you forget – after you've carried this message back to the Pope never meddle in my affairs, because if you do I'll give you the punishment you deserve, and then you'll realize the mistakes you've made.'

This man carried everything I had said back to the Pope, and twisted my words to give a much more brutal impression. The matter rested at that for a time; and I occupied myself with my business in the shop.

Meanwhile, that goldsmith Tobbia was finishing the adorning and ornamenting of the unicorn's horn, and besides this had been ordered by the Pope to begin the chalice in the same style that he had seen in mine. But when Tobbia came to show the Pope what he had done he was very dissatisfied and began to regret bitterly that he had fallen out with me over it: he found fault with Tobbia's other work, and with the people who had brought Tobbia to him. As a result Baccino della Croce kept coming along to urge me on behalf of the Pope to start work on the monstrance.

I told him that I begged his Holiness to let me rest after the severe illness I had been through, from which I had still not completely recovered. But I added that I would show his Holiness that all the hours I was capable of working would be devoted to his service. In fact I had

begun to make his portrait, and I had secretly designed a medal for him, constructing the steel dies to stamp it with in my own house. In the workshop I kept a partner, called Felice,[109] who had been my apprentice.

At that time, as young men do, I had fallen in love with a very beautiful young Sicilian girl; and she too showed that she felt very affectionately towards me. But her mother discovered this, and began to suspect what was going to happen. To tell the truth I had been planning to elope with the girl to Florence for a year, without telling her mother a word. Well, she discovered the plan and one night she left Rome secretly and went off in the direction of Naples. She gave it out that she was going by Civitavecchia, but she went by Ostia. I followed them to Civitavecchia and made an utter fool of myself trying to find her. It would take too long to tell the whole story in detail; all I need say is that I was on the verge of either going mad or dying. At the end of two months she wrote and told me that she was in Sicily, and that she was very unhappy. In the meantime I was indulging in every imaginable pleasure and had taken a new love, merely to drown the other.

A number of strange circumstances led to my striking up a friendship with a Sicilian priest. He was extremely intelligent and had a very good knowledge of Latin and Greek. Once when we were talking together our conversation turned on to the art of necromancy, and I remarked:

'All my life I've wanted to see or hear something of this business.'

When he heard me say this, the priest replied:

'The man who embarks on matters of that sort needs a brave soul and strong resolution.'

I replied that if I were given the chance I would show that I had strength and resolution in plenty. And then he said:

'If you're well equipped with that, I'll give you your bellyful of the rest.'

So we agreed to venture on the thing together, and one evening the priest made his preparations and told me to find not more than two others. I called on my very dear friend, Vincenzio Romoli, and the priest brought along a man from Pistoia who also practised necromancy.

We all went along to the Colosseum, and there the priest dressed himself up in the way that necromancers do, and then – with tremendously impressive ceremonies – began drawing circles on the ground. He had made us bring along precious perfumes and fire, and some evil-smelling stuff as well. When everything was ready he stepped inside the circle and, taking us by the hand, brought us in one by one with him. Then he assigned us our duties. He gave the pentacle to his necromancer friend to hold, and he put the rest of us in charge of the fire for the perfumes. And then he began his incantations. All this lasted for over an hour and a half. Several legions appeared, till the Colosseum was filled with them. I was busy with the precious perfumes, and when the priest saw so many devils he turned to me and said: 'Benvenuto, ask them something.'

So I asked them to bring me together with my Sicilian girl, Angelica. We were given no reply at all that night; but I was more than satisfied with what I had seen. The necromancer said that we would have to come back again and that I would be given complete satisfaction regarding everything I asked, but that he wanted me to bring a young boy with me, a virgin.

I took one of my shopboys, who was about twelve years old, and I also asked Vincenzio Romoli to come along again. In addition we brought a certain Agnolo Gaddi into the business, as he was a close friend of ours. When we again reached the place that had been agreed on the necromancer made the same, and then even more, elaborate preparations, and led us into the circle, which he had marked out with even more splendid art and ceremony. He had my Vincenzio, and Agnolo Gaddi as well, looking after the perfumes and the fire; and then he handed me the pentacle, telling me to turn it in the directions he showed me. I held my little apprentice boy under the pentacle.

The necromancer began to make his terrible incantations, calling up by name a whole host of major demons and commanding them by the virtue and power of the uncreated, living, and eternal God, in Hebrew, as well as in Latin and Greek. The result was that in a short space of time the Colosseum was filled with a hundred times more demons than there had been on the previous occasion. Vincenzio Romoli and Agnolo were busy with the fire and the great heap of precious perfumes; and

then, when the necromancer prompted me, I again asked to be united with Angelica. He turned to me and said: 'Did you hear them say that you will be where she is inside a month?'

Then he added once again that he begged me to hold fast, because there were a thousand more legions than he had called up, and they were the most dangerous kind. Since they had agreed to what I asked, he said, we must treat them gently and dismiss them patiently. Meanwhile on the other side, the boy, who was under the pentacle, cried out in terror that there were a million tremendously fierce-looking men there, who were all threatening us; then he added that four enormous giants had appeared and that they were all armed and advancing as if to break in on us. All the time the necromancer was trembling with fear and was trying as best he could to persuade them to go away, pleading with them softly and gently. Vincenzio Romoli, who was shaking like a reed, was still busy with the perfumes. I was as frightened as the rest of them, but I tried to show it less and I bolstered up their courage magnificently, though I nearly dropped dead when I saw how frightened the necromancer was.

The boy had stuck his head between his knees and was crying: 'I will die like this – we're all going to die!'

At this, I said to him: 'These creatures are only our slaves; all you can see is only smoke and shadow. So come on, look up!'

He lifted his head, and then he cried out again: 'The whole Colosseum is on fire and the flames are rushing towards us.'

Then he clapped his hands over his eyes, and started crying that he was dead and didn't want to see any more. The necromancer implored my help, begging me to stand firm and telling me to have some asafoetida fumes made. So I turned to Vincenzio Romoli and told him to do this straight away. While I was saying this I stared at Agnolo Gaddi, whose eyes were popping out of his head, and who was half-dead with terror.

'Agnolo,' I cried, 'there's no room for fear in a situation like this – you must lend a hand. Throw some of the asafoetida on at once.'

The instant he went to make a move, Agnolo blew off and shat himself so hard that it was more effective than the asafoetida. The tremendous stench and noise made the boy lift his head a little, and

when he heard me laughing he plucked up courage and said that the demons were running away like mad. We stayed where we were till matins were rung. Then the boy spoke up again and said that there were only a few devils left, some distance away from us.

After the necromancer had completed his ceremonies he took off his robes and gathered up a great pile of books that he had brought with him; then we all left the circle, pressing tightly together – especially the boy, who had got in the middle and was clutching the necromancer by his robe and me by my cloak. While we were walking towards our homes in the Banchi, he kept crying out that two of the demons he had seen in the Colosseum were leaping along in front of us, on the roof-tops and along the ground.

The necromancer said that he had often entered magic circles but that he had never before witnessed anything on such a scale, and he tried to persuade me to join him in consecrating a book to the devil. He said it would make our fortunes, because we could ask the demons to show us the treasures of which the earth is full and so we would obtain great riches. He added that all that business about love was stupid and useless, and did not lead anywhere. I replied that I would be only too willing to do what he asked, if I knew any Latin.

He kept on trying to persuade me, all the same; and he said that a knowledge of Latin was not worth having, and that if he wanted he could have found plenty of people who knew Latin, but that he had never met anyone as resolute as I was, and that I would be wise to listen to his advice. We went on talking in this strain till we reached our homes; and all that night every one of us dreamed about devils.

We used to meet every day after that, and the necromancer kept insisting that I should join him in the undertaking he had mentioned. So in the end I asked him how long it would take and where we would have to go. He replied that it would all be over in less than a month, and that the most suitable place was in the mountains of Norcia.[110] In fact, he added, one of his teachers had consecrated a book at a place quite near, called the Badia di Farfa,[111] but he had run into some difficulties that we would avoid in the mountains. Besides this, he went on, the peasants around Norcia were trustworthy people with some

experience of the black art, so if there were any need they would be a wonderful help.

This necromancer priest was certainly tremendously persuasive, and I became more than ready to join him in his undertaking, but I told him that first I wanted to finish the medals I was making for the Pope. I had taken the priest, and no one else, into my confidence about the medals, and I begged him to keep the secret to himself. At the same time I kept on asking him if he believed that, at the time promised, I would find myself with my Sicilian girl, Angelica; and seeing that the time was drawing near I was astonished I had heard no news of her. He replied that I would certainly find myself where she was, because the demons never failed to keep a promise like the one they had made to me; but that I should keep my eyes open and be on guard against a possible accident. He added that I should force myself to put up with something that I would find hardly bearable, and that I would run a very great risk. It would be to my advantage, he said, if I went with him to consecrate the book, because that way the great danger would be avoided and it would bring both of us wonderful good fortune.

By now I was beginning to be more eager than he was himself. But I told him that a certain Giovanni da Castel Bolognese,[112] who was an expert at making medals of the sort that I went in for, in steel, had arrived in Rome, and that my only ambition was to compete with that artist and let my achievements take the world by storm. By showing my skill in this way and not by my sword, I added, I would slaughter all my enemies. But he kept on urging me.

'Please, Benvenuto, please,' he said, 'come with me, and escape the great danger I see threatening you.'

But, come what might, I was determined to finish my medal first. The end of the month was already drawing near, but I was so passionately in love with my medal that I forgot Angelica and everything of that sort, and was completely absorbed by my work.

One day, towards vespers, I had for some reason or other to make a journey from my house to the shop, outside my usual time. I had my shop in the Banchi, and my house was behind the Banchi. I only occasionally went along to the shop, as I left all the business in the

hands of my partner, Felice. Anyhow, after I had been there a little while I remembered that I had to go and have a few words with Alessandro del Bene. So I left at once, and then when I arrived in the Banchi I ran across a very great friend of mine called Ser Benedetto.

Benedetto was now a notary, but he had been born in Florence, the son of a blind Sienese beggar. He had lived for any number of years in Naples; and then he had moved to Rome where he transacted business matters for some Sienese merchants of the Chigi family. As it happened my partner had been at him a hundred and one times for some money that was owing for some rings Felice had entrusted to him; that very day, in fact, he had met him in the Banchi and demanded the money in his usual brusque manner while Benedetto was in the company of his employers. As a result, when they saw what was going on, they gave him a severe dressing-down and said that as they did not want any more wrangling they would make use of someone else's services.

He tried to defend himself as best he could, saying that he had paid the goldsmith and that it was too much to expect him to restrain the violence of madmen. The Sienese merchants were cut to the quick by his use of that word, and they immediately sent him packing. After he had left them he shot off towards my shop, probably with the idea of having his revenge on Felice. It so happened, then, that we ran into each other just in the middle of the Banchi. I knew nothing of what had been going on, so I greeted him affectionately, in my usual way. The only answer I received was an outburst of cursing. At this all the necromancer's warnings came back to me, so I restrained myself as best I could from doing what his words were driving me to, and I said:

'My dear Benedetto, you don't want to lose your temper with me. I've never done you any harm, and I know nothing about these affairs of yours. As for your business with Felice, go and have it out with him; he knows the right sort of answer to give you. But as I know nothing about all this don't do me wrong by insulting me in such a way, especially as you know that I'm not the kind of man to put up with abuse.'

At this he said that I knew all about it, and that he was the sort of man who would give me more to put up with than that, and that Felice and I were two great scoundrels.

By this time a crowd had gathered round to watch the contest. I was goaded on by his ugly insults, stooped down quickly to pick up a lump of mud (it had been raining) and in a flash let him have it straight in the face. He ducked, and as a result it landed on the top of his head. Hidden in the mud there was a chunk of hard rock with sharp edges; one of the corners struck him on the head and he fell down in a dead faint. Seeing how much he was bleeding, all the bystanders jumped to the conclusion that he was dead.

While he was still lying on the ground and some of them were preparing to carry him off, that jeweller Pompeo, whom I mentioned before, happened to pass by. The Pope had sent for him about some jewellery business. Pompeo saw what a bad way Benedetto was in and asked who had struck him. He was told: 'Benvenuto did – but the fool asked for it.'

As soon as Pompeo arrived in front of the Pope, he blurted out: 'Holy Father, Benvenuto has just this very moment murdered Tobbia – I saw it with my own eyes.'

Livid with rage, the Pope ordered the Governor, who happened to be in the room, to seize me and hang me on the spot where the murder was committed. He told him to leave no stone unturned, and not to come back till he had hanged me. Meanwhile, when I saw I had knocked the poor wretch down, I immediately thought of the predicament I was in, considering the power of my enemies and what such a thing could lead to. I ran off and took refuge with Giovanni Gaddi, a clerk of the Camera, with the idea of making preparations as quickly as I could to clear out of Rome.

Giovanni, however, advised me not to be in such a furious hurry to leave, and he added that perhaps things were not as bad as they looked. Then he sent for Annibal Caro, who lived with him, and told him to go and see how matters stood. While he was making these plans, a Roman gentleman appeared on the scene. He was a member of Cardinal de' Medici's household,[113] and it was the Cardinal who sent him along. He called Giovanni and me aside and then told us that the Cardinal had repeated to him what the Pope had said, that there was no way he could help me, and that I must do all I could to escape this first storm of anger. He added that I should not trust to safety in any house in

Rome. As soon as he had left, Giovanni stared me in the face, and then looked as if he was going to burst into tears.

'Oh, what a miserable wretch I am!' he said. 'There's no way I can help you at all.'

'With God's support, I shall help myself,' I answered. 'All I ask you for is the loan of one of your horses.'

There was a black Arab horse, the finest, most handsome animal in Rome, already saddled. I mounted it and slung a loaded flint arquebus across the saddle-bow, ready to defend myself. When I reached the Ponte Sisto I found the whole police guard waiting there, on horseback and on foot. However, I made a virtue of necessity, boldly spurred on my horse to a trot and, thanks to God, who averted their eyes, I passed safely through them. Then, as fast as I could, I rode off to a village called Palombara, belonging to Giovanbatista Savello, and there I sent the horse back to Giovanni, though without letting him learn where I was.

Signor Giovanbatista let me enjoy his hospitality for two days, and then advised me to leave Palombara and to make for Naples, till the storm had blown over. He gave me an escort and set me on the road. On the way, I ran into a sculptor friend of mine who was journeying to San Germano to finish the tomb of Piero de' Medici at Monte Cassino. He was called Solosmeo,[114] and he gave me the news that on that same evening Pope Clement had sent one of his chamberlains to find out what condition Tobbia was in. He found Tobbia working, nothing had happened to him, and he did not even know anything about what had occurred. When this was reported to the Pope he turned to Pompeo and said:

'You're a miserable scoundrel, but let me warn you that you've stirred up a serpent who will bite you as you deserve.'

Then he turned to Cardinal de' Medici and told him to take good care of me, as he would not like to lose me for the world. And meanwhile Solosmeo and I, singing as we went, were on the road to Monte Cassino; and then we were going to Naples.

After Solosmeo had seen to his business at Monte Cassino, we went together towards Naples. We were about half a mile from the town when we were met by an innkeeper who invited us to his inn. He

told us that he had lived in Florence for many years, with Carlo Ginori,[115] and that as we were Florentines if we went to his inn we would be treated very hospitably. We repeated several times that we had no wish to go with him but – riding one moment in front and the next behind – he said over and over again that he would like us to visit his inn.

This began to annoy me, so I asked him if he could give me any information about a certain Sicilian woman, named Beatrice, and her beautiful daughter, Angelica, who were both courtesans. Thinking that I was mocking him, the innkeeper shouted: 'God damn all courtesans – and all their friends!'

Then he dug in his spurs and rode off as if he was finished with us. I imagined I had rid myself of that nasty brute very neatly, but I was out of luck because the memory of my great love for Angelica flooded back, and while I was talking about this to Solosmeo and sighing like a lover, we saw the innkeeper galloping back to us at a furious pace.

When he reached us he cried out: 'Two or three days ago a woman and a young girl came to stay at a house near my inn, and they had the names you mentioned, but I don't know whether they are Sicilians or not.'

My reply to this was that the name Angelica meant so much to me that I was now determined to visit him. So we rode on with him into Naples and dismounted at his inn. I unpacked my things quickly – though it seemed to take an eternity – and then I went into the house next door, where I found my Angelica. She gave me an unimaginably passionate welcome. I stayed with her from about two hours before nightfall till the next morning, tasting greater pleasures than I had ever known before. And while I was enjoying myself so delightfully I remembered that the month expired that very day, as the demons in the necromancer's circle had promised me. So anyone who meddles with spirits should bear in mind what tremendous risks I ran.

I happened to find a diamond ring in my purse, and I showed it round the goldsmiths in Naples. Although I was a young man, even in Naples my reputation was so high that I was given a wonderful welcome. Among the others was a very highly-respected jeweller called Domenico

Fontana. During the three days I stayed in Naples this excellent fellow abandoned his workshop and never moved from my side. He showed me a good number of fine antiquities, both in and outside Naples, and what was more he took me along to pay my respects to the Viceroy,[116] who had let him know that he very much wanted to meet me.

When I was shown into his Excellency's presence he greeted me very courteously, and as he did so his eye fell on the diamond that I mentioned. He made me show it to him, and then he begged me if I had to dispose of it not to forget him. At this I took the diamond, and then I handed it back to him, saying that the jewel, like myself, was at his Excellency's service. In reply he said that he was very pleased with the diamond, but that he would be even more delighted if I were to stay with him, and that he would treat me so generously that I would be more than satisfied. We carried on our conversation very politely; but then we came to discuss what the diamond was worth, and his Excellency told me to state, without hesitating, what price I put on it. I said that it was worth exactly two hundred crowns.

His comment on this was that he thought I had hit the mark, but that since I had set the stone myself, and he knew I was the finest craftsman in the world, it would not be displayed to such advantage if someone else set it. I replied that in fact the jewel had not been set by me, that the job had been done badly, and that its wonderful appearance was the result of the diamond's own brilliance. If I were to re-set it, I added, I would improve it beyond measure. I put my nail to the edges of the diamond's facets and prised it out of the ring; then I gave it a quick polish and handed it to the Viceroy. He was astonished and delighted, and wrote me out an order for the two hundred crowns I had asked.

When I returned to my lodgings I found waiting for me some letters from Cardinal de' Medici. He said that I should go back to Rome without delay, and that instantly I arrived I was to dismount at his Eminence's palace. I read the letter out to Angelica, and she started crying and pleaded with me lovingly either to stay in Naples or else to take her with me. I replied that if she meant to come with me I would give her the two hundred ducats I had received from the Viceroy, and

she could look after them for me. Then her mother, seeing us with our heads close together, came up and said:

'Benvenuto, if you intend to lead my Angelica off to Rome, leave me fifteen ducats to pay for having the baby, and then I shall come as well.'

I told the old schemer that I would be only too glad to let her have thirty, if she would let me have my Angelica. So we struck a bargain. Then Angelica begged me to buy her a black velvet dress, as the material was cheap in Naples. I agreed to everything, sent for the velvet, and settled the account. Then the old woman, who thought I was green as well as infatuated, wanted an expensive dress made for herself, a number of things for her daughter, and much more money than I had offered her.

At all this, I turned to her with a smile and said: 'Beatrice, my dear, isn't what I offered enough?'

She said, no.

'Well then,' I went on, 'what is not enough for you is enough for me.'

Then I kissed Angelica, and we parted company – she in tears, and I with a laugh – and I set out for Rome straight away.

I left Naples at night, with the money on my person, in case I fell victim to the usual Neapolitan custom and was attacked and murdered. In fact when I reached Selciata I had to put up a skilful and vigorous defence against a band of horsemen who made a murderous onslaught on me.

A few days later, after I had left Solosmeo to see to his business at Monte Cassino, I arrived in the morning at the inn in Anagni and decided to have some food there. I had almost reached it when I shot and killed a few birds with my arquebus and tore my right hand on an iron splinter in the lock of the gun. It was not a very serious wound, but it looked very ugly because my hand was bleeding profusely. I entered the inn, stabled my horse, and went upstairs to a gallery where I found a large gathering of Neapolitan gentlemen who were just about to sit down at table. There was a charming young lady with them – one of the most beautiful I have ever seen.

As I walked up the stairs my fine young servant came after me with a great pole-axe in his hand. As a result, what with the district being

known as a den of murderers, the sight of two armed men and all that blood struck such terror into those poor fellows that they rose from the table, and, trembling with fear, called on God to help them. I immediately started laughing and called out that God had already helped them, because I was the sort of man who would defend them against any attacker. Then I asked them for some help in bandaging my hand, and that beautiful young lady took out her handkerchief, which was richly embroidered with gold, to bind the wound. I objected to this but she impetuously tore it in half, and very gently bandaged my wound with her own hand.

So they were somewhat reassured, and we had a very pleasant meal. After we had finished we mounted our horses and all rode off together. But the gentlemen were still rather suspicious, and so, very neatly, they got me talking to the lady while they rode along a little way in the rear. So I trotted along at her side on my fine little horse, and at the same time I made a sign to my servant to keep his distance. We had a very agreeable talk together, and it wasn't about things you can buy in a shop. So my journey back to Rome turned out to be one of the pleasantest I have ever had.

Once there, I dismounted at Cardinal de' Medici's palace, and when I found his Eminence I had a little chat with him and thanked him for having me brought back. Then I begged him to protect me against being imprisoned and if possible against being fined. He was overjoyed to see me, told me not to worry about anything, and then, turning to one of his attendants, who was a Sienese gentleman called Pierantonio Pecci,[117] said that he was to inform the chief constable from him that he must not dare lay hands on me. Next he asked him how the man I had hurled the stone at was getting on. Pierantonio said that he was very ill and would get even worse, as he knew that I was back in Rome and had sworn that he would die, just to get even with me. The Cardinal roared with laughter at this and said:

'He couldn't find a better way of making us quite sure that he was born in Siena.'

Then he turned to me and added: 'For the sake of both of us, be patient for four or five days, and don't show yourself in the Banchi. After that go wherever you like, and let fools die as they please.'

I went off home and set to work to finish the medal that I had already started,[118] showing Pope Clement's head on one side and an image of Peace on the reverse. I represented Peace by the small figure of a woman, dressed in very light clothes caught up by her girdle. In her hand she had a little torch, with which she was setting fire to a pile of weapons stacked together in the form of a trophy; you could also see the wall of a temple, where I showed the figure of Fury loaded with chains. Round this I had the words: *Clauduntur belli portae.*

While I was finishing this medal the fellow I had knocked down recovered, and the Pope never left off asking for me. Meanwhile I avoided going to see Cardinal de' Medici, since every time I went his Eminence gave me some important commission which hindered me from finishing the medal. So Pietro Carnesecchi,[119] who was a great favourite of the Pope, undertook to keep an eye on me; he told me, very tactfully, how much the Pope wanted my services. In reply to this I said that in a few days I would show his Holiness that I had never left his service.

A few days later, having finished the medal, I stamped three copies of it, in gold, silver, and copper. I showed the result to Pietro, and he at once took me to the Pope. It was after dinner, on a beautiful April day; and the Pope was in the Belvedere. When I came into the presence of his Holiness I handed him the medals and the steel dies. He took them from me, immediately recognized what brilliant craftsmanship they showed, looked Pietro straight in the face and said: 'They never had such medals in the ancient world.'

While he and the others were examining now the dies, and now the medals, I said very modestly:

'If it hadn't been for the fact that there was a greater power to prevent my hostile stars doing what they threatened so violently, your Holiness – not through any fault of yours or mine – would have lost a faithful and loving servant. So, your Holiness, no mistake can be made if, when we have to play a card once and for all, we follow the advice of poor simple men who say that we should mark seven times before cutting once. The wicked, lying tongue of my worst enemy easily talked your Holiness into such a rage that you ordered the Governor to seize and hang me straight away. But later, when you saw how unjust you had

been, and that you had done yourself wrong by depriving yourself of a servant of the kind you said I was, I certainly think that you would have felt not a little remorseful before God and man. Good patrons, like good fathers, should not let their arm fall so precipitately on their sons and servants, since it is no use feeling regret after it's too late. As God has frustrated the hostility of the stars and saved me for your Holiness, I beg you, another time, not to be so easily enraged against me.'

The Pope had stopped looking at the medals and he sat there listening to me very attentively. As there were a number of very high-ranking noblemen present he blushed slightly and seemed ashamed. Not seeing any other way of escaping from his confusion, he said that he did not remember ever having given such an order. When I realized how embarrassed he was I began talking about other things in order to rescue him from his perplexity.

Then his Holiness began to talk about the medals, and he asked me how, seeing their size, I had managed to stamp them so splendidly; he added that he had never come across any antique medals that were as large as them. We talked about this for a while, and, because of his fear that I might give him another lecture harsher than the first, he said that the medals were exquisitely beautiful and that he was delighted with them. He added that if it were possible to make another reverse for such a medal he would like one done according to an idea of his own. I said that it could be done. Then his Holiness commissioned me to make a design for the reverse, showing Moses striking the rock, and the water gushing from it, and, written above, the words: *Ut bibat populus*.

Then he added: 'Go off now, Benvenuto, and before it's finished I shall see to all your wants.'

After I had left, the Pope started boasting in front of everyone that he would be so generous towards me that I would be able to live in luxury, without ever needing to work for anyone else. I gave all my time to finishing the reverse.

But meanwhile the Pope fell ill; and as his doctors decided that it might well prove fatal, that enemy of mine, frightened of what would happen, paid some Neapolitan to do to me what he feared I was going

to do to him. So I was hard put to it to defend my own poor life. All the same, I carried on and finished the reverse. When I took it to the Pope I found him in bed, at a very low ebb. Still, he welcomed me affectionately and wanted to see the medals and the dies. He sent for his spectacles and for some lights, but he was unable to distinguish anything. He began feeling my work with his fingers, then, after doing this for a little while, he sighed deeply and said he was very concerned about me, but that if God restored his health he would settle everything.

Three days later the Pope died;[120] and there I was with all my efforts wasted. But I cheered up and told myself that my medals had brought me such a high reputation that whoever became Pope would want my services, and perhaps would reward me better. In that way I reassured myself, and I let all the great injuries that Pompeo had done me go clean out of my mind. Then I put on all my armour, took my sword and went along to St Peter's where – not without tears – I kissed the dead Pope's feet. After that I returned to the Banchi to have a look at the great disorder that always reigns on such occasions. And while I was sitting in the Banchi, along with a crowd of friends, Pompeo happened to walk past. He was surrounded by ten heavily-armed men, and when he came opposite where I was he stopped and gave the impression that he wanted to pick a quarrel with me.

The friends I had with me – bold, dashing young men – made signs to me to draw my sword, but my immediate thought was that if I did so people who had nothing at all to do with the matter might suffer terribly. So I decided that it would be better if only I risked my life. After Pompeo had been standing there for the length of time it takes to say two Hail Marys he laughed scornfully in my direction, and then, all laughing together, he and his companions made off, snapping their fingers at me and provoking me with their insolent gestures.

My friends wanted me to make a fight of it, but I said with some heat that I knew how to deal with my own feuds and I could fight well enough by myself, so they could all mind their own business. They were annoyed at this and left me in a huff. Among them was my very dear friend Albertaccio del Bene,[121] a brother of Alessandro, and of

Albizzo who is now a very rich man in Lyons. This Albertaccio was the most admirable young man I have ever known, and he was certainly the bravest. He loved me as much as himself; and as he realized well enough that my patient attitude did not result from cowardice but from some extraordinary daring – for he knew my character thoroughly – he took me up on what I had said and begged me to let him in on whatever I intended to do.

I replied to him: 'My dear Albertaccio, I'm fonder of you than I am of all the others, and the time will certainly come when you can help me. But in this matter, if you return my affection, leave me alone and mind your own business, and get away from here quickly like the others, because there's no time to lose.'

I said all this in a rush.

Meanwhile those enemies of mine had walked slowly off towards the Chiavica, as the place was called, and had arrived at a crossroads. The streets went off in various directions, but the street where my enemy Pompeo lived led straight to the Campo di Fiore. For some reason Pompeo had gone into the chemist's shop at the corner of the Chiavica, and he stayed there a little while transacting his business. In the meantime I was told that he was going around boasting of the bold way he thought he had defied me. At all events it turned out badly for him, because just as I arrived at the corner, he left the chemist's, his hired ruffians made way for him and closed round him.

I grasped my little sharp-edged dagger, forced my way through his guards, and put my hands on his chest so coolly and swiftly that none of them could stop me. I aimed to let him have it in the face, but he was so terrified that he turned his head and my dagger struck him just under the ear. I followed this up with only two stabs more, for at the second he fell dead;[122] not that that had been my intention, but, as they say, there are no rules in war. Then I retrieved the dagger with my left hand, while with my right I drew my sword to defend my life. At this all those ruffians crowded round the dead body, and did not so much as make a move against me.

So I went off alone along the Strada Julia, wondering where I would be safest. I had walked about three hundred paces, when my very good friend Piloto, the goldsmith, came up to me and said:

'My friend, now that the harm's done we must think about your safety.'

I replied: 'Let's go along to Albertaccio del Bene's house – only a little while ago I was telling him that the time would soon come when I would need his help.'

When we arrived there I was given a tremendously enthusiastic welcome and very quickly all the best young men of the Banchi, of every city except Milan, flocked round; and they all offered their own lives in defence of mine. Luigi Rucellai[123] as well, with remarkable generosity, sent round to offer me anything of his that I might need, and the same was done by many other fine men like him. Then they all blessed my hands, maintaining that Pompeo had insulted me intolerably and wondering why I had stood it so long.

Meanwhile Cardinal Cornaro[124] found out what had happened and on his own initiative sent round thirty soldiers, with as many halberdiers, pikemen, and gunners, to escort me to him with every mark of respect. I agreed to go, and I walked along accompanied by the soldiers and by more than as many of those young men of mine. While this was going on, Traiano,[125] who was related to Pompeo and was the head Papal chamberlain, sent an important Milanese nobleman to tell Cardinal de' Medici of the great crime I had committed and to say that his Eminence was bound to punish me.

The Cardinal retorted: 'He would have committed a great crime not to have committed this petty one. Thank Messer Traiano on my behalf for informing me of something I didn't know.'

Then, while that Milanese gentleman was still present, he turned to the Bishop of Forlì,[126] one of his intimate attendants, and said:

'Make a thorough search for Benvenuto and bring him here, because I intend to help and protect him – whoever interferes with him, interferes with me.'

The Milanese flushed deeply, and made off; and then the Bishop of Forlì came and found me with Cardinal Cornaro. When he arrived he reported that Cardinal de' Medici had sent for Benvenuto as he wanted to be the one to protect him. Cardinal Cornaro, who was as irritable as a bear with a sore head, replied that he was just as capable of protecting me as Cardinal de' Medici. At this the Bishop asked if he might have

a word with me about another matter that had to do with some business of the Cardinal's. Cardinal Cornaro retorted that, as far as that day was concerned, he must reckon that he had already spoken to me. Cardinal de' Medici was highly indignant at this, but the following night – without Cornaro's knowing – I went along with a fair-sized escort and paid him a visit. I begged him to be kind enough to let me stay with Cornaro. I told him how hospitably I had been treated, and added that if his Eminence let me remain with Cornaro I would have yet one more friend in my troubles, but that in any case his Eminence might do with me just what he pleased. He replied that I should do whatever I thought best. So I returned to Cornaro's palace; and a few days later Cardinal Farnese was made Pope.[127]

As soon as the most important things had been seen to, the Pope sent for me, saying that he did not want anyone but me to design his coins. Hearing this, a nobleman called Latino Juvinale,[128] who was very intimate with the Pope, said that I was in hiding because of a murder I had committed on the person of a Milanese called Pompeo, and then he went on to give all the reasons he could to justify me.

The Pope answered: 'I know nothing about Pompeo's death, but plenty of the arguments used to justify Benvenuto. Make him out a safe-conduct then, so that he can be absolutely secure.'

There was a Milanese present, called Messer Ambrogio,[129] who was a friend of Pompeo, and also very close to the Pope.

He said: 'It would be very unwise to grant pardons of this kind in the first days of your Papacy.'

The Pope turned to him and replied: 'You don't understand the matter as much as I do. Men like Benvenuto, who are unique as far as their art is concerned, are not to be subjected to the law – especially not him, for I know what good cause he had.'

So my safe-conduct was made out,[130] and I began to serve the Pope at once and was treated with great favour.

The Latino Juvinale whom I mentioned sought me out and com-missioned me to make the Pope's coinage. This provoked all my enemies, and they began trying to obstruct me. When the Pope heard of this he gave them a thorough dressing-down and insisted that I was to do it. I then began to make the dies for the crown pieces, designing

them with a figure of St Paul and an inscription which ran: *Vas electionis*.[131] This coin made a far greater impression on the Pope than did anything my competitors produced, and as a result the Pope said that no one was to talk to him about the coins again, since he was determined that I, and no one else, should be responsible for them. So with this encouragement I set to work; and Latino Juvinale was given the duty of arranging my audience with his Holiness. I wanted to recover my post of die-stamper at the Mint, but the Pope let himself be advised on this matter, and told me that I must first be pardoned for the murder, and that I should obtain my pardon on Our Lady's feast day in August, through the district officers. The reason for this was that every year on this solemn feast day it is the custom to grant these officials the freedom of twelve outlaws. Meanwhile, he said, he would make me out another safe-conduct which would protect me till then.

When my enemies saw that there was no way they could prevent my getting the Mint they hit on another expedient. The dead Pompeo had left three hundred ducats to his bastard daughter for her dowry. They arranged it so that a certain favourite of Signor Pier Luigi,[132] the Pope's son, should use his master's help to ask for her as his wife. And this was done. This favourite was a young peasant who had been brought up by Pier Luigi, and it was said that he saw very little of the money, which was grabbed by Pier Luigi who meant to use it himself. Anyhow in order to please his wife the girl's husband kept begging his master to have me arrested. In fact Pier Luigi promised to do so as soon as he reckoned that the Pope felt less favourably towards me. The matter rested at this for about two months, and then when the servant tried to get his hands on the dowry Pier Luigi evaded the issue, but he assured the man's wife that whatever happened he would revenge her father. Although I had got wind of what was going on I frequently presented myself to Pier Luigi, and he pretended to regard me very highly. Meanwhile, he had made up his mind to do one of two things: either to have me murdered, or to have me arrested by the chief constable.

He commissioned a little devil of a Corsican soldier to arrange matters as neatly as he could; and at the same time my other enemies – led by Traiano – had promised the little Corsican a reward of a hundred

crowns. He said that he could do the job as easily as sucking a fresh egg. I knew all about this and went around with my eyes skinned, with a good escort and wearing a mail coat and armlets, for which I had official permission. The Corsican, who was greedy to get all that money without running any risk, imagined he could do the work by himself.

So one day, after dinner, he had me sent for on behalf of Signor Pier Luigi, and I set off at once, because he had in fact been talking to me about commissioning some large silver vases. I left home in a hurry, though as usual I was well armed, and I strode along Strada Julia not expecting to meet anyone at that time of day. I had reached the end of the street, and was turning towards the Farnese palace – giving the corner a wide berth as usual – when I saw the Corsican stand up and walk into the middle of the road. I was completely unruffled and merely prepared to defend myself, slowing down a little and moving nearer to the wall in order to give him plenty of room. At this, he did the same. We were already quite close to each other, and I saw from his attitude that he intended to do me some harm, and that, as I was alone, he reckoned he had as good as succeeded. I began to talk to him.

'My brave fellow,' I said, 'if it were night-time you could say that you'd mistaken me for someone else, but as it's still daylight you must know quite well who I am. I've never had anything to do with you, and I've never done you any harm; but I shall be only too ready to oblige you.'

In reply to this, he still blocked my path, struck up a threatening attitude, and said that he did not know what I was talking about.

Then I went on: 'I know perfectly well what it is you're after and what you're talking about, but the job you've taken on is more difficult and dangerous than you think, and you may find the tables turned on you. Remember, you're dealing with a man who'd take on a hundred attackers. This isn't at all the sort of enterprise for a brave man like you.'

Meanwhile I too began to look aggressive, and we both changed colour. While this was going on a crowd had gathered round, since they realized that our words meant bloodshed. As a result he could not pluck up the courage to lay hands on me, and he said: 'We shall meet again.'

I replied: 'I'm always ready to meet men who are worth while, or who seem it.'

Then I walked away and made for Pier Luigi's house, only to find that he had not sent for me. When I arrived back at my shop the Corsican sent word through a close mutual friend that I had no need to guard against him any more as he wanted to act like a comrade to me, but that I should be on the look-out against others, since I was in great danger and some very prominent men had sworn to have me killed. I sent back my thanks, and then I took as many precautions as I could. Not many days later I was informed by a friend of mine that Pier Luigi had given definite orders that I was to be arrested that very evening. I heard this news a few hours before nightfall and talked it over with some of my friends, who advised me to make my escape at once. As the order was to be carried out an hour after sunset, an hour before sunset I rode off with the post train towards Florence. What had happened was that when the Corsican showed he lacked the courage to do what he had promised, Pier Luigi, on his own authority and merely to appease Pompeo's daughter who kept wanting to know where her dowry had gone to, gave orders for my arrest. When he failed to satisfy her by taking revenge on me in either of the two ways he had planned he hit on yet another, which I shall tell about when the time comes.

After I had arrived in Florence I had an audience with Duke Alessandro who welcomed me with extraordinary warmth and tried to persuade me to stay with him. But meanwhile I had run into a sculptor who lived in Florence and who was an old crony of mine, since I had stood as godfather to his son. He was called Tribolo.[133] I was having a chat with him when he told me that his first master, Jacopo del Sansovino,[134] had sent for him to join him, and as he had never seen Venice and expected to make a good profit he was very eager to go there. Then he asked me if I had ever seen Venice, and I said, no. At this he begged me to go along with him, and I promised that I would.

So my reply to Duke Alessandro was that first I wanted to visit Venice, and afterwards I would be only too pleased to return to his service. He insisted on my promising to do so, and he ordered me to

have a talk with him before I left. The next day, having made all my preparations, I went to take leave of the Duke, and I found him in the Pazzi Palace, where at that time the wife and daughters of Signor Lorenzo Cibo[135] were living. I sent word to his Excellency that, with his gracious permission, I wanted to set out for Venice, and a reply was brought to me by the young lord Cosimo de' Medici (today, Duke of Florence). He told me that I was to go and find Niccolò da Monte Aguto, who would give me fifty gold crowns which his Excellency presented to me as a sign of his love.

After I had enjoyed myself I was to come back and work for him.

I received the money from Niccolò and then I went in search of Tribolo, who was ready and waiting. He asked me if I had bound up my sword. I told him that anyone setting out on a journey on horseback shouldn't do such a thing. Then he said that it was the custom in Florence, because there was in office a certain Ser Maurizio[136] who, for the merest trifle, would have whipped St John the Baptist himself; so one had to carry one's sword bound up till outside the gates. I roared with laughter at all this, and then we set off. We joined up with the courier to Venice, who was known as Lamentone, and in his company we travelled past Bologna to arrive one evening at Ferrara. There we found lodgings in an inn by the piazza and Lamentone went off to find some of the exiles, as he had some letters and messages from their wives. It was with the consent of the Duke that the courier might speak with them, but no one else, under the penalty of the same banishment as theirs.

Meanwhile, as there were still nearly two hours before nightfall, Tribolo and I set out to see the Duke of Ferrara returning from Belfiore,[137] where he had been watching the jousting. On the route we ran into a large number of exiled Florentines who stared hard at us, as if trying to force us to talk to them. Tribolo, who was the most timid man I've known, kept on saying: 'Don't look at them, and don't say a word to them – if you want to return to Florence.'

We waited to see the Duke come back, and then we returned to the inn where we found Lamentone. About an hour after sunset, Niccolò Benintendi,[138] his brother Piero, and another old man who I believe was Jacopo Nardi,[139] as well as several young men, appeared on the

scene. Straight away they all began to ask the courier for news about their relations in Florence. Tribolo and I kept our distance so that we could avoid talking to them. After they had been chatting for a while with Lamentone, Niccolò Benintendi said:

'I know those two fellows very well – why're they shitting themselves rather than speak to us?'

Tribolo, all the same, told me to keep quiet. Then Lamentone said to them that, unlike him, we had not been given permission. Benintendi replied that that was all bosh, and that we could go and rot for all he cared, and added other pretty things of that sort.

At this with all the gentleness I could command I raised my head and said:

'Gentlemen, you can do us a great deal of harm, but we can't give you any help, and though you've been talking about us very rudely even that won't make us lose our temper with you.'

The old fellow Nardi said that I had spoken like the fine young man I was. But Niccolò Benintendi broke in:

'They and their Duke can kiss my arse!'

I replied that he was mistaken about us and that we had nothing to do with his affairs. Then old Nardi took our part and told Benintendi that he was in the wrong; but he still continued insulting us. So I told him that I would say and do something to him that he would find very disagreeable, and that he should mind his own business and leave us alone. He repeated that we and the Duke could kiss his arse, and added that we were all a pack of asses. So then I threw the insult back at him, and drew my sword.

The old man, who wanted to get downstairs first, tripped over at the top, and they all piled on top of him. I dashed forward scraping my sword viciously along the wall, and shouting, 'I'll kill the lot of you.'

But I was careful not to hurt any of them, though it would have been only too easy. In the middle of all this commotion, the innkeeper started shouting, Lamentone cried out: 'Don't do it!', some of them were screaming: 'Help! Murder!' and the rest: 'Let's get out of here!' They were all in a wonderful muddle and looked just like a herd of swine. Then the innkeeper came along with a light, and I went back upstairs and sheathed my sword.

Lamentone started grumbling at Niccolò Benintendi because of the bad way he had behaved, while the innkeeper said to him:

'It's as much as your life is worth to draw a sword here, and if the Duke heard of your audacity he'd have you hanged. I won't do what you deserve, but if you show yourself in this inn again it'll be worse for you.'

Then he came up to me and refused to hear of it when I tried to make excuses for myself; he insisted that he understood perfectly well how intolerably I had been provoked, and he warned me to be on my guard against them on the journey.

After we had finished supper a boatman came in to take us on to Venice; I asked him if we could have the boat to ourselves, and when he agreed we struck a bargain. Next morning, good and early, we mounted our horses and set out for the landing-stage, which is a few miles or so from Ferrara. When we arrived there we found Niccolò Benintendi's brother and three others lying in wait for me. They were carrying two lances, while I was armed with a good pike that I had bought in Ferrara. As I was also well armed I was not the least bit scared – unlike Tribolo who began crying: 'God help us! They've come to kill us.'

Lamentone turned to me and said: 'The best thing for you to do is to go back to Ferrara. This looks dangerous. Please, Benvenuto, they're just like mad beasts – don't provoke their anger.'

I replied: 'Let's go on. God helps those who are in the right, and anyhow, you shall see how I can help myself. Isn't this the boat we hired?'

'Yes,' said Lamentone.

'Then, if I have anything to do with it, we shall get on it in spite of them.'

I spurred on my horse, and when I was within fifty paces of them I dismounted and walked boldly forward holding my pike. Tribolo had stayed behind, huddled on his horse as if he had been frozen, and Lamentone, the courier, was puffing and blowing like the wind itself. That was his usual habit, but he was doing it more than ever now, while he waited to see what the upshot of this devilish business would be. When I reached the boat the boatman came up to me and

said that those Florentine gentlemen wanted to join us in it, if I was willing.

I replied: 'The boat was hired for us and for no one else, and I'm heartbroken that I can't have their company.'

At this an arrogant young man of the Magalotti family said:

'Benvenuto, we'll make it possible for you to do so.'

I answered: 'If God, and the right that's on my side, and my own strength have anything to do with it, you'll do nothing of the kind.'

And as I said this I jumped into the boat. Then I pointed my pike at them and shouted:

'This'll prove to you how impossible it is.'

The young Magalotti, wanting to put up some sort of show, gripped his weapon and marched forward. I leapt on to the side of the boat and landed him such a thrust that if he had not fallen backwards I would have run him through. His friends, far from coming to his help began to move away.

I saw that I could kill him, but instead of attacking I said: 'Get up, my friend, take your weapons and go away. You can now see clearly enough that I can't be forced to do what I don't want to do, and that what I could have done, I didn't want to.'

Then I called Tribolo, and the boatman, and Lamentone; and we set off for Venice. We had gone ten miles along the Po when the young men, who had climbed on to a skiff, caught us up. As they drew level that fool Piero Benintendi said:

'Go on your way now, Benvenuto, but we'll meet again in Venice.'

'Hurry up then,' I called back, 'I'm going there, and I'm ready to meet you at any time.'

So we arrived at Venice. I went to ask advice from a brother of Cardinal Cornaro, and I asked him if I might carry arms. He told me that I might certainly do so, as the worst thing that could happen to me would be to lose my sword.

So, with weapons in our hands, we went to visit the sculptor, Jacopo del Sansovino, who had sent for Tribolo. He gave me a warm welcome and asked us to stay for dinner, which we did. While he was talking to Tribolo he told him that he had no use for his services just then, but

that he should come back some other time. At this I burst out laughing and said to Sansovino, with a smile:

'Your houses are somewhat too far apart if he has to come back some other time.'

Poor Tribolo, who was dumbfounded, managed to say:

'I've got your letter on me – the one you wrote telling me to come.'

Sansovino's reply to this was that outstanding artists of the kind that he was could do things of that sort, and more. Tribolo shrugged his shoulders and kept murmuring: 'Patience, patience.'

Despite the excellent dinner that Sansovino had given me this made me take Tribolo's part. He was clearly in the right, and at the same time all through the meal Sansovino never once stopped boasting about his great achievements, running down Michelangelo and all other sculptors, and praising himself beyond belief. This began to annoy me so much that I felt sick with every mouthful I took.

However I merely commented briefly: 'Messer Jacopo, outstanding artists act as such, and brilliant men who create good and beautiful works of art are shown in a much better light when others praise them than when they praise themselves so confidently.'

At this we all rose from the table, fuming with anger.

That very same day I was walking near the Rialto when I came across Piero Benintendi, who was with several others. I knew that they were out to do me some harm, so I slipped into a chemist's shop to wait till the storm had blown over. Afterwards I heard that the young Magalotti, whom I had treated with such courtesy, had given them a severe dressing-down; and so that business was settled.

A few days later we set off back towards Florence. On the way we happened to stay at a place on this side of Chioggia, on the left as you go towards Ferrara. The innkeeper wanted to be paid in his own way before we went to bed, and when I said that in other places it was usual to pay in the morning, he answered: 'But I want to be paid this evening, and in my own way.'

In reply to this I said that men who wanted to be paid to suit themselves had better make a world to suit themselves, since it was done differently in this world. The landlord answered that I should not go on tormenting him, because he was determined to do it the way he

wanted. Tribolo was shaking with fear and nudged me to keep quiet in case worse should happen; so we paid up in the way that was wanted and then went to bed.

We were provided with beautifully comfortable beds, with everything new and spotlessly clean. All the same I didn't sleep all night with thinking up what I could do to get my own back. One moment I planned to set his house on fire, and the next, to slit the throats of the four good horses that he had in his stable. I saw that it would be easy enough to do this, but I did not see how that would ensure the safety of myself and my friend. Finally what I did was to put Tribolo's and my own belongings into the boat; then, after the tow-ropes had been attached to the horses, I said that they were not to move the boat till I came back, as I had left a pair of slippers in the bedroom. I went back to the inn and called for the landlord, who said that he would have nothing to do with us and that we could go and stew in a brothel. Standing near me, half-asleep, there was a young lout of a stable-boy who said: 'The landlord wouldn't move a finger for the Pope – he's got a tart in bed with him that he's been after for a long time.'

Then he asked me for a tip, and I gave him a few of those small Venetian coins and told him to tell the man with the tow-rope to hang on a little till I found my slippers and came back. Then I went upstairs, got a sharp little knife, and used it to cut the four beds that were there into shreds; I reckoned that I had done more than fifty crowns' worth of damage.

I went back to the boat, with some strips from the bed-covers in my pocket, and hurriedly told the man on the tow-rope to move off at once. We had travelled a little way from the inn when my crony Tribolo said that he had left some of the little straps for his case behind and that he must certainly go back for them. I told him not to worry about a couple of little straps because I could make him some pretty big cracks on the spot.[140] He said that I was always having a joke, but that he had to go back for his straps whatever happened. He began ordering the man who was on the tow-rope to stop, while I told him to go on; and at the same time I explained to Tribolo the damage I had done, and showed him a few sample pieces of the bed-covers and the other stuff.

This threw him into such a panic that he never left off shouting to the fellow: 'Get a move on, get a move on quickly.'

He refused to believe that we were out of danger till we had arrived at the gates of Florence.

As soon as we were there Tribolo said: 'For God's sake, let's bind up our swords – and no more mischief. I've had shakings in my belly all the time I've been with you.'

'My dear old Tribolo,' I replied, 'there's no need for you to bind up your sword since you've never drawn it.'

I said this to him on the spur of the moment, since I had not seen him act once like a man on the whole journey.

At this he looked down at his sword and said: 'By God, you're right! It's still tied up as it was when I fixed it before leaving home.'

My friend thought I had made a poor companion, because I had stuck up for myself and defended myself against people who would have done us harm; and for my part, I thought he had behaved far worse in not coming to my help when I was in difficulties. The impartial observer can judge for himself.

As soon as I had dismounted I went off to find Duke Alessandro. I expressed my deep gratitude for the present of fifty crowns and told his Excellency that I was more than eager to serve him in anything I was capable of. He immediately commissioned me to make the dies for his coinage; and the first I made was a coin worth forty soldi,[141] with the head of his Excellency on one side and the figures of St Cosmas and St Damian on the reverse. They were silver coins, and they were so pleasing that the Duke went so far as to say that they were the finest coins in Christendom. And that was also what the whole of Florence and everyone who saw them thought. As a result I begged his Excellency to make me an allowance and to give me the rooms at the Mint. He told me to keep on working for him, and that he would let me have far more than I asked; meanwhile, he said that he had given instructions to the Master of the Mint – a certain Carlo Acciaiuoli – and that I was to go to him for all the money I wanted. I found that he had in fact done so, though I drew money so sparingly that, according to my account, I always kept in credit.

Next I went on to make the dies for the giulio; the design showed

St John, in profile, sitting down with a book in his hand; and in my opinion I had never done anything so well. On the other side were the arms of Duke Alessandro. After this I made the dies for the half-giulio, showing the young St John in full-face. This was the first coin ever made with the head full-face on so fine a piece of silver; only experts in the art can see how difficult it is. Finally I made the dies for the gold crowns; these were designed with a cross and some little cherubim on one side, and his Excellency's arms on the other.

When I had finished these four kinds I begged his Excellency to decide on my allowance and to give me over the rooms, if he was satisfied with what I was doing. In reply his Excellency said, very kindly, that he was very pleased with me and that he would have the matter arranged. While I was talking to him he was in his wardrobe, and he was examining a splendid little gun that had been sent him from Germany; seeing that I was eyeing it very intently, he put the beautiful instrument in my hand, saying that he knew very well how much pleasure I took in such things, and that, as a pledge of what he had promised, I might choose from his wardrobe any arquebus that took my fancy, except that one. He added that he knew there were many even more beautifully made, and as good. I accepted his offer and thanked him; and when he saw me looking round the room, he ordered his Master of the Wardrobe, a certain Pretino da Lucca, to let me take whatever I liked. Then after a few very affectionate words he went away. I stayed behind, chose the best and finest-looking arquebus I had ever seen or possessed, and carried it home.

Two days later I took his Excellency the little designs for some works of art in gold that he wanted me to make; he intended to send them as a present to his wife, who was still in Naples.[142] I asked him once again if he would hurry up the arrangements for what he had promised me, but his Excellency said that first he wanted me to make the dies for a fine portrait of himself, such as I had done for Pope Clement. I began the portrait in wax, and the Duke commanded that whenever I came along to work on it I should always be shown straight in. Realizing that the job would take some time, I sent for a certain Pietro Pagolo[143] from Monte Ritondo, near Rome, who had been with me in Rome from boyhood. I discovered that he was with a goldsmith by the name

of Bernardonaccio,[144] who was not treating him very well. So I took him away from there, and gave him expert training in how to strike coins from the dies. Meanwhile I was busy on the Duke's portrait. Quite a few times I found him having an after-dinner nap all alone with that Lorenzo of his,[145] who afterwards murdered him. I was astonished that a Duke should trust a man like that.

It happened that Ottaviano de' Medici,[146] who seemed to be in command of everything, wanted, against the Duke's will, to advance the old Master of the Mint who was called Bastiano Cennini.[147] He was an outmoded craftsman who had very little skill, and in the dies for the crown pieces he had mixed up some of his clumsy tools with mine. I complained of this to the Duke, and when he realized that I was in the right he became very annoyed and said: 'Go and tell this to Ottaviano de' Medici and show him what has been done.'

I went off at once and pointed out to him the damage that had been done to my beautiful coins. He answered like the ass he was: 'That's the way we want it.'

I replied that that was not the way it ought to be, and that it was not how I wanted it.

He said: 'And if the Duke wants it so?'

I answered: 'It would still not please me – such a thing is unfair and unreasonable.'

He told me to get out and said that I should have to swallow it, even if I choked. I went back to the Duke, reported the unpleasant argument between Ottaviano and myself, and begged his Excellency not to allow the fine coins I had made for him to be injured. Then I asked his permission to leave.

The Duke said: 'Ottaviano is going too far. You shall have what you want, as the harm done affects me as well.'

That very same day – a Thursday – an unrestricted safe-conduct arrived from the Pope in Rome, together with the order that I was to go at once to receive the pardon of Our Lady's mid-August feast day, in order to free myself from the charge of murder. I went to find the Duke and discovered him in bed; they told me he had been enjoying a debauch. In just over two hours I put the finishing touches to the wax medal, and when I showed him the completed work he was

delighted. Then I showed his Excellency the safe-conduct that the Pope had ordered to be sent to me, and added that his Holiness had recalled me to do some work for him. By this, I continued, I would regain my place in the fine city of Rome, but I would also carry on with his medal.

Half in anger the Duke replied: 'Benvenuto, do what pleases me and stay here. I shall arrange your allowance, give you the rooms in the Mint, and do much more for you than you would ever ask for, since you only ask what is right and reasonable. And who do you imagine would be able to look after the beautiful dies you've made for me?'

Then I said: 'My lord, everything has been thought of. I have one of my pupils here, a young Roman whom I've instructed and who will serve your Excellency admirably till I come back with the finished medal, ready to serve you for ever. I have a shop open in Rome, with workmen and a flourishing business; and as soon as I have received my pardon I shall leave all my affairs in Rome to an apprentice of mine who is there, and then, with your Excellency's kind permission, come back to you.'

The only other person present at this interview was the Lorenzo de' Medici I mentioned above; several times the Duke made signs that he too should encourage me to stay, but all that he would say was: 'Benvenuto, you would do better to remain here.'

When I said that I was determined to regain my place in Rome no matter what happened, he kept quiet, and stood there staring all the time malignantly at the Duke.

After I had finished the medal the way I wanted it, I closed it up in its little box and said to the Duke:

'My lord, you have no need to worry. I'll make you a much finer medal than the one I made Pope Clement. It stands to reason that I should make it better, as his was the first I ever attempted. Messer Lorenzo here, as a very learned and intelligent man, will provide me with some beautiful design for the reverse.'

Lorenzo immediately replied: 'All that I have been thinking about was how to provide you with a reverse worthy of his Excellency.'

The Duke smiled ironically, looked at Lorenzo, and said: 'Lorenzo,

you will provide the reverse, and he will execute it here, and not leave Florence.'

Lorenzo at once replied: 'I shall do it as quickly as I can, and I have hopes of accomplishing something that will astonish the whole world.'

The Duke, who sometimes regarded him as a silly idiot, and sometimes as a coward, turned over in bed and burst out laughing at what he had said. I went out without any more ceremony and left them alone together. The Duke, who did not believe that I would go, said nothing more to me. Later when he heard that I had left he sent after me one of his servants who caught me up at Siena and gave me fifty gold ducats with a message from the Duke that I was to take them with his love and come back as soon as I could, and 'from Messer Lorenzo I have to tell you that he is getting ready to provide you with a wonderful reverse for the medal you want to make'.[148]

I had left Pietro Pagolo, the Roman mentioned above, with full instructions how to use the dies; but as it was a tricky business he was never very successful. I remained in credit with the Mint, for having made the dies, to the extent of more than seventy crowns.

When I set out for Rome I took with me that handsome flint arquebus that the Duke had given me, and a number of times on the journey I was able to make very enjoyable use of it. In fact I worked wonders with it. On my arrival at Rome,[149] as my little place in the Strada Julia was not ready for me, I dismounted at Giovanni Gaddi's house. Before I left Rome I had asked Gaddi, who worked as a clerk at the Camera, to look after a large number of beautiful weapons and other possessions that I valued very highly. I decided not to go to the shop myself, but instead sent for my partner, Felice, and got him to put everything in my little house in good order straight away.

The next day, in order to prepare the clothes and other things that I needed, I went to sleep there, because the following morning I intended to call on the Pope and give him my thanks for what he had done. At that time I had two young servant boys and, living below the shop, a laundress who used to cook deliciously for me.

In the evening I asked a few friends in to supper, and after we had enjoyed a few wonderfully pleasant hours I went off to bed. The night was hardly gone – in fact it was still an hour before dawn – when I

heard a tremendous beating at the door, one knock following hard on the other. I called the elder servant, Cencio (the one I had introduced to necromancy) and told him to go and see who was the idiot knocking so rudely at that time of night. While he was doing this I lit another lamp in addition to the one I always have going at night, hurriedly put on a splendid coat of mail over my shirt and, on top of that, a few old clothes that I picked up at random.

When Cencio came back he cried out: 'Oh dear, sir, it's the chief constable with the patrol, and he says that if you don't open up at once he'll have the door down. They're carrying torches and heaven knows what else!'

'Tell them,' I said, 'that I'm just putting a few clothes on and shall be out in a minute.'

Imagining that this was a trap to murder me, like the one that Pier Luigi had set before, I grasped a splendid dagger in my right hand and the safe-conduct in my left. Then I ran to the back window, which looked out on some gardens, peered down, and saw below me more than thirty policemen. I realized that it would be no good trying to run away from that side of the house, so I made the two lads stand in front of me and told them to open the door when I gave the word. Then I stood ready, in a defensive attitude, with the dagger and safe-conduct in my hands, and said to the boys:

'Now don't be afraid – open the door!'

Like a flash, Vittorio the chief constable rushed in, with two others at his heels. He must have thought it would be easy to hold me fast, but when they saw how I was prepared they fell back and cried out: 'This is more than a joking matter!'

At that, I tossed the safe-conduct to them and told them to read it.

'And you shan't even touch me,' I shouted, 'let alone arrest me.'

Vittorio ordered some of them to catch hold of me and not worry about the safe-conduct till later. But in reply to this I thrust my dagger forward and cried:

'God will see justice done! If I don't get away, you'll arrest a corpse.'

The room was crowded with them. They made signs as if to take me forcibly, and I showed I was ready to fight. So in the end the chief constable realized that I meant what I said. He sent for his clerk and

had the safe-conduct read out, making a move as if to seize me two or three times – but I didn't relax once. Eventually they abandoned the attempt, threw the safe-conduct on the floor, and went off without me.

I went back to bed, but felt so upset that I couldn't drop off to sleep again. As soon as morning came I meant to have myself bled, but before doing so I asked Giovanni Gaddi his advice, and he referred me to some doctor or other[150] that he knew. The first thing that this man asked me was whether I had been frightened. Imagine what sort of doctor he must have been to ask such a question, after I told him what a terrifying night I had had! He was nothing but an absurd quack, continually giggling over trifles and then with a snigger, telling me to drink a good glass of Greek wine, keep my spirits up, and not be afraid.

At this Gaddi exclaimed: 'You yourself would have been alarmed, doctor, even if you were made of bronze and marble, let alone flesh and blood.'

'My dear sir,' said the quack, 'we're not all fashioned the same. This man is neither bronze nor marble – he's made of iron!'

Then he placed his fingers on my pulse, laughed in his usual stupid way, and added:

'Just feel this – it's not a man's pulse, it's a lion's or a dragon's!'

My pulse was in fact beating furiously, probably in a way that doctor had never read of in his Hippocrates or Galen, and I realized how ill I must be. But in order not to add to my fears, and make myself even worse, I pretended to be in high spirits. Meanwhile Gaddi had ordered dinner to be brought in, and so we all sat down to eat.

Beside Gaddi the company included Lodovico da Fano, Antonio Allegretti, Giovanni Greco (all very scholarly men), and a very young fellow called Annibal Caro. And all during dinner their conversation turned solely on the subject of my bravery. They had my servant repeat the story to them, and Cencio – who was incredibly high-spirited, intelligent, and handsome – all the time he was describing my daring behaviour, brilliantly imitating the way I had stood and the very words I had used, continually reminded me of incidents I had forgotten. They kept on asking him if he had been frightened, but, no, he said, they ought to ask his master if *he* had been frightened, because he had felt

the same as me. All this chatter began to annoy me, and feeling very agitated I got up from the table saying that I wanted to go and buy some new clothes and blue silk, for Cencio and myself, so that we would be ready to walk in the procession that was being held in four days' time, on the feast of Our Lady.[151] I also told them that I wanted Cencio to carry a white lighted torch.

So when I left them I had some blue material cut out to make the clothes; I also had made a fine blue jacket of sarsenet and a little doublet. For Cencio I got a doublet and a taffeta coat, also blue. After that had been attended to, I went to see the Pope, who told me to have a talk with his Messer Ambrogio, to whom he had given instructions that I was to make a large piece of gold plate. I found Ambrogio, and discovered that he knew all about my affair with the police, had plotted with my enemies to force me to return to Rome, and had reprimanded the chief constable for not arresting me. I learnt also that the chief constable had excused himself on the plea that he had been powerless against such a safe-conduct. Ambrogio began to discuss the directions given by the Pope, and then he told me to prepare the designs while he saw to everything else.

When Our Lady's feast day arrived I visited the Pope again and, as it is the custom for those who receive pardons on this day to surrender themselves and be clapped in gaol, I told him I had no desire to be thrown in prison and begged him to let me off. However he answered that it was the usual rule and that I had to obey it. At this I knelt down again, thanked him for the safe-conduct he had given me, and said that I would return to the service of my Duke in Florence, who was very eager to have me back.

The Pope turned aside when he heard this and said to one of his confidential servants: 'Let Cellini have his pardon without going to prison, and make sure that his pass is properly drawn up.'

When this was done the Pope signed it, and it was registered at the Capitol. Afterwards, on the feast day, I took part in the procession with great honour, walking between two noblemen; and I was completely pardoned.

About four days later I was attacked by a raging fever and found myself shivering with extreme cold. I went to bed at once, firmly

convinced that I was going to die. I had the best doctors in Rome called in, one of them being Francesco da Norcia,[152] who was a very old man and had the finest reputation in the city. I told these doctors what I thought had caused my illness, and added that at the beginning of the trouble I had wished to let some blood, but had been advised not to. I begged them, if it were not too late, to bleed me on the spot, but Francesco replied that although I would have been completely cured if this had been done at first it was too late now, and they would have to apply different remedies.

So they began to doctor me with everything they knew; and every day I grew worse. At the end of a week I was so far gone that they gave up in despair and said that in order to make me happy I might be given whatever I fancied.

Francesco added: 'As long as he is still breathing you may call me in at any time. Who knows what nature will work in a young man like him? If he loses consciousness, try these five cures on him, one after the other, and then send for me. I'm ready to come at any hour of the night. I'd rather save him than any cardinal in Rome.'

While I was ill Giovanni Gaddi used to come and visit me, two or three times a day. But whenever he came he would begin fondling one or other of my beautiful fowling-pieces, or coats of mail, or swords, murmuring all the time: 'This is a lovely piece of work! And this is even finer!'

He did the same with my models and other little belongings, till he nearly drove me mad with annoyance. A certain Mattio Franzesi,[153] who was in the habit of coming along with him, seemed to be upset because I was taking an eternity to die – not that he would come in for anything of mine, but he wanted Giovanni to get what he was after. Felice, the partner I've mentioned, stayed by me all the time, being as helpful as any man could be. I was utterly weak and exhausted, hardly able to draw in my breath, but my mind remained as clear and agile as it had been before I was ill. All the same, one day a terrifying old man appeared at my bedside and tried to drag me by force into his enormous boat. I cried out for Felice to come to me and drive the old wretch away, and Felice, who loved me deeply, ran up and shouted tearfully:

'Get out, you old traitor, trying to steal all I have!'

Gaddi, who happened to be present on this occasion, remarked:

'The poor fellow's raving – he'll be dead in a few hours.'

And Mattio added: 'He must have been reading Dante,[154] and now he's so ill that his wits are wandering.'

Then he laughed and shouted: 'Run away, you old villain, and leave our Benvenuto alone.'

Seeing that they were mocking me, I turned to Giovanni Gaddi and said:

'My dear sir, I tell you I'm not raving and there really is an old man tormenting me. But the best service you could do me would be to get rid of that little rat who is laughing at my misfortune. And then, if your lordship does me the honour of coming again, bring Antonio Allegretti or Annibal Caro, who are discreet and intelligent and don't act like beasts; or bring some of your other talented friends.'

Then, for a joke, Giovanni ordered Mattio to clear off for good, but when Mattio laughed the jest became serious, and Gaddi never wanted to see him again after that. He sent for Allegretti and Lodovico and Annibal Caro instead, and when these admirable men arrived I was greatly consoled, even managing to carry on a reasonable conversation. But I still continued begging Felice to drive the old man away.

Lodovico asked me to describe what it was I thought I saw, and what he was like. But while I was sketching him in words, the old man seized me by the arm and tugged me forcibly towards him. At once I screamed that they must rush to my help, because he was going to throw me down into his loathsome boat; then, as soon as I uttered the last word I fell back senseless, imagining that I had in fact been hurled into the boat. They told me afterwards that I tossed about in a fit, swearing at Gaddi and saying that he only came to rob me, not because he loved me. At these and other terrible insults, he evidently blushed for shame. Then, they said, I grew so quiet that they thought I was dead. They stayed by me for more than an hour, till I began to stiffen, and then they left me as lost. On their return home they broke the news to Mattio Franzesi, who wrote to my dear friend, Benedetto Varchi, at Florence, and informed him that they had seen me die at such and such an hour of the night. So that great genius and close friend

of mine composed a superb sonnet, inspired by his belief in my supposed death, which I shall insert later on.

Three long hours dragged by and still I did not recover. Felice tried all the remedies that Francesco had told him, and then, when he saw that I wasn't coming round, he ran as fast as he could to Francesco da Norcia's house, and knocked so insistently that he woke the doctor up and got him out of bed. With tears streaming down his face Felice entreated him to come to the house, where I was lying dead.

Hearing this, Francesco, who was a very hot-blooded man, retorted: 'My boy, what do you think is the good of coming now? If he's dead, I'm even more upset than you are. But do you imagine that if I go back with you, and bring my medicine along, I can bring him back to life by blowing breath up his arse?'

Then seeing the poor young fellow was going away crying, he called him back and gave him some oil with which to anoint my wrists and chest. He told him to pinch my little toes and fingers hard, and if I came to to send for him at once. Felice did all that he had been told, but by the time it was nearly day there didn't seem to be the slightest hope. So they gave orders for my shroud to be cut out and for the corpse to be washed. Then – suddenly – I regained consciousness, and shouted for Felice to come and drive out the old man who was trying to hurt me. Felice wanted to send for the doctor, but I told him instead of doing this to stand close by me, because the old man was moving away from him and was obviously frightened. When I touched Felice the old man appeared to run off in a rage, so I again pleaded with him to stay near me.

Soon after Francesco appeared, saying that he was determined to cure me at all costs and that he had never come across greater endurance in a young man. He wrote out a prescription for perfumes, lotions, unctions and plasters, and a host of other things; and when I came round I had more than twenty leeches stuck to my backside, and felt as if I had been pierced, crushed, and broken. Many of my friends flocked round to see the miraculous return to life, including a great number of very important men. In their presence I declared that what little money I had – about eight hundred crowns, reckoning all the gold, silver, jewels, and cash – should be given to my sister Liperata, who lived at Florence. All the rest of my property, my armour included,

I left to dear Felice, and I also bequeathed him fifty ducats to buy mourning clothes. When he heard this he flung his arms round me, saying that all he wanted was that I should live.

Then I said to him: 'If you want me to remain alive, hold me as you did before and threaten that old man who is so frightened of you.'

Some of those who were present were terrified out of their wits at this, for they knew I was speaking coherently, with a clear head, and that I was far from delirious.

My terrible illness continued to drag on, with little progress made, and that wonderful doctor, Francesco, came to visit me four or five times a day. But Gaddi, who was thoroughly ashamed of himself, did not trouble me again. My brother-in-law came from Florence to collect the bequest, but as he was a decent fellow he was overjoyed at finding me alive. It was a great comfort to see him, and on his arrival he embraced me, protesting that he had come merely to look after me himself – and so he did for several days. Then, fairly certain that I was on the verge of recovery, I sent him back home.

On his departure, he left with me Benedetto Varchi's sonnet, which runs as follows:

ON THE SUPPOSED BUT FALSELY-REPORTED DEATH
OF BENVENUTO CELLINI

Mattio, who shall cause our grief to cease,
Or who forbid our weeping that he's dead?
For now, alas, that noble soul has fled
In youth, without us, up to Heaven's peace.
So many loved his soul, here on this earth
Which saw his lofty genius nobly grow
To stature never equalled till his birth,
Nor ever to be rivalled, here below.
Now we have seen the greatest all depart.
O gentle soul! if then in Paradise
You love, behold the one who loved you weeps,
His loss has left him with a broken heart.
Now you in Heaven the Creator keeps
Whose image[155] your own hand did once devise.

My illness had been so incredibly severe that it seemed impossible that I would ever recover; but that worthy man Francesco da Norcia exerted himself more than ever, every day bringing me new remedies in the endeavour to strengthen my poor exhausted frame, though for all the trouble he went to my persistent illness still showed no sign of ever coming to an end. As a result every one of the doctors was on the verge of despair, and they were baffled as to what to do next. I was suffering from a terrible thirst, but on their orders I had refrained from drinking for a good many days. Felice, who was pleased with himself beyond words for having saved me, never left my side; and although that old man visited me once or twice in my dreams, he never worried me as he did before.

One day Felice had gone out and left an apprentice and a servant girl called Beatrice to look after me. I asked the apprentice what had happened to my shopboy, Cencio, and what was the reason for my never seeing him when I needed him. The apprentice replied that Cencio had been much more ill than I was, and that he was at death's door. Felice had ordered them not to tell me about this. When I heard about it I was tremendously upset; then I called the servant girl, Beatrice, who was from Pistoia, and begged her to bring me, full of clear fresh water, the large crystal water-cooler that was standing near by. She ran off at once and brought it back to me, filled to the brim. I told her to hold it to my mouth, and that if she let me drink a mouthful or so, as I wanted, I would give her a dress.

As it happened, this servant had stolen a few little things of some importance from me, and in her fear of being found out she would have been only too pleased to see me die. As a result twice running she let me drink as much as I could of the water, and so I greedily swallowed more than a flask of it. Then I covered myself up, began to sweat and fell asleep.

I must have been sleeping for more than an hour when Felice came back and asked the boy how I was.

He replied: 'I don't know. Beatrice brought him that jug full of water and he drank nearly all of it. I'm not sure now whether he's dead or alive.'

They say that Felice almost fell down unconscious, he was so morti-

fied. Then he grabbed hold of an ugly-looking stick and began to beat the girl madly, shouting at her: 'Oh, you traitress! So you've killed him!'

While Felice was thrashing her, and she was screaming, I had a dream. I dreamed that the old man was there, holding some pieces of rope, and as he was about to tie me up, Felice had rushed up and set about him with an axe, with the result that he ran away crying: 'Let me go, and I shan't come back for a long time.'

Meanwhile Beatrice had come running into my room, screaming her head off. This woke me up, and I cried out:

"Leave her alone, instead of doing me the harm she meant she may have done me a great deal of good – more than you have ever been able to do, for all your efforts. Now give me a hand, because I'm covered with sweat – and be quick about it.'

At this Felice brightened up, dried me, and then made me comfortable. Feeling very much better I promised myself that I would recover my health. Then Francesco appeared on the scene, to find me much better, the servant crying, the apprentice running here, there, and everywhere, and Felice in smiles; all this uproar made the doctor think that something really extraordinary must have happened to account for my great improvement. Meanwhile the other doctor, Bernardino – the one who at the beginning had been unwilling to bleed me – came in. Francesco, like the learned man he was, said:

'Oh, the powers of Nature! She knows what we need, and the doctors know nothing.'

That numskull Bernardino immediately added:

'If he had drunk one flask more, he would have been cured at once.'

Francesco da Norcia, who was an old man and a doctor of great authority, said:

'That would have been a tremendous misfortune, and I hope to God it happens to you.'

Then he turned to me and asked if I could have drunk more. I replied, no, because I had completely quenched my thirst. Then he turned to Bernardino and said:

'Do you see how Nature has taken exactly what she needed, and neither more nor less? In the same way she was asking for what she

needed when this poor young man asked you to bleed him. If you knew he would recover if he drank two flasks of water, why didn't you say so before? Then you would have got the credit for it.'

At these words the quack went off in a huff, and he never turned up again. Francesco said that I must be taken out of the room I had been in, and that they must have me carried up to one of the hills in Rome. Cardinal Cornaro, hearing of my recovery, had me taken to one of his estates on Monte Cavallo; that very evening I was carried carefully away on a chair, well protected and muffled up. When I arrived there I began to vomit, and as I was doing so I brought up a hairy worm, a quarter of a cubit in length. It was covered with long hairs, and looked repulsive, spotted with various colours, green, black, and red.

They kept it to show the doctor, who exclaimed that he had never seen anything like it, and then said to Felice:

'Take care of your Benvenuto now that he's cured; and don't allow him any excesses, because although he has survived one illness another would kill him. You see, his illness was so serious that if we had brought him extreme unction we would have been too late. Now I'm certain that with a little patience and time he'll be turning out beautiful works of art again.'

Then he turned to me and added: 'My dear Benvenuto, be sensible and don't indulge in any excess; and when you're cured I want you to make me a Madonna with your own hands as I want to pray to her from now on, because of my affection for you.'

I promised I would do this, and went on to ask if it would be all right for me to go back to Florence. He said that I should wait till I was a little better, and then we would see what Nature would do.

My state of health had so little improved, after a week's waiting, that I was thoroughly sick of myself. I had put up with that terrible suffering for more than fifty days. So I made up my mind and prepared to leave. In a pair of litters, my dear Felice and I myself were carried off to Florence.[156] I had not written at all, and therefore when I arrived at my sister's house she started laughing and crying over me at one and the same time.

The day I returned a large number of my friends came to see me,

including Piero Landi, the greatest and dearest friend I ever had in the world. The next day, Niccolò da Monte Aguto, another close friend of mine, called on me. He had heard the Duke say:

'Benvenuto would have done far better to have died, since he has come here to have a rope put round his neck, and I shall never forgive him for what he has done.'

When Niccolò joined me, he said in despair:

'My dear Benvenuto, what have you come here for? Don't you know how much you've offended the Duke? I heard him swear that you were certainly putting a rope round your own neck.'

I answered: 'Niccolò, remind his Excellency that Pope Clement once wanted to do as much to me, and that he was just as much in the wrong. Tell him that I must be taken care of, and that he should let me get better, because then I shall show him that I've been the most faithful servant he'll ever have in his life. Some envious enemy of mine must have done me this bad turn – so let him wait till I'm recovered, and then I'll be able to give an account of myself that will astonish him.'

In fact this bad turn had been done me by the Aretine painter, little Giorgio Vasari,[157] perhaps to repay me for the many good turns I had done him. I had, to tell the truth, entertained him in Rome and paid for his expenses, and he had turned my house topsy-turvy. This came of his having a dry skin-disease, and he was always tearing himself and scratching away with his hands. He had slept with a good-natured young man I had, called Manno,[158] and thinking that he was scratching himself he had taken the skin off one of Manno's legs, with those filthy little claws whose nails he never cut. Manno had left my service and sworn to kill him. I made it up between them, and then got Giorgio a position with Cardinal de' Medici, and I never left off helping him in one way or another.

So, in return for this, he told Duke Alessandro that I had spoken ill of his Excellency, and that I boasted of wanting to be the first to leap up on to the walls of Florence with the Duke's exiled enemies. According to what I heard later all this had been put into his mouth by that fine gentleman, Ottaviano de' Medici, who wanted to get his revenge for the Duke's anger with him because of the coins and my leaving Florence.

But, as I was innocent of the treachery they accused me of, I was not the slightest bit afraid.

That able doctor, Francesco da Montevarchi,[159] treated me with great skill. He had been brought to me by my dear friend, Luca Martini,[160] who used to keep me company during most of the day.

Meanwhile I had sent my faithful Felice back to Rome, to look after the business there. Then, at the end of a fortnight, when I could raise my head off the pillow a little, though I could not stand on my own feet, I had myself carried to the Medici palace, up to where the little terrace is; they left me resting there, waiting for the Duke to come past. A good few friends of mine from the court came up and chatted with me. They were astonished at my having suffered the discomfort of being carried there in that way, after I had been so weakened by my illness. They said that I should wait till I was better, and then visit the Duke. Quite a crowd gathered round, all staring at me as if they were looking at a miracle, not so much because they had heard I was dead as because at the time I had the appearance of a corpse.

Then, in front of them all, I explained how some wicked scoundrel had told his Excellency the Duke that I had boasted of intending to be the first to scale his Excellency's walls and that besides this I had spoken ill of him. As a result, I said, I didn't care whether I lived or died till I had cleared myself of this monstrous charge and found out who was the rash scoundrel guilty of such slander. Hearing what I was saying a large number of those nobles gathered round me, expressing great sympathy, and some saying one thing, and others another. I repeated that I did not intend to leave that spot till I had found out who had accused me. At this the Duke's tailor, Maestro Agustino, made his way through all those gentlemen and said:

'If that is all you want to know, I can tell you this very minute.'

Just then Giorgio, the painter I mentioned, passed by. Agustino said:

'There's the man who accused you. Now you can find out for yourself whether it's true or not.'

Then, unable to move, as fiercely as I could I asked Giorgio whether what had been said was true. He replied, no, that it wasn't true, and that he had never said such a thing. Agustino retorted:

'You gallows-bird – don't you realize I know it for certain?'

Giorgio instantly made off, still saying, no, that he had done no such thing. A little later, and the Duke came past. I at once had myself raised up in front of his Excellency, and he stopped. Then I told him that I had come there in that fashion merely to clear my name. The Duke stared at me, expressed his astonishment at my being still alive, and then told me to make sure I remained an honest man, and to get better.

After I had returned home Niccolò da Monte Aguto came in search of me to say although he would not have believed it I had weathered one of the worst storms he had ever seen; for he had seen me marked down irrevocably as a doomed man. He advised me to build up my health as quickly as possible, and then to clear out of Florence, because I was threatened from a quarter and a certain man who would do me great harm. He went on to say that I must be very careful, and then he added: 'What injury have you done that great scoundrel Ottaviano de' Medici?'

I answered that I had never done him any harm but that he had done a great deal to me, and I told him all about what had happened at the Mint.

He said: 'Clear out as soon as you can, but don't worry – you'll have your revenge sooner than you think.'

I concentrated on restoring my health; gave instructions to Pietro Pagolo about stamping the coins; and then cleared out of Florence and made my way back to Rome, without a word to the Duke or anyone else.

On my return to Rome I relaxed for a while in the company of my friends, and then I started on the Duke's medal. At the end of a few days I had already finished the head, in steel, and it proved the finest work of that kind that I had ever done. At least once every day a great oafish lout called Francesco Soderini used to visit me. Once or twice, when he saw what I was doing, he remarked:

'What a cruel man you must be to want to immortalize that ferocious tyrant. Since you've never made anything so beautiful before, you must be as much our bitter enemy as you are their great friend. And this even though both he and the Pope have twice wanted to have you hanged without reason. That was the doing of the Father and the Son – now you look out for the Holy Ghost!'

It was, by the way, held as certain that Duke Alessandro was the son of Pope Clement.[161]

Francesco also solemnly swore that if he could he would have robbed me of the dies for the medal. I replied that it was just as well he had told me, and I would take care that he never set eyes on them again.

I then let it be known in Florence that Lorenzo should be told to send me the reverse of the medal. Niccolò de Monte Aguto, to whom I had written, replied that he had asked that mad, brooding philosopher, Lorenzo, and had been told in reply that he never thought of anything else, night or day, and that he would do it as soon as he possibly could. But he added that I was not to rely on him, and that I should make one for myself, from my own design; then, when it was finished, I should bring it boldly to the Duke, and it would prove well worth my while.

After I had made what I thought was a suitable design for the reverse I pushed on with the work as carefully as I could. However, as I had still not completely recovered from my terrible illness, I used to find enjoyment by going off on shooting expeditions with my dear Felice. He was hopeless as far as helping me with my art was concerned, but because we were always together, day and night, everyone imagined that he was an expert craftsman. He was a very agreeable and amusing fellow, and so we were always laughing together over the great reputation he had won. As his name was Felice Guadagni, he used to joke: 'I would call myself Felice Guadagni-poco, if you hadn't won me such a great reputation that I can call myself Felice de' Guadagni-assai . . .'[162]

I told him that there are two ways of making a profit; the first being that by which one saves for oneself, and the second that by which one saves for others; so I praised him for the second far more than for the first, since he had saved my life for me.

We were always chatting together like this, but I remember especially one day round about the Epiphany, when we were together near the Magliana,[163] and it was already near to nightfall. That day I had shot a good number of ducks and geese; then, as I had almost decided to pack up for the day, we began moving back fairly smartly towards Rome. I called my dog, Barucco, and then, seeing that he wasn't in

front of me, I turned round and discovered that the well-trained animal was watching some geese that had settled in a ditch. So I at once dismounted, loaded my gun, and fired at them from a long way off, hitting two of them with a single shot. I never liked to use more than one ball and I could fire at a range of two hundred cubits and nearly always hit the target. My method was the only way to make sure of success. Anyhow, of the two geese I had hit, one was almost dead and the other was badly winged, though even so it flapped along painfully till my dog went after it and brought it back. Then, seeing that the other one was plunging into the ditch, I hurried forward after it. I relied on my boots, which were very tall and thrust one foot forward – but it sank down under the mud. So although I secured the goose, my right boot was filled with water. I lifted my foot up high and let the water run out. Then we mounted our horses and rode off swiftly towards Rome.

It was so bitterly cold that my leg felt as if it were freezing, and I called out to Felice: 'We must do something about this leg – I can't stand it any longer.'

Felice, like the good fellow he was, without saying a word leapt off his horse, gathered together some thistles and twigs and began to make up a fire, while I waited with my hands thrust into the breast-feathers of the geese, keeping very warm. When I noticed this I stopped him going on with the fire, and instead filled my boot with goose feathers. Almost immediately I felt so much better that I was completely reinvigorated.

We mounted and rode off hurriedly towards Rome. Then as we arrived at the top of a gentle slope – it was already night – and looked towards Florence, both of us exclaimed in astonishment:

'Good God! What's that tremendous thing we can see over Florence?'

It was like a huge beam of fire, shining brightly and filling the sky with a brilliant light.

I said to Felice: 'We shall certainly hear tomorrow of some great thing that has befallen Florence.'

It was pitch-black when we arrived in Rome. We were approaching the Banchi, and home, and my little horse was galloping along at a furious speed. So when we came to a great pile of plaster and broken

tiles that had been left in the middle of the street neither my horse nor
I saw it, and he charged up it only to stumble on the descent and come
a complete cropper. He had his head forced between his legs, and
only the power of God brought me through unscathed. Hearing the
commotion all the neighbours rushed out with lights; but I had jumped
to my feet, and, without remounting, I ran off home, laughing at having
escaped unharmed when I might have broken my neck.

When I reached the house I found some of my friends waiting there,
and while we were having supper together I told them how full of
mishaps the day's shooting had been, and about the diabolical beam of
light that we had seen. They exclaimed: 'What will tomorrow bring
in explanation of this?'

I said: 'Something new has certainly come to pass in Florence.'

We had supper together very agreeably, and then, late next day, the
news of Duke Alessandro's death arrived in Rome.[164] As a result many
of my acquaintances came up to me and said: 'You were certainly right
about something tremendous happening in Florence.'

In the middle of this Francesco Soderini came jogging along on a
shambling old mule, laughing his head off like an idiot. He cried out
to me:

'This is the reverse of that wicked tyrant's medal that your Lorenzo
de' Medici promised you.'

Then he added: 'You wanted to make the dukes immortal – we
want no more dukes!'

Then he started jeering at me, as if I had been the leader of those
factions that set the dukes up. Meanwhile a certain Baccio Bettini,[165]
who had a head swollen like a pumpkin, joined us and took his turn
in jeering at me about dukes.

'We have unduked them,' he said, 'and we won't have any more
dukes – and you wanted to make them immortal!'

He carried on talking stupid nonsense of this sort, till I grew sick of
it and said:

'You idiotic fools, I'm a poor goldsmith, and I work for anyone who
pays me, and there you are jeering at me as if I were a political leader.
All the same I shan't throw the stupidity, and the greed and the laziness
of your predecessors up at you now. But in return for your idiotic

mockery I can tell you that before as many as two or three days have gone by you will have another duke, perhaps a great deal worse than the last.'

The very next day Bettini came to my shop and said:

'It's not worth spending money on couriers when you know things before they happen. What supernatural voice tells them to you?'

Then he told me that Cosimo de' Medici, Giovanni's son, had been made duke,[166] but only under certain conditions that would stop him playing around just as he liked. At this it was my turn to laugh at them.

'Those men at Florence,' I said, 'have set a young fellow up on a splendid horse, then they've given him spurs, and put the bridle freely in his hands, and they've let him loose in a beautiful meadow, full of fruits and flowers and other delights. Then they've told him not to ride beyond the boundaries marked out for him. Now you tell me – who's going to stop him when he's made up his mind to cross them? The laws can't be enforced against the man who is the laws' master.'

After this they left me alone, and I had no more trouble with them.

I started attending to my business, and I began working, but not yet on anything very important because I was waiting till my health was completely restored. I still reckoned I had not recovered from that dangerous illness. About this time the Emperor was returning in triumph from his expedition against Tunis, and the Pope had sent for me to discuss what suitable gift of honour I thought should be given to him. I replied that I thought it would be most suitable to give his Majesty a gold crucifix,[167] and that I had almost completed such an ornament which would be very fitting, and would reflect great credit both on his Holiness and on myself.

I had in fact already made three little gold figures, in the round, about a palm's length high (they were the ones I had begun to make for Pope Clement's chalice, representing Faith, Hope, and Charity). So I completed the base of the cross, added a figure of Christ and many other fine embellishments – all in wax – and carried the result to the Pope. His Holiness was delighted with it, and before I left him we had agreed about everything that was to be done, and estimated what the work would cost.

This all took place one evening, about four hours after sunset, and the Pope ordered Latino Juvinale to have me paid the following morning. This Latino, who had an idiotic side to his nature, thought that he would present the Pope with an idea that he had thought up all by himself. By doing this he muddled up all the arrangements, and in the morning, when I called for my money, he said with his usual beastly arrogance:

'It is for us to make the designs, and for you to execute them. Before I left the Pope last night, we thought of something far better.'

As soon as I heard him say this, without letting him add anything more, I broke in:

'Neither you nor the Pope can ever think of anything better than a work where Christ appears – so now you can talk as much foppish nonsense as you like.'

Without another word he stalked off in a temper and tried to get the commission transferred to another goldsmith. But the Pope refused and in fact immediately sent for me and said that I was perfectly right, but that they wanted to make use of a Book of Offices of Our Lady,[168] which was superbly illuminated – it had cost Cardinal de' Medici more than two thousand crowns to have it done. This, he said, would be a very suitable gift for the Empress, and then they would make the thing I had prepared for the Emperor, as it was certainly worthy of him.

He explained that this was only being done because there was very little time, seeing that the Emperor was expected to arrive in Rome within a month and a half. He wanted the book to be bound in a solid gold cover, richly ornamented and thickly studded with gems. The precious stones were worth about six thousand crowns. So when I had been given the gold and the gems I set to, and by working briskly for a few days made such a beautiful job of it that the Pope was astonished, heaped favours on me, and gave his word that I would not be bothered any more by that beast Juvinale.

The work was almost finished when the Emperor arrived.[169] A great number of splendid triumphal arches were erected for him, and after his entry into Rome, with marvellous pomp (which I leave others to describe, as I want to deal only with what concerns me) he immediately

presented the Pope with a diamond that he had bought for twelve thousand crowns. The Pope sent for me, and then gave me the diamond and asked me to make a ring that would fit his own finger; but first, he said, he wanted me to bring him the book at whatever stage I had brought it to. I carried the book to him, and he was more than satisfied; then he asked my advice as to what valid excuse he could give the Emperor for its not being completed.

In reply to this I said that the best way out would be for me to tell him about my illness, and that his Majesty would readily accept this when he saw how wasted and pale I looked. The Pope said that he thought this was a very good idea, but that when presenting the book I was to add, from him, that he was also making the Emperor a present of myself. He told me exactly how I should behave, and what I was to say. I repeated the words I had to use, and asked the Pope whether he would be pleased if I spoke like that.

He said: 'If you have it in you to speak to the Emperor in the same way as you're talking to me, you'll do it only too well.'

Then I said that I would be far more confident in speaking to the Emperor, because the Emperor dressed in the same way as I did, and I would imagine that I was talking to a man like myself; which was not the case when I spoke to his Holiness. In him, I said, I saw far greater signs of divinity, because of his ecclesiastical trappings, which gave him an aureole of holiness, and because of his impressive and venerable appearance. All these things made me stand more in awe of him than of the Emperor.

At this the Pope said: 'Away with you, Benvenuto; you're a very skilful man. Do us credit, and it will be worth your while.'

The Pope got ready two Arab horses, which had belonged to Pope Clement and which were the most handsome that had ever been brought to Christendom. He ordered his chamberlain, Messer Durante,[170] to lead these two horses down through the corridors of the palace, and then present them to the Emperor, together with a little speech that the Pope prepared for him. We went along together, and when we reached the Emperor's presence the two horses made their way through the halls with such dignity and spirit that his Majesty and everyone else marvelled at it.

At this point Durante stepped forward so awkwardly and said his piece in such a tongue-tied fashion, with some of his Brescian dialect thrown in, that one never saw or heard anything worse. The Emperor had to laugh a little. Meanwhile I had uncovered my work, and when I saw the Emperor look very graciously in my direction I stepped forward and said:

'Sacred Majesty, our Holy Father Pope Paul sends this Book of Our Lady as a gift to your Majesty. It has been copied out by hand, and illuminated by the greatest craftsman who ever studied such an art. And this rich binding of gold and gems is incomplete, in the way that you see it, because of my indisposition. Therefore his Holiness presents me, as well as the book, so that I may come along with your Majesty in order to finish it; and in addition, in whatever your Majesty has a mind to have done, as long as I live I shall serve you.'

To this the Emperor replied: 'I am pleased both with the book and with you yourself; but I want you to finish it for me in Rome; and when it is finished, and you are better, seek me out and bring it to me.'

Then, when he was talking with me, he called me by my name, which astonished me because so far it had not been mentioned; and he told me that he had seen the morse for Pope Clement's cope, with all the wonderful figures I had executed on it.

We talked on in this way for an entire half-hour, discussing a whole host of pleasant, artistic subjects; and then, with the thought that I had carried the thing off with far greater credit to myself than I had anticipated, when there was a slight lull in the conversation I bowed and left. The Emperor was heard to say: 'Have five hundred gold crowns given to Benvenuto at once'; and then the man who carried them in asked who was the Pope's man who had spoken to the Emperor. And Durante stepped forward and filched my five hundred crowns. I complained to the Pope, who told me not to worry as he knew all that had happened, and how well I had conducted myself when I was talking to the Emperor; and he said that I would most certainly have my share of the money.

I returned to my shop and gave all my attention to finishing the diamond ring. Four craftsmen – the finest jewellers in Rome – were sent along to see me about it, because the Pope had been told that the

diamond had been set in Venice by a man called Miliano Targhetto,[171] and that he was the finest jeweller in the world, and that as the diamond was rather thin such a difficult undertaking would require great consideration. I was delighted to see these four jewellers, one of whom was a Milanese called Gaio.[172] He was the most self-opinionated beast in the world, knowing least and thinking that he knew most; the others were very modest and very competent craftsmen. This Gaio started speaking before anyone else.

'Benvenuto,' he said, 'preserve Miliano's tint, and in fact touch your hat to it; for as to giving diamonds a tint, that is the finest and hardest part of the jeweller's art. Now, Miliano is the greatest jeweller the world has ever known, and this is the most difficult diamond.'

My answer to this was that competition with such an accomplished craftsman would only bring me greater glory; then I turned to the other jewellers and said:

'Look, I have kept Miliano's tint, but I shall see whether I can better it with something of my own composition. If not, I shall use Miliano's again.'

That beast Gaio said that if I made a foil like that, he would be only too ready to take his hat off to it.

I replied: 'Then if I do it better it will deserve two marks of respect.'

He said, yes, it would. And so I began work on my tints. I set out to make them very carefully, and in the proper place I shall give instructions as to how it is done. It is certainly true that that diamond was the most difficult I have ever come across, either before or since, and Miliano's tint was brilliantly made; but I wasn't frightened by that. I sharpened up my wits, and I did so well that I not only rivalled but surpassed it. Then, knowing that I had beaten him, I set out to beat myself; by using new methods I made a tint which far surpassed the one I had made first of all. Then I sent for the jewellers. First I tinted the diamond with Miliano's foil, and then I cleaned it thoroughly and tinted it with my own.

When I showed it to the jewellers, one of the most accomplished of them, Raffaello del Moro, took the diamond in his hand and said to Gaio:

'Benvenuto has beaten Miliano's work.'

Gaio was reluctant to believe this but he took the diamond all the same, and then said:

'Benvenuto, this diamond is worth two thousand ducats more than it was with Miliano's tint.'

And then I replied: 'Since I've surpassed Miliano's effort, let's see if I can surpass myself.'

I begged them to hold on for a minute, went up to a little alcove of mine, and there, out of sight, I retinted the diamond. Then I brought it back to them. At once Gaio exclaimed:

'In all my life, I've never seen anything more wonderful; this diamond is worth more than eighteen thousand crowns, and we reckoned it was hardly worth twelve thousand!'

The other jewellers turned to Gaio and said: 'Benvenuto is the pride of our profession, and it is only right that we should take off our hats, both to his work and to him.'

Then Gaio replied: 'I will go and tell the Pope about this, and I want Benvenuto to have a thousand gold crowns for setting this diamond.'

He ran off to the Pope and told him everything. In consequence, three times that day the Pope sent to find out if the ring was finished. An hour before sunset I brought the ring to him. I was allowed to come and go as I liked, and so I discreetly lifted the door-curtain, and there I saw the Pope, together with the Marquis of Guasto.[173] He must have been urging the Pope to do something against his will; and I heard his Holiness say: 'I tell you, no. It's my duty to be neutral, and nothing else.'

Straight away I began to withdraw, but as I was doing so the Pope himself called me in. So I immediately stepped forward, holding that exquisite diamond in my hand; and the Pope beckoned me to him, while the Marquis walked away from us. As he was examining the diamond, the Pope said to me:

'Benvenuto, start talking to me, and make it seem important: and don't stop once till the Marquis has left the room.'

Then he began to walk up and down the room. This idea, which was likely to be to my advantage, tickled me, and I began discussing the method I had used to tint the diamond. The Marquis stayed where

he was, reclining against an arras, and balancing now on one leg, now on the other.

The subject-matter of my talk was of such importance that to have dealt with it adequately would have taken at least three hours; it delighted the Pope so much that he quite forgot how annoyed he had been with the Marquis, who was still standing there. I brought into the discussion that branch of philosophy which deals with our profession, and then, after I had been discussing it for nearly an hour, the Marquis ran out of patience and went off in a huff. Then the Pope treated me with extraordinary courtesy, and said:

'Just wait a while, Benvenuto, and the reward your ability receives from me will be worth far more than the thousand crowns that Gaio says your work deserves.'

After I had left the Pope went on to praise me in the presence of his attendants, among whom was that Latino Juvinale to whom I had spoken before. As I had made an enemy of him he tried as hard as he could to do me harm; and when he saw the affection and enthusiasm with which the Pope was talking about me, he said:

'No one doubts that Benvenuto is an extremely clever man. But although everyone is naturally meant to love people from his own homeland more than others, all the same one should be careful of the way one talks about a pope. He has been heard to say that Pope Clement was the finest-looking ruler that ever was, and as brilliant as he was handsome, but that he was unlucky. And he says that your Holiness is quite the opposite, and that it's a tight squeeze to get the tiara on your head; that you look like a dolled-up bundle of straw, and that there's nothing more to you than your good luck.'

These words, coming from a man who knew only too well how to express himself, carried such force that the Pope believed them. In fact not only had I never said them but such thoughts had never entered my head. If the Pope could have done so without harming his reputation he would have dealt me a very hard blow; but, like the shrewd man he was, he pretended to laugh it off. All the same he began to cherish such bitter hatred of me that words fail to describe it; and I became aware of this when instead of being allowed in with the same freedom as before I could only see him with the greatest difficulty.

As I had been about the court for a good many years, I guessed that someone had done me this bad turn; and after making some astute inquiries I discovered everything that had happened, except the name of the man behind it. If I had known that there would have been no half-measures about my revenge.

I gave all my attention to finishing the little book; and when I had done so I carried it to the Pope who, as a matter of fact, found it impossible not to praise me to the skies. I asked him to send me off with it, as he had promised. He replied that he would do what he thought fitting and that my part in the business was finished. Then he gave orders that I was to be well paid. For the work I had done, in a little over two months, I made five hundred crowns; for the diamond, I was paid at the rate of a hundred and fifty crowns and no more; all the rest was given me for my work on the book[174] which in fact was worth more than a thousand, seeing that it was richly embellished with figures, foliage, enamelling, and jewels. I took what I could get and made up my mind to clear out of Rome.

Meanwhile the Pope sent the book to the Emperor through his grandson, Signor Sforza.[175] When he presented it the Emperor was tremendously grateful and at once asked after me. The young Sforza, who had been told what to say, replied that I had not come myself because I was ill. I was told about this later.

In the meantime I prepared to set off for France; I wanted to go by myself, but this proved impossible because of a young man I had, called Ascanio.[176] He was extremely young, and he was the most splendid servant imaginable; when I took him in he had just left a Spanish goldsmith called Francesco. I had been reluctant to take him, for fear of crossing the Spaniard's path, so I said to him: 'I don't want you, because I may offend your master.'

But he so arranged matters that his master wrote me a note saying that I was quite free to have him. So he had been with me for a good few months. When he first came to me he had been very thin and pale, and we called him 'the little old man'; and in fact that was how I regarded him, because he was such a capable assistant and because he was so knowing that it hardly seemed credible for a boy of thirteen, which he said was his age, to be so intelligent.

To return to what I was saying: in the few months he was with me he filled out and became so robust that he ended up the most handsome young fellow in Rome. He was such a good assistant, as I said before, and he made such progress at the trade, that I began to love and look after him as if he were my own son. When he saw how his fortunes had mended he reckoned himself very lucky to have come my way. Very often he used to go along and thank his former master for having been the cause of this good fortune of his. As it happened this Spaniard was married to a very beautiful young girl, who on one of these occasions said to him:

'Surgetto,' (that was what they used to call him when he stayed with them) 'what have you been doing to become so handsome?'

Ascanio replied: 'Madonna Francesca, that's my master's doing, and he's made me much more good, as well.'

Her spiteful character was such that what he said made her furious; besides this she had the reputation of being a loose woman, and so she knew how to fondle him in a way that was probably far from decent. I began to notice that he was going along to see her far more than he used to. Then one day it happened that Ascanio gave one of the shopboys a beating; and when I returned home, with tears in his eyes the boy complained that Ascanio had waded into him for no reason at all.

When I heard this I turned to Ascanio and said: 'With or without reason, don't you ever set about anyone in my household, or you'll have me to deal with.'

He answered me back; and at that I immediately threw myself on him, and with plenty of punches and kicks gave him the severest beating he had ever had. As soon as he could escape he ran out without his hat or coat, and for two days I had no idea where he was, let alone go and look for him. But then a Spanish gentleman, called Don Diego, came to see me. He was the most generous-hearted man I've ever known. I had already done some work for him and I was doing some at the time, so we were on very good terms. He told me that Ascanio had gone back to his old master, and asked me, if I would, to send along the coat and hat I had given him. My reply to this was that Francesco had behaved very badly, just like a boor; for if he had told me as soon as

Ascanio had gone back to his house, I would have been only too pleased to let him go; but as he had kept him for two days without saying a word I had no intention of letting him stay, and he should take care that I did not catch sight of the boy in his house. Don Diego reported what I had said, and Francesco made a joke of it.

The following morning I saw Ascanio, at his master's side, working on some trifling rubbish in wire. As I walked past Ascanio bowed to me and his master started sneering. Then he sent word through that nobleman Don Diego, asking if I would be kind enough to let Ascanio have the clothes I had given him; but he added that he didn't care one way or the other, seeing that Ascanio would never want for clothes. When I heard this I turned to Don Diego and said:

'Signor Don Diego, you yourself show in everything you do that you're the most generous and upright man I've ever come across; but this Francesco – this disreputable renegade – is completely the reverse. Tell him from me that if before vespers he himself hasn't brought Ascanio back to my shop, I shall certainly kill him; and tell Ascanio that if he doesn't quit his master by that time, he'll get pretty well the same treatment.'

Don Diego said nothing, but he went along and so put the fear of God into Francesco that he was at his wits' end what to do. Meanwhile Ascanio had gone off to look for his father, who had come to Rome from his native place, Tagliacozzo: and when his father heard about the row he too advised Francesco to take Ascanio back to me.

Francesco cried: 'All right, go off of your own accord, and let your father go with you.'

Don Diego added: 'Francesco, I can see some terrible trouble brewing; you know better than I do what sort of man Benvenuto is: be bold and take Ascanio back yourself, and I shall come with you.'

Back at the shop, I was all ready, and I was walking up and down waiting for vespers to sound and feeling in the mood for one of the most violent deeds I had ever done in my life. Then, in the middle of this, Don Diego, Francesco, Ascanio, and Ascanio's father – whom I had never met before – all appeared on the scene. When Ascanio came in I stared at them with my eyes blazing, and then Francesco, pale as death, said:

'See, I've brought Ascanio back. I had no idea I was annoying you by keeping him.'

Then Ascanio said, very respectfully: 'Sir, forgive me: I've come to do all you order.'

'Have you come to finish the time you promised to put in?'

He said, yes, that he had, and that he would never leave me again. At this I turned to the boy he had beaten and told him to hand Ascanio his bundle of clothes: at the same time I said:

'Here are all the clothes I gave you; take your freedom along with them and go wherever you like.'

Don Diego, who had expected anything but this, was completely astonished. And then Ascanio, and his father as well, begged me to forgive him and take him back. I asked who the man was who was pleading on his behalf, and he told me it was his father. So after some further entreaty I said:

'Since you're his father, I shall take him back for your sake.'

As I said a short while ago, I had made up my mind to set off for France. My reason for this was that I realized the Pope no longer thought so highly of me, because my loyal service had been smeared by evil talk; and also I was frightened of my enemies doing even worse. So I was anxious to find another country where I could perhaps better my fortunes; and I was ready to clear off by myself. One evening I made up my mind to leave the next morning: so I told my faithful Felice that he should use all my belongings until I came back, and that, in the event of my not coming back, I left everything to him. I had a Perugian assistant,[177] who had helped me finish the work I did for the Pope; so I paid him for what he had done and then dismissed him. However he begged me to let him come with me; he said that he would pay his own way, and, if it came about that I settled down to work for the King of France, that it would still be better for me to have my own Italian countrymen with me, and especially those I knew I could rely on. He got round me so well that I agreed to take him on the basis he himself had suggested.

Ascanio, who was present when this took place, was almost in tears, and he began saying: 'When you took me back I said I wanted to stay with you as long as I lived; and so I shall.'

I answered that I would not agree on any condition; and then the poor young lad started making his preparations to follow after me on foot. When I saw what he had decided to do I got a horse for him as well. I put a bag on the crupper, and I burdened myself with far more lumber than I would otherwise have needed.

From Rome I travelled to Florence;[178] from Florence to Bologna; from Bologna to Venice; and from Venice to Padua: and there my dear friend Albertaccio del Bene made me leave the inn for his own house. The next day I went along to kiss the hands of Messer Pietro Bembo,[179] who had not yet been made a cardinal. Pietro gave me the most affectionate welcome imaginable; then he turned to Albertaccio and said:

'I want Benvenuto and all his servants to stay here, even if there're a hundred of them. If you want Benvenuto's company as well make up your mind to stay here with me, otherwise I mean to keep him to myself.'

So I spent a very agreeable time with this brilliant gentleman. He had prepared me a room that would have been too splendid even for a cardinal; and he wanted me to take all my meals with him. Later on he began to drop delicate hints that he would like me to make his portrait: there was nothing I could have wanted more, and so I mixed some spotless white stucco in a little box and began work on it. The first day I worked two hours at a stretch, reproducing his fine head so beautifully that his lordship was astounded. He was a very great man of letters and a poet of extraordinary genius, but since he was completely ignorant about my own art he imagined that I had already finished, whereas in fact I had hardly begun.

I found it impossible to make him understand that to do it well required a long time. In the end I decided to put into it all I knew, and to give it all the time it needed: and since he wore his beard short, in the Venetian fashion, it proved very troublesome to make a head that I was satisfied with. But I finished it, and I reckoned that on every score I had produced the finest work I had ever done. He was flabbergasted at all this, because he reckoned that after I had made the wax model in two hours I ought to finish the steel one in ten; and there I was, only able to complete the wax model in two hundred hours, and asking his

permission to leave for France. He was terribly upset at this and begged that I should at least do a reverse for the medal,[180] showing the horse, Pegasus, with a wreath of myrtle round it. I did this in about three hours and made a lovely job of it. He was delighted with the work and commented:

'But I think it's ten times more difficult to do a horse like this than to do the little head that gave you so much trouble. I don't understand the difficulty.'

Then he began pleading with me to execute it in steel.

'I beg you to do it,' he said, 'as a special favour. You could do it quickly enough if you had a mind to.'

I assured him that, although I did not want to do it there, I would certainly do it for him when I settled down to work. While this debate was going on I had been along to hire three horses for the journey to France. As it happened without my knowing, Bembo, since he had great authority in Padua, was able to check up on my activities. So when I wanted to pay for the horses, having settled the price at fifty ducats, the owner said:

'As you're such a great artist I make you a present of them.'

'It's not you who're making the present,' I said, 'and I don't want to accept them from the man who is doing so, since I haven't been able to do any work for him.'

This pleasant fellow then told me that if I did not take those horses it would be impossible for me to get any others in Padua, and so I would have to make the journey on foot. At this I went back to the illustrious Pietro, who pretended not to know what had happened, but welcomed me affectionately and told me that I should stay on in Padua. As this was utterly against my wishes, and I was thoroughly determined to leave Padua, I was forced to accept the three horses; and I started off with them.

I took the route through the Grisons, as all the other roads were unsafe because of the war that was going on. We crossed the Albula and the Bernina, which were covered with deep snow, on the eighth of May, in danger of our lives. Then we stopped in a place called, if I remember rightly, Wallenstadt. We found lodgings, and that same night we were joined by a Florentine courier called Busbacca. I had heard

him spoken of as being trustworthy and capable, and I was ignorant of the fact that his rascally behaviour had lost him this good reputation. When he saw me in the inn he called me by name, and then said that he was going on important business to Lyons, and he went on to ask if I would lend him some money for the journey.

I replied that I had no money to lend him, but that if he wanted to come along with me I would pay his expenses as far as Lyons. With tears in his eyes the rogue started spinning a fine yarn, saying that when a poor courier engaged on important affairs of state found himself in need of money, a Florentine of my rank was bound to assist him: and he added that he was carrying things of very great importance belonging to Messer Filippo Strozzi. He had with him a leather-covered case, and he whispered in my ear that there was a silver goblet inside, full of jewels worth many thousands of ducats, as well as letters of great importance sent by Filippo Strozzi.

When I heard this I told him that he should let me conceal the precious stones about his person, which would be far less risky than carrying them in the goblet; and that he could let me have the goblet, which must be worth about ten crowns, and I would give him twenty-five for it. In reply the courier said that there was nothing he could do except come with me, since it would be dishonourable for him to part with the goblet.

So we left it at that: and in the morning, after we had set out, we came to a lake, in between Wallenstadt and Wesen. It stretches a distance of fifteen miles to where it reaches Wesen. I grew frightened when I saw the sort of boats they had on this lake, because they are made of pine, they're small and insubstantial, and they are not caulked, let alone pitched. If I had not seen four German travellers embark on one of these boats, along with their horses, I would never have done so myself; I would in fact have turned back without hesitating. But seeing their rash folly I thought to myself that these German lakes could not drown people as our Italian ones could. All the same my two young companions said:

'Benvenuto, we'd be very rash to go with four horses on board a boat like this.'

'Haven't you cowards noticed that those four gentlemen have

embarked in front of us, and that they're moving off laughing?' I remarked. 'If this was wine, I'd reckon they were being merry at the thought of drowning in it; but seeing it's water I'm sure they're no more eager to drown than we are.'

The lake was fifteen miles long and about three across: one side was overshadowed by a high, cavernous mountain, the other was level and green. We had moved some four miles offshore when a storm began to blow up, and the rowers asked us to give them a hand; which we did for a while. I began to make signs to them and shouted that they should land us on the farther shore. They protested that it was impossible, as the water there was too shallow and there were shoals which would break up the boat and drown the lot of us. And they once more begged us to help them.

Then the boatmen started shouting to each other for help. When I saw what a sorry state they were in, as I had an intelligent horse I put the bridle round its neck and grasped the halter in my left hand. The horse, which had the instinct of its kind, seemed to understand what I meant to do: having turned its head towards the fresh grass, I wanted it to swim in that direction and to draw me after it. But just then a huge wave broke over the boat. Ascanio, crying: 'Mercy, father – help me!' was on the point of throwing himself on me, when I seized my little dagger and ordered them to follow my example. I shouted that the horses would save their lives, and that that was how I meant to escape too, but that if he clung to me again I'd kill him. So we battled forward several miles, in great danger.

When we were half-way down the lake we found a stretch of flat land where we could rest; and I saw that the four Germans had disembarked. When we wanted to do the same the boatman stubbornly refused; so I said to my young fellows:

'Now's the time to show them what sort of men we are. Draw your swords, and we'll compel them to put us ashore.'

They resisted strongly, but in the end with a great deal of effort we got our own way. Eventually we were landed, and then we had to climb two miles up the mountain-side, which was harder than climbing a ladder. I was wearing a complete suit of mail, with big boots, and a gun in my hand; and God was sending us all the rain He had. Those

German devils, holding the bridles of their little horses, were making stupendous progress, while our horses were completely useless for the job and we were cracking up under the strain of forcing them up that difficult climb. We had made a little progress when Ascanio's splendid Hungarian horse (Ascanio was just in front of the courier, Busbacca, and had given him his lance to carry for him) because of the treacherous going stumbled and staggered back. It was completely helpless, and then it impaled itself on the point of the lance held by that villain of a courier, who hadn't the presence of mind to get it out of the way.

It pierced the horse right through the neck. Then my other workman went to give a hand, when his horse, too, stumbled back towards the lake and was just saved by a very small bush. This horse, a black one, was carrying a pair of saddle-bags with all my money and other valuables inside it: I told the lad to save his own life and let the horse go to hell. From where we were it was a sheer fall of about a mile, straight into the lake. Directly below us was the place where the boatmen had stationed themselves, so if the horse had fallen it would have crashed straight on to them. I was in front, and we waited to see the horse hurtle down, certain in our minds that it was doomed.

Meanwhile I said to my young men: 'Don't worry about anything, let's save ourselves and thank God for it. I'm only upset about that poor fellow Busbacca having tied his goblet and those jewels of his, worth several thousand ducats, on to the horse's saddle-bow, reckoning it was the safest place. I've only a few hundred crowns there myself, and with God's help I'm not worried in the slightest.'

Then Busbacca cried: 'I'm not worried about my belongings, but I'm very upset about yours.'

'Why trouble yourself about my few belongings,' I said, 'and not about your own valuable things?'

'By God,' answered Busbacca, 'I shall have to tell you: in the sort of predicament we're in one has got to tell the truth. You've lost some crowns – and they're real crowns: I know that. But you know that goblet case that I said was filled with so many jewels, and that I lied about so much? Well, it's full of caviare.'

At this all I could do was laugh; my young friends burst out laughing

as well; and Busbacca wept. And then, after we had given it up for lost, the horse recovered its footing. So laughing away we pulled ourselves together and continued up the mountain. The four Germans had reached the top of that precipitous mountain before us, and then they sent down some men to give us a helping hand. At long last we reached that wild resting-place; and there, wringing wet, exhausted, and famished, we were given a wonderful welcome and were able to dry ourselves, have a rest, and satisfy our hunger. The wounded horse was cured by the use of certain herbs that we were told about. The hedges were full of this species of herb, and we were informed that if we kept the wound stuffed with it the horse would recover, and moreover serve us as well as if it had never been injured: and we followed these instructions. After we had thanked those gentlemen, feeling fully restored we set out again on the journey, thanking God for having saved us from such tremendous danger.

The next place we arrived at was beyond Wesen, and we spent the night there. All night long we could hear a watchman singing out the hours, in a very pleasant fashion. All the houses in the town were built of pine-wood, and so the watchman's only job was to warn against fire. Every time he sang, Busbacca, who had been badly shaken up by the day's events, groaned in his sleep and cried: 'Help! God! I'm drowning . . .' This was partly the result of his having been so terrified the day before; but besides this he had been drunk that evening because he had tried to outdrink all the Germans he could find. One minute he would scream: 'I'm burning!' and the next, 'I'm drowning!' And there were times when he dreamt that he was being tormented in hell, with the caviare hanging round his neck.

That night was so enjoyable that all our troubles were turned to laughter. Next morning we got up to find that the weather was perfect; and we went to eat at a charming little place called Lachen.

We were splendidly entertained there, and then afterwards we hired some guides who were on their way back to a town called Zürich. Our guide led the way along a causeway by the lake. There was no other road, and even the causeway was covered with water. As a result that idiot of a guide stumbled, and he and his horse went under water. I was immediately behind him: I pulled up my horse and then waited to

see the fool clamber out. As if nothing had happened he started singing again and beckoned me on.

At this I plunged off to the right, breaking through some hedges and showing the way to Busbacca and my young men. The guide shouted after us, in German, that if anyone saw me I'd be shot. But we rode forward and escaped that danger as well. Then we arrived at Zürich, a wonderful city, sparkling like a little jewel. We rested a whole day and were off again early next morning to another beautiful city called Solothurn. From there we went to Lausanne, from Lausanne to Geneva, and from Geneva to Lyons, laughing and singing all the way.

I stayed at Lyons four days, had a good time with some friends of mine, and was reimbursed what I had paid out for Busbacca. After the four days were up I took the road for Paris. It was an enjoyable journey, save for an incident near La Palice, when a band of robbers, the Adventurers, tried to murder us. But we fought them off boldly, and pushed on to Paris. We arrived there safely, singing and laughing all the way and not meeting with the slightest accident.

In Paris I rested for a time, and then I set out to find the painter, Rosso, who was in the King's service. I regarded this fellow, Rosso, as the best friend that I could have in the world, since when he was in Rome I had shown him every imaginable mark of kindness. I can sum up the generous way I treated him in a few words, so, to show up his brazen-faced ingratitude, I shall give an account of what happened.

Well then, in Rome his wicked tongue got him into trouble when he started belittling the work of Raphael of Urbino. Raphael's pupils were all set to kill him, and it was I who saved him from his deserts and guarded him night and day, at great inconvenience to myself. And then again, he slandered that excellent architect, Antonio da San Gallo,[181] and as a result Antonio had a commission that he had been given by Agnolo da Cesi taken away from him. Then Antonio began to persecute him so much that he brought him near to starvation. So I lent him a good few dozen crowns to live on.

He still owed me this money: and knowing that he was in the King's service I went along, as I said, to call on him. It was not so much that I expected him to pay me back my money, as that I was hoping he would use his influence to help me get into the King's service myself.

When he saw me he was quite disconcerted. The first thing he said was:

'Benvenuto, you've made your long journey at too great a cost, especially at this time when everyone is concentrating on war, rather than on our trifling efforts.'

In reply to this I said that I had brought enough money to take me back to Rome in the same way as I had come to Paris, that this was not the return I expected for the way I had put myself out for him, and that I was beginning to believe what Antonio da San Gallo had said about him. Realizing what a villain he appeared, he wanted to laugh the whole thing off; but then I showed him a letter of exchange for five hundred crowns on Ricciardo del Bene. The wretch was thoroughly ashamed of himself and was all for forcing me to stay; but I laughed in his face and went off with a painter who had been standing there.

This man, who was called Sguazzella,[182] was also a Florentine. I went to lodge in his house, with three horses and three servants, at so much a week. He looked after me very well, and I paid him even better. Later on I tried to get an interview with the King, and I was introduced to him by his treasurer, a certain Giuliano Buonaccorsi.[183] I had to wait a long time for this audience, and I was ignorant of the fact that Rosso was doing his best to prevent it. When Giuliano learnt about this, he immediately took me to Fontainebleau,[184] straight into the King's presence; and I was given a very gracious audience with him, lasting a whole hour. As the King was preparing to set out for Lyons he told Giuliano to take me along with him, and he added that on the journey we would discuss some works of art that his Majesty was thinking of commissioning.

So I went along, following in the train of the court, and on the road I paid great attention to the Cardinal of Ferrara,[185] who had not yet received his Cardinal's hat. I used to have a long talk with his Eminence every evening, and he told me that I ought to remain at his abbey in Lyons and enjoy myself there till the King came back from the war. He said that the King was going on to Grenoble, but that if I stayed at his abbey I would have everything I wanted.

When we reached Lyons I fell ill, and my young Ascanio was attacked

by the quartan fever: as a result I found myself growing sick of the French and of their court, and it seemed an eternity before I could be back in Rome. When the Cardinal saw I was anxious to return to Rome he paid me to make him a silver basin and jug once I was there. So we rode back towards Rome, on some splendid horses, by way of the Simplon, and for part of the journey accompanied by a few Frenchmen. Ascanio was suffering from his quartan fever, and I was ill with a persistent feverishness that seemed as if it would never leave me. My stomach was so queasy that for four months I believe I did not succeed in eating one loaf of bread a week. I was longing to return to Italy; wanting to die there, and not in France.

After we had passed the Simplon mountains we came to a river near a place called Indevedro. It was a very wide river, very deep, and over it there was a long, narrow bridge, without rails. There had been a thick white frost that morning; and after I had reached the bridge in front of the others, seeing how dangerous it was I ordered my young men and servants to dismount and lead their horses by hand. I crossed over safely and on the way fell into conversation with one of the two Frenchmen, who was a nobleman. The other, who was a notary, stayed some distance behind us and started making fun of the nobleman and myself because we had gone to the trouble of walking when there was nothing to fear.

At this I turned round, and seeing him half-way across I begged him to go carefully, as he was on a very dangerous part of the bridge. His French nature asserted itself and he shouted out in his French jargon that I was a coward and that there wasn't the slightest risk. Just as he was saying this he went to spur his horse on a little, and as a result the horse slipped over the edge, and with its legs pointing up towards the sky fell beside a huge rock. Since God is often merciful to fools, the beast – and the beastly fool who was riding it – were hurtled into deep water, and they both went under. As soon as I saw this, I began running as fast as I could, managed with some difficulty to leap up on to the rock, and leaning forward caught hold of a fold of the coat he was wearing: I pulled him up by it, for he was still under water. He had swallowed gallons of water and had just escaped drowning; so when I saw he was out of danger I began congratulating him on his good luck

in my having saved his life. All he did was to answer, in French, that I had done nothing and that what mattered were his documents, which were worth a good few dozen crowns. There he was talking angrily, all wet and spluttering!

At this I turned to the guides we had, and told them to help the fool, and that I would see them paid. One of them gave him a hand, and with great skill and effort salvaged the documents, so that not one was lost: but the other guide would not stir a finger.

We had, by the way, made a common purse, and I was in charge of it. So after we had arrived at the place I mentioned above and had eaten dinner, I gave some coins from it to the guide who had helped to draw him out of the river. At this he said that I could give the money out of my own pocket, since he had no intention of giving any more than we had agreed to pay the man for his services as a guide. This made me tell him what I thought of him. And then the other guide – the one who had made no effort at all – confronted me and wanted me to pay him as well.

'Only the man who has carried the cross deserves the reward,' I said.

He retorted that he would very soon show me a cross that would bring tears to my eyes; and in reply to that I said that in that case I'd light a bit of candle to it and trust that he would be the first to weep.

The place where we were was on the border between the Germans and the Venetians. The fellow ran off and came back leading a crowd of people, with a great spear in his hand. I was mounted on my splendid horse, and I lowered the muzzle of my arquebus. Then I turned to my companions and said:

'First, I'll kill him. The rest of you must do your duty as well, since they're highway murderers and have seized on this trivial pretext only to slaughter us.'

The owner of the inn where we had eaten called on one of the leaders, who was a fine old fellow, and begged him to put a stop to all the disorder.

'He's a very daring young man,' he said, 'and even if you were to succeed in cutting him to pieces he'd still kill a good few of you –

and perhaps, after doing his worst, slip through your hands after all.'

The tumult died down, and their old leader said to me:

'Go in peace: you would be hamstrung even if you had as many as a hundred men with you.'

I knew only too well that he was talking sense, and I had already made up my mind to die; but when I heard the insults die down I tossed my head and said:

'I'd have done all I could to prove to you that I'm very much alive, and that I'm a man to reckon with.'

Anyhow we continued our journey, and that evening, at our first resting-place, we settled our accounts. Then I parted company with that detestable Frenchman, though I remained on very good terms with the other, the nobleman. We went on by ourselves to Ferrara, my three horses with us.

After I had dismounted I went along to the Duke's court to pay my respects to his Excellency, so that I could leave next morning for Santa Maria da Loreto. I waited till two hours after nightfall, and then the Duke appeared. I kissed his hands, and, giving me a very affectionate welcome, he gave orders that I should be brought water for my hands. Then I said to him with a smile:

'My lord, for over four months now I've eaten so little that one would hardly think I could have remained alive. So as I know I couldn't enjoy the food on your royal table, I shall stay and talk with you while your Excellency is having supper; and both of us will enjoy ourselves at the same time, much more agreeably than if I were to eat with you.'

So we started talking to each other, spending the next three hours together in that way. Then I took my leave and went back to the inn, where I found a wonderful feast waiting for me: the Duke had sent me plenty of good wine and what remained of the food from his own table. So as it was more than two hours after the time I usually ate I did so with a great appetite; and it was the first time for over four months that I had been able to.

Next morning I left for Santa Maria da Loreto;[186] and from there, after I had made my devotions, I journeyed to Rome,[187] where I found my faithful Felice.[188] I made him over the shop, with all its furniture

and goods, and opened another next door to Sugherello the perfumer: it was bigger and more spacious. I reckoned that the great King of France would forget all about me, so I undertook a great deal of work for various noblemen, and besides this I worked away on the jug and basin that the Cardinal of Ferrara had commissioned.

I employed a whole crowd of workmen, and I did a good trade in gold and silver work. I had agreed with my Perugian workman that he should himself keep a note of all that was spent on him – for clothing and many other things – and this, together with the expenses of the journey, came to about seventy crowns. We had also agreed that he should work off his debt by paying three crowns a month, since he was able to earn more than eight crowns through me. At the end of two months the rogue ran off, leaving me in the shop overwhelmed with work, and said that he refused to pay any more.

I was advised to seek redress by legal means, though my immediate impulse was to cut his arm off: and I would certainly have done so if my friends had not persuaded me that it was not worth while, since I would only lose my money, and perhaps once again lose Rome. There is no knowing what will happen in a fight, they said, but on the other hand, with the agreement I had, written in his own hand, I could have him arrested at once. I took their advice, even though I wanted to settle the matter in my own way. In fact I brought the case before the auditor of the Camera, and I won it. It took several months, but the upshot was that I had him imprisoned.

Then I was overwhelmed with important commissions: among other things, I had to take in hand all the gold and jewelled ornaments for the wife of Signor Gerolamo Orsino,[189] father of Signor Paulo, who today is the son-in-law of our Duke Cosimo. These were nearly finished, but important work was heaped on me without respite. I had eight workmen, and all of us, for the sake of reputation and profit, worked day and night.

While I was so energetically employed I received a letter, dispatched in great haste, from the Cardinal of Ferrara. It read as follows:

'Benvenuto, our dear friend. During these past few days the great and most Christian King remembered you and said that he wished to have you in his service. I told him in reply that you had promised to

return without delay, whenever I should send for you on his Majesty's behalf. At this his Majesty said that you must be sent whatever was necessary for the journey, and that it should be what a man of your sort deserved: and then straight away he ordered his Admiral to have me paid a thousand gold crowns from the Exchequer. Cardinal de' Gaddi, who was present when this conversation took place, immediately made his way forward and told his Majesty that there was no need for him to give that order, because, he said, he had sent you enough money and you were already on your way. Now if, by chance, the contrary to what he said is true – and I suspect that this is the case – reply to my letter at once, and I shall pick up the thread and have you sent the money that our magnanimous King promised.'

Now let the whole world and all mankind witness how powerful adverse fortune and the malignant stars are in acting against us human beings! In all my life I had not addressed more than a couple of words to that wretched little idiot of a Cardinal; and this presumption of his was not meant to do me any harm, but was merely the consequence of his soft-headed ignorance, as he wanted to show that he too, like the Cardinal of Ferrara, had dealings with the great artists whose services were wanted by the King. But then, having done that, he was so stupid that he didn't say a word to me; for certainly, for love of our native place, in order to let the idiotic simpleton escape blame I would have found some excuse to cover up his brainless conceit.

As soon as I received the letter from his Eminence the Cardinal of Ferrara, I replied that I had heard nothing at all from Cardinal de' Gaddi, and that even if he had written to me about the matter I would not have left Italy without his Eminence's knowing, especially as I had far more business on hand in Rome than I had ever had before. But, I added, a word from his most Christian Majesty, sent me through such a lord as his Eminence, would make me move off at once, and I would abandon everything to look after itself.

After I had sent this letter that treacherous Perugian workman of mine hit on a piece of malice that succeeded at once, partly because of the avarice of Pope Paul Farnese, but mainly because of his bastard son, who was then called the Duke of Castro.[190] The workman gave one of Pier Luigi's secretaries to understand that, as he had been employed

by me for several years, he knew all my business: so he could swear to
Signor Pier Luigi that I was worth more than eighty thousand ducats,
and that most of this wealth consisted in precious stones which were
the property of the Church. He said that I had stolen these in Castel
Sant'Angelo, at the time of the sack of Rome; and he urged that I
should be arrested swiftly and secretly.

One morning I had been working since three hours before dawn on
the ornaments for that bride[191] whom I mentioned; and then, while
the shop was being opened and cleaned out, I had put on my cloak to
go out for a short walk. I went along Strada Julia and came out at the
corner of the Chiavica. Then Crespino, the chief constable, with all
his men came up to me and said:

'You're the Pope's prisoner!'

I replied: 'But Crespino, you've arrested the wrong man.'

'No,' he answered, 'you're the artist, Benvenuto, and I know you
only too well: and it's my duty to take you along to Castel Sant' Angelo
– that's where noblemen and artists of your kind go.'

Then four of his men flung themselves on me and tried to seize by
force the dagger I had at my side and some rings I wore on my finger.

But Crespino said to them: 'None of you touch him! You must just
do your duty and see that he doesn't escape.'

Then he came up to me and asked me politely to surrender my
weapons. While I was doing so the thought struck me that I was
standing exactly on the spot where I had killed Pompeo. They led me
away to the castle, and locked me up as a prisoner in a room at the top
of the keep. This was the first time, in all my thirty-seven years, that I
had ever had a taste of prison.

When Signor Pier Luigi, the Pope's son, reflected what a great sum
it was that I had been accused of stealing, he at once asked his father
to let him have the money as a gift. The Pope readily agreed, and added
that he would help recover it himself. So after I had been kept in prison
for a whole week, to get the affair over and done with they sent for
me to be examined. I was summoned into one of the great halls of the
Papal castle, a very impressive place. The examiners were the Governor
of Rome, a Pistoian called Benedetto Conversini,[192] who afterwards
became Bishop of Jesi; the Procurator Fiscal, whose name I forget; and,

thirdly, the judge of the criminal court, who was called Benedetto da Cagli.

The three men began the examination very gently, but then they started threatening me brutally because I said to them:

'My lords, for more than half an hour you've not stopped questioning me about some fantastic story or other; one could in fact say that you're babbling, or rambling.[193] By babbling, I mean, that you're talking nonsense; by rambling, that you're saying nothing at all. So please tell me what you want from me and let me hear you talk sense instead of all this fantastic babbling.'

In reply to this the Governor, who was from Pistoia and could no longer conceal his violent nature, cried out:

'You're very sure of yourself, in fact you're too presumptuous altogether: I'll have you crawling like a puppy when you hear what I have to say. And it won't be a question of babbling nonsense, as you call it, but a chain of reasoning that'll force you to try and explain yourself.'

Then he started as follows:

'We know for certain that you were in Rome at the time when that unfortunate city was sacked; and you were then in Castel Sant' Angelo, employed as a gunner. Since you're a goldsmith and jeweller, Pope Clement, because he had known you before and because there was no one else of your trade available, took you into his confidence and got you to remove from their settings all the jewels out of his tiaras, and his mitres, and his rings. Then, as he trusted you, he asked you to sew them into his clothes; and while you were doing so, without his Holiness knowing you helped yourself to some of them, to the value of eighty thousand crowns. You gave this away to one of your workmen and boasted about it, and it was he who told us what had happened. Now, we order you plainly – find the jewels or bring what they're worth, and then we shall let you go free.'

When I heard this all I could do was roar with laughter. Then, when I managed to control myself, I said:

'I thank God for the fact that now, when for the first time the Almighty has seen fit to have me imprisoned, it hasn't been the result of some indiscretion such as usually gets young men into trouble. If

what you said were true then there'd be no risk of my being given corporal punishment for it, since at that time the laws were suspended: and I could therefore have excused myself by saying that, as an official, I might guard the treasure for the Sacred and Holy Apostolic Church till the time came for me to return it to a good pope – or as a matter of fact to the man who asked me for it, who if there were any truth in the story would be you.'

Then, refusing to let me finish my defence, that raving Pistoian Governor broke in angrily:

'Dress it up how you like, Benvenuto, all we want is what belongs to us. So be quick about it or we'll give you something more than words.'

They prepared to stand up and leave, but I said:

'My lords, I'm still being examined; so please finish the business, and then go where you please.'

They at once resumed their seats, but they were furiously angry with me and they made it seem that they had heard enough and were almost convinced that they had found out all they wanted to know. Then I began talking to them.

'My lords,' I said, 'you must know that I've lived in Rome for about twenty years, and neither here nor anywhere else have I ever been imprisoned . . .'

At this that police hound of a Governor called out: 'But you've got some murders to your credit.'

'You say so, not I,' I retorted. 'And anyway, if someone tried to kill you, priest as you are you'd defend yourself: and if you killed him, God's laws would justify you. So – if you want to let the Pope hear your report and to give me a fair hearing – let me go on with my defence. I repeat, I've been living in this wonderful city of Rome for nearly twenty years, and during that time I've produced some very great works of art: and as I know that this is the seat of Christ, I have always assured myself that if a temporal prince meant to harm me unjustly, I could go for protection to the Sacred Throne and to the Vicar of Christ, who would defend my cause. Now, heaven help me, where can I go now? What prince will defend me from such a treacherous attack? Before you arrested me shouldn't you have found out where I

had disposed of those eighty thousand ducats? And shouldn't you have inspected the record of jewels that has been so carefully kept by the Apostolic Camera for the past five hundred years?

'And if, after that, you had found something missing, you ought to have seized my accounts as well as me. I can tell you that the books which contain a list of all the jewels of the Pope and all the regalia are quite in order; and you won't find any that belong to Pope Clement missing, unless the fact is carefully noted. There is just one thing: when that unhappy man, Pope Clement, wanted to make peace with those thievish Imperialists, who had despoiled Rome and spat at the Church, a man called Cesare Iscatinaro[194] came, if I remember rightly, to negotiate the treaty; and when he had almost finished his discussions with that maltreated Pope, to show him a mark of affection the Pope let fall from his finger a diamond ring that was worth about four thousand crowns; and as Iscatinaro bent down to pick it up the Pope told him to keep it for his sake. I was present when that happened: and if the diamond is missing I've told you where it went. But I'm perfectly certain you'll find even that has been noted.

'So you can go off and blush at the unjust way you've attacked a man of my sort, a man who has done such great things for the Papal throne. I can tell you that, if I weren't the man I am, the morning when the Imperial troops entered the Borgo they would have penetrated the castle without any opposition. It was me – and I got no reward for what I did – who rushed up without hesitation to the guns which had been abandoned by the bombardiers and the garrison soldiers; and I inspired one of my comrades, Raffaello da Montelupo,[195] a sculptor, who had also deserted his post and gone to hide in a corner, where I found him useless and terrified. I pulled him together, and we two by ourselves killed so many of the enemy that eventually their troops had to go by another road.

'I was the man who let fire at Iscatinaro, for talking disrespectfully to the Pope, with brutal insolence, like the Lutheran and infidel that he was. When this happened Pope Clement had the castle searched, to discover and hang the man who did it. I was the man who shot and wounded the Prince of Orange in the head, there down below the castle's trenches. Besides this, how many gold and silver and jewelled

ornaments, how many beautiful, famous medals and coins haven't I made for the Holy Church! And now, is this the outrageous reward that you priests give to a man who has served and loved them so well and faithfully? All right then, go and tell everything I've said to the Pope, and add that, as for his jewels, he has got every one of them, and that I've never had anything from the Church except the wounds and stonings that I suffered when Rome was sacked; and say that I never built my hopes on anything, except a small reward that Pope Paul had promised me. Now I'm quite clear both about his Holiness and about you, his servants.'

They had been waiting for me to finish, thunderstruck at what they heard; and then, exchanging glances, they left in astonishment. All three of them went along together to let the Pope know all I had said. Feeling ashamed of himself the Pope ordered a very careful scrutiny of the records. Then, when it was found that not one of the jewels was missing, they let me linger on in the castle, without saying a word. Even Signor Pier Luigi reckoned that he had made a bad mistake; and then everything possible was done to bring about my death.

These things had been going on only a short while, but King Francis had already been given a detailed account of the grossly unjust way the Pope was holding me prisoner. He had sent one of his noblemen, Monsignor di Morluc,[196] as ambassador to the Pope, and so he wrote telling him to ask the Pope to hand me over, as I was one of his Majesty's men. The Pope was a wonderfully able man, but as far as I was concerned he behaved like a petty fool, and he replied to the ambassador that his Majesty shouldn't worry about me since I was always provoking armed fights; and so he advised his Majesty to ignore me, seeing that I was held a prisoner because of the murders and the other devilish crimes I had committed.

The King sent back word that in his kingdom he dispensed perfect justice, and that in the same way as he heaped magnificent rewards and favours on talented well-behaved men, so, on the contrary, he chastised the unruly. He added that as his Holiness had not cared a jot about Benvenuto's service and had let him leave, when he saw him in his kingdom he, the King, had been only too glad to take him into his service. And so he demanded that I should be handed over, as one of his men.

All this caused me a great deal of harm and a great deal of trouble, for all that it reflected the most notable favour that a man of my sort could possibly desire. The Pope was thrown into such a rage because of his worry that I might go off and tell how wickedly and brutally he had treated me that he started thinking up all the methods he could use to ensure my death without injuring his own reputation.

The castellan of Castel Sant'Angelo was one of our Florentines, called Messer Giorgio, and he was a knight of the Ugolini family.[197] This excellent man was courteous beyond belief; he let me go about the place freely and the only restraint put on me was my own word of honour. As he knew how shamefully I had been wronged, when I wanted to give him some security for my being able to come and go as I liked he refused to accept, since, he said, the Pope took my case far too seriously; but he added that he would be only too glad to accept my word, as everyone told him that I was an honest man. So I pledged my word; and he made it possible for me to keep my hand in at my trade.

At this, in the belief that, because of my innocence as much as because of the good offices of the King, the Pope's anger would blow over, I kept the shop open; and my apprentice, Ascanio, used to visit the castle and bring me things to work on. Although there was little I could do, seeing the way I was imprisoned so unjustly, all the same I made a virtue of necessity and put up with my misfortunes as cheerfully as I could. I had won the friendship of all the warders and many of the soldiers in the castle. Now and then the Pope used to have supper there, and on these occasions there were no guards on duty and the place remained open to the world like an ordinary palace. For as long as he was there, all the prisoners used to be confined with greater strictness than usual: but nothing of this sort was done to me, and in fact I used to walk about the castle as I liked. More than once some of the soldiers advised me to make my escape, and knowing how greatly I had been wronged offered to give me a hand. I told them that I had pledged my word to the castellan, who was an admirable man and had done a great deal to help me. Among them there was a very bold, intelligent soldier, who said to me:

'My dear Benvenuto, don't you know that anyone who's a prisoner

needn't and can't be forced to keep his word, or anything else. Do as I tell you: make your escape from this villain of a pope and his bastard son, who are set on having your life.'

But my mind was made up that I would rather lose my life than break faith with that admirable castellan; and so I endured my suffering, along with a friar who belonged to the Pallavicini family[198] and was a very great preacher.

This man had been seized as a Lutheran; as a friend and companion he was first-rate, but as a friar he was the wickedest rogue in the world, and he practised every kind of vice. I admired his fine virtues but I detested his bestial vices and openly reproached him about them. He never did anything except remind me that, since I was a prisoner, I wasn't bound to keep faith with the castellan. My reply to this was that it was true enough for a friar, but that it didn't apply to a man; anyone who was a man rather than a friar, I said, had to keep his word no matter what circumstances he found himself in; and therefore, seeing that I was a man and not a friar, I would never go back on my simple word of honour.

When the friar realized that he could never succeed in corrupting me by means of the subtle sophistries he employed so skilfully, he thought of tempting me some other way. He waited till a few days had passed, and during that time he read me the sermons of Girolamo Savonarola: his splendid commentary on these was more impressive than the sermons themselves. I was utterly spellbound, and in fact except, as I said, for breaking my word there was nothing in the world I would not have done for him. When he saw how amazed I was at his ability, he thought up another approach. In a very specious way he began to ask me what I would have done, supposing I had the desire, if they had locked me up and I wanted to break out and escape.

At this, as I wanted to show this brilliant friar that I too was sharp-witted, I told him that I would certainly find no trouble in opening the most complicated locks, especially those of the prison, which would be as easy as eating a piece of new cheese.

Then the friar, in an attempt to worm the secret out of me, started jeering: he said men who had established a reputation for being intelligent had often said things of that sort, but that if they had to put their

boasting into effect they'd lose their reputation and never recover it. He added that the things I had said were so incredible that if I were put to the test I'd survive with very little credit. When this devil of a friar had put my back up in this way, I told him that I was in the habit of claiming in words much less than I could do in fact, and that what I had claimed with regard to the keys was the easiest thing in the world. It would only take me a few words, I went on, to make him fully realize how right I was. Then without thinking I showed him how easy it was to do everything I had said. The friar pretended that he wasn't taking any interest; but in less than no time, very cunningly, he had a thorough grasp of the matter.

As I said before, that admirable castellan let me roam at will throughout the castle, and even at night he did not lock me in like the others. He also allowed me to work at whatever I wanted, whether in gold or silver or wax. In fact for some weeks I had been working on a bowl that I was making for the Cardinal of Ferrara, but my imprisonment grew so tiresome that I became quite sick of what I was doing, and so to relieve the strain all I did was work on some little wax figures. The friar stole some of this wax, and with it he began getting the keys made in the way I had so thoughtlessly shown him. As friend and accomplice he had one of the castellan's clerks, a Paduan called Luigi.

But when he tried to get the keys made the locksmith betrayed them. As it happened the castellan used to come and inspect my room, and on one of these occasions, when he saw the kind of wax I was using, he recognized it. This led him to say that 'although poor Benvenuto has suffered an outrageous wrong, he ought not to have treated me like this, especially as I showed him more kindness than I should have done'. He added that in future he would keep me strictly confined, and that he would never again do me the slightest favour.

So he had me locked up, and it was all very unpleasant: especially in view of what some of his devoted servants said to me. They were very fond of me, in fact, but now they reproached me with all the kindness that the castellan had shown me, and called me ungrateful, untrust-worthy, and faithless. One of these servants overstepped the mark with his insults, and knowing that I was innocent I retorted heatedly that I never failed to keep my word, that I would sacrifice my life to prove

the truth of this, and that if he or anyone else continued to fling such insults at me I would call them to account for their lies.

He found this attack so intolerable that he ran to the castellan's room and returned with the wax and the model that had been made for the keys. As soon as I saw the wax I told him that we were both in the right, but that he should let me talk to the castellan, and I would explain to him the truth of the whole matter – which was much more important than they thought. The castellan sent for me at once, and I told him all that had happened. As a result he confined the friar more strictly; the friar denounced the clerk; and the clerk came near to being hanged. The castellan hushed the thing up, but it had already come to the ears of the Pope. However, he saved his clerk; and he allowed me the same freedom as before.

When I saw the rigorous measures that were taken I began to think things over.

'If there were another outburst like that,' I said to myself, 'and that man lost confidence in me, I would no longer regard myself as being under any obligation: I'd do a little hard thinking, and I'm sure that it would bring me more success than that rogue of a friar had.'

After this I began to get them to bring me some new, coarse sheets and I did not send back the soiled ones. When my servants asked me for them, I told them to keep quiet about it, as I had given them to some of those poor soldiers, and if this were found out the unlucky fellows would risk being sent to the galleys. So my young men and servants – especially Felice – kept this business of the sheets a close secret. The next thing I did was to empty a mattress, and I was able to burn the straw because there was a fire-place in my cell where I could set light to it. Then I began to cut the sheets into strips, about a third of a cubit wide: and then, when I reckoned I had made enough to descend from the great height of the keep of Castel Sant'Angelo, I told my servants that I had given away all I wanted to, and that from now on they were to bring me better quality sheets and I would always return the soiled ones. The whole incident was forgotten.

Cardinal Santiquattro[199] and Cardinal Cornaro made my workmen and servants close down my shop, and they told me frankly that the

Pope had not the slightest intention of letting me go, and that the great favours shown me by the King had done more harm than good. The last words that Monsignor di Morluc had said on behalf of the King had been that the Pope should hand me over to the ordinary court judges, and that if I had done wrong he could punish me, but that if I had not done wrong justice demanded that he should set me free. This had so enraged the Pope that he had made up his mind never to set me free. But I must say that the castellan helped me as much as possible.

Meanwhile when my enemies saw that my workshop had been closed down not a day went past without their insulting and jeering at my servants and friends, who used to visit me in prison. On one of those occasions it happened that Ascanio, who was in the habit of coming to see me twice a day, asked me if he could have a jacket made for himself out of a blue satin cloak of my own that I never used: I had only once made use of it when I wore it in that procession. In reply I told him that neither the time nor the place was suitable for wearing such clothes. The young fellow was so hurt at my not giving him the wretched stuff that he said he wanted to go home to Tagliacozzo. I lost my temper and said that I would be glad to get rid of him; and he swore vehemently that he would never set eyes on me again. While we were arguing we were strolling round the keep of the castle. The castellan also happened to be taking a walk there, and when we ran into him Ascanio said:

'I'm leaving you then – for ever!'

'I hope you're right,' I replied, 'and that it is for ever. I shall tell the guards never to let you in here again.'

Then I turned to the castellan and begged him urgently to order the guards never to let Ascanio through again.

'My troubles are bad enough already,' I said, 'and this silly little peasant only comes to add to them: so I beg you, my lord, never let him in again.'

The castellan was very upset at this, because he knew that Ascanio was wonderfully talented, and besides this the young man was so handsome that it seemed impossible for anyone to set eyes on him without immediately being greatly attracted towards him. The young

fellow went away with tears in his eyes. He was carrying with him the little scimitar that he sometimes wore hidden under his clothes.

As he left the castle, his face wet with tears, he ran into two of my worst enemies, the Perugian, Jeronimo, whom I've mentioned before, and a certain Michele: they were both goldsmiths. This Michele, who was a friend of that Perugian ruffian and an enemy of Ascanio's, said:

'What's Ascanio crying for? Perhaps his father is dead? You know – his father is in the castle.'

'He's alive,' shouted Ascanio, 'but you're going to die this instant.'

Then he lifted his hand and aimed two blows with the scimitar, straight at his head. The first knocked him down, and with the second, though he was aiming at his head, Ascanio cut three fingers off his right hand. He lay stretched out as if dead. The Pope was at once informed of what had happened, and he said in a terrible fury:

'Since the King wants him to be tried, go and tell him he has three days to prepare his case.'

The Pope's order was carried out at once; and then straight away that admirable castellan went along to the Pope and made it clear that I knew nothing of what had taken place, and that I had just driven Ascanio away. He defended me so skilfully that he averted that tremendous fury and saved my life. Ascanio fled home to Tagliacozzo, and from there he wrote to me begging forgiveness a thousand times, saying that he had been wrong to add to my troubles, but that if God allowed my release from prison he would never leave me again. I wrote back saying that he must carry on learning his trade, and that if God gave me my freedom I would certainly send for him.

Every year the castellan used to be attacked by a disorder that sent him mad; and when it began to come on him he used to talk, or rather babble, without stop. And every year his delusions took a different form: one year he imagined that he was an oil-jar; another year he thought he was a frog, and went jumping about like a frog; another time he was convinced he was dead, and they had to bury him. Every year one or other of these delusions seized him. This time he began to imagine that he was a bat, and so when he was out walking every now and then he would give a high-pitched squeak like a bat and move his

arms and body as if he wanted to fly. When they saw what was coming his doctors and his old servants offered him every pleasant distraction they could think of; and as they believed he was very fond of hearing me talk they were always coming in for me to keep him company.

Sometimes the poor man would keep me four or five hours, without my once being allowed to let the conversation flag. I used to eat at his table, sitting opposite him, and he never left off talking himself and making me talk: but during these conversations I used to eat very well. As for him, poor fellow, he neither ate nor slept; and the result was that he wore me down till I was completely exhausted. Sometimes when I stared at him I saw a horrible look in his eyes, with one of them turned in a different direction from the other.

He began to ask me if I had ever had a fancy to fly. I replied that I had tried to do, and done, all those things that men found most difficult; and as for flying, I said that the God of nature had endowed me with a body that was unusually agile and capable of running and leaping exceptional distances, and that I would be able to make use of the little skill I had in my hands, and so I certainly had it in me to fly.

Then he started to question me as to how I would do it. I replied that when I considered what animals were able to fly, with the idea of imitating by art what they had from nature, there was none I could possibly imitate except the bat. As soon as the poor man heard me say bat, which tied up with the delusion he had fallen into that year, he started shrieking: 'He's right, he's right! That's it, that's it!'

Then he turned to me and said: 'Benvenuto, if you were given the chance, would you be brave enough to fly?'

I answered that if he would give me my freedom afterwards I was up to flying as far as Prati, on a pair of wings made of waxed linen.

He replied: 'And I'd have it in me to do the same: but as it happens the Pope has given me orders to guard you as carefully as if you were his own eyes; and I know you're a clever enough devil to escape, so I'm going to confine you behind a hundred locks to prevent your running away from me.'

At this I began to plead with him, reminding him that I could have escaped but that because I had given my word of honour I would never have broken faith with him. I begged him for the love of God, in view

of all the kindness he had shown me, not to add a greater burden to what I was suffering already. While I was talking he gave strict orders that I was to be tied up and taken to a strongly-barred cell. Realizing that there was no help for it, I told him, in the presence of all his attendants, that he should lock me up carefully and guard me closely, because I would do all I could to escape. Then they led me away and confined me with the most elaborate precautions.

After this I began to plan how I would have to make my escape. As soon as I saw myself shut in I went round examining the cell. When I thought I had found the way to get out I began to consider how I could descend from the great height of the keep, as that huge tall tower is called. I took my new sheets which, as I have already said, I had cut up and sewn securely together, and started to work out how much I would need to make the descent. When I had calculated the length I needed and got everything ready, I found a pair of pincers, which I had taken from a Savoyard who was one of the castle guards.[200]

This fellow was in charge of the pipes and cisterns, and he also did woodwork as a hobby; he had several pairs of pincers, one of them very large and solid. Thinking that it would suit my purpose, I filched it from him and hid it inside the straw mattress. When the time came to make use of it, I began to try the nails that fastened the iron bands. As the door was a double one it was impossible to see where the nails were clinched; so when I tried to draw one out I found it very hard going. But in the end I succeeded. After I had drawn out this first nail, I tried to think what I should do to prevent it being noticed. Straight away I mixed a few rusty iron filings with a little wax, so that it was exactly the same colour as the heads of the long nails that I had extracted. Then, with the wax, I started to imitate the nail heads on the iron bands; and one by one I substituted a wax counterfeit for as many as I had drawn out.

I left the bands, each attached at the top and bottom by some of the nails that I had extracted and then cut short before replacing. When I put them back gently the nails just secured the iron bands in place. All this proved a very tricky business because every night the castellan used to dream that I had escaped, and as a result every now and then he had my cell inspected.

The fellow who came to do this had the name and attitude of a typical policeman. He was called Bozza, and whenever he came he brought along with him another man, Giovanni, nicknamed Pedignone: he was a soldier, while Bozza was a servant. This Giovanni never once entered my cell without insulting me. He came from the Prato district where he had been in a chemist's shop. Every evening he would inspect the hinges on the door and the entire cell, very carefully, and I used to say to him: 'Have a good look, because I've made up my mind to escape no matter what happens.'

These words made us bitter enemies. So I took great care to hide all my tools in my mattress – that is to say, my pincers, and a fine big dagger, and the other things of the same sort; they were all there, carefully hidden away. And I kept my strips concealed in the mattress as well. I used to sweep my room out myself as soon as it was daybreak; and, although I am naturally fond of cleanliness, at that time I was unusually meticulous. After cleaning up I used to make my bed very neatly and place some flowers on it. I had these brought to me by a certain Savoyard; he was in charge of the pipes and the cisterns, and he was also very keen on woodwork. And it was from him that I stole the pincers that I used to draw out the nails from their hinges.

To get back to the bed: when Bozza and Pedignone came in, all I used to do was to tell them to keep themselves away from my bed so as not to dirty it and spoil it for me. Sometimes, when they used to touch the bed very lightly just to provoke me, I would shout:

'You filthy cowards! I'll grab one of your swords and give you a whack that you won't forget in a hurry. Do you think you're worthy to touch the bed of a man of my sort? I don't mind risking my life, since I'll have yours first. So leave me alone with my suffering and misery and don't add any more burdens to the ones I have already, or else I'll show you what a desperate man can be driven to.'

They reported all this to the castellan, who gave them explicit orders never to go near my bed and not to wear swords when they came to see me; but otherwise, he said, they were to keep a close watch on me. When I had made sure about the bed I thought I had done everything, since the whole enterprise depended on that.

One evening, it was a feast day, the castellan felt very ill-disposed

and all his fantasies began to gain ground: all he would say was that he was a bat, and that if they heard that Benvenuto had flown away they should let him go too, because he would certainly be able to fly better than me by night, and so he would catch me up.

He kept saying: 'Benvenuto is a fake, but I'm a real bat: and as he's been given me to guard, let me see to it and I'll catch him.'

He had been in this state for several nights, and he had utterly exhausted all his servants. I got to hear everything through various channels, especially through that Savoyard who was very friendly towards me. That evening, then, I made up my mind that I would escape at all costs. First, I prayed very devoutly to God: I asked His Divine Majesty to defend and help me in such a perilous undertaking. Then I got hold of everything that was necessary, and worked away all through the night.

Two hours before daybreak, after tremendous efforts, I removed the iron bands: but the wooden door and the bolt offered such great resistance that I couldn't open it. I had to cut into the wood, but eventually I succeeded. Then I picked up the strips, which I had wound round two pieces of wood, like thread round a bobbin, and went out towards the latrines of the keep. From there I caught sight of two tiles on the roof, and straight away jumped on to them without difficulty. I was wearing a white doublet, a pair of white stockings, and also a pair of tall boots, into one of which I had slipped the dagger that I mentioned before. Then I took one end of the strips and tied it to a piece of ancient tile that was built into the wall of the keep: as it happened the tile jutted out a little, just under four fingers. I arranged the strip like a stirrup. After I had attached it to the tile, turning towards God I said:

'Lord God, help me in this endeavour because, as You know, I have justice on my side, and I'm helping myself.'

Then I let myself go, very, very gradually, letting my arms take the strain, till I reached the ground. There was no moonlight but the sky was brilliantly clear. When I reached the ground, I stared up at the great height I had descended so boldly; and then, thinking myself free, I moved away with a light heart.

But I was mistaken, because the castellan had had built on that side

two very high walls, to enclose a stable and poultry-yard; the place was closed by two heavy bolts on the outside. Seeing that it was impossible to get out, I was seized with fury. While I was pacing backwards and forwards, wondering what to do, I stumbled on a pole that was covered over with straw. With a great effort I propped it against the wall, and then, using all the strength in my arms, I climbed up it to the top. As the wall was sharply ridged I couldn't muster enough strength to pull the pole up after me. So I decided to make use of one of the strips that I had wound round the second reel. I had left the other one attached to the keep. So, as I said, I took a length of the strip, tied it to the beam, and climbed down the wall. I was thoroughly exhausted and worn out, and as well as this I had torn the palms of my hands and they were bleeding. So I took a rest, and bathed my hands in my own urine. After a while, when I thought my strength had returned, I moved quickly on to the last wall that looks towards Prati: then I arranged my bundle of strips, intending to attach one end to a battlement so that I could descend this lesser height as I had done the greater one.

I had just arranged my strips, when I discovered that one of the sentries was behind me, on guard duty. Realizing that my plan was threatened and my life in danger, I decided to confront him. When he saw the determined look on my face, as I walked up to him holding a weapon in my hand, he quickened his step to keep out of the way. I had come some way from my strips, so I walked rapidly back; and although I saw another sentry it seemed that he didn't want to see me. When I reached my bundle I tied the strips to the battlement and let myself go.

On the way down, either because I really thought I was near the ground and so let go with my hands to jump, or else because my hands were so worn out that the strain was too much for me, I fell and struck the back of my head as I hurtled down. As far as I can judge I remained stunned for more than an hour and a half.

Then, when daybreak was approaching, the slight freshness that comes an hour before sunrise revived me; but I was still dazed, imagining that my head had been cut off and that I was in purgatory. Then, little by little, my faculties were restored, I noticed that I was outside the

castle, and all at once I remembered everything I had done. I became aware of the blow to the back of my head before I realized that my leg was broken; I put my hands to my head and drew them away covered with blood. Then I examined myself carefully and came to the conclusion that no great harm had been done. But when I went to get up I found my right leg broken three inches or so above the heel. Even that didn't dismay me: I drew out my dagger, together with the sheath which was tipped at the end with a heavy, solid ball. This was the cause of my leg's having been broken, since the bone had been forced against it and, being unable to bend, had snapped.

I threw the sheath away, used the dagger to cut off a piece of the strips that I had left, and bound up my leg as best I could. Then, holding the dagger, I went on hands and knees towards the gate, only to find it was shut. However I noticed a large stone just under the gate which did not seem to be very firmly wedged. I tried to shift it; I put my hands to it and felt it move, and then it came away easily and I drew it out. Finally I crawled through the gap I had made.

From where I fell from the wall to the gate where I entered Rome had been a distance of over five hundred yards. When I entered the city some mastiffs hurled themselves at me and started biting savagely. They came back several times, and kept on worrying me till I struck at them with my dagger and wounded one of them so severely that it howled with pain. The others, following their instincts, ran up to it, and I struggled on towards the church of the Traspontina, still on all fours.

When I arrived at the top of the street which leads to Sant'Angelo I took the road towards St Peter's, because the sky was lightening above me and I realized that things would get dangerous. Then I ran into a water-carrier, who had his donkey loaded with pitchers of water. I called him over and begged him to lift me and take me up to the top of the steps of St Peter's.

'I'm an unlucky fellow,' I said to him, 'I was trying to get down from a window after an amorous adventure when I fell and broke a leg. The place I came from is a very important establishment, and I'm running the risk of being cut to pieces. So please lift me up quickly, and I'll give you a gold crown.'

I shook my purse, which was fairly full, and straight away he took hold of me and was only too pleased to put me on his back. Then he carried me up to the top of the steps of St Peter's, where I made him leave me and told him that he should run back to his donkey. Still on my hands and knees I at once set off again, going this time towards the house of the Duchess:[201] she was the wife of Duke Ottavio, and the daughter of the Emperor – a natural, not a legitimate, daughter – and she had been the wife of Duke Alessandro of Florence.

I went to her, since I knew for certain that she had round her a large number of my friends who had accompanied her from Florence, and also I was in the good books of this great princess because of the efforts of the castellan. In his anxiety to help me he had told the Pope that when the Duchess made her entry into Rome I prevented more than a thousand crowns' worth of damage. What had happened, he said, was this: there had been a heavy rainstorm and he was in despair, when I revived his spirits by directing several pieces of artillery towards where the clouds were thickest and where it was already raining heavily: I began to fire the guns, the rain stopped, and at the fourth salvo the sun came out. So, he added, it was entirely because of me that the festival had been a success. When she heard this the Duchess was led to remark:

'This Benvenuto was one of those artists whom my husband, Duke Alessandro, thought very highly of: and I too shall not forget men like him if an occasion for helping them presents itself.'

At the same time she had spoken of me to her present husband, Duke Ottavio. Because of all this I was making straight for her Excellency's home, which was in a very fine palace in the Borgo Vecchio; I would have been completely safe there, because the Pope himself wouldn't have touched me. However, what I had accomplished up to then had been beyond human strength; and as God was unwilling for me to become too puffed up, He decided that for my own good He would send me a greater trial than the one I had already been through. What happened was that as I was going on all fours up the steps one of Cardinal Cornaro's servants suddenly recognized me. The Cardinal was staying at the palace. The servant then ran to the Cardinal's room and woke him up, saying:

'Reverend Monsignor, your Benvenuto is down there – he's escaped from the castle, and he's crawling along all covered in blood: as far as we can see he's broken one of his legs, and we have no idea where he's going.'

The Cardinal said straight away: 'Run and carry him in here.'

When I was brought into his room he told me not to be afraid. Then without delay he sent for the best doctors in Rome, and I was treated by them. One of them was from Perugia, he was called Jacomo, and he was a first-rate surgeon. He set the bone wonderfully well, then he bound up my leg and bled me with his own hands. My veins were more swollen than usual and he wanted to make a rather wide cut, so the blood spurted out with such force that it struck him in the face. He was so covered with blood that he had to leave off treating me. He looked on this as a very bad omen, and carried on treating me with great reluctance. Several times he made up his mind to leave me, remembering that he was risking severe punishment for having attended me, or rather for carrying on with the treatment. The Cardinal had me lodged in a secret room, and then went off at once to the palace with the idea of asking the Pope for my freedom.

Meanwhile there was a tremendous uproar in Rome, since the strips attached to the great tower of the castle had already been noticed, and everyone was flocking to see this extraordinary sight. At the same time the castellan had been attacked by one of his worst fits of madness and was struggling with all his attendants in an attempt to fly off from the tower himself; he said that the only way I could be recaptured would be for him to fly in pursuit. And while all this was going on Roberto Pucci, the father of Pandolfo, having heard of the great event that had taken place, went to see it in person: then he made his way to the palace where he met Cardinal Cornaro, who told him everything that had happened and how I was in one of his rooms and had already been given medical attention. These two admirable men went along together and threw themselves on their knees in front of the Pope. But before they could utter a word, he said:

'I know all you want from me.'

Roberto Pucci replied: 'Holy Father, we're asking you for that unfortunate man, as an act of grace. He deserves some kindness because

of his great talents; and besides this he has displayed such courage and ingenuity that it hardly seems human. We don't know for what crimes your Holiness has kept him so long in prison, but if they were too outrageous, your Holiness is wise and holy and may have your will done in all things. But if they can be pardoned we beg you to do so for our sake.'

The Pope felt rather ashamed at this, and he said that he had been requested to keep me in prison by some of his courtiers, because I had been too big for my boots.

'But,' he went on, 'knowing his great talents, and also because we want to keep him with us, we had arranged to confer on him such favours that he would have no reason for returning to France. I am very grieved that he has been so badly hurt: tell him to get better, and once he is healed we shall make it up to him for all his misfortunes.'

These two splendid men came back and told me their good news from the Pope. Meanwhile all the nobility of Rome came to visit me – young and old, of every rank. The castellan, who was beside himself, had himself carried to the Pope, and when he arrived in front of his Holiness he began to groan, saying that if the Pope did not send me back to prison he would be doing him a great wrong.

He went on: 'He ran away from me against his word of honour. Look! he has flown away from me, and he promised not to.'

The Pope, laughing out loud, replied: 'Go away, go away now. I shall give him up to you whatever happens.'

The castellan added: 'Send the Governor to him to find out who helped him escape; because if it's one of my men I shall hang him by the neck from the same battlement that Benvenuto made his get-away from.'

When the castellan had left the Pope called the Governor and said to him with a smile:

'He's a brave man, and this is a marvellous business, even though when I was a young man I made a descent from the same place.'

The Pope was telling the truth when he said that, because he had been thrown in prison for forging a brief when he was abbreviator of the *Parco Majoris*.[202] Pope Alexander had kept him in prison for some time, but then, as his crime was so notorious, he had determined to

cut his head off, but he wanted to wait till after the feast of Corpus Christi. Farnese knew what was intended, so he arranged for Pietro Chiavelluzzi to come with some horses and bribed some of the castle sentinels. Then, on the feast of Corpus Christi, while the Pope was going in procession, Farnese was put in a basket and lowered to the ground by a rope. The outer ring of walls had not then been built, and there was only the great tower, so he did not have so many tremendous obstacles to overcome as I did; also, he was justly and I was wrongly arrested.[203] All he wanted to do was boast to the Governor that he too had been brave and adventurous when he was young, and he didn't realize that he was revealing what a great villain he was.

He said: 'Go and tell him he may speak freely about the man who helped him; no matter who he is, it's enough that he is forgiven; and you can assure him of that.'

When this Governor, who had been made Bishop of Jesi two days before, came to visit me he said:

'My dear Benvenuto, although I have a position that fills men with terror, I've come to reassure you. I've come to do this, on the express orders of his Holiness, who has told me that he too escaped from the castle, but that he had a great deal of help of various kinds and many accomplices, without which he wouldn't have been able to do it. I swear to you by the sacraments I administer – for I was made a bishop two days ago – that the Pope has freed you and forgiven you, and is very grieved about your terrible accident. But make sure you get better, and look on everything as being for the best, because this imprisonment which you have been suffering – without doubt, innocently – will prove to have established your well-being for good and all. You will trample on poverty, and you'll have no need to return to France and wear yourself out travelling from one place to another. So tell me without hesitation exactly what happened, and who helped you. Then you must set your mind at ease, have a rest, and get well again.'

I started at the beginning and went over everything, exactly as it had happened, going into corroboratory details down to the water-carrier who had taken me on his back. When the Governor had heard it all he said:

'These exploits were really too great for one man to have done by himself: in fact you're the only man capable of them.'

Then he made me hold out my hand, and he went on: 'You have no need to worry and you must set your mind at ease, because by this hand I'm grasping I promise that you're a free man, and if you live you shall be a happy one.'

During his visit he had been holding up a whole host of great lords and gentlemen who had come to find me, because, as they said to one another, they wanted to go and see the man who worked miracles. So when he went his way they remained with me. One offered his services, another pressed gifts on me.

Meanwhile the Governor had returned to the Pope and began to report what I had told him. The Pope's son happened to be present; and everyone there was utterly astonished. The Pope said:

'This is certainly too tremendous for words.'

Then Signor Pier Luigi joined in and said:

'Holy Father, if you set him free he'll do even more tremendous things, because he is far too audacious a man altogether. Let me tell you another exploit of his that you didn't know about. Before he was imprisoned this Benvenuto of yours quarrelled with a gentleman in Cardinal Santa Fiore's household[204] over some trifling remark he had made to him. Because of this remark Benvenuto retorted with such violent ferocity that it seemed as if he wanted to force a fight. The gentleman took the matter to Cardinal Santa Fiore who said that if he laid hands on Benvenuto he would knock the nonsense out of him. When he heard about this Benvenuto loaded his gun and kept practising with it, firing at a coin. Then one day, when the Cardinal happened to be looking out of the window, Benvenuto, whose shop is under the Cardinal's palace, seized his gun and prepared to fire. But the Cardinal was warned and made a quick disappearance. To provide himself with an alibi Benvenuto fired at a wood-pigeon which was brooding in a hole at the top of the palace; and he hit it in the head – an incredible feat. Now, your Holiness may do whatever you like with him; I only thought that I ought to tell you about this incident. One day, persuaded that he has been wrongly imprisoned, he may even decide to fire at your Holiness. He is altogether too fierce and too sure of himself. When

he killed Pompeo he stabbed him twice in the throat with his dagger, and he did this surrounded by ten men who were guarding him, and then – to their great shame, they were all fine outstanding men – he got away safely.'

While all this was being said that gentleman of Santa Fiore's, with whom I had had the tiff, was standing near by: he confirmed all that the Pope's son had told him. The Pope swelled with fury, but did not say a word.

Now I think I ought to give, fairly and honestly, my own explanation of this affair. One day that gentleman of Santa Fiore's household came to me bringing a little gold ring that was all stained with quick-silver. 'Clean away this ring,' he said, 'and be quick about it.' I happened to have on hand a great number of important works, in gold and precious stones, so what with that and being given orders so arrogantly by a man I had never spoken to or seen before, I told him he should go to someone else, as I had no 'cleaning-away' tool ready at the moment.

Then, for no reason at all, he told me I was an ass. I replied that he was wrong there and that I was a better man than him on every count, but if he provoked me, I said, he'd find that I could kick much harder than an ass. He told the Cardinal what had happened, and painted me as if I had been the devil himself.

Two days later I was behind the palace, firing up towards a hole where there was a pigeon brooding: I had seen a Milanese goldsmith called Giovan Francesco della Tacca fire at the same bird several times without success. On this occasion, when I was firing, the pigeon – which had become wary because of the other times it had been shot at – just let its head peep out. Now, as this Giovan Francesco and I were rival gamesmen, some noblemen and friends of mine, who were in the shop, called me and said:

'Look up there – it's Giovan Francesco della Tacca's pigeon – the one he's forever shooting at. Just look, the poor creature's so suspicious it's hardly showing its head.'

I glanced up and said: 'It's showing enough to let me hit it, if it only waits till I take aim.'

The noblemen said that even the inventor of the fowling-piece

couldn't do that. 'Well,' I replied, 'let's bet a bottle of Palombo's good Greek wine that if it stays put till I take aim with my splendid Broccardo' (that was the name I had given my gun) 'I shall knock its little head off.'

So, without giving a thought to the Cardinal or anyone else, I took aim, using my arms and no other support, and I did what I had promised. As a matter of fact I looked on the Cardinal as a good patron of mine. So let everyone witness how many different cards Fortune has up her sleeve when she wants to ruin a man.

So there was the Pope, swelling with fury and muttering to himself, brooding over what his son had told him.

Two days later Cardinal Cornaro went to ask the Pope for a bishopric for one of his gentlemen called Andrea Centano. The Pope, it is true, had promised him a bishopric, and now that one was vacant the Cardinal reminded him of his promise. The Pope admitted that this was so and said that he intended to keep his word but that he wanted his reverend lordship to do a favour for him: and what he wanted was the Cardinal to put me into his hands.

The Cardinal said: 'Oh, but seeing that your Holiness has forgiven him and made him over to me as a free man, what would everyone say of us?'

The Pope retorted: 'I want Benvenuto and you want the bishopric; so let them say what they like.'

The good Cardinal begged his Holiness to give him the bishopric, but to think the rest over by himself and then do all that his Holiness wanted and was able to order. The Pope, who was half-ashamed at the wicked way he was going back on his word, added:

'I shall send for Benvenuto, and to please myself a little I shall put him down below in the rooms of my private garden where he'll be able to recover his health. I shan't prevent him from having all his friends coming to see him, and as well I shall pay all his expenses till I've satisfied this little whim of mine.'

The Cardinal returned home and at once sent the man who was waiting on the bishopric to tell me that the Pope wanted to have me back, but that he would lodge me in a ground-floor room by his private garden, where everyone could visit me as if I were in his house. At

this I begged Andrea to be good enough to tell the Cardinal not to give me up to the Pope but to let me look after myself: I would have myself hidden inside a mattress and carried out of Rome to a safe hiding-place. To give me up to the Pope, I added, was sending me to certain death.

It is believed that when the Cardinal heard this he would have been only too glad to do what I asked: but that Andrea, who was after the bishopric, gave the game away. The Pope sent for me at once and had me lodged, as he had said, in one of the lower rooms by his private garden. The Cardinal sent word warning me not to eat any of the food that the Pope gave me. He added that he would send me food himself and that he had been forced into doing what he had, but that I was to keep my spirits up and he would help me to get free.

In these circumstances I was visited every day, and I received important offers of help from many great noblemen. The Pope used to send me food, but I left it untouched and ate what came from Cardinal Cornaro. So the days went by.

Among my other friends was a young Greek, aged twenty-five. He was incredibly vigorous, and the best swordsman in Rome; and although he was faint-hearted he was a good trustworthy fellow, and very credulous. He had heard about the Pope's saying that he meant to make it up to me for my misfortunes. And it was in fact true that, at the beginning, the Pope had said this; but he ended up saying quite different things. So I took this young Greek into my confidence.

'My dear brother,' I said to him, 'they're determined to assassinate me, so now is the time to help. They think that with their doing me such extraordinary favours I don't realize that the only reason for it is that they want to trick me.'

In reply the good young fellow said: 'Dear Benvenuto, they say in Rome that the Pope has given you a post with an income worth five hundred crowns, so I beg you not to let your suspicions rob you of such a good thing.'

However, with my arms crossed over my breast, I begged him to get me away from where I was: I realized a pope like him could do me a great deal of good, but, I added, I knew for certain that – on the sly, in order to save appearances – he was doing his best to deal me a nasty

blow. Therefore, I went on, he should act quickly and try to save my life; if he helped me escape in the way I told him I would always acknowledge that I owed him my life, and I would lay down my life for him, if necessary. By now he was in tears.

'My dear brother,' he said, 'you're determined to ruin yourself; but I can't refuse to do what you ask me. Tell me how, and I'll do all you say even though it's against my will.'

So we settled matters: I told him all my plans, which could easily have been successful. However, when I imagined that he was just about to put what I had arranged into operation, he came to tell me that for my own good he intended to disobey me, and that he fully believed what he had heard from men who were well in with the Pope and knew all about my case. There was no other way I could help myself; so I remained in misery and despair. This was on the feast of Corpus Christi, 1539.

The whole day went past, and then, that same night after the dispute, a great abundance of food was brought me from the Pope's kitchen: a fine supply came from Cardinal Cornaro's kitchen as well. As some of my friends were present I made them stay to supper with me. I was in bed, with my leg in splints, but I made a cheerful meal with them and they stayed on. An hour after nightfall they left me; two of my servants settled me ready for sleep, and then lay down in the antechamber.

I had a dog, black as a mulberry, with a shaggy coat; he was splendid for hunting, and he never strayed more than a yard from my side. During the night he slept under my bed, and at least three times I called my servant to take him out, because he was whining terrifyingly. When the servants came in the dog rushed at them and tried to bite them. They panicked and were scared that the dog had gone mad, he was howling so persistently.

This went on till about four hours after nightfall. Then, as the clock was striking, the chief constable with a large escort walked into my room; the dog came from under the bed and flew at them so furiously, tearing their cloaks and stockings, that they thought in their terror that he had gone mad. However, the chief constable was an experienced man and he said:

'It's perfectly natural that a good dog should know by instinct of any harm about to come to its master. Two of you grab hold of some sticks and beat him off, and the rest of you, tie Benvenuto to this chair and take him where you've been ordered.'

As I said, the day that had just passed was the feast of Corpus Christi, and it was about four hours after nightfall. They carried me along well hidden and covered, with four of them walking in front to move on the few men who were still on the streets. In this way they brought me to the place called the Torre di Nona, where they put me in the condemned cell, setting me down on a scrap of mattress. They left one of the guards with me and all night long this fellow kept sympathizing with me over my bad luck: 'Oh dear! Poor Benvenuto! what have you done to them?'

So from the place I was in, and from what the guard said, I was quite certain what was to happen to me. I spent some of the night racking my brains as to the reason why it had pleased God to punish me in this way; and since I couldn't think of any I was terribly disturbed. The guard started doing his best to console me, but I begged him for the love of God to keep quiet and stop talking to me, since I could set my mind at rest better and more quickly if I were left alone. He promised that he would.

Then I turned my mind completely to God, praying fervently that He would in His mercy take me into His kingdom; I prayed that although I had complained because I thought that as far as the laws were concerned such an end would be undeserved, and although I had committed murders, His own Vicar had called me from my native town and forgiven me by the authority of human laws and of His own. All that I had done had been to protect the body that His Divine Majesty had lent to me: so I could not allow that, under the rules by which we lived in this world, I deserved such a death. It seemed to me that I was like an unfortunate man walking along the street who is killed by a stone falling from a great height above him: this is clearly the influence of the stars. Not that the stars have plotted together to do us good or evil, but we are all subject to the influence of their conjunctions. I know that I have free will, and I know for certain that if I showed my faith like a saint the angels of heaven would carry me

out from this dungeon and give me sure protection against all my afflictions; but seeing that God does not seem to have made me worthy of such a thing it must be that the celestial influences are working malignantly against me. For a while I pondered in this way, then I calmed myself and soon I was asleep.

At daybreak I was woken up by the guard who said: 'You're a good man, but you're an unlucky one! There's no time for sleeping now – there's a man come who has some bad news for you.'

'The sooner I escape from the earthly prison, the better I'll be pleased,' I said, 'especially as I'm certain that my soul is saved, and that I'm dying unjustly. Our glorious divine Saviour is making me one with His disciples and friends, who like Him were killed unjustly. Now it's my turn to be put to death unjustly, and I devoutly thank God for it. Why doesn't the man who has to sentence me come?'

'He's too upset about it all: and he's crying.'

At this I called him by name – Benedetto da Cagli – and I said:

'Come forward, my dear Benedetto, I'm perfectly calm and ready; it's far more glorious for me to die unjustly than it would be if I deserved death. Come forward, I beg you, and bring me a priest so that I may have a few words with him – not that I need to, since I've made my holy confession to the Lord God. But I want to observe the decrees of our Holy Mother Church: although She is doing me this wicked wrong, I am only too glad to forgive. So come along, dear Benedetto, and be quick about it, before other feelings get the better of me.'

After I had said all this, that admirable man told the guard to lock the door, because the business couldn't be done unless he was there. Then he went along to the house of Signor Pier Luigi's wife, who was with the Duchess whom I mentioned before. When he arrived before them, he said:

'Noble lady, be good enough, I beg you for the love of God, to ask the Pope to send someone else to pass sentence on Benvenuto and perform my office, because I renounce it and I shall never do it again.'

Then, sick at heart, he went his way, sighing deeply.

The Duchess, who was present, said with a frown: 'This is the

wonderful justice one finds in the Rome ruled by God's Vicar! The Duke, my husband, who is now dead, thought very highly of this man because of his goodness and his talents; he loved to have him by his side and was against his returning to Rome.'

Then, muttering angrily to herself, she left the house.

And then Pier Luigi's wife (she was called Signora Jerolima) went along to the Pope and, throwing herself down on her knees – there were several cardinals present – she spoke so passionately that she made his Holiness blush for shame, and he replied:

'For your sake we shall let him be, though in fact we never bore him any ill will.'

But he only added this because of the cardinals who were standing there, and who had heard everything that splendid, brave-hearted woman had said.

Meanwhile I was waiting in great fear and trembling. My heart was beating furiously, and all the men whose duty it was to carry out the wretched sentence were waiting as miserably as I was. Then, after supper time had passed, they went off to see to themselves and I was brought some food. I was astounded at this, and I said:

'Now truth has prevailed against the malignity of the stars! I pray God if it is His will to save me from this storm.'

I started eating; and as earlier on I had resigned myself to my evil fate so now I began to hope for better fortune. I ate with a good appetite, and then waited, without seeing or hearing anyone, till an hour after nightfall when the chief constable came along with a fair number of his patrol and put me back in the chair in which, the evening before, they had carried me to that place. Then, after repeating several times in a very kind voice that I was not to worry, he ordered his men not to jolt my broken leg, and to treat me as carefully as their own eyes. They did what he said, carrying me into the castle I had escaped from. We climbed to the very top of the keep, to a small courtyard where, for a while, they shut me up.

Meanwhile the castellan had himself carried to where I was: ill and afflicted as he was, he said:

'You see how I've caught you again?'

'Yes,' I replied, 'but do you see how I escaped as I said I would?

And if I hadn't been sold under Papal guarantee for a bishopric, by a Venetian cardinal and the Roman Farnese, both of whom have scratched the face of God's law, you would never have caught me again. But since they behaved so foully, you go and do your worst as well: I haven't a care left in the world.'

The poor man began to shout aloud: 'Ah! Ah! he doesn't care whether he lives or dies, and he's bolder now than when he was well. Put him down there below the garden, and never talk to me about him again: he'll be the death of me.'

I was carried down below the garden into a very dark, dank room full of tarantulas and noxious worms. They threw a miserable hemp mattress on the ground, and that evening I was left without food, locked in behind four doors. I stayed like that till five hours before nightfall the next day. Only then was I brought something to eat. I asked them to let me have some of my books to read. None of them replied, but they reported what I had said to that wretched castellan who had asked them to tell him. The next morning I was given my Italian Bible and another book containing Giovanni Villani's Chronicles. I asked for some of my other books, but they told me I couldn't have any more and had too many as it was. So I passed the time very miserably, on that damp scrap of mattress, which within three days was wringing wet. I was completely unable to move because of my broken leg; and when I wanted to get out of bed, because of the demands of nature, I had to go on hands and knees, suffering terrible agonies to avoid fouling the spot I slept on.

For an hour and a half every day I got a faint gleam of light filtering into my squalid cell through a tiny chink. Just for that short space of time I could read, otherwise, night and day, I waited patiently in the darkness, thinking all the time of God and of our human weakness. I was convinced that before many days passed, in these conditions and in that place, my unhappy life would come to an end. However I consoled myself as best I could, reflecting how much more painful it would have been to have died under the terrible agony of the executioner's knife; but as it was I was meeting death half-drugged with sleep, which was a much more agreeable way to end. Little by little I felt strength ebbing, till my strong constitution had become used

to the purgatory I was suffering. Then, when this happened and I was inured to it all, I resolved to bear my tremendous suffering as long as my strength held out.

I began the Bible from the beginning, devoutly reading and meditating on it. I was so fascinated that if it had been possible I would have spent all my time reading it. But, as the light failed, all my sufferings immediately flooded back, and I was so tortured that more than once I made up my mind to put out my life with my hand. They had left me without a knife, however, and so I had no easy means of doing such a thing. All the same on one occasion I took a solid wooden beam that was lying there and propped it up in such a way that it would fall like a trap. I wanted to make it crash down on my head, which would have been smashed at the first blow. But when I had set up the whole contraption, and was resolutely preparing to knock it down, as I went to put my hand to it I was seized by an invisible hand and hurled a distance of about four cubits.

I was so terrified that I remained there in a dead faint: and I stayed like that from dawn till five hours before nightfall, when they brought in my dinner. They must have come in several times without my noticing them, because, when I did notice them, I heard Captain Sandrino Monaldi[205] say:

'Oh, the unhappy man – he was such a unique genius, and look at the end he came to!'

I opened my eyes when I heard this and saw standing there some priests in their cassocks, who cried out:

'Oh, you said he was dead!'

Bozza said: 'I found him dead, that's why I said so.'

Without delay they lifted me up, took hold of the mattress, which was as soggy as a plate of macaroni, and threw it out of the room: when they told the castellan about it he had me given another one.

On reflecting as to what it was that frustrated my attempt I decided that it must have been a divine power, my guardian angel.

The following night a wonderful vision in the form of a beautiful young man appeared to me in a dream and started rebuking me.

'Do you know who it was who lent you that body that you were ready to wreck before the appointed time?' he said.

I seemed to answer that I recognized everything as having come from the God of nature.

'So then,' he replied, 'you despise His works, and you want to destroy them? Leave Him to guide you, and do not abandon hope in His saving power.'

And he added a great deal else, in very impressive words, of which I don't remember the thousandth part. I began to be convinced that this angelic being had spoken the truth; and then, glancing round my cell, I caught sight of some pieces of musty brick. So rubbing one piece against another I managed to make a little paste. Then, still crawling on my hands and knees, I went up to the cell door and gnawed at the edge with my teeth till I had bitten off a small splinter. After that was done, I settled down to wait for the time when some light would creep into the prison; it first came in three and a half hours before sunset, and lasted an hour. Then I started to write as best I could on some superfluous pages in my Bible, and I rebuked the powers of my intellect for being impatient with life: they replied to my body, excusing themselves on account of their sufferings: and then my body held out the hope of better things. All this I wrote in dialogue, as follows:

'Powers of my soul, in torment,
How cruel it is of you to hate this life!'
'If you against Heaven are bent,
Who then will succour us in this our strife?
Let us depart, to seek a better life.'
'Wait, be not so swift to go:
Heaven promises you will
Be yet more happy than you were before.'
'A short while we'll stay below,
If our great God intends to grant us still
The grace that we shall never suffer more.'

My strength came back to me, and after I had calmed myself by my own efforts I carried on reading my Bible: and my eyes grew used to the darkness, so that whereas before I could read for an hour and a half I could now read for three whole hours. I began to meditate with

extreme wonder on the greatness of God's power over those simple men, who believed so fervently that God would grant them all they hankered after. I assured myself that God would help me too, because of His divine mercy as well as because of my own innocence. I remained continually in communion with God, sometimes praying and sometimes deep in meditation; my delight in meditating on God in this way began to grow so intense that I forgot all my past sufferings, and all day long I sang psalms and compositions of my own, all addressed to Him.

There was one thing, however, that made me suffer terribly: what had happened was that my nails had grown so long that I could not touch myself without their wounding me. I was unable to dress without their turning inwards or outwards and causing me great torment. At the same time my teeth began to decay. I became conscious of this when the dead teeth started being pushed out by those teeth that were still living; little by little they pierced my gums, and the end of the roots started breaking through their sockets. When I realized what was happening I pulled them out, just as if I was drawing a sword from its scabbard, without any pain or bleeding. I lost a great many in this way. However, I reconciled myself to these new afflictions; and I carried on, sometimes singing, sometimes praying, and sometimes writing with that brick paste I mentioned. I began to write a poem in praise of the prison, and in it I gave an account of the things that had happened to me there. I shall write it down here in its appropriate place.

The good castellan often used to send secretly to find out what I was up to. As it happened, on the last day in July I was full of great rejoicing, thinking to myself that it was the occasion of the great festival that is usually celebrated in Rome on the first day of August; and I was saying to myself:

'All these years past I've kept this happy feast with worldly trivialities, but this year I shall observe it by pondering on the divine things of God.'

Then I added: 'Oh, how much happier I am now than I was then!'

I was overheard saying this, and they reported my words to the castellan. In astonished fury, he said:

'Oh, God! there he is thriving on misfortune; and while he triumphs

I am suffering in the middle of so much comfort. And all by himself he's bringing me to the grave. Go quickly and thrust him into the lowest dungeon – the one where the preacher Foiano[206] was starved to death. Perhaps when he sees how wretched he is his cheerfulness will be knocked out of him.'

Straight away Captain Sandrino Monaldi came along to my cell, followed by about twenty of the castellan's servants. They found me on my knees; and when they came in, without turning round I carried on with my prayers. I was adoring a figure of God the Father, surrounded by angels, and one of the risen Christ in His triumph, that I had drawn on the wall with a little piece of charcoal I had unearthed. It was then four months that I had been on my back, lying in bed with a broken leg. I had dreamed so many times that the angels came to heal me that after those four months my leg was as sound as if it had never been broken.

They came in, so cluttered up with weapons that one would have thought I was a fiery dragon. The captain said:

'You know how many there are of us, and we made enough noise coming in, yet you don't turn round.'

At these words I was well aware of the terrible harm they could inflict on me, but since I was steeled to misfortune I replied:

'To this God who bears me up, to Him in heaven, I have turned my soul, and heart, and the power of my intellect: and I've turned to you exactly what belongs to you. You're not worthy to look on what is good in me and you cannot touch it; so do to what belongs to you all in your power.'

The captain, who was frightened seeing that he had no idea what I meant to do, turned to four of his most stalwart guards and said: 'Lay aside your arms.'

When they had done this, he added:

'Now – on him quickly and hold him down. There are enough of us not to be frightened even if he were the devil himself. Hold him fast so that he doesn't escape.'

They seized me and started handling me roughly; and then, expecting much worse than in fact happened, I lifted my eyes to Christ and said:

'O just God, You have redeemed all our sins on Your high Cross: why then does my innocence have to pay the debts of someone I do not know? But may Your will be done.'

Meanwhile they bore me away by the light of a great burning torch. I thought they intended to throw me into what is called the Sammalò pit, a fearful place which has swallowed up a great many living men who have been hurtled down into a well in the foundations of the castle. But I was spared this; and so I reckoned I had made a good bargain when they threw me into the foul dungeon I mentioned above, where Foiano had died of hunger, and left me there without doing me any more harm.

When they had gone I began to sing the *De profundis clamavi*, a *Miserere*, and the *In te domine speravi*. I kept the feast of that first day of August with God, and the whole day my heart was bursting with faith and hope. The second day they moved me from that hole, taking me back to the cell where I had made those first sketches of the image of God. When I arrived there and found myself back with my drawings my eyes flooded with tears of delight and happiness. After that the castellan wanted to know day by day everything I said or did.

The Pope, who knew all the circumstances (the doctors, by the way, had already said there was no hope for the castellan) remarked:

'Before my castellan dies I want him to put Benvenuto to death in whatever way he likes, so that he doesn't die without having his revenge on the man who killed him.'

When Pier Luigi himself reported these words to the castellan, he said:

'So the Pope gives Benvenuto to me and wants me to take my revenge? Forget the matter and leave it to me.'

So if the Pope was choked with bitterness towards me, it seemed at first as if the castellan hated me with even more malice. At this juncture that invisible spirit which had prevented me when I intended to kill myself came to me, still invisible but speaking distinctly, shook me and lifted me to my feet, and said:

'Benvenuto, hurry now, hurry: turn to God and say your prayers, shout them out as loud as you can.'

At once I fell on my knees in terror and repeated many of my prayers

in a loud voice. Then I said a *Qui habitat in adjutorio*; and then I conversed with God for a while. In an instant, the same voice as before said distinctly and clearly:

'Go and rest now, and don't be afraid any more.'

And what had happened was this: the castellan, having given brutal orders for my death, suddenly rescinded them, and said:

'Isn't he the same Benvenuto that I defended so eagerly and that I know for certain is innocent and has been wrongfully punished? Oh, how will God ever have mercy on me and my sins if I don't forgive those who have done me great harm? Do I have to injure a worthy, innocent man, who has served and honoured me? There! instead of bringing him death, I bring him life and liberty; and I leave it in my testament that no one is to ask him for any of the great sum he would have to pay for his expenses here.'

The Pope heard what had happened and he was furious.

Meanwhile I carried on with my usual prayers and with writing my poem. I started experiencing the happiest, most delightful dreams imaginable, every night: and it seemed that all the time I had near me that invisible being I had so often heard, and still heard. I asked him for no other favour except that he would take me where I could see the sun. I said earnestly that this was the only desire I had, and that if I could only once set eyes on the sun then I would die happy. All the torments I had suffered in that prison, all of them had become dear and pleasing to me, and I was no longer troubled by them. But the hangers-on of the castellan, who had been waiting for him to do what he had said he would and hang me from the battlement I had climbed down from, couldn't tolerate it when they saw that he had completely changed his mind, and they kept trying by various means to frighten the life out of me.

However, as I said, I was so used to all those things that I was no longer frightened of anything: all I wanted was to have a dream in which I might see the sphere of the sun. So I carried on with my great prayers, directing them fervently towards Christ, and I never left off saying:

'O true Son of God! I implore You by Your birth, by Your death on the Cross, and Your glorious resurrection, make me worthy to see

the sun, even if only in a dream. But if You deign to let me see it, with these mortal eyes, then I promise to come and visit You in Your Holy Sepulchre.'

These great prayers to God and this vow I made on the second of October, in the year 1539. Next morning, the third of October, I woke on the edge of daybreak about an hour before the sun was up; and rising from my squalid corner I put on a scrap of clothing I had, since it was getting chilly, and then standing up I started praying more fervently than I had ever done before. I besought Christ to grant me at least the grace to know by divine inspiration for what sin I was doing such great penance; and, seeing that His Divine Majesty had not seen fit to make me worthy to see the sun, even in a dream, I begged Him by all His might and power to deign to let me know what was the reason for this punishment.

When I had said this I was seized by that invisible force and carried away as if by a wind: I was taken to a room where that invisible companion of mine became visible and appeared in the form of a young man with light down on his cheeks. His face was marvellously beautiful, but austere rather than sensual, and as he showed me into the room he said:

'These men that you see, they are all those who have ever been born and then suffered death.'

I asked him why he had brought me there, and he replied, 'Come with me, and you will soon understand.'

I found myself dressed in a coat of mail, with a dagger in my hand; and he led me like this through that great hall, showing me all those people wandering here and there in their infinite thousands. He led me on and then went before me through a little door into a place like a narrow street, and when he drew me after him I found myself unarmed and dressed in a white garment, with my head uncovered: and I was standing on his right hand. When I saw what had happened I was filled with wonder; I was unable to recognize the street, but on raising my eyes I saw that the sunlight was striking on to a wall, like the front of a house, above my head.

Then I said: 'My friend, what must I do to ascend so high that I can see the sphere of the sun itself?'

He showed me a great flight of stairs on my right hand and he answered: 'Go there by yourself.'

With this, I moved away from him and climbed those great stairs, facing the way I had come: little by little I began to feel the nearness of the sun. I quickened my step; and so went up and up, until the whole sphere of the sun was revealed to me. The strength of his rays made me instinctively close my eyes; but when I realized my error I opened them fully, stared fixedly at the sun, and cried:

'The sun – the sun that I have so much desired! I never want to see anything else again, even if your rays blind me.'

I remained with my eyes intent on him; and after I had been there for a short while all of a sudden I saw the force of those tremendous rays cast itself on to the left side of the sun; the sun remained clear, without his rays, and I stared at him with great contentment, astonished at the way the rays had been taken away. I began to ponder on the divine grace that had been granted me that morning by God; I cried out: 'What splendid power! What glorious virtue! How much greater is the privilege You have granted me than what I expected!'

Without his rays the sun appeared just like a bath of the purest liquid gold. While I stood there contemplating this great vision the middle of the sun began to swell out and the bulge increased till, in an instant, it took the form of Christ on the Cross, made out of the very stuff of the sun: He was of such entrancing beauty and so gracious in His appearance that human imagination cannot reach to a thousandth part of what I saw.

As I contemplated this I cried aloud: 'A miracle! A miracle! O God, O merciful God! O infinite power! What marvels You have permitted me to behold this day!'

While I was staring and saying these words the figure of Christ moved towards that part of the sun where the rays had gone; the middle of the sun swelled up again, as it had done before, and as the swelling grew larger it suddenly took the shape of a most beautiful Madonna, seated on high with her Son in her arms, full of grace and appearing to smile. On either side were two angels of such great beauty that it is beyond imagining. I also saw, on the right hand of the sun, a man robed like a priest; he turned his back to me and kept his face looking

towards the Madonna and Christ. All these things I saw, truly, clearly, and vividly; and all the time, in a loud voice, I praised the glory of God in my thankfulness. This wonderful vision remained before my eyes for just over an eighth of an hour, and then it departed. I was carried back to my wretched pit.

At once I began to shout out aloud:

'God in His greatness has made me worthy to set eyes on His glory; on things perhaps never seen before by mortal eyes. So this proves my freedom, and my happiness, and my favour with God: while you, you villains, you shall always be villains, unhappy and in disgrace with God. Listen to this: I know for certain that on All Saints' Day – the very day that I was born into the world in the year 1500, the first day in November, four hours after nightfall – on that day coming you'll be forced to lead me from this gloomy cell; and you'll not be able to do otherwise, because I've seen it with my own eyes on the very throne of God. That priest who was turned towards God and who had his back to me, that was St Peter, and he was pleading for me, ashamed that such brutal injustices should be done to Christians in his house. Tell anyone you like – no one has the power to do me further harm: and tell that lord who is keeping me here that if he gives me either some wax or paper, and the means to express the glory of God that I have seen, I shall make only too clear what he may now be doubtful of.'

Although his doctors believed there wasn't a scrap of hope, the castellan remained with a sound mind, and the mad fantasies that used to trouble him every year had left him. His only concern now was over the state of his soul; his conscience was gnawing at him, and he was convinced that I had suffered and was suffering a great injustice. He sent the Pope information about the wonderful things I spoke of, and the Pope – like a man who believed in nothing, neither in God nor in anything else – sent back word that I must be mad, and that he was to do all he could to cure himself. When the castellan received this reply he sent to comfort me, and had me given writing materials, some wax and some little instruments for working on wax. His kind message was brought by one of his servants who was fond of me. This man was quite the opposite to that collection of villains who would have liked to see me dead.

I took the paper and wax and set to work: and while I was at it I wrote this sonnet, dedicated to the castellan.

> If I, my lord, could only prove to you
> That light eternal God Himself has shown
> To me, in this base world, why then you'd own
> That to my princely words all credit's due.
> And if the Pastor of Christ's Church but knew
> The vision of God's glory I have seen –
> These wonders, never shown to anyone
> Before the dark world's griefs are lost to view –
> Then would the holy doors of justice move,
> And impious Fury bound in chains would fall,
> Shrieking to Heaven at her bitter loss.
> If only I had light! My art would prove
> An image of divinity, and then would fall
> Away the heavy burden of my cross.

Next day when the castellan's servant – the one who was fond of me – came in with my food, I gave him this sonnet written out: without telling those other vicious servants, who hated me, he handed it to the castellan. The castellan would have been only too glad to set me free, since he believed that the great wrong that had been done me was the chief cause of his own death. He took the sonnet, read it through more than once, and then said:

'These are neither the words nor the ideas of a madman: rather, it's the work of a good, worthy man.'

Straight away he ordered his secretary to take it to the Pope, to deliver it into the Pope's own hands, and to beg him for my release. While his secretary was carrying the sonnet to the Pope, the castellan sent me lights, both for day and night, and also provided me with every comfort the place needed. As a result my general health, which had been at a very low ebb, began to improve.

The Pope read the sonnet several times; then he sent word to the castellan that he would very soon be doing something that would please him. And the Pope would certainly have let me go; but Signor

Pier Luigi, his son, kept me there by force, almost against his father's wishes. The death of the castellan was drawing near: and in the meantime I had been drawing and modelling a representation of that marvellous miracle. On the morning of All Saints' Day he sent his nephew, Pier Ugolini, to show me some jewels. Immediately I saw them I cried:

'This is the pledge of my liberation.'

At this the young man, who was rather dull-witted, said:

'Never rely on that, Benvenuto.'

I replied: 'Take your jewels away. I'm so badly treated here that the only light I see is what's in this gloomy hole, and it's not good enough for me to make out the quality of the jewels. But as for my leaving this prison, before the day is over you'll be coming to release me: this must be so and you can do nothing to stop it.'

Then he left, leaving me locked in again. He was away for more than two whole hours. And then he came back without an armed escort, but with two boys who were to give me a helping hand. I was led into the large apartment I had had before (that is, in 1538),[207] and I was given every comfort I desired.

A few days later the castellan, who was under the impression that I had been set free, stricken down by his terrible illness departed this life. His place was taken by his brother, Antonio Ugolini, who had given the dead castellan to understand that I had been released.

As far as I could make out this Antonio had been ordered by the Pope to let me stay confined in my spacious rooms until he told him what to do with me. Meanwhile, Durante of Brescia, whom I've already mentioned, plotted with that soldier – the one who had been a chemist in Prato – to mix with my food some substance of a poisonous nature, with a deadly but not instant effect: it was to take effect at the end of four or five months. They were planning together to put some powdered diamond into my food. This, although not at all poisonous itself, is so incredibly hard that when pounded it still retains its sharp edges. The diamond isn't like other stones, which lose their sharp edges and become almost rounded, for it keeps its sharpness even when powdered. As a result of this, when it enters the stomach along with one's food, in the process of digestion the diamond becomes embedded in the lining of

the stomach and in the bowels. Then, little by little, as fresh food comes in and presses it forward, before very long the diamond pierces one's inside; and the result is death. On the other hand, if any other kind of stone or glass is mixed up with one's food it hasn't the power to adhere, and so it passes out with the food.

Now, this Durante I mentioned gave one of the guards a diamond of some small value. It was said that a great enemy of mine, a certain goldsmith of Arezzo called Lione,[208] was entrusted with the job of pounding it. However, since he was very poor and the diamond must have been worth a few dozen crowns, he gave the guard something which he pretended was the powdered diamond to be administered to me. That morning I ate the powder, mixed with all my food – it was a Friday. I had it in the salad, in the ragout, and in the soup.

I ate with great gusto, since I had been fasting the evening before. The Friday was a feast day. As a matter of fact I did feel the food scrunching between my teeth, but no suspicion of such devilry entered my mind. After I had finished there was a little salad still left on the plate, and then I caught sight of some fine splinters that remained with it. Straight away I went over with them to the window, where the light was very strong, remembering while I was looking at them that the food had scrunched more than usual that morning. After a careful inspection I became convinced that as far as I could judge it was powdered diamond.

I at once gave myself up for dead and with a heavy heart took devout refuge in prayer. Having made up my mind that I was doomed, for a whole hour I poured out prayers to God, thanking Him for such a pleasant death. Since my stars had willed that it should be so, I reckoned I had made a good bargain in quitting this life so easily. I was quite content to bless the world and the years I had spent in it. Now I was returning to a better kingdom, secure in my knowledge of the grace of God. With these thoughts passing through my head I was holding in my hand some very fine grains from what I was certain was a diamond. But, since it never dies away, I let myself be tempted to indulge in a little vain hope. As a result I took hold of some small knife and tipped a few of the grains on to one of the prison bars. Then I touched them lightly with the point of the knife, pressed down hard,

and felt the stone crumble. Peering closer I saw that it had in fact done so. At once hope flooded back, and I said to myself:

'This isn't Durante's durable stone, it's a poor, cheap stone which won't do me the slightest harm.'

So, although I had reconciled myself to remaining quiet and dying in peace, I began to make fresh plans. But first I thanked God and that blessed state of poverty, which although very often causing death this time was the real cause of my remaining alive. Since my enemy, Durante – or whoever it was – had given Lione a diamond, worth more than a hundred crowns, and told him to pound it for me, his poverty had persuaded him to take it for himself, and instead he ground up a greenish beryl worth only a couple of carlins. He probably thought that, seeing it was a stone, it would have the same effect as the diamond.

At that time the Bishop of Pavia – brother of the Count of San Secondo – called Monsignor de' Rossi of Parma,[209] was imprisoned in the castle because of some disturbances that had happened in Pavia. As the Bishop was a great friend of mine I thrust my head through the hole in my cell and called to him in a loud voice that in order to murder me those criminals had given me a powdered diamond. At the same time through one of his servants I sent him some of the powder that was left, but I didn't tell him I had discovered that it wasn't a diamond. Instead I told him that they had certainly poisoned me, after the death of that admirable castellan; and for the little time I had left alive I begged him to let me have one of his loaves every day, since I wasn't anxious to eat anything that came from them. So he promised to send me some of his own food. That Messer Antonio, who had certainly known nothing of the plot, made a great stir about it and asked to see the powdered stone, which he too believed to be a diamond. Then, judging that the Pope must be behind it all, after he had thought the matter over he shrugged it off.

I restricted what I ate to the food sent me by the Bishop and I carried on writing that poem of mine on the prison, setting down every day all the new things that happened to me, detail by detail. Antonio also used to send along some food which was brought me by Giovanni, that Prato chemist whom I mentioned before, who was then a soldier in the castle. This man was very hostile towards me, and it was he who had brought me the powdered diamond; so I told him that I refused

to eat anything he brought me unless he tried it first. His answer to this was that only popes had their food tasted first. I said that in the same way as noblemen were obliged to taste the Pope's food, so he, a soldier and a low-class Prato chemist, was obliged to taste the food of a Florentine of my quality. We ended up swapping insults.

Messer Antonio, who was growing a little ashamed of himself, especially as he intended to make me pay the expenses that the dead castellan had let me off, got my food brought me by another of his servants, who was a friend of mine. This man was gracious enough to try the food for me without any objection. He also told me how every day the Pope was being pestered by that Monsignor di Morluc, who was continually asking for me on behalf of the French King, and he added that the Pope showed little inclination to give me up and that Cardinal Farnese[210] – formerly my great patron and friend – had had to say that I shouldn't count on getting out of prison for some time. I commented that I would find a way out in spite of them all.

The admirable young man begged me to hold my peace and not let anyone hear me say such things, since it would do me no good. He added that, trusting in God as I did, I ought to wait for His mercy and remain patient. I told him that the powers of God had no need to fear the malignant workings of injustice.

After a few days had passed the Cardinal of Ferrara arrived in Rome; and when he went to pay his respects to his Holiness, the Pope detained him so long that supper time came round. The Pope was a very knowledgeable man, and wanted to have a leisurely talk with the Cardinal about all those wretched French affairs. Now it happens that when men eat together they often say things which might otherwise remain unsaid. Well then, as the great French King was always very liberal in his dealings, and as the Cardinal, who thoroughly understood the King's disposition, went out of his way to concede far more to the Pope than had been expected, the Pope ended up in a very good mood. He was all the more merry because it was his custom once a week to indulge in a violent debauch, after which he would vomit. When the Cardinal saw how cheerful the Pope was and how he was in a mood to grant favours, with great insistence he asked for me on behalf of the King, emphasizing how anxious the King was to have his request

granted. Then with a great laugh the Pope, who felt that his time for vomiting was drawing near and had drunk so much wine that it was beginning to have its effect, cried:

'This very instant, I want you to take him home with you.'

Then he gave express orders for my release and rose from the table. The Cardinal sent for me at once before Signor Pier Luigi, who in no circumstances would have let me leave prison, could know of what was happening. The Pope's messenger arrived along with two great noblemen from the Cardinal's household: and after the fourth hour of the night had passed I was led from my cell and taken to the Cardinal, who greeted me very affectionately. There I found comfortable lodgings and stayed on to enjoy myself.[211]

Messer Antonio, who had replaced his brother, the dead castellan, had me pay all the expenses and the other various fees demanded by the police and suchlike people, and he ignored the instructions that the dead castellan had left with regard to me. This matter cost me a good few dozen crowns, and besides this the Cardinal told me that if I valued my life I should have to go carefully, and that if he had not secured my release from prison the night he did I would never have been freed; he had already heard it said that the Pope very much regretted having let me go.

I must retrace my steps a little, since all these events are mentioned in my poem. While I had been staying those few days in the Cardinal's apartments, and then in the Pope's private garden, among other dear friends of mine, one of Bindo Altoviti's cashiers, called Bernardo Galluzzi, looked me up: I had entrusted property worth several hundred crowns to him, and he sought me out in the Pope's private garden and wanted to return it all. At this I protested that there was nowhere else it could go, either to a dearer friend or a safer place. He twisted and turned in his determination not to keep it, and I almost had to force him to do so. When I finally escaped from the castle I found that this poor young Bernardo Galluzzi was ruined: and so I lost my belongings.

Again, while I was in prison I had a terrible dream, and it seemed that words of the utmost importance were being written on my forehead as if with a pen; the writer told me three times that I must keep quiet, and not speak of them to anyone. When I woke up I found there were marks

on my forehead. In my poem about the prison I mention a number of things of this sort. Also I was foretold, without then knowing its significance, all that later happened to Pier Luigi, so clearly and exactly that I am convinced it was an angel from heaven who revealed it to me.

There is one thing I must not leave out – perhaps the greatest that ever happened to any man – and I write this to testify to the divinity and mysteries of God, which He deigned to make me worthy of. From the time I had my vision till now, a light – a brilliant splendour – has rested above my head, and has been clearly seen by those very few men I have wanted to show it to. It can be seen above my shadow, in the morning, for two hours after the sun has risen; it can be seen much better when the grass is wet with that soft dew; and it can also be seen in the evening, at sunset. I became aware of it in France, in Paris, since in that region the air is so much freer from mists that it can often be seen, far more clearly than in Italy where mists are much more frequent. But this is not to say that I cannot see it on all occasions and can point it out to others, but not so well as in that part of the world.

I will write out my poem that I composed in prison, and in praise of my prison. Then I shall carry on with my story of the ups and downs that I have experienced from time to time, and also the story of what is yet to come.

I DEDICATE THIS CAPITOLO TO
LUCA MARTINI,
AND, AS WILL BE SEEN,
I ADDRESS HIM
IN IT[212]

He who would know God's power and mighty ways
And how far man may reach to things divine,
Some time in prison should drag out his days.

Torn from his people, let him sadly pine,
Stricken in body, with tormented mind,
A thousand miles away his native shrine.

If ever true success you've wished to find,
Be wrongly kept in harsh imprisonment,
Submit unaided to a world unkind;

And when they rob you, let them be intent
To strip you down, and then to take your life,
While you lose hope in your bewilderment.
Driven to frenzy, stir up bitter strife,
Break from your prison, leap the Castle wall:
Then let recapture add to your deep grief.
But Luca, listen to the richest joke –
Your leg is broken, treachery's around,
Your cell is sodden, you're without a cloak,
And left in silence, prostrate on the ground.
Food comes, but with it comes sad news,
The soldier quack of Prato brings it round.
Mark well how fame her children will abuse:
You're left no resting-place except a stool,
And yet new ventures you would not refuse.
'Leave him in silence' – that's the servant's rule,
Who gives you nothing, not a single word;
The door's just opened to admit the fool.
See how delightfully my mind is stirred!
Warmth and paper, pen and ink away,
No means to tell the many truths I've heard.
My one regret's how little I can say:
Increase each detail just a thousandfold,
My comment on each one will take a day.
But now to my first purpose I must hold,
And talk of prison, pouring out my praise:
The story should be by an Angel told.
No honest man will on a prison gaze,
Unless bad government or base envy,
Hatred or feud has tricked him in the maze.
But here's the truth, unravelled now by me:
A man in prison prayers to God will send,
Though suffering hellish pains eternally.
It may be he's an evil life to mend,
Give him two years in harsh captivity,
He'll make a saint, to every man a friend.

Both soul and body find true purity,
And when of all his grossness he is purged,
A man will glimpse heaven's divinity.
Now hear this marvel: once when I was urged
By some stray impulse, how the need to write
Drove me to satisfy emotion's surge.
Frowning, I pace the room, and then my sight
Falls on a crack that runs across the door,
And I secure a splinter with a bite.
Taking some brick I find upon the floor
I crumble it to powder; then for ink
Upon the brick my own urine I pour.
And then to forge the great poetic link
Enters my body inspiration's gleam
Using the way that bread goes out, I think.
But to return to my initial theme:
Before he finds his good, a mortal man
Must take from God more evil than he'd dream.
There's art, and science, within the prison's plan –
If you must needs to treatment have recourse,
Then would it heat your veins until blood ran.
Besides, all prisons have a natural force
To make you eloquent, and fierce and bold,
Debating well of good and ill the source.
Lucky the man the gaolers long time hold
Fast in his prison, and who then breaks free,
He knows of war and peace, how pacts unfold,
And all things undertakes successfully.
For prison gives him such fine powers and strength,
His wits won't take him dancing on a spree.
'The years you've lost!' you may protest at length,
'And what you write of prison is untrue,
No gaol sustains a man's soul or his heart.'
But, as for me, I'll praise it through and through,
Though there is just one law that I would make,
Gaoling a man, when prison is his due.

All those who would the reins of office take
Should learn the lessons that a prison gives,
They'd then rule wisely for their subjects' sake.

They'd then act justly, and throughout their lives
They'd never swerve from justness, nor permit
The great confusion that with order strives.

But I, when in my cell I used to sit,
Saw many priests and friars and soldiers there,
Though few for whom such punishment was fit.

The pain you feel, the grief so hard to bear,
When you are left and one of them is freed!
There's nothing left to nurse save deep despair.

But I am turned to gold; I must pay heed
To my high value. I must say no more,
For better things than this of gold have need.

Now one more thing into your ears I'll pour,
That I remember, Luca, left unsaid:
God's holy book was where I set my score.

With agony that on my body fed
I wrote in that book's margins with my pen,
With such a wretched paste that all the dead

In hell can never suffer worse, for then
Three times I dipped before an O was read.
I shall be silent, not the first of men

To suffer without cause. But here I'll write
Of what I suffered, of harsh torture's den.
A prison cell I praise with all my might,

And those in ignorance I here advise –
Without it they can never storm the height.
If only, as I read of, someone wise

Would say to me, as He said at the shore:
'Now, Benvenuto, take your clothes and rise.'
Salve Regina, Credo, prayers I'd pour

To God, with *Paternosters*; I'd give alms
To poor men, blind, and lame, for evermore.
How many times have I not suffered qualms

The lilies making me seem pale and dead;
Of France and Florence I forget the charms.
If in a hospital my way I tread
And see an Angel greeting Mary there
I do not linger; like a beast I've fled!
No harm I speak of that sweet lady fair
Nor of the holy flowers her hand enfolds
That light to earth and heaven always bear.
But everywhere I look my sight beholds
Those lily flowers, whose petals like a hook
I shake to see so many thousandfolds.
The many slaves, no matter where you look,
To that Farnese emblem born in thrall,
Those lofty souls that God from heaven took!
But I have seen that deadly emblem fall
Swift from the sky, among a people vain;
Then on the stone a new light brightening all.
Before my cherished freedom I could gain
The Castle bell must crack: this was made known
By the Creator who makes all things plain.
And then I saw a dark bier near the stone,
With broken lilies, crosses and sad tears
And on their beds afflicted men who moan.
My eyes saw Death, the one who cruelly sears
And tortures souls at random; then she said:
'I'll take whomever Benvenuto fears.'
Then wrote that noble being on my head
With Peter's pen the words which once begun
He three times ordered me to leave unsaid.
I saw the powerful Ruler of the sun
Clothed in its splendour, and the Court around,
Which human eye before has never done.
One solitary sparrow there I found
And cried, to hear it sing so tunefully:
'This means I live, but you go underground!'
I sang and wrote my plea for liberty,

Asked help and pardon from my God alone,
Since I knew how my eyes fell lifelessly.
Tiger or bear, or lion, or wolf: not one
Of these thirsts more for blood than he,
A viper with more venom there is none.
This cruel captain skilled in robbery,
The greatest rascal of a wicked troop;
But I'll speak softer, words betraying me.
If you have seen rapacious police-hounds swoop
Intent on theft into a poor man's home
Rifling his holy shrines in search of loot,
You know how on that August day did roam
The mob that led me to a harsher tomb:
'November – scattered, and their curses come.'
I heard a trumpet with a sound like doom;
With all revealed, I told them what it meant,
My rashness forced on me by darkest gloom.
And then, frustrated in bewilderment,
A powdered diamond they would have me eat,
With my sure murder as their fixed intent.
But first I made him taste, that wicked cheat
Who brought my food: it was to him I said:
'This action cannot be Durante's feat.'
Before this, all my thoughts to God I sped
Beseeching Him to pardon me my wrong,
And *Miserere* prayed, with lowered head.
My grief was softened; then with mind more strong
To God my soul I rendered willingly
To take to that kingdom for which I long.
An Angel sent from God came gloriously
Bearing a palm; who then with joyful face
Promised to lengthen my mortality.
'By harsh war, God,' he said, 'will crush the race
Of all your enemies: and then your mirth
Will once again abound. You'll rest in grace
With Him who rules the heavens and the earth.'

I remained in the Cardinal of Ferrara's palace; everyone thought very highly of me and I was visited more often than ever before. They all marvelled at how I had made my escape and was still alive after suffering so many indescribable misfortunes. While I was getting my breath back, and trying to recover my skill, I very much enjoyed rewriting the Capitolo. Then to help recover my strength I decided to go on a journey and enjoy the open air for a few days. My good friend, the Cardinal, gave me some horses, along with his consent, and I set off with two young Romans: one of them was a craftsman following the same trade as myself, unlike his friend who came along to keep me company.

I left Rome and made my way towards Tagliacozzo in the hope of finding my pupil, Ascanio, there; and when I arrived I found Ascanio himself, together with his father and brothers and sisters and stepmother. It is impossible to convey how well I was looked after and how affectionately they treated me. Then after two days I started back towards Rome, taking Ascanio with me. On the way we began discussing matters of art, with the result that I was burning to get back to the city and begin work again. When we did arrive I immediately prepared to start work, and first of all I rescued a silver bowl that I had begun for the Cardinal before I was imprisoned. Along with it I had also begun work on an exquisite little jug, but this together with a host of other very valuable objects was stolen from me.

I set Pagolo to work on the bowl: at the same time I made a fresh start on the jug. I made the design with figures both in the round and in low relief, and the bowl was designed likewise, with figures in full relief and fishes in low relief. The work was so rich and so perfectly arranged that everyone who saw it was astonished at the force and ingenuity of the design, and at the neatness of my young men's crafts-manship.

At least twice a day the Cardinal used to come and pass some of his time with me. He would bring Luigi Alamanni and Gabriello Cesano[213] along with him, and we spent many pleasant hours together. Even though I had a great deal on my hands he kept loading me with new work; and he commissioned me to make his pontifical seal. This seal was as large as the hand of a twelve-year-old boy; I cut two scenes on

it, in low relief, each of which told a story. One showed St John, preaching in the desert; and the other, St Ambrose, on horseback and with a whip in his hand, driving the Arians away. This showed such force and excellence of design and such neat workmanship that everyone said that I had surpassed the great Lautizio, who specialized in this kind of work. In fact the Cardinal used to compare it with great self-satisfaction to the seals which had been made for the other cardinals of Rome and which were nearly all from the hand of Lautizio.

In addition to those two works the Cardinal ordered me to make the model for a salt-cellar, but he insisted on its being different from the usual kind. Luigi made a splendid speech, with the proposed salt-cellar as his theme; and then Gabriello Cesano in turn gave an eloquent description of how he envisaged it should be. The Cardinal listened to them very politely and was extremely pleased with the designs that these two men of letters had sketched for him with their words. Then he turned to me and said:

'My dear Benvenuto, I'm so pleased with both of their designs – Luigi's and Gabriello's – that I wouldn't know which of the two to pick. So, seeing that it's you who have to execute it, I leave it to you.'

'You know, my lords,' I replied, 'how important the sons of kings and emperors are, and you know how magnificently splendid and divine they appear. All the same, if you ask a poor humble shepherd whom he loves more deeply, those boys or his own sons, without any doubt at all he'll answer that he loves his own sons more. Just so, I have a great love for the sons I create for my art. The first design I shall show you then, most reverend monsignor, my patron, will be my own work and invention. There are many things which appear beautiful when spoken about, but, when put to the test, don't result in good work.'

Then I turned to those two great men of letters and added: 'You have spoken, and I shall act.'

At this Messer Luigi Alamanni broke into a laugh, and then, very pleasantly, started making a brilliant little speech in praise of me: it suited him very well, since he was very handsome, had a well-proportioned body, and spoke with a charming voice. Messer Gabriello Cesano was quite the reverse, he was so ugly and disagreeable. So he spoke the same way as he looked.

The design Messer Luigi had envisaged when he was talking about it had been for a figure of Venus, together with one of Cupid, as well as a number of appropriate ornaments. Messer Gabriello had offered as his idea a model of Amphitrite, the wife of Neptune, along with Neptune's Tritons, and many other things that were very fine to talk about but not to make.

Anyhow, I made an oval shape, a good deal more than half a cubit in size – in fact almost two-thirds – and on it I modelled two large figures, to represent the Sea embracing the Land. They were a good deal more than a palm in size, sitting with their legs entwined in the same way as certain long branches of the sea cut into the land. In the hand of the male figure, the Sea, I put a very richly ornamented ship, that could easily and conveniently take a good quantity of salt; underneath him I positioned the four sea-horses, and I placed the trident in his right hand. I represented the Land by a woman, whose beauty of form was such that it demanded all my skill and knowledge. She was beautiful and graceful, and by her hand I placed a richly ornamented temple; it was placed on the ground, and she rested her hand on it. I made this to hold the pepper. In her other hand I put a horn of plenty, adorned as exquisitely as I knew how. Beneath this goddess, on the part which was meant to be the earth, I grouped all those wonderfully beautiful animals that the earth produces. Corresponding to this, I fashioned for the Sea every kind of beautiful fish and shell that the small space could contain. The rest of the oval I filled in with a host of rich designs.

Then I waited for the Cardinal. He came along with those two men of letters, and I brought out my wax model of the work.[214] When he saw it, Messer Gabriello was the first to raise his voice and shout:

'It would take more than ten men working all their lives to finish this work: and as for you, most reverend monsignor, you may want it, but you'll never have it in your lifetime. Benvenuto wanted to show his children but he didn't want to give them away as we did: we were talking about things that could be done and what he's showing us simply can't be done.'

At this Luigi Alamanni took my part, but the Cardinal said that he

did not want to commit himself to such a great undertaking. Then I turned to them and said:

'Most reverend monsignor, and learned gentlemen, I tell you this: I hope to complete this work for whoever is to have it, and you shall all see it finished a hundred times more elaborate than the model is. I trust there's still plenty of time left to do much more ambitious things than this.'

The Cardinal replied angrily: 'If you don't make it for the King, to whom I'm taking you, I don't think it can be made for anyone else.'

Then he showed me the letter containing a passage where the King wrote that he should return straight away, bringing Benvenuto with him. I lifted my hands to heaven and cried: 'But oh, when will this "straight away" be?'

The Cardinal said that I should have all my affairs in Rome cleared up and be quite ready within ten days.

When it was time for us to leave he gave me a fine handsome horse, which was called Tornon because it had been given him by the Cardinal of Tornon.[215] My apprentices, Pagolo and Ascanio, were also provided with mounts.

The Cardinal divided his following, which was very large, into two. The more distinguished part he took with himself, going with it by way of the Romagna, in order to visit the shrine of Our Lady of Loreto and then go on to his home, Ferrara. The other part he directed by way of Florence. This was the more numerous, consisting in a whole host of people including the flower of his horsemen. He told me that if I wanted to travel safely I should go with him, for if not I'd be in danger of my life. I told his Eminence that I wanted to accompany him: but – such was the will of heaven – it pleased God to remind me of my poor sister, who had been so anxious and upset about my great misfortunes. I also remembered my cousins, who were nuns at Viterbo, one the abbess and the other the refectorer, so that between them they were in charge of the rich convent there. Seeing what grave anxiety I had caused them and how much they had prayed for me, I was firmly convinced that the prayers of those poor virgins had moved God to grant me my safety. So, bearing all this in mind, I decided to go by way of Florence: and although I could have set out, with my expenses

paid, either in the company of the Cardinal or with the other part of his following, I determined to go by myself. I travelled in the company of a very famous clockmaker called Cherubino:[216] he was a great friend of mine. We came together by chance and we travelled together very happily.

The three of us left Rome on our own on the Monday of Holy Week, and we met the company I mentioned at Monte Ruosi. As I had spread it around that I was going with the Cardinal I felt sure that none of my enemies would be looking out for me. However I came off badly at Monte Ruosi, for a band of well-armed men had been sent ahead of us to assault me. As God would have it, while we were at dinner, having found out that I wasn't travelling in the Cardinal's party they made their plans to attack. But at this point the Cardinal's troop arrived, and so with a light heart I travelled safe in their company as far as Viterbo. From then on there was no fear of danger, especially as I rode a few miles ahead and the best men in the Cardinal's train kept a close eye on me. Thanks to God I arrived safe and sound at Viterbo, where I was welcomed with the warmest affection by my cousins and the rest of the nuns.

I left Viterbo with the people I mentioned and we rode on our way, sometimes in front of and sometimes behind the Cardinal's train. So on Maundy Thursday, two hours before nightfall, we found ourselves within travelling distance of Siena. There were some horses there waiting to be brought back to the city and the post officials were ready to hire them at a small charge to anyone who would take them back to the post-station at Siena. When I saw this I dismounted from my horse, Tornon, put my pillion and stirrups on one of the waiting horses, and gave a giulio to one of the postboys. I left my horse for the young men to bring after me, and without delay I set off in advance in order to arrive at Siena half an hour earlier, as I wanted to visit a friend of mine and see about some other business. Although I moved pretty fast, however, I didn't race the horse. When I reached Siena I booked some good rooms at the inn, for five people, and got a serving-lad to lead the horse back to the post-station, which was outside the Camollìa gate; but I forgot to remove my pillion and stirrups.

We spent the evening of Maundy Thursday very pleasantly, and then

next morning – Good Friday – I remembered my stirrups and pillion. When I sent for them the postmaster said that he refused to return them since I had raced the horse. We exchanged messages, backwards and forwards, and he kept repeating that he wouldn't return them, and he threw in some intolerable insults. The innkeeper where I was lodging said:

'You're getting off lightly if all he does is keep your pillion and stirrups.'

Then he added: 'You know, he's the most brutal fellow we've ever had in this city, and his two bold warlike sons are even worse. So buy what you want, and then go on your way without saying another word.'

I did in fact buy a pair of stirrups, but I thought that if I spoke in a friendly way I'd get my fine pillion back again. Besides, I was well horsed, well armed with a coat of mail and gauntlets, and I had a splendid arquebus slung across the saddle; so despite the innkeeper's saying how brutal that mad beast was I wasn't the slightest bit afraid. I had also accustomed my young men to wear mail coats and sleeves and I had every confidence in the young Roman, who while we were in Rome had never, as far as I could see, left his off; while Ascanio, young as he was, also used to wear them.

Anyhow, seeing that it was Good Friday I reckoned that, as far as their madness was concerned, madmen would have the day off. We reached the Camollìa gate, and I recognized the postmaster when I saw him from the signs that had been given me, for he was blind in the left eye. I left my young men and travelling companions some way off, rode up to him, and said courteously:

'Postmaster, if I assure you that I didn't race your horse, why aren't you good enough to give me back my pillion and stirrups?'

He replied exactly as I had been told he would, like a mad beast. At this I exclaimed:

'What, aren't you a Christian? Do you want both of us to cause scandal on a Good Friday?'

He said that he didn't care a damn whether it was Good Friday or Bad Friday, and that if I didn't clear off he'd knock me down – and my arquebus as well – with the halberd he had taken hold of. Hearing

these violent words, an old Sienese gentleman made his way towards us. He was wearing an ordinary citizen's clothes and he was returning from his Good Friday devotions. From a distance he had caught quite clearly the drift of my argument, and he took my part and began giving the postmaster a sound dressing-down. He told off the two sons for not behaving properly towards a passing stranger; he said that this was flying in God's face and a disgrace to the city of Siena. The two young men shook their heads without saying anything and went inside the house. Their frenzied father, exasperated by what that fine old gentleman was saying, straight away started blaspheming shamefully, lowered his halberd, and swore that whatever happened he would murder me with it.

When I saw his brutal intention, in order to make him keep his distance, I made as if to point my gun at him. He came at me more furiously than ever. I was ready to defend myself, and I had the arquebus ready, but I hadn't lowered it to the extent that it was pointing at him, and in fact it was pointing upwards; and then it went off by itself. The ball hit the arch of the doorway, glanced back, and struck him in the windpipe. He fell down dead; and then his two sons came rushing out. One of them armed himself from the stand they had there and the other seized his father's halberd. Then they rushed on my young men. The one with the halberd attacked Pagolo, the Roman lad, striking him about the left breast; the other ran at a Milanese who was travelling with us. His face was stupid with fear: without success, he tried to save himself by crying out that he had nothing to do with me, and then he defended himself from the pike that was thrust at him with a little cane he had in his hand. But all this did not prevent his receiving a slight wound in the mouth.

Cherubino was in clerical dress, for although he was a first-rate clockmaker, as I said before, he also held some very profitable benefices from the Pope. Ascanio was well armed, and so unlike the Milanese he stood his ground. So he and Cherubino weren't touched. As for me, I had clapped spurs to my horse and while I was galloping away I quickly prepared and loaded my gun; and then I turned back, almost choking with rage. I had been treating the matter as a joke, but now, I thought, it was time to take it seriously. Under the impression that

my young lads had been killed I determined to die myself. But my horse had not galloped back far when I met them coming towards me and asked if they were hurt. Ascanio replied that Pagolo had been mortally wounded by a halberd.

'Pagolo, my dear son,' I said, 'then the halberd pierced your coat of mail?'

'No,' he answered, 'I packed it in my bag this morning.'

'So coats of mail are worn in Rome to please the ladies, but when there's danger and they have a purpose to serve they're packed away? You deserve all you've got – and it's your fault that I'm riding to my death as well.'

While I was saying this I continued to ride back recklessly along the road. Both he and Ascanio implored me for the love of God to save myself along with them, since I was certainly going to my death. Then I met Cherubino together with the wounded Milanese. He at once shouted out that no one had been hurt and that Pagolo had only been grazed, adding that the old postmaster lay dead, that his sons and a crowd of others were getting ready for us, and that we would certainly all be cut to pieces.

'So Benvenuto,' he cried, 'seeing how fortune has saved us from the first storm, don't tempt her again or she'll desert us.'

'If that's how you want it,' I replied, 'I'm satisfied too.'

Then I turned to Pagolo and Ascanio and said: 'Spur your horses on. We'll ride to Staggia without stopping, then we'll be safe.'

The wounded Milanese cried: 'God damn all our sins! That's the only reason I've been wounded – because yesterday as there wasn't anything else to eat I had a little broth.'

For all our trials and tribulations we were forced to laugh a little at this fool and the nonsense he was talking. We spurred on our horses and left Cherubino and the Milanese to follow on at their leisure.

Meanwhile the dead postmaster's sons ran to the Duke of Melfi,[217] and begged for some light horsemen to overtake and capture us. The Duke, knowing that we were the Cardinal of Ferrara's men, refused to give them the horsemen and also refused them permission to pursue us.

In the meantime we reached Staggia and safety. On arrival we found

a doctor – the best they had in the town – and had Pagolo examined. The wound was only skin deep and there was no call for anxiety. So we ordered dinner. Meanwhile Cherubino and that fool of a Milanese appeared on the scene. He kept calling down curses on men who started brawls, and he complained that he was excommunicated, because on that holy morning he hadn't been able to say a single Our Father. He was an ugly-looking devil, and nature had given him a large mouth, which the wound he received had made a couple of inches larger. What with his prattling Milanese jargon and the silly things he was saying, he sounded so funny that instead of lamenting our bad luck we couldn't help laughing at every word he said.

The doctor began sewing up his wound and had already made three stitches when he told him to hold off for a while, since he didn't want him to sew his mouth up altogether, out of spite. He took hold of a spoon and said that he wanted enough of his mouth left open to let the spoon in, so that he would be able to get home to his own people alive. What he was saying and the way he kept wagging his head was so comic that instead of moaning about our bad luck we never stopped laughing. And so, laughing all the way, we went on to Florence.

We dismounted outside my poor sister's house, where she and my brother-in-law gave us a wonderfully affectionate welcome. Cherubino and the Milanese went about their business. We stayed in Florence for four days, and by the time we left Pagolo had recovered. It was wonderful how whenever we talked about that idiotic Milanese we were forced to laugh as much as our other troubles had made us cry: so we kept laughing and crying at the same time. Pagolo recovered without any difficulty; then we set off for Ferrara, and we found that the Cardinal himself had not yet arrived there.

He had heard about all our mishaps and to express his sympathy he said: 'All I pray God is that He allows me to bring you safe and sound to the King whom I've promised you to.'

He gave me rooms in Ferrara in one of his own palaces, a beautiful place called Belfiore just by the city walls. And he placed at my disposal all I needed for my work. But then he prepared to leave for France without me, and when he saw how much I was upset by this he said:

'Benvenuto, all that I'm doing is for your own good, because I want to make quite certain, before taking you away from Italy, of what you are going to do in France. Meanwhile, press on as hard as you can with that bowl and jug of mine, and I'll leave my steward instructions to let you have all you need.'

So he went on his way, leaving me very disgruntled and thinking more than once of clearing off altogether. The only thing that kept me there was the fact that he had freed me from Pope Paul: as for the rest, he left me very dissatisfied, and what he had done was to my great loss. All the same I persuaded myself that the kindness he had shown deserved my gratitude, and I decided that I would wait patiently and see how things turned out. I set to work, with my two young men helping me, and began to make considerable progress on the bowl and jug.

The air where we were lodging happened to be very unhealthy, and so, as summer was approaching, we all became rather unwell. While we were indisposed we went round inspecting the estate. It was very extensive and a mile of open ground was left completely wild. A host of indigenous peacocks were breeding there, just like wild birds. When I discovered this I charged my gun with a certain noiseless powder, and then used to lie in wait for the young birds. By killing one every other day I provided an abundant supply of nourishing food, and the result was that we soon got rid of our sickness. We spent those few months working happily, pushing on with the bowl and jug which demanded a great deal of time.

It was about then that the Duke of Ferrara came to terms[218] with Pope Paul of Rome about some long-standing matters of dispute between them concerning Modena and certain other cities. As the Church had a right to them the Duke had to spend a great deal of money in order to obtain peace. I believe that it amounted to more than three hundred thousand ducats of the Camera. At that time the Duke had as his treasurer an old man called Girolamo Giliolo, who had been brought up by his father, Duke Alfonso. The old fellow could not bear the thought of so much money being lost to the Pope, and he used to roam the streets complaining that the Duke's father, Alfonso, would have used the money to capture Rome rather than have let the Pope set eyes on it: and he could not be persuaded to pay it out. In the

end the Duke compelled him to make the payment, and as a result he had such a fierce attack of dysentery that he nearly died.

While he was ill the Duke sent for me and ordered me to make his portrait. I did it on a round piece of black stone, about the size of a little dinner plate. The Duke took great pleasure in my work, as well as in the many pleasant conversations we had together; and this meant that very often he would sit for his portrait for at least four or five hours, and several times he made me have supper with him. The portrait of his head was finished in a week and then he ordered me to do the reverse. The design for this showed Peace, represented by a woman with a torch in her hand, setting alight a pile of weapons. I showed her with an extremely joyful and graceful expression, wearing very light drapery. Under her feet I depicted the figure of Fury, in despair, heavily laden with chains and affliction. I took great pains to perfect this work, and it brought me a great deal of honour.

The Duke could not leave off saying how satisfied he was; and he gave me the inscription for the head and the reverse. The one for the reverse read: *Pretiosa in conspectu Domini*, meaning that peace had cost a mint of money.

While I was working on the reverse for the medal[219] the Cardinal had written saying that I should prepare to leave as the King had sent for me, and adding that his next letter would give details about all he had promised me. I had my bowl and jug safely packed up, since I had already shown them to the Duke.

The Cardinal's affairs were looked after by a Ferrarese gentleman called Messer Alberto Bendedio; this man had a grave ailment which meant that he had been completely confined to his house for twelve years. One day he sent for me in a tremendous hurry, saying that I must join the post straight away and present myself to the King, who had been insistently asking for me in the belief that I was in France. The Cardinal had excused himself by saying that I was a little ill and that I was staying at an abbey of his in Lyons, but that he would summon me to his Majesty without delay. So he insisted that I should hurry up and travel with the post as quickly as possible.

This Alberto was a very upright man, but he had an arrogant nature that his illness had made intolerable. As I said, he ordered me to get

ready immediately and set off with the post. My comment on this was that my art was not carried on in the post, and that if I had to go I intended to travel in easy stages, and take with me Ascanio and Pagolo, the assistants I had brought from Rome. What was more, I added, I wanted a servant on horseback to look after my needs, and as much money as would be necessary.

The sick old fellow came back with a very high-handed reply, to the effect that it was for the sons of dukes to travel in the way I had described, but only for them. I retorted that the sons of my profession went about in the manner I had told him, that since I had never been the son of a duke I had no idea how they travelled, and that if he was going to pour such fantastic speeches into my ear I would refuse to go at all. Seeing that the Cardinal had broken his word to me, I said, and that I had been treated to such abuse, I was quite determined never to get involved with the Ferrarese. Then I turned my back on him, and, to the sounds of my complaints and his threats, I walked away.

I went to the Duke in order to let him have the finished medal. He received me with incomparable warmth and courtesy, and he had already told his Messer Girolamo Giliolo that, as a reward for my labours, he was to obtain a diamond ring worth two hundred crowns and give it to the chamberlain, Fiaschino, who was to hand it to me. This was done. One hour after nightfall, on the evening of the day that I had handed over the medal, Fiaschino brought me a ring with a very imposing diamond and recited this message on behalf of the Duke:

'In remembrance of his Excellency, may this diamond adorn the unique hand of an artist who has done such fine work.'

When day came I inspected the ring and found that the diamond was a miserably thin stone, worth perhaps ten crowns. Since I hardly thought that the splendid tribute paid me by the Duke could be associated with such a scrappy reward, seeing that the Duke reckoned he had given me cause for satisfaction, and guessing that this was the doing of that rascally treasurer of his, I gave the ring to a friend of mine to return to Fiaschino as best he could. The friend I used was Bernardo Saliti, and he did the job admirably.

Fiaschino came back to me straight away, shouting his head off that

if the Duke knew I was returning in that way the gift he had so kindly given me he'd be mightily offended, and perhaps I would come to regret it. I replied that the ring his Excellency had given me was worth about ten crowns, and that the work I had done for him was worth more than two hundred. But, to show his Excellency that I appreciated his generous act, he had only to send me a ring of the sort that are worn for cramp (they come from England and are worth about a carlin) and I'd treasure it in remembrance of him as long as I lived. I would preserve it along with my recollection of the courteous message he had sent me because, I said, I reckoned that his Excellency's great liberality had amply repaid me for my labours, whereas that miserable jewel insulted them.

These words upset the Duke so much that he sent for his treasurer and rated him far more severely than he had ever done before. Then he ordered me, under pain of his displeasure, not to leave Ferrara without letting him know. Finally he commanded his treasurer to present me with a diamond worth up to three hundred crowns. That miser of a man found one worth little more than sixty crowns and gave it out that it was worth much more than two hundred.

Meanwhile the Messer Alberto I was talking about came to his senses and provided me with everything I had asked for. I made up my mind that no matter what happened I would leave Ferrara that very day. But the Duke's interfering chamberlain had arranged with Alberto that I shouldn't get any horses on that day.

I had loaded a mule with a great deal of luggage, packing in with it the bowl and jug that I had made for the Cardinal. While I was doing this a Ferrarese gentleman called Messer Alfonso de' Trotti came up.[220] He was a very kind old man and passionately fond of beautiful things, but he was one of those people who are extremely hard to please and who if they ever happen to see something that pleases them are so impressed that they think they will never see anything as good again. Well, when this Messer Alfonso appeared on the scene, Alberto said:

'I'm sorry you've arrived so late, because the bowl and jug that we're sending to the Cardinal in France are already packed away.'

Alfonso replied that he did not mind at all; then he beckoned his

servant and sent him to his house to fetch a jug that he had there, very exquisitely worked in white Faenza clay. While his servant was going and coming, Alfonso said to Alberto:

'I'll tell you why I don't worry whether I see any more vases: the truth of the matter is that I once saw a silver antique vase that was so wonderfully beautiful that no human mind can imagine the like. So I don't want to look at any other vase in case by doing so I spoil the marvellous impression I have of that one. This antique vase was shown secretly to a discriminating nobleman who went to Rome on some private business. Using a great sum of money as bait he bribed the fellow who was in charge of it and brought it back here, but he has it kept hidden carefully away in case the Duke gets to hear of it and he loses it altogether.'

While Alfonso was telling this long story he did not look at me though I was standing near, because he didn't know me.

Meanwhile his precious clay model was brought to him, and he uncovered it with so much self-satisfaction and ostentatious self-deception that I turned to Messer Alberto and said:

'What a stroke of luck for me to have seen it!'

At this Alfonso lost his temper and shouted rudely:

'And who are you? You don't know what you're talking about.'

I retorted: 'Now listen to me, and then we'll see which of us really knows what he's talking about.'

I turned to Alberto, who was an intelligent, serious-minded sort of man, and told him that it was copied from a little silver vessel, of such and such a weight, that I had made at such and such a time for that charlatan of a doctor, Jacomo da Carpi.

'He was the fellow,' I said, 'who came to Rome and stayed there six months, daubing scores of poor gentlemen and noblemen with one of his ointments and fleecing them of many thousands of ducats. It was then that I made him this vase and another, different one. He paid me very meanly for both of them, and now all the unfortunate wretches he treated are miserable cripples. I count it a very great honour that my works should be so highly esteemed by rich lords like yourselves, but I assure you that over the years I've tried as hard as I can to improve my skill, and as a result I think that the vase I'm taking to France is

much more worthy of the King and the Cardinal than the one that belonged to that quack of yours.'

When I had said this that Alfonso was so impatient to see the bowl and jug that he looked as if he might drop down dead any minute: but I stuck to my refusal. After we had argued for a while, he said that he would go and see the Duke and get his Excellency to make me show it. Then Alberto Bendedio, who was, as I've said, a very high-handed man, broke in with:

'You will see it before you leave us, Messer Alfonso; and there'll be no need to use the Duke's influence.'

At these words I went off, leaving Ascanio and Pagolo to show it to them. Pagolo told me afterwards that I had been praised to the skies. Alfonso then wanted to strike up a friendship with me; and it seemed an eternity before I would be able to leave Ferrara and get away from them all. All the good I had got out of the place had been the company of Cardinal Salviati and the Cardinal of Ravenna and of some very talented musicians there, but of no one else. The natives of Ferrara are very avaricious people, and they enjoy robbing others as much as they can: they're all the same.

Two hours before nightfall Fiaschino arrived and handed me the diamond worth about sixty crowns, the one I mentioned. With a sour face and as briefly as he could he told me that I should wear the ring for his Excellency's sake.

I replied: 'And so I shall.'

Then, while he was still there, I placed my foot in the stirrup and cleared off on my journey. He noted my action and words and reported them to the Duke, who lost his temper and would have moved heaven and earth to bring me back.

That evening, trotting all the way, I pushed on more than ten miles: the next day, when I had left Ferrarese territory, I cheered up tremendously, seeing that, except for the peacocks I had eaten which had restored my health, I hadn't derived any good from the place. We took the Mont Cenis route, avoiding the city of Milan, because of the qualms I had, and then we arrived safe and sound at Lyons. There were four of us altogether, myself, Pagolo and Ascanio, and a servant; and we had four very good horses. After we had reached Lyons we stayed

there for a few days, waiting for the muleteer who was bringing the silver bowl and jug and the rest of our luggage. We had lodgings in the abbey belonging to the Cardinal. When the muleteer arrived we put all our belongings into a little cart and sent them off to Paris. Then we set off towards Paris, running into some trouble on the way but nothing very serious.

We found the King's court at Fontainebleau, where we presented ourselves to the Cardinal who immediately found us quarters; and for that night we were very comfortably placed. Next morning the little cart arrived. We secured our belongings, and when the Cardinal heard of this he told the King, who at once wanted to see me. I went to his Majesty, taking the bowl and jug with me, and when I entered his presence I kissed his knee and he received me very graciously. I thanked his Majesty for having freed me from prison, saying that a prince such as his Majesty, a man of his unique goodness, was bound to liberate men who had some talent, and especially innocent men like me, and that such generous deeds were written down in God's book, ranking higher than anything else.

That good King listened till I had finished, behaving with great courtesy, and interposing a few words typical of his fine nature. When I had come to an end he took the bowl and jug and said:

'I am certain that such beautiful work was never known to the ancients: I well remember having seen all the best works done by the finest craftsmen of all Italy, but I never saw any that moved me more than this.'

The King said this to the Cardinal of Ferrara, in French, and he added a number of other even more complimentary remarks. Then he turned to me and said in Italian:

'Benvenuto, spend a few days enjoying yourself, set your mind at rest and have a good time. Meanwhile we shall plan how to let you have all you need to start on some fine work for us.'

The Cardinal of Ferrara saw that the King was delighted at my arrival, and he realized that, on the strength of the few objects I had shown him, the King had promised himself to have executed some of the very important works he had in mind. But at this time we were following the court, or rather, struggling along behind, because the King's train

always drags along behind it twelve thousand horsemen; in peacetime when the court is complete there are eighteen thousand, and so with twelve thousand the number is at its lowest. So there we were, following the court through places where sometimes there were scarcely two houses to be seen. We pitched canvas tents like the gipsies; and more than once we had to suffer great discomfort.

I kept begging the Cardinal to urge the King to send me away so I could start work, but he told me that the best course was to wait till the King remembered me without being prompted, and that I might sometimes let myself be seen by his Majesty while he was at table. I did this, and then one morning while he was having dinner the King called me over. He began to talk to me in Italian and said that he intended to have some very important works done for him, and that before very long he would give me instructions where I was to operate and provide me with all I needed. He added a variety of other pleasant remarks.

The Cardinal of Ferrara was present, as he almost always used to eat in the morning at the King's table; he overheard our conversation and when the King rose to his feet he said on my behalf, as I was told later:

'Sacred Majesty, this Benvenuto is very anxious to start work. It's almost a sin to waste such an artist's time.'

The King replied that he was perfectly right and that he should arrange with me the details of all I needed for my upkeep. The evening following this the Cardinal sent for me after supper and told me on behalf of the King how his Majesty had decided that I was to start work, but first he wanted me to know what my allowance was to be.

The Cardinal added: 'It seems to me that if his Majesty allows you three hundred crowns a year, you'll be very well off. Anyhow, I want you to leave all the arrangements to me, because every day provides me with an opportunity of achieving something in this great kingdom, and I'll always help you lavishly.'

I replied: 'Without any request from me, when your Eminence left me in Ferrara you promised never to take me away from Italy unless I first knew exactly on what footing I would be with the King. And then, instead of sending this information, your reverend lordship sent express orders that I was to travel with the post, as if art like mine could

be carried on post-haste. If you had sent to tell me about the three hundred crowns that you mention now I wouldn't have budged – not even for six. All the same I thank God, and I thank your lordship as well, since God has used you as the instrument for that great favour, my liberation from prison. Let me tell your lordship this: that all the hard blows you're dealing me now can't detract a thousandth part from the great benefits you've given me. I thank you with all my heart, and I take my leave of you. Wherever I shall be, as long as I live, I shall always pray for you to God.'

The Cardinal, losing his temper, burst out angrily: 'Go where you like. No one can be helped by force.'

Some of his good-for-nothing courtiers said: 'He thinks he's doing something marvellous in refusing an income of three hundred ducats.'

But the more discerning among them commented: 'The King will never find another man like him, and here's our Cardinal trying to bargain over him as if he were a bundle of wood.'

I was told later that it was Luigi Alamanni who said this. All this took place in Dauphiné, in a castle whose name I forget, on the last day of October.[221]

I left the Cardinal and set off for my lodgings, which were three miles distant. I was accompanied by one of the Cardinal's secretaries, who was making for the same place. All the way he never left off asking me what I intended to do with myself and what sort of reward I had imagined I should receive. I merely said tersely: 'I knew it all.'

I arrived at my quarters and found Pagolo and Ascanio there. Seeing that I was upset they made me tell them what was wrong. Then, when I realized how dismayed they were, I said:

'Tomorrow morning I shall give you more than enough money to get you home with ease. I shall go off by myself to see about some very important business that I've been meaning to attend to for a long time.'

Only one wall separated our room from the secretary's, and it is quite likely that he wrote to the Cardinal telling him all I meant to do, though I never found out for certain.

I had a sleepless night, and it seemed an eternity before day came and I could carry out what I had resolved. At dawn I had the horses led out, prepared myself quickly, and gave the two young men all I

had brought with me, and fifty gold ducats besides. I kept as much for myself, and also the diamond that the Duke had given me. I took only two shirts and the rather worn riding-clothes that I was wearing. But it was impossible to get away from my two young men, who were set on coming along with me no matter what happened. So I had to treat them harshly, saying:

'One of you has grown his first beard, and the other is just about to do so, and you've learnt from me as much of my poor art as I could teach you. As a result you're the foremost young craftsmen of all Italy. Aren't you ashamed you haven't the courage to do without your leading-strings? It's too pitiful for words. If I let you go without any money what would you say then? Now, be off with you – and God give you a thousand blessings. Good-bye!'

I turned my horse and rode off, leaving them with tears in their eyes. I took a beautiful road leading through a wood, intending to cover at least forty miles that day to a region as much off the map as possible. I had already gone about two miles, and on that short stretch had made up my mind never again to frequent places where I was known. I had no desire to do any more work, except a figure of Christ, that would stand about three cubits high and that would approach as near as possible the infinite beauty He Himself had revealed to me. With my mind completely made up I turned my horse in the direction of the Holy Sepulchre.

I was just reflecting that I had come so far that no one could ever find me, when I heard from behind the sound of horses. This made me rather uneasy, seeing that in the region I was in there lives a certain band of brigands called Adventurers who have the habit of murdering people on the highway: and although a fair number of them are hanged every day this does not seem to worry them. When they came nearer I recognized one of the King's messengers, along with Ascanio; and when he caught up with me he said:

'On the King's orders you are to return to him without delay.'

I replied that he came from the Cardinal, and so for that reason I refused to come back. He answered that since I refused to yield to persuasion he had authority to call on the local people and get them to bind me like a prisoner. Ascanio as well began pleading with me as

earnestly as he could, reminding me that once a man had been made a prisoner it was at least five years before the King would release him. The mention of prison – bringing to mind the prison in Rome – struck so much terror into me that I quickly turned my horse in the direction I was told by the King's messenger. All the way he never left off chattering in French, and he didn't stop once till he had brought me to the court: he threatened me, then he would say one thing, and then another, till I almost died of vexation.

As we rode towards the King's quarters we passed in front of the Cardinal of Ferrara's. The Cardinal, who was standing at his door, called me over and said:

'Of his own choice our Most Christian King has made you the same allowance that his Majesty gave to the painter Leonardo da Vinci,[222] that is, seven hundred crowns a year. Besides this he will pay you for all the work you do; and in addition he is giving you five hundred gold crowns for your journey here, and they're to be paid you before you leave.'

When he had finished I replied that the sums mentioned were worthy of such a King. The King's messenger, who had been ignorant as to who I was, when he had heard the great offers that were being made to me on behalf of the King kept asking my pardon.

Pagolo and Ascanio said: 'You see, God has helped us return to such honoured leading-strings.'

The following day I went to give my thanks to the King and he commissioned me to make models for twelve silver statues,[223] which he wanted to use as candlesticks round about his table. They were to represent six gods and six goddesses and to be exactly the same height as his Majesty himself, who was a little under four cubits. When he had ordered this he turned to his treasurer and asked if he had paid me the five hundred crowns. The treasurer said that he had been given no instructions. The King was furious at this, seeing that he had ordered the Cardinal to tell him.

He also said that I was to go to Paris and find somewhere suitable for carrying out the work he would commission, and that he would have the room made over to me. So I took the five hundred crowns, went to Paris, to a room belonging to the Cardinal of Ferrara, and

there, invoking the name of God, I set to work. I made four small models in wax, each two-thirds of a cubit high: Jupiter, Juno, Apollo, and Vulcan.

Meanwhile the King came to Paris himself and so I at once went to see him, taking with me the models, along with my two young men, Ascanio and Pagolo. The King showed his satisfaction with the models, and after he had ordered me to start work first of all on the Jupiter, which was to be in silver of the height mentioned before, I presented my two young men, telling his Majesty that I had brought them from Italy to serve him. I added that as I had trained them myself to begin with they would be much more of a help to me than anyone I could find in Paris. The King answered that I should have them paid whatever salary seemed sufficient for their maintenance. I replied that a hundred crowns for each of them would do very well and that I would make certain they earned their money. So we reached agreement.

Besides this I told his Majesty that I had found a place I thought ideally suited to the work he had given me to do; it was part of his Majesty's personal property, called the little Nesle, and it was now, I said, held by the Provost of Paris who had been granted it by his Majesty. But, I went on, seeing that the Provost made no use of it his Majesty could give it to me and I would use it in his service.

The King at once replied: 'The place belongs to me personally and I know perfectly well that the man I gave it to doesn't live there and makes no use of it; so you shall take it over for our business.'[224]

Then straight away he ordered his lieutenant to install me in the Nesle. When this officer started demurring and saying that he could not do it, the King retorted angrily that he meant to give what belonged to him to whomever he liked and to someone who would work to serve him – seeing he got no service from the other man – and there was nothing more to be said about it. The lieutenant went on to say that it would be necessary to use a certain amount of force; and to this the King replied: 'Go on then, and if a little force isn't enough use a lot.'

Straight away he took me to the place, and he had to use force to put me in possession. Then he warned me to be on my guard against being murdered. I took possession, hired servants, bought some large

pikes, and for some days remained in a very awkward position, since the Provost ranked as a very important nobleman in Paris and all the others were hostile to me. As a result they were so offensive that I was unable to hold out against them. I must not forget to say that when I began serving his Majesty it was during 1540, and I was in my fortieth year.

The bitter attacks that were made drove me back to the King to beg him to accommodate me somewhere else. When I made my request his Majesty remarked: 'Who are you? What's your name?' I was dumbfounded and had no idea what he meant. As I stood there, struck speechless, the King repeated the same words again as if he had lost his temper. So then I replied that my name was Benvenuto.

The King said: 'Well, if you're the Benvenuto I've heard of, act as you usually do – and I give you full permission.'

I told his Majesty it was good enough for me to remain in his favour, and as for the rest there was nothing that could hurt me. The King smiled slightly and said: 'Go off then, and you'll always be able to rely on my favour.'

Then he at once ordered his first secretary, who was called Monsignor di Villurois,[225] to see that I was provided for and supplied with all I needed. This Villurois was a very great friend of the nobleman, known as the Provost, who had the Nesle. The place itself was in the form of a triangle, and was up against the walls of the city. It was an ancient castle, but there was no garrison in it. It was a good-sized place.

This Monsignor di Villurois advised me to look for somewhere else and whatever happened to leave where I was, since the man it belonged to was very powerful and would certainly have me killed. I replied that my only reason for leaving Italy and coming to France was to serve that magnificent King: and as for death, I knew I had to die some time so whether it was a little sooner or a little later didn't bother me at all. This Villurois had a very powerful character, everything about him was splendid, and he was extremely rich: there was nothing he would not have done to annoy me, but he showed no trace of his real feelings. He was a serious man, very handsome to look at, and he spoke slowly and deliberately. He passed the matter on to another nobleman called Monsignor di Marmagna,[226] who was treasurer of Languedoc.

The first thing this man did was to choose the best rooms in the castle and have them prepared for himself. I told him that the King had given the place to me to use in his service, and that I did not intend anyone to live there save myself and my servants. He was a proud, forceful, hot-tempered man; and he told me that he would do what he liked and I might as well run my head against a wall as oppose him; everything he did, he said, he had been given authority to do by Villurois.

So then I retorted that I had authority from the King, and that neither he nor Villurois could do such things. When I said that, this haughty man speaking in his own French language started pouring abuse on me; and I told him, in Italian, that he was a liar. Flushed with anger, he made as if to draw his little dagger; so I clapped my hand to the large dagger I always wear for my own defence, and cried: 'If you dare draw that weapon I'll kill you on the spot.'

Marmagna had two servants with him and I had my two young men; he hesitated for a while, not certain what to do, but more inclined to make mischief than otherwise, and muttering to himself: 'I'll never put up with this.'

I saw that things were taking a turn for the worse and making a sudden resolution I turned to Pagolo and Ascanio and said:

'As soon as you see me draw my dagger, throw yourselves at those two servants and, if you can, kill them. I'll kill this fellow at a blow, and then we'll get out of here together.'

After hearing what I proposed Marmagna thought himself lucky to escape from the place alive. I wrote and told the Cardinal of Ferrara all that had happened, though I modified it a little. He at once reported it to the King; and his Majesty in exasperation put in charge of me another member of his bodyguard, called the Viscount of Orbec. This man in the pleasantest way imaginable provided me with all I needed.

After I had prepared my living quarters and workshop, arranging the whole household as usefully and fittingly as I could, without any delay I set to work on three models, making them exactly the same size as they were to be in silver: these were the Jupiter, Vulcan, and Mars. I made them in clay, well strengthened with iron, and then I went to

see the King who had me given, if I remember rightly, three hundred pounds of silver so that I should begin work. While I was making a start on these I finished the little vase and the oval bowl, after several months' work.

As a finishing touch I had them beautifully gilded: and they stood out as the most beautiful work that had ever been seen in France. I at once carried them to the Cardinal of Ferrara who thanked me warmly and then himself took them along to the King and made him a present of them. The King was delighted[227] and he praised me more lavishly than any man like me had ever been praised before. In return he gave the Cardinal of Ferrara an abbey worth seven thousand crowns in revenue, and he wanted to make me a present as well. But the Cardinal stopped him, telling his Majesty that it would be too precipitate seeing that I had not yet done any work for him. The King, who was an extremely generous man, said:

'Then I mean to encourage him to do so.'

The Cardinal, somewhat ashamed of himself, replied:

'Sire, I beg you to leave it all in my hands, and I shall give him an allowance of at least three hundred crowns, as soon as I have taken possession of the abbey.'

In fact I never had a thing from him, and it would take too long to tell about all his devilish tricks; I want to restrict myself to things of greater importance.

I went to Paris, and there, with so much favour shown me by the King, I was the wonder of everyone. I had the silver, and I began work on the statue of Jupiter. After hiring a great many workmen I started work very diligently and never stopped, day or night, and so before long, when I had finished the clay models of Jupiter, Vulcan, and Mars and done a fair amount of work on the silver statue of Jupiter, my workshop looked very impressive. In the meantime the King arrived in Paris and I went to visit him. As soon as his Majesty caught sight of me he called me over cheerfully and asked if there was anything beautiful in my work-place that he could have a look at, since if there was he would call on me. I told him all I had been doing, and he was at once seized by a strong desire to have a look at the work. So after dinner he set out with Madame d'Étampes,[228] the Cardinal of Lorraine,[229] and

several other lords including the King of Navarre[230] (the King's brother-in-law), and the Queen, Francis's sister,[231] as well as the Dauphin[232] and the Dauphiness. So that day all the flower of the court came to visit me.

Meanwhile I had returned home and began working. When the King appeared at the door of my castle he heard the hammers going, and ordered everyone to keep quiet. Everyone in the shop was hard at it and as a result, not expecting the King, I was taken by surprise. He entered my hall, and the first thing he saw was me myself, standing there working on a great piece of silver, which I was using for the body of the Jupiter. One man was beating out the head and another the legs, and the noise was deafening. While I was working I had a little French lad of mine helping me: he had annoyed me in some way or another and so I had given him a kick, and, as luck had it, catching him in the crutch I had sent him hurtling forward a good few yards. So as the King came in the little lad clung to him to keep his balance.

His Majesty burst out laughing, while I stood there, dumbfounded. Then the King began to ask me what I was doing, and wanted me to go on working. He said that I would please him far more if I didn't exhaust myself but instead hired as many men as I needed and made them do the work, since he wanted me to safeguard my health so as to be able to serve him longer. I replied that if I didn't work myself I would fall ill immediately, and besides this I wouldn't achieve the results I wanted to achieve for him. Thinking that I was saying this merely to sound impressive and not because it was, in fact, the truth, the King made the Cardinal of Lorraine repeat what he had said. I explained to the Cardinal the reasons for my attitude so frankly and fully that he was thoroughly convinced and advised the King to let me work little or much, just as I liked.

The King returned to the palace, highly satisfied with my work. He overwhelmed me with favours and it would take too long to describe them all. The very next day, at dinner, he sent for me. The Cardinal of Ferrara was there dining with him. When I arrived the King was still on the second course. I approached his Majesty and he began to talk to me at once, saying that since he had such a beautiful bowl and jug from my hand he wanted a fine salt-cellar[233] to keep them company.

He added that he would like me to make a design for one, but that he wanted it in a hurry.

I answered: 'Your Majesty will see a design much sooner than you ask, because when I was making the bowl I thought that a salt-cellar should be made to match: it's already done, and if you like I shall show it to you without delay.'

The King turned in great animation to the noblemen who were with him – the King of Navarre, the Cardinal of Lorraine, and the Cardinal of Ferrara – and said:

'He certainly knows how to win the love and friendship of everyone who knows him.'

Then he turned to me and said that he would be only too pleased to see the design I had made. I ran the errand very quickly, since I had only to cross the river, that is, the Seine; and I brought back with me a wax model I had already made in Rome at the request of the Cardinal of Ferrara. When I was back in the King's presence I uncovered the model, and he said in astonishment:

'This is a hundred times more heavenly than I'd ever have thought: what a marvel the man is! He should never stop working.'

Then, smiling happily, he turned to me and said that it was a work that pleased him very much and that he would like me to make it in gold. The Cardinal of Ferrara who was present stared me in the face and let me know that he had recognized it as being the same model as the one I had made for him in Rome. At this I told him that I had already said that I would do the work for whoever was to have it. The Cardinal, recalling the very words I had used and disturbed at the thought that I was out to get my own back, said to the King:

'Sire, this is a very formidable undertaking and my only misgiving is that I don't think it will ever be finished: because those clever artists who have such ambitious ideas are only too eager to begin, but don't give much thought to whether they will ever finish. So if I commissioned such works I'd want to know when I was to have them.'

The King's reply to this was that whoever racked his brains about finishing a piece of work would never begin anything: and he said this in a way that implied that such work was not for faint-hearted men.

Then I added: 'All those princes who encourage their servants in the

way that his Majesty does by his words and actions succeed in making every great enterprise easy; seeing that God has given me such a splendid patron I hope to finish many great and splendid works for him.'

'And I believe you will,' said the King, as he rose from the table. He called me into his own room and asked me how much gold I would need for the salt-cellar. I told him, a thousand crowns. He immediately called his treasurer, the Viscount of Orbec, and ordered him to hand me over without delay a thousand old gold crowns of good weight.

I left his Majesty and sent word to the two notaries who had obtained for me the silver for the Jupiter and a number of other things. Then I crossed the Seine and collected a very small basket that my cousin the nun had given me when I passed through Florence (and good luck had it that I took this basket and not a bag) thinking that I could get the business over while it was still daylight, for it was still quite early, and not wanting to disturb my workmen or take a servant with me. When I arrived at the treasurer's house he already had the money in front of him, and he was selecting the coins according to the King's instructions. All the same it seemed to me that that thieving treasurer was very cunningly putting off the time when he would have to pay me the money; and I received none of it till three hours after nightfall. I didn't fail to take precautions and I sent for some of my workmen to come and escort me, since it was a very important transaction.

When they failed to arrive I asked the messenger if he had delivered my message. A certain thievish servant said that he had and that they had said they were unable to come, but that he would be quite willing to carry the money for me. I replied that I would carry the money myself. Meanwhile the contract was completed and everything done. The money was counted out, and I put it all in the little basket and thrust my arm through the two handles. As I had to force my arm through the coins were well secured and I carried them more comfortably than if they had been in a bag. I was well armed, with a mail coat and gauntlets and carrying a sword and dagger, and I sped on my way as fast as I could.

Just then I caught sight of some servants whispering among themselves, and they hurriedly left the house too and set off as if to go in the opposite direction to me. I walked along swiftly, crossed the Pont

au Change, and came out by the river wall which led to my home in the Nesle. Then I drew near the monastery of the Augustinians: this was a very dangerous spot, it was only five hundred yards from where I lived but, as the inhabited part of the castle was as far again inside, if I had called out my voice would not have been heard. But when I saw four men advancing towards me with drawn swords in a flash I made up my mind what to do. I quickly covered the basket with my cloak and, seeing that they were closing in fast, I cried out:

'All you can win from a soldier is his cloak and his sword: and I hope you'll be the losers before I surrender mine.'

I began fighting fiercely, and every now and then I opened my arms so that if they had been incited to this attack by those servants who had seen me take the money they'd have reason to see that I had no such sum with me. The fight was soon over; they gave way, step by step, saying in their own language:

'This Italian's a brave fellow, and he's certainly not the one we were after – or if he is he has nothing on him.'

I shouted at them in Italian; and I kept on thrusting and cutting, coming near more than once to dealing a deadly blow. Seeing how wonderfully skilful I was they decided that I was a soldier rather than anything else: and little by little they drew away from me, keeping close together and muttering quietly in their own language. I myself kept saying, very gently, that anyone who was after my weapons and my cloak wouldn't find them easy to take. I began to quicken my pace, and they slowly followed on after me: I grew more alarmed at this, thinking that if there were another ambush waiting for me I'd be attacked on two sides. So when I was about a hundred yards from where I lived I took to my heels and started bellowing: 'To arms! To arms! Outside! Outside! I'm being murdered.'

Four young men armed with pikes ran out immediately: and when they were for pursuing my attackers – who could still be seen – I said in a very loud voice:

'Those four cowards couldn't plunder one man by himself of the thousand gold crowns that are breaking my arm. So let's go and put the money away, and then with my big two-handed sword I'll come along with you wherever you like.'

We went to put the money away: those young men of mine began sympathizing with me over the terrible danger I had been in, and then went on to reproach me.

'You rely too much on yourself,' they said, 'and one of these days you'll give us cause to regret it.'

I told them what I thought; they came back with more; and my adversaries fled. Then, in very high spirits, we all had supper, laughing at the roads made by fortune – as much for good as for ill. When fortune misses the target it's as if nothing had happened. Certainly, people say: 'You'll learn your lesson for next time.' But in fact next time is always different and never the same as expected.

First thing next morning I started work on the great salt-cellar; I pressed on very diligently with this and with my other work. By this time I had hired a large number of workmen to help either with sculpturing or with the goldsmith work. They included Frenchmen, Italians, and Germans, and sometimes I employed very many indeed, if I found them good enough. I changed them from day to day, picked out the ones who knew most, and urged them to work hard. They kept hard at it in their anxiety to keep up with me; but I had a better constitution than they did, and finding the strain too great for them they thought they could restore their strength by copious drinking and eating. Some of the Germans who were more expert than the others could not stand the strain of keeping up to my standard, and it killed them.

While I was making progress with the silver statue of Jupiter, reckoning that I had plenty of silver to spare, I put my hand without telling the King to making a large vase with two handles, about a cubit and a half tall.[234] I also felt inclined to cast in bronze the large model I had made for the silver statue of Jupiter. It was the sort of work I had never tackled before, and after starting on this new undertaking I asked the advice of some of those fine old Parisian craftsmen. I told them all the methods employed in Italy for that sort of work. They said that they had never used such methods, but that if I let them do it their own way they would return it to me, finished and cast as beautiful and clean as the clay model itself.

I decided to strike a bargain, giving the work over to them and

promising to pay several crowns over and above what they had asked. They started the work; and then, when I saw they were not going the right way about it, I hurriedly began work on a head of Julius Caesar, a bust in armour and much larger than life-size. I copied it from a little model I had brought with me from Rome that was reproduced from a splendid antique. I also began work on another head of the same size,[235] but this time I used as my model a very beautiful girl[236] whom I kept to satisfy my sexual appetites. I gave it the name of Fontainebleau, after the place the King had chosen for his own delight and recreation.

After a beautiful little furnace had been made for melting the bronze and after our moulds had been prepared and baked – the Jupiter by them, and my two heads by me – I said to them:

'I don't think you're going to succeed with the Jupiter, since you haven't left enough air-holes below for the air to circulate: so you're wasting your time.'

They answered that if their work was a failure they would return me all the money I had given them on account, and refund me all I had lost on expenses; but that I had better look out, because those fine heads of mine that I wanted to cast by the Italian method would never come to anything. While we were arguing the treasurers and other gentlemen who used to come and visit me on the King's orders were present; and they reported everything that was said and done to the King. The two old fellows who were to cast the Jupiter put it off for a while, because they said they would like to look after the two moulds for my heads, seeing that the method I was using couldn't possibly succeed and it was a pity to spoil such fine works. When the King heard about this he commented that they should spend their time learning and not try to teach their master.

With a great deal of laughter they put their work into the furnace; and then, impassively, neither laughing nor losing my temper (though I felt like doing so) I placed my two moulds either side of the Jupiter. When the metal was perfectly melted, with tremendous satisfaction we let it pour in: it filled the mould of the Jupiter very nicely, and at the same time filled the moulds for my two heads. So they began rejoicing, and I was content: I was pleased to have been wrong about their work, and they seemed very pleased that they had been wrong about mine.

Then, following the French custom, very boisterously they ordered something to eat and drink; I was only too happy to have a lavish meal served to them. Then they asked me for the money they were to receive and the bonus I had promised them.

At this I said: 'You've been laughing at what I'm afraid may make you weep: I thought that much more metal went into your mould than should have done. So I don't intend to give you any more money than you've had till tomorrow morning.'

The poor fellows began to think over what I had said to them, and then went off home without a word. Next morning, very, very gently, they began to empty the furnace. They could not uncover their own large mould till they had taken out my two heads; they took them out – perfectly formed – and then stood them up in a prominent position. Then they began to dig out the Jupiter; they had only dug down two cubits when they and the four workmen let out such a yell that I heard it from where I was. In the belief that they were shouting with joy I began running towards them: I happened to be in my bedroom, more than five hundred yards away. When I came up I found them looking desolate and aghast – just like one depicts those who guarded Christ's tomb. I glanced at my two heads and saw that they were all right, and so my regret was mixed with pleasure. They began excusing themselves, saying that it was just their bad luck.

In reply to this I said: 'You've had very good luck; it's your lack of knowledge that's been bad. If I'd seen you put the block into the mould one word would have been enough for me to teach you how to make sure of a perfect result. Then I would have added to my reputation, and you would have made a good profit. I shall keep my reputation, anyhow, but you'll come out of this with neither reputation nor profit. So another time learn how to work, and not how to laugh at others.'

They they began to beg me to help them, saying that I was in the right but that if I refused to assist them, seeing that they had to cover their great expenses as well as paying for the loss, they and their families would have to go begging. I answered that if the King's treasurers wanted to make them pay what they owed I promised to let them have it out of my own pocket, since I had seen how they had done everything for the best, with what knowledge they had. All this bolstered up to

an incredible extent my good reputation with the King's treasurers and ministers. The King received word of everything that had taken place, and – with his unequalled generosity – he gave order that all was to be done as I said.

About this time that wonderfully courageous man Piero Strozzi[237] arrived on the scene: and when he reminded the King about his naturalization papers, his Majesty at once ordered them to be drawn up.

'And along with them,' he added, 'make out papers for *mon ami* Benvenuto; take them to where he lives straight away; and give them to him from me, without any charge.'

The great Piero Strozzi's papers cost him many hundreds of ducats. Mine were brought to me by one of the King's chief secretaries, called Messer Antonio Massone.[238] He handed me the papers and at the same time paid me some magnificent compliments on behalf of the King.

'His Majesty makes you a present of these,' he said, 'so that you can serve him more enthusiastically; these are your naturalization papers.'

Then he told me how, after a long time and as a great favour, they had been granted to Piero Strozzi at his own request, but that the King had sent me mine as a present, on his own initiative. No one in France, he went on, had ever been done such a favour before. When I heard this I very enthusiastically expressed my gratitude to the King; then I begged the secretary to be gracious enough to let me know what these naturalization papers meant. He was an accomplished, well-mannered man, and he spoke very good Italian: at first he began laughing, then he recovered his dignity and told me in my own language exactly what the papers meant, and how they were one of the greatest marks of respect that could be shown to a foreigner.

'This is more of an honour,' he said, 'than being made a Venetian noble.'

After he had left me and returned to the King, he told his Majesty all that had happened; the King laughed for a while and then said:

'And now I want him to know what was the reason for my sending him the papers. Go and make him lord of the castle of the little Nesle,

where he's living and which is my own patrimony. He'll understand what that means much more easily than he understood what the papers meant.'

This present was brought me by a messenger, and I wanted to give him a tip; but he would accept nothing, saying that such were his Majesty's orders. When I returned to Italy I carried with me the naturalization papers along with the title-deeds of the castle: wherever I go, and no matter where I end my life, I am determined to keep them always.[239]

Now I shall carry on with the story of my life. I had on hand the work already mentioned – that is, the silver Jupiter, on which a start had been made, the gold salt-cellar, the great silver vase, and the two bronze heads – and I worked away at them intently. I also made preparations to have the base for the Jupiter cast; this was a very elaborate work in bronze, intricately ornamented. As one of the ornaments I sculptured in low relief a scene showing the rape of Ganymede, and on the other side I depicted Leda and the Swan. I cast it in bronze and it came out beautifully. I made a similar base to take the statue of Juno, which I was waiting to begin when the King gave me enough silver for it. By working diligently I had already put together the silver statue of Jupiter as well as the gold salt-cellar; I had the vase well in hand, and the two bronze heads were already finished. I had also completed a few little objects for the Cardinal of Ferrara; and in addition I had made a little silver vase, very richly ornamented, to give to Madame d'Étampes. I had done a good deal of work for a fair number of Italian noblemen, for Signor Piero Strozzi, for the Count of Anguillara, for the Count of Pitigliano, for the Count of Mirandola, and for many others.[240]

As for the great King, I have already said that I was making good progress with the work I was doing for him, and then he returned to Paris, and on the third day after his arrival he visited me with a large escort of the most important nobles of the court. He was amazed at how much work I had on hand, and at the quality of it all. His Madame d'Étampes was with him, and they began to talk about Fontainebleau. Madame d'Étampes told his Majesty that he ought to commission me to make some beautiful decoration for his Fontainebleau.

The King at once answered:

'That's an admirable suggestion, and I shall decide what he is to do this very instant.'

Then he turned to me and began asking what I thought would be suitable for his beautiful fountain. I conjured up a few ideas for him, and then his Majesty expressed his own opinion. Then he told me that he was going away for fifteen or twenty days to St-Germain-en-Laye, which was twelve leagues distant from Paris, and that meanwhile I was to construct a model for that beautiful fountain of his. In all his kingdom it was the spot he most loved to enjoy his leisure in, so I was to make the model with the most elaborate adornment I could devise; and he commanded and implored me to exert myself to the utmost in the effort to produce a work of beauty. I promised to do so.

When he saw all the work I had so well in hand the King said to Madame d'Étampes:

'I've never had a man of his profession who has pleased me more or deserved a greater reward. So we must consider how to keep him here. He's generous with his money, he's a good companion, and he's a hard worker, so we must certainly bear him well in mind. And what's more, madam, look how all the times he has come to see me, and all the times I've come here, he has never asked me for anything. He gives his heart and soul to his work. We must do something good for him without delay, in case we lose him.'

Madame d'Étampes said: 'I shall remind you.'

They left: and then I pressed forward diligently with the work that was already begun, and in addition I began work on the model for the fountain, and applied myself to it with zest.

At the end of a month and a half the King came back to Paris. I had been working day and night; and I went along to see him, bringing with me the model, so skilfully executed that it could be easily understood. By then the devilish war[241] between him and the Emperor was breaking out again, so I found him very distraught. However, I spoke to the Cardinal of Ferrara and let him know that I had with me some models that his Majesty had commissioned. I begged him to say a few words, when he saw his chance, so that I would be able to show the models; and I added that I thought the King would be delighted with them.

The Cardinal did what I asked, and when he mentioned the models, straight away the King came to see them.

First of all I had made a model for the doorway of the palace of Fontainebleau, slightly correcting its proportions, as it was wide and squat in that bad French style of theirs. The opening of the doorway was almost square, and above it there was a half-circle, squashed like the handle of a basket. In this half-circle the King wanted to have a figure representing Fontainebleau. I made a beautifully-proportioned doorway, and then I placed over it an exact half-circle. At the sides I designed some charming projections, with socles underneath to match the cornices above. At each side, instead of the two columns usually found with this style, I had two satyrs. One of them stood out in rather more than half relief, and with one of his arms was making as if to hold up the part of the doorway which would have rested on the column; in the other hand he was grasping a heavy club. He looked very fierce and aggressive and was meant to strike terror into the beholder. The other satyr had the same stance, but the head and several things of that sort were different. He was holding a whip, with three balls attached to some chains. Although I call them satyrs, they had nothing of the satyr about them except for their little horns and goats' heads, otherwise they looked like humans.

In the half-circle I had made a woman reclining in a beautiful attitude; she had her left hand resting on the neck of a stag, which was one of the King's emblems. On one side I showed some little fawns in half relief, and there were some wild boars and other wild beasts in lower relief. On the other side there were hunting-dogs and hounds of various kinds, since these are found in that beautiful forest where the fountain springs.

I had enclosed the whole work in an oblong, and in each of the upper angles I had designed a Victory, in low relief, with torches in their hands as we see in representations left by the ancients. Above this I had shown the salamander, the King's own device, and a host of other charming ornaments all harmonizing with the work, which was in the Ionic style.

As soon as the King saw this model[242] he brightened up, and it took his mind off the tiresome discussions he had been having for more than

two hours. Seeing that he was as amiably disposed as I wanted, I uncovered the other model; and this he wasn't expecting at all as he thought he had seen all he could hope for.

This model was more than two cubits high; in it I had fashioned a fountain in the form of a perfect square, and around it there were some very fine flights of steps, intersecting each other, a thing which had never been seen in France before and which is rare in Italy. In the middle of the fountain I had constructed a pedestal, which was a little taller than the basin of the fountain itself: on the pedestal I had shown a nude figure, in correct proportion and full of beauty and grace. Its right hand was raised on high, holding a broken lance; and the left hand rested on the hilt of an exquisitely designed scimitar. With its weight resting on its left foot, its right had under it a rich and elaborately worked helmet. At the corners of the fountain I had fashioned four seated figures, each one of them raised up, with its own fanciful emblems.

The King began by asking me what was the idea behind the beautiful design, saying that without a word from me he understood all I had done as regards the doorway, but that though he appreciated that the model of the fountain was very beautiful he didn't understand it at all: and, he added, he was well aware that I hadn't worked like the kind of fool whose art had a certain amount of grace but was completely devoid of significance. At this I prepared to explain, for having pleased him by what I had done I wanted to please him with what I had to say.

'You must know, sacred Majesty, that this little work of mine is so exactly calculated to the last detail that when executed it will lose none of its present grace. This figure in the middle is to be fifty-four feet high' (at this the King made a tremendous gesture of amazement), 'and it is meant to represent the god, Mars.[243] The other four figures stand for the Arts and Sciences, which your Majesty protects and in which he finds such pleasure. This, on the right hand, is meant for the world of Learning; you see how she has her emblems, showing Philosophy and the various branches of philosophy. This other represents all the Arts of Design, that is, Sculpture, Painting, and Architecture. This other is for Music, which rightly accompanies all these branches of knowledge. Next, this gracious, kindly figure represents Liberality, for without her

the splendid talents given us by God would be stifled. The great statue in the centre represents your Majesty himself, the god Mars, unique in valour: and you employ your valour justly and devoutly, in the defence of your glory.'

The King hardly had the patience to let me finish before he said in a loud voice: 'In very truth, I've found a man after my own heart.'

Then, calling the treasurers appointed to me, he said that they should provide all I needed no matter what it cost; then, tapping me on the shoulder, he said to me:

'*Mon ami*' (that is, my friend), 'I don't know which is the greater, the pleasure of a prince at having found a man after his own heart, or the pleasure of an artist at having found a prince ready to provide him with all he needs to express his great creative ideas.'

I answered that if it was me his Majesty meant then my fortune was by far the greater. He answered with a laugh: 'Let's say that it's equal.' I left him in very high spirits, and went back to my work.

As my bad luck had it I was not warned to play the same act before Madame d'Étampes; and that evening, after she had learnt from the King's own mouth all that had happened, such poisonous anger accumulated in her breast that she burst out:

'If Benvenuto had shown me his fine works of art he would have given me cause to remember him when the time comes.'

The King tried to make excuses for me, but it was useless. I heard about all this a fortnight later, for they had gone on a progress through Normandy to Rouen and Dieppe and had then returned to St-Germain-en-Laye. So I took the beautiful little vase that I had made at Madame d'Étampes's request, thinking that by giving it to her I would recover her favour. I went to see one of her nurses, bringing the vase with me.

I showed her the beautiful vase that I had made for her mistress, and explained that I meant to give it to her. She welcomed me with extraordinary kindness and said that she would have a word with Madame, who was not yet dressed, and that as soon as she had spoken to her I would be admitted. The nurse told Madame everything, and she replied contemptuously: 'Tell him to wait.'

When I heard this I submitted with a good grace – a thing I find very difficult – and waited patiently till after her dinner-time. Then,

seeing how late it was, my hunger made me so angry that I could not endure it any longer and went away, devoutly saying to myself that she could go and rot. I went to the Cardinal of Lorraine and gave him the vase as a present, begging him only to keep me in the King's good books. He said that there was no need for him to do anything, but that when there was need for it he would be only too glad to do so: then he called his treasurer and whispered something in his ear. The treasurer, after he had waited for me to leave the Cardinal's presence, said:

'Benvenuto, come with me and I'll give you a good glass of wine.'

Not knowing what he meant I replied:

'Please, sir, let me have just one glass of wine and a bite of bread. I really could do with it, seeing that from early this morning till now I've been without food, waiting at Madame d'Étampes's doorstep in order to make her a gift of that beautiful little silver-gilt vase. I told her about it, but to torment me she sent word that I was to wait. Now I'm overcome by hunger and I feel faint. God has willed it that I should give the fruit of my labour to someone much more deserving of it, and all I beg of you is a little refreshment: I'm very easily sick, and fasting upsets me so much that I shall fall down unconscious.'

While I was forcing out these words I was brought some excellent wine and other delicacies; so after I had this snack my strength flowed back and my anger subsided. Then that admirable treasurer offered me a hundred gold crowns: but I refused to take them under any conditions. When he reported this to the Cardinal he was given a thorough dressing-down and ordered to make me take them by force, or else not show his face again. The treasurer returned to me in a temper, saying that the Cardinal had never abused him so much before. He tried to give me the money and when I made some show of resistance he told me furiously that he would force me to take it. So I accepted. When I wanted to go and thank the Cardinal, he sent word through one of his secretaries that whenever he could he would be only too glad to make himself agreeable to me. I went back to Paris that same evening. The King heard all that had happened. They laughed at Madame d'Étampes, and that increased her venomous desire to do me harm to such an

extent that I was in great danger of my life: I shall tell what happened in the appropriate place.

Long before this I should have recorded my having won the friendship of the most talented, lovable, and companionable gentleman I have ever known in the world: this was Messer Guido Guidi, an excellent physician and doctor, and a noble Florentine citizen.[244] But the endless disasters brought upon me by my bad fortune have resulted in my neglecting him a little. I did not think, however, that this was of very great importance, seeing that he was always near to my heart, and that was good enough. But then, realizing that the story of my life would not be complete without him, I have included mention of him here, among the details of my greatest tribulations. During them he was my support and comfort, and now I can acknowledge his goodness here.

After Messer Guido had arrived in Paris, and after I had first made his acquaintance, I took him home to my castle and there let him have a free apartment to himself: we enjoyed several years together. The Bishop of Pavia, that is to say, Monsignor de' Rossi, brother of the Count of San Secondo, also came to Paris. I took this lord from the inn where he was lodging and gave him as well an apartment in the castle. He stayed there very comfortably, with his servants and horses, for a good few months. On another occasion I gave hospitality for a few months to Luigi Alamanni and his sons. Thus God was kind enough to allow even me the means of doing a good turn to great and talented men.

Messer Guido and I enjoyed our friendship together all the years I stayed in Paris; we would often congratulate ourselves on the fact that we were cultivating our talents, in our respective professions, through the generosity of such a great and splendid prince. In fact I can truly say that what I am, and what worthwhile works of art I have produced, have all been because of that marvellous King. But I must pick up the thread of my story about him, and about the great work I did for him.

There was a tennis-court in my castle which I made very profitable use of. The place contained some small rooms which were lived in by various people, including among them a very expert book-printer. He had nearly all his workshop inside the castle, and it was he who printed

for Messer Guido his first fine book on medicine.[245] As I wanted to make use of these apartments I sent him away, though not without considerable difficulty. There was also a saltpetre manufacturer living there, and when I wanted to make use of the little rooms he had for some of my first-rate German workmen he refused to budge. I asked him time and time again to let me have my rooms back, because I wanted to use them for the men working for me in the King's service; but the more humbly I pleaded, the more arrogantly the beast answered me back. So finally I gave him three days' definite notice. At this he burst out laughing and said that he would begin to think about it at the end of three years. I did not know that he was one of Madame d'Étampes's favoured servants, and if it weren't that the encounter I had had with her made me more circumspect than before I would have sent him packing at once. But I decided to remain patient for those three days.

When they had gone by, without saying a word more, I mustered some Germans, Italians, and Frenchmen – all with weapons in their hands – and a good number of unskilled labourers, and in next to no time wrecked his place and threw all his belongings outside my castle.

I took this somewhat drastic step because he had told me that he knew no Italian who had it in him to dare move one link from its place. When it was all over he appeared on the scene, and I said:

'I'm the least Italian of all Italy, and I've done nothing to you in comparison with what I'm capable of doing and what I shall do if you say a single word.'

Then I added some more insults for good measure. He was thunder-struck and terrified: he gathered his belongings together as best he could, and then he ran off to Madame d'Étampes and painted a picture of what had happened as if it had been hell itself; and that great enemy of mine – eloquent and influential as she was – painted it far worse for the King.

Later I was told that he became so exasperated that twice he was on the point of issuing brutal orders against me. But as it happened his son, the Dauphin Henry (today the King of France) had had his path crossed several times by that presumptuous woman, and so, along with the Queen of Navarre, King Francis's sister, he defended me so adroitly

that the King laughed the whole thing off. Because of this, by the true help of God I escaped a great storm.

There was another man that I had to do the same thing to, but I did not wreck his place, though I threw out all his belongings. As a result of this Madame d'Étampes was bold enough to say to the King: 'I think that one of these days that devil will sack Paris itself.'

The King replied angrily that I was thoroughly justified in defending myself against the rabble who hindered me from serving him. The spiteful woman's rage grew fiercer every hour. Then she sent for a painter, who was staying at Fontainebleau, where the King nearly always resided. He was an Italian from Bologna, and he was known as Il Bologna though his real name was Francesco Primaticcio.[246] Madame d'Étampes told him that he should ask the King for the commission that his Majesty had given me in connexion with the fountain, and she added that she would use all her influence to help him obtain it. So they agreed together on what to do.

This Bologna went into greater raptures than he had ever known before, thinking that the commission was as good as his, although it was not his sort of work. However, he was a competent draughtsman and he had gathered round him a number of workmen who had been trained in the school of Rosso, that Florentine painter of ours, a marvellously able artist. Whatever good there was in his work was copied from Rosso's splendid style. Rosso himself was already dead. The cunning arguments they used were very effective: Madame d'Étampes gave all the help she could, and they hammered away at the great King day and night, now Madame, and now Bologna. The main reason for his giving way was their saying together:

'How is it, sacred Majesty, that Benvenuto is to make you twelve silver statues – and that's what you want – when he hasn't yet finished one? If you use him for this great undertaking you'll certainly have to go without the other things you want so much, seeing that a hundred great artists couldn't finish the tremendous works that this one clever man has taken on. It's obvious how anxious he is for work – and that will result in your Majesty's losing both him and his work at one stroke.'

This, and arguments like it, meant that when they found the King in a good frame of mind he agreed to all they had asked: but as yet he

had not been shown a single one of Bologna's designs or models.

While this was going on the second tenant that I had chased out of the castle brought an action against me in Paris: he began a lawsuit on the plea that when I had evicted him I had stolen a lot of his property. The lawsuit caused me so much anxiety and took up so much of my time that more than once I nearly cleared off in despair. In France they have the habit of making a great deal of money out of any lawsuit begun against a foreigner, or against anyone who seems to be rather incompetent in litigation. As soon as the action begins to look profitable they try to sell it: some lawsuits have even been given as dowries to the sort of men who make it their profession to trade in them.

Another nasty habit of theirs is that the people of Normandy – or the majority of them – are in the practice of giving false testimony. What happens is that the men who buy the lawsuits immediately prime four or half a dozen of these witnesses, according to need, and then the man who has not been warned to bring forward an equal number of witnesses as a counter, and who is ignorant of the custom, at once finds the verdict going against him.

I found myself mixed up in this business. The whole thing seemed very unjust, but I appeared at the Great Hall of Justice in Paris to defend my cause. There was a judge there, acting as representative for the King in civil cases, seated on a lofty tribunal. He was a tall, fat man, very thickset, with a tremendously forbidding appearance; grouped round him on both sides was a crowd of solicitors and advocates, drawn up on the right and on the left. All the time there were others coming up one at a time, and stating their cases to the judge. Every now and then I noticed the advocates at his side all speaking at once, and I was astonished at how that marvellous man, looking just like Pluto, held himself alertly, cocked his ear now to this man, now to that, and answered them all expertly. Since I have always taken delight in witnessing and growing familiar with every kind of expertise I would not have missed this splendid business for worlds.

As it was, the hall was very large and thronged with crowds of people: they were careful not to let anyone in unless he had a reason for being there, and the door was kept barred and guarded. Sometimes, in trying to prevent someone from coming in, the guard on the door made such

a commotion that he interrupted that marvellous judge, and then, losing his temper, the judge would turn and give him a good dressing-down.

This happened several times, and I studied the occurrence, noting the exact words that the judge used himself. He observed two noblemen, who were coming to see what was going on, and as the porter started forcibly resisting their entry, the judge yelled out in a loud voice: 'Be quiet, be quiet, Satan, get out of here, and be quiet.'

In French, these words sound like this: 'Phe phe Satan phe phe Satan alè phe.' I had acquired a mastery of French, and when I heard this phrase I realized what Dante meant when he went with his master Vergil inside the gates of the Inferno.[247]

Now, together with the painter Giotto, Dante was in France,[248] and especially in Paris; and for the reasons I mentioned one could truly say that the place where the lawsuits are held in Paris is an Inferno. So, as Dante understood French very well, he employed that very expression: and it seems extraordinary to me that this interpretation had never been offered before. In fact I believe and maintain that the commentators make him say things he never thought of.

To return to my own affairs. When I saw the court coming to certain decisions about my case, which were passed on to me by those lawyers, seeing there was no other way to help myself I had recourse to my large dagger. I have always loved owning fine weapons, and the first man to use this one on was the leading spirit in that unjust lawsuit that was brought against me. One night I stabbed him so many times in the legs and arms (taking care, however, not to kill him) that I deprived him of the use of both his legs. Then I went after the fellow who had brought the suit, and notched him so effectively that he abandoned it.

Thanking God for this and for everything else, and reckoning that I would be left unmolested for a while, I told the young men in my service – especially the Italians – that for the love of God they were to apply themselves to their work and carry on assisting me for some time till I could complete the works that were already begun and that would soon be finished. Then I meant to go back to Italy because I could not stand the ruffianly ways of those Frenchmen. I added that if the good King once lost his temper with me he would make my life very

unpleasant on account of the other things I had done in self-defence.

The Italians I mentioned were, first and dearest, Ascanio, from a place called Tagliacozzo in the Kingdom of Naples; the other was a Roman of very low birth, called Pagolo, who didn't know who his own father was. These two were the ones I had brought with me from Rome, and who had been living with me in Rome. There was another Roman, who had also left Rome on purpose to find me. His name too was Pagolo, and he was the son of a poor Roman nobleman of the Macaroni family: this young man did not know much about art, but he was a courageous fighter. Then there was a Ferrarese called Bartolomeo Chioccia. And then there was a Florentine called Pagolo Miccieri.

He had a brother nicknamed Gatta who was a very competent clerk, but had overspent when he was managing the property of Tommaso Guadagni, an extremely wealthy merchant. This Gatta put in order the books in which I kept the accounts of the great Christian King and of various other people. Pagolo Miccieri, having learnt from his brother how to do so, kept them up for me, and I gave him a generous allowance. He appeared to be a very trustworthy young man, I remarked his religious nature, I constantly heard him muttering prayers, and saw him holding his rosary, and so I thought – trusting in his assumed piety – that I could rely on him thoroughly.

I called him aside and said to him: 'Pagolo, my dear brother, you can see how well off you are with me, and you know that you had nothing to begin with, and besides this you're a Florentine. And I trust you all the more because I can see how devout you are in practising your religion, which pleases me very much. So I beg you to come to my help, since I don't trust any of the others overmuch. I beg you to take care of two most important matters, both of which could give me a great deal of anxiety. First, I want you to take good care of my belongings so as to prevent anything being stolen: and don't touch any of them yourself. And as well as this; there's the matter of that poor young girl Caterina whom I keep chiefly to assist me in my art, and whom I can't do without. Besides this, since I'm a man I've used her for enjoyment in bed, and it could be that she will give me a child. I don't want to bear the expense of other men's children, and I certainly

won't stand such an injury being done me. In fact if anyone in this house were rash enough to do such a thing and I came to know about it, I can say for certain that I would kill both of them. So I beg you, my dear brother, to be of help to me, and if you see anything to tell me at once. If anything happened I'd have her and her mother hanged along with anyone who did such a thing. So first of all make sure you keep an eye on yourself.'

The rascal made a sign of the cross, from his head to his feet, and cried out:

'O blessed Jesus! God keep me from ever thinking of such a thing! first, because I'm not given to such evil ways, and then, don't you believe that I fully recognize the great debt I owe you?'

At these words, seeing that he said them in such a simple, affectionate way, I believed that everything was exactly as he said.

Two days later happened to be a feast day, and Mattio del Nazaro[249] – who was also an Italian serving the King very ably in the same profession as myself – had invited me and my young men to enjoy the pleasures of a garden party. I thought that for the time being I had subdued all the clamour arising from that troublesome lawsuit, so I got myself ready and told Pagolo to come along as well and enjoy himself for a while.

The young man replied: 'Surely it would be a great mistake to leave the house alone like this: think how much gold and silver and jewellery you have here. Seeing that we're living in a city of thieves we ought to be on the alert day and night. I shall guard the house, and pass the time away saying my prayers: you can set your mind at rest, go off to enjoy yourself, and have a good time. Another occasion someone else can stay on duty.'

Thinking that I could leave without anxiety I set off for the garden, along with Pagolo, Ascanio, and Chioccia. We spent a good part of the day there very agreeably; and then, after midday, as the evening began to approach I became rather pensive, and I began brooding on the words which that wretch had said to me with such persuasive simplicity. I mounted my horse and returned to the castle with two of my servants where I all but caught Pagolo and that slut Caterina in the very act. As soon as I appeared on the scene that French

strumpet of a mother of hers screamed out: 'Pagolo, Caterina, the master's here.'

When I saw them coming forward, terrified and confused, hardly knowing what they were saying, or, in their panic, where they were going, it was clear what they had been up to. My anger got the better of me and I drew my sword, determined to kill both of them. Pagolo fled, and the girl threw herself on her knees, screaming to heaven for mercy. My first impulse was to let fly at the man, but I did not catch him at once, and when I did do so I had in the meantime made up my mind that the best thing would be to throw them both out of the house, seeing that if I killed them on top of all my other recent actions I would have difficulty escaping with my own life.

So I said to Pagolo: 'If I had seen with my own eyes, you wretch, what you force me to believe, I would have run this sword through your guts a dozen times. Now, get out of my sight, and if you ever say an Our Father make it St Julian's.'[250]

Then very fiercely I drove the girl and her mother away, using both my feet and my fists. They planned to have their revenge on me and they consulted a Norman lawyer, who advised them that she should say I had used her in the Italian fashion, that is to say, unnaturally, like a sodomite.

'At least,' he said, 'when this Italian hears about it, knowing what a dangerous position he's in he'll be all too eager to give you a few hundred ducats to keep you quiet, seeing the terrible punishment that is meted out in France for such an offence.'

So they made their agreement: they lodged the accusation against me, and I was summoned.

The more I sought for rest, the more my tribulations increased. Every day I was assailed by various kinds of bad fortune, and I began to ponder which of two things I should do: either clear out and let France be damned; or really fight this battle as well and see what God had in store for me. I worried over the matter for a long time; then in the end I made up my mind to clear off and not tempt my bad luck too much in case I ended by coming a cropper. I made all possible preparations, took steps to dispose quickly of the property I could not take with me, and accommodated my small belongings, as best I could, on my own

person and on my servants: but I was taking my departure very unhappily. I remained by myself in my small study, having said to my young men who had advised me to flee the country that it would be as well for me to think matters over a little entirely by myself, although I realized that in great part they were talking sense. If I escaped imprisonment and allowed the storm a little while to blow over, I would be in a much better position to make my excuses to the King, letting him know by letter that this treacherous attack was only the result of spite. As I said, I had made up my mind that this was what I would do. Then, just as I made a move, I was seized by the shoulder and turned round, and I heard a voice say encouragingly:

'Benvenuto, behave as you usually do and have no fear.'

At once I completely reversed my decision; I said to my young Italians:

'Get hold of some good weapons and come along with me. Do whatever I order, and don't think of anything else, because I mean to fight it out. If I were to leave, the very next day you would all go up in smoke. So do what I say and come with me.'

In complete agreement those young men replied: 'Since we are here and owe our livelihood to him we ought to go along and help him to do what he proposes, as long as there's life in us. He has reached the truth better than us; as soon as he left this place our enemies would send us all packing. We ought to reflect seriously on the great works that have been begun here, and on their important nature. We're not up to the task of finishing them without him, and his enemies would say that he had left because he wasn't up to carrying such enterprises through to the finish.'

They made a good few other relevant observations besides these. The first to rouse their spirits was that young Roman of the Macaroni family; he also called in some of the Germans and Frenchmen who were fond of me. We were ten in all: I set out with my mind resolved, determined not to be taken alive.

When I appeared before the criminal judges I found there Caterina and her mother, and as I came up they were laughing with their lawyer. I marched in and called boldly for the judge, who was seated high above the others on his tribunal, swollen out, bulky, and fat. When

this man saw me he shook his head in a menacing way, and said in a lowered voice: 'Although your name is Benvenuto this time you're *malvenuto*.'

I heard what he said and I called out a second time: 'Now be quick about it, tell me what I'm here for.'

Then the judge turned to Caterina and said: 'Caterina, tell us about all that happened between you and Benvenuto.'

Caterina said that I had had intercourse with her in the way they did in Italy.

The judge turned to me and said: 'You hear what Caterina says, Benvenuto.'

Then I said: 'If I had had intercourse with her in the Italian way, I would have done so only in my desire to have a son, in the same way as you do.'

Then the judge replied: 'She means that you did it by another way than the way for begetting children.'

To this I answered that such was not the Italian way, and that on the contrary it must be the French way, since she knew all about it and not I: and I said that I wanted her to explain exactly what I had done with her. Then that beastly whore without any shame said openly and clearly what was the filthy practice she accused me of. I made her repeat it three times in succession; and when she had finished, I said in a loud voice:

'My lord judge, lord lieutenant of His Most Christian Majesty, I ask you for justice: I know that the laws of the Most Christian King punish such an offence with burning, for both active and passive partners. That woman confesses her sin; as for me, I have had no relations of any kind with her. Her strumpet of a mother is here too, and, for one crime or another, she deserves burning. I ask you for justice.'

I kept repeating these words in a loud voice, continually demanding that she and her mother be sent to the stake, and telling the judge that if he did not send her to prison in my presence I would run to the King and inform him of the injustice that his lieutenant in the criminal court was doing me. With my making this tremendous commotion, they began to lower their voices; then I raised mine higher, the little whore and her mother began to cry, and I roared at the judge: 'Burn them! Burn them!'

The coward, seeing that things had not gone the way he planned, began speaking more softly and making excuses for the weaker sex. At that I came to the conclusion that I had won a great battle and, muttering threats, I was only too glad to take myself off. In fact I would willingly have paid five hundred crowns never to have appeared there. I had escaped the tempest, and I thanked God with all my heart. Then in cheerful spirits I returned with my young men to the castle.

When adverse fortune, or our evil star if we like to call it that, sets out to persecute a man, it never lacks new ways of taking the field against him. I thought I had weathered such an overwhelming tempest that for a short while my evil star should leave me alone; and yet before I had recovered my breath after that appalling danger it threatened me with two more at the same time. In the course of three days two events happened, both of which nearly sent me toppling into death. What happened was that I went to Fontainebleau to talk with the King: he had written me a letter, saying that he wanted me to make the dies for all the coinage of the realm, and with the letter he had sent a few sketches showing me something of what he wanted. But he gave me a free rein to proceed in the matter as I pleased. I had made some new designs, following my own ideas and the beauty of form demanded by the art.

After I had reached Fontainebleau one of those treasurers whom the King had commissioned to see to my needs (he was called Monsignor della Fa)[251] immediately said to me:

'Benvenuto, the painter Bologna[252] has been commissioned by the King to make your great Colossus;[253] and all the commissions that were made over to you by our King earlier on, they have been taken away from you and given to him. We've regarded this as a very bad business, and it seems to us that this Italian of yours has treated you outrageously, since by virtue of your models and the hard work you put in the commission was already yours. This man has filched it from you only by means of the favour shown him by Madame d'Étampes: and although the commission has already been his for a good few months he hasn't shown any sign of making his preparations.'

I said in astonishment: 'How can it be possible for me to have known nothing of all this?'

Then he told me that Bologna had kept it very secret and that he had found it very hard to obtain the commission, since the King was unwilling to give it him, but that he had won it only through the persistence of Madame d'Étampes. Realizing how wickedly I had been wronged, and seeing filched from me a work I had won with so much toil, I resolved to assert myself vigorously and I went straight away to find Bologna, taking my sword with me.

I found him studying in his room: he had me called in, welcomed me in his typical Lombard fashion, and asked what good business had brought me there.

'A very good business,' I said, 'and a very important one.'

The man ordered his servants to bring in something to drink, and then he said:

'Before we discuss anything I want us to drink together, because that's the custom in France.'

I replied: 'Messer Francesco, understand that the discussions we must have don't call for drinking beforehand; perhaps we'll be able to drink afterwards.'

Then I began to reason with him.

'All men,' I said, 'who have a claim to be regarded with respect make their behaviour prove how upright they are: and if they do otherwise, then they don't keep their reputation any longer. I know that you knew that the King had commissioned me to make that great Colossus – the thing had been discussed for eighteen months and neither you nor anyone else came forward to add a word to what was said. By my strenuous exertions I made myself known to the great King, and, as my models pleased him, he commissioned me to execute this important work; and during all these months I have heard nothing to the contrary – only this morning did I hear that it was given to you, and that you had stolen it from me. I won the commission by my splendid performance, and you filch it from me merely by using empty words.'

To this Bologna replied: 'But Benvenuto, everyone seeks to advance his own interests in every way he can: if this is how the King wants it, what can you say in opposition? You'd be wasting your time, seeing that I've had the matter settled and the commission is mine. Now tell me what you want and I'll listen to you.'

I replied as follows: 'Understand, Francesco, that there is a great deal I could say to you, and by perfectly reasonable and cogent arguments I would force you to confess that the methods you've used and talked about aren't practised among rational beings. But I shall come to the point at issue in a few words: open your ears and listen carefully, since it's important.'

The fellow made as if to get up from his seat, since he saw that I was flushed and my face had completely changed its expression: I told him that it was not yet time for him to move, and that he was to stay sitting down and listen to me. And then I began as follows:

'Francesco, you know that the work was mine to begin with and that by accepted standards the time had already passed for anyone to raise the matter again. Now, I tell you that I shall be satisfied if you construct a model, and I – in addition to what I've already done – will make another. Then, without the slightest fuss, we'll take our models to the great King, and whoever in this test wins credit for having done the better work will thoroughly deserve the Colossus. If the commission falls to you, I'll forget the great injury you've done me, and I shall bless your hands as being worthier than mine of such a high honour. So let's agree on this and we'll be friends; but otherwise we'll be enemies: and God, who is always on the side of right, and I, who know how to assert it, will show you what a great mistake you've made.'

Francesco replied: 'The work is mine, and since it has been given me I don't intend to risk what belongs to me.'

To this I answered: 'Francesco, seeing that you won't take the proper way out – the way which is just and reasonable – I'll show you the other way, which will be like yours – ugly and unpleasant. I tell you this: that if I ever hear that you've spoken in any way about this work of mine I'll kill you without hesitation as I would a dog. And as we're not in Rome or Bologna or Florence – they live differently here – if I ever get to hear that you've spoken about it to the King or to anyone else, somehow or another I'll have your life. Make up your mind which way you want to go: the first, good way that I offered, or the other, disagreeable way that I offer now.'

The fellow was at a loss what to say or do, and I felt like finishing the business there and then, rather than allowing more time to elapse.

All Bologna said was: 'If I behave in the way an upright man should then I shan't have a fear in the world.'

'You've spoken the truth,' I said, 'but if you do the contrary then you'll have cause to fear, because this is a serious matter.'

I left him at once, and went to see the King; and for a long time I discussed with his Majesty the making of his coinage.[254] We were not very much in agreement about it, and his Council, which was present, persuaded him that the money should be made in the French style, as it had been up to that time. I retorted that his Majesty had had me come from Italy in order to produce good work for him, and if his Majesty were to order the contrary I would never have the heart to do it. At this the matter was postponed for discussion another time: I at once went back to Paris.

No sooner had I dismounted than one of those good people who enjoy finding evil came to tell me that Pagolo Miccieri had taken a house for that little whore Caterina and her mother, that he was always going there, and that when he spoke of me he always said with contempt:

'Benvenuto set the geese to guard the lettuce, and he thought I wouldn't eat it: now he's content to go around swaggering, and he thinks I'm afraid of him. But I've got this sword and dagger by my side to show him that my weapons too have a sharp edge, and I'm a Florentine as well as him – of the Miccieri family, a much better family than the Cellinis.'

The rogue who carried this story to me told it with such effect that I suddenly felt an attack of fever (I use the word fever, and not merely as a metaphor). Seeing that such a fierce passion might have been the death of me I followed my inclinations and found a remedy in giving it the outlet that was available. I told my Ferrarese workman, who was called Chioccia, to come with me, and I had a servant follow on behind with my horse. When we arrived at the house where the villain was, finding the door ajar I went inside. I saw that he was wearing a sword and dagger, and he was sitting on a chest with his arms round Caterina's neck: just as I arrived I heard him and her mother joking about my affairs. I threw open the door and at the same time seized my sword and thrust the point at his throat, without giving him time to remember that he also had a sword. While I was doing this I shouted out:

'You vile coward – say your prayers, for you're as good as dead.'

He sat stock still and cried out a few times: 'Dear mother! Help me!'

I had meant to kill him whatever happened, but when I heard him use these mawkish words half my anger subsided. Meanwhile I had ordered my workman, Chioccia, to allow neither the girl nor her mother to leave the house, since when I had set about him I meant to do as much harm to those two whores. I kept the point of my sword steady at his throat (now and then giving him a slight prick), and I threatened him continually. Then, with his not making the least effort to defend himself and my not knowing what to do next, it looked as if my threatening would go on for ever: then the idea entered my head of making them get married, as the lesser evil and in order to have my revenge later on.

So, with my mind made up, I said:

'Take off that ring you have on your finger, you coward, and marry her, so that then I can take my revenge the way you deserve.'

He said at once: 'If you don't kill me I'll do anything.'

So then I told him to put the ring on her finger. I withdrew the sword a little from his throat and he put the ring on her.

And then I said: 'That's not enough. I want to have two notaries sent for so that this can be made into a contract.'

I told Chioccia to go for the notaries, and straight away I turned to her and her mother and speaking in French I said:

'The notaries and other witnesses are coming: the first one of you I hear say a word about what has happened I'll kill without hesitation – I'll kill all three of you, so don't forget it.'

Then I said to him, in Italian: 'If you make any objection to what I propose, just one word from you and I'll stab you so many times that I'll make you spill out your guts.'

'All I ask,' he said, 'is that you don't kill me; and I'll do what you want.'

The notaries and witnesses appeared on the scene, and a splendid, valid contract was drawn up; and then my rage and fever left me. I paid the notaries and left the house.

Next day, Bologna went out of his way to come to Paris and sent Mattio del Nazaro for me. I went along and found the man, who met

me with a very cheerful face, and then begged me to look on him as a loving brother of mine and said he would never talk of the work again, as he realized perfectly well that I was in the right.

If when describing these events I did not admit that I know I was sometimes acting wrongly, it would not ring true when I treat of actions which I know were justified. I know I made a mistake in wanting such an extreme revenge on Pagolo Miccieri. But if I had known he was a man of such weakness I would never have contemplated taking the humiliating revenge that I did. Not satisfied with having made him take such a shameless little whore as his wife, as well as this – to round off my revenge – I used to send for her to make use of her as my model. Every day I gave her thirty soldi; and I made her pose in the nude. First, she wanted to be paid in advance, and then she wanted to make a good meal, and then I had my revenge by having intercourse with her, mocking at her and her husband for the various horns I was giving him. The fourth thing I did was to make her pose in great discomfort for hours at a stretch. And, in her discomfort, she was as much annoyed as I was delighted, since she was very beautifully made and won me great honour.

When she realized that I did not treat her as considerately as I used to before her marriage, she grew tremendously angry and began to show off, bragging in her French way about her husband who had gone to serve the Prior of Capua, Piero Strozzi's brother.[255] As I said she began talking about her husband, and as soon as I heard her mention him I was overwhelmed with a choking fury. But I put up with it grudgingly, as best I could, reflecting that I could not find a more suitable model for my work than she was.

I said to myself: 'I get two kinds of revenge out of this. First, she's married, and so these horns are the real thing, unlike hers when she was playing the whore with me. So I'm taking an excellent revenge against him, and an extravagant one against her, by making her pose in such discomfort and so winning credit and profit for myself. What more can I want?'

While I was weighing matters up in this way, the slut redoubled her insults, besides talking about her husband. What she said and did nearly drove me out of my mind, and giving in to my rage I seized her by the

hair and dragged her up and down the room, beating and kicking her till I was exhausted. There was no one there who could come to her help. When I had given her a good pummelling, she swore that she would never come to me again; so for the first time I realized what a mistake I had made, since I was losing a splendid opportunity of winning honour. Besides this, with her all torn and bruised and swollen, I realized that even if she did come back it would be necessary to have her treated for a fortnight before I could make use of her.

To return to the girl: I sent one of my servants to help her dress. She was a very kindly old woman, called Ruberta, and when she went in to the little hussy she gave her something to eat and drink again; then she rubbed some bacon fat into the worst bruises I had given her, and what was left over they ate together. Having dressed, she went off abusing and cursing all Italians and the King who sheltered them. So, crying and muttering all the way, she walked home.

In fact this first time it seemed to me that I had done wrongly; and my Ruberta scolded me as well, saying:

'You're very cruel to treat such a beautiful young girl so roughly.'

I tried to make excuses to Ruberta, telling her how wickedly Caterina and her mother had treated me when they stayed with me; but she still told me off, insisting that this was nothing to complain of since it was the French custom, and that she knew for certain that there was no French husband who hadn't got his pair of horns. At this I burst out laughing, and then I told Ruberta to go and see how Caterina was, since I would like to be able to use her in finishing my work.

My Ruberta scolded me, saying that I didn't understand how to live, since as soon as day came Caterina would come of her own accord; 'while if you send to ask how she is, or go to visit her, she'll grow haughty and won't come at all'.

The following day Caterina came to my door and started knocking on it furiously. I was downstairs, and I ran to see if this was a madman or someone living in the house. When I opened it the creature laughed, threw herself round my neck, hugging and kissing me, and asked if I was still furious with her. I said, no. She answered: 'Give me a good breakfast then.'

I did so, and I ate with her as a sign of peace. Then I began to model

from her; and in between times we made love together, and then, at the same hour as the day before, she provoked me so much that I had to give her the same beating: and this went on for several days, everything after the same pattern each time, with little variation.

Meanwhile I had finished my figure in a very creditable style and I prepared to cast it in bronze. I encountered some difficulties in this matter and to describe them would be very profitable as far as art is concerned, but it would take me far too long and so I shall pass them over. Enough to say that it came out beautifully, and was as finely cast as anything ever has been.

While I was forging ahead with this work I set aside certain hours of the day to work on the salt-cellar, and others to work on the Jupiter. As there were more men working on the salt-cellar than I could manage to employ on the Jupiter, by this time I had already finished it down to the last detail. The King had returned to Paris, and I went to find him, bringing the salt-cellar with me. As I have said before, it was oval in shape, about two-thirds of a cubit high, entirely in gold, and chased by means of a chisel. And, as I said when describing the model, I represented the Sea and the Land, both seated, with their legs intertwined just as some branches of the sea run into the land and the land juts into the sea: so, very fittingly, that was the attitude I gave them. I had placed a trident in the right hand of the Sea, and in his left hand, to hold the salt, I had put a delicately worked ship. Below the figure were his four sea-horses: the breast and front hoofs were like a horse, all the rest, from the middle back, was like a fish; the fishes' tails were interlaced together in a charming way. Dominating the group was the Sea, in an attitude of pride and surrounded by a great variety of fish and other marine creatures. The water was represented with its waves, and then it was beautifully enamelled in its own colour.

The Land I had represented by a very handsome woman, holding her horn of plenty in her hand, and entirely naked like her male partner. In her other hand, the left, I had made a little, very delicately worked, Ionic temple that I intended for the pepper. Beneath this figure I had arranged the most beautiful animals that the earth produces; the rocks of the earth I had partly enamelled and partly left in gold. I had then given the work a foundation, setting it on a black ebony base. It was

of the right depth and width and had a small bevel on which I had set four gold figures, executed in more than half relief, and representing Night, Day, Twilight, and Dawn. Besides these there were four other figures of the same size, representing the four chief winds, partly enamelled and finished off as exquisitely as can be imagined.

When I set this work before the King he gasped in amazement and could not take his eyes off it. Then he instructed me to take it back to my house, and said that in due course he would let me know what I was to do with it. I took it home, and at once invited in some of my close friends; and with them I dined very cheerfully, placing the salt-cellar in the middle of the table. We were the first to make use of it. Then I set out to finish the silver Jupiter and the large vase I have mentioned before that was charmingly ornamented with a host of figures.

About that time the painter Bologna, whom I've referred to above, gave the King to understand that it would be well worth his Majesty's while to let him go to Rome, recommending him with letters of introduction, so that he could take casts of the foremost antiques, that is, the Laocoön, the Cleopatra, the Venus, the Commodus, the Zingara, and the Apollo. These certainly are the most beautiful works in all Rome.

He told the King that after his Majesty had set eyes on those marvellous objects, then he would really understand the art of design, since all the work he had seen come from the hands of us moderns was far removed from the craftsmanship of the ancients. The King was agreeable, and granted all his requests. So the beast shambled off on his own unlucky path. It was not in him to rival me with the work of his own hands, so he played the typical Lombard trick of seeking to discredit my work by making himself a copyist of antiques. And though he had his casts very well made, he ended up by producing quite the opposite result to what he had expected, as I shall describe later when the time comes.

I had chased that wretched girl Caterina right away, and that poor unfortunate husband of hers had cleared out of Paris. Then, as I wanted to put the finishing touches to my Fontainebleau which was already cast in bronze, and also to make a good job of the two Victories which were meant for the side angles in the half-circle of the door, I found myself a poor young girl, about fifteen years old. She was very beautifully

formed, and rather swarthy. Since she was inclined to be wild, spoke very little, was swift in her movements, and had brooding eyes, all this led me to give her the name Scorzone;[256] her real name was Gianna. With the help of this delightful girl I finished the Fontainebleau to my satisfaction in bronze, as well as the two Victories for the door.

This young girl was untouched, and a virgin, and I got her pregnant. She bore me a daughter on the seventh of June, at the thirteenth hour of the day, 1544; and that was just the forty-fourth year of my own life. I gave her the name Costanza:[257] she was held at her baptism by Guido Guidi, the King's physician and, as I have written before, a very good friend of mine. He was the only godfather, since that is the custom in France, to have one godfather and two godmothers. One of these latter was Signora Maddalena, the wife of Luigi Alamanni, a Florentine gentleman and a marvellous poet. The other godmother was the wife of Ricciardo del Bene, one of our Florentine citizens and a substantial merchant in Paris. She was a high-ranking French lady. This, as far as I remember, was the first child I ever had. For her endowment I assigned the girl as much money as an aunt of hers – into whose care I gave her – would agree to: and that was the last I had to do with her.

I carried on working hard and made a great deal of progress: the Jupiter was nearing completion, and so was the vase, and the doorway was beginning to reveal its beauty. At that time the King arrived in Paris. Although I gave 1544 as the year when my daughter was born, we are still in 1543; there was a suitable opportunity for me to speak of my daughter here, and I did so in order not to distract from other, more important matters. I shall say nothing more of her till the proper time.

As I said, the King came to Paris. He at once paid me a visit, to find my work so well in hand that anyone would have been fully satisfied: and to tell the truth that splendid King was as pleased as one who had taken the pains I had taken could possibly desire. He immediately remembered of his own accord that the Cardinal of Ferrara had given me nothing – neither an allowance nor anything else – of what he had promised me: and he whispered to his Admiral that the Cardinal had behaved very badly in not giving me anything, but that he meant to remedy this unfitting state of affairs because he saw that I was not the

man to make a song and dance about it, but that some day before you could bat an eyelid I would clear off without saying a word. His Majesty returned home, and after dinner he told the Cardinal to give orders on his behalf to the royal treasurer to pay me seven thousand gold crowns, as quickly as possible, in three or four instalments according to his convenience, but not to forget to do so.

And he added: 'I gave Benvenuto into your care, and you have forgotten him.'

The Cardinal said that he would gladly do all that his Majesty asked. But his evil nature was such that he let the matter rest.

Meanwhile, the wars grew worse; and it was at this time that the Emperor with his huge army was making in the direction of Paris.[258] The Cardinal realized that France was acutely short of money and one day, having been discussing me with the King, he said:

'Sacred Majesty, acting for the best I have not had any money given to Benvenuto. For one thing, we have only too much need of it at present; and for another, such a handsome sum of money would have meant losing your Benvenuto more quickly; because thinking that he was a rich man he would have bought some property in Italy and then one day, when the fancy took him, he would have left you without a second thought. So I have come to the conclusion that the best thing would be for your Majesty to give him something within the kingdom, if you want him to stay longer in your service.'

The King approved these arguments as he was short of money. But all the same, since he possessed a nobility of mind that was truly worthy of such a great King, he reckoned that the Cardinal was motivated more by the desire to ingratiate himself than by the necessity of having beforehand taken into account the needs of so great a kingdom.

So although, as I have said, the King acted as though he approved of the Cardinal's arguments, in his own mind he had decided not to act on them. What happened was that, as I said above, he returned to Paris, and the following day, without any advances from me, he came of his own accord to my house. There I met him and led him through various rooms in which work of various kinds was displayed. Starting with the less important things, I showed him a great number of works in bronze, more than he had seen for a long time

past. Then I took him to see the silver statue of Jupiter, showing it to him nearly finished, with all its beautiful adornments. It struck him as being much more splendid than any other man would have judged it. This was because of a terrible thing that had happened to him a few years before.

At that time, after the capture of Tunis, the Emperor was passing through Paris by agreement with his brother-in-law, King Francis; and the King wanted to make him a gift worthy of so great an Emperor. So he had made a silver statue of Hercules, of exactly the same size as I made the Jupiter. Now this Hercules, the King admitted, was the ugliest work he had ever seen, and he had said as much to the Paris craftsmen who claimed to practise their art better than anyone else in the world. They gave the King to understand that that was the best that could be achieved in silver, and despite this they wanted to be paid two thousand ducats for their abortive work. So when the King saw the craftsmanship of what I had done it struck him as being unbelievably beautiful. He made a fair judgement and decided that my Jupiter should also be valued at two thousand ducats.

'I paid them nothing by way of salary,' he said, 'and I allow this man about a thousand crowns a year: so, taking his allowance into account, he can certainly make it for me for the price of two thousand gold crowns.'

Then I took him to have a look at some other work, in silver and gold, and at a large number of models for new ventures. Just before he left I showed him the huge giant that stood on the castle lawn; and on seeing it the King was more astonished than he had ever been before. Turning to the Admiral, who was called Monsignor Aniballe,[259] he said:

'The Cardinal hasn't provided him with anything, and he himself is too slow in coming forward, so without any more talk I intend to see to what he wants – these men aren't in the habit of asking for anything, but they believe that their work asks a good deal for them. So provide him with the first abbey with revenue worth up to two thousand crowns that falls vacant; and if no vacancy of that worth occurs let him have the amount spread over two or three, since it's all the same to him.'

I was standing near so I heard everything, and straight away I thanked the King as if the gift were already given. I told his Majesty that after this favour I meant to work for him without any more reward – in the shape either of a salary or other payment for my work – till the day when old age forced me to give up working: then I would be able to end my tired life in peace, living honourably on the income he had given me and remembering how I had served a king as great as his Majesty. At these words of mine the King smiled very encouragingly and said: 'And so may it be!' Then, very contentedly, his Majesty left me to myself.

When Madame d'Étampes heard how my affairs were progressing her spite against me increased more than ever.

'Today,' she said to herself, 'I rule the world – and a little man like that shrugs his shoulders at me!'

She went the whole hog in her determination to harm me. When a certain man came her way – an expert distiller, who supplied her with some splendid liquid perfumes, for removing wrinkles, which were up to then unused in France – she sent him to the King and he showed his Majesty some of his essences. The King was delighted with them, and while he was in this agreeable mood she got him to ask his Majesty for a tennis-court that I had in my garden, as well as for a number of little apartments near by which he said I wasn't using. The good King realized who was behind this and would not answer him. Then Madame d'Étampes set out to persuade him by use of the arts which women practise with men; and as a result her plan easily succeeded, because she found the King in one of those amorous moods to which he was very subject and he conceded all that she wanted.

The man came to see me in the company of the treasurer Grolier,[260] a great French nobleman. When he arrived at my castle the treasurer, who spoke excellent Italian, addressed me in my own language and began joking with me: then, when he saw the time was ripe, he said:

'On behalf of the King I put this man in possession of the tennis-court and the apartments that go with it.'

To this I retorted: 'Everything comes from our sacred King; so you could have entered the place as freely as you liked. Acting through notaries and court officials looks more like an attempt at fraud than a

genuine commission from so great a King. So I assure you that before I go and complain to his Majesty I shall protect myself in the way that the King commissioned me to the other day, and if I don't see a plain warrant in the King's own hand I shall throw the man you've installed here out through the window.'

After he had heard what I said the treasurer went off, threatening and grumbling, and left me behind to do the same – though I did not intend to make any other move as yet. Then I went to find the notaries who had put the fellow in possession. I knew them very well, and they told me that the proceedings were in fact in order, and had been done at the King's command, but that this did not matter very much. They said that if I had made some show of resistance he would not have taken possession as he had, and that these were acts and customs of the court which did not concern in the slightest obedience to the King. So, they concluded, if I succeeded in depriving him of possession in the same way as he had entered it would be well done and nothing would happen.

This hint was good enough. Next day, I began to make use of my weapons, and although it proved a difficult undertaking I looked on it as a pleasure. Every day I made an unexpected assault with rocks, pikes, and arquebuses. I fired without ball, but I put so much fear into them that no one was willing to come and help him. One day when I found that he was resisting only feebly I forced my way into the house and threw him out, hurling all his belongings after him. Then I went to the King and told him that I had done just exactly what his Majesty had commanded, by defending myself against all those who tried to hinder me from serving him. The King burst out laughing at this, and then he had a new patent drawn up to protect me against further molestation.

Meanwhile I gave all my attention to finishing the fine silver statue of Jupiter[261] together with its gilded base, which I had placed on a wooden plinth. Only a part of the plinth was visible and I had fixed in it four small balls, made of hard wood, more than half concealed in their sockets, like the nut in a crossbow. These were so skilfully arranged that a small child could easily, without the slightest effort, push the statue of Jupiter backwards and forwards or turn it round on itself.

When I had set everything up to my satisfaction I took it to Fontainebleau, where the King was staying.

By then Bologna had brought from Rome the statues I mentioned, and he had taken great pains in having them cast in bronze.[262] I knew nothing of this, partly because he had kept his doings very secret, and partly because Fontainebleau is more than forty miles away from Paris: so I was kept completely in the dark. When I wanted to find out from the King where to place the Jupiter, Madame d'Étampes, who was present, told him that there was no place more suitable than his beautiful gallery. This is what we call in Tuscany a loggia, or, more accurately, a corridor – a corridor, because a loggia is the name given to apartments open along one side.

Anyhow, this room was more than a hundred paces in length, was richly furnished, and was hung with a number of paintings from the hand of our splendid Florentine, Rosso; under the paintings were grouped a great many pieces of sculpture, some in the round and others in low relief. The room was about twelve paces across. Bologna had brought here all his antiques, beautifully cast in bronze, and had arranged them magnificently with each one raised on its own pedestal. And, as I said before, they were the most exquisite works of art, copied from the antiques of Rome. I brought in my Jupiter; and then, when I saw such a splendid spectacle with everything so skilfully set out, I said to myself:

'This is certainly running the gauntlet – now God help me.'

I put it in its place, positioning it as well as I could, and I waited for the arrival of the great King. In Jupiter's right hand I had placed his thunderbolt, so that it looked as if he were about to hurl it; and in his left I had placed a globe. Among the flames I had very neatly introduced a length of white taper.

Madame d'Étampes had managed to keep the King distracted till nightfall, with the intention of ensuring one of two unfortunate results for myself – either his not coming at all, or, because of the darkness, my work's being shown at a disadvantage: but, as God rewards those of us who trust in Him, quite the opposite happened, because seeing that it was growing dark I lit the taper that the Jupiter was holding, and as this was lifted a little way above the statue's head its light fell down

from above, making the work appear much more beautiful than it would have done in daylight.

The King appeared on the scene along with his Madame d'Étampes, the Dauphin his son (today the King),[263] the Dauphiness, his brother-in-law the King of Navarre, with Madame Marguerite his daughter,[264] and several other great lords whom Madame d'Étampes had carefully instructed to speak against me. As soon as I saw the King come in I had my assistant, Ascanio, push the beautiful statue of Jupiter forward in his direction; he moved it very gently, and since I had done the job very skilfully and the figure was very well constructed this slight movement made the statue seem alive. The antique statues were left somewhat in the background, and so my work was the first to delight the spectators.

Straight away the King said: 'This is much more beautiful than anything that has ever been seen before: even though I'm a connoisseur I would never have come near imagining anything like this.'

As for those noblemen who were to speak against me, it seemed that they could not say enough in praise of my work.

Madame d'Étampes exclaimed fiercely: 'Have you lost your eyes? Don't you see how many beautiful bronze figures there are placed farther back? The true genius of sculpture resides in them, not in this modern rubbish.'

Then the King came forward, followed by the others. He glanced at those figures, which were not shown to any advantage since the light came from below, and he said:

'Whoever it was wanted to do this man a bad turn has done him a great favour: the comparison with these splendid works of art only serves to make it apparent that his is more impressive and beautiful by a long chalk. We must rate Benvenuto very highly indeed: his work not only rivals, it surpasses the antiques.'

At this Madame d'Étampes said that if my work were to be seen in the daylight it would not appear a thousandth part as beautiful as it did by night; besides, she added, they were to notice how I had put a veil on my statue in order to hide its faults. This, in fact, was a piece of fine gauze that I had placed with exquisite grace over the Jupiter to add to its majesty. When I heard what she said I took hold of it, lifting it

from below to reveal the statue's fine genitals, and then, with evident annoyance, I tore it off completely. She thought that I had unveiled those parts in order to mock her. When the King saw how insulted she was and how I myself, overcome by passion, was trying to force out some words, like the wise man he was he said with deliberation in his own tongue:

'Benvenuto, I forbid you to say a word: keep quiet, and you'll be rewarded with a thousand times more treasure than you desire.'

Unable to say anything I writhed with fury – which made her growl even more angrily. Then the King left much sooner than he would have done, saying in a loud voice, to encourage me, that he had brought from Italy the greatest artist ever born.

I left the Jupiter where it was, and when I wanted to make my departure in the morning, I was given a thousand gold crowns, partly for my salary and partly in settlement of what I had spent myself. After I had collected the money I returned to Paris satisfied and in good spirits; and as soon as I arrived there I held a celebration in my house. After supper I had all my clothes brought in. They included a great quantity of silk articles, some very expensive fur, and also some of very fine cloth. I gave these as presents to all my workpeople, handing them out according to merit, down to the servant girls and the stable-boys, and so encouraging them to carry on helping me cheerfully.

With renewed strength I set out enthusiastically and carefully to finish my great statue of Mars which I had constructed on a nicely fitted wooden frame, over which there was a crust of plaster, an eighth of a cubit deep, cleverly made for his flesh. Having seen to that, I had begun to cast the figure in several pieces which were afterwards to be dovetailed together in the right way; and this proved very easy to do. I must not forget to mention one incident relating to this huge work which well deserves a laugh. I had forbidden anyone I employed to bring prostitutes either into the house or into the castle, and I was very strict in enforcing the rule. Now, my young Ascanio had fallen in love with a very pretty girl, and she with him. And so, having run away from her mother, one night she came to find him: she was very reluctant to leave him again and, not knowing where to hide her, as a last resort like the ingenious fellow he was he put her inside the figure of Mars and made up a place

for her to sleep in the head itself. There she remained for a while, and Ascanio sometimes brought her out at night, secretly. As it happened, I had left the head all but complete, and – the result of some trifling conceit on my part – uncovered so that it could be seen by nearly all Paris. Those who lived near had begun to climb on their roofs to have a look at it; and crowds of people used to come just to see it.

It was said in Paris that my castle was haunted from ancient times, though I myself never saw anything to make me believe this (all the ordinary people of Paris called the ghost Lemmonio Boreò):[265] but since the young girl who was living in the head could not prevent some of her movements sometimes being seen through its eye-holes, a few of those silly people said that the ghost had entered into the statue's body, and was moving its eyes and mouth as if it wanted to say something. A number of them went off in terror, and some of the more astute ones who came to see for themselves could not gainsay the fact that the eyes were flashing, and so they too claimed that there was a spirit inside the statue. They little guessed that there was not only spirit, but excellent flesh as well.

In the meantime I was busy assembling my beautiful doorway together with all the adornments mentioned. I have no wish to write in my life story about matters that concern those who write chronicles, so I have not mentioned the approach of the Emperor with his great army, or the King's raising all his forces. But that was the time when he asked my advice on the rapid fortification of Paris: he came purposely to my house to find me, and he led me on a tour of inspection all round the city. On discovering that I was ready to fortify Paris, basing my work on sound principles and doing the job quickly, he gave me express orders to do what I had said without delay; and he ordered his Admiral to command the citizens to obey me under pain of his Majesty's displeasure.

The Admiral had won his position because of Madame d'Étampes's favour rather than through any good work of his own, and he was a man of little intelligence. So because of that, and because his name was d'Annebault (which translated into our language is Monsignor d'Aniballe) the people pronounced his name in their own language as if it were Ass-Ox. Anyway, this fool told Madame d'Étampes all that

had happened and she ordered him to send at once for Girolimo Bellarmato.[266] This man was a Sienese engineer who was then at Dieppe, a little more than a day's journey from Paris. He came at once, and then set in motion the most tedious method of fortification, and so I retired from the business altogether. And if the Emperor had advanced farther he would have taken Paris with the greatest ease. It is said that in the treaty which was made later, Madame d'Étampes, who was involved in the matter more than anyone else, betrayed the King:[267] I shall say nothing more about this as it's outside my scope.

I applied myself energetically to constructing the bronze doorway, and to putting the finishing touches to the large vase and to two other medium-sized vases which were made from my own silver. After all his trials, the good King came to Paris to rest for a while.

That cursed woman must have been brought into the world merely to bring about its destruction, seeing that I was her chief enemy I think I must be a man of some consequence. She happened to begin talking with the good King about my affairs, and she said such wicked things about me that to please her the good man swore that he would never again pay the slightest regard to me, and would treat me as if he had never known me. This news was immediately carried to me by a page belonging to the Cardinal of Ferrara, called Villa: he said that he himself had heard those very words from the King's own mouth. This threw me into such a rage that I hurled my tools and whatever I was working on across the room. I got ready to clear out of Paris, and I set off at once to find the King.

After he had finished supper, I entered the room where his Majesty was, and I found him with only one or two attendants. I made the proper reverence due to a king, and when he saw me he immediately smiled and inclined his head towards me. So I was reassured and I gradually drew near to his Majesty. They were showing him some objects connected with my own profession. After these things had been discussed a little while, the King asked me if I had anything beautiful in my house to show him, and then he asked when I wanted him to come and have a look. At this I said that if he was willing I was prepared to show him something straight away. He at once replied that I should go home and that he would come without a moment's delay.

I went off to wait for this wonderful King, who had gone to take leave of Madame d'Étampes. She wanted to know where he was going, and she said that she would accompany him: when he told her, she said that she did not want to go with him after all, and she begged him not to go that day himself, for her sake. She had to make several attempts to dissuade the King from his purpose: however, he did not come to my house that day.

The following day, at the same hour, I went back to see him: and as soon as he set eyes on me he protested that he meant to come to my house at once. As usual he went to take his leave of Madame d'Étampes, and when she realized that, for all her influence, she had not been able to change his mind for him, she began using her sharp tongue to slander me as much as if I were a mortal enemy of the throne. In reply to this the good King said that his intention in going to visit me was solely to give me a terrifying dressing-down, and he gave her his word of honour that this was what he would do. Immediately, he came to the house, and I led him into some large rooms on the ground floor where I had assembled the great door in its entirety. When the King saw it he was so stupefied that he could not see his way to giving me the dressing-down he had said he would. All the same he did not want to miss the opportunity of abusing me as he had promised, and so he began saying:

'There is one very important thing, Benvenuto, that you artists, talented as you are, must understand: you cannot display your talents without help; and your greatness only becomes perceptible because of the opportunities you receive from us. Now you should be a little more obedient and less arrogant and headstrong. I remember giving you express orders to make me twelve silver statues, and that was all I wanted. But you have set your mind on making me a salt-cellar, and vases, and busts, and doors, and so many other things that I'm completely dumbfounded when I consider how you've ignored my wishes and set out to satisfy yourself. If you think you can go on like this, I'll show you the way I behave when I want things done my way. So I warn you, make sure you obey my orders: if you persist in your own ideas you'll run your head against a wall.'

All the time he was talking, the noblemen with him remained very attentive, watching him as he shook his head, and frowned and

gesticulated, now with one hand and now with the other. They were trembling with fear of what was going to happen to me, though for my part I was determined not to let myself panic in the slightest.

As soon as he was finished with the harangue that he had promised his Madame d'Étampes he would make, I knelt down on one knee, and kissing his robe just above his knee I said:

'Sacred Majesty, I admit that everything you say is true; all I can reply is that continually, day and night, with all my heart and soul I have been intent only on obeying and serving your Majesty; and as for anything that may appear to disprove what I say, your Majesty must blame it not on Benvenuto, but on my evil destiny or my bad fortune, which has tried to make me unworthy of serving the most splendid prince the world ever had. So I beg you to forgive me. I would only add that I was under the impression that your Majesty gave me enough silver for only one statue, and seeing that I myself hadn't any I could only make that one statue. With the small amount that was left over I made the vase, so that your Majesty could see the beautiful style that was appreciated by the ancients, which perhaps you hadn't seen before.

'As for the salt-cellar, if I remember rightly I believe that one day your Majesty asked me for it of your own accord, after you had been discussing another salt-cellar that was shown you. Because of this, I showed you the model that I had already made in Italy, and then of your own free will you immediately had me given a thousand gold ducats so that I could execute the work for you. You said that you were very grateful to me for the idea, and, more than that, I believe that you thanked me very much when I gave you the finished work. As for the door, I was under the impression that once, when we happened to be discussing it, your Majesty gave orders to your chief secretary, Monsignor di Villurois, who commanded Monsignor di Marmagna and Monsignor della Fa to ensure that I continued with the work and was given an allowance for it: and if it hadn't been for this commission, I would never have been able to carry on with such a great undertaking by myself.

'As for the bronze busts and the work on the pedestal of the Jupiter and so on, I did in fact make the busts on my own initiative, because being a foreigner I had no acquaintance with these French clays, and I

wanted to experiment with them; I wouldn't have set about casting the large works unless I had done so. The work on the pedestal I did because I thought that it was very suitable for the figures. So everything I've done was meant for the best, and never meant in opposition to your Majesty's wishes. It's certainly true that up to its present stage that great Colossus has been at my own expense, because my only thought was, with your being such a great king, that an insignificant artist like myself should make a statue, for your glory as well as for my own, such as the ancients never had.

'Now that I see that God is unwilling to make me worthy of the honour of serving you, I beg your Majesty, in place of the honourable reward you intended to give me for my work, just to allow me a little of your good favour and to allow me to take my leave. And now, if you are good enough to allow it, I shall return to Italy, and I shall always give thanks to God and to your Majesty for the happy hours I have spent in your service.'

He took hold of me with his hand, and then, very graciously, raised me from my knees and said that I should be content to serve him, and that everything I had made was good and pleased him very much. Then he turned to the noblemen with him, and used these very words: 'I firmly believe that if doors had to be made for paradise, nothing finer than this could be achieved.'

I paused a little, after this forceful praise, and then with very great respect I thanked him once again, but because I was still angry I repeated that I would like to be given leave to go. When that great King realized that I had not received his unusually generous acts of kindness the way they deserved, in a loud, terrifying voice he ordered me not to say another word or it would be worse for me. And then he added that he would drown me in gold, and that he was quite content with my working on my own initiative in addition to the works commissioned by him, and that I would never again have any dispute with him, because now he understood me; and he said that for my part I should try to understand him in the way my duty commanded.

I replied that I gave thanks for everything to God and to his Majesty, and then I begged him to come and see the great statue and how far I had advanced it: so he came with me. I had it uncovered, and he was

astonished beyond words. Straight away he ordered his secretary to give me without any delay all the money I had spent on it out of my own pocket, no matter what it was so long as I wrote the amount down myself. Then he left saying: 'Good-bye, *mon ami*' – words rarely spoken by a king.

After he had returned to his palace he began turning over in his mind the way I had spoken to him at first with incredible humility and then with tremendous pride. My words had irritated him greatly, and he happened to repeat some particular phrases in the hearing of Madame d'Étampes and Monsignor di San Polo,[268] a great baron of France. This same fellow had in the past gone out of his way to profess himself a friend of mine, and on this occasion he certainly showed himself as such very adroitly and in the French fashion. What happened was that after a great deal of discussion the King complained about the Cardinal of Ferrara, saying that he had given me into his care, and that he had never given a thought to my affairs. He added that it was no thanks to the Cardinal that I had not cleared out of the kingdom, and that he would think about putting in charge of me someone who would appreciate me better, since he did not want to give me another opportunity of escaping.

At this, Monsignor di San Polo at once offered his services, asking the King to put me in his charge and saying that he would take great care I never had any further cause to leave his kingdom. In reply the King said that he was perfectly agreeable to this, if San Polo would tell him how he meant to stop me leaving. Madame was there looking very sullen at all this, and San Polo held his hand and would not tell the King how he would do it. His Majesty asked him again, and, to please Madame d'Étampes, he said: 'I would string him up by the neck – this Benvenuto of yours: and that way you'd never lose him.'

At once Madame d'Étampes shrieked with laughter, saying that I well deserved it. Then to keep them company the King began to laugh as well, and said that he was perfectly willing for San Polo to hang me, provided he first found someone of the same worth: and even though I had never deserved it, he said, he gave him full permission. In that way the day came to an end, and I remained safe and sound: for which I give praise and thanks to God.

By then the King had brought to a peaceful end the war with the Emperor, but not with the English: so those devils[269] continued to cause us great anxiety. His Majesty had to think about other matters than pleasure and he had commissioned Piero Strozzi to lead some galleys into English waters.[270] This was a difficult and formidable undertaking even for that splendid soldier, who was at the time unique as far as his profession was concerned, and unique in his misfortunes.

Meanwhile a few months had passed by without my receiving any money or any commissions. So I had dismissed all my workmen, apart from the two Italians whom I set to work on two great vases to be made from my own silver, since they did not know how to handle bronze. After the two vases were finished I went off with them to a city belonging to the Queen of Navarre, called Argentan, which is a good few days distant from Paris. When I arrived there I found that the King was indisposed. The Cardinal of Ferrara told his Majesty of my arrival but the King made no comment, and as a result I had to spend several days very disagreeably. In fact, it was all tremendously annoying. But, when a few days had gone by, I presented myself to the King, and held out before his eyes those two fine vases, which pleased him beyond measure.

When I saw that the King was in a very good mood, I begged his Majesty to be kind enough to allow me to make a trip to Italy, and I said that I would ignore the seven months' salary that was owing to me, though perhaps his Majesty would be good enough to have it paid to me later, if I needed it for my return. I begged him to do me this favour, seeing that it was a time for making war and not for making statues; I added that he had done as much for his painter, Bologna, and so I earnestly begged him to grant me the same favour. While I was saying this the King studied the two vases very closely, now and then staring at me with that terrible look in his eyes; all the same, with as much insistence as I was capable of, I begged him to grant me the favour I asked. All at once I saw him grow angry; he rose from his seat and said to me:

'Benvenuto, you're a great fool: take those two vases to Paris – I want them gilded.'

And without another word he went out.

I approached the Cardinal of Ferrara, who was present there, and begged him, seeing he had done so much for me in securing my release from imprisonment in Rome and in so many other ways, to try and obtain this favour for me as well, so that I could return to Italy. He said that he would be only too pleased to do all he could for me in the matter, that I could leave it completely in his hands, and that also, if I wished, I could go off without worrying, since he himself would keep me in the King's good books. I told him that I knew the King had put me under his reverend lordship's charge, and that if he gave me permission I would go with a light heart, ready to return if he made the least sign of wanting me to do so. Then the Cardinal told me that I should go to Paris, wait there a week, and meanwhile he would obtain the King's consent to my leaving: in the event of the King's being unwilling for me to depart he would inform me without fail, otherwise if he did not write to the contrary I was to take it that I could go without worry.

I went to Paris, following the Cardinal's instructions, and I made three splendid cases for those three silver vases. When twenty days had gone by, I began to make my preparations and packed the three vases on to a mule which had been lent me as far as Lyons by the Bishop of Pavia, whom I was again lodging in my castle. So, as my bad luck had it, I left Paris. I went with Signor Ippolito Gonzaga, who was in the King's pay and in service with Count Galeotto della Mirandola, and with some other noblemen of the count's household. Lionardo Tedaldi, our fellow Florentine, also came along with us.[271]

I left Ascanio and Pagolo in charge of the castle and of all my belongings, including some little vases I had begun. These I left so that the two young men would have something to keep them busy. There was also a great deal of valuable domestic furniture, since I lived in style. The value of my belongings amounted to more than fifteen hundred crowns. I told Ascanio not to forget the great benefits he had received from me, adding that up to then he had been a thoughtless child but that it was now time for him to have the mind of a man. I said that I meant to leave all my belongings, and my honour as well, in his care, and that if he had any trouble at all from those beasts of Frenchmen he was to let me know at once, so that I could ride back

post-haste from wherever I was in view of the strong obligation I was under to the great King, and for the sake of my own honour.

With false, treacherous tears this Ascanio said to me: 'I have never known a better father than you; and I shall always act towards you exactly as a good son should towards a good father.'

So having settled matters I went my way, together with a servant and a little French lad.

After midday some of the royal treasurers who were far from friendly towards me arrived at my castle. This villainous riff-raff immediately accused me of having decamped with the King's silver, and they urged Messer Guido and the Bishop of Pavia to send after me for the King's vases: if not, they said, they would send after me themselves in a way that I wouldn't like. The Bishop and Messer Guido showed much more fear than there was cause for, and without delay sent that traitor Ascanio post-haste after me: he caught me up about midnight. I had been lying awake, worried, and I was saying to myself:

'Look whom I've left my belongings and my castle to . . . Oh, how I'm dogged by misfortune in being forced to make this journey! I hope to God the Cardinal isn't an ally of Madame d'Étampes: all she wants is for me to lose that good King's favour.'

While I was fretting in this way I heard Ascanio calling me: straight away I jumped out of bed and asked him if his news was good or bad.

The thief said: 'It's good news: all you have to do is to send back those vases, because those rogues of treasurers have raised the alarm and as a result the Bishop and Messer Guido say that you must send them back at all costs. Otherwise there's nothing to worry about, and you can carry on enjoying your journey with a light heart.'

I immediately handed the vases over to him, though two of them were mine, together with the silver and everything else. I was taking them to the Cardinal of Ferrara's abbey at Lyons: although I was accused of intending to take them to Italy, everyone knows that it's impossible to take out money or gold or silver without very special permission. So one can imagine whether I could take out those three big vases[272] which, with their cases, needed a mule to carry them. True enough, seeing that they were very beautiful and worth a great deal, I was

worried in case the King died, since I had certainly left him in a very poor state.

I said to myself: 'If such a thing were to happen I would know they were in the Cardinal's possession, and so I can't lose them.'

Anyhow, what happened was that I sent back the mule, with the vases and other important things, and the following morning in the company I mentioned I set out on the next stage of the journey. I never once found it possible to stop sighing and weeping. But sometimes I drew comfort from God, praying to Him:

'Almighty God, You possess the truth, and You know that this journey of mine is only so that I can bring help to six poor, unhappy young girls and to my own sister, their mother. True, they have a father, but he is so very old and his trade earns him nothing. They could so easily be ruined. So in doing this pious work, I rely for help and guidance on Your Divine Majesty.'

This was the only relief I had on my journey.

One day when we found ourselves a day's distance from Lyons (it was nearly two hours before sunset), we heard the crackling of thunder and noticed how very clear the sky was: I was a bow's shot in front of my companions. After the thunder we heard such a tremendous, fearful noise reverberating in the skies that I was convinced it must be the Day of Judgement. I paused for a while, and there was a fall of hail, without a drop of water. The hail was bigger than pellets shot from a blow-pipe, and when it hit me was very painful: little by little its size increased, till it was like the bullets from a crossbow. Realizing that my horse was terrified out of his wits, I turned round and galloped back furiously till I met up with my companions, who being frightened like me had taken shelter in a pinewood. The hail-stones grew to the size of large lemons. I sang a *Miserere* and while I was praying to God in this devout way a hail-stone fell that was so large that it smashed a very thick branch from the pine under which I thought I was safe; another fall of stones crashed on to the head of my horse, which staggered as if to fall; and one of them struck me, though not directly or I would have been killed.

In the same way one of them fell on poor old Lionardo Tedaldi who, as he was kneeling down like me, was forced on to his hands. At this, seeing that the branch could no longer protect me and that one

must do something else as well as saying the *Miserere*, I hurriedly began to gather up my clothes over my head. To Lionardo, who was screaming for Jesus to rescue him, I said that Jesus would help him if he helped himself. I found it more difficult looking after him than after myself. The storm continued some while, and then stopped: we had all been given a pounding, but we remounted our horses as best we could and rode on towards our next stopping-place, showing each other the scratches and bruises we had received. Then a mile in front we found a spectacle of ruin so much greater than our own misfortune that it defies description.

All the trees were stripped and smashed; all the animals around had been killed, as well as a good number of shepherds. We saw a mass of stones which were so large that it was impossible to get both your hands round them. So we reckoned that we had escaped lightly and realized that our calling on God and singing *Misereres* had afforded us better protection than we would have got from our own efforts. So, giving thanks to God, the next day we pushed on to Lyons, and there we stayed put for a week. When the week was up we carried on with our journey thoroughly refreshed, and passed through the mountains very pleasantly. On the other side, as some small items of luggage I had with me had somewhat strained my horses, I bought a little pony.

After we had been a day in Italy we were joined by Count Galeotto della Mirandola, who was travelling in the post. He stopped at the place where we were and told me that I had been wrong to leave and that I should go no farther, because if I went back straight away things would go better than ever for me. But if I went on, he said, I was leaving the field to my enemies, and they had every opportunity for doing me harm. On the other hand, if I returned at once I would frustrate the plot that they had formed against me. Those in whom I had most trust, he said, were the ones who were betraying me. He would only tell me what he knew for certain, and that the Cardinal of Ferrara had entered into a conspiracy with the two rogues I had left to look after all my affairs.

The young lord kept on insisting that I should return at all costs. Then he joined the post and carried on with his journey, and I myself, because of my companions, also decided to go forward. I was in two

minds as to whether to head straight for Florence or to go back to France: I was so distraught and undecided that in the end I resolved to join the post and arrive at Florence without delay. I had made no arrangement to travel with the first post; and then I made a firm decision to go and suffer in Florence.

I parted company with Signor Ippolito Gonzaga, who took the road for Mirandola while I went towards Parma and Piacenza, and after I had arrived at Piacenza I met Duke Pier Luigi in one of the streets. He stared at me very hard and recognized me. Knowing that it was entirely because of him that I had suffered so much in Castel Sant'Angelo, in Rome, I nearly choked when I saw him: but, as I saw no way of slipping through his hands, I decided to go and visit him. I appeared on the scene just after he had risen from eating: he had with him those men of the Landi family who afterwards killed him. When I joined his Excellency the man gave me an incredibly affectionate welcome. Among other things, as he was talking to the people who were present he said that I was at the very top of my profession and that for a long time I had been imprisoned in Rome.

Then he turned to me and said: 'Benvenuto, my dear friend, I was very upset over your sufferings. I knew that you were innocent, and I could do nothing to help you, since my father was determined to satisfy some enemies of yours who had even given him to understand that you had been backbiting him. I was certain that there was no truth in this, and I grieved very much for you.'

He went on and on in this strain to such an extent that it seemed as if he was asking for my forgiveness. Afterwards he asked me about all the work I had done for the Most Christian King: and when I was telling him about it he listened attentively, providing the most gracious audience imaginable. Then he asked me if I would serve him. To this I replied that my honour would not allow me to do so, though if I had left all the important works of art I had begun for the great King in a finished state I would rather serve his Excellency than any other great lord.

Let me say here how the power of God is such that no man – no matter who he is – who inflicts injustice and wrong on the innocent is left unpunished. This man, in effect, begged my pardon, in the

presence of those who shortly after avenged me and all the many others who had been treacherously oppressed by him: so no lord, however great he is, should make a mockery of God's justice, as is done by some I know, who, as I shall describe when the time comes, have behaved brutally towards me.

There is no motive of worldliness in my writing down these affairs of mine; all I want to do is to give thanks to God for rescuing me from so many great afflictions. In the trials by which I am continually afflicted I appeal to Him, I call on His protection and commend myself to Him. And always, after I have relied on myself as much as possible, when I begin to falter and my feeble strength is insufficient, straight away God's great power reveals itself: it acts unexpectedly on those who sinfully oppress others and on those who misuse the great and honourable duties God has laid upon them.

I went back to the inn where I found that the Duke had sent me a vast quantity of very excellent food and drink. I ate with a keen appetite; then I mounted my horse and set off towards Florence. When I arrived I found there my sister and her six young daughters, ranging from one who was ready for a husband to one who was still at nurse. Her husband, who as a result of certain events in the town no longer worked at his trade, was there with her.

Over a year before I had sent back some jewels and some gold ornaments made in France, which were worth more than two thousand ducats; and I had brought with me some more, worth about a thousand crowns. I discovered that although all the time I had been giving them four gold crowns a month, they also regularly made an income out of selling some of my jewellery day by day. But that brother-in-law of mine was such an upright man that for fear of arousing my anger – and seeing that the money I sent him by way of a free allowance was not enough – he had pawned nearly all he had in the world, letting himself be eaten up by interest rather than touch the money which was not really his. By this I recognized how honest he was, and I determined to do more for him and I also intended to make provision for all his daughters before I left Florence.

At that time our Duke of Florence was at Poggio a Caiano, a place ten miles distant from Florence: it was the month of August, 1545. I

went there to find him, with the sole purpose of paying my proper respects, seeing that I too was a Florentine citizen and my forefathers had been great friends of the House of Medici, and I more than any of them loved Duke Cosimo.[273]

As I said, I went to Poggio only to pay my respects and without the slightest intention of staying with him, as turned out to be God's will, who orders all things for the best. When I encountered the Duke he greeted me with tremendous affection, and then he and the Duchess[274] asked me about the work I had done for the King: I was only too pleased to tell him the whole story. After I had finished he said that he had understood as much and that I had spoken the truth; then he added with a gesture of sympathy:

'What a small reward for all your great and wonderful toil! My dear Benvenuto, if you were to do something for me I would reward you in a way very different from the way that King, whom your good nature makes you praise so much, has done.'

At this I went on to mention the great obligations I was under to his Majesty, who had rescued me from such unjust imprisonment and then given me the chance to do more splendid work than any craftsman of my kind had ever been able to undertake. While I was talking in this fashion the Duke twisted and turned and looked as if he could not wait for me to finish. When I did finish he said: 'If you do some work for me, I'll treat you so generously that I imagine you'll be astonished: provided your work pleases me, and of that I have no doubt at all.'

Then I, poor wretch, in my eagerness to show the splendid Florentine school[275] that since my departure I had been engaged far more than it imagined on other branches of art, said in reply that I would be only too pleased to make him a great statue, either in marble or bronze, for that fine piazza of his. He answered that all he wanted as my first work for him was a Perseus; he had been wanting this for a long time, and he begged me to make him a little model of it.

I gladly set to work on the model and in a few weeks I had finished it. It was about a cubit in height, in yellow wax, properly finished, and beautifully made with great care and skill.[276] The Duke came to Florence, but several days passed before I had an opportunity of showing him the

model, and it seemed just as if he had never seen or known me. As a result I was beginning to feel very downcast about my relations with him. But then one day after dinner, when I had brought it with me into his wardrobe, he came to inspect it, along with the Duchess and a few other noblemen. It pleased him as soon as he had set eyes on it, and he began praising it extravagantly. This rather led me to hope that he knew something about the matter. After he had studied it a good while, becoming more and more delighted, he said:

'My dear Benvenuto, if you produce a large work which is as excellent as this little model it will be the finest work on the piazza.'

'Your Excellency,' I replied, 'there are works on the piazza[277] by the great Donatello, and by the marvellous Michelangelo, and those two men have proved themselves the greatest artists since the time of the ancients. But as your Most Illustrious Excellency is very enthusiastic about my model let me say that I have it in me to produce a work that will be three times better still.'

At this there was no little argument, because the Duke kept saying that he was quite expert on the matter and that he was perfectly aware of what could be done. So I told him that what I produced would settle both his doubts and the argument, and that I would certainly achieve for him something that would be far greater than I promised: but, I said, he must provide me with the means to do so, since I could not provide him with the great work I had promised unless he did. His Excellency answered that I should petition him for the amount I needed, and that I should give in detail all I required; then, he said, he would see to it that my petition was granted in full. Certainly, if I had been astute enough to secure by contract all that I needed in my work I would not have had all the trouble that came to me through my own fault; for he was tremendously insistent on having the work done and on making the arrangements. But not realizing that this lord behaved more like a merchant than a duke, it was as with a duke rather than a merchant that I dealt with him.

I made my petitions, and his Excellency responded very liberally.

In them I said: 'Most rare patron, the real petition and the real agreement do not consist in these words or in these documents, they depend on how far I succeed in doing the work as I promised: and if

I do succeed, then I am certain that your Most Illustrious Excellency will remember only too well all that you promised me.'

His Excellency was delighted with these words, and with the way I acted and expressed myself; and both he and the Duchess heaped favours on me to an unimaginable extent.

I was extremely anxious to start work, and so I told his Excellency that I was in need of a house where I could accommodate myself and my furnaces, some for the work to be done in clay or bronze and others, separate, for the work in gold and silver. I said that I knew he understood how eager I was to serve him in these branches of my art, and that I needed suitable rooms to do so. And in order that his Excellency might see how keen I was to serve him, I added, I had already found the house that suited my purpose, and it was in a locality that I found very attractive. And as I did not want to trouble his Excellency for money or anything else before he had seen my work, I begged him to buy me the house with two jewels that I had brought from France, and to keep them till I earned the house by the work of my own hands. These jewels had been beautifully set by my workmen, following my own designs. When he had examined them for some time he said to me encouragingly, in a way that filled me with false hope:

'Take your jewels, Benvenuto: I want you, not them, and you shall have your house for nothing.'

Then he wrote a rescript[278] under my petition which I have always kept; the rescript read as follows: 'Let the house be seen, and let it be ascertained whose it is to sell, and the price that is asked, for we desire to please Benvenuto.'

I imagined that with this rescript I was sure of the house, seeing I was convinced that my work would be much more pleasing than I had promised. His Excellency had afterwards given express orders to a certain majordomo of his, who was called Ser Pier Francesco Riccio.[279] He was from Prato and had acted as some sort of tutor for the Duke. I spoke to this beast and told him about what I needed, how there was a kitchen-garden by the house where I wanted to build a workshop. Straight away he handed my business over to a contractor, a lean, harsh man called Lattanzio Gorini.[280] As the devil would have it, this little pipsqueak, with his spidery hands and tiny gnat's voice, had stones, and

sand, and lime brought along: he was as quick about it as a snail and sufficient quantities were delivered to build a pigeon-house, though with some difficulty.

I began to despair at the crawling pace that things were going at, but I said to myself: 'Sometimes little beginnings lead to great ends.' And besides this I found cause for hope in the fact that the Duke had thrown away so many thousands of ducats on some abortive works of sculpture from the hand of that beast of a blockhead Bandinello. So I cheered up a little, and gave that Lattanzio Gorini a poke in the backside to make him get a move on; it was just like shouting at a collection of lame donkeys led by a blind boy.

In the face of all these difficulties, and then using my own money, I had marked out the site for the shop and cleared away the trees and vines. In my usual way I carried on with the project energetically and forcefully. In other matters I was in the hands of the carpenter Tasso, a very good friend of mine. I got him to construct some wooden frames in order to make a start on the great Perseus. This Tasso was a superb artist, in my opinion the best ever in his own craft. But besides this he was a pleasant, happy man, and every time I went to see him he used to greet me with a laugh and a snatch of song, in falsetto. I was already well on the road to despair, because there was news that in France my affairs were going badly, and at the same time I put little hope in my chances at Florence because of the tepid way they were proceeding; but he forced me into listening to at least half of his little song, and in the end I used to find myself cheering up in his company. I forced myself as much as possible to drive away some of my sombre thoughts.

I had made a start on all the projects I mentioned, and had begun to make more energetic preparations for the building work (part of the lime was already used) when suddenly I was sent for by that majordomo. So I went along and, after his Excellency had had dinner, I found the majordomo in the Clock Hall.[281] I greeted him very respectfully, but he replied very coldly, asked me who had installed me in the house, and demanded to know by what authority I had begun building on the site. He said he was astounded at my rash presumption. I replied to this that I had been installed by his Excellency, and that his lordship, in his

Excellency's name, had passed the order on to Lattanzio Gorini, that this Lattanzio had brought the stone, and the sand, and the lime, and had seen to what I wanted, saying that he had been commissioned by his lordship to do so. At this the brute attacked me more sharply than before and said that neither I nor any of the people I had mentioned were telling the truth. So then I lost my temper.

'Majordomo,' I said, 'so long as your lordship talks in a way that is in keeping with your noble rank, I shall respect you and address you as submissively as I do the Duke; but if you do otherwise, I shall talk to you as to the ordinary Ser Pier Francesco Riccio.'[282]

At this the fellow fell into such a rage that I thought he would go mad on the spot, and so make the process quicker than Heaven had decided. He retorted, with a volley of insults, that he wondered why he had deigned to allow me to talk to a man of his sort. I was provoked by this into saying:

'Now listen to me, Ser Pier Francesco Riccio, while I tell you who are my sort and who are your sort – masters who teach children their letters.'

Then – with his face all contorted – he raised his voice and repeated even more insolently what he had said before. So I put on an aggressive expression, assumed some of his own arrogance, and told him that men like me were fit to talk with popes, and emperors, and a great king, and that likely as not there was only one man of my sort in the whole world; but you could find a dozen like him in any street doorway. At this he jumped up on to a window-seat that was in the hall, and then asked me to repeat over again the words I had just used. I did so, a little more heatedly, and I added that I no longer had any wish to serve the Duke and that I was going back to France, which I could do freely enough.

The brute remained where he was, stupefied, and with his face the colour of clay; and I went off in a fury, determined to clear out – and would to God I had done so. His Excellency the Duke could not have learned of this devilish encounter straight away since I waited several days without anything happening. I was no longer concerned with Florence, except as regards my sister and my little nieces, and I made arrangements for them to be taken care of. With the little money I had

brought I wanted to leave them settled as best I could, and then as quickly as possible after that wanted to go back to France, and I did not care whether I ever saw Italy again.

I had made up my mind to hurry off as quickly as I could, without asking permission from the Duke or anyone else; and then one morning that majordomo of his own accord sent for me very humbly and embarked on a pedantic oration in which I could find not the slightest order, or grace, or wit, and which had neither beginning nor end. All I could grasp was that he claimed to be a good Christian and that he did not want to be at enmity with anyone, and he asked me on behalf of the Duke what salary I wanted for my upkeep. At this I stood there, busy with my own thoughts, and, as I did not intend to remain, I made no reply. When he saw me standing there without saying a word he at all events had the wit to say:

'Benvenuto, dukes expect an answer; and I am talking to you on behalf of his Excellency.'

Then I said that if he was talking on behalf of his Excellency I was only too willing to give him an answer. He should tell his Excellency, I continued, that I had no intention of taking second place to any other artist in his service.

The majordomo replied: 'Bandinello is paid two hundred crowns as his allowance, so if you're content with that your salary is settled.'

I said that I was satisfied, that whatever more I deserved should be given me when my work was seen and that I left everything to the sound judgement of his Most Illustrious Excellency. So, against my will, I picked up the thread and set to work, with the Duke showing me every imaginable mark of favour.

I had been receiving frequent letters from France, from that very loyal friend of mine, Guido Guidi; up to then they had brought me nothing save good news. That Ascanio of mine also sent to say that I should only worry about enjoying myself, and that if anything happened he would let me know. The King was informed how I had begun working for the Duke of Florence, but, seeing that he was the best man in the world, he kept saying: 'Why doesn't Benvenuto come back?' He questioned both of my young men in turn, and they both replied that I wrote to them saying that I was well off as I was and that I no

longer wanted to return and serve the King. His Majesty was furious at this, and in response to those rash words, which never came from me, he said:

'Since he left us without any cause whatsoever I shall never ask for him again: let him stay where he is.'

Those treacherous criminals had arranged matters the way they wanted, since if once I returned to France they returned to being workmen under me, as they were before; whereas if I did not come back, they remained free as they were, in my place. As a result they directed all their efforts to prevent my coming back.

While I was having the workshop built, so that I could begin the Perseus, I worked in a ground-floor room where I modelled the Perseus in plaster, the same size that the finished work was to be, with the idea of casting it from this mould. Then, coming to the conclusion that this procedure would take me rather too long, I hit on another expedient, since there had already been built, brick by brick, a shanty of a workshop, so wretchedly constructed that it makes me wince to remember it. I began the figure of Medusa, making an iron framework which I then covered with clay, and when I had finished that I baked it.

I had only one or two little apprentice lads, one of whom was very pretty; he was the son of a prostitute called Gambetta. I used this boy as a model,[283] seeing that nature is the only book from which we can learn art. I tried to hire some workmen in order to hurry the work on, but I was unsuccessful, and I could not do everything by myself. There were some workmen in Florence who would willingly have joined me, but Bandinello immediately prevented my having them; and then, after he had made me do without them for a while, he told the Duke that I was trying to get hold of his men since I myself lacked the skill to make a great statue without help. I complained to the Duke of the great annoyance that beast was giving me and begged him to obtain for me some of the workmen from the Opera.[284]

This led to the Duke's believing what Bandinello said to him: and when I became aware of this I decided that I would do as much as I could by myself. I set about it with the most exhausting efforts, and then the husband of my sister fell ill, and died within a few days.[285] My sister was still a young woman, and he left her on my hands with her

six children of all ages. This was my first great trial in Florence: to be left father and guardian to those unfortunate creatures.

However, I was anxious that nothing should go wrong, and as my garden was littered with rubbish I sent for two labourers, who were brought from the Ponte Vecchio. One of these was an old man of sixty, the other a young fellow of eighteen. After they had been with me about three days the young one told me that the old man had no liking for work, and that I would do better to send him away, seeing that not only did he not want to work himself but he also prevented his companion from working. He added that the little there was to be done he could do himself, and that there was no need to throw money away on other people: this young man's name was Bernardino Mannellini of Mugello.[286] Seeing his readiness to work hard I asked him if he would like to stay and be my servant; and we came to an agreement straight away. He used to look after my horse and work in the garden, and then he learned to help me in the workshop; and gradually he began to master the art with such a good grace that I've never had a better assistant. I was resolved to do everything with only his help, and I was beginning to show the Duke that Bandinello was a liar and that I could do very well without his workmen.

At that time my kidneys began to give me some pain and as I was unable to work I was only too glad to spend my time in the Duke's wardrobe, along with some young goldsmiths called Gianpagolo and Domenico Poggini.[287] I got them to make a little gold vessel, decorated in low relief with figures and other beautiful adornments; this was for the Duchess and had been ordered by her Excellency for drinking water out of. Besides this I was asked to make a gold girdle, which was also to be very richly worked with jewels and a number of pretty decorations such as little masks and so forth; and I did so.[288] The Duke used to visit the wardrobe nearly every minute, and he took great pleasure watching us at work and talking to me.

As my kidneys had begun to get a little better I had some clay brought to me, and while the Duke passed the time away with us I made a model of his head, much larger than life-size.[289] He was tremendously pleased with this work and grew so fond of me that he said it would make him very happy indeed if it could be arranged for me to work in

the palace: he would find some spacious apartments there and I should move in with my furnaces and all that I needed, because he took great pleasure in those things. I told his Excellency that this was not possible, because it would mean my not finishing my work in under a hundred years.

The Duchess began to heap favours on me, and she would have liked me to give all my attention to working for her and not to worry about the Perseus or anything of that sort. But when I took note of these meaningless marks of favour I knew that my perverse, malignant destiny could not delay long in overwhelming me with some fresh misfortune: all the time I was aware of how badly I had acted in the belief that I was doing everything for the best – I refer to the business in France.

The King could not swallow the affront he had received from my leaving, and yet he would have liked me to return so long as he did not lose face. For my part I thought I was completely in the right, and I did not want to humiliate myself; I was convinced that if I had lowered myself to the extent of writing humbly, those men, like the Frenchmen they were, would have said that this proved the sins I had committed, and that certain despicable acts of which I was accused were true. So I stood on my dignity, and wrote with some amount of pride, like a man who is in the right. And nothing could have more pleased those two treacherous apprentices of mine.

When I wrote to them I used to boast of the great favour that was being shown me in my native town by a lord and lady who were absolute rulers of the city of Florence, where I was born: so whenever they received a letter of that kind they would go along to the King and beg his Majesty to give them my castle, in the same way as he had given it to me. The King, who was a remarkably fine man, would never consent to what those great thieves asked so boldly, since he had begun to realize their evil intentions: but to throw them a sop, and to encourage me to return at once, he had a rather angry letter written me by one of his treasurers, Messer Giuliano Buonaccorsi, a Florentine citizen. The letter was to this effect: that if I wanted to keep my reputation of being an upright man, in view of the fact that I had left without cause I was certainly obliged to render an account of all that I had done and administered for his Majesty.

I was so gratified to receive this letter that I would not have altered it a jot, even if I could. I sat down to write and covered nine sheets of ordinary paper, giving in great detail an account of all the work I had done and everything that had happened while I was doing it; I described how much money I had spent and how I had always received it through two notaries and one of the King's treasurers, and had obtained receipts from the individuals I had paid for their goods or their labour. As for myself, I had not pocketed a single coin, and I had not been given anything at all for my finished work; all I had brought into Italy were some marks of favours and some royal promises, as befitted his Majesty.

I was unable to claim, I went on, that I had gained anything from my work except for the allowances his Majesty had made me for my upkeep – and as regards them I was still owed more than seven hundred gold crowns, which I had left behind on purpose so that they could be sent to me for my safe return. I knew that some evil-minded men had done me a bad turn out of envy, but, I said, the truth always prevailed: I found my glory in his Most Christian Majesty, and I was not motivated by avarice. I said that, although I realized I had done much more for his Majesty than I had undertaken and that although the reward I was promised had not been forthcoming, I had no want in the world other than to retain his Majesty's favour and be regarded as the upright and honourable man I had always been. If there was any doubt of this in his Majesty's mind, I continued, at the slightest sign I would return like a shot to give an account of myself, even at the risk of my life. But seeing so little account taken of me I had not wanted to return and offer my services, because I knew that I would always be able to earn my bread wherever I went: if I were sent for, however, I would never fail to respond.

My letter contained a host of other details fit for that splendid King to read, and in vindication of my honour. I carried the letter to the Duke before sending it, and he took pleasure in looking at it; then, without delay, I sent it to France, addressed to the Cardinal of Ferrara.

At that time Bernardo Baldini,[290] who acted as his Excellency's agent in the purchase of precious stones, had a huge diamond weighing more than thirty-five carats brought from Venice: Antonio di Vittorio Landi

was also interested in getting the Duke to buy it. The diamond had already been cut to a point, but as it did not possess the limpidity and lustre that one expects from such a stone, its owners had shorn off the point, and in fact it was not much good, either for table-cutting or cut to a point. The Duke, who took a great pleasure in jewels but knew nothing about them, gave that rascal of a Bernardo every reason to believe that he would buy the diamond; and as Bernardo wanted to keep for himself the privilege of perpetrating this deceit on the Duke of Florence, he did not confide a word of what he was doing to that partner of his, Antonio Landi.

This Antonio had been a very close friend of mine since boyhood and, seeing that I was on such intimate terms with the Duke, one day he called me aside (it was near midday, in a corner of the New Market) and said:

'Benvenuto, I'm certain that the Duke is going to show you a diamond which it seems he wants to buy: it'll be a large diamond, and you must help sell it. I can tell you that I'll let it go for seventeen thousand crowns. I'm sure that the Duke will seek your advice, and if you see that he's keen to have it I shall arrange matters to make sure he does.'

He seemed to be very certain of his being able to dispose of the diamond. I promised him that if it were shown to me and my opinion asked, I would say just what I thought, without prejudice to the jewel. Now, as I said above, every day the Duke used to come into that goldsmith's workshop and stay there several hours. More than a week from the time when Antonio Landi had spoken to me, one day after dinner the Duke showed me the diamond, which I recognized from the indications Antonio had given me of its shape and weight. Since the stone was, as I said above, of a rather muddy water (that was why they had shorn off the point) on seeing it I would certainly have advised against its purchase. So when he showed it to me, I asked his Excellency what he wanted me to say, on the grounds that it was a very different matter if a jeweller had to value a stone after his lord had bought it, from his valuing it so that he could make up his mind as to buying it. So then his Excellency said that he had in fact bought it, and that I was only to give my opinion. I could not help giving him some slight

indication of how little I thought of it. He told me that I should consider the beauty of the diamond's long edges. At this I said that they were not as wonderfully beautiful as his Excellency imagined, and that what beauty there was as far as this was concerned was because of the point's being shorn off. The Duke, who realized that I was speaking the truth, frowned unpleasantly at this and told me to get on with my valuation and tell him what I thought it was worth.

Reflecting that as Antonio Landi had offered it to me for seventeen thousand crowns the Duke must have obtained it for at the most fifteen thousand, and seeing that he did not like it when I was honest with him, I thought I would not disillusion him, passed him the diamond, and said: 'You paid eighteen thousand crowns.'

At this he cried out, making an O! bigger than the mouth of a well, and said: 'Now I'm convinced you know nothing about these things.'

I said: 'In fact, my lord, you're convinced wrongly. You concern yourself with keeping your jewel's good name, and I'll concern myself with understanding these matters: tell me at least how much you spent on it, so that I may learn to understand things in your Excellency's light.'

He rose with rather a scornful sneer and said: 'It cost me twenty-five thousand crowns and more, Benvenuto . . .' and then he went away.

The goldsmiths Gianpagolo and Domenico Poggini were present while this was going on, and the embroiderer Bachiacca[291] was working in a room next to ours: when he heard all the hubbub he ran in himself.

I said: 'I would never have advised him to buy it; but if he had wanted it all the same, a week ago Antonio Landi offered it to me for seventeen thousand crowns: I think I'd have got it for fifteen or less. But the Duke means to safeguard his jewel's reputation. After Antonio Landi offered it to me at such a price, how the devil can Bernardo have worked such a foul swindle!'

Refusing to believe that it could be possible, we passed off the Duke's naïvety with a laugh.

As I said, I had already begun work on the figure of the large Medusa, and had constructed its iron framework. Then I covered it in clay, with anatomical correctness, half a finger thinner, and baked it thoroughly.

Then I spread on the wax, and finished it as I wanted it to be. The Duke had come to see it very often and he was so worried that I might not succeed with the bronze that he would have liked me to call in some expert to cast it for me.

Meanwhile his Excellency was always talking with great admiration of my artistic skill. And then his majordomo, who was forever on the look-out for some way to make me break my neck, hit on a way to do it. He had authority over the police officers and all the officials of that poor unfortunate city of Florence: to think that this incredibly ignorant man, an enemy of ours born in Prato and the son of a cooper, should have won such great authority by having been the miserable tutor to Cosimo de' Medici before he became Duke! Anyhow, as I was saying, he was always on the look-out for some way of harming me, and after he had been unable to find any pretext for bringing an accusation against me he then thought up a way of achieving his end. He went along to the mother of my shopboy, Cencio, and the two of them – that dishonest whore Gambetta, and that villain of a pedagogue – plotted together to give me such a fright that I would pack my bags and go. Gambetta, using the methods of her own profession, followed in the wake of that mad, wicked schoolmaster of a majordomo, and they were also leagued with the chief constable (who was a certain Bolognese the Duke later on banished for this sort of behaviour).

Well, one Saturday evening, getting on for three hours after sunset, this Gambetta came to me with her son and told me that because of me she had kept him locked in for several days. I answered that she should not keep him shut up on my account; and, laughing at her prostitute's tricks, I turned to the boy in her presence and said:

'You know, Cencio, if I've done anything wrong with you.'

He said very tearfully, no.

Then the mother, shaking her head, said to the boy: 'Ah, you little villain, then I don't know what's been going on?'

Then she turned to me and said that I should keep him hidden in my house, since the chief constable was looking for him and was determined to seize him if he was found outside, but would not touch him if he were in the house. I replied that my widowed sister with six pure little girls was in the house with me, and that I wanted no one

else there. At this she said that the majordomo had given orders to the chief constable and that they would arrest me no matter what happened: but since I refused to take her son into the house, if I gave her a hundred crowns, she said, I needn't worry any more, because the majordomo was such a close friend of hers that I could rest assured she would be able to make him do whatever she liked, provided I gave her the hundred crowns.

By this time I had fallen into a tremendous rage and I shouted at her:

'Get out of here, you shameless bitch. If it weren't for my not wanting to cause a scandal and for the innocence of that unhappy boy you have there, I'd already have cut your throat with this dagger: I've put my hand to it two or three times already.'

With these words, and a good few nasty blows, I drove her and her son out of the house.

Then, after I had pondered on the wickedness and power of that evil pedagogue, I decided that the best thing would be to let that devilish business blow over; and so early next morning, having consigned to my sister some jewels and odd belongings worth nearly two thousand crowns, I mounted my horse and set off towards Venice, taking with me my friend Bernardino of Mugello.

When I reached Ferrara I wrote to his Excellency the Duke to say that although I had left without being sent away, I would return without being sent for. Then after arriving at Venice, I considered how ingeniously I was attacked by my cruel destiny but that I was all the same safe and sound, and so I determined to fight back as usual. I went along, reflecting on my affairs in this manner and finding distractions in that beautiful and wealthy city: then I went to pay my respects to that splendid painter, Titian,[292] and our Florentine citizen, that expert sculptor and architect, Jacopo Sansovino, who was very well looked after by the Venetian Signory. We had known each other in our youth at Rome, and also in Florence, where he came from. These two great artists greeted me very affectionately.

The next day I ran into Messer Lorenzo de' Medici who at once took me by the hand and gave me the warmest of welcomes, for we had known each other in Florence, when I was making Duke

Alessandro's coinage, and afterwards in Paris when I was serving the King. He had then been staying with Giuliano Buonaccorsi, and, as there was nowhere else he could spend his time without great risk, he used to spend most of his time in my house, watching me engaged on those great works of mine. As I said, because of this past acquaintance of ours he took me by the hand and led me to his house where I found the Lord Prior degli Strozzi, Lord Piero's brother. While they were welcoming me joyfully they asked me how long I meant to remain at Venice, thinking that I was on my way back to France, I told these noblemen the reasons why I had left Florence – which I have given above – and said that in two or three days' time I meant to return there to serve the great Duke. When I said this, both the Prior and Lorenzo stared at me so sternly that I grew very afraid, and then they said:

'You would do better to return to France, where you're rich and famous: if you go back to Florence you'll lose all you've gained in France, and you will get nothing except trouble in return.'

I made no reply, and the following day, leaving as secretly as I could, I set off towards Florence. Meanwhile the devilish business had come to a head, since I had written telling the great Duke all the circumstances that had led to my moving to Venice. He received me with his usual reserve and severity when, without making any fuss, I went to visit him. He acted coldly for a while, and then he turned to me pleasantly and asked where I had been. I replied that my heart had never strayed a finger's breadth from his Most Illustrious Excellency although for certain understandable reasons I had been forced to let my body roam a little way. Then, unbending still more, he began to ask me about Venice, and so we chatted for a while. Then finally he said that I should get on with my work and that I should finish his Perseus. So I went happily back home, with a light heart, and brought comfort to my family, that is my sister and her six daughters. I took up my work again, and pushed it forward as energetically as possible.

The first work to be cast in bronze was that large bust of his Excellency that I had made in clay in the goldsmith's room, when I had those pains in my back. This was a very pleasing work, but my only reason for making it was to get experience of the clays for bronze-casting.[293] I knew that the splendid Donatello had cast his works in bronze, and

used clay from Florence, but I judged that he had only succeeded with the greatest difficulty; and as I imagined this must have been because of a defect in the clay, before casting my Perseus I wanted to make these first experiments. By doing so I discovered that the clay was good, though the splendid Donatello had not understood it very well and his works had only been completed with great difficulty. Anyhow, as I mentioned, I made up the clay to perfection and it served me admirably. As I have said, I cast the bust with it, but as I had not yet made my own furnace I made use of the furnace belonging to Zanobi di Pagno, the bell-founder.[294]

When my head came out beautifully clean, I immediately set to work on the construction of a little furnace in the shop that the Duke had let me have, it was after my own ideas and design and meant for the house I had been given. As soon as the furnace was finished, as diligently as I could I began to get ready to cast the statue of Medusa, the woman writhing under the feet of Perseus.[295] As this casting was a very difficult operation I was determined to make use of all the skill and experience I had acquired, in order to avoid any error. As a result the first cast I made in my little furnace came out superlatively well and was so clean that my friends thought I would be wrong to retouch it at all. How to do this has been discovered by certain Germans and Frenchmen who maintain (and they claim some very fine secrets) that they can cast bronzes without retouching: a really foolish claim, seeing that after bronze has been cast it must be worked on with hammers and chisels, as the most expert ancients used to do, and the moderns as well – or at least those moderns with any knowledge.

This cast delighted his Most Illustrious Excellency and he came a good few times to see it, giving me great encouragement to work well. But Bandinello's mad envy was so effective (he was always pouring it into his Excellency's ears) that he made him think that although I had cast one or two of the statues I would never succeed with making the group, because it was an unknown art as far as I was concerned, and that his Excellency ought to take good care not to throw his money away. These words had so much effect when spoken in the Duke's noble hearing that some of the allowance for my workmen was taken from me; as a result I had to complain vigorously to his Excellency. So

one morning I waited for him in the Via de' Servi and when he arrived I said:

'My lord, I am not assisted in my needs, so I fear your Excellency places no trust in me: let me repeat that as I promised I have it in me to bring this work off three times better than the model I showed you.'

After I had said this I realized, since he did not reply, that my words were bearing no fruit at all: suddenly I was seized with rage, almost choked with passion, and began saying to him:

'True enough, my lord, this city has always been a school for the highest genius; but when a man has won a reputation for himself and has learned a few things, then if he wants to add glory to his city and his glorious prince, he would do well to go and work elsewhere. And to prove the truth of this, my lord, I know that your Excellency remembers Donatello, and the great Leonardo da Vinci in the past, and the splendid Michelangelo Buonarroti in the present: by their genius these men add to your Excellency's glory. And I hope to play my part too; so, my lord, give me permission to leave. But let your Excellency take good care not to let Bandinello go; rather, always give him more than he asks for, because if he goes elsewhere he is so puffed up and so ignorant that he's likely to bring the noble school of Florence into disrepute. Now, give me permission to take my leave, my lord, and I won't ask anything for my labours up to now, except for your Most Illustrious Excellency's good favour.'

Seeing how determined I was, his Excellency turned to me rather angrily and said:

'Benvenuto, if you're willing to finish the work you'll want for nothing.'

So then I thanked him and said that my only desire was to show those who were envious of me that I had it in me to finish what I had promised. After I had left his Excellency, I was given a little assistance: so little that as I wanted the work to proceed at more than a crawl I had to dip into my own pocket.

In the evenings I always used to go and spend the time in his Excellency's wardrobe, where Domenico and his brother Gianpagolo Poggini were working. They were engaged on the gold vessel for the

Duchess that I mentioned before, and on a gold girdle. His Excellency had also set me to work on the design for a pendant, in which was to be set the large diamond that Bernardo and Antonio Landi had made him buy. Although I did my best to get out of it, the Duke with persuasion and flattery had me working away every evening until four hours after nightfall. He also urged me as agreeably as possible to work there during the day as well; but I would never consent to such a thing, and I knew for certain that because of this his Excellency was angry with me. One evening I happened to arrive later than usual, and the Duke said: 'You are *malvenuto*.'

'My lord, that is not my name,' I replied, 'my name is Benvenuto, but as I imagine your Excellency is having a joke with me I shall forget the matter.'

At this the Duke said that he was speaking in deadly earnest and was not joking, and that I should take care as to how I behaved since it had come to his ears that, relying on his favour, I was deceiving now one man and now another. When I begged his Most Illustrious Excellency to be good enough to tell me just one man I had ever cheated, he immediately turned to me in a temper and said:

'Go and give back what you have belonging to Bernardo – there's one man for you.'

At this I said: 'My lord, I thank you, and I beg you to be kind enough to listen while I say a couple of words: it's true enough that he lent me a pair of old scales, and two anvils, and three little hammers; and a fortnight ago today I told his Giorgio da Cortona that he should send for these things, and Giorgio came for them himself. And if ever your Excellency discovers that, since the day I was born, I ever filched anything from anyone either at Rome or in France, whether you learn of it from the men who have told you such things or from others, if you find such is the case then punish me without any half-measures.'

When he saw what a passion I was in, like the discreet and loving lord that he was, the Duke looked at me and said:

'Such a reproof isn't meant for those who aren't guilty: if things are as you say, I shall always receive you gladly, as I have done in the past.'

At this I said to him: 'Now, your Excellency, the villainous behaviour of Bernardo forces me to ask you what you paid for that large diamond

with the point shorn off, because I hope to show you why that wicked great scoundrel is trying to bring about my disgrace.'

His Excellency replied: 'The diamond cost me twenty-five thousand ducats. Why do you ask?'

Then I told his Excellency that on such and such a day, at such and such an hour, on the corner of the New Market, Antonio di Vittorio Landi had told me to try and arrange for his Excellency to purchase it: and the first price he asked was sixteen thousand ducats.

'Now your Excellency knows what you paid for it. And if you want proof of this, ask Domenico Poggini, or his brother Gianpagolo, both of whom are here. I told them immediately after it happened, but since then I haven't said a word, seeing that your Excellency said I understood nothing about the matter. I thought from this that you wanted to keep the diamond's good name. I must say, my lord, that I do understand these matters, and, as for the rest, I claim to be as upright a man as any ever born, no matter who he is. I'm not the man to try and rob you of eight or ten thousand ducats at a blow; on the contrary I would try to earn them by my labours. I undertook to serve your Excellency as a sculptor, goldsmith, and Master of the Mint: but to carry tales about the affairs of others – never. What I'm telling you now is in my own defence, and I have no desire for an informer's reward. I'm telling you it in the presence of all these honest men standing around so that your Excellency will refuse to believe what Bernardo says.'

Straight away the Duke rose angrily to his feet and sent for Bernardo. Both of them – he and Antonio Landi – were forced to flee to Venice, and Antonio told me that he had meant a different diamond. They went to and came back from Venice: and I sought out the Duke and said:

'My lord, what I told you was true, and what Bernardo told you about the tools was a lie; you would be well advised to put it to the proof and let me go to see the chief constable.'

At this the Duke looked at me and said: 'Benvenuto, concern yourself with living honestly as you have done in the past: and never worry about anything else.'

The whole affair went up in smoke, and that was the last I heard of it. I worked hard to finish his jewel; and then one day when it was

finished I carried it to the Duchess, who herself told me that she valued my craftsmanship as much as the diamond that fellow Bernardo had made them buy. She wanted me to attach it to her bosom with my own hand, and handed me a large pin with which I did so. Then, with many marks of favour from her, I went my way. Later I heard that they had had it reset by a German or some other foreigner – how true this was I don't know – because Bernardo said that the diamond would make a better show if it were set less elaborately.

As I believe I said before, Domenico and Gianpagolo Poggini, who were goldsmiths and brothers, used to work in his Most Illustrious Excellency's wardrobe, using my designs, on certain little gold vases chased with groups of figures in low relief, and on other objects of great worth. I was always saying to the Duke:

'My lord, if your Most Illustrious Excellency would hire some workmen for me, I'd make the coins for your Mint, as well as medals engraved with your Most Illustrious Excellency's head: I would compete with the ancients and hope to improve on them, because since making Pope Clement's medals I have gained so much knowledge that I shall be able to do far better work. I shall surpass the coins I made for Duke Alessandro, which are still regarded as fine specimens. And I shall make you large gold and silver vases, like those I made so many of for that splendid King Francis of France, because of the many ways in which he assisted me – nor did I ever lose time in working on the great giants or the other statues.'

In answer to this the Duke said: 'Go on, and I shall see about it.'

But he never provided me with any facilities or any help whatsoever. Then one day his Most Illustrious Excellency had me given several pounds of silver, and he said:

'This comes from the silver from my mines:[296] make me a beautiful vase.'

I did not want to neglect my Perseus, but at the same time I was very anxious to serve him, so I gave the work, along with my designs and little wax models, to a villain of a goldsmith called Piero di Martino to do. He began badly, and he made such poor progress that I wasted more time on the business than if I had done all of it myself. So after several months were lost with Piero neither working on it himself nor

having any work done on it I made him return it to me. I had tremendous trouble in getting back the body of the vase, on which as I said he had made a crude beginning, and the rest of the silver that I had handed over to him. The Duke who had heard something of the dispute sent for the vase and the models without letting me know what he was after: anyhow the upshot was that he had it made by various hands, both in Venice and elsewhere, and he was very badly served.

The Duchess was always asking me to do some goldsmith's work for her: in response to this I told her more than once that everyone knew perfectly well, and the whole of Italy knew, that I was a good goldsmith, but Italy had never seen works of sculpture from my hand. There were in my profession a number of virulent sculptors who jeered at me and described me as the new sculptor, but I hoped to show them that I was an old hand at sculpture, if by the grace of God I could finish my Perseus and exhibit it on his Excellency's noble piazza.

Then I went back home, spent all my time, day and night, at work, and never appeared at the palace. All the same, thinking I should keep in the good books of the Duchess, I made a few little vases for her.[297] They were in silver, about the size of a cheap pot, and ornamented with beautiful masks in very unusual style, after the antique. When I took them to her she received me with extraordinary kindness and paid me for the silver and gold I had put into them: I commended myself to her Most Illustrious Excellency, and begged her to tell the Duke that I was receiving very little help for the great work I was engaged on and that he should not pay so much attention to that wicked tongue of Bandinello's, which was preventing me from finishing my Perseus. After this tearful complaint, the Duchess shrugged her shoulders and said:

'Certainly the Duke ought to know that: that this Bandinello of his is worthless.'

I remained at home, rarely showed myself at the palace, and worked very diligently in order to finish my statue. Then it fell to me to pay my workmen. What happened was that after the Duke had directed Lattanzio Gorini to pay me in respect of a number of workmen for eighteen months, he began to find it irksome and took the subsidy away from me. As a result I questioned Lattanzio as to why he did not

pay me. In reply, gesticulating with his spidery hands and speaking in his tiny gnat's voice, he said:

'Why don't you finish your statue? It's believed that you'll never finish it.'

I immediately replied, very angrily: 'To hell with you and anyone else who thinks I won't finish it!'

Then in desperation I returned home to my unlucky Perseus – not without tears, as I remembered the fine position I had left in Paris, where I was serving that splendid King Francis who gave me an abundance of everything, whereas in Florence I went completely without. More than once I made up my mind to abandon everything in despair. On one occasion, when I was in that mood, I mounted my handsome little horse, and with a hundred crowns in my pocket rode off to Fiesole to see a natural son of mine, whom I was keeping at nurse with a crony of mine, the wife of one of my workmen. When I arrived I found the boy in very good health: sad at heart, I kissed him; and then when I wanted to leave he refused to let me go, holding me fast with his little hands and breaking into a storm of crying and screaming. Seeing he was only somewhere around two years old, this was beyond belief.

As Bandinello used every evening to pay a visit to his farm above San Domenico,[298] and in my desperation I had decided that if I came across him I would throw myself on him, I detached myself from my little boy and left him crying his eyes out. Just as I arrived at the Piazza di San Domenico on the way to Florence, Bandinello entered from the other end. I straight away resolved to carry out the murderous attack I had planned. I went up to him and then when I looked up I saw that he was unarmed and riding on a sorry-looking mule or donkey, along with a little boy of ten years old. As soon as he saw me he went white as death and began trembling from head to foot. Then, realizing what a vile action it would be on my part, I said: 'Don't be afraid, you miserable coward, I won't lower myself by hitting you.'

He looked at me timidly and said nothing. Then my better self won and I thanked God whose power and goodness had prevented me from committing such a crime. Having got free of my diabolical rage my spirits rose and I said to myself:

'If God gives me the grace to finish my work I hope by that means to vanquish all my perfidious enemies, and in that way I shall have a far greater and more glorious revenge than I would have had merely on one.'

And with this good resolution I went back home. Three days later I heard that my crony had smothered my only son.[299] My grief was greater than any I had ever felt before. However I knelt down, and, not without tears, I thanked God in my usual fashion, saying:

'My Lord, You gave him to me, and now You have taken him away; and for all things, with all my heart, I thank You.'

Then, for all that my grief had nearly crushed me, in my usual way I made a virtue out of necessity, and as best I could tried to accustom myself to it.

It was at this time that a young man, called Francesco, the son of Matteo the blacksmith, left Bandinello. He asked me if I would give him work: I was agreeable and set him on cleaning the Medusa, which had already been cast. A fortnight later this young man told me that he had been speaking with his master, that is with Bandinello, and that Bandinello sent to say that if I wanted to do a marble statue, he made the offer of a fine block of marble as a gift.

I immediately replied: 'Tell him I accept: and it may well be the marble for his epitaph, since he's always provoking me, and seems to have forgotten the great risk he ran when he met me on the piazza of San Domenico. Now tell him that I want it in any case. I never speak of him but the beast is always annoying me. In fact I believe that you came to work for me because he sent you to spy on my affairs. Anyhow go and tell him that I will have the marble in spite of him; and bring it back with you.'

After many days had passed without my putting in an appearance at the palace, on the spur of the moment I went along there one morning to find that the Duke had all but finished dinner. From what I heard his Excellency had been talking favourably about me that morning, and among other things had praised my skill in setting jewels. As a result, when the Duchess saw me, she sent for me through Messer Sforza,[300] and when I presented myself her Most Illustrious Excellency begged me to set for her a small pointed diamond. She said that she would

always wear the ring on her finger and gave me the measurements and the stone, which was worth about a hundred crowns, begging me to do the work quickly. Immediately the Duke began to discuss the matter with the Duchess.

'Certainly,' he said, 'Benvenuto used to be without rival in this art: but now that he's given it up I imagine that it will be too much trouble for him to make a small ring like the one you want. I beg you not to burden him with it; even though it's a small matter it will be troublesome for him, seeing that he's out of practice.'

At this I thanked the Duke and then begged him to let me render this small service to the Duchess. I began work on it without delay, and it was finished in a few days. It was for her little finger, and so I fashioned four little cherubs in relief and four little masks, to form the ring. I also fashioned some enamelled fruits and links so that together the jewel and the ring made a beautiful show. Straight away I took it to the Duchess who very graciously told me that I had made her a lovely object, and said that she would not forget me. She sent the ring as a gift to King Philip,[301] and from then on she was always ordering something or other from me, but so charmingly that I always forced myself to serve her, for all that I saw little money in return – and God knows I had great need of some, seeing that I wanted to finish my Perseus and had hired some young men to help me, paying them out of my own pocket. Once more I began to put in an appearance more often than I had been doing.

One feast day or other I went along to the palace, after dinner, and arriving at the Clock Hall noticed that the door of the wardrobe was open. I approached nearer and then the Duke called out, greeting me pleasantly:

'You're welcome! Look at that little chest that the lord Stefano of Palestrina[302] has sent me as a present: open it and let's see what it is.'

I opened it at once and said to the Duke: 'My lord, it's a statue in Greek marble, and it's a splendid piece of work: I don't remember ever having seen such a beautiful antique statue of a little boy, so beautifully fashioned. Let me make an offer to your Most Illustrious Excellency to restore it – the head and the arms and the feet. I'll add an eagle so

that we can christen it Ganymede. And although it's not for me to patch up statues – the sort of work done by botchers, who still make a bad job of it – the craftsmanship of this great artist calls me to serve him.'

The Duke was tremendously delighted that the statue was so beautiful, and he asked me a multitude of questions, saying:

'Tell me, my dear Benvenuto, exactly what is the achievement of this artist that makes you marvel so much?'

So then, as far as I could, I did my best to make the Duke appreciate such beauty, and the fine intelligence and rare style that it contained. I held forth on these things for a long time, all the more willingly as I knew how much his Excellency enjoyed my doing so.

While I was entertaining the Duke in this agreeable way a page happened to leave the wardrobe and, as he went out, Bandinello came in. When he saw him the Duke's face clouded over and he said with an unfriendly expression: 'What are you after?'

Bandinello, instead of replying at once, stared at the little chest where the statue was revealed and with his usual malignant laugh, shaking his head, he said, turning towards the Duke:

'My lord, here you have one of those things I have so often mentioned to you. You see, those ancients knew nothing about anatomy, and as a result their works are full of errors.'

I remained silent, taking no notice of anything he was saying; in fact I had turned my back on him. As soon as the beast had finished his disagreeable babbling, the Duke said:

'But Benvenuto, this completely contradicts what you have just been proving with so many beautiful arguments. Let's hear you defend the statue a little.'

In reply to this noble little speech of the Duke's, so pleasantly made, I said:

'My lord, your Most Illustrious Excellency must understand that Baccio Bandinello is thoroughly evil, and always has been. So no matter what he looks at, as soon as his disagreeable eyes catch sight of it, even though it's of superlative quality it is at once turned to absolute evil. But for myself, being only drawn to what is good, I see things in a more wholesome way. So what I told your Illustrious Excellency

about this extremely beautiful statue is the unblemished truth; and what Bandinello said about it reflects only the badness of his own nature.'

The Duke stood there, listening with great enjoyment, and while I was talking Bandinello kept twisting and turning and making the most unimaginably ugly faces – and his face was ugly enough already. Suddenly the Duke moved off, making his way through some ground-floor rooms, and Bandinello followed him. The chamberlains took me by the cloak and led me after them. So we followed the Duke till his Most Illustrious Excellency reached an apartment where he sat down with Bandinello and me on either side of him. I stood there without saying anything, and the men standing round – several of his Excellency's servants – all stared hard at Bandinello, sniggering a little among themselves over what I had said in the room above. Then Bandinello began to gabble.

'My lord,' he said, 'when I uncovered my Hercules and Cacus I am sure that more than a hundred wretched sonnets were written about me, containing the worst abuse one could possibly imagine this rabble capable of.'[303]

Replying to this, I said: 'My lord, when our Michelangelo Buonarroti revealed his Sacristy,[304] where there are so many fine statues to be seen, our splendid, talented Florentine artists, the friends of truth and excellence, wrote more than a hundred sonnets, every man competing to give the highest praise. As Bandinello's work deserved all the abuse that he says was thrown at it, so Buonarroti's deserved all the good that was said of it.'

Bandinello grew so angry that he nearly burst: he turned to me and said: 'And what faults can you point out?'

'I shall tell you if you've the patience to listen.'

'Go on then.'

The Duke and all the others who were there waited attentively, and I began.

First I said: 'I must say that it hurts me to point out the defects in your work: but I shall not do that, I shall tell you what the artists of Florence say about it.'

One moment the wretched fellow was muttering something

unpleasant, the next shifting his feet and gesticulating; he made me so furious that I began in a much more insulting way than I would have done had he behaved otherwise.

'The expert school of Florence says that if Hercules' hair were shaven off there wouldn't be enough of his pate to hold in his brain; and that one can't be sure whether his face is that of a man or a cross between a lion and an ox; that it's not looking the right way; and that it's badly joined to the neck, so clumsily and unskilfully that nothing worse has ever been seen; and that his ugly shoulders are like the two pommels of an ass's pack-saddle; that his breasts and the rest of his muscles aren't based on a man's but are copied from a great sack full of melons, set upright against a wall. The loins look as if they are copied from a sack of long marrows. As for the legs, it's impossible to understand how they're attached to the sorry-looking trunk; it's impossible to see on which leg he's standing, or on which he's balancing, and he certainly doesn't seem to be resting his weight on both, as is the case with some of the work done by those artists who know something. What can be seen is that he's leaning forward more than a third of a cubit; and this by itself is the worst and the most intolerable error that useless, vulgar craftsmen can make. As for the arms, it's said that they both stick out awkwardly, that they're so inelegant that it seems you've never set eyes on a live nude; that the right leg of Hercules is joined to that of Cacus in the middle in such a way that if one of the two were removed both of them – not merely one – would be without a calf. And they say that one of the feet of the Hercules is buried, and the other looks as if someone has lit a fire under it.'

The fellow couldn't stay quiet patiently and let me carry on describing the great defects of the Cacus. First, because I was telling the truth, and second, because I was revealing it clearly to the Duke and the others standing around. They were expressing their amazement and showed that they realized I was justified up to the hilt.

Suddenly the fellow cried out: 'Oh, you wicked slanderer, what about my design?'

I replied that anyone who was good at designing would never make a bad statue, therefore I judged that his design was the same quality as his work. And then, seeing how the Duke and the others were looking,

and outraged at their attitude and expressions, he let his insolence get the better of him, turned his foul, ugly face towards me and burst out: 'Oh, keep quiet, you dirty sodomite!'

At that word the Duke frowned angrily, and the others tightened their lips and stared hard at him. In the face of this wicked insult I choked with fury, but instantly found the right answer and said:

'You madman, you're going too far. But I wish to God I did know how to indulge in such a noble practice: after all we read that Jove enjoyed it with Ganymede in paradise, and here on earth it is the practice of the greatest emperors and the greatest kings of the world. I'm an insignificant, humble man, I haven't the means or the knowledge to meddle in such a marvellous matter.'

At this no one could restrain himself: the Duke and the others raised a great shout of laughter which shook the whole place. But for all that I took the incident jokingly, I can tell you, my kind readers, my heart was bursting at the thought that this man, the most filthy scoundrel ever born, was bold enough – in the presence of such a great prince – to hurl at me an insult of that kind. But, you know, it was the Duke, not me, whom he insulted. For if I had not been in such noble company I'd have struck him dead.

When the filthy, ruffianly blockhead saw that those noblemen couldn't stop laughing, in order to prevent their mocking him so much he began to change the subject.

'This Benvenuto,' he said, 'goes around boasting that I've promised him a block of marble.'

When he said this I immediately interrupted: 'What! Didn't you send Francesco, the son of Matteo the blacksmith and your own apprentice, to tell me that if I wanted to work in marble you'd give me a block? And I've accepted your offer, and I want it.'

Then he replied: 'You can be sure you'll never have it.'

At this, still fuming at the lying insults he had hurled at me before, I lost control of myself and, forgetting the presence of the Duke, said in a great fury:

'I tell you plainly that if you don't send the marble to my house, you had better find yourself another world, since in this one I'll not rest till I've deflated you.'

Immediately, remembering that the great Duke was present, I turned humbly to his Excellency and said:

'My lord, one fool makes a hundred: this man's madness has made me lose sight of your Excellency's right to respect, and I forgot myself. Forgive me.'

Then the Duke said to Bandinello: 'Is it true? Did you promise him the marble?'

Bandinello said that it was true. The Duke said to me: 'Go to the Opera and choose a piece that suits your purpose.'

I told him that Bandinello had promised to send it to my house. There was a tremendous argument, but I would not have it any other way. The next morning a block of marble was brought to my house; I asked who sent it, and they told me that it was from Bandinello and that it was the one he had promised me.

I at once had it carried into the workshop, where I began to use a chisel on it. I made the model at the same time as I was working on the marble, but I was so eager to work in marble that I was too impatient to make a model with the care that is necessary. Then I heard the marble ring false, and more than once I regretted ever having begun. All the same I carved what I could from it – that is, the Apollo and Hyacinth,[305] which can still be seen in its imperfect form in my shop. While I was working the Duke used to visit me, and he said very often: 'Leave the bronze for the time being and let me see you do some work on the marble.'

Straight away I would take the chisels and work away with confidence. The Duke questioned me about the model I had made for the marble and in reply I said:

'My lord, the marble is all cracked, but despite that I shall carve something out of it. I haven't therefore been able to decide about the model, though I shall carry on with the statue as best I can.'

Acting very quickly, the Duke had a block of Greek marble sent to me from Rome, so that I might be able to restore his antique Ganymede,[306] which had been the cause of my quarrel with Bandinello.

When it had arrived I decided that it was a shame to cut it up to make the head and arms and so forth for the Ganymede, and so I provided myself with some other marble. For the block of Greek marble I made a little wax model which I called Narcissus.[307]

As there were in the marble two holes, more than a quarter of a cubit deep and a good two fingers wide, I gave my statue the attitude that can be seen, so as to avoid the holes and cut them out of the figure. But for tens of years the marble had been exposed to rain, and with the holes always full of water the rain had penetrated so deeply that the block was decayed; and how rotten the top hole was was proved later on, when the Arno was in flood[308] and the water rose more than a cubit and a half in my shop. The Narcissus was on a wooden block, and as a result the water toppled it over and it broke across the breasts. I pieced it together, and in order to disguise the crack I added the garland of flowers which can be seen on its chest. I brought it to completion, working before dawn and even on feast days with the sole idea of not losing time from my work on the Perseus.

Then one morning when I was preparing some little chisels for my work a very fine steel splinter flew into my right eye and buried itself so deeply in the pupil that I found it impossible to get out. I thought for certain that I would lose the sight of that eye. After a few days I sent for the surgeon, Raffaello de' Pilli, who took two live pigeons, made me lie on my back on a table, and then holding the pigeons opened with a small knife one of the large veins they have in their wings. As a result the blood poured out into my eye: I felt immediate relief, and in under two days the steel splinter came out and my sight was unimpeded and improved.

As the feast of St Lucy[309] fell three days later, I made a golden eye out of a French crown piece and had it offered to the saint by one of my six nieces, the daughter of my sister Liperata, who was about ten years old. I gave thanks with her to God and to St Lucy. For a while I was reluctant to work on the Narcissus. But, in the difficult circumstances I mentioned, I continued with the Perseus, with the idea of finishing it and then clearing off out of Florence.

I had cast the Medusa – and it came out very well – and then very hopefully I brought the Perseus towards completion. I had already covered it in wax, and I promised myself that it would succeed in bronze as well as the Medusa had. The wax Perseus made a very impressive sight, and the Duke thought it extremely beautiful. It may be that someone had given him to believe that it could not come out

so well in bronze, or perhaps that was his own opinion, but anyhow he came along to my house more frequently than he used to, and on one of his visits he said:

'Benvenuto, this figure can't succeed in bronze, because the rules of art don't permit it.'

I strongly resented what his Excellency said.

'My lord,' I replied, 'I'm aware that your Most Illustrious Excellency has little faith in me, and I imagine this comes of your putting too much trust in those who say so much evil of me, or perhaps it's because you don't understand the matter.'

He hardly let me finish before exclaiming: 'I claim to understand and I do understand, only too well.'

'Yes,' I answered, 'like a patron, but not like an artist. If your Excellency understood the matter as you believe you do, you'd trust in me on the evidence of the fine bronze bust I made of you: that large bust of your Excellency that has been sent to Elba. And you'd trust me because of my having restored the beautiful Ganymede in marble; a thing I did with extreme difficulty and which called for much more exertion than if I had made it myself from scratch: and because of my having cast the Medusa, which is here now in your Excellency's presence; and casting that was extraordinarily difficult, seeing that I have done what no other master of this devilish art has ever done before. Look, my lord, I have rebuilt the furnace[310] and made it very different from any other. Besides the many variations and clever refinements that it has, I've constructed two outlets for the bronze: that was the only possible way of ensuring the success of this difficult, twisted figure. It only succeeded so well because of my inventiveness and shrewdness, and no other artist ever thought it possible.

'Be certain of this, my lord, that the only reason for my succeeding so well with all the important and difficult work I did in France for that marvellous King Francis was because of the great encouragement I drew from his generous allowances and from the way that he met my request for workmen – there were times when I made use of more than forty, all of my own choice. That was why I made so much in so short a time. Now, my lord, believe what I say, and let me have the assistance I need, since I have every hope of finishing a work that will

please you. But if your Excellency discourages me and refuses the assistance I need, I can't produce good results, and neither could anyone else no matter who.'

The Duke had to force himself to stay and listen to my arguments; he was turning now one way and now another, and, as for me, I was sunk in despair, and I was suffering agonies as I began to recall the fine circumstances in which I had been in France.

All at once the Duke said: 'Now tell me, Benvenuto, how can you possibly succeed with this beautiful head of Medusa, way up there in the hand of the Perseus?'

Straight away I replied: 'Now see, my lord: if your Excellency understood this art as you claim to then you wouldn't be worried about that head not succeeding; but you'd be right to be anxious about the right foot, which is so far down.'

At this, half in anger, the Duke suddenly turned to some noblemen who were with him and said:

'I believe the man does it from self-conceit, contradicting everything.'

Then all at once he turned towards me with an almost mocking expression that was imitated by the others, and he said:

'I'm ready to wait patiently and listen to the arguments you can think up to convince me.'

'I shall give such convincing ones,' I said, 'that your Excellency will understand only too well.'

Then I began: 'You know, my lord, the nature of fire is such that it tends upwards, and because this is so I promise you that the head of Medusa will come out very well. But seeing that fire does not descend I shall have to force it down six cubits by artificial means: and for that very cogent reason I tell your Excellency that the foot can't possibly succeed, though it will be easy for me to do it again.'

'Well then,' said the Duke, 'why didn't you take precautions to make sure the foot comes out in the way you say the head will?'

'I would have had to make the furnace much bigger,' I replied, 'and build in it a conduit as wide as my leg, and then the weight of the hot metal would have enabled me to bring it down. As it is, the conduit now descends those six cubits I mentioned before down to the feet,

but it's no thicker than two fingers. It was not worth the expense of changing it, because I can easily repair the fault. But when my mould has filled up more than half-way, as I hope it will, then the fire will mount upwards, according to its nature, and the head of the Perseus, as well as that of Medusa, will come out perfectly. You may be sure of that.'

After I had expounded these cogent arguments and endless others which it would take me too long to write down here, the Duke moved off shaking his head.

Left to myself in this way, I regained my self-confidence and rid myself of all those troublesome thoughts that used to torment me from time to time, often driving me to bitterly tearful regret that I had ever quit France, even though it had been to go on a charitable mission to Florence, my beloved birthplace, to help out my six nieces. I now fully realized that it was this that had been at the root of all my misfortunes, but all the same I told myself that when my Perseus that I had already begun was finished, all my hardships would give way to tremendous happiness and prosperity.

So with renewed strength and all the resources I had both in my limbs and my pocket (though I had very little money left) I made a start by ordering several loads of wood from the pine forest at Serristori, near Monte Lupo. While waiting for them to arrive I clothed my Perseus with the clays I had prepared some months previously in order to ensure that they would be properly seasoned. When I had made its clay tunic, as it is called, I carefully armed it, enclosed it with iron supports, and began to draw off the wax by means of a slow fire. It came out through the air vents I had made – the more of which there are, the better a mould fills. After I had finished drawing off the wax, I built round my Perseus a funnel-shaped furnace. It was built, that is, round the mould itself, and was made of bricks piled one on top of the other, with a great many gaps for the fire to escape more easily. Then I began to lay on wood, in fairly small amounts, keeping the fire going for two days and nights.

When all the wax was gone and the mould well baked, I at once began to dig the pit in which to bury it, observing all the rules that my art demands. That done, I took the mould and carefully raised it up by

pulleys and strong ropes, finally suspending it an arm's length above the furnace, so that it hung down just as I wanted it above the middle of the pit. Very, very slowly I lowered it to the bottom of the furnace and set it in exact position with the utmost care: and then, having finished that delicate operation, I began to bank it up with the earth I had dug out. As I built this up, layer by layer, I left a number of air holes by means of little tubes of terracotta of the kind used for drawing off water and similar purposes. When I saw that it was perfectly set up, that all was well as far as covering it and putting those tubes in position was concerned, and that the workmen had grasped what my method was – very different from those used by all the others in my profession – I felt confident that I could rely on them, and I turned my attention to the furnace.

I had had it filled with a great many blocks of copper and other bronze scraps, which were placed according to the rules of our art, that is, so piled up that the flames would be able to play through them, heat the metal more quickly, and melt it down. Then, very excitedly, I ordered the furnace to be set alight.

The pine logs were heaped on, and what with the greasy resin from the wood and the excellence of my furnace, everything went so merrily that I was soon rushing from one side to another, exerting myself so much that I became worn out. But I forced myself to carry on.

To add to the difficulties, the workshop caught fire and we were terrified that the roof might fall in on us, and at the same time the furnace began to cool off because of the rain and wind that swept in at me from the garden.

I struggled against these infuriating accidents for several hours, but the strain was more than even my strong constitution could bear, and I was suddenly attacked by a bout of fever – the fiercest you can possibly imagine – and was forced to throw myself on to my bed.

Very upset, forcing myself away from the work, I gave instructions to my assistants, of whom there were ten or more, including bronze-founders, craftsmen, ordinary labourers, and the men from my own workshop. Among the last was Bernardino Mannellini of Mugello, whom I had trained for a number of years; and I gave him special orders.[311]

'Now look, my dear Bernardino,' I said, 'do exactly as I've shown you, and be very quick about it as the metal will soon be ready. You can't make any mistakes – these fine fellows will hurry up with the channels and you yourself will easily be able to drive in the two plugs with these iron hooks. Then the mould will certainly fill beautifully. As for myself, I've never felt so ill in my life. I'm sure it will make an end of me in a few hours.'

And then, very miserably, I left them and went to bed.

As soon as I was settled, I told my housemaids to bring into the workshop enough food and drink for everyone, and I added that I myself would certainly be dead by the next day. They tried to cheer me up, insisting that my grave illness would soon pass and was only the result of excessive tiredness. Then I spent two hours fighting off the fever, which all the time increased in violence, and I kept shouting out: 'I'm dying!'

Although my housekeeper, the best in the world, an extraordinarily worthy and lovable woman called Fiore of Castel del Rio, continually scolded me for being so miserable, she tended to all my wants with tremendous devotion. But when she realized how very ill I was, and how low my spirits had fallen, for all her unflagging courage she could not keep back her tears, though even then she did her best to prevent my noticing them.

In the middle of this dreadful suffering I caught sight of someone making his way into my room. His body was all twisted, just like a capital S, and he began to moan in a voice full of gloom, like a priest consoling a prisoner about to be executed.

'Poor Benvenuto! Your work is all ruined – there's no hope left!'

On hearing the wretch talk like that I let out a howl that could have been heard echoing from the farthest planet,[312] sprang out of bed, seized my clothes, and began to dress. My servants, my boy, and everyone else who rushed up to help me found themselves treated to kicks and blows, and I grumbled furiously at them:

'The jealous traitors! This is deliberate treachery – but I swear by God I'll get to the root of it. Before I die I'll leave such an account of myself that the whole world will be dumbfounded!'

As soon as I was dressed, I set out for the workshop in a very nasty

frame of mind, and there I found the men I had left in such high spirits all standing round with an air of astonished dejection.

'Come along now,' I said, 'listen to me. As you either couldn't or wouldn't follow the instructions I left you, obey me now that I'm here with you to direct my work in person. I don't want any objections – we need work now, not advice.'

At this, a certain Alessandro Lastricati[313] cried out:

'Look here, Benvenuto, what you want done is beyond the powers of art. It's simply impossible.'

When I heard him say that I turned on him so furiously and with such a murderous glint in my eye that he and all the others shouted out together:

'All right then, let's have your orders. We'll obey you in everything while there's still life in us.'

And I think they showed this devotion because they expected me to fall down dead at any minute.

I went at once to inspect the furnace, and I found that the metal had all curdled, had caked as they say. I ordered two of the hands to go over to Capretta, who kept a butcher's shop, for a load of young oak that had been dried out a year or more before and had been offered me by his wife, Ginevra. When they carried in the first armfuls I began to stuff them under the grate. The oak that I used, by the way, burns much more fiercely than any other kind of wood, and so alder or pinewood, which are slower burning, are generally preferred for work such as casting artillery. Then, when it was licked by those terrible flames, you should have seen how that curdled metal began to glow and sparkle!

Meanwhile I hurried on with the channels and also sent some men up to the roof to fight the fire that had begun to rage more fiercely because of the greater heat from the furnace down below. Finally I had some boards and carpets and other hangings set up to keep out the rain that was blowing in from the garden.

As soon as all that terrible confusion was straightened out, I began roaring: 'Bring it here! Take it there!' And when they saw the metal beginning to melt my whole band of assistants were so keen to help that each one of them was as good as three men put together.

Then I had someone bring me a lump of pewter, weighing about

sixty pounds, which I threw inside the furnace on to the caked metal. By this means, and by piling on the fuel and stirring with pokers and iron bars, the metal soon became molten. And when I saw that despite the despair of all my ignorant assistants I had brought a corpse back to life, I was so reinvigorated that I quite forgot the fever that had put the fear of death into me.

At this point there was a sudden explosion and a tremendous flash of fire, as if a thunderbolt had been hurled in our midst. Everyone, not least myself, was struck with unexpected terror. When the glare and noise had died away, we stared at each other, and then realized that the cover of the furnace had cracked open and that the bronze was pouring out. I hastily opened the mouths of the mould and at the same time struck out the two plugs.

Then, seeing that the metal was not running as easily as it should, I realized that the alloy must have been consumed in that terrific heat. So I sent for all my pewter plates, bowls, and salvers, which numbered about two hundred, and put them one by one in front of the channels, throwing some straight into the furnace. When they saw how beautifully the bronze was melting and the mould filling up, everyone grew excited. They all ran up smiling to help me, and fell over themselves to answer my calls, while I – now in one place, now another – issued instructions, gave a hand with the work, and cried out loud: 'O God, who by infinite power raised Yourself from the dead and ascended into heaven!' And then in an instant my mould was filled. So I knelt down and thanked God with all my heart.

Then I turned to a plate of salad that was there on some bench or other, and with a good appetite ate and drank with all my band of helpers. Afterwards I went to bed, healthy and happy, since it was two hours off dawn, and so sweetly did I sleep that it was as if I hadn't a thing wrong with me. Without a word from me that good servant of mine had prepared a fat capon, and so when I got up – near dinner time – she came to me smiling and said:

'Now then, is this the man who thought he was going to die? I believe the blows and kicks you gave us last night, with you so enraged and in such a devilish temper, made your nasty fever frightened that it would come in for a beating as well, and so it ran away.'

Then all my poor servants, no longer burdened by anxiety and toil, immediately went out to replace those pewter vessels and plates with the same number of earthenware pots, and we all dined happily. I never remember in my life having dined in better spirits or with a keener appetite.

After dinner all those who had assisted came to visit me; they rejoiced with me, thanking God for what had happened and saying that they had learnt and seen how to do things that other masters held to be impossible. I was a little boastful and inclined to show off about it, and so I preened myself a little. Then I put my hand in my purse and paid them all to their satisfaction.

My mortal enemy, that bad man Pier Francesco Riccio, the Duke's majordomo, was very diligent in trying to find out how everything had gone: those two whom I strongly suspected of being responsible for the metal's curdling told him that I obviously wasn't human but rather some powerful fiend, since I had done the impossible, and some things which even a devil would have found baffling.

They greatly exaggerated what had happened – perhaps to excuse themselves – and without delay the majordomo wrote repeating it all to the Duke who was at Pisa, making the story even more dramatic and marvellous than he had heard it.

I left the cast to cool off for two days and then, very, very slowly, I began to uncover it. The first thing that I found was the head of Medusa, which had come out beautifully because of the air vents, just as I had said to the Duke that the nature of fire was to ascend. Then I began uncovering the rest, and came to the other head – that is the head of the Perseus – which had also succeeded beautifully. This came as much more of a surprise because, as can be seen, it's a good deal lower than the Medusa.

The mouths of the mould were placed above the head of the Perseus, and by the shoulders, and I found that all the bronze there was in my furnace had been used up in completing the head of the Perseus. It was astonishing to find that there was not the slightest trace of metal left in the channels, nor on the other hand was the statue incomplete. This was so amazing that it seemed a certain miracle, with everything controlled and arranged by God.

I carried on happily with the uncovering, and without exception I found everything perfect until I reached the foot of the right leg on which it rests. There I discovered that the heel was perfectly formed, and continuing farther I found it all complete: on the one hand, I rejoiced very much, but on the other I was half disgruntled if only because I had told the Duke that it could not come out. But then on finishing the uncovering I found that the toes of the foot had not come out: and not only the toes, because there was missing a small part above the toes as well, so that just under a half was missing. Although this meant a little more work I was very glad of it, merely because I could show the Duke that I knew my business. Although much more of the foot had come out than I had expected, the reason for this was that – with all that had taken place – the metal had been hotter than it should have been, and at the same time I had had to help it out with the alloy in the way I described, and with those pewter vessels – something no one else had ever done before.

Seeing that the work was so successful I immediately went to Pisa to find my Duke. He welcomed me as graciously as you can imagine, and the Duchess did the same. Although their majordomo had sent them news about everything, it seemed to their Excellencies far more of a stupendous and marvellous experience to hear me tell of it in person. When I came to the foot of the Perseus which had not come out – just as I had predicted to his Excellency – he was filled with astonishment and he described to the Duchess how I had told him this beforehand. Seeing how pleasantly my patrons were treating me I begged the Duke's permission to go to Rome. He gave me leave, with great kindness, and told me to return quickly and finish his Perseus; and he also gave me letters recommending me to his ambassador, who was Averardo Serristori:[314] these were the first years of Pope Julius de' Monti.[315]

Before I left I gave instructions to my workmen to continue the work using the methods I had shown them. The reason for my going was this. I had done a bronze bust of Bindo d'Antonio Altoviti,[316] life-size, and had sent it to him in Rome, where he put it in his study, which was beautifully furnished with antiques and other fine objects. But the study was not suitable for works of sculpture, still less for

paintings, because the windows were on a lower level than the works themselves, and so the light reached them badly and this spoiled the effect they would have had in a proper light.

One day this Bindo happened to be standing at his door when Michelangelo Buonarroti the sculptor passed by, and he begged him to be kind enough to come in and see the study. He led him inside, and as soon as he was there Michelangelo said:

'Who was the artist who has portrayed you so well and in such a fine style? You know, that bust pleases me as much and rather more than the antiques, although there are some excellent ones among them. If these windows were above them instead of below they would make a far better impression, and your bust would hold the place of honour among all those beautiful works.'

As soon as Michelangelo had left the house he wrote me a very charming letter, which ran as follows:

'My dear Benvenuto, I have for many years recognized in you the best goldsmith we know of; but now I shall acknowledge that you are no less a sculptor. I must tell you that Messer Bindo Altoviti took me to see a bust of himself, done in bronze, and told me that it was your work. I took a great deal of pleasure in it, but I thought it very annoying that it should be placed in a poor light, since if it were shown in a reasonable light it would stand out as the fine work it is.'

This letter was full of friendly and flattering sentiments, and before leaving for Rome I showed it to the Duke who read it very attentively and said to me:

'Benvenuto, if you write to him and rouse in him the desire to come back to Florence I shall make him one of the Forty-Eight.'[317]

So I wrote him a very affectionate letter[318] and in it I promised on the Duke's behalf more than a hundred times what I had been commissioned to. In order to avoid making any false steps I showed it to the Duke before sealing it, and I said to his Most Illustrious Excellency:

'Perhaps, my lord, I have promised him too much.'

'No,' he replied, 'he deserves more than you have promised, and I shall make sure he has it.'

Michelangelo never replied to this letter of mine and I knew that in consequence the Duke was very angry with him.

After arriving at Rome I went to stay at Bindo Altoviti's house, and he at once told me how he had shown his bronze bust to Michelangelo and that he had praised it highly: we discussed this at great length. Now, he had belonging to me twelve hundred gold crowns, which were in his charge and formed part of five thousand crowns that he had lent the Duke – four thousand of them were his, my share of the loan was in his name, and I received the interest on my part as it fell due.[319] This was the reason for my beginning his bust. When Bindo saw the wax model he sent me fifty gold crowns through a Ser Giuliano Paccalli, one of his notaries who lived with him: but I did not want to accept the money and sent it back to him through the same man. Later I told him that I was satisfied with his keeping my money invested, so that it earned me something. But I realized that he was feeling hostile towards me because, instead of welcoming me affectionately as he usually did, he behaved very coldly; and although he put me up in his house he never treated me frankly but acted in a very surly way. All the same, we settled the matter very briefly: I sacrificed my work on the bust, and the bronze that went into it, and we arranged that he should retain my money at fifteen per cent for the rest of my natural life.

I went first thing to kiss the feet of the Pope; and while I was conversing with the Pope, Averardo Serristori, who was our Duke's ambassador, arrived on the scene. I had made certain proposals to the Pope which, I believe, would easily have resulted in an agreement, and I would have been only too glad to return to Rome, because of the great obstacles I had encountered in Florence: but I learnt that the ambassador had acted against my interests.

Then I went to find Michelangelo Buonarroti and repeated what I had written him from Florence on behalf of the Duke. He said in reply that he was employed on the fabric of St Peter's, and so for that reason was unable to leave. Then I answered that having decided on the model for the fabric he could leave his Urbino[320] in charge, and he would carry out his instructions to the letter; and I added a host of other promises on behalf of the Duke. All at once he stared hard at me and said with a sly smile: 'And how satisfactory do you find him?'

Although I said that I was very satisfied and that he treated me very

well, he showed that he was informed of most of my reasons for being disgruntled; and then he said again that he would find difficulty in leaving. I retorted that he would do better to return to his homeland, which was governed by a very just prince, who was more fond of talent than any other prince ever born.

As I said before, he had with him a lad from Urbino who had served him for a good few years, more as a general helpmate than anything else: it was clear that he had learnt nothing about art. I had harassed Michelangelo with so many sound arguments that he was at a loss what to reply, and suddenly he turned to his Urbino as though to ask his opinion. This Urbino of his, in his uncouth way, suddenly shouted out loud: 'I shall never part from my Michelangelo till either he or I is under the ground.'

I couldn't help laughing at these silly words, and then, without saying anything and rather down in the mouth, I turned and left.

I had conducted my affairs so badly with Bindo Altoviti, what with losing my bronze bust and giving him my money for life, that I was left without any illusions as to what the faith of a merchant was worth: and it was in a very depressed mood that I went back to Florence. I straight away went to the palace to call on the Duke, but his Excellency was at Castello,[321] beyond Ponte a Rifredi. I found Pier Francesco Riccio, the majordomo, in the palace, and as I approached to greet him in the usual way, he suddenly said with every sign of astonishment: 'Oh, you've come back!'

Then with the same air of astonishment, clapping his hands together, he added: 'The Duke is at Castello.' And then he turned his back on me and walked off. I did not know and could not imagine why the idiot had acted in that way. At once I made my way to Castello and there went into the garden where the Duke was. I saw him in the distance, and when he noticed me he made a gesture of amazement and gave me to understand that I should go away. I had been promising myself that his Excellency would treat me with the same and even greater kindness than he had shown when I left, so when I saw such extraordinary behaviour I went back to Florence very downcast. I resumed work, being anxious to finish the statue, but I could not imagine what could have caused the change. However when I observed

how Messer Sforza and some other intimates of the Duke regarded me, I was impatient to ask Sforza what this meant: when I did so he said with a smile: 'Benvenuto, pay attention to being an honest man, and don't worry about anything else.'

A few days later I was given the chance to talk with the Duke. He greeted me in rather a lukewarm way and asked what had happened at Rome. So I carried on the conversation as best I knew how and told him about the bronze bust I had made for Bindo Altoviti and all that had followed. I noticed he was listening very attentively, and I added all the details about Michelangelo Buonarroti. He appeared somewhat annoyed, and when I came to what his Urbino had said about their being under the ground, he roared with laughter; and then he said: 'It's his loss.' And I left.

Without any doubt that Ser Pier Francesco, the majordomo, had tried to do me a bad turn with the Duke, but it did not succeed because God, who loves the truth, defended me then as He has always protected me during my life from so many tremendous dangers. And I hope He will continue to protect me to the end of my life, however troubled it is. However, I make my way forward boldly relying only on His power; nor am I afraid of any rage of fortune or the perversity of the stars, provided I remain in His grace.

And now, my dear reader, I have to tell you of a most terrible misfortune. With the greatest possible diligence and application I was concentrating on finishing my work, and I used to spend my evenings in the Duke's wardrobe, helping those goldsmiths who were working there for his Most Illustrious Excellency. The greater part of their work was based on my own designs. I saw that the Duke derived great pleasure both from watching me work and from chatting with me, and so I thought it a good idea if I sometimes put in an appearance during the day as well. On one occasion I was in the wardrobe, and the Duke came in as usual – all the more gladly since he knew I was there – and as soon as he arrived he began discussing with me a variety of pleasant topics. I gave my answers and they proved so entertaining that he behaved with more charm than he had ever shown in the past.

Then all at once one of his secretaries came along and murmured something in his Excellency's ear: it must have been something very

important, because straight away the Duke rose and accompanied the secretary into another room. Meanwhile, the Duchess had sent to see what his Excellency was doing, and her page reported to her that he was talking and laughing with Benvenuto, and was in a very good mood. On hearing this the Duchess immediately came into the wardrobe and, on finding the Duke absent, sat down next to us. She watched us work for a while, and then very graciously turned to me and showed me a string of large and really very rare pearls. When she asked me for my opinion I said that it was very beautiful. At this her Most Illustrious Excellency said to me:

'I want the Duke to buy it for me, so, my dear Benvenuto, praise it to the Duke as highly as you are capable of doing.'

When I heard what she wanted, as respectfully as I could I spoke my mind to the Duchess.

'My lady,' I said, 'I was under the impression that this pearl necklace belonged to your Excellency, and so it would not have been right for me to say what now, knowing that it doesn't belong to you, I am bound to say. I must confess, your Excellency, that from my intimate knowledge of these things I can perceive very many defects in these pearls, and for that reason I would never advise your Excellency to buy them.'

At this she said: 'The merchant is offering them to me for six thousand crowns, and if it weren't for those little defects they'd be worth more than twelve thousand.'

In answer to this I said that even if the necklace were absolutely flawless I would never advise anyone to pay as much as five thousand crowns; for pearls were not jewels, they were fishes' bones, and they suffered with time, but diamonds and rubies and emeralds did not grow old, any more than sapphires: all those were jewels, I said, and it was advisable to buy them.

The Duchess was somewhat annoyed at this, and she went on: 'But I want these pearls, and so I beg you to take them to the Duke and praise them as highly as you possibly can, and although you may have to tell one or two little lies, do so for me and it will be well worth your while.'

I have always been a lover of the truth and a hater of lies, which

were now being forced on me, but I was unwilling to lose the favour of so great a princess and so very miserably I took those damned pearls and went with them into the other apartment where the Duke had retired. As soon as he saw me he said: 'Ah, Benvenuto, what are you up to?'

I uncovered the pearls and said: 'My lord, I've come to show you a very beautiful string of pearls, they're very rare, and really worthy of your Excellency: there are eighty of them, and I don't believe that as many as that number could be found to make a better necklace. So do buy them, my lord, because the necklace really is a miracle.'

At once the Duke replied: 'I have no intention of buying them; they're not the pearls you claim them to be nor are they as excellent as you say. I've seen them, and they don't please me.'

'Pardon me, my lord,' I said, 'these pearls are infinitely finer than any pearls ever assembled on a necklace before.'

The Duchess, meanwhile, had got up and was standing behind the door, hearing all I was saying. And then, after I had said a thousand things more than I am writing here, the Duke looked at me with a friendly expression and remarked:

'My dear Benvenuto, I know that you know all about these things, and if these pearls possessed that rare excellence you attribute to them I wouldn't hesitate to buy them, whether to please the Duchess or merely to possess them: in fact I need such things, not so much for the Duchess as in connexion with my arrangements for my sons and daughters.'

Then having begun to tell lies I followed them up with others, even more boldly, and made them as plausible as I could to make the Duke believe me, relying on the Duchess to come to my help when I needed her. If the bargain were concluded more than two hundred crowns would fall to me – the Duchess had said as much – but, if only for safety's sake, I had made up my mind and was fully determined not to touch a single crown, so that the Duke would never imagine that I had done it from greed. The Duke – very graciously – began to address me again, saying:

'I know that you're expert on these matters, and so if you're the honest man I've always taken you for tell me the truth now.'

So then, blushing and with my eyes rather moist from tears, I said:

'My lord, if I tell your Excellency the truth the Duchess will become my deadliest enemy; and as a result I'll be forced to move away from Florence and my enemies will at once attack me on the score of my Perseus, which I've promised to your Excellency's noble school of artists: so I beg your Excellency to protect me.'

After the Duke had learnt that all I had been saying I had as it were been compelled to, he said to me:

'If you trust in me there's no need to worry about anything in the world.'

Again I said to him: 'But look, my lord, what can possibly stop the Duchess from finding out?'

Then, as a pledge of his good faith, the Duke raised his hand and said: 'Everything you say will be kept under lock and key.'

At these noble words I immediately told him the truth as to my opinion concerning the pearls and I said that they were not worth much more than two thousand crowns. The Duchess thought we had finished because as far as possible we were talking softly, and so she came forward and said:

'My lord, I hope your Excellency will be kind enough to buy me that string of pearls, because I am very anxious to have them, and your Benvenuto says that he has never seen any more beautiful.'

Then the Duke said: 'I don't want to buy them.'

'But, my lord, why does your Excellency not want to please me by buying the necklace?'

'Because it does not please me to throw money away.'

The Duchess insisted: 'But oh, what do you mean by "throw money away", when your Benvenuto, who so much deserves the trust you put in him, has told me it would be a good bargain even if it cost more than three thousand crowns?'

At this the Duke said: 'Madam, my Benvenuto has told me that I would be throwing my money away if I bought it, since the pearls are neither round nor even, and many of them are old. And to prove it, look at this one, and that, and look here and here . . . No, they're not for me.'

As he said this, the Duchess shot a malevolent look at me, and with a menacing nod of her head left us to ourselves. My immediate impulse was to run away and be rid of Italy; but as my Perseus was all but finished I was reluctant to go without having displayed it. But you can understand what a serious plight I found myself in.

In my presence, the Duke had ordered his porters to let me have access to him wherever he was; and the Duchess ordered the same men to chase me away whenever I showed myself at the palace. As a result whenever they caught sight of me they immediately left their lodges and drove me away; but they took care not to be seen by the Duke, for if the Duke caught sight of me before those ruffians did he either called me or made me a sign that I was to come forward.

The Duchess meanwhile sent for the broker, Bernardo – the man of whose idleness and thorough good-for-nothingness she had so often complained to me – and pleaded for his help as she had done for mine.

'My lady,' he said, 'rely on me.'

Then this rogue went to the Duke with the necklace in his hand. As soon as the Duke saw him he ordered him to get out. So then the great rogue, braying down his ugly nose like a donkey, said:

'But my lord, please buy this necklace for that poor lady who is dying to have it and will pine away unless she does.'

He went on in this stupid, idiotic strain till the Duke lost patience and said: 'Get out or I'll give you a slap on the face.'

The great villain, who knew perfectly well what he was doing, because if by blowing out his cheeks or by singing[322] 'La bella Franceschina' he could persuade the Duke to make the purchase, he would gain the favour of the Duchess and his commission as well (a matter of several hundred crowns), puffed out his cheeks, and the Duke gave him several good slaps on his ugly face. And in order to be rid of him he hit him a little harder than usual. The blows were so violent that his cheeks reddened, and tears sprang to his eyes as well.

And for all that he began to say: 'Look, my lord, look at your faithful servant – he tries to do his best and he's ready to put up with any kind of bad treatment provided only that poor lady is happy.'

By now the oaf was really beginning to strain the Duke's patience, and so because of the blows he had given him and because of his love

for the Duchess, whom his Most Illustrious Excellency always tried to please, he suddenly said:

'Get out of here and go to the devil: go and buy them, I'm ready to do all my lady wants.'

Now here one can see the way ill fortune rages against a poor man and the shameless way in which a villain is favoured. I completely lost the favour of the Duchess, and as a result nearly lost the Duke's, and he won a fat commission and their regard. So it is not enough merely to be an honest, virtuous man.

It was at that time that the war of Siena broke out:[323] the Duke intended to fortify the town, and so he distributed the duty of seeing to the gates among his sculptors and architects.[324] I was consigned the Prato gate and the little gate leading to the Arno, which is by the meadow on the way to the mills. Cavaliere Bandinello was given the San Friano gate; Pasqualino d'Ancona, the San Pietro Gattolino gate; Giuliano di Baccio d'Agnolo, the wood-carver, the gate of San Giorgio; Particino, the wood-carver, the gate of Santo Niccolò; Francesco da Sangallo, the sculptor, known as Margolla, the gate of Santa Croce; and Giovanbatista, known as Tasso, the Pinti gate. Besides these, certain other bastions and gates were put under the charge of various engineers, whom I do not remember and whose names do not matter.

The Duke, who really had always been a very capable man, made a tour of inspection round the city, and when he had conducted a thorough examination and made up his mind he sent for Lattanzio Gorini, one of his paymasters. As Lattanzio Gorini also liked this sort of work his Most Illustrious Excellency made him produce designs of the various ways in which he wanted the gates fortified, and then he sent each of us the appropriate one. When I received mine I decided that the design was entirely incorrect, let alone unsuitable, and so straight away I went off, the plan in my hand, to find the Duke. My idea was to point out to his Excellency the defects in the plan that I had been given, but no sooner had I begun to speak than the Duke turned on me in a fury and said:

'Benvenuto, when it comes to making statues I bow to your knowledge, but in this business I want you to give way to me: so keep to the plan I've given you.'

When I heard these angry words I replied as gently as I knew how, saying:

'But my lord, even with regard to the sculptor's art I've learnt from your Most Illustrious Excellency, because we've always discussed it together to some extent. So in the same way, in this matter of the fortification of your city which is much more important, I beg your Excellency to condescend to listen to me. And as a result of the discussion it will be easier for your Excellency to show me the way I must serve you.'

After this courteous little speech of mine the Duke very kindly began discussing the matter with me. I pointed out to his Excellency, as forcefully and clearly as possible, the reasons why the plan he had given me would be useless.

Then he said: 'You go and produce your own plan, and I shall see if I like it.'

I therefore drew up two plans, following the correct method for fortifying the two gates, and brought them back to his Excellency. He was able to distinguish the correct method from the false, and he said very agreeably:

'Go and follow your own method, I shall be content with that.'

And so, very diligently, I began work.

There was a Lombard captain on guard at the Prato gate: he was an extremely powerfully-built fellow, of very coarse speech, as well as being overbearing and extraordinarily ignorant. He immediately began to ask me what I was up to. In reply I very courteously showed him my plans, and took great pains to let him understand the procedure I was going to follow. But while I was doing so the vulgar brute kept shaking his head, and twisting and turning, balancing first on one leg and then on the other, tugging at his moustache, pulling the peak of his cap over his eyes, and muttering at the same time: 'What in hell's name is all this about!'

Beginning to lose patience with the idiot, I answered: 'Very well, then, leave it to me. I do know what it's about.'

Then I turned my back on him, intending to go about my own business. At this the fellow began tossing his head angrily, dropped his left hand to the pommel of his sword, and lifted the point a little.

'Wait a minute, my master,' he said, 'so you want to make a fight out of it?'

I spun round in a temper – he had so provoked me – and retorted: 'It would mean less effort on my part to have a battle with you than to make a bastion for this gate.'

In an instant both of us clapped hands on our swords, but before we could draw them we were suddenly surrounded by a crowd of honest fellows, some, Florentine citizens, and others, courtiers. Most of them abused him, telling him that he was in the wrong, that I was the sort of man who would give a good account of himself, and that if the Duke heard what had happened it would be worse for him. As a result he went off about his business and I began work on my bastion. When I had seen to all the arrangements I made my way to the other gate, the little one by the Arno, where I found a captain from Cesena. He proved the most courteous warrior[325] I ever came across, with the exquisite manners of a young girl, and yet, when necessary, showing himself incredibly bold and ruthless. The charming man watched what I was doing so attentively that several times it proved embarrassing; he was anxious to understand everything, and so I explained it all to him, very courteously. The upshot was that we so rivalled each other in kindness that I made this bastion much better than the first.

I had almost finished them when some of Piero Strozzi's men made a sudden incursion and so terrified the Prato district that all the inhabitants evacuated their homes; they poured into the city, with all their belongings laden on to their carts. There was tremendous confusion, with endless lines of carts, all touching, and I warned the guards to take care that the same mishap didn't happen here as had happened at the gates of Turin,[326] because if it had proved necessary to use the portcullis the attempt would have been frustrated as it would have stuck on one of the carts.

When he heard what I was saying, that great brute of a captain turned round and began insulting me, and I gave as good as I got. We would have set to with more fury than before, but we were kept apart. When I had finished the bastions I was slipped several crowns which I had not expected, and so I went back to finish my Perseus in very high spirits.

It was at that time that certain antiquities were unearthed in the countryside of Arezzo, and among them was the Chimera,[327] that bronze lion which is to be seen in the rooms near the great hall of the palace. Besides this a quantity of statuettes were found; they were also made of bronze, covered with earth and rust, and all missing a head or the hands or the feet. The Duke amused himself by cleaning them with goldsmith's chisels. Once when I happened to be talking with his Excellency he handed me a tiny hammer with which I struck the little chisels he was holding. In that way we cleaned away the earth and rust, and spent several evenings at it. Then the Duke set me to work, and I began to restore the parts of the statues that were missing. The Duke enjoyed this little business so much that he had me working during the day as well, and, if ever I was late in arriving, sent for me himself.

More than once I explained to him that if I spent the day without working on my Perseus there would be several unfortunate conse-quences. The most worrying of these was that the inordinate length of time I was taking over the work might begin to irritate the Duke – and that in fact did afterwards happen. Besides this I was employing several workmen, and when I wasn't with them, there were two very grave consequences: first, they ruined my work, and then they worked as little as possible. Anyhow, the Duke agreed to my going to him only from sunset onwards. I had made myself so agreeable to him that every time I arrived his welcome was more affectionate than before.

In those days the new apartments near the Via dei Leoni were being built: his Excellency wanted more private quarters, and so he had furnished for his use a little room in the new apartments. He had told me that I was to make my way there through his wardrobe; so I used to pass secretly across the gallery of the great hall and through a number of little box-rooms, entering his room very privately. And then, inside the space of a few days, the Duchess deprived me of this convenience by having the passage barred to me. As a result, every evening I came to the palace I had to wait a long time, all because the Duchess was engaged in her affairs in the ante-rooms I had to pass through. And as her health was poor my arrival always upset her. Now for this and for other reasons she came to dislike me so much that she couldn't bear

the sight of me; but for all the great unpleasantness and trouble involved I persisted in my visits.

The Duke's express orders were such that as soon as I knocked at the doors they were opened to me, and, without a word being said, I was allowed to go where I liked. In consequence it sometimes happened that on my coming quietly and unexpectedly through those private rooms I found the Duchess engaged in her affairs. On such occasions she would at once begin railing at me, with such rage and fury that I was terrified.

She was always saying: 'When will you ever finish restoring those little statues? This coming and going of yours is really getting to be too much of a good thing.'

I answered her gently: 'My lady, my only patron, I have no other wish than to serve you, with loyalty and absolute obedience. But this work that the Duke has given me will last a good few months, so please, your Most Illustrious Excellency, tell me frankly: if you don't want me to come any more I shall certainly obey you, and even if the Duke sends for me I shall say that I'm ill, and I shall certainly never come again.'

At this she said: 'I do not say that you're not to come, and I do not say that you're to disobey the Duke: but all the same it strikes me that the work you're doing will never have an end.'

Whether it was that something of this came to his Excellency's ears, or whether it was for some other reason, he began sending for me again: he would send as it was getting near nightfall, and his messenger always said: 'Take care you don't fail, the Duke is expecting you.'

So for several evenings I carried on under these difficulties. On one occasion as I was entering as usual, the Duke, who must have been discussing what were probably private matters with the Duchess, turned on me with the greatest imaginable fury and all of a sudden, while I was standing there rather terrified, anxious to get away quickly, he said: 'Come in, Benvenuto, and get on with your work: I shall be with you shortly.'

As I was walking through, the lord Don Garzia[328] seized me by the cloak: he was still quite a child, and he began playing with me in the

most amusing way. The Duke was astonished and cried out: 'Look what a charming friendship my children have with you!'

Every evening while I was working on these unimportant trifles, the Prince, and Don Giovanni, and Don Arnando,[329] and Don Garzia used to stand near and poke me playfully whenever their father's back was turned. I begged them to be kind enough to leave me alone, and all they answered was: 'We can't.'

'Very well,' I said, 'if you can't, you can't: so carry on.'

Then all at once the Duke and the Duchess burst out laughing.

Another evening, after I had finished those four little bronze figures,[330] which are set into the base (the Jupiter, the Mercury, the Minerva, and Danaë, the mother of Perseus, with her little son sitting at her feet) I had them carried into the room where I used to work in the evenings, and there I arranged them in line, a little above eye-level, so that they made a very beautiful spectacle. When the Duke was informed he came in rather sooner than he usually did: and because whoever told his Excellency about them must have used excessive praise – saying 'better than the ancients' and suchlike things – my Duke came along with the Duchess, talking happily about my work. I immediately rose to my feet and went to meet them. He greeted me with princely courtesy, lifted up his right hand, in which he was holding a very large and fine pear-branch, and said:

'Take it, my dear Benvenuto: plant this pear in your own garden.'

I replied smilingly: 'My lord, does your Excellency in fact mean that I should plant it in my own garden – the garden of my house?'

The Duke repeated: 'In the garden of your house – your own house. Have you understood me?'

At this I thanked his Excellency and likewise the Duchess as best I knew how. Then both of them sat down, facing the statues, and all they talked about, for more than two hours, was those beautiful figures. The Duchess was so enraptured by them that she said to me:

'I don't want you to waste those statues by throwing them away on the pedestal down in the piazza, where they'll risk being spoilt: why not arrange them for me in one of my apartments where they'll be treated with the respect that their unique qualities deserve?'

I opposed this idea with a whole host of powerful arguments, but I realized that she was determined to prevent my placing them in the

base, where they are now; so I waited till the next day and then went to the palace two hours before sunset. I discovered that the Duke and Duchess were out riding, and as the base was already prepared I had the little statues brought down and straight away soldered them in, each one in its right place. And then! Well, when the Duchess heard what I had done she was so furious that if it had not been for the Duke, who very nobly came to my help, I would have come a nasty cropper. Anyhow, what with her anger over the incident in connexion with the pearls, and now this, she so arranged matters that the Duke abandoned his little pastime, and as a result I had to give up going there: and whenever I entered the palace I had to endure the same bother as before.

I returned to the Loggia, where I had already brought my Perseus, and tried to finish it, working in the difficult circumstances I have already mentioned: what with being penniless and afflicted, I reckon that half my misfortunes would have wrecked a man of iron. However I carried on in my usual way.

Then, one morning or other, I had just heard Mass when the broker Bernardo, a shocking goldsmith and – because of the Duke's kindness – the purveyor to the Mint, passed in front of me. This was in San Piero Scheraggio. He was hardly through the door of the church when the filthy pig let loose four cracks which could have been heard from San Miniato. I cried out: 'You whimpering pig, you beast! Is that what your filthy talents sound like?' And I ran for a stick. He made off into the Mint, and I stood just inside my own door, stationing one of my young boys outside to give me the word when the pig should come out of the Mint. After I had waited for some time I lost patience and my anger subsided; and then remembering that anything can happen in a fight and that this affair might lead somewhere unexpected, I decided to take my revenge some other way. All this took place within a day or so of the feast of St John, so I composed a verse and stuck it up in the corner of the church where one goes for a piss or a shit.

> Here's Bernardo, pig and mule,
> The thievish broker, and the spy:
> From him Pandora's evils fly
> Into booby-Baccio, the other fool.

The story and the verse circulated in the palace and gave the Duke and the Duchess a good laugh. And before he himself got to hear of it, scores of people stopped and saw the verse and roared with laughter; then they would look towards the Mint and stare at Bernardo. When his son Baccio noticed it he tore it down in a passion. Bernardo went round shaking his fist and breathing threats and defiance down his great bellowing nose.

When the Duke was informed that my Perseus was ready for exhibition one day he came along to see it. He showed very plainly how satisfied he was, but turning to some noblemen who were with him his Excellency said:

'For all that the work strikes us as being very beautiful it still has to please the people. So, my dear Benvenuto, before you give it the finishing touches I wonder if you would do me the favour of opening the screen, a little, for half a day, so that it can be seen from my piazza. Then we shall be able to hear what the people think of it. After all, there's surely a great difference between seeing it enclosed like this and seeing it fully revealed.'

In answer to this I said humbly: 'I must assure you, my lord, it will look twice as fine. How can your Excellency forget that you have seen it in my garden, where it was displayed in a wide space and looked so impressive that Bandinello came to see it through the garden of the Innocenti, and for all his malicious, evil nature he was compelled to praise it, even he, who never spoke well of anyone in his life. I know that your Excellency trusts in him only too much.'

At this he twisted his lips rather irritably but all the same said in an agreeable voice:

'Do it, Benvenuto, just to give me a little satisfaction.'

Then he went away and I began to see about uncovering it. But there was still some gold missing, and it needed varnishing here and there and a number of other things, so I could not help grumbling and complaining, cursing the wretched day that ever saw me come to Florence. By now I was well aware of the great loss I had ensured for myself by leaving France, and I could not see any grounds for hope as far as serving this prince of mine in Florence was concerned. All the way through, from beginning to end, everything I had done had turned

out to my loss and disadvantage. It was with these misgivings that I revealed the statue the following day.

And then, as God would have it, as soon as it was shown, the people praised it with such unrestrained enthusiasm that I was given some consolation. They never left off attaching verses to the posts of the doors, where I had some curtaining so that I could give the finishing touches. I know that on that day, when it was on show for a few hours, more than twenty sonnets, all praising my statue to the skies, were attached to the posts. After I had covered it up again, every day a host of sonnets were attached there, and with them Latin and Greek verses as well, since it was vacation for the University of Pisa and all the celebrated professors and scholars rivalled each other in what they wrote.

But what pleased me more than anything else, and gave me hopes of establishing better relations with the Duke, was the fact that my fellow artists, that is the sculptors and painters, also rivalled each other in singing its praises. In this connexion I especially valued the opinion of the talented painter, Jacopo da Pontormo,[331] and more than his, that of his excellent pupil, the painter Bronzino.[332] Not content with having attached several sonnets to the posts, he also sent me some, through his lad Sandrino,[333] to my house; these were so eloquently written, in his incomparably beautiful style, that they helped to console me. So I covered the statue up again and bent all my energies to the task of finishing it.

The Duke knew about the compliments that had been showered on me by the excellent artists of Florence after they had glimpsed the statue, but all the same he remarked:

'I am very glad that Benvenuto has been given this little measure of satisfaction: it will be the cause of his finishing the work the way it's wanted with more diligence and speed. But he mustn't imagine that it will get the same reception when it has been completely revealed and can be seen from every side. More than likely this will emphasize all the defects that there are – and many that there aren't. So he must prepare to be patient.'

Now these were the words that Bandinello had spoken to the Duke, citing the works of Andrea del Verrocchio,[334] who had made that fine

bronze of Christ and St Thomas which is displayed on the façade of Orsanmichele, and also a number of other works, even the divine Michelangelo Buonarroti's marvellous David which he said only looked impressive from the front. Then he mentioned the infinite number of scornful sonnets that had been written about his own Hercules and Cacus, and he began abusing the Florentines.

The Duke, who put too much trust in him, had been prompted by him to say what he did, and his Excellency was certain that what Bandinello said would come to pass, since the envious beast never left off speaking evil. On one occasion among many when that scoundrel of an agent Bernardo happened to be present, in an effort to back up what Bandinello was saying he remarked to the Duke:

'You know, my lord, making large statues is a very different kettle of fish from making small ones: I don't mean to say that he hasn't done a good job on the small statues, but you'll find that he hasn't succeeded with the other.'

He mixed this nasty abuse with a great deal more, behaving like the tale-bearer he was and telling a mountain of lies.

Then, as pleased my immortal and glorious Lord and God, I put the final touches to the statue: and one Thursday morning I completely uncovered it.[335] It was not yet full day, but immediately such a vast crowd of people gathered round that it would have been impossible to number them. They all began praising it unanimously, and rivalling each other with their tributes. The Duke was standing at one of the lower windows of the palace, above the door, and so, half-hidden inside the window, he heard everything that was said about the statue. After listening there for several hours he rose to his feet with great animation and joy, and turning to his Messer Sforza he said:

'Sforza, go and find Benvenuto and tell him he has made me far happier than I expected, and tell him I'll reward him in a way that he'll find astonishing. He's not to worry about anything.'

Messer Sforza carried me this wonderful message and I was tremendously encouraged, both because of his good news and because all that day the people kept pointing out to me now this and now that detail of the statue as something splendid and new.

Among the others were two noblemen who had been sent by the

Viceroy of Sicily[336] on a mission to our Duke. These two agreeable men came up to me in the piazza (I was pointed out to them as I was passing, and so they ran up furiously) and straight away, with their hats in their hands, they made me a ceremonious oration which would have been excessive even for a pope. I was as modest as possible, but they so overwhelmed me that I began to implore them both to be good enough to leave the piazza, since the onlookers were stopping to stare at me more than at my Perseus. In the middle of their effusion they carried their enthusiasm so far that they asked me to go to Sicily, promising terms that would suit me very well: they told me how Friar Giovanagnolo de' Servi[337] had made them a complete fountain, adorned with a number of little statues, and that they had made him a rich man, though his statues didn't compare with the Perseus.

I did not allow them to finish all they would have liked to say, but broke in with the remark:

'I'm more than astonished that you should try and persuade me to leave such a unique lover of the arts as my prince, especially as I'm in my native town, the school of all genius. Believe me, if ever I had an appetite for great gain I could have stayed in France, in the service of that great King Francis, who gave me a thousand gold crowns for my upkeep, and as well as that paid me for all the work I did, so that every year I was handed over more than four thousand gold crowns: and I left in Paris the fruits of the past four years' work.'

With these and other remarks I cut their demonstrations short and thanked them for the high praise they had given me, which was the finest reward anyone who had created a fine work of art could ask for. I said that they had so increased in me the will to shine in my profession that I had every hope of exhibiting in a few years' time another work which would please the splendid artists of Florence much more than the Perseus had done. The two noblemen wanted to carry on with their praises from where they had left off, but I raised my hat, bowed politely, and said good-bye.

After I had let two days pass by, with praise for the Perseus mounting all the time, I made up my mind to go and show myself to my lord Duke. With tremendous good will he said to me:

'My dear Benvenuto, you have pleased and satisfied me; but I promise

to satisfy you in such a way that will make you astonished, and what's more I assure you that I don't intend to wait beyond tomorrow.'

When I received these splendid promises I immediately gave my whole soul and body in a moment to God, thanking Him from my heart; and at the very same moment I approached the Duke, and half crying with joy kissed his robe.

Then I said: 'My glorious lord, faithful and generous patron of the arts and of the men who labour on them, I beg your Most Illustrious Excellency to give me gracious permission to go off first of all for a week, so that I can give thanks to God: I know the tremendous toil it has cost me, and I know that my strong faith has moved God to help me. And in return for that, and for every other miracle He has performed to help me, I want to go on a week's pilgrimage, to spend all my time thanking the immortal God who always assists those who call on Him with true devotion.'

Then the Duke asked me where I wanted to go. I replied:

'I shall leave tomorrow, and I shall go to Vallombrosa, and then to Camaldoli and to the Eremo; and from there I shall go as far as the Baths of Santa Maria,[338] and perhaps Sestile, because I understand that there are some beautiful antiquities there. Afterwards I shall return by San Francesco della Vernia, and then – never ceasing to thank God – I shall return content to serve you.'

Straight away the Duke said to me in a happy voice: 'Go, and then come back to me, for I am really pleased with you: but leave me a couple of lines as a reminder, and then rely on me.'

I at once wrote a few lines, in which I thanked his Excellency, and gave them to Messer Sforza, who handed them for me to the Duke. The Duke took them, and then gave them back to Sforza, saying:

'Remember to show them to me every day, because if Benvenuto were to return and find that I had not fulfilled my promise I believe he'd kill me.'

And so, with a laugh, his Excellency said that he was not to be allowed to forget. The Duke's very words were reported to me that evening by Messer Sforza, who repeated them with a laugh and said that he was astonished at the great favour the Duke was showing me.

Then he added very charmingly: 'Go, Benvenuto, but come back again, though I envy you.'

Invoking the name of God I left Florence, never ceasing to repeat psalms and prayers for the glory and honour of God during the entire journey, which proved extremely enjoyable since the summer weather was perfect and I was astonished and delighted at the beauty of the countryside I passed through, which I had never seen before. I had brought along as my guide one of my young workmen, called Cesare, who came from Bagno.[339] So I was given a very affectionate welcome by his father and all his family, which included an old man of over seventy who was a really delightful person. He was Cesare's uncle, a surgeon by profession, but he dabbled a little in alchemy. This good fellow pointed out to me that Bagno had a gold and silver mine, and he showed me many very beautiful features of the countryside, so that I thoroughly enjoyed my stay. In his own way he became very intimate with me, and then one day he said:

'I mustn't fail to tell you something that's in my mind which would prove very useful if your Duke got wind of it. It's this: near to Camaldoli there's a pass so open that Piero Strozzi could not only make his way through but could also sack Poppi without any opposition.'

And then, not content with having told me, he took a sheet of paper from his pocket showing a map of the whole country which the good old man had drawn so clearly that his information could be seen as very reliable. I took it from him, and straight away left Bagno and went back to Florence as fast as I could, returning by Prato Magno and San Francesco della Vernia. Then, pausing only to take off my riding-boots, I hurried to the palace. I was just by the Badia when I ran into the Duke who was coming along by the palace of the Podestà. As soon as he caught sight of me he welcomed me very graciously, though with an air of surprise, and said:

'But why are you back so soon? I didn't expect you for another week.'

'I've come back on your Excellency's service,' I replied. 'I myself would have been only too glad to have spent a few days' holiday in that lovely countryside.'

'And what's the good news?' asked the Duke.

'My lord,' I replied, 'I have matters of very grave importance to show and tell you about.'

Then I went with him to the palace. When we arrived he led me into a private room where we were by ourselves. So I told him everything and showed him the little sketch-map, which he seemed very pleased to have. When I said that the situation must be remedied without delay the Duke pondered a little while and then answered:

'I can tell you that we have made an agreement with the Duke of Urbino,[340] and he is to look after that pass: but keep this to yourself.'

Then, after he had shown me every mark of favour, I returned home.

The next day I showed myself at the palace, and after we had conversed for a while the Duke said to me pleasantly: 'Tomorrow I shall see to you without fail; so don't worry.'

Feeling perfectly confident I waited eagerly for the following day, and when at last it came I made my way to the palace. But, as always happens, one is given bad news more quickly than good, and so Messer Jacopo Guidi,[341] his Excellency's secretary, called me and, talking through his twisted mouth, said in a haughty voice: 'The Duke says that you are to let me know what you want for your Perseus.'

He held himself as stiff as a rod while saying this.

I stood there speechless with astonishment. And then suddenly I replied that I never set a price on my work, and that this was not what his Excellency had promised me two days ago. At once, in an even louder voice, the fellow said that he gave me express orders from the Duke to say what I wanted under pain of falling into complete disgrace with his Excellency.

The affectionate way his Illustrious Excellency had treated me had led me to expect something from him, and, what was more, I had been under the impression that I had won his favour entirely: especially since all I had ever asked had been to remain in his good books. And so this way of behaving – which was completely unexpected – made me furiously angry, above all because of the way the message was delivered to me by such a venomous toad. I said that even if the Duke were to give me ten thousand crowns it would not be enough; and if I had ever imagined that this was to be my reward, I added, I would never have

stayed with him. At once the spiteful beast began to hurl insults at me, and I flung them back.

The following day, when I came to the court to pay my respects, his Excellency beckoned to me and when I approached said angrily: 'Cities and great palaces are built with tens of thousands of ducats.'

I immediately replied that his Excellency would find any number of men who knew how to build cities and palaces, but as for making statues like my Perseus, I doubted whether he would find a single one in the whole world. Then straight away, without adding another word or anything, I made off.

A few days later the Duchess sent for me and told me to leave her to settle the difference I had had with the Duke, since she thought she could arrange everything to my satisfaction. To these kind words I replied that the greatest reward I had ever asked for my labours had been the Duke's favour, and that this was what his Most Illustrious Excellency had promised me: and I added that there was no need for me to put into their Excellencies' hands what, from the first day I had begun to serve them, I had been only too glad to leave to them. And in addition I said that even if his Excellency gave me only an old Tuscan penny, worth about five farthings, I would reckon myself a happy and satisfied man, provided I remained in his good books. At this the Duchess, smiling a little, said to me: 'Benvenuto, you would be well advised to do what I tell you.'

Then she turned her back on me and went away. I had imagined that the best thing for me would be to speak in the humble way I did, but as it turned out it was the worst thing I could have done because, despite the fact that she had that small grudge against me, her nature often prompted her to act generously.

At that time I used to be very friendly with Girolamo degli Albizzi,[342] who was commissary of his Excellency's troops. One day or other he said to me:

'By the way, Benvenuto, it would be wise to settle this quarrel of yours with the Duke, and I assure you that if you put your trust in me I'll be able to arrange it, and I know what I'm talking about. With the Duke growing more and more annoyed you're going to come a cropper. That will do for now – I can't tell you everything.'

Now as it happened, after the Duchess had spoken to me, someone – probably a rogue – said to me that he had heard that, for some reason or other, the Duke had remarked: 'For two pins I'd throw the Perseus away, and then the whole dispute would be over and done with.'

So being anxious as a result of that, I told Girolamo degli Albizzi that I put everything in his hands and that provided I retained the Duke's favour I would agree to everything he did. Now this good-hearted fellow knew all about soldiering and he was especially skilled with the militia, who are all countrymen, but he didn't appreciate sculpture at all, and so knew nothing at all about it. When he spoke to the Duke he said:

'My lord, Benvenuto has put himself in my hands and has asked me to plead his cause with your Excellency.'

'And I put myself in your hands as well,' replied the Duke, 'and I shall abide by your decision.'

Then Girolamo wrote a very ingenious letter, greatly in my favour, in which he stated that the Duke should pay me three thousand five hundred crowns, in gold, and that this was not the price of my fine achievement but was to be a contribution towards my upkeep and a way of enabling me to say I was satisfied. I was to be satisfied first of all; and then he added a number of other considerations, all designed to settle the price.

The Duke agreed to this with an eagerness only matched by my dissatisfaction. When the Duchess heard what had happened she remarked:

'It would have been better for the poor man if he had relied on me. I would have got him five thousand gold crowns.'

And one day when I was at the palace she repeated those very words to me, in the presence of Alamanno Salviati,[343] and she began mocking me, saying that I deserved all my bad luck.

The Duke made arrangements for me to be paid a hundred gold crowns every month until the total was reached, and for a few months I was paid in this way. Then Messer Antonio de' Nobili,[344] whose duty it was, began to pay only fifty, and later it was sometimes twenty-five, and sometimes nothing. When I saw how the payment was being delayed I spoke to Antonio very courteously and begged him to let me

know the reason for his not finishing the payment. He answered me no less politely, but I rather think he gave himself away in what he said, because (and the reader may judge for himself) first he said that the reason he did not keep up the payments was because of the shortage of money at the palace but that he promised to pay me as soon as the money was available, and then he went on to remark: 'But what a villain I'll be if I don't pay you!'

I was surprised to hear him say that, but I assured myself that when he could do so he would pay me. But I was proved completely wrong. As a result, realizing how badly I was being treated, I lost my temper with him and in my anger reminded him heatedly what sort of man he had said he would be if he didn't pay me. However, as it happened, when he died the money still wasn't paid, and to this very day I'm still owed five hundred gold crowns: and here we are near the end of 1566.

I was also owed the remainder of my salary, which they appeared to have no intention of paying, since about three years had passed. But then the Duke fell dangerously ill – being unable to urinate for forty-eight hours – and knowing that the doctors could do nothing for him he very likely had recourse to God, and because of this he ordered that everyone should be paid what was owing to him; so I was paid my arrears though I was not given the balance still outstanding for the Perseus.

I had pretty well made up my mind not to say another word about my unfortunate Perseus, but I am compelled to because of something very extraordinary that happened: so I shall go back a little and pick up the thread. I imagined that I was doing it for the best when I told the Duchess that I was no longer able to come to an arrangement about something which was outside my control, since I had told the Duke that I would be satisfied with whatever his Excellency meant to give me. And I said this in order to make myself agreeable and I acted mildly because I wanted somehow or other to appease the Duke, who a few days before he had made the agreement with Albizzi had clearly shown that he was very incensed against me.

The cause of his annoyance had been my complaining to his Excellency about the brutal, treacherous behaviour of Messer Alfonso Quistello, and Messer Jacopo Polverino,[345] the chancellor, and especially

Ser Giovanbatista Brandini, of Volterra: I was putting my case to him with some show of passion, when the Duke suddenly flew into an uncontrollable rage, and while he was still struggling with his temper his Excellency said to me:

'This is just the same as happened over your Perseus when you asked ten thousand crowns for it: you let your self-interest get the better of you. I shall have it valued and I'll give you whatever it's said to be worth.'

I replied to this rather boldly and angrily – an unwise thing to do with great lords – and cried out:

'But how on earth can the value of my work be estimated when there's not a man in Florence who's capable of doing it?'

Then the Duke became even angrier than before, and he made a number of bitter remarks including the comment that:

'In Florence today there certainly is a man who could make a work like it and who therefore will be able to judge it perfectly.'

He meant Bandinello, knight of St James.

'My lord,' I replied, 'your Most Illustrious Excellency has made it possible for me to produce, in the midst of the greatest artists in the world, an important and very elaborate work: it has been praised more than any other work ever displayed to the marvellous Florentine school; and what makes me most proud is that one of those great men who understand and practise the arts – the painter Bronzino – went out of his way to write four sonnets in a remarkably appropriate and noble style: and following him the whole city became tremendously excited. I assure you that if this splendid artist concentrated on sculpture as much as he does on painting he would be capable of doing it. And besides this, I assure your Excellency that when he was younger my master Michelangelo Buonarroti could have done it, though with no less effort than it took me. But now that he's a very old man he's probably not up to it. So I don't think there's anyone we know alive today who could match my Perseus. I couldn't ask for a greater reward for my work than the one it has already received: especially since your Most Illustrious Excellency not only said that you were delighted with it but praised it more than anyone else. What greater or more flattering reward could one want? I insist that your Excellency could not have

paid me in more glorious coin, and no treasure whatsoever could add to it. In fact I have been paid too much, and for this I thank your Excellency from the bottom of my heart.'

To this, the Duke replied: 'More likely you think I haven't the wherewithal to pay you; well, I tell you I shall pay you much more than it's worth.'

'I didn't expect to have any other reward from your Excellency,' I answered, 'and I count myself amply rewarded by what the artists of Florence first gave me, and with that I shall clear off this very minute, without ever going back to that house your Excellency gave me. Nor will I ever worry about setting eyes on Florence again.'

We were then just by Santa Felicità, and his Excellency was making his way back to the palace. After my outburst the Duke suddenly turned on me, very angrily, and said: 'You are not to leave – and take care you don't do so.'

So then, not a little afraid, I went with him to the palace. After he had arrived his Excellency sent for Bishop Bartolini,[346] who was the Archbishop of Pisa, and called in Messer Pandolfo della Stufa,[347] and told them to tell Baccio Bandinello from him that he was to give my statue of Perseus a thorough examination, and value it, since the Duke wanted to pay me a just price for it. Those two honest men went at once in search of Bandinello, and carried out their orders: he said that he had studied the work thoroughly and knew only too well what it was worth, but that as he was at odds with me over some other past matters he had not the remotest intention of meddling in my affairs in any way whatsoever.

Then those two noblemen went on to say: 'The Duke has said that you are commanded, under pain of his displeasure, to fix a price for it; and if you want two or three days for a thorough study, then take them, and afterwards tell us what you reckon the work deserves.'

Bandinello replied that he had already considered it carefully, and that he could not but obey the Duke's commands: a very elaborate and beautiful work had been produced, and it seemed to him that it was worth sixteen thousand gold crowns, and more. Those two upright noblemen immediately reported back to the Duke, who was extremely annoyed; and they informed me in the same way. I told them that I

had no intention of accepting Bandinello's praises, since that wicked man spoke evil of everyone. These words of mine were repeated to the Duke, and it was for that reason that the Duchess wanted me to put the matter in her hands. All this is the unadulterated truth; and I shall only add that I would have done best to accept the judgement of the Duchess, for I would have been paid promptly and have had that much more reward.

The Duke gave me to understand through his auditor, Messer Lelio Torello,[348] that he wanted me to execute a number of scenes in low relief and in bronze for the choir of Santa Maria del Fiore. But as this choir was Bandinello's work I did not want to enhance his clumsy efforts by my own labour, although he himself had not designed it as he had not the slightest knowledge of architecture. In fact the design was by the wood-carver Giuliano,[349] the son of Baccio d'Agnolo who spoilt the cupola: I need only say that it was without any distinction whatsoever. So for one reason and another I was unwilling to do the work in any circumstances. All the same I was always telling the Duke politely that I would do whatever his Most Illustrious Excellency commanded. So he commissioned the vestry-board of Santa Maria del Fiore to cooperate with me: his Excellency would merely provide me with my allowance of two hundred crowns a year, and the committee were to supply everything else that was needed.

As a result I appeared before them and was informed of the instructions the Duke had given. As it seemed to me that I could explain my arguments to them far more safely, I got them to see how so many bronzes would mean a very great expense, which would be entirely thrown away: I stated all my reasons and they understood me perfectly.

First I said that the way the choir was constructed was all wrong: it was built without judgement, and it entirely lacked art, reason, grace, and design. Next, the bronze reliefs would have to be placed so low that they would be too far beneath eye-level, and would provide a piss-house for dogs, and always be choked with filth. So, for those reasons, I refused to do it at any price. But I added that in order not to waste the remainder of the best years of my life, and in order to do something for his Excellency, whom I wanted so much to please and

serve, if the Duke wanted to make use of my labour he should let me make the central door of Santa Maria del Fiore, which would be a work of art that everyone could see and which would bring his Excellency much more honour. I went on to say that I would bind myself by my written word that if I did not make it better than the most beautiful door of San Giovanni[350] I would take nothing for my pains. But if I made it as I promised I would be content to have it valued, and then they should give me a thousand crowns less than what it was judged worth by members of the guild.

What I had proposed to them pleased the committee very much, and they went to discuss it with the Duke. One of them was Piero Salviati,[351] and he thought that what he had to say his Excellency would find very pleasing. But it was by no means so, and he said that I was always wanting him to do exactly the opposite to what he wanted done. So, without coming to any decision, Piero left him.

When I heard of this I immediately went to find the Duke myself. He appeared rather angry, but I begged him to be gracious enough to listen to what I had to say, and he consented. I began at the beginning and employing a whole host of skilful arguments tried to make him understand the truth of the matter, showing him that it would be a great expense, and all for nothing; and then I appeased him by saying that if he was not agreeable to my making the door, then there were two pulpits needed for the choir, and that they would be very important works and bring his Excellency great honour. I went on to say that I would make a large number of bronzes for them, in low relief and with elaborate decoration. In that way I calmed him down, and he commissioned me to produce some models.[352]

I made several designs, and took great pains over them: amongst others I made one with eight panels, taking more care over it than over the rest, and it seemed to me that it was much more suitable for the purpose. I brought them along the palace several times, and then his Excellency gave me to understand, through Messer Cesare, his keeper of the wardrobe, that I was to leave them there. Then he saw them, and I discovered afterwards that he had selected the least beautiful of them all. And then one day his Excellency sent for me and while we were discussing the designs I told him – backing up my opinion with

a multitude of arguments – that the one with eight panels would have been far more appropriate for the purpose and much more beautiful to look at. The Duke said in reply that he wanted me to make it square, since he preferred that style: and then he carried on chatting with me for a long time, very pleasantly.

I did not fail to say all that came to me in the interests of good work. It may be that the Duke knew that I was in the right, but he still wanted to have his own way and I waited a long time before anything else was said to me about the matter.

It was at that time[353] that the great block of marble, intended for the Neptune, was brought up the river Arno, and then by way of the Grieve along the road by Poggio a Caiano. This was done in order to bring it more easily to Florence by that level road, and it was there that I went to see it. And although I knew for certain that the Duchess as a mark of personal favour had given it to Cavaliere Bandinello, I was motivated not by envy of Bandinello but by pity for that poor, unfortunate marble. One can see how when something, no matter what it is, is destined for an evil end, if one tries to rescue it from immediate misfortune it always falls into a worse one – as the marble did when it came into the hands of Bartolomeo Ammanati, about whom I shall tell the truth when the time comes.

Anyhow, after I had seen that splendid block of marble I measured it up thoroughly and then after returning to Florence constructed several little models of the right proportions. Afterwards I made my way to Poggio a Caiano where the Duke and the Duchess, and the little Prince, their son, were staying. I found them all at table, the Duke and Duchess eating by themselves. So I began to chat with the Prince. After we had talked together for a good while, the Duke, who was in an adjacent room, heard my voice and very politely sent for me.

I went in to where their Excellencies were and then with great charm the Duchess began to talk to me: and as we were talking, little by little I moved the discussion towards the subject of that splendid block of marble I had seen. I was reminding her how their ancestors had made their noble school as brilliant as it was only by encouraging rivalry among all the various artists;[354] and it was in that way, I said, that the magnificent cupola and the beautiful doors of San Giovanni had been

brought into being, as well as all the many other fine churches and statues which provided the city, unparalleled from the days of the ancients, with such a brilliant crown. Suddenly the Duchess said very angrily that she understood perfectly well what I was hinting at, and that I was never to speak of that marble in her presence again, since I annoyed her by doing so.

I replied: 'So I annoy you by my wanting to act on your Excellencies' behalf and arranging everything that you may be better served? But consider, my lady: if your Most Illustrious Excellencies agree to every-one's making a model of a Neptune, even though you're still determined that Bandinello shall have it, it will force him, for the sake of his reputation, to apply himself with far greater zeal to producing a fine model than he will if he knows he has no competitors. And in that way you, our patrons, will be far better served, and will not dishearten your brilliant artists. You will discover who stands out in the skilled practice of this splendid art, and you will show yourselves to be patrons of discrimination and understanding.'

Furiously angry, the Duchess said that I made her sick to death and that she meant Bandinello to have the marble. Then she added: 'Ask the Duke about it, for he too intends it to go to Bandinello.'

After the Duchess had spoken, the Duke, who had been keeping so quiet all the time, said:

'It is twenty years since I had that beautiful marble specially quarried for Bandinello, and so I intend that he shall have it for himself.'

Straight away I turned to the Duke and said: 'My lord, I beg your Excellency to let me say a few words in your service.'

He replied that I was to say all I wanted, and that he would listen to me.

'Then, my lord,' I said, 'I must inform you that that marble from which Bandinello made his Hercules and Cacus was quarried for the marvellous Michelangelo Buonarroti, who had made for it a model of a Samson, four figures in all, which would have proved the world's most beautiful work: and your Bandinello got only two figures out of it, badly made and hopelessly contorted. And to this day the artists of Florence grieve over the dreadful wrong that was inflicted on that lovely marble. I believe that more than a thousand sonnets were stuck

up, all abusing that clumsy abortion, and I know that your Excellency remembers it perfectly well.

'And so, my noble lord, if those men who had the responsibility were so ignorant as to take that fine marble away from Michelangelo – the marble that was quarried for him – and give it to Bandinello – who as we can see ruined it – well then, would you ever tolerate this much more beautiful block of marble not being handed over to an expert artist who would use it well, even though it belongs to Bandinello who would ruin it? See to it, my lord, that anyone who wants to may make a model, and then let all the models be exhibited to the school. Your Most Illustrious Excellency will hear what the school has to say, and then, with your own good judgement, will know how to choose the best; and in this way you neither throw your money away nor dishearten a splendid company of artists, who are unique in the world today and who cover your Excellency with glory.'

The Duke, having listened very indulgently, at once rose from the table and said to me:

'Go along, Benvenuto, make your model[355] and win that fine marble, because you're telling me the truth and I know it.'

The Duchess made menacing signs, furiously muttering I don't know what; and I took my leave and returned to Florence, where it seemed an eternity before I began work on the model.

When the Duke arrived at Florence he came to my house without any warning. I showed him two different little models, and he said that one of them pleased him more than the other, though he praised them both. He told me to put the finishing touches to the one he liked and added that it would be well worth my while. The Duke had seen Bandinello's and also some other artists' work, but he praised mine at far greater length, or so I was told by many of the courtiers who had heard him.

Among the other things of importance that I remember is one incident very relevant here. The Cardinal of Santa Fiore happened to come to Florence, and the Duke took him to Poggio a Caiano. As they were journeying along, the Cardinal saw the marble and praised it highly; and then he asked whom his Excellency had commissioned to work on it.

The Duke immediately said: 'My Benvenuto, who has made a very fine model for it.'

And this was reported to me by men who can be trusted. As a result I went to find the Duchess and brought her some pretty little trinkets which pleased her immensely. She then asked me what work I was engaged on, and I answered:

'My lady, I have undertaken for my pleasure, one of the most laborious works ever produced by anyone: I am doing a figure of the Crucified, in snow-white marble, on a cross of the blackest marble, and it stands as high as a tall living man.'

At once she asked me what I meant to do with it, and I answered:

'I must tell you, my lady, that I wouldn't sell it for two thousand gold ducats, for no man has ever put such effort into such a work; still less would I undertake to do it for any patron whatsoever, for fear of disgracing myself by the result. I bought the slabs of marble out of my own money, and I have had a young man helping me for about two years; and what with the marble, and the iron support, and his wages, it has cost me more than three hundred crowns. So I wouldn't sell it for two thousand gold crowns. But if your Most Illustrious Excellency will do me one harmless favour, I'll be only too glad to give it to you as a free gift: all I ask is that your Excellency neither favours nor speaks against me in the matter of the models that his Excellency has commissioned to be made of Neptune for the great block of marble.'

She said very angrily: 'So you set no store by my help or my opposition?'

'Rather,' I replied, 'I do set store by them, my lady: or why do I offer to give you what I set store by to the amount of two thousand ducats? But I have so much confidence in the laborious and meticulous studies I have done that I rely on winning the contest, even were it against that great Michelangelo Buonarroti, from whom alone and from no one else I have learnt all I know. And I'd be far more pleased if he who knows so much should make a model, rather than those who know so little. For by competing with this great master of mine I'd gain a great deal of honour, whereas with these others I cannot gain a thing.'

When I said this she rose from her seat, with some show of anger,

and I went back to my work and made as much progress as I could with the model. Then, after I had finished it, the Duke came to see it. There were two ambassadors with him, one from the Duke of Ferrara and the other from the Signory of Lucca. His Excellency was very pleased with the model and said to the two noblemen with him: 'Benvenuto certainly deserves to win.'

Then both of them began praising me to the skies, especially the ambassador from Lucca, who was a very learned scholar. I had drawn apart a little so that they could say what they thought, but when I heard their compliments I immediately approached them, and turning towards the Duke I said:

'My lord, here is another excellent step your Excellency should take: you should give orders that whoever wants to may make a model in clay of exactly the same size as the figure one can get from the marble, and then your Excellency will be in a far better position to judge who deserves it. Let me add that if your Excellency gives the marble to someone who doesn't deserve it, it won't injure the man who does deserve it so much as you yourself, because it will be to your own loss and shame. But if you do the opposite and give it to the man who deserves it you'll acquire great honour, you'll be spending your treasure wisely, and the artists will recognize that you're a man of taste and understanding.'

As soon as I finished the Duke shrugged his shoulders and began to move away in order to leave; then the ambassador from Lucca said to him:

'My lord, this Benvenuto of yours is a terrible fellow.'

'He's much more terrible than you imagine,' replied the Duke, 'and it would be better for him were he less so, because he would now have had things he has lost.'

These exact words were repeated to me by that same ambassador, as if to urge me to behave differently. I told him that, as a loving faithful servant, I was fond of my master, and I didn't know how to play the flatterer. Then a few weeks later Bandinello died:[356] it was believed that, leaving aside his excesses, the shock he received over the prospect of losing the marble was the main cause of his death.

Bandinello had heard about my making the Crucifix that I mentioned

above, and he straight away set to work on a piece of marble and made the Pietà that can be seen in the church of the Annunziata. I had made over my Crucifix to Santa Maria Novella and had already fixed the hooks for it, asking only that I should be allowed to construct on the ground under the foot of my Crucifix a little tomb to receive me after I was dead. The brothers told me that they could not allow this without asking their vestry-board.

At this I said to them: 'But, brothers, then why didn't you ask the committee about allowing me to put the Crucifix up, seeing that you've allowed me to fix up the hooks and the other things without their permission?'

So as a result of this I was no longer willing to give the church of Santa Maria Novella the fruits of my arduous labours, even though the committee afterwards came to find me and begged me for the work. Instead I at once approached the church of the Annunziata and explained my wishes as I had to Santa Maria Novella. The holy friars of the Annunziata were all agreed in telling me that I should place it in their church,[357] and build my sepulchre there, in whatever way I liked and thought suitable. When this came to Bandinello's ears he set to work very diligently in the attempt to finish his Pietà, and he asked the Duchess to obtain for him the Pazzi chapel. This was done with some difficulty, and as soon as it was assured he erected his work in a tremendous hurry. It was not completely finished before he died. The Duchess said that she had helped him while he was alive, and that she would also help him now he was dead: she said that although he was dead I should put all thoughts of getting that block of marble out of my head. And then one day, when I met him in the country, Bernardo the broker told me that the Duchess had disposed of the marble.

'Oh, what unfortunate marble!' I replied. 'It would have suffered at the hands of Bandinello, but it's a hundred times worse off with Ammannati!'[358]

The Duke had commissioned me to make a clay model of the height that the marble would allow, and he had seen to it that I was supplied with wood and clay, besides having a small screen set up in the Loggia where my Perseus is, and paying a labourer for me. I set to work as energetically as possible and, following my own reliable principles, I

built the wooden framework and brought the work cheerfully towards completion, not worrying about whether I did it in marble or not, since the Duchess was determined on my not having it, so I refused to care. In fact I was pleased to go to such trouble and I promised myself that when I had finished it the Duchess, who after all was a person of intelligence, as I found out later, would regret that she had done the marble and herself a great wrong.

Besides me, Giovanni the Fleming[359] made a model in the cloisters of Santa Croce, and Vincenzio Danti[360] of Perugia made one in the house of Messer Ottaviano de' Medici. Another was begun by the son of Moschino[361] at Pisa, and yet another was done by Bartolomeo Ammanati in the Loggia, which we had divided between us. I had already blocked it out well, and I was intending to begin final work on the head, which I had already marked out roughly, when the Duke arrived from the palace and was led by the painter Giorgetto[362] into Ammanati's workshop to let him see the Neptune on which Giorgetto had worked himself a good few days, along with Ammanati and all his assistants.

While the Duke was inspecting it, it was said to me that he was not at all satisfied; and then, when Giorgetto wanted to spout his rigmarole, the Duke shook his head and turning to Messer Gianstefano said:

'Go and ask Benvenuto if his giant is far enough advanced for us to be given a look at it.'

Gianstefano with great courtesy and kindness gave me the Duke's message and added that if I did not think my work was ready to show I was to tell him without hesitation, since the Duke knew perfectly well that in that tremendous undertaking I had had very little assistance. I said that I would be grateful if he would come, and that although my work was little advanced his Excellency was so perceptive that he would be able to tell accurately what it would be like when finished.

So that gentleman brought word back to the Duke and he came very willingly. As soon as he entered the workshop he stared at my work and showed how very pleased he was with it. Then he walked all round it, stopping to inspect it from all four sides just as an expert would have done. And then he gave signs of his evident satisfaction,

merely remarking: 'Benvenuto, you have only to give it the final surface.'

Then turning to his companions he praised my work very highly.

'The little model I saw in his house,' he said, 'I find very delightful, but this is even more excellent.'

As it pleased God, who always arranges things for our good (I am talking of those who acknowledge and believe in Him: God always defends them), my path was crossed by a certain rogue from Vicchio, called Piermaria d'Anterigoli: he was nicknamed Sbietta. He works as a sheep farmer, and as he is closely related to Guido Guidi, the doctor who is today Provost of Pescia, I listened to what he had to say. He offered to sell me one of his farms for the term of my natural life. I was unwilling to go and see the farm beforehand, because I was anxious to finish my model of the giant Neptune, and also because there was no need to do so as he sold it to me as an investment, which he had calculated for me in so many bushels of grain, so much wine, oil, corn, chestnuts, and so forth. I worked it out that at the period we were in all this was worth well over a hundred gold crowns, and I gave him six hundred and fifty crowns, including taxes.

As he had left me a guarantee, written in his own hand, that he would always provide me with the same income as long as I lived, I did not worry about going to see the farm. But all the same as well as I was able I found out whether Sbietta and Ser Filippo, his brother, were prosperous enough to make me secure. By a good number of various people, who knew them, I was assured that I was as secure as could be wished. Then by agreement we sent for Ser Pierfrancesco Bertoldi, notary to the Mercatanzia, and first of all I handed him the note containing all that Sbietta meant to keep up for me, in the belief that it would appear in the contract. But the notary who drew it up was attending to the twenty-two boundaries which Sbietta enumerated and so, I believe, he forgot to include in the contract what the seller had offered me: and while the notary was writing I was getting on with my work. As it took him several hours to write it down I had time to make a good part of the Neptune's head. When the contract was completed Sbietta began to behave towards me with extraordinary affection, which I returned. He presented me with kids, cheeses, capons,

curds, and a variety of fruits, so that it became almost embarrassing. In return for his affectionate generosity, every time he visited Florence I made him leave his inn and stay with me, often with one or more of the relations who were with him.

Then in a charming way he began to say that it was a shame that after I had bought a farm so many weeks had already passed without my making up my mind to leave my work to my assistants for a few days and go and see it. His subtle pleadings were so effective that, in an evil hour, I did go to see it. Sbietta received me in his house with such affection and ceremony that he could not have put himself out more for a duke, and his wife treated me even more warmly than he. So we carried on for a while after this fashion, till all that the two of them – he and his brother, Ser Filippo – had plotted to do was ready.

I did not neglect to work hard on the Neptune, which I had already blocked out, as I said before, using a first-rate method which no one ever used or knew before me. So although I was certain that the marble was not mine to have – for the reasons I gave above – I thought that I would finish the work quickly and immediately display it on the piazza, merely for my own satisfaction. As the weather was warm and pleasant and those two rogues were treating me with every possible kindness, one Wednesday – it was a double feast day – I set out for my country house at Trespiano. I had eaten a good lunch, so it was less than three hours before nightfall when I arrived at Vicchio. Straight away I ran into Ser Filippo at the gate of Vicchio. He seemed to know that I was coming, overwhelmed me with his attentions, and led me to Sbietta's house, where we found his bitch of a wife, who also gave me an enthusiatic welcome. I presented her with a very fine straw hat, and she said she had never seen a more beautiful one. Sbietta himself was away at the time.

As evening came on we had supper together, very agreeably, and then I was given an excellent room, where I slept in a spotless bed. And my two servants were treated the same way, according to their status. Next morning, after I had got up and been treated with the same attention as before, I went to visit my farm, which I found very satisfactory. I was handed over so much grain and other kinds of corn,

and then returned to Vicchio. After I arrived there, the priest, Ser Filippo, said to me:

'Benvenuto, don't worry: although you haven't found everything just as you were promised there's no need to trouble youself, it will be maintained for your profit, because you're dealing with honest people. I must tell you that we've sacked the labourer, because he was a bad lot.'

This labourer was called Mariano Rosegli; and afterwards he often said to me: 'Keep an eye on your affairs – in the end you'll find out which of us is the worse lot.' When he told me this the yokel sniggered in a nasty way, tossing his head as if to say: 'Go there and you'll discover for yourself.' I was rather disturbed at this but I never guessed anything of what was to happen to me.

Anyhow, after I had returned from the farm, which is two miles distant from Vicchio, towards the Alps, I found the priest waiting for me with his usual charming welcome. We all went to have lunch together; it was a light repast rather than a full meal. Afterwards I went for a stroll through Vicchio. The market had already begun and I found myself stared at by all the inhabitants as if there were something strange about me. I noticed that I was being stared at more than by anyone else by an honest old fellow who has lived many years in Vicchio, and whose wife bakes and sells bread. He has several good properties of his own about a mile from the place, but he's content to remain as he is. The worthy fellow lives in a house belonging to me, in Vicchio, made over to me with the farm, which is called the Fountain Farm.

He began saying to me: 'I'm living in your house, and when it's due I shall give you your rent; or if you require it beforehand I shall do exactly as you want. All I need say is that there'll never be cause for disagreement with me.'

While we were talking together I noticed that he was fixing his eyes on me intently, and I couldn't help saying:

'Here tell me, my dear Giovanni, why do you keep staring at me so hard?'

The honest fellow replied: 'I'll be only too glad to tell you why, if you promise like the good man you are not to let it be known that I've done so.'

I promised what he asked; and then he said:

'I must tell you that that lout of a priest, that Ser Filippo, not many days ago went around boasting how clever his brother Sbietta was, and how he had sold his farm to an old man for his lifetime, who wouldn't last out the year. You've got mixed up with some rascals so take care you live as long as possible, and keep your eyes open, because you need to. I won't say any more.'

While I was walking about in the market-place I ran into Giovan-batista Santini, and he and I were taken to supper by the priest: as I've already said, it was about four hours before sunset, and we had an early meal to suit my convenience because I had said that I wanted to return to Trespiano that evening. So everything was prepared quickly, with Sbietta's wife busying herself about the place, together with a hanger-on of theirs called Cecchino Buti. After the salads had been mixed and we were about to sit down, that evil priest gave one of his malicious smiles and said:

'You must excuse me, but I can't have supper with you as I have some very important business to transact for my brother Sbietta. As he's not here I have to see to it for him.'

We all begged him, but we could not make him change his mind; and he went off and we began eating. After we had eaten the salad from some plates which served for all of us, we were given a bowl each and helped to the boiled meat. At this point Santini, who was sitting opposite me, said: 'You're being given crockery different from the rest: did you ever see anything finer?'

I told him that I hadn't noticed it. Then he told me that I should call Sbietta's wife to come and eat. She and that Cecchino Buti were running backwards and forwards, both of them extraordinarily busy. In the end I got her to sit down, and she began saying in a grumbling voice: 'My food doesn't please you, you're hardly eating a thing.'

I praised the supper over and over again, insisting that I had never eaten better food or with a better appetite, and then I said I had eaten just as much as I wanted. I never dreamt why she insisted so much on my eating. By the time we had finished it was less than three hours to nightfall, and I was anxious to return to Trespiano that night so that the next day I would be able to get on with my work in the Loggia.

So I said good-bye to everyone, thanked the woman, and made off.

I had not gone three miles when I began to feel as if my stomach was burning, and I was in such agonies that it seemed an eternity before I arrived at my farm at Trespiano. As it pleased God, I arrived during the night, utterly exhausted, and at once got ready for bed. I could not sleep a wink all night, and what was more my bowels kept moving and several times I was forced to go to the closet. When dawn came I felt my anus burning, turned to see what it was, and found that part of my clothing all covered with blood.

I guessed straight away that I must have eaten something poisonous, and over and over again tried hard to think what it could have been. And then I remembered the plates and the bowls, and the little platters, different from the others, that were given to me by Sbietta's wife; and then I remembered how that wicked priest, Sbietta's brother, had worn himself out in looking after me and then had not wanted to stay for supper with us. I also recalled what he had said about his brother Sbietta having made such a fine deal by selling a farm to an old man for the duration of his life, when the old man would never last out the year. These words had been reported to me by that honest fellow, Giovanni Sardella. So I came to the conclusion that they had given me a helping of sublimate in a little bowl of sauce which had been very well made and very tasty. It must have been sublimate because sublimate causes all the symptoms I found I had; I am in the habit of using only a little sauce or condiment, other than salt, with my meat, but as it happened I ate two little mouthfuls of that sauce since it was so delicious. And I went on to remember how Sbietta's wife had pressed me in various ways to eat the sauce. So then I was convinced that they had given me that dose of sublimate with the sauce.

Although I found myself so extremely ill, I nevertheless determined to work on my great statue in the Loggia, and the result was that in a few days I became so ill that I had to stay in bed. As soon as the Duchess heard of this she had the working of that unlucky marble given as a gift to Bartolomeo Ammannati. He sent to tell me through Messer—, living in the Via del—, that I should do whatever I liked with the model I had begun, since he had won the marble. This Messer—was one of the lovers of Bartolomeo Ammannati's wife, and since he was

gentle and discreet, he was the most favoured and Ammanati gave him all the opportunities he wanted: and I could say a good deal about this. However, I don't want to follow the example of his master Bandinello, who never stuck to the point. I shall just say that I told . . . that I had always expected it and that he should tell Bartolomeo to work very hard so that he could show his gratitude to Fortune for the great and undeserved favours she was showing him.

So, very miserably, I stayed in bed; and I had myself attended by that wonderful man, Francesco da Monte Varchi, the physician, and as well as him by the surgeon Raffaello de' Pilli, as the sublimate had so burned my bowels that I had constant diarrhoea. Francesco knew that the poison had done all the harm it could and had not been sufficient to defeat the sound constitution he found I had, and so one day he said:

'Benvenuto, thank God, because you've pulled through: and don't doubt for an instant that I mean to cure you, and that way we'll get our own back on the villains who have tried to harm you.'

Then Raffaello added: 'This will be one of the finest, most difficult cures ever known. You know, Benvenuto, you swallowed a good mouthful of sublimate.'

At this Francesco checked him and said: 'Perhaps it was some poisonous maggot.'

I told them that I knew for certain what sort of poison it was and who had given it to me; and then we were all silent. They went on giving me medical treatment for more than six whole months, and it was more than a year before I could carry on with my normal life.

At this time the Duke went off to make his entry into Siena,[363] and Ammanati had gone ahead a few months before to make the triumphal arches. A bastard son of his had remained in the Loggia and had removed certain of the hangings that were still on my model of the Neptune.[364] I had kept it covered since it was not yet finished. I immediately went to complain to lord Don Francesco, the Duke's son, who had taken a liking to me; and I told him how they had uncovered my model before it was ready, though I wouldn't have minded if it had been finished. He made one or two threatening gestures, and then he said:

'Benvenuto, don't worry about its being uncovered; they're only

working for their own downfall. But if you want it covered up again I shall have it done at once.'

And then his Most Illustrious Excellency added a great deal in my favour, in the presence of a great many noblemen. Then I said that I begged his Excellency to give me the means to finish it, since I wanted to make his Excellency a present of it, along with the little model. He replied that he gladly accepted them both, and that he would have me given all I asked for. So I took strength from this small favour, which really saved my life, since I was about to fail from having seen so many tremendous ills and misfortunes fall on me at one stroke. This small favour comforted me and gave me the hope of carrying on.

It was now a year since I had bought the Fountain Farm from Sbietta, and not only had he done me all those injuries – both in the matter of the poison and in regard to some other robberies – but I now realized that the farm was not yielding me half of what they had offered. Now I had, besides the contract, a document in Sbietta's hand in which he bound himself before witnesses to maintain me in the supplies that I mentioned. So I went off to the Lords of the Council. At the time Messer Alfonso Quistello was alive; he was the Chancellor and he sat with the councillors, among whom were Averardo Serristori and Federigo de' Ricci – I don't remember all their names. There was also one of the Alessandri family among them. But anyhow they were an assembly of very important men.

Now after I had explained my case to the magistrates they all unanimously agreed that Sbietta should give me back my money, save for Federigo de' Ricci who at that time was making use of Sbietta. So then they all said they were sorry, but that Federigo de' Ricci was preventing them from concluding the case. Averardo Serristori said the same as the rest of them, though he made a great fuss about the matter, as did the member of the Alessandri family. Then, after Federigo had delayed things till the magistrates had finished their term of office, Serristori found me one morning, as they were coming out on to the Piazza dell' Annunziata, and without caring about anyone said in a loud voice:

'Federigo de' Ricci could exert so much more influence than the rest of us that you've been ruined against our will.'

I shall say no more about this, because it would be too offensive to the supreme power of the Government. I shall only add that I was dealt with treacherously at the wishes of a rich citizen, merely because that shepherd was in his service.

The Duke was at Livorno, and I went to find him merely to ask for my dismissal. With my strength coming back to me, and realizing that I was not being made use of, I was grieved at doing so much harm to the practice of my art. So with my mind made up I went to Livorno and found the Duke, who welcomed me very graciously. I stayed there several days, and every day I went out riding with his Excellency and I had every opportunity to say all I wanted, as the Duke used to ride out of Livorno and four miles along the sea-shore to where he was building a little fort; and unwilling to be troubled by too many people he liked me to talk with him. So one day, when I saw that he was treating me with very unusual favour, I deliberately began to talk about Sbietta, that is about Piermaria d'Anterigoli.

'My lord,' I said, 'I want to tell your Excellency about an extraordinary affair which will explain to your Excellency what it was that prevented me from being able to finish my clay model of Neptune that I was working on in the Loggia. I must explain, your Excellency, that I had bought a farm for life from Sbietta . . .'

Enough that I gave him full details and never mingled any falsehood with the truth. Now when I came to tell of the poison I said that, if his Excellency had ever looked on me as a good servant, instead of punishing Sbietta and those who gave me the poison he ought to reward them; because the poison was not sufficient to kill me, but had been exactly the right amount to cure me of a mortal viscosity that I had in my stomach and intestines. The result, I said, was that whereas in the state I had been in I was good for three or four years, their medicine was so effective that I believed I had won more than twenty years' life; and I added that I thanked God for this even more fervently than ever before.

'It's true enough what I have often heard men say,' I concluded, 'that God only sends us evil to do us good.'

The Duke listened to me with great attention for more than two miles of the journey, merely exclaiming: 'What wicked men!' I came

to an end, saying that I was under an obligation to them, and then began discussing other, pleasant topics.

I waited for the right day, and when I found him in a favourable mood I begged his Excellency to grant my dismissal, so that I need not waste the few years I still had in me to achieve something; and as for what was still owing me for my Perseus, I said that his Excellency should give it to me when it pleased him. While I was addressing him I went out of my way to thank his Most Illustrious Excellency very elaborately; but he did not answer a single word, and in fact he appeared to be very offended. The following day Messer Bartolomeo Concino,[365] one of the Duke's most important secretaries, came up to me and said in a half-threatening manner:

'The Duke says that if you want your dismissal, he will give it to you; but if you want work he will give you that, and may you be able to accomplish all that his Excellency will give you!'

I replied that my only desire was for work, and especially from his Excellency, more than from any other man on earth: whether they were popes or emperors or kings, I'd be more willing to serve his Excellency for a penny than any of them for a ducat.

'If that's how you feel,' he answered, 'you've agreed without saying anything else: so go back to Florence and there's no need to worry, since the Duke wishes you well.'

So I returned to Florence.

As soon as I arrived there I was visited by a man called Raffaellone Scheggia, a weaver of cloth of gold, who said to me: 'My dear Benvenuto, I want to make it up between you and Piermaria Sbietta.'

I replied that no one except the Lords of the Council could reconcile us, and that in the present session Sbietta would not have a Federigo de' Ricci who in return for a present of two fat kids, without any regard for his own honour or for God, was prepared to support such an infamous cause and deal sacred justice such a brutal wrong. After I had said this, and a great deal else besides, this Raffaellone, still talking in a very ingratiating manner, said that it was much better to eat a thrush in peace than to wage such a war for a very plump capon, even if one was certain of winning it. And he added that the process of litigation

sometimes took so long that I would by the end of it have done much better to have spent the time on some fine work, which would win me far more honour and much more profit.

I knew he was telling the truth, and I began to pay attention to what he had to say, with the result that he soon brought about a reconciliation in the following way: Sbietta was to lease the farm from me for seventy gold crowns a year for all the remaining years of my life.

But when we were about to settle the contract, which was arranged by Ser Giovanni, the son of Matteo da Falgano, Sbietta said that the way we had handled things would mean paying the largest tax, but that he would not back out, and so it would be better to arrange the lease for five years at a time, and that he would keep faith with me, without ever resorting to a lawsuit again. And his brother, that roguish priest, promised me the same. So in that way we made a contract to run for five years.

I would like to talk about other matters and leave off discussing this outrageous villainy for a while, but first I am bound to describe what happened when the five-year agreement expired. After the time was up those two rascals were reluctant to keep any of the promises they had made me, and in fact wanted to give me back the farm and discontinue the lease. As a result I began to make complaints, but they waved the contract before me, and so because of their bad faith there was nothing I could do. When I realized this I told them that the Duke and the Prince of Florence would not tolerate such brutal treacherous behaviour in their city.

Now this frightened them so effectively that they sent back that same Raffaellone Scheggia who had brought about the first agreement. They said that they were reluctant to pay me seventy crowns in gold as they had been doing for the past five years. I retorted that I would not take any less. This Raffaellone came to see me, and said: 'My dear Benvenuto, you know that I'm on your side: and now they've placed everything in my hands.' And then he showed me their written instructions.

In ignorance of the fact that he was a close relation of theirs I thought that this was all very well, and so I put myself utterly in his hands. Then one evening this fine fellow came to see me – it was about half an hour

after sunset, in the month of August – and overwhelming me with words forced me to have the contract drawn up, only because he knew that if it were left till morning the fraud he meant to perpetrate would not come off. So the contract was made on the agreement that they were to pay me as rent sixty-five crowns, in two payments a year, for the rest of my life. Although I complained about it hotly and was determined to repudiate it, Raffaellone pointed to my own signature and convinced everyone that I was in the wrong. And he protested that he had done it all for my benefit, and that he was looking after my interests. As neither the notary nor the others knew that he was related to them, they all said I was in the wrong. As a result I very soon gave in to them, but I shall do my best to live for as long as possible.

After this I made another mistake; it was the following year, in the December of 1566. I bought half the farm of Poggio from them, that is from Sbietta, for two hundred crowns in cash. It was adjoining the first one, Fountain Farm, and by the agreement it was to revert at the end of three years, during which time I rented it to them. I did this for the best, but it would mean too long a digression if I were to give in detail the great villainies they practised against me. I mean to leave it utterly in God's hands: He has always protected me against those who have wanted to do me ill.

I had completely finished my marble Crucifix,[366] and I decided that by setting it up and raising it a few feet off the ground it would make a far more impressive show; although it looked very fine on the ground, it looked much better after I had raised it, and I was extremely pleased with it. So I began to show it to whoever wanted to see it. As was God's will, the Duke and Duchess heard about it, and so, after they had returned from Pisa, one day both of their Excellencies, with all the nobility of their court, arrived unexpectedly at my house just to see the Crucifix. The Duke and Duchess were so delighted with it that they never left off praising me to the skies, and all the lords and gentlemen who were present followed their example.

When I saw how pleased they were I began to thank them very pleasantly for having removed from me the burden of the marble for the Neptune, which was the real cause of my having produced such a

work, the like of which had never been done before. Although I had never been so exhausted, I said, I thought that the pains I took had been well worth while, especially as their Excellencies praised it so much; and, I went on, as I didn't think I could find anyone more worthy of it than their Most Illustrious Excellencies, I willingly made them a present of it, but before they went away I begged them to be kind enough to visit the ground floor of my house.

At this they immediately rose very courteously, left the workshop and went into the house where they saw my little model of the Neptune, and the fountain, which the Duchess had never seen before. The Duchess was so impressed by it that she immediately cried out in great astonishment, and turned to the Duke to say:

'In all my life, I have never imagined a tenth part of such beauty.'

In reply the Duke kept saying: 'But didn't I tell you?'

And then for a good while they talked among themselves, in a way very flattering to me: and then the Duchess called me to her, overwhelmed me with praises by way of excusing herself – she spoke in such a way as if to ask my forgiveness – and afterwards said that she wanted to have a suitable piece of marble quarried for me to carry out the work. In reply to these kind words I said that if their Excellencies gave me the wherewithal I would be only too willing, for love of them, to embark on such an arduous enterprise.

Straight away the Duke replied: 'Benvenuto, you'll be given anything you imagine you will want, and in addition there'll be what I shall give you of my own accord, which will be by far and away more valuable.'

And after those charming words they made off, leaving me feeling very content.

Many weeks went by and nothing more was said about me. So seeing that no one was making a move I was almost in despair. At that time the Queen of France sent Messer Baccio del Bene to our Duke with an urgent request for a loan which, so it was said, the Duke very kindly supplied. As Baccio del Bene and I were very intimate friends, we were both extremely happy when we came across each other in Florence. He described to me all the great favours that his Excellency had done him, and while we were talking he asked me what important work I had in hand.

So I told him, as it had happened, all that business about the great Neptune and the fountain, and the great wrong that the Duchess had done me. Then he said on behalf of the Queen that her Majesty was very anxious to finish the tomb of her husband, King Henry, and that Daniello da Volterra[367] had undertaken to make a great horse of bronze, but that the time by which he had promised to do so had passed, and that very important decorations were needed for the tomb. So if I wanted to return to my castle in France she would have me given all I could ask for, provided I would serve her. I told Messer Baccio to ask the Duke on my behalf for permission to return to France. Baccio then said cheerfully: 'We shall return together.' And he looked on it as already done. So the next day when he was talking to the Duke he began to discuss me and he said to the Duke that if he was willing the Queen would make use of my services.

The Duke immediately replied: 'Benvenuto is still the able craftsman the world knows about, but nowadays he doesn't want to work any more.'

And then they moved on to other subjects.

The next day I went to find Messer Baccio and he reported all this to me. When I heard what he said I could no longer restrain myself, and I cried out:

'If, after his Excellency left me with nothing to do, on my own initiative I have accomplished one of the most difficult pieces of work ever made anywhere, and at a cost of more than two hundred crowns, paid out of my own poor pocket, what would I not have accomplished if only his Excellency had put me to work himself! I tell you honestly that I have been very gravely wronged.'

The good fellow reported all that I had said to the Duke. His Excellency told him that it was a joke, and that he wanted me for himself. The upshot was that several times I was strongly tempted to clear off. The Queen dropped the matter, for fear of offending the Duke, and so I stayed on, feeling very miserable.

At that time the Duke left Florence with all his court and all his sons, save for the Prince who was in Spain:[368] they travelled through the marshes of Siena, and by that route to Pisa.[369] The Cardinal breathed in the poison of that evil air first of all; and as a result after a few days

he was attacked by a pestilential fever which shortly after killed him.[370]

He was the Duke's right eye; a handsome and a good man, whose death meant a very great loss. I let a few days go by, till I thought their tears must be dried; and then I set off for Pisa.[371]

THE END

NOTES

Among English translations of the *Life*, that of Robert Cust using the text of Orazio Bacci provides the fullest set of sometimes illuminating notes to the historical background of Cellini's autobiography. The more recent Italian edition of the *Life* edited by E. Camesasca is also well annotated.

1. Here and below, Cellini uses the words *virtuosa* and *virtù*, thus beginning the explosive story of his life with one of the challenging themes of Renaissance achievement and genius: the human need, in order to succeed, to be endowed with the special quality of *virtù*, as well as to be favoured by fortune. *Virtù*, from the Latin *virtus* with its signification of both manliness and virtuousness, was a key word and concept for many Renaissance writers, notably for Machiavelli (1469–1527) who said that his hero Cesare Borgia was successful through his *tanta ferocia e tanta virtù* (*The Prince*, Chapter 7) but defeated because the life of his father, Pope Alexander VI, was cut short and he himself fell ill at a critical juncture. For Machiavelli *virtù* had come to embrace ideas of exceptional ability and achievement. Cellini's resonant opening phrases with their echoes of both Michelangelo and Machiavelli are: *Tutti gli uomini d'ogni sorte, che hanno fatto qualche cosa che sia virtuosa o si veramente che le virtù somigli, doverieno . . . descrivere la loro vita . . . Con tutto che quegli uomini, che si sono affaticati con qualche poco di sentore di virtù . . .*

Michelangelo hardly ever used the word *virtù* himself but once sarcastically told the notorious Pietro Aretino that he, Aretino, his *signore* and brother, was *unico di virtù al mondo . . .* (*Il Carteggio di Michelangelo* Vol. IV, Letter CMLV).

2. Villani (*c.* 1276–1348) merchant and traveller whose chronicle (*Cronica*) of Florence in twelve books, inspired by the example of the history of Rome, begins with biblical and mythological material and extends – thanks to his brother and nephew – very informatively to 1363. The colony Julia Augusta Florentia was founded by the Romans in the first century BC. Cellini's

403

genealogical comments are inventive but his grandfather and father were indeed Florentine citizens.

3. Roman engineer and architect of the first century B C whose treatise on architecture (in ten books) *De Architectura*, based largely on Greek precedents, was highly influential in the Renaissance, notably through the works and writings of Alberti, Bramante, Antonio da San Gallo the Younger and Palladio.

4. Piero de' Medici (1471–1503), first son of Lorenzo de' Medici, fled from Florence in 1494, after the invasion of Italy by King Charles VIII of France. After the death of Savonarola, Piero Soderini (1452–1533) was elected Florence's Gonfalonier for life in 1502; he was deposed and banished in 1512.

5. The Medici family were forcibly restored to power in Florence in September 1512 by the chiefly Spanish forces of the Holy League. Cardinal Giovanni de' Medici (1475–1521), the future Pope Leo X (1513–21), was the second son of Lorenzo the Magnificent.

6. Giuliano della Rovere, born 1443, reigned as Julius II 1503–13. Patron of Michelangelo, Bramante and Raphael, he was also the fierce defender of the papacy's territorial interests. He is immortalized in Raphael's portrait (National Gallery, London).

7. Gonfalonier in January and February 1514, he was married to Lucrezia, the eldest daughter of Lorenzo the Magnificent.

8. Baccio Bandinelli (1488–1560) changed the family name of Brandini to make it that of a noble Sienese house. His father was a respected goldsmith in Florence. Knighted by both Pope and Emperor (hence the Cavaliere) Baccio Bandinelli, invariably referred to contemptuously by Cellini, constantly and hopelessly tried to rival Michelangelo. His sculptures include reliefs in the cathedral and the *Hercules and Cacus* in Florence.

9. A famous *condottiere* best known as Giovanni dalle Bande Nere (1498–1526) from the black ensigns carried by his soldiers, this descendant of the Medici and the Sforzas was to die bravely from wounds received in battle; his son by Maria Salviati became Cosimo I, Duke of Tuscany.

10. A board of magistrates responsible for keeping law and order inside Florence.

11. Giulio de' Medici (1478–1534) the illegitimate cousin of Giovanni de' Medici who made him Archbishop of Florence in 1513. As Pope Clement VII (1523–34) he proved himself a great patron of the arts, a grim failure as pontiff.

12. Piero or Pietro Torrigiano (1472–1528) a neglected and underrated artist who studied under the Florentine master Bertoldo and is remembered for having broken the nose of Michelangelo, not without provocation, when they were both young. He worked in England in Westminster Abbey on the too little appreciated tombs of Margaret Beaufort and of Henry VII and his wife Elizabeth of York. A forceful, entrepreneurial artist, according to Vasari's

doubtful account of his end, he starved himself to death in Spain after being charged with heresy and thrown into prison.

13. Michelangelo Buonarroti (1475–1564) after learning the elements of fresco painting in the workshop of Domenico Ghirlandaio, started to work as a sculptor under Medici patronage and carved his first important works (the *Bacchus* and the St Peter's *Pietà*) in Rome. He then worked in Florence from 1501 to 1505, carving the giant *David* after whose completion in 1504 he began the enormously influential cartoon for a great fresco in the Council Hall of the Florentine Republic, showing a dramatic incident in the Pisan war. This *Battle of Cascina* was left unfinished when Michelangelo was recalled to Rome by Pope Julius II.

14. Leonardo da Vinci (1452–1519) in 1500 returned from Milan, after its occupation by the French, to Florence where he worked on three important projects: the wall-painting to commemorate the Florentine victory of the battle of Anghiari; several versions of the Madonna and Child (sometimes with St Anne); and the technically brilliant portrait in oils known as the *Mona Lisa* or *La Gioconda*.

15. The Sistine Chapel was built as a ceremonial papal chapel and sanctuary for Pope Sixtus IV (Francesco della Rovere, 1414–84), decorated by painters from Umbria and Florence, including Ghirlandaio, and magnificently transformed by Michelangelo through his stupendous frescos on the vault, of the history of mankind awaiting salvation from the time of creation and the fall (1508–12), and of the *Last Judgement* over the high altar (1536–41).

16. One of the greatest innovatory masters of the fifteenth century, Tommaso di Ser Giovanni di Monte Cassai (1401 to *circa* 1428) – nicknamed Sloppy Tom or *Masaccio* – with Masolino (Tommaso di Christofano Fini) (*circa* 1383 to after 1435) decorated the Brancacci Chapel of Santa Maria del Carmine with scenes from the Life of St Peter, later completed by Filippino Lippi, which long served as a school for artists for their vitality, grandeur and realism.

17. Filippino Lippi (1457–1504), son of the Carmelite painter, Fra Filippo, had three sons, of whom the goldsmith Giovanni Francesco was born on 15 May 1501.

18. Battista di Marco del Tasso (1500–1555) was a skilled woodcarver, and a lifelong friend of Cellini. He was encouraged by Duke Cosimo de' Medici to turn himself into a (not very good) architect, as noted by Vasari in his Life of Tribolo.

19. This Lombard craftsman, Giovanni de' Giorgio, shared a shop with two other goldsmiths, Giovanni da Caravaggio and Giannotto Giannotti (*see below*) and later served for the year 1528 as consul of the guild in Rome.

20. This was the brother of the scholar and political writer Donato Giannotti who became one of Michelangelo's close friends in Rome.

21. The monument *della Rotonda*, the Pantheon (A D 118–25) was converted into a Christian church by Pope Boniface IV (608–15). The porphyry sarcophagus copied by Cellini survives in the Lateran on the tomb of Pope Clement XII.

22. A member of the Goldsmiths' Guild, Arsago (died by 1563) kept his shop in Rome by the beautiful sixteenth-century church of Sant' Eligio, patron of goldsmiths.

23. Cellini's *Treatises* contains succinct praise for Salvadore Guasconti as a versatile craftsman, who had done praiseworthy work in niello and enamel.

24. This 'Fatty' was a priest, Giovan Battista, whose brother Benedetto Varchi (1503–65) was a famous scholar and writer, closely involved with the foundation of the Florentine Academy in 1540, painted by Titian and an important correspondent with Michelangelo. Varchi was a follower of the Strozzi family in exile till recalled to Florence in 1543 by Duke Cosimo who commissioned him to write an account of Florence's recent history.

25. For his first assault on Gherardo Guasconti, Cellini was fined not four but twelve bushels of flour, and both sides had to promise to keep the peace. At the second sitting of the *Otto di guardia e balia* after Cellini's second assault on Gherardo with a stiletto he was condemned to death by hanging (Cellini's phrase is literally that he was to be marched out into the country i.e. to the place of execution outside the city). The records show that Cellini severely wounded both Gherardo and one of his helpers.

Also in 1523 Cellini had been charged with sodomy before the *Otto* and as an adult first offender fined twelve bushels of flour. This 'first Cellini conviction is not unusual . . . it is typical of the kind of association and practice one finds at this time'. (Cf. 'The writer and the man . . . *il caso Cellini*', Paolo Rossi in *Crime, Society and the Law in Renaissance Italy*, Cambridge, 1994.)

26. This Bishop of Salamanca, Don Francesco de Bobadilla, arrived in Rome in 1522 to attend the Lateran Council and died in Spain in 1529. During the sack of Rome and the siege in 1527 he had been immured with Pope Clement VII in Castel Sant'Angelo.

Gianfrancesco Penni (1496 to after 1528) – called *il Fattore* – was Raphael's pupil, friend and co-heir with Giulio Romano. Vasari included him in his *Lives* of the artists, praising him as a good colourist and a great help to Raphael.

27. Chigi (*c.* 1466–1520), an immensely wealthy and ostentatious banker who had a controlling interest in the distribution of papal alum, was a special patron and friend of Raphael, and of many other artists and men of letters. His splendid villa in the Trastevere (Villa Farnesina) was planned by Baldassare Peruzzi. Of Chigi the story is told that at a banquet he held in a loggia by the Tiber, the silver was thrown into the river after each course (but with a hidden net in position for its recovery).

28. The wife of Sigismondo Chigi was Sulpicia (Petrucci) of Siena, whose younger sister was Porzia, or Portia.

29. The Italian phrases are *quelle bordellerie* and *sue coglionerie*.

30. The wife and cousin of the Emperor Marcus Aurelius (A D 121 – 80) notorious for her lust and beauty.

31. The Italian phrase is *il ferragosto*; surely the feast of the Assumption of the Virgin Mary, held on 15 August, though the word may derive from the Roman *Feriae Augusti* of 1 August.

32. The Belvedere was planned as a loggia and garden by Pope Innocent VIII (1484–92) and grew into a splendid summer villa with fine views of the countryside. Julius II employed Bramante to build elaborate corridors from the Apostolic Palace to the pavilion, forming the spectacular Belvedere courtyard, around which developed the ever-growing complex of Vatican gardens and piazzas, galleries and museums.

33. Cellini's word was *Marrani*, abusively used to describe Moors and Jews forced to convert to Christianity.

34. This was Innocenzo Cibo (d. 1550), son of Maddalena, the sister of Giovanni de' Medici (Leo X) who elevated him to the purple in 1513. A generous patron of writers and artists, he was much involved in the politics of the period.

35. The nephew of the renowned Queen of Cyprus, Caterina, Marco Cornaro was made a cardinal in 1500 and died in Venice in 1524. Cardinal Niccolò Ridolfi was Bishop of Florence and nephew of Giovanni de' Medici, Leo X; he died in 1550. Giovanni di Jacopo Salviati was another nephew of Giovanni de' Medici, created cardinal in 1517 along with Ridolfi and twenty-nine others, chosen to pack the Sacred College with supporters following a failed conspiracy against the Pope's life.

36. On 24 June Florentines celebrate the feast day of their patron saint. Their 'national' church in Rome – San Giovanni de' Fiorentini – was begun by Jacopo Sansovino after a competition ordered by Leo X.

37. Rosso – for his red hair – was the handsome, talented, charming Florentine Giovanbattista di Jacopo (1494–1540) whom Cellini was to meet later in Paris. He was strongly influenced by Michelangelo's *Battle of Cascina* cartoon and by the nudes of the Sistine ceiling, and in turn influenced mid-sixteenth-century French painters. His surviving works include the painting of the *Dead Christ* in the Louvre.

38. Lorenzo da Ceri served the Venetians, the Pope, and then the French as a *condottiere* against the Imperialists. Not very successful, he died in 1528.

39. Lautizio, a respected Perugian goldsmith, the son of Bartolomeo Rotelli, was also mentioned by Cellini in his *Treatise* on goldsmithing (and later in the *Life*) as a specialist in making cardinals' seals. With Cesare Rossetti (Cesarino)

he was appointed superintendent of the Mint at Perugia in 1516, and he died in 1527.

40. Cristoforo Foppa originally from Pavia (c. 1452–1526/7) who, Cellini wrote in his *Treatises*, was a splendid goldsmith, especially good at enamelling, and who served several popes.

41. Minerva, the Roman goddess identified with the Greek Athena, represented Wisdom and War and protected mankind's arts and crafts, including those of the potters and the goldsmiths. Renaissance artists used her image frequently using classical prototypes. Hercules, the most acclaimed of the gods of ancient Greece, adventurous, often imperilled, was the mortal hero who won immortality through his famous twelve labours and stood for the virtue of Hope. His penultimate labour was to bring Cerberus, the three-headed watchdog of Hades, into this world from the Underworld.

42. Iacomo Berengario da Carpi, professor at Pavia and then Bologna, famous doctor and pioneering anatomist with an eye for the main chance. He wrote about syphilis which was spreading fast in Europe at this time. He was the third husband of Lucrezia Borgia.

43. Alfonso I d'Este (d. 1534) ruler of Ferrara who is remembered as a patron of artists including Bellini and Titian and of Ludovico Ariosto, creator of the heroic epic, *Orlando Furioso*.

44. Domenico di Cristofano Iacobacci, Roman nobleman and lawyer, made a cardinal by Leo X in 1517 and died in 1528.

45. Cerveteri is a village near Bracciano. The count was probably Averso di Flaminio of Anguillara whose daughter married Giordano di Valerio Orsini, a general of the Venetian Republic.

46. Michelagnolo di Bernardino di Michele (d. 1540) a pupil of Giacomo Cozzarelli, he executed the tomb of Pope Adrian VI in Santa Maria dell'Anima dei Tedeschi in Rome, following the designs of the influential painter and architect, Baldassare Peruzzi.

47. Giulio Romano (1499–1546) son of Piero Pippi, painter and architect, pupil and one of the heirs of Raphael, who also taught him architecture. Giulio worked in the Vatican and then in Mantua for Duke Federico II Gonzaga; his drawings of different modes of copulation were used for the engravings by Marcantonio Raimondi which inspired the notorious sonnets by Pietro Aretino.

48. Francesco Ubertini (1494–1557) who trained with Perugino but was also influenced by Northern prints and by his Florentine contemporaries such as del Sarto and Bronzino. He later worked for Duke Cosimo I.

49. The handsome Bithynian youth who was loved by the Emperor Hadrian (reigned AD 117–38), and who after drowning in the Nile in AD 130 inspired

several romantic legends. By at least 1520, a Roman statue of a nude youth whose Greek pose appealed to many Renaissance artists was known in Rome.

50. Probably Eurialo Morani from Ascoli, well known at the court of Leo X as a wit and versifier.

51. The Flemish Adrian VI was pope for a short while (1522–3) between the Medici pontiffs Leo X and Clement VII. He was a devout canon lawyer intent on reform of the Church.

52. Federico II Gonzaga (1500–1540) for whom Giulio Romano worked especially on decorating the Palazzo del Tè.

53. Luigi Pulci was also grandson of the talented Florentine poet Luigi Pulci (1432–84) who wrote notably the burlesque, chivalrous and influential poem *Morgante*.

54. A rare reference to any concern with music on the part of Michelangelo.

55 Giovanni di Baldassarre (d. 1536) who was also a sculptor, a friend of the painter Perino del Vaga and collaborator of Michelangelo, criticized by Giorgio Vasari in his Life of Bastiano da San Gallo for keeping bad company and for slanderous talk that led to his murder.

56. Girolamo Balbo, Bishop of Gurck in Carinthia (d. 1555), a poet, Latin orator and envoy.

57. Benvegnato Narducci of Perugia, at one time papal governor of Ostia.

58. '*Era di già tutto il mondo in arme*' Cellini wrote, referring to the war between the Emperor Charles V and the French king, Francis I, from 1521 to 1529 which ended in the uneasy peace of Cambrai and with the humiliation of the Pope and the French, the final restoration of the Medici to Florence, and the assertion of Imperial power over most of Italy.

59. Salviati from a patrician Florentine family was related by marriage to Pope Clement but 'Savonarolan' – against the tight control of the Medici government – in political sympathies. His son-in-law, the dashing Giovanni dalle Bande Nere, died in December 1526 after being wounded in a skirmish against the Imperialist soldiers, as movingly described in one of the memorably glowing letters of Pietro Aretino.

In March 1527 the Pope disbanded his hired soldiers, partly to save money, and in May 1527 the Imperial army under Charles de Bourbon – the cousin and opponent of King Francis – entered Rome and brutally sacked the city. During the siege of Rome Bourbon was killed by a stray shot from an arquebus.

The horror of the sack of Rome – the culmination of almost fifty years of warfare and attendant atrocities in Italy – meant for scores of craftsmen and artists captivity, flight or death.

60. A soldier of fortune, like the Renzo da Ceri, Baglioni (1493–1531) was the son of the murderous Gianpagolo, last of the notorious Baglioni family to

rule the papal city of Perugia who having cleverly maintained his rule under Julius II was executed in Castel Sant'Angelo on the orders of Pope Leo X in 1520. Orazio Baglioni after taking a bloody revenge on his father's betrayers died in Naples while commanding the *Bande Nere* during the war which followed the sack of Rome. His brother Malatesta betrayed Florence during the last year of the siege of the Republic in 1530.

61. *The Angel* was a statue lost during the sack of Rome and replaced by the marble figure carved by Raffaello da Montelupo (1504 to before December 1566). This in turn was replaced by a bronze St Michael in 1753.

62. Francesco Maria della Rovere (1490–1538) heir to his uncle the childless Duke Guidobaldo da Montefeltro, and also nephew of Pope Julius II (Giuliano della Rovere) who made him Prefect of Rome, then commander of the papal forces. In 1516 he was driven from Urbino by the Medici Pope Leo X who bestowed the duchy on his own nephew, Lorenzo de' Medici; but he reconquered Urbino in 1521, and served the Medici Pope Clement (very badly) against the imperialists.

63. The Cardinal of Ravenna (d. 1549), at this time secretary to Pope Clement, was the lawyer and historian Benedetto Accolti of Arezzo, who was made a cardinal a few days before the sack of Rome. Niccolò Gaddi, Bishop of Ferrara. (d. 1552), a Florentine, was made a cardinal at the same time as Accolti and became one of Cellini's protectors in Rome; they shared many friends.

64. Cardinal Alessandro Farnese (1546–1549), later Pope Paul III, was at this time dean of the Sacred College. A scholarly, cultivated bon vivant, he was in the 1520s a patron of the architect Antonio da San Gallo and avid, when pope at last, to secure the services of Michelangelo.

65. Lieutenant-General to the Philibert Prince of Orange (who had deserted the French and succeeded Bourbon as General Commander of the Imperialists) this courageous but apparently arrogant and cruel Spanish captain caused the death of Orazio Baglioni during a sortie from the besieged city of Naples in 1528 and died himself the next year.

66. Related to the Medici family (he married Piero de' Medici's daughter, Clarice). Filippo Strozzi (1488–1538), who was from a rich patrician family of bankers in Florence, was a friend to Michelangelo and his family, at one time ambassador of Florence to the French court and the Papal Curia, and papal banker, and an active opponent of the Medici, who died in sinister circumstances as the prisoner of Cosimo de' Medici.

67. From one of the famous turbulent families exercising seigneurial jurisdiction around Rome, the Orsini, this Franciotto (d. 1533/4) started his career as a soldier, was widowed and then made a cardinal in 1517.

68. After offering his services to the best local goldsmith, Niccolò (d'Asti),

Cellini prepared a drawing and wax model for the reliquary which, probably because of professional jealousies, was not executed.

69. The Roman soldier who in Christian tradition pierced the side of the dead Christ with his lance and was subsequently martyred.

70. Ercole Gonzaga (1505–63), Bishop of Mantua, created a cardinal in 1527, and so in need of a seal, splendid patron of artists and writers, who died in 1563 when presiding at the Council of Trent. The seal (in silver, showing the assumption or ascent of the Virgin Mary to heaven observed by the twelve Apostles) no longer exists but there is an impression of it in the Curia Vescovile at Mantua (Cf. Pope-Hennessy, *Cellini* (1985), pp. 44–5).

71. After the first sack of Rome on 7 May 1527 the Medici government was overthrown in Florence (on 16 May), the papal governor, Cardinal (Silvio) Passerini, rode away to Lucca with the young princes (Ippolito and Alessandro). After the declaration of peace between the Emperor Charles V and Pope Clement, Florence was besieged for eleven months, finally yielding to the re-imposition of Medici control, after appalling suffering through plague and famine, in August 1530.

72. Reporting the praise of Michelangelo (then working on the statues for the Medici Chapel) in his *Treatise* (Chapter XII) Cellini said that this made him ambitious to try larger work. If the medal were bigger, Michelangelo had said, with such an exquisite design, whether in marble or bronze, 'it would astonish the world . . .'

73. (1475–1554) This Florentine painter had worked as a boy under Bertoldo and Ghirlandaio in company with Granacci and Michelangelo who relished his unsophisticated company calling him '*beato*' or blessed, because unlike Michelangelo he was always satisfied with what he made.

74. Like the medal for Marretti, probably done in very high relief, this was produced through the technique of '*lavorare in tondo*' – working in the round – carefully described in the *Treatise* where Cellini adds that after Ginori's death the medal came into the possession of Luigi Alamanni who presented it to King Francis.

Luigi Alamanni (1495–1556) poet and opponent of the Medici, among those who with Machiavelli had taken part in the famous political conversations in the gardens of the Rucellai family (Orti Oricellari) in Florence after 1512. He died in France, in exile.

75. This was before the middle of 1529 by which time Cellini was doing work for Pope Clement.

76. The Dominican Fra Niccolò Schomberg della Magna, was made a cardinal by Pope Paul III in 1535. He died in 1537.

77. The morse or clasp for the papal cope was the first important work by

Cellini to have been well recorded. It was apparently melted down in 1797 under the terms of the Treaty of Tolentino, to meet the cost of part of an indemnity exacted from Pope Pius VI by Napoleon after he had marched on Rome. Coloured drawings of the front, back and profile of the morse were made in 1729 by Francesco Santi Bartoli for John Talman, an English antiquarian. The watercolours are in the British Museum, London. (Cf. Pope-Hennessy *Cellini*, pp. 47–9.)

78. Francis I, King of France (1515–47), who later became a patron of Cellini.

79. A Milanese cleric surnamed Alicorno who was a spoilt friend of Pope Clement, enjoying many benefices, as well as being notary and secretary of the private bedchamber.

80. Tommaso Cortesi (1470–1543) a highly esteemed jurist and friend of Pope Leo X, who was ordained after the death of his wife and made Bishop of Cerenzia and Cariati in 1529 and of Vaison in 1533 by Clement VII who also appointed him an official of the Papal Revenues and Datary and endowed him with various other offices.

81. Cellini remained Maestro delle Stampe (*incisore di zecca*), charged with making the designs and stamps, from June 1529 to January 1534. His *Treatise* clearly describes three separate coins – two two-ducat coins in gold and a silver *doppio carlino* – in all of which 'the effort to give a convincing embodiment to the Pope's not wholly orthodox concepts is very evident'. (Pope-Hennessy, *Cellini*, pp. 50–51.)

82. This was Jacomo Rastelli (1491–1566), originally from Rimini who was in the service of Clement VII and succeeding popes till he died.

83. Giovanni di Taddeo Gaddi. Born in Florence, Gaddi was a spiky, business-like administrator who was dean of the Apostolic Chamber and a patron of artists and writers including Annibale Caro who composed a sonnet in his honour when he died in 1543.

84. Either Giovanni Vergerio (a learned Greek living in Rome who later visited Florence and presented some splendid Greek typefaces to Duke Cosimo), or Giovanni Lascaris.

85. A writer (e.g. author of a volume called *De Religione antiqua* – *Ancient Religion*) and poetry lover.

86. A gregarious Florentine poet who later wrote verse (two sonnets are extant) in praise of Cellini's statue of Perseus.

87. Annibale Caro (1507–66), humanist, skilled and versatile writer and secretary to important ecclesiastics (notably Cardinal Alessandro Farnese). Caro later played a key part in the genesis and development of Vasari's *Lives* of the artists.

88. Sebastiano (Luciani) del Piombo (*c.* 1485–1547) was born in Venice, influenced by the Bellini and Giorgione and developed from painting frescos

for Agostino Chigi in Rome, where he later collaborated with Michelangelo, into a superb colourist and portrait painter, capable of strong dramatic effects and psychological insights.

89. Giambattista Sanga's career culminated in his appointment as secretary to Pope Clement. He was a graceful (neo-Latin) poet and an enthusiast for reform in the Catholic Church; he died from being poisoned accidentally in 1532.

90. Alessandro de' Medici (1511–37), illegitimate son of Giulio de' Medici, was nominated as Duke of Civita di Penna in 1522 by the Emperor Charles V through the influence of Giulio de' Medici before the latter became pope. He became Duke of Florence in 1532, ruled harshly and was brutally assassinated.

91. This was Bernardo Strozzi who served the Florentine Republic in 1530; reputedly arrogant and time-serving he was present with the Florentine commander, Francesco Ferrucci, at the battle of Gavinana (near Pistoia) where Spanish troops hacked Ferrucci to death. A week later a delegation of Florentine citizens agreed to the terms of surrender demanded by the ₊Emperor and the Pope.

92. The chief constable (*bargello*) in 1529–30 was Maffio di Giovanni in charge of a police guard of twenty-five footmen and ten horsemen,

93. A Florentine serving with Cardinal Ippolito de' Medici on an expedition to meet the Emperor in Naples; he died with several others, allegedly poisoned on the orders of Duke Alessandro.

94. One of Rome's chief prisons, especially for those under sentence of death.

95. Literally, *i ferri della Zecca*, the tools used for coining.

96. 'Torre Sanguigna' i.e. the Bloody Tower.

97. For a while Bandini served Duke Alessandro and later opposed Duke Cosimo on the side of Filippo Strozzi. He and Lodovico Martelli fought a famous duel with Giovanni Rigogli and Dante da Castiglione during the siege of Florence. He was later imprisoned by Cosimo on a charge of sodomy.

98. Francesco del Nero had worked (apparently corruptly) with Filippo Strozzi in Florence after 1513 when the latter was Pontifical Treasurer; Zana for Giovanni (Biliotti); the Bishop of Vasona was Girolamo Schio, the Pope's confessor and occasional envoy, Bishop of Vaison near Avignon since 1523, he died in 1533.

99. Superintendent of the Pontifical Mint from 1529, later imprisoned and tortured on suspicion of forgery.

100. Donato Bramante (*c.* 1443/4–1514) trained initially as a painter; it is for his architectural works in Rome that he is chiefly remembered. He worked for popes Alexander VI, Julius II and Leo X, built churches, palaces and roads, and initiated the rebuilding of St Peter's.

101. Also called Baccio Valori, a Florentine who during the siege of Florence

was the Pope's Commissary-General to the Prince of Orange, he later conspired against the Medici with Filippo Strozzi, was captured at the battle of Montemurlo which saw the anti-Medicean exiles finally crushed and was executed with his son and a nephew in August 1537.

102. Entered into holy orders after the death of his wife, obtained the bishoprics of Pistoia, Amalfi and Ravello, and was made a cardinal by Pope Paul III in 1542. His earlier career as a papal commissary had been inglorious; he abandoned his artillery before a successful Sienese onslaught in 1526.

103. Pope Clement left Rome on 18 November 1532 for Bologna. He stayed till March 1533 and he and the Emperor discussed ideas for a General Council of the Church, a League against the Turks, and the marriage of Caterina de' Medici (1519–89) the daughter of Leo X's nephew Lorenzo, Duke of Urbino. Caterina – Catherine de' Medici – married Henri of Orleans, the future King Henri II, in 1533.

104. King Francis I (1515–47) whose inventory of plate and jewels drawn up at Fontainebleau in 1560–62 records the horn as mounted by Tobbia. Cellini's design which was not executed looked forward to his work at Fontainebleau on animal figures surrounding the nymph. The horn was intended as a wedding gift for Catherine de' Medici and the King's second son, Henri. Clement attended the wedding in Marseilles, chiefly to strengthen ties with the French.

105. Tommaso d'Antonio from Perugia, nicknamed 'bean' (meaning thickhead) and appointed joint die-stamper (with Giovanni Bernardi of Castel-Bolognese) at the Pontifical Mint in 1534.

106. Pier Giovanni Aliotti (d. c. 1562) later became Master of Robes to Pope Paul III and, under Pope Julius III, Bishop of Forlì in 1551. As a general factotum for the Pope he dealt with many of the Vatican's suppliers and clients, including Michelangelo who called him *Tantecose* (Busybody).

107. The learned Roman Governor Gregorio Magalotti, a lawyer: he became a bishop in 1532. He died in 1537 in Bologna, serving there as the legate of Pope Paul III.

The Procurator Fiscal Benedetto Valenti came from Trevi where he had a fine collection of antique statues.

108. Cellini later recorded that the unfinished chalice (or ostensory for carrying the Host) was pledged to Bindo d'Antonio Altoviti for two hundred *scudi* in gold and redeemed by Duke Cosimo's chamberlain in February 1553. It was later finished by Niccolò di Francesco Santini, a goldsmith at the ducal court. Cosimo then presented the chalice with its figures of Faith, Hope and Charity to Pope Pius V on 4 March 1569 when he was crowned as Grand Duke of Tuscany. Later the chalice was broken up.

109. Felice Guadagni, Cellini's assistant who features later in the narrative.

110. In Umbria, this district was well known for its demons and witches, as well as for being the birthplace of St Benedict and his sister St Scholastica.

111. A Benedictine abbey in a village in the Sabine hills (Farfa) about twenty kilometres from Rome.

112. Giovanni Bernardi (d. 1553) a gem cutter, invited to Rome by the historian Paolo Giovio, described by Vasari as an excellent engraver of medals and crystals.

113. Cardinal Ippolito de' Medici (1511−35) was the natural son of the brother of Pope Leo X, Giuliano, Duke of Nemours. Made cardinal in 1529, when aged eighteen, he was handsome and talented (as witnessed by the portrait by Titian in the Pitti in Florence and some of his verse) and a perspicacious, wealthy patron. A failed conspirator (against Duke Alessandro) and inept military commander (against the Turks) he died in 1535.

114. Antonio di Giovanni da Settignano, a Florentine painter and sculptor, among the many Vasari said were taught by Andrea del Sarto and Sansovino.

115. Carlo di Lionardo Ginori, praised by Vasari as a patron of artists, Gonfalonier of Florence for two months in 1527.

116. Pietro Alvarez di Toledo (d. 1553), Marquis of Villafranca, was Viceroy of Naples for twenty years from 1532.

117. Pecci was born in Siena. The Sienese rather like the people of Bologna were reputed to be not too bright (at least by fellow Tuscans). This one later served Catherine de' Medici, and was involved in a plot against the Spanish rulers of Siena in 1551.

118. Cellini describes this medal also in his *Treatise* on goldsmithing (Chapter XV), adding details on his technique and those of the ancient world. On the two medals dated 1534 with a common obverse and alternative reverses (*see* p. 126 and the quotation *Ut bibat populus*: 'That the people may drink', which celebrates the well in Orvieto commissioned by Pope Clement) Pope-Hennessy comments that the portrait of Pope Clement put them among the finest of their time. About a hundred of the two medals were struck and they 'remained a byword for quality'. (*See* Pope-Hennessy, *Cellini*, pp. 52−4 with plates 31−4 of dies in the Museo Nazionale, Florence.)

119. Pope Clement's noble and scholarly Florentine secretary, Carnesecchi (1508−67) who later associated with the group of 'reforming' Catholics in Rome influenced by the Spanish mystic Juan de Valdès. He was finally condemned to death and beheaded and burned as an impenitent heretic in Rome after Duke Cosimo surrendered him to Pope Pius V.

120. Clement died on 25 September 1534.

121. Alberto del Bene, brother of Alessandro del Bene, claimed often by Cellini

as a close friend, was a well-educated, discriminating man who died in 1554 in a skirmish during the campaign of 1553–4 ending with the defeat by Florence of French and Sienese troops under Piero Strozzi.

122. This was on 26 September 1534, conveniently for Cellini within twenty-four hours of the death of a pope, and the time for a general amnesty when a new pope was announced.

123. Rucellai (1495–1549) a voluntary Florentine exile in Rome who married Dianora di Pandolfo della Casa, heiress of Monsignor Giovanni della Casa who wrote the famous book of manners, *Galatea*.

124. Cardinal Cornaro (d. 1543). Created a cardinal though not yet in holy orders in 1528, the Venetian Francesco Cornaro brother of the earlier mentioned Marco; after military training and several engagements against Islam, he served the Republic of Venice as a diplomat. In 1531 he was given the Bishopric of Brescia which he soon resigned to his nephew Andrea.

125. Related to Pompeo. Traiano Alicorni, a Milanese, was a well-rewarded intimate of Pope Clement, who held a succession of curial posts.

126. Bernardo di Michelozzo Michelozzi, envoy and negotiator for successive popes starting with Leo X who took him into the Medici household, and for Duke Cosimo. He became a bishop in 1516.

127. Alessandro Farnese elected on 13 October 1534 and crowned on 1 November as Pope Paul III, reigned till 1549. He moved quickly to secure the services of Michelangelo for a series of frescos beginning with the *Last Judgement*, and appointed him chief sculptor, painter and architect. During his pontificate after the Peace of Crépy between the Emperor and the French king in 1544, the Council of Trent opened for sessions in 1545 which were finally completed in 1563. He was generous to scholars and artists but most of all to members of his own family.

128. The Roman Latino Giovenale de' Manetti (1486–1553) a career courtier with some talent as a poet, who numbered many brilliant scholars and writers such as Castiglione and Bembo among his friends. A canon of St Peter's, he was made Treasurer of Piacenza in 1534 and subsequently Commissary-General for the Antiquities of Rome.

129. Ambrogio Recalcati, first secretary to Pope Paul III, whose corruption eventually caused his disgrace and imprisonment in Castel Sant'Angelo.

130. The original – in effect a provisional decree of amnesty – survived in the Vatican and was published in 1894 (Arch. Stor. dell'Arte, Anno VII, Fasc.V, Sett-Ott. p. 373).

131. The inscriptions for this 29 mm coin were PAULUS III PONT. MAX. on the obverse showing the Farnese coat of arms and S. PAULUS. VAS. ELEC-TIONIS on the reverse with extant examples showing a full-length figure of

St Paul. The significance was that the Pope, sharing the name of Paul, was elected by acclamation rather than majority vote.

132. Pope Paul III's hopelessly spoilt natural son Pier Luigi (1503–47), Gonfalonier of the Church, Duke of Nepi and Castro, Marquess of Novara, was created Duke of Parma and Piacenza in 1545 and was assassinated in 1547 when Spanish forces asserted Imperial control of Piacenza.

133. Nicknamed so because he was always teasing and troubling himself and others ('*sempre travagliava e tribolava* . . .') wrote his friend and admirer Vasari in his *Life*. Niccolò di Raffaello (1500–1550), sculptor and architect of Florence, trained under the carpenter Nanni Unghero and Jacopo Sansovino, copied in clay and briefly collaborated with Michelangelo on statues for San Lorenzo in Florence, completing the mosaic pavement for the Laurentian Library, and worked for Duke Cosimo on the enhancement of the villa of Castello, rapturously described by Vasari.

134. Jacopo Tatti or Sansovino (1486–1570), a sculptor and architect, pupil of Andrea Sansovino, did most of his great work in Venice where he was appointed head architect to the Procurators of San Marco after his flight from Rome during the sack in 1527, and left as his finest monument the richly decorated but simply presented Library of St Mark's.

135. Brother of Cardinal Giambattista Cibo, Archbishop of Marseilles. Lorenzo was Marquess of Massa (near Pisa and famous for its marble quarries) through his (acrimonious) marriage. He served the Church as a *condottiere*, and was *comandante generale* of the papal troops from 1530 to 1534. He died in 1549.

136. A Milanese, chancellor in Florence to the magistracy of the Eight, by all accounts an arrogant and cruel official.

137. Ercole II d'Este (1534–59), son of the splendid ruler Alfonso I, the patron of Titian and Ariosto among others, married the daughter of King Louis XII of France, Renée d'Anjou. Belfiore was a superb villa near the city.

138. Benintendi had been one of the Eight and captain of the Florentine troops in 1529 when he left Florence in defiance of the Signoria and the Medici and was sentenced to being 'confined' away from the city.

139. Nardi (1476–1563), historian and translator of Livy, from a still celebrated Florentine family, served the Republic in high office and after the return of the Medici in 1512, like Machiavelli, stayed immersed in the study of contemporary politics and took part in an anti-Medicean uprising before the sack of Rome (when the raised arm of Michelangelo's statue of David was broken by a bench hurled by rioting Florentines). In about 1531 he was banished, and from Venice he later went to Naples to present to the Emperor the grievances of the exiles againt Duke Alessandro. Primary sources for the history of Florence include Nardi's *Istorie della città di Firenze* (ed. L. Arbib, 2 vols, Florence 1838–41).

140. Cellini is punning on *coregge*, which means 'straps' or, vulgarly 'wind'.

141. For the wildly dissolute Alessandro, four coins were produced from Cellini's designs: the 'forty soldi', the *giulio*, the half-*giulio* or *grossone*, each in silver, and the gold crown or *scudo*. For detailed descriptions *see* Pope-Hennessy (op.cit. pp. 74–5) who comments that the *quaranta soldi*'s figures of Saints Cosmas and Damian with their freely rendered poses and their loose classical robes '. . . possess some of the attributes of sculpture . . .' On the obverse of the same coin the portrait of Alessandro had a subtlety 'fully apparent only when it is enlarged'. Examples are in the Museo Nazionale, Florence.

142. The marriage had taken place in Naples in February 1536; in May the arrival was magnificently celebrated in Florence of the 14-year-old bride, Margaret of Austria, natural daughter of the Emperor Charles V.

143. Pietro Paolo of Monterotondo, family name Galeotti, was also with Cellini in Ferrara in 1540 and in Florence in 1552 when he helped clean the figures of the Perseus. He died in 1584.

144. Bernardo Baldini (d. 1573), jeweller and goldsmith, who was later purveyor to the Mint in Florence.

145. Reviled as Lorenzaccio, Lorenzino de' Medici (1514–48) the son of Pier Francesco de' Medici and Maria Soderini, after a dissolute life in Rome went to Florence to become the freakish, mysterious drinking companion of the debauched Alessandro whom, using a hired killer, he murdered atrociously on 6 January 1537.

He was himself, after being hailed by many Florentine exiles as a new Brutus, assassinated in Venice in 1548, leaving a notorious written *Apologia*. His killing of Alessandro (subject of a play by De Vigny) led almost at once to the crucially decisive choice as *capo* and *primario del governo della città* (the head and leader of the government) of Cosimo de' Medici, the future Duke and eventual Grand Duke of Tuscany.

146. This distant Medici relation and supporter had gained roughly used influence through marriage to Francesca di Jacopo Salviati, Cardinal Salviati's sister.

147. Bastiano di Domenico di Bernardo Cennini (1481–1535) is praised by Cellini in the introduction to his *Treatise* on goldsmithing as a craftsman of great talent who with his ancestors had made dies for the coinage of Florence up to the time of Duke Alessandro.

148. A medal in the Museo Nazionale in Florence shows the bust of Alessandro facing to the right, on the obverse, and a laurel wreath on the reverse with the motto *Solatio Luctus Exigua Ingentis* and was attributed controversially by Plon to Cellini.

149. This was between 20 March, the date of the safe-conduct, and 12 June

when the poet Mattio Franzesi (*see* note 153) wrote to Benedetto Varchi in Florence about a medal Benvenuto was waiting for and sent his regards.

150. Cellini uses the disparaging word *mediconzolo*, and this doctor may have been Bernardino Lilli of Todi, the Curia's physician from 1528.

151. The feast of the Assumption, *il giorno delle Sante Marie*, on the eve of which images of Christ and the Virgin Mary were carried in torchlit procession respectively from the churches of S. Giovanni in Laterano and Santa Maria Maggiore. Members of the Butchers' Confraternity carrying firebrands surrounded the image of Christ to protect it from the crowds, but this confraternity was suppressed by Pope Julius III and nobles supplied the escort for the procession till the time of Pius V when their troop was disbanded in turn.

152. The prosperous collector of ancient statues and living artists, Francesco Fusconi, physician to popes Adrian V, Clement VII and Paul III, who died in 1550.

153. Florentine writer of humorous verse attached to the Curia and a familiar of many writers and artists, including Cellini.

154. Canto III of Dante's *Inferno* describes the approach of the demon boatman Charon who ferries the souls of the damned across the river Acheron to Hell:

> *Ed ecco verso noi venir per nave*
> *un vecchio bianco per antico pelo,*
> *gridando: 'Guai a voi, anime prave!'*

> And see there coming in his bark
> an old man hoary with his ancient locks
> who shouts: 'All woe to you, depraved souls!'

155. The representation of God the Father on the morse for Clement VII.

156. Cellini arrived in Florence on 9 November 1535, as noted in a letter from Varchi to Pietri Bembo.

157. Giorgetto Vassellario, one of Cellini's usually disparaging versions of Giorgio Vasari's name. Vasari (1511–74), painter, architect and author of the *Lives* of the artists, referred quite often to Cellini, with circumspect praise as, for example, a peerless goldsmith when young, an incomparable medallist and the creator of the excellent Perseus, comparable to Donatello's Judith, and the very beautiful Crucifix in marble. Cellini, he remarked, was spirited, proud, vigorous, very resolute and truly terrible.

158. Manno Sbarri (active 1548–61), a well-regarded Florentine goldsmith, with whom Vasari, his close friend, took refuge in Pisa when Florence was besieged in 1529.

159. Francesco Catani da Montevarchi, patron of the arts as well as a physician, also lauded in *Ercolane* (Herculaneum) by Benedetto Varchi (whose love of literary Florentine did not stop him from declining Cellini's request that he improve the language of Cellini's *Life*).

160. Another burlesque poet in the manner of the notorious Francesco Berni but also a courtier and scholar appointed by Duke Cosimo de' Medici as Proveditore at Pisa in 1555. He too was a friend of Varchi.

161. It was alleged that Alessandro was the son of Giulio de' Medici, Pope Clement VII, and that his mother was a mulatto; but it is more likely that his father was Lorenzo, Duke of Urbino, who had died in 1519.

162. 'I would call myself Felice Little-Profit, if you hadn't won me such a great reputation that I can call myself Felice of the family of Great-Profit.'

163. A hunting lodge on the bank of the Tiber, near Rome, built for Pope Innocent VIII and much used by the pleasure-loving Pope Leo X.

164. The assassination took place during the night of 5–6 January 1537.

165. Bartolomeo Bettini, a Florentine in Rome, whose bank was often used by Michelangelo to transmit or receive money and letters and who later (1549) wanted to have one of his nieces married to Michelangelo's nephew – 'He's not our equal,' Michelangelo warned Lionardo. According to Vasari, Michelangelo presented him with a 'divine' drawing of Cupid kissing Venus.

166. Cosimo (1519–74), descended from Lorenzo de' Medici, brother of Cosimo, *pater patriae* – the 'father' of the country, was proclaimed as head of state by the Council of the Forty on 9 January 1537. Later that year, with the approval of the Emperor, he assumed the title of Duke of the Republic.

167. Never executed but also described in Chapter VIII of Cellini's *Treatise* on goldsmithing as a Christ of gold set on a ground of lapis lazuli with three gold figures for narrative medallions on the base of the crucifix symbolizing Faith, Hope and Charity.

168. This, according to Cellini in his *Treatise*, had been made for Giulia Gonzaga at the behest of Cardinal Ippolito de' Medici with a cover already put together and looking splendid 'with all its gorgeous jewels set upon it . . .'

169. This was on 5 April 1536. Charles and his six thousand-strong retinue passed through the Porta San Sebastiano and the arches of Constantine, Titus and Septimius Severus over the Capitoline Hill to the Vatican. Artists who contributed to the statues and decorations for the triumphal visit included Piloto and Antonio da San Gallo. The Emperor made the pilgrim's traditional round of the seven churches and delivered a diatribe in Spanish against the King of France. He left on 18 April.

170. Durante Durante of Brescia (d. 1558), was Prefect of the Apostolic Chamber to Pope Paul III who made him a cardinal in 1544.

171. Emiliano Targhetta also mentioned in Cellini's *Treatise* on goldsmithing as the master.

172. Giovanni Pietro Marliano of Milan was jeweller to Pope Paul III from 1528 to 1548 and at one time Solicitor of Letters Apostolic.

173. Alfonso d'Avalos (1502–46), Marchese del Vasto, heir to his cousin the Imperial commander Ferdinando Francesco d'Avalos, Marchese di Pescara, who after a brilliant career died suspected of treachery, leaving his widow the childless Vittoria Colonna who then adopted Alfonso. He made a pious death in 1546.

174. There is no record of what happened to the 'richly embellished' little book though in the past several beautifully bound books have been wishfully ascribed to Cellini.

175. This sixteen-year-old Sforza, son of Bosio, Count of Santa Fiora and Costanza Farnese, natural daughter of Pope Paul III, had been appointed captain-general of the Italian and Spanish cavalry in the army of Charles V. He died in 1575 after soldiering with the French.

176. Ascanio de' Mari, from Tagliacozzo, later followed Cellini to Paris where he stayed to become one of the court goldsmiths to Henri II. He married Costanza, a daughter of one of the della Robbia family.

177. Girolamo Pascucci who was often at odds with Cellini, whom he later accused of stealing Pope Clement's precious stones during the sack of Rome and from whom after a dispute in 1538, he received a guarantee that Cellini would not injure him.

178. This was just after Easter, 1537.

179. Bembo (1470–1547) was a noble Venetian scholar and writer whose fastidious published works include innumerable letters modelled on Cicero, the book *Gli Asolani* (a highly polished disquisition on love from differing viewpoints) and the *Prose della Volgar Lingua* (influential rules for the literary use of Tuscan speech). From being member of the refined court circles at Urbino and Ferrara, he became a papal secretary under Leo X and after retirement to Padua was made a cardinal by Paul III in 1539.

180. It is generally supposed that Cellini never did finish the medal for Bembo on which he began to work in Padua and which had been under discussion since 1535.

181. Antonio di Bartolomeo Cordinai (*c.* 1484–1546), called Antonio da San Gallo the Younger, trained in Rome as an architect with his uncles Giuliano and Antonio. A skilful architect of palaces and also a military engineer, under Pope Leo X (1520) he became chief architect of St Peter's, his grandiose plans for which were dramatically modified and enhanced by Michelangelo.

182. Andrea Sguazzella or Chiazzella was a follower of Andrea del Sarto whom

he accompanied to France where he remained in the service of Francis after del Sarto's return to Italy in 1519.

183. Giuliano Buonaccorsi (d. 1563) was born in Florence and moved to France in 1507. He rose quickly to prominence through his involvement in royal finances and became close to Francis I. He was also a friend of Alamanni.

184. Called *Fontana Beliò* by Cellini. Italian artists working at the court of Francis I included Rosso (who died the year Cellini arrived) and Primaticcio and, later (arriving with Cellini) the architect Sebastiano Serlio, and their many assistants.

185. Ippolito d'Este (1509–72) son of Alfonso, Duke of Ferrara, Archbishop of Milan at the age of fifteen, was created a cardinal by Paul III in 1539 and even aspired to be pope on the death of Julius III. He had built the magnificent Villa d'Este at Tivoli.

186. The shrine at Loreto in the Marches famous for the belief that the Santa Casa, the house of the Virgin Mary, had been transported there miraculously from Nazareth by angels in stages in the thirteenth century.

187. Cellini arrived in Rome on 16 December 1537.

188. The shop was kept loyally by Felice Guadagni till his death, when in his will (date of execution 31 August 1543): *legavit Jacobo filio Antonii Mannelli omnes massaritias existentes in apotecha sua aurificine ad illius usum pertinentes (exceptis illis que spectant ad magistrum Benvenutum Cellinum aurificem, cui per infrascriptam heredem suam restitui mandavit).*

He left to Jacopo, son of Antonio Mannelli, all the goods in his goldsmith shop that pertain to his use (with the exception of those which belong to master Benvenuto Cellini goldsmith, to whom he ordered that they were to be restored through the heiress mentioned below).

189. Gerolamo Orsini, lord of Bracciano, famous as a *condottiere*, whose son Paolo was made a duke. After Cellini's goods had been impounded and Cellini imprisoned in 1538, Orsini moved quickly to recover the gems and gold he had entrusted to him, as described in the inventory drawn up at the time. (Cf. Cust, *The Life of Benvenuto Cellini*, Vol. I, p. 386; Sansovino, *Degli uomini illustri della casa Orsina*, Lib. IV, and Ratti, *Della famiglia Sforza*, parte I, p. 226.)

190. Pier Luigi Farnese was made Duke of Castro by the Pope in 1538.

191. Isabella de' Medici.

192. Conversini (1491–1553) was appointed Governor of Rome on 21 March 1538 and on 15 October 1538 was appointed *vice camarlengo & auditore generale delle cause della Curia della Camera Apostolica*. He was also appointed Governor of Bologna in 1542. Bishop of Forlimpopoli since 1537 he was transferred to the See of Jesi in 1540.

193. Cellini's Italian for this was *voi cicalate o [che] voi favellate*.

194. In fact Giovan Bartolomeo Gattinara, nephew of Mercurio di Gattinara, Grand Chancellor and Regent in Naples of the Emperor Charles V, concluded the terms of the – never observed – capitulation of Pope Clement on 5 June 1527.

195. Sculptor (1504–66) from the Sinibaldi family of Montelupo who worked in Florence under Michelangelo in the sacristy of San Lorenzo and later in Rome as an architect of Castel Sant'Angelo. In his *Life* of Raffaello and his father, Baccio da Montelupo, Vasari praised his draughtsmanship and said he followed Michelangelo's style in his architectural decorations.

196. Jean de Morluc, brother of Blaise de Morluc, Marshal of France, who was made Bishop of Valence in 1554.

197. This Giorgio Ugolino, who was succeeded by his brother Antonio (*see below*), is mentioned in papal account books and in Varchi's *Storia fiorentina*.

198. Very little is known about this Pallavicino save that he was an impressive preacher and his imprisonment lasted seven months and eighteen days.

199. Antonio Pucci (d. 1544) nephew of Roberto Pucci and a respected Vatican diplomat, was made a cardinal in 1531, taking his title, as did other members of the Florentine Pucci family, from the church of Quattro Santi Coronati.

200. This was Enrico di Oziaco, gunner in charge of the sanitation at Castel Sant'Angelo.

201. Margaret of Austria whose second marriage to Ottavio Farnese, the Pope's nephew, was arranged in 1538 at the meeting in Nice between Pope and Emperor to settle treaty terms with the French king. She made her state entry into Rome on 5 November 1538 when Cellini had been in prison eighteen days. She was still under fifteen.

202. Pope Pius II (1458–64) founded the College of Abbreviators in 1463. The *abbreviatores de parco majori* and *de parco minore* were a subgroup of this College and in the Roman Curia (the main judicial, financial and administrative body of the Catholic Church) the abbreviators worked in the general administrative section (the Chancery) concerned with papal letters, including solemn bulls, producing and able to suggest corrections to these documentary decisions and instructions.

203. Alessandro Farnese (elected as Paul III in 1534) was imprisoned by Pope Innocent VIII (1484–92), not by Pope Alexander as Cellini states. His offence apparently had been to imprison his mother.

204. The cardinal was Guido Ascanio Sforza (d. 1564), son of Bosio, Count of Santa Fiore, and Costanza Farnese, Paul III's daughter. He had been made a cardinal in 1534, at the age of sixteen.

205. Alessandro Monaldo commanded the Florentine troops during the siege of Florence and was imprisoned in 1530 for opposing the Medici.

206. Fra Benedetto Tiezzi da Foiana in Valdichiana, a Dominican from Florence's Convent of Santa Maria Novella, and a follower of Savonarola, he was imprisoned by Clement VII for having preached against the Medici during the siege of Florence.

207. In fact, in 1539.

208. Leone Leoni (died *c.* 1590) was an outstanding medallist and goldsmith and also a bronze sculptor, who succeeded Tommaso of Perugia as engraver to the Roman Mint in 1537 and was sent to the galleys for an act of violence against the papal jeweller in 1540. He later entered the service of the Emperor Charles V who made him a knight. Giorgio Vasari, a fellow Aretine, included his biography in his *Lives*. He honoured Michelangelo with a medal showing his profile and an image of him as a blind pilgrim with a staff, led by a dog. This was copied in great numbers.

209. Giovan Girolamo de' Rossi (d. 1564) was made Bishop of Pavia by Clement VII in 1530 and imprisoned on suspicion of conspiracy to murder from 1538 to 1540 when he went into exile. In 1550 Pope Julius III restored this friend of Cellini to his bishopric and made him Governor of Rome.

210. Alessandro Farnese (1520–89) son of Pier Luigi, was appointed Cardinal Archbishop of Parma by his grandfather Pope Paul III in 1534 when aged fourteen and in 1539 appointed legate to oversee the meeting of King Francis I and the Emperor Charles V in that year. Balked of the succession to the papacy through Medici opposition, he was influential in the Catholic reform movement. He was a busy patron of the arts, an activity which his numerous benefices helped to finance.

211. On 5 December 1539 Annibale Caro wrote telling Benedetto Varchi that Cellini was living with the Cardinal of Ferrara, (Ippolito d'Este) to whom, wrote Luigi Alamanni in a letter to Varchi of the same date, Cellini owed his life. (Quoted Cust: *The Life of Benvenuto Cellini*, Vol II, p. 79.) Ferrara – for whom Cellini made *inter alia* four silver candlesticks and a chalice at this time – was in turn the guest of Cardinal Gonzaga, while waiting to take possession of his own palace.

212. *Capitoli* was the name given to verses, usually in *terza rima*, of a burlesque, and often as not, obscene in kind, which originated in Florence. (Cf. Symonds, *Renaissance in Italy: Italian Literature*, Part II.) Cellini's *Capitolo* is a curious but revealing rigmarole which I have translated very freely. He alludes to the death of the castellan ('the Castle bell must crack') and to the murder of Pier Luigi ('a dark bier near the stone'). His references to lilies are explained by their presence in the Farnese arms, as well as in the arms of France and Florence, and in paintings of the Annunciation.

213. Gabriello Maria da Cesano (1490–1568) was a lawyer and scholar who

served the Papacy as an envoy and was made Bishop of Saluzzo in 1556 by Pope Paul IV.

214. *See also* Cellini's description of the completed salt-cellar and his description of the technique of enamelling in the *Treatise* on goldsmithing, Chapter XII and Chapter III respectively.

In his *Cellini* (pp. 107–16) Pope-Hennessy lists the discrepancies between Cellini's three descriptions of the salt-cellar (two in his autobiography and one in the *Treatise*) and comments that advice on the project may have come from Luigi Alamanni whose poetry's 'imaginative world' was closely akin to that of the salt-cellar.

Pope-Hennessy notes the influence on Cellini's figures of the times of day of Michelangelo's statues in the Medici Chapel and, on the four reliefs of Winds (depending on Ovid's imagery in the *Metamorphoses*), of the tondi of Pontormo and Bronzini in the Capponi Chapel, Santa Felicità, 'which Cellini must have known'.

After lauding Cellini's liberal experimentation in colourful enamelling, Pope-Hennessy explores the salt-cellar's upper surface division into Earth and Ocean supported by a large oval plate of gold made in one piece, and its 'miracles of workmanship' as in the modelling and engraving of the sea horses. Life study, one of the procedures of classical sculpture, was central to Cellini's art, Pope-Hennessy decides.

'Capricious the salt-cellar may be, but in it Cellini successfully assembles poetic detail into a richly poetic whole.'

This fine criticism illuminates the centrality of Cellini's most ambitious work at this stage to the developing post High Renaissance art of Florence and Rome.

215. François de Tournon (1489–1562), French Minister of State, made a cardinal in 1530, was a wealthy patron of art and literature.

216. Cherubino Sforzani from Reggio Emilia, a cleric and master watchmaker for both the Pope and the Este family.

217. Alfonso Piccolomini, Duke of Amalfi, at this time governed Siena for the Emperor Charles V from 1529 till 1541 when he was dismissed for failure to sustain order.

218. In 1539 a treaty was concluded between Duke Ercole II d'Este and Pope Paul III under which the former for a hundred and eighty thousand gold ducats was reinvested with certain territories that had been granted to his family by Pope Alexander VI.

219. An original cast of the obverse of the lost wax model for this double-sided medal is in the Goethe Museum in Weimar. (Cf. Pope-Hennessy, *Cellini*, p. 302 n. 40.)

220. A minister of Duke Alfonso I d'Este.

221. Cellini recalled the wrong place and the wrong date: he was still in Ferrara in September 1540; nor was the French court in Dauphiné in 1540 or the immediately following years. (Cf. Cust, *The Life of Benvenuto Cellini*, Vol. II, p. 122, n. 2.)

222. Leonardo had been in France (at the invitation of Francis I) lodging in the castle of Cloux, near Amboise, from 1516 till his death in 1519.

223. Of these twelve statues, only one, the *Jupiter*, had been finished when Cellini left France in 1545, after five years. The idea apparently came from King Francis himself, who presented what he thought was a dreadfully ugly statue of Hercules (made by French craftsmen to the design of Rosso) to the Emperor Charles V in Paris in January 1540, and who wanted the statues to be of his own height, and so nearly two metres each.

For Cellini's technique *see* Chapter XXV of the *Treatise* on goldsmithing and Pope-Hennessy's comment on its empiricism (*Cellini*, p. 104). Pope-Hennessy also gives (pp. 104–5) a general reconstruction of the probable appearance of the *Jupiter* and the mechanism for moving it, and of its counterpart the *Juno* (based on a chalk drawing in the Louvre and a small bronze model in the Stavros Niarchos collection in Paris).

224. Le Petit Nesle was part of the Château de Nesle on the left bank of the Seine and had been granted to an office bearer associated with the University of Paris, then administered by the Grand Prévôt of Justice, at this time the very grand Jean d'Estouteville, Seigneur de Villebon, later Chevalier de S. Michel, Conseiller du Roi, and Royal Lieutenant in Normandy and Picardy.

225. Nicolas de Neufville (d. 1598), financial secretary to the King in succession to his father.

226. Jean Lallemant, Seigneur de Marmaignes, another royal secretary in 1551.

227. Cellini received seventy-four gold *scudi* for gilding a basin and oval ewer in chased silver, adorned with figures, made for the cardinal to be presented to the King, on 12 December 1540. (See Cust, *The Life of Benvenuto Cellini*, Vol. II, p. 134, n.1.)

228. Beautiful and clever, Anne de Pisseleu (1508 to *circa* 1580), maid of honour to Louise of Savoy and soon mistress to Louise's son, Francis I. In 1536 she married Jean de Brosse, who was made Duc d'Étampes. She later converted to Calvinism and died disgraced.

229. Jean de Lorraine (d. 1550), son of Renée II, Duke of Lorraine, an intelligent patron, had been created a cardinal by Leo X in 1518.

230. Henri II d'Albret (1503–55), King of Navarre and Sovereign Count of Béarn and Foix, spent most of his life at the court of Francis I whom he followed to Italy; he managed to escape after being taken at the battle of Pavia. His

daughter married Antoine de Bourbon and became the mother of King Henri IV.

231. Marguerite de Valois (1492–1549) widowed through the death of her first husband, the Duke of Alençon, had married Henri II (the King of Navarre) in 1527; she was erudite and beautiful and acclaimed as the Fourth Grace and the Tenth Muse.

232. Francis I's second son, Henri (1519–59) became Dauphin when his elder brother Francis died, and was crowned King of France as Henri II, to reign from 1547 to 1559. In 1533 he married Catherine, the daughter of Lorenzo de' Medici, Duke of Urbino. He drove the English finally out of France when he took Calais in 1558; he died in a tournament the following year and left France to a disastrous succession of young or weak kings and to decades of civil war.

233. On 16 March 1541, the Cardinal of Ferrara, Ippolito d'Este, presented King Francis at Fontainebleau with the gilded basin and ewer made by Cellini. In Paris, the King visited Cellini's workshop in the Nesle, then over dinner said he wished for Cellini's design for a matching salt-cellar, Cellini showed him the model he had made in Rome. The salt-cellar, completed in 1543 and presented in 1570 by the wretched French king, Charles IX, to the Archduke Ferdinand of the Tyrol, is now in the Kunsthistorisches Museum, Vienna.

234. Described by the Ferrarese ambassador as 'a silver vase in the style of the antique with two handles all worked in relief, a work judged universally to be exceptional and singular' (Pope-Hennessy, *Cellini*, p. 115). This is now lost.

235. No trace exists of either work.

236. Caterina, later used as the model for the Nymph of Fontainebleau.

237. Piero (d. 1558), the son of Filippo Strozzi, was a Florentine exile who gained honours through his service in the army of Francis I. He was also a writer using the pseudonym of Sciarra Fiorentino.

238. Antoine le Maçon, author of a romance and first translator of Boccaccio's *Decameron* into French, pubished 1545 at the suggestion of Queen Marguerite of Navarre whom he served as secretary.

239. So he did, till he died when they were listed in Lodovico Gennari's Inventory of Cellini's belongings as *Two privileges from the King of France conceded to Benvenuto*. Now in the Biblioteca Nazionale the two documents, the Letters of Naturalization and the Confirmation of the Gift of Petit Nesle (i.e. the second deed which Cellini mentions further on), bear the dates July 1542 and 15 July 1544 respectively.

240. These included Flaminio Anguillara di Stabbia, perhaps then a soldier in France under the command of the Strozzi; Giovan Francesco Orsini or his son Niccolò, also soldiering for France with the Strozzi and at odds with his own extended Orsini family whose fiefs included Anguillara and Pitigliano; Galeotto

Pico, son of Luigi Pico della Mirandola, who had fled after a murderous family feud to France where he died in 1550 after loyal service to the King.

241. Fighting between the parties to the Treaty of Nice (signed in 1538 and meant to last ten years) started in July 1542 and was ended in 1544 by the short-lived Peace of Crépy between the King and the Emperor.

242. The imagery of the door designed by Cellini for the Porte Dorée of Fontainebleau, built by Gilles Le Breton in 1538, was linked to that of a fresco by Rosso in the Gallery of Francis I (known through an engraving) which recounts the legend of Fontainebleau, where the spring and its presiding goddess were discovered by a hunting dog called Bleu or Bliaud. (Cf. Pope-Hennessy, *Cellini*, p. 137.)

In his *Treatise* on sculpture, Cellini again describes the doorway (Chapters I and IV) and the technique of casting in bronze. He cast the Nymph (which measures 205 x 409 cm), but apparently nothing else, before he left France in 1545. Removed from the château of Diane de Poitiers at Anet during the French Revolution to Paris, it has been repatinated and is now in the Louvre, near Michelangelo's statues of the so-called Dying Captive and Struggling Captive which arrived in France in 1546. The statues of Victories disappeared a few years after the sack of the Château of Neuilly in 1848, but casts of them remain in the Musée des Arts Decoratifs. (Cf. Cust, *The Life of Benvenuto Cellini*, Vol. II, p. 158, n. 2, and especially Pope-Hennessy, *Cellini*, pp. 133–46, where the relevant chapter notes that after finishing the salt-cellar, Cellini 'veered decisively' towards sculpture and also proved himself 'the finest animal sculptor of the sixteenth century'.)

243. Unique in value, the history of this flattering statue of King Francis/the god, Mars, introduced by Cellini's priceless verbal flattery, is uncertain, but the project may have been the statue referred to in 1545 as part of a planned fountain for Fontainebleau and as being 'larger than any made by the Romans as far as is known . . .' (Pope-Hennessy, *Cellini*, p. 142).

244. This Florentine doctor, grandson, through his mother, of the painter Domenico Ghirlandaio, served Francis I from 1542 to 1548 and then Duke Cosimo. In holy orders, he held several church benefices in Italy and France, and was appointed to the chair of Medicine and Philosophy in Pisa where he died in 1569.

245. Guido Guidi's book printed by Pierre Gauthier in 1544 was a translation of works on surgery by Hippocrates, Galen and Oribasio, and was dedicated to King Francis.

246. Primaticcio (1504/5–70) was trained by, among others, Giulio Romano: this versatile artist was best at painted and high relief stucco decoration which he developed at Fontainebleau where he served Francis from 1532, making

sorties to Rome to buy and secure casts of famous works including the *Laocoön* and Michelangelo's *Pietà*. In his life of Primaticcio, Vasari praised his generosity towards other artists and said he lived more like a nobleman than a craftsman.

247. Cellini refers here to the opening line of Canto VII of the *Inferno*, the words of Plutus when he first perceives Dante and Vergil coming towards the Fourth Circle: 'Papè Satan, papè Satan aleppe.' There is only conjecture as to their meaning. The French that Cellini heard would correspond to: 'Paix paix, Satan, paix paix, Satan, allez, paix.'

248. Perhaps so, but works in France (Avignon) attributed by Vasari to Giotto have been variously attributed to Simone Martini and his assistants or Matteo Giovanetti.

249. From Verona, a shoemaker's son, Mattio or Matteo del Nassaro as Vasari called him was both designer and musician. Paid a salary from 1515 by King Francis who esteemed him especially for his lute playing and skill in engraving medals, gems and pieces of crystal, and in executing cartoons for tapestries. He died *c.* 1547 soon after King Francis's death.

250. The reference here is to *The Decameron*, the second story of the second day, in which Rinaldo d'Asti attributes his success in love to his habit of saying an Our Father and Hail Mary for the souls of the father and mother of St Julian, after each night's lodging.

251. Jacques, Monseigneur de la Fa, was charged by King Francis with settling the accounts for Cellini's work in the Nesle, from 1541 to 1545 when he died and was succeeded by his son, Pierre.

252. In the end, Primaticcio, this painter Bologna, did finish this fountain, for work on which payments to him were recorded for 1540–50.

253. The statue of Mars for the proposed fountain at Fontainebleau.

254. No more is known about this work. However, probably on his first visit to France, Cellini did make for Francis a medal of which several examples in bronze and lead are extant e.g. in the Museo Nazionale, Florence, and the Fitzwilliam Museum, Cambridge respectively. They show the bust of Francis I crowned with laurel with the inscription FRANCISCUS. I FRANCORUM (.) REX and on the reverse a mounted knight trampling on Fortune with the words 'DEVICIT FORTUNAM VIRTUTE'. The signature is given as BENVEN. F.

255. Leone Strozzi (1515–54) who after having valiantly served France, joined his brother Piero in the ferocious fighting between Duke Cosimo's Florence and Siena in which he died after being wounded by an arquebus shot.

256. 'Little serpent.'

257. The girl probably died in infancy while Cellini was still in Paris. Her baptism is recorded in the Register of the Parish of S.-André-des-Arcs (now des-Arts). (Cf. Cust, *The Life of Benvenuto Cellini*, Vol. II, p. 202, n. 1.)

258. In 1544 Charles V's army took the Duchy of Luxemburg and was threatening to march on Paris from Champagne. He was let down by his ally, the English king, Henry VIII, who halted after the siege of Boulogne (which he kept till 1550) and was forced into the Peace of Crépy which secured Milan for France's royal family.

259. Claude d'Annebaut, noble friend and servant of Francis I who created him Marshal in 1538 and Admiral of France in 1543. He died in 1552.

260. Jean Grolier (b. 1479), of Lyons, held the office of Superintendent of Finance till his death in 1565. He left a famous collection of books and medals.

261. Cellini's *bel Giove*, 'fine silver statue of Jupiter' or Jove, which disappeared without trace, is described in the *Treatise* on goldsmithing (Chapter XXV) as having been soldered with the help of four of his young men, cleaned and polished and given a bronze base, succeeding beautifully as a figure holding the lightning bolt in its right hand and in the left a ball to symbolize the world.

262. The castings were done at Fontainebleau by Laurent Renaudin, Francisque Ribon, Pierre Beauchesne, Benoit Leboucher, Guillame Durant and others. (Cf. Cox-Rearick, *The Collections of Francis I, Royal Treasures*, p. 326).

263. Henri II succeeded Francis in 1547 and died on 14 July 1559.

264. Marguerite of Navarre (1523–74) married Emanuele Filiberto, Duke of Savoy, in 1559, making a very popular and gracious queen. She was a patron of writers and used her influence and intelligence to attract some of the best minds to the University of Turin.

265. It has been suggested that this is either a corruption of *Le démon Bourreau* (the demon Executioner) or that Cellini meant *Le moine bourru*, the ghost of a monk dressed in a coarse cloth called *bourre*. The castle of Petit Nesle had been the site for the outrages by Queen Jeanne, wife of Philip V (1316–22).

266. Bellarmati (1493–1555) taught mathematics and military architecture in his native Siena, then, after banishment, became Francis I's chief engineer and a cultivated correspondent and author.

267. Anne, the King's mistress, the beautiful Madame d'Étampes, allegedly from spite towards Diane de Poitiers apparently betrayed the French to the forces of the Emperor as they advanced in 1544 towards Épernay where the bridge was not cut in time. The Dauphin (the lover of de Poitiers) was then defeated in battle and Parisians began to flee to Orleans.

268. François de Bourbon (b. 1491), Comte de Saint Paul and Duc d'Estouteville, was close to the King, fighting with him at the battle of Marignano in 1515, captured with him by the Spanish at Pavia in 1525. He died in 1545.

269. In Italian: *questi diavoli*; in an earlier reference (p. 37) to the English (concerning Torrigiano's work in England) Cellini called them *quelle bestie*.

270. In July 1545 Piero Strozzi (brother of Leone, p. 289) embarked at Le Havre where the French fleet under Admiral d'Annebaut set off with Italian galleys to engage in naval skirmishes off the Isle of Wight on which Strozzi made a landing. He died in 1558.

271. Little is known about Cellini's companions on this journey from Paris. Ippolito Gonzaga was Governor of Mirandola from 1537 to 1538. Galeotto della Mirandola was married to Ippolita Gonzaga. Tedaldi, from an originally Polish family that came to be well known in Florence, may have been the father of Bartolo di Leonardo, an anti-Medicean Florentine mentioned in contemporary letters.

272. Writing to Bartolomeo Concino, secretary to Cosimo I, on 22 April 1561, Cellini mentioned that the French king had given him three hundred pounds of silver from which he was to make a statue of Jupiter and that after he had done this 'of the remainder I made four big Vases alike very richly ornamented . . .' (*feci quattro gran Vasi simili ricchissimamente lavorati* . . .). These presumably refer to the large vase (*see* note for p. 264) and others now lost (*see* Cox-Rearick, *The Collections of Francis I, Royal Treasures*, pp. 396–7). Cf. *Vita, Ricordi, prose e poesie di Cellini*, ed. Tassi, p. 335 and Cust, *The Life of Benvenuto Cellini*, Vol. II, p. 236, n. 1, which also discusses the romance and melodrama about Ascanio written by Dumas and Giovanni Peruzzini respectively.

273. Cosimo de' Medici (1519–74) became Duke of Florence in 1537 and Grand Duke of Tuscany in 1570. The magnificent villa at Poggio a Caiano was designed for Lorenzo il Magnifico (1449–92) by Giuliano da San Gallo (work beginning in 1485), and its Great Hall decorated at the behest of Pope Leo X by artists including Andrea del Sarto, Jacopo Pontormo and Franciabigio, but only completed by Allori in 1582.

274. Eleonora di Toledo (1522–62) married Cosimo de' Medici in 1539. She was the daughter of Don Pedro Alvarez, the Spanish Viceroy of Naples and was both very rich and politically well connected, to Cosimo's great advantage.

275. Cellini called the Academy of Design *questa mirabile Iscuola*. It was founded on the prompting of Giorgio Vasari by Cosimo in January 1563 to enhance the standing and skills of the fine arts of painting, sculpture and architecture, and to assist artists elected for their excellence to encourage each other, and ensure that religious devotions such as their obsequies were well observed.

276. Reporting his conversation with the Duke, Cellini said that Cosimo asked for '*solo un Perseo* . . .' (a *Perseus* only), doubtless a reflection of how the Duke saw himself triumphant in Florence over his republican enemies. Pope-Hennessy notes that, wanting a Perseus for the Loggia dei Lanzi for reasons springing from 'the interaction of symbolism and symmetry', the Duke commissioned a statue 'simpler and smaller than the statue Cellini eventually

produced'. Cellini's aim was to rival the *Judith* of Donatello, shown with her left hand in the hair of the slaughtered Holofernes.

The wax model in the Museo Nazionale in Florence – not necessarily the first seen by Cosimo – is the earliest extant model of the Perseus, already showing the body of Medusa under the feet of Perseus. A cast model of the two figures also survives, in the Museo Nazionale. The creative process of producing the *Perseus* itself (by which the statue must be as perfect as possible from every point of view) was magisterially described by Cellini in a letter of 28 January 1547 to Benedetto Varchi, responding to the questions Varchi had asked Florentine artists including Michelangelo and Bronzino about the rival merits of painting and sculpture. (Cf. Pope-Hennessy, *Cellini*, pp. 168–70.)

277. Donatello's *Judith* is still on the Piazza della Signoria but Michelangelo's *David* was removed to the Accademia in 1873 and a marble replica erected on the piazza in 1910. The Piazza della Signoria was called at this time the Piazza del Granduca.

278. The petition (*supplica*) and the deed or rescript (*rescritto*) are preserved in the Biblioteca Nazionale of Florence. The access to Cellini's house is now at 59 Via della Pergola. The site was Via del Rosaio, now Via della Colonna.

279. Riccio (1490–1564) was born in Prato. He became provost of the collegiate church of Prato as well as majordomo to Duke Cosimo and won praise as a generous benefactor and scholar from Benedetto Varchi among others. In his life of Fra Giovanni Montorsoli, Vasari said perhaps too vehemently that Riccio – no friend of Montorsoli – died after being mad for several years. (Cf. Cust, *The Life of Benvenuto Cellini*, Vol. II, p. 250, n. 1.)

280. This agent and supplier to government (*pagatore* was Cellini's description) who was purveyor to the *Otto di Practica* (Florence's magistracy for foreign policy) from 1543 to 1545, may have been related to the friar Alessandro Gorini who fancied he must be a de' Medici rather than a de' Gorini, he looked so like Pope Clement VII.

281. This *Sala del Oriolo* in the Palazzo della Signoria was so named for containing the famous cosmographic or astronomical clock made in 1484 by Lorenzo della Volpaia for Lorenzo de' Medici; it marked the risings and conjunctions of planets.

282. The translation could be 'just plain mister', *ser* being the courteous mode of address for a plebeian with modest position, *messer* for someone of lesser gentility and *signore* for a man of princely rank.

283. Gambetta was a Margherita di Maria di Jacopo da Bologna who later, as Cellini reports (*below* p. 326) made against him an unsubstantiated accusation of having sodomized her son.

284. The Opera del Duomo, or Office of Works, was established to maintain the fabric of the cathedral at Florence.

285. Raffaello Tassi died in 1545.

286. About Mannellini Cellini wrote in a letter of 22 April 1561 to Bartolomeo Concino, secretary to Duke Cosimo, that when he saw the fine bodily proportions (*bella proporzione di corpo*) of this eighteen-year-old country lad (*villanello*), 'I started to draw him, partly for my own study (*studio*), and partly for the work on (*le opere del*) Perseus, whereby I drew (the) Mercury that is in the base at the back of the Perseus.' (Cf. *Ricordi, prose e poesie*, ed. Tassi, p. 337 and Cust, *The Life of Benvenuto Cellini*, Vol. II, p. 261, n. 3, where details are given of Mannellini's outburst of violence.)

287. The Poggini brothers were sons of the Florentine Michele Poggini, a craftsman excelling in cutting cameos. Giampaolo (1518–80) specialized in making coins, medals and engraving on gems and later worked for Philip II of Spain; Domenico (1520–90) was a versatile goldsmith, sculptor and medallist, Master of the Dies of the Pontifical Mint (serving Sixtus V), highly praised by Vasari and Varchi.

288. Both are lost. The drinking vessel for which Cellini made designs and models was chiselled in half relief with two small figures in full relief; the girdle was decorated with jewels and masks in half-relief. A bas-relief metal dog made at this time to test the clays for Cellini's *Perseus* survives in the Museo Nazionale in Florence. (Cf. Cust, *The Life of Benvenuto Cellini*, Vol. II, p. 263, nn. 1 and 2.)

289. On a colossal scale, this bronze bust of Cosimo was completed by 20 May 1548 after being modelled from life in 1545. Praising the technical skill with which it was executed (the animated mask, the grotesque heads, the Medusa head and the eagle heads being all 'of incomparable vividness') Pope-Hennessy comments that the 'rhetorical' bust, out of key in the Florence of that time, importantly showed how Cellini apprehended the head 'as a sequence of inter-related surfaces . . . [Cellini's] bust represents the first valid transposition to three dimensions of the principles implicit in mannerist portrait painting'. It is now in the Museo Nazionale at Florence. (Cf. Cust, *The Life of Benvenuto Cellini*, Vol. II, p. 264, n. 1 and Pope-Hennessy, *Cellini*, pp. 215–18.)

290. Referred to by Cellini disparagingly as alternatively *Bernardone* or *Bernardaccio*, Antonio di Vittorio Landin was a Florentine merchant and man of letters whose works included a comedy called *Il Commodo*. (Cf. Cust, *The Life of Benvenuto Cellini*, Vol. II, p. 268n.)

291. Antonio Ubertini, brother of the painter Bachiacca.

292. Titian, the supreme colourist in oils, born Tiziano Vecellio (*c.* 1485/90–1576) had broken magnificently through the conventions of Venetian painting with his huge altarpiece of the *Assumption* and turned to portrait painting of chiefly secular leaders, notably the Emperor Charles V. He was by then the

most sought-after painter in Europe, living sumptuously and still vigorously developing his rich and powerful style, moving on a few years after Cellini's visit to self-sufficient erotic compositions featuring mythological scenes.

293. In his *Treatise* on sculpture (Chapter II), Cellini describes where best to find and prepare the clay for casting and reveals his trade secret of letting the mixture of cloth and clay decompose for several months so that it becomes like an unguent. (Cf. C. R. Ashbee, *The Treatises*, p. 113.)

294. Of the Portigiani of Fiesole, a family of craftsmen, chiefly founders.

295. Medusa (meaning 'Queen') was in Greek mythology the mortal monster among the three Gorgons, daughters of the sea-deities Ceto and her brother Phorcys who sprang from the Sea and the Earth (Pontus and Gaia). Her terrifying gaze under a head of serpents could turn men into stone; when decapitated by Perseus she instantly gave birth from her shed blood to Pegasus and Chrysaor, the winged horse and the golden sword. The son of Zeus and Danaë, Perseus was favoured by the gods, who to secure his triumph over Medusa gave him a helmet for invisibility (from Pluto), wings for his feet (from Hermes), a looking-glass to see Medusa at a slant (from Athena) and a wallet for Medusa's head (from the nymphs). He fulfilled the prophecy that he would kill his grandfather Acrisius (though accidentally) and his story is one of miraculous power and brave achievement.

296. Cosimo had mines worked for silver and other metals at Pietrasanta and Campiglia chiefly for his own domestic purposes.

297. Now lost.

298. In his *Life* of Baccio Bandinelli, Vasari comments that he was especially anxious to become rich and buy property and had a very beautiful farm, Lo Spinello, on the heights of Fiesole and another, with a fine house, called Il Cantone, on the plain above San Salvi, and a big house in the Via de' Ginori. Bandinelli, Vasari records, was jealous of the favours shown to Cellini when he arrived from France and perplexed that this rival had changed 'in a moment' from a goldsmith into a sculptor.

299. This son, Jacopo Giovanni, was born on 27 November to Cellini's model Dorotea, legitimized in April 1554, and died in infancy. Cellini later adopted Dorotea's legitimate son Antonio by Domenico Parigi (renaming him Benvenutino). In 1562 Cellini secretly married his maid Piera di Salvatore Parigi. The son, Giovanni, he had already had by Piera was legitimized in November 1561 and died fifteen months later. Piera then had three daughters, two of them lived, and then another son, Andrea Simone, after Cellini and Piera married officially in March 1567.

300. Sforza Almeni of Perugia, Chamberlain to Duke Cosimo, was killed by him on the night of 22 May 1566, in the Palazzo Vecchio, as punishment for

his having revealed to the Prince Regent, Don Francesco, that Cosimo was sexually involved with and contemplating marriage to Eleonora degli Albizzi.

301. Philip II (1527–98) son of the Emperor Charles became King of Naples and Sicily in 1554 and King of Spain in 1556. Through marriage to Mary, daughter of Henry VIII, he became King Consort of England, 1554–8.

302. Stefano Colonna (d. 1548), from one of the famous families providing *condottieri* to successive rulers. After a hectic career in the service of several powers, Colonna was appointed Lieutenant-General by Duke Cosimo in 1542.

303. Bandinelli was given the commission to match Michelangelo's statue of David on the Piazza della Signoria with a free-standing group of Hercules slaying Cacus, which he finished in 1534. He won several important commissions from Cosimo, including the tomb for Cosimo's father, Giovanni dalle Bande Nere. Some of the critics of the clumsy *Hercules and Cacus* wrote so vituperatively that Duke Alessandro had them imprisoned as a caution. In his *Life* of Bandinelli, Vasari damned the group with faint praise, lauding Bandinelli for effort rather than elegance.

304. The new sacristy built by Michelangelo for Pope Clement VII during 1519–34 to correspond with the old sacristy designed by Brunelleschi at the church of San Lorenzo and to make the stupendous Medici tombs.

305. This group, 191 cm in height, shows the god Apollo caressing the hair of Hyacinth kneeling at his side, son of the high priest of Apollo, Oebalus, who in the myth was accidently killed by Apollo's discus. The damaged and much repaired statue is in the Museo Nazionale, Florence.

306. The *Ganymede* finished by late March 1550 for the Piazza della Signoria to a height of 105.5 cm shows the young, beautiful Ganymede side by side with the eagle (mythically the god Jove [Jupiter], who had fallen in love with him) and was modelled on a statue of Bacchus by Sansovino. Pope-Hennessy emphasizes the poetic purpose of the *Ganymede* in contrast to the prosaic spirit of Bandinelli's sculptures. 'The carving of the figure, and especially that of the eagle's wings, is of consummate delicacy' (Pope-Hennessy, *Cellini*, p. 229).

307. Now in the Museo Nazionale, the marble Narcissus (height 149 cm) so painstakingly carved by Cellini is 'among the greatest mannerist marble statues of the sixteenth century' (Pope-Hennessy, *Cellini*, p. 232). The story as told in Ovid's *Metamorphoses* describes the son of a river god and a nymph whom the goddess Aphrodite punished for rejecting the love of the nymph Echo by causing his deadly despair from hopeless infatuation with his own pining image. This inspired Cellini to produce, with further inspiration from Bronzino's *Saint Michael* painting on the ceiling of the chapel of Eleonora of Toledo, a lithe serpentine figure displayed in one graceful movement gazing vacuously at his

own languid image in the imaginary pool. It is of weathered Greek marble with insertions of Carrara marble.

308. One of the most serious floods of the Arno occurred in August 1557 when the Florentine historian Bernardo Segni wrote that the sudden inundation of the Arno was greater than had been heard of for this river for a quarter of a century. The whole quarter of Santa Croce had been submerged. (Cf. Cust, *The Life of Benvenuto Cellini*, Vol. II, p. 307, n. 1 citing Segni Lib. XII, p. 470.)

309. Lucy of Syracuse died in 304 and her feast day in the Roman Martyrology is 13 December. Her aid was invoked, especially in the Middle Ages, against fire and sore throats as well as blindness.

310. Cellini's description of his method of building furnaces for casting bronzes in Chapter IV of his *Treatise* on sculpture notes that they must be built by each master according to the special needs of the piece he is making.

311. Cellini's technical terms in his description of the casting of the *Perseus* with translations used here include: *Tonaca di terra*, clay tunic; *sfiatatio*, air vents; *manica* (a kind of) funnel-shaped furnace; *mandriani*, iron hooks (or bent pieces of iron with long handles); *spine*, plugs (iron cones to close the furnace's opening for the molten metal).

312. The Italian is *dal cielo del fuoco* i.e. 'from the sphere of flame', which, according to the Ptolemaic system, existed between the earth and the moon.

313. Sculptor and founder who with his previously mentioned brother Zanobi helped Cellini prepare the furnace and cast the head of Medusa. He directed the preparations for the obsequies of Michelangelo in 1564, contributing a marble statue of Fame.

314. Described by the historian Benedetto Varchi as grasping and ill-educated but amiable, eloquent and loyal, Serristori was Duke Cosimo's ambassador to Emperor Charles V in 1537, and till 1564 Florence's ambassador in Rome.

315. Giovanni Maria Ciocchi of Monte Sansovino became pope on 22 February 1550, taking the name of Julius III. He was a generous and devoted patron of Michelangelo and he strove for the reform of the Church and the peace of Christendom but his energies and resources petered out well before his death in 1555.

A page in the manuscript of Cellini's *Life*, struck out at this point in the narrative, anticipates by several years the death of Bindo Altoviti and Cellini's subsequent journey to Rome and describes the financial negotiations he conducted to secure the payments Altoviti had been contracted to make to him. (*See* Cust, *The Life of Benvenuto Cellini*, Vol.II, p. 329, n. 1.)

316. Bindo Altoviti (1491–1557) was an anti-Medicean merchant and banker from a prominent Florentine family, who in Rome helped and lavishly financed the exiles opposed to the regime in Florence and was portrayed by Raphael

in paint (Washington, National Gallery of Art) as well as by Cellini in bronze.

The extant letter of *c.* 1552 from Michelangelo to Cellini (whose authenticity has been doubted) as Cellini reports, says that Michelangelo had known Benvenuto for years as the greatest goldsmith ever and now would acknowledge him as likewise a sculptor. 'Know that messer Bindo Altoviti took me to see the portrait of his head in bronze . . . it gave me such pleasure but it seemed to me a great shame (*molto male*) that it was put in a bad light; for, if it had its rightful (*ragionevol*) light, it would be seen for the beautiful work it is.' (*Il Carteggio di Michelangelo*, Vol. IV, p. 387 MCLXXXI.) The bronze is now in the Isabella Stewart Gardner Museum, Boston.

Bindo backed Piero Strozzi's opposition to the Medici, was declared a rebel, and suffered the confiscation of his belongings in Florence.

317. One of the three Councils created in 1532 for the government of Florence; alongside the Two Hundred (*Dugento*), the Forty-Eight formed a senate from which were chosen four persons to hold office as *Gli Ottimati* for three months.

318. This letter dated 14 March 1560 to Cellini's *Eccellentissimo et divino precettor mio* said that all Florence and especially its most glorious Duke wished fervently for Michelangelo's return home, which now seemed certain. But Michelangelo never went back. (*Il Carteggio di Michelangelo*, Vol. V, p. 208, MCCCXX.)

319. Cellini must have meant either that five thousand two hundred crowns were lent to the Duke, or that three thousand eight hundred of the five thousand crowns were Altoviti's. The page which has been struck out in the manuscript confirms that Cellini's share was twelve hundred.

320. Francesco di Bernardino d'Amadore of Casteldurante (*c.* 1515–55), from about 1530, Michelangelo's assistant, helpmate and factotum to whom he was profoundly attached and whose death pained him grievously. One of Urbino's two sons by Cornelia Colonelli was christened Michelangelo.

321. Castello was the villa acquired by the Medici family in the late fifteenth century which housed, among other treasures, many of the family's commissioned paintings. It was restored by Duke Cosimo using Bronzino and Pontormo.

322. The Italian for the act of abject buffoonery by which, Cellini suggests, Bernardo would invite the Duke to slap his cheeks is *per via del gonfiare*. The song 'La bella Franceschina' was a popular ballad celebrating a beautiful little Francesca.

323. This was following the rebellion of Siena in 1552. Subsequently, with French support, Piero Strozzi, a marshal of the King of France, after his arrival in Siena was attacked by Cosimo de' Medici, seeking to assert Florence's domination of the strategically important city. After a famous Florentine victory at Marciano and a harsh siege, Siena capitulated to Cosimo on 12 April 1555.

324. Among those allocated gates along with Cellini and Bandinelli, Pasqualino of Ancona was a member of this provincial city's Boni family; Giuliano, the son of Baccio d'Agnolo, was an architect who succeeded his father as director of works at the cathedral of Florence; Antonio Particino was admired by Vasari as a 'rare master' in woodcarving; Francesco, the son of Giuliano da San Gallo (1494–1576) was a sculptor and architect who had also been employed as an engineer of the defences of Florence, notably during the siege of 1529–30 after Michelangelo, the supervisor of the fortifications, had fled the city.

325. The brave but refined captain who captivated Cellini has been variously identified, most convincingly with Giovanni Masini from Cesena (son of the Giacomo Masini who bravely opposed Cesare Borgia) who served Duke Cosimo in the 1550s before and during the war with Siena. Cosimo made him a knight and then the governor of the Order of Santo Stefano, and he died childless *c.* 1587. (Cf. Cust, *The Life of Benvenuto Cellini*, Vol. II, pp. 352–3, n.1.)

326. In February 1543 the Imperial commander tried to smuggle some of his own men into the French-occupied city by hiding them in six carts laden with hay. The plot was discovered, the portcullis descended on the carts, and the invading soldiers were attacked. (Cf. Cust, *The Life of Benvenuto Cellini*, Vol. II, p. 352, n.2.)

327. In Greek myth, the Chimera was a fire-breathing monster with the body of a she-goat, lion's head and snake's tail. Vasari in the Preface to his *Lives*, recording that sculpture was esteemed and perfected by the Etruscans, cites the discovery in 1554 of the bronze *Chimera* of Bellerophon when ditches and walls were being made to strengthen Arezzo's fortifications.

328. In Cellini's common speech, *il signor don Garzia*, this child was the fourth of Cosimo's five sons, who died aged seventeen in 1562. Cosimo's three daughters were Maria, Isabella and Lucrezia.

329. Cosimo's first-born son, 'the Prince', was Francesco de' Medici (1541–87) who succeeded as the second Grand Duke of Tuscany in 1574. Giovanni de' Medici (1543–62) was made a cardinal by Pope Pius IV in 1560, in gratitude to Cosimo for supporting his election, and died from a fever aged nineteen at about the same time as Garzia. Arnando or Ferdinando de' Medici (1549–1609) was also made a cardinal in 1563 and succeeded as Grand Duke in 1587. Pietro de' Medici (1554–1604) the youngest son, was notorious as a promiscuous waster who strangled his wife through jealousy.

When Francesco, Giovanni, Garzia and Ferdinando teased Cellini they were respectively aged twelve, ten, six and four.

Cosimo's daughters Maria and Lucrezia died young, at seventeen and sixteen respectively. Isabella married an Orsini – Paolo Giordano, Prince of Bracciano,

the then head of the doomed family – who strangled her at the urging of his mistress.

330. The originals are now in the Museo Nazionale, Florence.

331. Pontormo (1494–1556), often classified as one of the first Mannerists and arguably the finest painter of his generation; most of his paintings, fully described in Vasari's *Lives*, have survived. They include the Borgherini panels in the National Gallery, London. His diary reveals his amazing eccentricity. His early work was highly praised by Michelangelo.

332. Angelo di Cosimo Tori (1503–72) was taught by Pontormo, and was also influenced by Michelangelo but, in contrast to both, was a stylistic, coldly restrained and polished artist, albeit brilliantly accomplished. He was Grand Duke Cosimo's court painter and a fluent versifier.

333. Alessandro Allori (1535–1607) was adopted by Bronzino, a friend of his father, and became the painter's pupil. He has been described as an imitator rather than an innovator. For Michelangelo's lavish obsequies in 1564 this 'excellent painter' (as Vasari claimed him to be) depicted Michelangelo in the Elysian fields surrounded by famous sculptors and painters of antiquity and great artists from Giotto and Cimabue onwards.

334. The work of the painter and sculptor Verrocchio (1435–88) mentioned by Cellini is on the façade of the church of Orsanmichele in Florence. Describing the commissioning of this bronze group in his *Life* of Verrocchio, Vasari says the figures of Christ and St Thomas were 'solid, complete, and beautifully fashioned', worthy of being set up in a shrine made by Donatello.

335. Unveiled in April 1554, the *Perseus* for which Cellini had foolishly not insisted on a contract, was part of Cosimo de' Medici's programme for the artistic enrichment of the Palazza della Signoria and the piazza, meant as a counterpart to Donatello's *Judith* with which (as with Michelangelo's *David*) it challenged and still challenges comparison. Based on life studies rather than academic exercise, it also challenged the artistic intention and style of Cellini's hated rival Bandinelli and the coarseness of his *Hercules and Cacus*.

The total height of all the sculptured surface – the *Perseus*, the base with its beautifully modelled figures (now in the Museo Nazionale of the Bargello) and the bronze narrative relief of *Perseus rescuing Andromeda* – is about 600 cm. The progress of Cellini's work on this superbly elegant sculptural complex, charged with political and artistic significance, is followed scrupulously by Pope-Hennessy in his *Cellini* (op.cit.) where the critically relevant chapter ends by recording 'the simple fact that in the *Perseus* Cellini, through imaginative effort and creative intelligence, produced a work which, in the pantheon of Renaissance sculpture, still stands, in terms of people appeal, second only to the *David* of Michelangelo'.

336. From 1547 to 1557 this was Don Juan de Vega.

337. Usually known as Montorsoli (as he came from this village near Florence) this sculptor (1507?–63) designed the fountain for Messina's Piazza del Duomo completed in 1553. In his *Life* of the generous, prosperous and pious Fra Giovanni Agnolo Montorsoli, Vasari especially praised him for his help in establishing the Academy of Design after his final return to Florence in 1561.

338. The Baths of Santa Maria: *Bagni di Santa Maria* or *Bagno in Romagna*. Below, Cellini refers simply to 'Bagno'.

Sestile should perhaps be Sestino, now Foglia, where Florentine exiles under Piero Strozzi were badly defeated in 1536.

The monasteries of Vallombrosa, Camaldoli and La Vernia are on the slopes of the Apennines to the north-east of Florence and the last is especially renowned as the spot where St Francis received the stigmata, the signs of the wounds of Christ.

339. Cesare di Niccolò di Mariani Federigi (*c.* 1530–64) had studied sculpture under Tribolo and worked with Cellini on the base of the *Perseus* before leaving for Milan to study the crafts of glass and cameo cutting. His uncle was Federigo Federigi who died in 1562.

340. Guidobaldo della Rovere (1514–74) succeeded his father Francesco Maria in 1538 and was commander of the Venetian and pontifical armies as well as a thoughtful patron of the arts. As an heir to Pope Julius II, he was involved in protracted negotiations with Michelangelo over the latter's contractual obligations regarding Julius's tomb.

341. Secretary to Duke Cosimo who was made Bishop of Penna (now Penne) by Pope Pius IV in 1561 and attended the Council of Trent as an ecclesiastical lawyer.

342. Gerolamo degli Albizzi (d. 1555) was related to, and a staunch supporter of, the Medici, becoming Commissary-General of the Florentine Ordnance under Duke Cosimo.

343. Alamanno was the son of Jacopo Salviati, Duke Cosimo's maternal uncle, and apparently a loafer.

344. From 1553 to 1562, Antonio de' Nobili was Comptroller-General of Duke Cosimo's Treasury, having supported the Medici when they were out of power. He was painted by Vasari.

345. The former, father of a talented painter Lucrezia praised by Vasari and taught by Alessandro Allori, Bronzino's pupil, was auditor of the Exchequer in Florence, then Captain of Justice at Siena. Polverino, Cosimo's *fiscale*, was among the Duke's most hated ministers, among other things for having devised an especially harsh law (The *Polverina*) against the sons of rebels.

346. Onofrio Bartolini (*c.* 1501–56), made Archbishop of Pisa by Pope Leo X

in 1518 (when he was about seventeen) was all his life a staunch supporter of the House of Medici. He was one of the hostages handed over to the Imperialists after the sack of Rome in 1527, was declared a rebel against Florence in 1529, and accompanied Alessandro de' Medici on the latter's expedition to Naples in 1535.

347. After serving Catherine de' Medici, wife of the Dauphin of France, as cup-bearer, Pandolfo di Luigi della Stufa was imprisoned for allegedly revealing King Francis's military plans to Cosimo de' Medici. He was then freed on condition that he left France. Cosimo de' Medici appointed him one of Florence's Forty-Eight Senators in 1561.

348. Torelli (1489–1576), from Fano, was successively Duke Cosimo's chief auditor and first secretary. A writer on law and of verse, he was made a senator in 1571.

349. It was his father Baccio d'Agnolo, not Giuliano himself, who designed the gallery for the dome. (Cf. Cust, *Life of Benvenuto Cellini*, Vol. II, p. 391.)

350. Cellini is referring to Lorenzo Ghiberti's *Porta del Paradiso* on the Florence Baptistery. Completed in 1452, it consisted of ten large panels with scenes from the Old Testament and broke new ground in the depiction of space and narrative.

351. Piero d'Alamanno d'Averardo Salviati (1504–64), after being prominent in opposing the Medici grew friendly as he grew older with Duke Cosimo who appointed him one of the Forty-Eight.

352. Cellini did start work on the reliefs, the pulpits and the door for the (third) choir of Santa Maria del Fiore, which had been commissioned from Bandinelli and Giuliano di Baccio d'Agnolo in 1547. In July 1563 Cellini was working on a 'scene with Adam' modelled in wax on slate for casting in bronze; but probably from impatience over the progress being made, his involvement stopped. (Cf. Pope-Hennessy, *Cellini*, pp. 269–70.)

353. There is a gap of several years in Cellini's narrative at this point. It picks up with his inspection of the marble for the statue of Neptune in 1559. In 1556, after brutally assaulting the goldsmith Giovanni di Lorenzo with a cudgel, he was imprisoned for forty-six days before being released on bail. In February 1557 came his imprisonment after he had confessed to sodomy with Ferrando da Montepulciano. (Cf. Introduction p. xii.) *Chi dice ch'io son per Ganimede*, Cellini wrote in a Sonnet (XXXIV) composed in gaol, alluding to this episode. He was released on 27 March and confined to his house.

354. Florence was a notoriously competitive city, at least for artists. The competitions for the cupola of the Duomo and the Baptistery doors respectively, to which Cellini refers, are dramatically described in Vasari's *Lives* of Brunelleschi and Ghiberti; *see also* Ghiberti's *Second Commentary*.

355. By the time Bandinelli died in February 1560, five other sculptors were competing to make the figure of Neptune: Bartolomeo Ammannati, Giovanni Bologna, Vincenzo Danti, Francesco Moschino and Vincenzo de' Rossi, Bandinelli's inept pupil. The *Fountain of Neptune* carved by the winner Ammanati is on the Piazza della Signoria, Florence. For its development cf. Pope-Hennessy *Italian High Renaissance and Baroque Sculpture*, pp. 374–6. A record of one of the wax models may be provided by the bronze statuette of Neptune in the North Carolina Museum of Art. (*See also* Pope-Hennessy, *Cellini*, p. 274.)

356. Bandinello or Bandinelli was aged seventy-two when he died on 7 February 1560, according to Vasari, who noted that he left to his family many possessions in land, houses and money and to the world works in sculpture and many excellent drawings.

357. The marble Crucifix (overall height 185 cm, height of figure 145 cm) is in the monastery of San Lorenzo el Real, Escorial, Spain. Reconstructed by P. Calamandrei (*Scritti e inediti Celliniani*, Florence, 1971, pp. 59–98) the story of the Crucifix is summarized admirably by Pope-Hennessy from the time of Cellini's vision in Castel Sant'Angelo in 1539, to its installation in the Escorial in 1576. Following Michelangelo's perfected marble carving technique, using life-size models, Cellini challenged the beauty of Michelangelo's *Risen Christ* to produce with the full resources of his visionary power a work conceived as drama, 'a work of incomparable accomplishment' embodying 'the technical sophistication, the humanity, and the imaginative sweep of the Renaissance at its height' (*Cellini*, pp. 255–60).

358. Bartolomeo d'Antonio Ammannati (1511–92), Florentine sculptor and architect, studied with Jacopo Sansovino. In his *Life* of Sansovino, Vasari told how he found work for his friend Ammannati with Pope Julius III and Duke Cosimo e.g. statues in marble and bronze and on the fabric of the Pitti palace as well as the numerous fortifications throughout Tuscany. He is credited with reconstructing Ponte SS Trinita after the great flood of 1557.

359. Giambologna (*c.* 1529–1608) was born at Douai in Flanders, then a flourishing and innovative artistic centre, studied with Vasari in Rome, and after producing numerous secular, sensuous works under the Grand Duke in Florence, turned to religious themes to 'forge virtually single-handed an acceptable Counter-Reformation style of sculpture'. (Cf. Charles Avery, *Giambologna*, London 1987, p. 28.)

360. Danti (1530–76) worked for Duke Cosimo in bronze (not always successfully) and marble, and was befriended by Vasari as 'a young man truly rare and of fine talent'. (Cf. Vasari's *Lives 'Degli Accademici del Disegno'*.) His brother was a renowned mathematician, the Dominican friar Ignazio Danti.

361. In fact it was Moschino (Francesco di Simone Mosca 1546–78) who began

the model. In his short life he worked in the Duomo at Orvieto, was then attached by Duke Cosimo to the Office of Works of the Duomo at Pisa and then briefly joined the Farnese at Parma.

362. Giorgio Vasari.

363. With his family and courtiers, Duke Cosimo made a state entry into Siena on 28 October 1560.

364. Two wax models of Neptune were listed in the inventory of Cellini's possessions when he died: a *modellino non finito* and a *modello*, the latter definitely related to the fountain. A bronze statuette in the North Carolina Museum of Art at Raleigh may well record one of the wax models. (Cf. Pope-Hennessy *Cellini*, pp. 274–5.) Cellini, through illness and perhaps disappointment with it, never finished his *Neptune*.

Ammannati's figure on the Piazza della Signoria speaks dismally for itself; Giambologna's lost model of Neptune, which was followed by the execution of his 'magnificent colossus' of the same sea god for Bologna in 1566, was surely the best. (Cf. Avery, *Giambologna*, p. 18 and pp. 206–7.)

365. A criminal lawyer, of peasant origins, who flourished in the service of Duke Cosimo and was eventually created Duke of Penna.

366. The Crucifix was bought from Cellini by Duke Cosimo in 1565 and it stayed in the Pitti palace till 1576. Grand Duke Francesco I – creator of the Uffizi picture gallery – sent it with other gifts to Madrid to propitiate King Philip II of Spain.

367. Daniele Ricciarelli of Volterra (1509–66) was a pupil of Peruzzi and assisted and then succeeded the painter Perino del Vaga in numerous projects in Rome where he emulated and became a staunch professional friend of Michelangelo. He became obsessed with sculpture and through Vasari's influence won commissions from Duke Cosimo. Catherine de' Medici had him make a bronze horse to take the statue of her dead husband King Henri II which was eventually re-used to take the figure of Louis XIII in the Place Royale (now the Place des Vosges) in Paris where it stayed till 1792 after which it was melted down. It was he who painted over parts of Michelangelo's *Last Judgement* in the Sistine Chapel deemed to be indecent, after Michelangelo's death. For this, he was nicknamed *Braghettone* (Breeches Maker).

368. The Prince, Francesco de' Medici, left Livorno (Leghorn) for Spain in May 1562. While he was away, Cosimo renounced the government of the Grand Duchy in his favour.

369. Going by Siena and Grosseto, Cosimo, with his wife and children, left Florence for the fortress of Rosignano in October 1562.

370. Cardinal Giovanni, the Duke's second eldest son, died at Rosignano in November 1562.

371. Giovanni's brothers, Don Garzia and Don Ferdinando, also fell ill at this time. Garzia died at Pisa on 6 December and 12 days later his mother Eleonora of Toledo also died.

Here the manuscript of Cellini's *Life* ends suddenly. Cellini died on 13 February 1571 and was buried in the chapel of the Academy of Design in the church of the Annunziata. The detailed inventory of the contents of his house included in the *anticamera*: swords, pistols, a Turkish knife, a silver dagger and an assegai; a large quantity of clothes and sheets; and, in a chest, the privileges awarded him by the King of France; in the dining *sala*: trestles, chairs and six brass candlesticks; in the *camera*, next to a closet with the clothes of his late wife, Madonna Piera: pewter plate and dishes and a packet of low value jewels; in another large room: a painting of St Sebastian, a framed portrait of Cellini himself; an inlaid wooden bed by Tasso; the *gesso* model of the *Perseus* and '*una Cleopatra*'; in the vault: casks of wine and hangings waiting for repair; in the stable: with saddle and saddle cloth, a white horse blind in one eye. (Cf. Pope-Hennessy, *Cellini*, pp. 283–4.)

SELECT BIBLIOGRAPHY

A general, enthusiastic and authoritative assessment of Cellini's artistic achievement is to be found in the Introduction by Pope-Hennessy to one of the texts of Symonds' translation of the *Life* (Phaidon, 1949). For a fuller discussion of Cellini's work as a sculptor, both the student and the general reader can profitably go to Pope-Hennessy's illuminating volumes *Italian High Renaissance and Baroque Sculpture* (Phaidon, 1963). *Tutta L'Opera del Cellini* (Rizzoli, 1955) provides a useful, illustrated companion to the *Life*.

Avery, C., *Giambologna: The Complete Sculpture* (London, 1987)

Borsellino, N., 'Benvenuto Cellini' in *Dizionario biografico degli Italiani*, Vol. 23, pp. 440–51 (Rome, 1979)

Bull, G., *Michelangelo: A Biography* (London, 1995; New York, 1997)

Bush, V. L., *Colossal Sculpture of the Cinquecenta* (New York, 1976)

Cervigni, Dino Sigismondo, *The 'Vita' of Benvenuto Cellini: Literary Tradition and Genre* (Ravenna, 1979)

Cox-Rearick, J., *The Collections of Francis I: Royal Treasures* (Antwerp, 1995)

Plon, E., *Benvenuto Cellini, orfèvre, médailleur, sculpteur: Recherches sur sa vie, sur son oeuvre, et sur les pièces qui lui sont attribuées* (Paris, 1883)

Pope-Hennessy, J., *Cellini* (London, 1985)

Rossi, P. L., 'Sprezzatura, patronage and fate; Benvenuto Cellini and the world of words' in *Vasari's Florence: Artists and Literati at the Medicean Court*, ed. P. Jacks, pp. 55–69 (Cambridge, 1998)

—— 'The writer and the man – real crimes and mitigating circumstances – il caso Cellini' in *Crime, Sexual Misdemeanour and Social Disorder in Renaissance Italy*, eds K. Lowe and T. Dean, pp. 157–83 (Cambridge, 1994)

Rubin, Patricia Lee, *Giorgio Vasari: Art and History* (New Haven and London, 1995)

Scalini, M., *Benvenuto Cellini* (New York, 1995)

Scher, Stephen K. (ed.), *The Currency of Fame: Portrait Medals of the Renaissance* (New York, 1994)

Vasari, Giorgio, *The Lives of the Artists*, a selection translated by G. Bull, 2 vols. (Penguin Books, 1987)
Wittkower, Rudolf, *Sculpture: Processes and Principles* (London, 1977)

Italian texts

Benvenuto Cellini: Opere non esposte e documenti notarili, ed. Dario Trento (Florence, 1984)
Cellini *Vita*, Ms in Biblioteca Mediceo-Laurenziana, codice Mediceo Palatino 234², Florence.
——*Vita di Benvenuto Cellini: Testo critico. . .*, ed. O. Bacci (Florence, 1901)
——*Vita, Ricordi, Prose e Poesie di B. Cellini*, 3 vols. ed. F. Tassi (Florence, 1829)
Cellini, B, *Vita*, ed. E. Camesasca (Milan, 1995)
Opere di Baldassare Castiglione Giovanni Della Casa Benvenuto Cellini, ed. Carlo Cordie (with excellent *Nota Bio – Bibliografica*) (Milan–Naples, 1960)
Cellini, B., *Due Trattati*, intro. A. Altomonte, ed. Aldine, Modena, Fac. of 1568 ed. (Pieri, 1983)
Avery, C., Barbaglia, S., *L'opera completa del Cellini* (Milan, 1981)
Guglielminetti, M., *Memoria e scrittura autobiografia da Dante a Cellini* (Milan, 1977)
Calamandrei, P., *Scritti e inediti Celliniani* (Florence, 1971)

Translations into English

The Life of Benvenuto Cellini, trans. T. Nugent, 2 vols. (London, 1771)
The Life of Benvenuto Cellini, trans. J. A. Symonds, 2 vols. (London, 1887)
The Life of Benvenuto Cellini, trans. R. Cust, 2 vols. (London, 1910)
The Treatises of Benvenuto Cellini on Goldsmithing and Sculpture, trans. C. R. Ashbee (London, 1888; New York, 1967)
The Autobiography of Benvenuto Cellini, ed. and abridged Charles Hope and Alessandro Nova, from the translation by John Addington Symonds (Oxford, 1983)

INDEX

408
851
2399